Appoined Mannifeseturing Sean Product Analysis Third Edition

Ruth E. Glock Iowa State University

Grace I. Kunz Iowa State University

Prentice Hall

Upper Saddle River, New Jersey

Columbus, Ohio

Library of Congress Cataloging-in-Publication Data

Glock, Ruth E.

Apparel manufacturing: sewn product analysis / Ruth E. Glock and Grace I. Kunz. — 3rd ed.

p. cm.

ISBN 0-13-084663-5

1. Clothing trade. 2. Clothing factories—Quality control.

3. Quality of products. I. Kunz, Grace I. II. Title.

TT497.G56 2000

687-dc21

99-16434

CIP

Cover Art: The Stock Market Editor: Elizabeth Sugg

Production Editor: Mary M. Irvin

Editorial Production and Design: Carlisle Publishers Services

Design Coordinator: Diane C. Lorenzo

Cover Design: Ceri Fitzgerald

Production Manager: Pamela D. Bennett Director of Marketing: Debbie Yarnell Marketing Manager: Shannon Simonsen Marketing Coordinator: Adam Kloza

This book was set in Garamond by Carlisle Communications, Ltd. and was printed and bound by R. R. Donnelley & Sons Company. The cover was printed by Phoenix Color Corp.

©2000, 1995 by Prentice-Hall, Inc.

Pearson Education

Upper Saddle River, New Jersey 07458

All rights reserved. No part of this book may be reproduced, in any form or by any means, without permission in writing from the publisher.

Earler edition © 1990 by Macmillan Publishing Company.

Printed in the United States of America

1098765

ISBN: 0-13-084663-5

Prentice-Hall International (UK) Limited, London Prentice-Hall of Australia Pty. Limited, Sydney Prentice-Hall of Canada, Inc., Toronto Prentice-Hall Hispanoamericana, S. A., Mexico Prentice-Hall of India Private Limited, New Delhi

Prentice-Hall of India Private Limite Prentice-Hall of Japan, Inc., Tokyo

Prentice-Hall (Singapore) Pte. Ltd., Singapore

Editora Prentice-Hall do Brasil, Ltda., Rio de Janeiro

Preface

As academicians, our goal for the revision of this textbook is to provide an improved representation of a broad conceptual and somewhat theoretical perspective of apparel manufacturing to provide a foundation for future apparel professionals. Realizing the importance of including an "insider's" perspective, we consulted professionals about the operation of their businesses and response to their markets. We have developed close working relationships with many apparel professionals, have used trade publications liberally, and have participated in numerous apparel-related conferences and workshops to supplement academic research and personal observations.

As teachers and student mentors, we believe the purpose of the third edition of Apparel Manufacturing: Sewn Product Analysis is the same as the purpose of the first edition (only to do it better): to assist textile and apparel students to better understand garment manufacturing and the decision making involved in marketing, merchandising, and producing apparel. We strongly believe that a study of apparel manufacturing unifies many of the traditional offerings of textiles and clothing programs, including garment design, pattern making, retail merchandising, and textile science. Based on the assumption that the ultimate goal of a successful business is satisfying target customers, this third edition of the text offers a comprehensive, professional approach to apparel manufacturing, using industry language with an academic orientation and an improved conceptual framework reflective of changes in the industry.

This textbook is still divided into five parts that focus on the factors that determine the cost, price, quality, performance, and value of garments; but the conceptualization of the parts has been refined and the sequence reordered in response to comments from our reviewers. As with the second edition, the processes involved in merchandising, marketing, and producing product lines are presented as a system of interrelated management decisions.

Part I, "Introduction to Apparel Manufacturing," still deals with issues associated with the concepts of product performance and quality, the functional organization of apparel manufacturing firms, and the complexities of operating in a world market. The first chapter in this part is "Organization of the Apparel

Business." Part I also includes updated versions of the chapters "Marketing Strategies" and "Merchandising Processes." Merchandising includes a new application of merchandise planning concepts.

Part II is titled "Product Development." It includes three chapters that deal with issues related to the role of product analysis including career opportunities, product standards and specifications, and creative and technical design, including a new section on fit.

Part III is titled "Dimensions of Apparel Management." It includes chapters that deal with management of quality in a global textile complex, a new chapter that integrates materials sourcing and selection, a new chapter on production planning and sourcing, and an updated chapter on costing, including a new section on cost/volume relationships.

Part IV, "Focus on Production," now consists of five chapters related to the production function beginning with apparel engineering. Additional chapters include production management; preproduction operations; stitches, seams, thread, and needles; and equipment for assembly and finishing.

Part V is now called "Findings Management" and includes three chapters focusing on issues related to support materials, closures, and trims. The detail provided in these chapters is essential for development of effective product specifications.

As with the second edition, three appendices discuss applications of the garment analysis system. Styling, materials selection, and assembly methods for three basic products are analyzed relative to target markets, price range, and consumer expectations.

This sequence of presentation and the many updates and revisions in every chapter guide students from the general to the specific and from observation/exploration to application, analysis, and synthesis. Throughout the study of this subject matter, it is essential to give hands-on experiences examining garment assemblies and materials while analyzing issues, processes, and costs. The fundamentals of textile science are related to merchandising and marketing decisions involved in manufacturing apparel at different price levels. It is assumed that students using this text will have taken a beginning textiles course.

Acknowledgments

We appreciate the ongoing support of our colleagues at Iowa State University. In particular we would like to mention three recent graduates: Donette Ambrosy, Nicole Bakley, and Elizabeth Bull, and graduate student Seung Eun Lee. We would also like to thank many individuals in the apparel industry, including Regina Bakker, Mike Fralix, Travis Horton, Doug Kanies, Ken Sandow, and Nancy Staples, for their helpful suggestions, comments, and materials.

We are most grateful to the many apparel organizations and firms who provided information, materials, advice, and generous assistance: Airtex, Ameri-

Preface v

can Apparel Manufacturers Association Education Committee and Quick Response Leadership Committee; American Efrid Inc.; Apparel Industry Magazine; Bierrieba International; Bobbin Group-Miller Freeman, Inc.; Byte Systems, Inc.; Cotton Inc.; Courtaulds, DeLong Sportswear; Healthtex; Iowa Textile Apparel Association; John Boyt Industrial Sewing; Juki Union Special Corp.; Lands' End; Milliken and Co.; Pendleton Woolen Mills; ShopKo; Singer Company; Textiles/Clothing Technology Corp.; and Touch of Lace.

We would like to thank the reviewers of this manuscript for their helpful suggestions, including Iowa State graduate students Natalie Johnson and Hyunmee Joung. Faculty peer reviewers included Jane Farrell-Beck, Iowa State University and Anne-Marie Allen, Fashion Institute of Design and Merchandising; Bonnie D. Belleau, Louisiana State University; Muthu Govindaraj, Philadelphia College of Textiles and Science; and Saul Smilowitz, Fashion In-

stitute of Technology.

Ruth E. Glock Grace I. Kunz

Contents

Introduction to Apparel Manufacturing

Organization of the Apparel Business

Structure of the Apparel Industry

Nature of Apparel

PART I

Chapter 1

	Functional Organization of Apparel Firms 18	
	 Summary 26 • References and Reading List 26 • Key Words Discussion Questions and Activities 28 	27
Chapter 2	Marketing Strategies 29	
· · · · ·	Marketing Responsibilities in Apparel Firms 30 Strategic Marketing Processes 32 Retail and Wholesale Marketing Strategies 38 Labeling and Licensing 45	
	 Summary 57 • References and Reading List 58 • Key Words Discussion Questions and Activities 59 	59
Chapter 3	Merchandising Processes 61	
	Context of Merchandising 62 Concepts of Apparel Product Lines 64 Dimensions of Product Change 66 Nature and Timing of Merchandising Responsibilities 71 • Summary 89 • References and Reading List 90 • Key Words	90
	Discussion Questions and Activities 91	
PART II	Product Development 93	
Chapter 4	Role of Product Analysis 96	
	Processes of Product Analysis 99 Professional Perspectives on Product Development 125	

	 Summary 133 • References and Reading List 134 • Key Words Discussion Questions and Activities 135 	134
Chapter 5	Product Standards and Specifications 137 Sources of Product and Quality Standards 138 Standards for Quality, Fit, and Performance 139 Using Specifications 142 Writing Specifications for Apparel Manufacturing 147 • Summary 153 • References and Reading List 153 • Key Words • Discussion Questions and Activities 154	154
Chapter 6	Creative and Technical Design 155 Influences on the Design Process 156 Creative Design 158 Technical Design 173 Apparel Design Technology 183 • Summary 187 • References and Reading List 188 • Key Words • Discussion Questions and Activities 189	188
PART III	Dimensions of Apparel Management 191	
Chapter 7	Management of Quality 193 The Global Textile Complex 194 Systems for Quality Management 200 Methods for Assuring Quality 208 Costs and Benefits of Quality Programs 217 • Summary 221 • References and Reading List 222 • Key Words • Discussion Questions and Activities 223	222
Chapter 8	Materials Sourcing and Selection 225 Role of Sourcing in an Apparel Firm 226 Materials Sourcing Processes 231 Selecting Fabrics 234 Predicting Aesthetics and Performance 241 Evaluating Fabric Quality 250 • Summary 261 • References and Reading List 262 • Key Words • Discussion Questions and Activities 263	262
	Production Planning and Sourcing 265 Production Strategies and Concepts 266 Planning Production 269 Determining Sources of Production 276 Production Sourcing Priorities and Processes 283 • Summary 290 • References and Reading List 290 • Key Words 2	291
	• Discussion Questions and Activities 291	

Chapter 10	Costs, Costing, Pricing, and Profit 293 Costs and Profits 294 Systems of Costing 297 Stages of Costing 304 Determining Product Costs 307 Cost/Volume Relationships 313 Pricing Strategies 319 • Summary 326 • References and Reading List 326 • Key Words 3 • Discussion Questions and Activities 328	27
PART IV	Focus on Production 329	
Chapter 11	Apparel Engineering 331 Work Flow 332 Apparel Production Systems 337 Production Processes 347 Work Study 351 Ergonomics 358 • Summary 362 • References and Reading List 363 • Key Words 3 • Discussion Questions and Activities 364	63
Chapter 12	Production Management 365 Productivity Concepts 365 Human Resource Management 367 Inventory Management 377 Equipment Management and Plant Modernization 379	
	• Summary 386 • References and Reading List 387 • Key Words 3 • Discussion Questions and Activities 388	87
Chapter 13	Preproduction Operations 389 Initiation of Preproduction Operations 390 Marker Making 392 Spreading 399 Cutting 410 • Summary 423 • References and Reading List 424 • Key Words 4 • Discussion Questions and Activities 425	:24
	Stitches, Seams, Thread, and Needles 427 Stitches 428 Seams 441 Sewing Threads 456 Needles 467 Seam Appearance and Performance 470 • Summary 477 • References and Reading List 477 • Key Words 4 • Discussion Questions and Activities 479	178

Glossarv

Index

647

667

Chapter 15 Equipment for Assembly and Pressing 481 Stages of Technology Advancement 482 Sewing Machine Fundamentals Work Aids 494 Pressing Equipment 498 Summary 506 References and Reading List 506 Key Words 506 Discussion Questions and Activities 507 PART V Findings Management **Chapter 16 Support Materials** Purposes of Support Materials 512 Interlinings 515 Linings 524 Other Support Materials 530 • Summary 535 • References and Reading List 535 • Key Words 536 Discussion Questions and Activities 536 Chapter 17 Closures 537 Purposes and Costs of Closures 538 Zippers 539 **Buttons and Buttonholes** 546 Snaps and Hooks 559 Elastic 562 Hook-and-Loop Tape 567 • Summary 570 • References and Reading List 570 • Key Words 570 Discussion Questions and Activities 571 Chapter 18 Trims 573 Types and Sources of Trims 574 Knit Trims 577 Embroidery 578 Appliqués, Insets, and Lace Trims 591 Screen, Heat Transfer, and Digital Printing 594 Labels • Summary 602 • References and Reading List 602 • Key Words 603 Discussion Questions and Activities 603 Appendix Garment Analysis Application #1 Analysis of T-Shirts 605 Garment Analysis Application #2 Analysis of Men's Dress Pants 613 Garment Analysis Application #3 Analysis of Men's Dress Shirts 629

PART WAL

Introduction to Apparel Manufacturing

Chapter 1 Organization of the Apparel
Business

Chapter 2 Marketing Strategies

Chapter 3 Merchandising Processes

Organization of the Apparel Business

OBJECTIVES

- Examine aspects of the apparel business that make it unique.
- Obscribe the organizational structure of the apparel business and the trend toward verticalization.
- Identify and define business terminology as used by the apparel manufacturing industry.
- Obscuss the trend toward globalization in the world market.
- **©** Examine the functional areas of specialization necessary for an apparel firm.

Over the past 150 years, the apparel business has evolved from custom fitting and assembling of individual hand-sewn garments to the mechanized, automated, and sometimes robotized mass production and distribution of ready-to-wear in the global market. Looming on the horizon is the newest innovation in apparel manufacturing known as **mass customization**. Compared to many other product lines, apparel manufacturing remains labor-intensive. Because of the variety of product categories, the endless change in materials and styling, and the difficulty in handling soft goods, manual production operations are usually needed. Advancements in technology have

increased the functions and capabilities of machines and equipment, but complexities of manipulating flexible materials and dealing with constantly changing styles limit the degree of automation for many production operations.

Nature of Apparel

The apparel industry is a broad-based global system of merchandising, marketing, producing, and distributing. Business success is dependent on meeting customers' needs. Apparel industry participants seek levels of apparel performance and quality suited to price limitations, cost structures, product standards, profit goals, and target customers' needs and wants. However, assumptions about correlation among price, performance, and quality may be faulty in today's apparel markets.

The apparel business involves a diverse group of products made primarily of textile materials. The variety of product types that make up apparel is reflected by the North American Industry Classification System (NAICS) that replaced the U.S. Standard Industrial Classification (SIC) in 1997. NAICS was developed to allow consistent coding of industry activity within the United States, Canada, and Mexico, the three countries currently participating in the North American Free Trade Agreement (NAFTA). NAICS is a hierarchical system that uses a six-digit code for defining industries. The first two digits define the major economic sector, the third digit the economic subsector. The textile and apparel manufacturing subsectors identified by three-digit codes are 313—textile mills, 314—textile product mills, 315—apparel manufacturing, and 316—leather and allied products. The fourth digit indicates the industry group and the fifth digit the specific industry. The sixth digit is used by individual countries to define smaller industry segments (see Table 1–1).

Table 1–1 Example of NAICS hierarchy.

NAICS Level	NAICS Code	Description
Economic Sector	31–33	Manufacturing
Economic Subsector	315	Apparel Manufacturing
Industry Group	3152	Cut and Sew Apparel
		Manufacturing
Industry	31521	Cut and Sew Apparel
		Contractors
U.S. Industry	315212	Women's and Girl's Cut and
		Sew Apparel Contractors

Source: Based on Farr, B., & Stone, J. (1998, January). *NAICS codes replace SIC system for NAFTA traders*. Iowa State University: Textiles and Clothing Extension.

Timing of Product Change

The apparel business is widely known as the **fashion business** because fashion change is so intimately associated with apparel in the minds of most people. According to fashion theory, consumers quickly become bored with whatever is widely accepted; thus, they constantly seek new and different variations of products and activities. **Fashion change** relates to changes in color, styling, fabrication, silhouette, and performance to reflect fashion trends. **Seasonal change** is often confused with fashion change. Seasonal change results in modification of products available on the market and used by consumers according to the time of the year. Factors influencing seasonal change include the weather, holidays, beginning and ending of the school year, and cultural and religious traditions. Change in apparel is accepted and expected by most manufacturers, retailers, and consumers.

The combination of fashion change and seasonal change makes the apparel business the most change-intensive business in the world. Apparel professionals plan and implement product changes based on interpretations of target customers' needs and wants. Apparel firms must be flexible and completely oriented to change since many develop five product lines a year; some introduce new styles on a monthly or even weekly basis. Managing change requires careful timing. A **fashion** or seasonal product that hits the market a few days late may be totally unsalable. Thus, apparel manufacturers and retailers are constantly working against deadlines. Labor intensity, soft materials, fashion trends, seasonal change, and critical timing make the apparel business unique.

Quality

The term *quality* as applied to apparel has a multiplicity of meanings. **Quality** is the essential nature of something, an inherent or distinguishing characteristic or property, superiority, excellence, or a perceived level of value. Exact characteristics that are perceived as **quality features** vary according to the standards of each individual. However, interpretations of relationships between apparel quality and performance are subject to individual experiences, understandings, standards, and expectations. To some people, quality is goodness or luxury. To others, quality is durability, beauty, labels, or high prices. Clearly, consumers rely on a wide variety of cues to determine whether products meet their quality standards. The quality characteristics that should be incorporated into a product line are those that customers desire and are willing to pay for and that can be cost-effective.

Perceived quality is a composite of intrinsic and extrinsic cues to quality. Intrinsic quality is created during product manufacturing and is dependent on styling, fit, materials, and assembly methods. Intrinsic cues relate to the innate and essential parts or inherent nature of a garment. In general, customers are not well-informed about properties of fibers, yarns, fabrics, finishes, and garment assembly processes to evaluate intrinsic quality and performance

of apparel. Therefore, an objective analysis of the intrinsic quality or performance of apparel is often not possible.

Consequently, extrinsic cues are sometimes regarded as indicators of intrinsic quality. **Extrinsic cues** originate from outside the product and are not inherent parts of the product. Prices, brand names, reputations of retailers, visual merchandising techniques, and advertising are common extrinsic cues (see Figure 1–1). Extrinsic cues seem to be less complex to interpret than intrinsic cues. Manufacturers and retailers frequently use extrinsic cues to influence perceptions of product quality, value, and performance.

Price

Price is one of the primary extrinsic cues relative to quality. The general **price** classifications of low-end, budget, moderate, better, bridge, and designer are widely used to describe merchandise sold in apparel markets. Each price classification represents a general price range.

Low-end and budget price classifications make up well over half the apparel merchandise sold in U.S. retail markets. Mass merchandisers and discounters, such as Kmart, Wal-Mart, Target, and Sears, have high proportions of their assortments made up of budget merchandise. Most budget merchandise, while comparatively low in price, provides adequate performance and quality to meet the needs of a large proportion of the U.S. population. In low-end and budget markets, price is the primary point of competition, which makes con-

Figure 1–1
Extrinsic cues create
perceptions of quality, value, &
performance.
Courtesy of Pendleton Woolen Mills

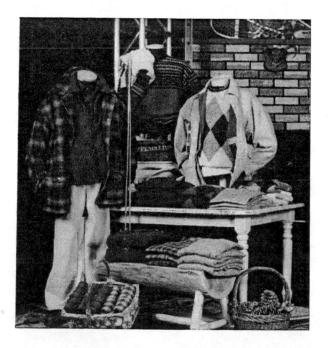

trolling costs of production and materials a necessity. Low-end and budget manufacturers control costs by using less expensive fabrics and other materials. Production costs may also be contained by combining or eliminating steps in manufacturing processes or implementing less rigid quality standards. However, interpretations of relationships between apparel quality and performance are subject to individual experiences, understandings, standards, and expectations.

Moderate price classifications have their own core customers plus fringe customers from the budget and better price ranges. Budget customers may shop for moderate-priced garments when they are on sale or for special-occasion garments. Better customers may shop for moderate merchandise when they perceive styling, quality, or status to be less important. Moderate merchandise makes up most of what is sold in community and regional malls in the United States. Most department and specialty stores carry the majority of their merchandise in the moderate and upper-moderate category. Nationally advertised brands of apparel tend to be upper-moderate-, moderate-, or lower-moderate-priced merchandise. Moderate-priced merchandise often has a conglomeration of product characteristics, some of which may be typical of budget or better categories. Moderate merchandise is designed to meet the fashion, performance, and quality needs of middle America.

Markets for apparel sold within the better, bridge, and designer price classifications represent a comparatively small proportion of the total U.S. population. A few nationally known retailers, such as Neiman-Marcus and Saks Fifth Avenue, specialize in better, higher-priced apparel, as well as a few specialty chains and local independent retailers. Some mainstream department stores carry better apparel in a few departments that specialize in upscale quality. Manufacturers of better, bridge, and designer apparel meet market demands with more focus on styling and fit, selection of unique fabrics and other materials, and use of more complex construction techniques. Styling and quality are the primary selection criteria for this price classification. Manufacturers of better apparel have more options available in design and production because they have different cost limitations than manufacturers of budget or moderate. The better market demands more exclusivity, uniqueness, and commitment to a total image. The result is usually greater focus on intrinsic quality.

Constant of the Apparel Industry

Structure of the Apparel Industry

The organizational structure of the apparel industry can be divided into four levels, beginning with the production and distribution of materials at the mill products level and ending with the consumer (see Figure 1–2). The model reflects the strong trend toward both forward and backward vertical integration in the industry (Henricks, 1997). At the **mill level** (Level 1), materials, such as fabrics, zippers, threads, trims, and buttons, are manufactured and sold to

Figure 1–2
Organization of the current U.S. apparel industry.

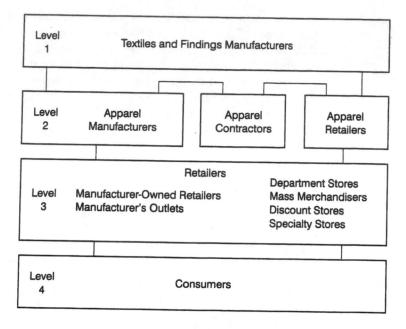

apparel firms. Some apparel manufacturers buy from vendors' open stock, and others have products developed to their specifications. A few apparel manufacturers are backward vertically integrated with textile production and therefore may produce in their own plants all or some of the materials used to make their garments.

At the **apparel manufacturing level** (Level 2), apparel firms are responsible for the marketing, merchandising, and production of products. Apparel manufacturers have two types of organizational structures: (1) those that perform all or nearly all of their manufacturing within their own facilities and by their own employees and (2) those that contract some or all of the manufacturing functions to other firms.

Apparel contractors are sources of many goods and services. Contractors are firms that make a profit by providing sewing or specialty services to one or more apparel manufacturers, retailers, or government agencies. Contractors may also source materials and develop patterns for the manufacturing firm. They sometimes enter competitive bidding for sewing jobs by submitting bids based on estimates of production costs for a given volume of output. Contractors can be located anywhere in the world where there is an inexpensive labor supply. Regardless of location, they are responsible for meeting specifications and delivery dates set by the firms that contract their services. Contractors do not own the products on which they work.

Notice that Level 2 of Figure 1-2 indicates backward vertical integration of apparel retailers into the manufacturing sector through interaction with apparel contractors. This shows that retailers sometimes develop their own products and hire contractors to produce apparel that they want to sell in their stores, thus bypassing the manufacturer who is the traditional supplier. Retailers are also identified by store type in their traditional roles in Level 3, the **retail level**. Apparel firms (either manufacturer or retailer) that hire contractor services often buy materials, design, and sell the products produced. Sewing contractors may use the materials and patterns provided by manufacturers or retailers and provide equipment and labor to produce the finished garments according to the manufacturer's or retailer's specifications.

Many manufacturers and retailers hire **specialty contractors** to perform processes for which they lack skills or equipment. Special **operations**, such as making belts, pleating, printing, and/or embroidering, are contracted as needed for certain styles in a line. In addition, during the peak of a seasonal production period, many manufacturers hire contractors to supplement their own production capabilities. Contracting part of the regular production allows a manufacturer to maintain a consistent workforce without having to hire additional personnel to meet seasonal demands. It is also common for some manufacturers to provide contract services to other manufacturers. Contracting may provide work during otherwise slow periods or may add extra income for the manufacturer.

At the same time, as shown in Level 3, the production and distribution system for apparel has evolved so that manufacturers may be **forward vertically integrated** into the retail sector through owning their own stores. This gives the manufacturer direct contact with the consumer, which can aid decision making during product development. Retailers and manufacturers may be competitors at both the manufacturing and retailing levels, as well as suppliers and users in the distribution process. If manufacturers and retailers are not vertically integrated, merchandise is sold at wholesale through apparel markets or traveling sales representatives.

Level 4 represents **consumers**, who are the target and purpose of the entire textile and apparel industry. Satisfied consumers make business growth and profitability possible. Apparel manufacturing and retailing uses a complex, global trade matrix to integrate materials suppliers with manufacturers and retailers to provide finished goods for their customers.

Basic Business Concepts Applied to the Apparel Industry

Understanding fundamental business terminology is essential for describing the dynamic structure and organization of the apparel industry and the participating firms. An apparel manufacturing **firm**, **business**, or **company** is an association of people whose primary purpose is merchandising, marketing, producing, and distributing apparel for a profit. In this text the term *firm* is used when referring to a business organization. Firms are often composed of a combination of facilities that might include administrative offices, production facilities, sales offices, and/or retail stores. Administrative offices serve as a firm's

headquarters. A firm may own several plants. **Plants** are establishments that produce, package, and/or distribute items or services. It is important to use appropriate terminology when describing a firm's organization so that the meaning is clearly understood. Notice the use of the terms *plant* and *firm* in the following description:

Good Sports Manufacturing is a firm that has four production plants. Good Sports is engaged primarily in the manufacture of athletic wear. The headquarters and administrative offices of the firm are located adjacent to one of the four plants. The distribution center is also at the same location. Two other plants are located in the same town as the headquarters while the fourth plant is located about 60 miles away. Two plants produce primarily shorts and warm-up suits, and two produce T-shirts. The production from all plants is sent to the firm's distribution center for shipping to retailers.

LEGAL ORGANIZATION OF APPAREL FIRMS. As with most industries in the United States, an apparel firm may have one of five different types of legal organization: proprietorship, partnership, corporation, cooperative, or franchise. A **proprietorship** is a business owned by one person. That person has rights to all profits as well as all liabilities and losses. A **partnership** is a contractual agreement between two or more people who agree to share, not necessarily equally, in the profits and losses of the organization. A **corporation** is a company that is legally chartered to act as an individual. The capital of a corporation is divided into shares that are owned by **stockholders**. Stockholders share in a firm's expenses and profits based on the amount of their ownership, although they enjoy limited liability. Limited liability means stockholders are not financially liable for debts of a firm beyond the amount they have individually invested.

Another type of business organization sometimes used in the apparel business is the cooperative. A **cooperative** is a business enterprise, jointly owned by a group of persons or businesses, and operated without profit for the benefit of the owners. Cooperatives are sometimes used to provide services that individual apparel firms may not be able to afford to provide for themselves. For example, a group of apparel manufacturers located in the same geographic area might jointly establish a service for pleating fabrics or other specialty services.

A growing form of business organization in the apparel industry is franchising. **Franchising** is a contractual arrangement between a franchiser (a manufacturer, retailer, or service sponsor) and a franchisee that allows the franchisee to conduct a given form of business under an established name and according to a given pattern of business. Franchising is being used by some U.S. designers in establishing designer boutiques around the world.

Some firms are privately owned and others are publicly owned. **Publicly owned** companies have stock traded on a stock exchange and are required by law to publish annual reports of their business activities. **Privately owned**

firms have the assets or stock in the company owned by a few individuals who completely control the firm but they may be organized as proprietorships, partnerships, corporations, conglomerates, or cooperatives. Private firms are not required to reveal sales or profit figures; thus, little information is available as to their financial status. Since 1980, two of the largest apparel manufacturers in the United States, Levi Strauss and Blue Bell, went private after being publicly held for several decades. VF Corporation, which is a publicly held conglomerate, subsequently took over Blue Bell.

ESSENTIALS OF BUSINESS. Successful business management provides for growth and profit. **Growth** is measured by trends in sales, market share, productivity, earnings, profits, number of employees, and/or size or value of facilities and equipment. A firm has to grow just to stay even. Employees expect increases in pay over time; thus, a firm must experience growth in income to cover those increases. In an inflationary economy, costs increase, so a firm must have an increase in sales and/or productivity in order to pay for materials and overhead. Firms that do not grow tend to become static, stagnant, nonproductive, and nonprofitable.

Profits are monetary assets remaining after a firm has satisfied all of its financial obligations. Profit is the reward to the entrepreneur(s) or the corporation for the risks assumed in the establishment, operation, and management of a business enterprise. Profits can increase the income of owners of a firm or the earnings of shareholders, or profit can be reinvested in a firm to improve sales, productivity, and business opportunities. *Profit is the vehicle of growth*.

If firms are to grow and make a profit, there must be a market for the products they produce. A **market** for a product is the sales potential for a particular type of goods. **Market share** is a firm's percentage of the total sales in a market. It is one measure of a firm's success. A firm that is increasing its market share has sales rising more rapidly than the total market is increasing. In other words, the firm is taking some of the market away from its competitors. The market power of a particular firm is indicated by that firm's market share. **Market power** is the ability of a firm to control price and quantity of products in the market.

The level of competition in a particular market is measured by the market power of individual firms. Under competitive conditions, markets are characterized by many small firms, each with a small market share. From a social and economic standpoint, competition is desirable because it promotes efficiency in the use of resources and the lowest possible prices for the products produced. The apparel industry is a classic example of a highly competitive industry. While high levels of competition are viewed as desirable, firms seek to increase market share and market power so that they can price their products in a profitable manner.

Figure 1-3 provides an example of market shares of the largest firms in the athletic shoe market: Nike has the largest market share with 44 percent, Reebok is next with 16 percent, Fila is third with 7 percent, and Adidas is

Figure 1–3

Example of market share in athletic shoes.

Source: Barmash, I. (1997, October 9). In athletic shoes Nike/Footlocker, Reebok/Athlete's Foot are top brands, retailers. *Money Talks: The*

Emporium. Retrieved from the World Wide Web on March 3, 1998: http://www.talks.com/library/ib100997.html.

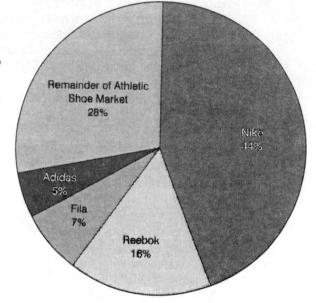

fourth with 5 percent. The combined market shares of the four largest firms is 72 percent with Nike controlling more than half. The remainder of the athletic shoe market (28 percent) is controlled by numerous firms, a growing number of which are U.S. apparel designers. As recently as 1990, Nike had a 30 percent market share and Reebok had 24 percent. Over the last few years Nike has come to dominate the supply of athletic shoes.

How Firms Grow. Growth is a necessity to stay in business. Growth can be accomplished through (1) internal growth, (2) vertical integration, (3) horizontal integration, or (4) conglomerate merger.

Increasing sales of established product lines is called **internal growth.** Product differentiation through effective advertising can result in increased demand from consumers and retailers and thus increased sales. An increase in a firm's sales may also be related to a general increase in sales in the market or an increase in the firm's market share.

Vertical integration is another means of growth for an apparel manufacturing firm. Vertical integration occurs when there is a merger between suppliers and users in the distribution matrix. A merger is the acquisition of the assets of one firm by another firm. As described earlier, vertical integration can be both forward and backward. While vertical integration appears to have several advantages, a limitation is reduced flexibility in production and distribution of the product line.

The Limited, Inc., a specialty retail conglomerate, seems to have maximized the benefits of vertical integration through its wholly owned subsidiary, Mast Industries. Mast provides one of the most sophisticated **sourcing** organizations in the world. A sourcing organization determines who will produce or provide the materials, products, and services needed to implement the firm's business plan. A few apparel manufacturers, such as Pendleton Woolen Mills, are fully vertically integrated in that they manufacture and distribute their products from the textile mill level through retail sales to the consumer. Pendleton is a privately owned firm based in Oregon that grows sheep for their wool, makes yarns, designs and manufactures fabrics, designs and makes apparel, sells first-quality goods to many retailers and in their own retail stores, and sells seconds and overruns in factory outlet stores.

Another means of growth for an apparel firm is through horizontal integration. Horizontal integration is accomplished through a merger with a competitor, that is, another firm in the same market. A horizontal merger reduces competition in the market. Thus, a horizontal merger increases market power. For example, if Firm A, a men's work clothing manufacturer, buys out Firm B, another men's work clothing manufacturer, the number of firms in that market will be diminished by one. Total sales in the market would not necessarily diminish because Firm B disappears from the market. Rather, the sales of Firm B become a part of the market share of Firm A. Thus, Firm A has achieved higher sales, a larger market share, and more market power without the promotional costs associated with stimulating internal growth.

A conglomerate merger is a takeover of a firm that is neither a supplier or user in the chain of production nor a competitor in the market. Therefore, a conglomerate is formed when firms involved in unrelated markets join under common ownership. Conglomerate mergers are used to secure a larger economic base, to acquire better leadership, and to gain greater potential profit. Conglomeration was a strong trend during the 1980s and 1990s.

Global Issues in Apparel Manufacturing

From a business standpoint, the term *globalization* is associated with viewing multiple sites in the world as markets and/or sources for producing or acquiring merchandise. **Global firms** use advanced communication and transportation technology to coordinate manufacturing and distribution in multiple locations simultaneously (Bonacich, Cheng, Chinchilla, Hamilton, & Ong, 1994). Both large and small firms are impacted by globalization because both are suppliers and buyers in the global market.

Many textiles and apparel industry participants believe that globalization favors large firms because of capitalization requirements, economies of scale, breadth of product lines, and sophistication of technology and communications systems. At the same time, globalization factors that favor smaller firms include flexibility; ability to serve niche markets; and offering unique, differentiated

products, and higher margin products (Made on Planet Earth, 1994). Disperse locations of production units have resulted in using more functional, smaller scale, and less expensive production equipment (Goldman, Nagel, & Preiss, 1995). Globalization of trade in textiles and apparel is so pervasive that it is nearly impossible for an apparel manufacturer or retailer not to be involved (Kunz, 1998).

International Trade Regulation

Globalization of the apparel industry means that most firms are involved in international trade. International trade is the exchange of goods between nations and all the issues associated with that exchange. International trade regulations establish barriers and limits on types and quantities of goods that cross political boundaries. Quantitative relationships between exports and imports determine the trade balance: exports — imports = trade balance. If the trade balance is negative, it is called a trade deficit. The United States has long had a trade deficit in apparel and developed a trade deficit in textiles during the 1980s. This means that the quantity and/or value of apparel imported exceeds the quantity and/or value exported. Most of the over 200 countries in the world export apparel to the United States.

A number of theories consider why nations trade; two of them are considered here. The **availability hypothesis** suggests that imports result when goods are not available in the domestic market because of lack of natural resources, lack of technological progress, and lack of product differentiation. The **variety hypothesis** suggests that consumers are able to buy greater varieties of goods as real income (spending power) increases. Since greater varieties of goods are available from a global market than from a domestic market, demand for imported goods increases when customers have more buying power. The variety hypothesis is particularly relevant for fashion goods because demand for fashion goods also increases as real income increases.

Whatever the reason for the exchange of goods between nations, international trade is always politically controversial. Should producers of domestic goods be "protected" from the competition of foreign-made goods? When goods can be made better or less expensively outside the country, jobs are lost in the domestic economy and domestic manufacturers lose market shares to foreign producers. Unemployment tends to have a downward spiraling effect on the economy. Workers may have to be retrained or even relocated in order to regain employment. Thus, textile and apparel manufacturers may lobby for protection from the competition of foreign-made goods.

On the other hand, economists agree that free trade promotes the most efficient allocation of resources and thus results in higher standards of living for all trading nations. Cost containment and the availability of unique assortments are of great concern to retailers. A greater variety of goods is available at lower prices from international markets than from domestic markets. These factors motivate retailers to lobby for international free trade.

Because of the controversy concerning the benefits of international trade, many types of trade regulations are practiced throughout the world. The current form of textile and apparel trade regulation has developed during the 20th century. See Table 1–2 for a summary of the recent negotiations of U.S. trade

regulations.

Trade regulation is now based primarily on the World Trade Organization (WTO) that replaced the General Agreement on Tariffs and Trade (GATT) in 1994 after over 50 years of GATT agreements. The original GATT established the ground rules for international trade following World War II. Fundamental purposes of the GATT and WTO remain the same: (1) promotion of free trade through reduction of tariff and nontariff trade barriers and (2) equalization of trade among countries.

Under WTO, the **Multi-Fiber Arrangement** (M-FA) is being phased out. The M-FA was basically an exception to the GATT since the fundamental purpose of GATT was promotion of free trade. The M-FA allowed its signatories to control trade of textiles and apparel through bilateral agreements (agreements between two countries). By 1992, the United States had over forty bilateral agreements with the major textile and apparel producing countries of the world limiting the quantities of textiles and apparel that could be imported into the United States.

International trade regulation involves tariffs, quotas, embargoes, and other strategies. **Tariffs** impose taxes on imported goods, **quotas** regulate quantities that can be traded, and **embargoes** stop trade altogether. The **U.S. Customs Service** administers international trade regulations under the **Harmonized System of Tariffs** (**HS**) HS was developed to provide a single worldwide classification system for all imports and exports (Priestland, 1988).

Item 807/Chapter 98 is a special provision of the tariff schedules that allow products to be partially made in the United States, then exported for further manufacturing processes. To qualify for Item 807/Chapter 98, the product has to be made from fabrics cut in the United States, but the manufacturer that imports the apparel does not have to be domestically owned or located in the United States. Labor unions are opposed to Item 807/Chapter 98 because, in their view, it exports jobs. Most Item 807/Chapter 98 operations are in the Caribbean Basin, Mexico, and Latin America because of their proximity to the United States.

Illegal Trade Activities

Three types of illegal activities (according to WTO) are common in the international trade of textiles and apparel: dumping, transshipment, and government subsidies. **Dumping** is the practice of selling goods in a foreign country below the domestic price of the goods. Sometimes firms use dumping as a means of getting rid of excess inventory. When dumping occurs, the importing country

Table 1–2 Historic development of apparel trade policy.

Year	Event
1935	President Roosevelt appointed a special cabinet-level committee to examine the apparel/textile import problem; the committee proposed voluntary restraints on imports from Japan.
1940–1952	World War II and the outbreak of hostilities in Korea kept the textile/apparel trade problem submerged.
1956	The Eisenhower administration negotiated the first quotas on apparel trade—a 5-year voluntary bilateral agreement with Japan to control trade of cotton products.
1961	Short-term Cotton Arrangement (STA), the first multilateral arrangement was negotiated.
1962	Long-term Cotton Arrangement (LTA) was concluded (renewed in 1967 and 1972); imports of wool and man-made fiber products grew rapidly.
1967	Apparel imports at 6 percent of U.S. consumption; apparel trade deficit \$477 million.
1968–1971	AAMA and other apparel and textile organizations ask Congress for legislative protection from import competition.
1971	First multifiber bilaterals were negotiated with Japan, Hong Kong, Korea, and Taiwan, the principal suppliers of apparel.
1973	Multi-Fiber Arrangement (M-FA) was negotiated and approved; India and the Philippines became important apparel suppliers.
1974	Apparel trade deficit \$1.8 billion.
1978	M-FA renewed.
1979	Apparel trade deficit \$4.2 billion.
980	Apparel imports at 25 percent of U.S. apparel consumption; People's Republic of China became a major supplier.
981	M-FA renewed.
arly 1980s	Apparel imports exploded as the dollar grew stronger; strong import growth for items not covered in the M-FA agreement such as silk, ramie, and linen.
984–1985	Textile and apparel industry lobbied for increased trade restraints.
986	The Jenkins Bill (H.F. 1562), which was supported by the textiles and apparel lobby, was passed by both houses of Congress but was vetoed by President Reagan.
986	A tougher M-FA renewed.
988	Another textiles and apparel bill was approved by both houses of Congress and vetoed by President Reagan.
988	United States enacted Omnibus Trade and Competitiveness Act.
988	Harmonized Commodity Code (HS) replaced Tariff Schedules of the United States (TSUS).
988	United States/Canada Free Trade Agreement (FTA) eliminated duties on most products traded between the countries.
992	President Bush signed the North American Free Trade Agreement (NAFTA).
994	Implementation of United States, Canada, Mexico North American Free Trade Agreement (NAFTA).
94	Uruguay Round was signed to create the World Trade Organization.
95	World Trade Organization (WTO) replaced the General Agreement on Tariffs and Trade (GATT).
95	World Trade Organization began phase-out of the Multi-Fiber Arrangement.
97	Clinton administration proposed expansion of North American Free Trade Agreement (NAFTA) to include selected Central and South American countries.

Source: Developed by Grace I. Kunz.

can impose a **countervailing duty**, a special tax that will increase the price of the goods to a more normal competitive level.

Transshipment involves changing the country of origin of the goods to avoid tariffs or quota limitations. Goods are made in one country and then transported to another where there are lower tariffs or no quota restrictions. New country-of-origin labels are inserted, and the garments are then shipped to the country that has the trade restrictions. The actual quantities of goods that are transshipped are unknown. However, it is clear that the problem increases as trade restrictions increase. U.S. Customs Service has recently stepped up surveillance of the problem (Jacobs, 1997).

Government subsidies for industry are also illegal under the WTO. Government subsidies are payments by the government to manufacturers to defray costs of production. Sometimes they are called negative trade taxes because instead of the firm paying the government, as is commonly the case, the government pays the firm. Government subsidies are regarded as a form of unfair competition because the products can be sold at abnormally low prices. According to the trade agreements, countervailing duties can also be used to counteract subsidies and raise prices to a more competitive level.

Problems of Sweatshops

Exploitation of labor by the apparel industry has had high visibility in recent years. News reports have documented exploitation in apparel manufacturing in the United States as well as in many other parts of the world. Exploitation, in this sense, is unethical use for one's own advantage; to make a profit from the labor of others without giving just return. The apparel business is extremely price competitive and continually under pressure to reduce costs. Seeking the lowest labor costs is a common way to try to reduce costs. The lowest of the lowest labor costs may be offered under sweatshop conditions.

Sweatshop conditions tend to be characterized by low pay, poor working conditions, safety violations, and generally inhuman treatment of employees. Sweatshops exploit the exploitable. In the United States, sweatshop employees tend to be aliens and illegal aliens. Exploited employees in the less developed countries tend to be young women and children often in their first and perhaps only opportunity for regular employment. With unemployment and poverty rates high, parents often need their children to work so the family can have basic necessities. Under these conditions, deciding on "fair" employment policies by firms operating in global markets is extremely difficult (Kunz, 1998).

Most apparel manufacturing plants are not sweatshops. The few that are sweatshops have created image problems for the entire industry. Legitimate manufacturers are looking for ways to fight back. Many U.S. companies, both manufacturers and retailers are making comprehensive efforts to improve their business ethics. They have developed ethics statements that encompass

decision making and relationships in all aspects of the business. Applying these business ethics in a domestic market is challenging; applying them in the global market is extremely complex.

Each country in the world has a unique mix of customs, laws, values, and ways of doing business. What is regarded as exploitation in one part of the world is standard practice in another. Most countries have laws and regulations regarding exploitation of labor, particularly child labor. For example, it is fairly common for age 14 to be the minimum age for employment in many countries. Major differences among countries, however, lie in the effectiveness of enforcement of the law, in the cultural standards and expectations relative to employment, and in the socioeconomic conditions under which people live.

The Department of Labor (1997) issued a study of apparel industry codes of conduct, business guidelines for employee working conditions, and prohibition of child labor. The report shows that, even though most apparel firms have codes of conduct, enforcement may be neglected. The following recommendations were made to the apparel industry:

- 1. Manufacturers, retailers, buyers, and merchandisers should all consider adopting codes of conduct banning child labor and sweatshop conditions.
- 2. All parties should consider developing more standardized codes.
- 3. U.S. importers should take an active role in monitoring subcontractors and homeworkers.
- 4. All parties, particularly workers, should be adequately informed about codes of conduct so that the codes can fully serve their purposes.

Functional Organization of Apparel Firms

Apparel firms, whether large or small, may have executive leadership and six areas of specialization to support their business: quick response, marketing, merchandising, production, operations, and finance. The relationships among these areas of specialization including interaction and integration of responsibilities are represented by Figure 1–4. In a well-run apparel firm, the target market is the central focus of decision making. Firms seek to produce lines of apparel that their target customers will buy each season and each year. Styling, colors, sizing, and quality level are all determined by firms' perceptions of their customers' preferences.

Business organizations are regarded increasingly as teamwork environments with interactive structures. Each area of specialization has its own objectives and responsibilities. At the same time, divisions must interact and co-

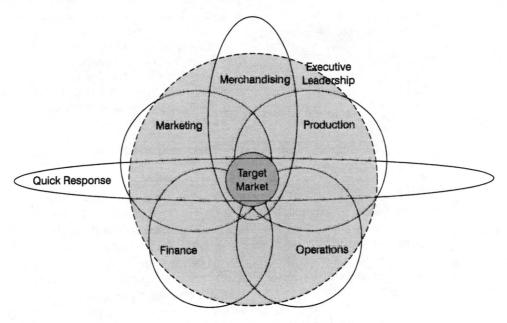

Figure 1–4 Interaction of areas of specialization in an apparel firm.

ordinate their activities in order to achieve their common goals: serving the target customer, growing, and making a profit. The role of each division and the interaction among the divisions of an apparel firm determine how the firm relates to the global apparel business as a whole (Kunz, 1998). These modes of operation are reflected in Figure 1–4.

Executive Leadership

Executive leadership of apparel firms consists of heads of divisions, owner/managers, and/or chief executive officers. Executive leaders set goals for the organization and make decisions that will help the organization meet those goals and make a profit. The leadership process includes strategic planning, motivating, coordinating, and directing activities both inside the firm and within the environment in which the firm operates. Decision making for a manufacturing firm revolves around developing a product line that will meet the needs of the target market. Fundamental leadership decisions include selecting target markets and identifying appropriate product lines, price ranges, and quality levels. Executives provide guidance and motivation for the people in the functional areas of specialization of the firm. Table 1–3 summarizes the responsibilities of executives.

Table 1–3
Responsibilities of executives.

- · Articulate the firm's mission.
- · Identify target customers.
- Establish the firm's goals.
- · Identify the merchandise mix.
- · Determine the fashion emphasis.
- · Establish policies and practices.
- Determine quality levels.
- · Empower employees.
- · Inspire futuristic thinking.

THE BUSINESS PLAN. **Strategic planning** is a responsibility of executive leadership. Strategic planning is an effective process for focusing an organization's energy and resources. The concept is borrowed from the military. Stratagem is a military maneuver designed to deceive or surprise an enemy (American Heritage Dictionary, 1994). In the apparel business, strategic planning involves understanding the firm's target customer, its products, and the competition, and developing profitable business strategies to operate in its markets. Strategic planning can be geared to either the short run or the long run. In the apparel industry, long run plans may be made for 5- or 10-year periods. More commonly, plans are short run, involving 1 year, 6 months, or perhaps only a selling period. A strategic plan provides focus and continuity for decision making in all of the firm's divisions. A strategic plan (1) defines a firm's purpose, (2) establishes the priority for budgets, and (3) provides a basis for the development of the strategies by the firm's functional divisions.

The first step in developing a strategic plan is defining a firm's purpose, which includes a statement of mission, description of the target customer, and description of the product line. The **mission statement** identifies the purpose of the firm relative to service, organization, and profit. It is a statement of the central concept of the firm. "Businesses exist at the discretion of consumers" (McCarthy, 1978, p. 68). Businesses can exist only as long as they serve customers; when they cease to serve customers, they disappear. A mission statement reflects a purpose directed toward satisfying customers' needs. The focus may be on timely service to consumers in terms of quality, styling, and value. Identifying the mission assists the company in developing the organization that provides a needed service. If adequate service is provided to the appropriate market segment, reasonable profits can be made.

The strategic plan determines whether the apparel firm operates primarily at the wholesale level, the retail level, or both. The identification of types of products to be offered, basic assortment strategies (separates or coordinates), size ranges, and price range(s) are often included in the strategic plan. The price range in which a firm operates (low-end, budget, moderate, better, bridge, designer) is a policy decision determined by executive leadership after careful

consideration of the target market, competition, and profit goals. This provides the merchandiser, in cooperation with other managers, a basis for line plan-

ning, line development, and sourcing strategies.

The amount of emphasis placed on fashion innovation and creativity in styling may also be reflected in the business plan. A fashion firm may determine that original designs and creativity are extremely important to the image and market position of the firm. This type of firm must be prepared to invest in being fashion-forward and to deal with rapid product change and short selling periods. Other firms may use knockoffs of other firm's styles or minor modifications of their own past seasons' lines. In the apparel business, knockoffs are used at nearly all price levels. Firms primarily in the basics business may focus on performance of materials, garment assembly automation, and development of Quick Response (QR), which is discussed later. In this case, quality features appropriate to the price range and preferences of target customers must be built into products from the beginning and figured into product cost.

BUDGETS. **Budgets** are comprehensive financial plans that establish the allocation of resources for achieving the goals of a firm. They are based on sales goals, growth goals, cost containment goals, and profit objectives. All of a firm's divisions supply data needed for formulating budgets. Involving employees in budget preparation helps ensure support for the goals reflected. A budget is prepared for each product, line, and functional division for a selling season and/or year. Budgets specify the expected dollar investment, number of units to be produced and/or sold, and revenue to be earned. Comparisons of actual sales and costs to budgets determine the level of success related to execution of the business plan.

Based on resource allocations reflected in the budget, the following leader-

ship/management actions can be taken:

- · Prepare sales goals for each line, territory, and/or store.
- Plan shipping volumes and deadlines.

Project costs of production.

 Make sourcing decisions to determine where, when, and how many of each style will be produced.

Determine inventory levels for materials.

Schedule fabric deliveries to coordinate with the production schedules.

· Project sales, shipping, and administrative costs.

Project timing and dollar value of capital expenditures.

• Determine additional investment in equipment.

- Project timing and dollar value of accounts receivable.
- Project timing and dollar value of accounts payable.
- Evaluate cash flow.

Quick Response (QR)

The progressive members of the apparel industry have realized that new forms of cooperation and empowerment are required in order to be profitable in the global market. Quick Response (QR) is a comprehensive business strategy incorporating time-based competition, agility, and partnering to optimize the supply system, the distribution system, and service to customers (Kunz, 1998). Shortening the time between conceptualizing a new product and delivering the finished product to the ultimate consumer is the goal of timebased competition. QR seeks to compress time-lines throughout the manufacturing and distribution process to make production closer to time of sale. Successful QR strategies result in increased turnover and reduced investment in inventory for both manufacturers and retailers. A recent development in time-based competition is shipping merchandise floor ready. Floor ready means goods can go directly from the truck to the retail sales floor without passing through a retailer's distribution center. The manufacturer has installed the proper hangers and tickets. The retailer only has to place the merchandise on the fixtures for display. Time spent in the distribution center is eliminated (Abend, 1997).

Agility requires information-based decision making along with flexible supply and distribution systems. Agile business systems result in timely offering of goods desired by customers in the appropriate styles, quantities, and qualities (Kunz, 1998). The QR concept depends on rapidly moving the right merchandise through the supply matrix in response to better information on consumer demand moving back through the supply matrix. The challenge remains to optimize information technology systems throughout the apparel trade matrix using electronic data interchange (EDI) or other interactive systems. One of the requirements is to make the manufacturing and distribution process less linear and more interactive. EDI is regarded as essential technology for QR but implementation can be a source of serious problems without adequate partnership agreements (Wirtz, 1997). Many retailers and manufacturers are seeking more interactive systems that allow buyers and customers to seek information in each other's databases (Zimmerman, 1998).

Achievement of QR is facilitated by partnering arrangements between vendors and buyers along with implementation of computerized equipment and electronic communication systems. **Partnering** involves negotiated agreements relative to aspects of a business relationship that will benefit both parties. Unusual levels of cooperation, collaboration, and trust are required within firms and among suppliers and customers to make the strategic partnering work. The communication of financial information within and among apparel firms requires a new way of relating to peers, suppliers, and customers.

From the retailer's point of view, QR translates into quicker and more accurate response to changes in consumer demands, lower risk, a higher rate of sell-

through at first price, and fewer markdowns. Retailers participating in QR programs have experienced dramatic increases in turnover, that is, in the amount of products sold in relation to the amount of inventory on hand. Because of complete assortments and quick replacement of the best-selling merchandise, turnover has increased from 30 to 90 percent, and markdowns were reduced for both manufacturers and retailers. QR systems provide the opportunity to optimize workflow processes to improve efficiency and customer service (Gaffney, 1997). Table 1–4 itemizes responsibilities of those involved in planning, implementing, and evaluating QR programs.

Marketing

In the apparel business sector, there is considerable confusion in the use of terminology related to functions of the firm and areas of specialization. In particular, the terms **marketing** and *merchandising* are sometimes used interchangeably. For example, in a particular firm, a division might be called "marketing," but executives describe their responsibilities as being "merchandising." To clarify this muddle, we have identified functional responsibilities and defined marketing and merchandising accordingly. It is important to recognize that in business practice these functions exist, but different terminology might be used to identify them.

A marketing division is responsible for "shaping and strengthening the image of a company and its products through promotion, optimizing sales opportunities, and developing alternate strategies for corporate growth" (Bertrand Frank Associates, 1982, p. 12). Marketing divisions develop marketing strategies and conduct research to describe target customers. Marketing also establishes the market position of a firm relative to the competition and coordinates advertising and promotional objectives to attain the sales goals. Marketing establishes wholesale and/or retail strategies and provides feedback from buyers and consumers to merchandising personnel. Table 1–5 itemizes responsibilities of marketers.

Table 1–4Responsibilities of quick response.

- Develop QR implementation plans.
- Educate executives, merchandising, marketing, operations, finance, and production personnel on the benefits of QR.
- Establish partnership agreements with suppliers and customers.
- · Coordinate methods to reduce cycle times.
- · Develop plans to increase agility.
- Implement appropriate communication technology among partners and divisions.
- Evaluate impact of QR on performance.

Table 1–5
Responsibilities of marketers.

- · Conduct and report customer research.
- Position the firm relative to target market(s).
- · Position the firm relative to the competition.
- · Develop the firm's image.
- · Propose marketing program(s).
- Propose advertising/promotion strategies.
- · Forecast sales.

Merchandising

A merchandising division surrounds the concept of the target customer and translates customer preferences into a product line for the rest of the apparel firm. **Merchandising** is the planning, development, and presentation of product line(s) for identified target market(s) with regard to prices, assortments, styling, and timing. Merchandising divisions are central coordinating points for line development, design, execution, and delivery of product lines. Table 1–6 itemizes responsibilities of merchandisers.

Production

Production divisions are responsible for the procedures and processes required in actually making products. Production schedules are planned based on the delivery deadlines determined by merchandising and marketing. The planning and execution of product assembly requires final approval of technical design and developing engineering specifications and costing. Additional production responsibilities include making production patterns, grading patterns, generating markers, cutting, sewing, finishing, and distributing. These processes must be maintained at a high level of productivity in order to meet deadlines and control costs. Table 1–7 itemizes production responsibilities.

Table 1–6 Responsibilities of merchandisers.

- Evaluate merchandise classifications.
- · Evaluate past seasons.
- · Synthesize current issues/trends.
- Plan merchandise budgets.
- · Plan merchandise assortments.
- · Develop line concepts.
- · Present product lines.
- · Carry out technical design.

Table 1–7Responsibilities of producers.

- · Engineer the product and the workplace.
- · Production planning.
- · Negotiate product requirements with contractors.
- Manage cutting, assembly, and finishing operations.
- Carry out quality assurance program.
- · Package and ship products.

Operations

An operations division is responsible for the procedures and processes required to manage people and physical property. Acquiring, supporting, and educating human resources is a primary responsibility. If the firm operates in the manufacturing sector, operations supervises production facilities. If the firm operates in the retail sector, operations supervises stores. Operations often oversees management information systems (MIS) personnel that implement and support computer technology and communications systems. Table 1–8 itemizes responsibilities of operations personnel.

Finance

Finance divisions manage the organization's money. It is the responsibility of finance personnel to evaluate the profitability of past business and set goals for future business. They are responsible for financial planning, management of accounts receivable and payable, planning and payment of salaries and wages, overall financial productivity, and profit. Table 1–9 itemizes responsibilities of finance personnel.

Table 1–8 Responsibilities of operations.

- Select sites for production plants and/or retail stores.
- Operate production plants and/or retail stores.
- Manage physical facilities.
- · Select, support, and educate personnel.
- Implement and support technology and equipment.

Table 1–9 Responsibilities of finance.

- · Propose financial goals.
- · Create and protect cash flow.
- · Manage finances.
- · Operate accounting systems.
- · Establish sources of funds.

Summary

The apparel industry is a highly competitive global business. To be successful, manufacturers and retailers must serve their consumer markets. Manufacturers must produce apparel that meets performance, quality, and value expectations of retailers and consumers. Manufacturers produce goods with appropriate intrinsic quality to be merchandised and marketed with the desirable extrinsic appeal. The centrality of the apparel manufacturing function to the apparel industry makes apparel production a key factor in the successful merchandising and marketing of apparel products.

In order to stay in business, each firm must grow and make a profit. Apparel firms grow through internal growth, vertical and horizontal integration, and conglomerate mergers. Manufacturers and retailers have become partners in QR, competitors in both manufacturing and retailing, and suppliers and users in the trade matrix. Apparel firms operate in an international market that involves international trade regulation and image problems related to sweatshops. Excesses of imports over exports have created a severe trade deficit in apparel.

Executive leadership and six areas of specialization are required in order to operate an apparel firm: marketing, merchandising, production, operations, finance, and quick response. These functions must be performed, regardless of the size of the firm or product line, in order to carry out the manufacturing process and meet the needs of the target market. Cooperation among these functional areas of specialization are the keys to success for an apparel manufacturing firm. Information technology and computer to computer communication are key factors for profitability. The focus of this textbook is on apparel manufacturing processes interrelating quick response, marketing, merchandising, and production areas of specialization.

References and Reading List

Abend, J. (1997, March). The last leg— Transportation's role in Quick Response. Bobbin, pp. 44–50.

American Apparel Manufacturers Association. (1998). Apparel import digest. Arlington, VA: Author.

Bertrand Frank Associates. (1982). Profitable merchandising of apparel. New York: National Knitwear and Sportswear Association. Bonacich, E., Cheng, L., Chinchilla, N., Hamilton, N., & Ong, P. (1994). Global production: The apparel industry in the Pacific rim. Philadelphia: Temple University Press.

Department of Labor issues report on apparel industry codes of conduct. (1997, February). Human Resources Newsletter, p. 1.

Farr, B., & Stone, J. (1998, January). NAICS codes replace SIC system for NAFTA

traders. Iowa State University: Textiles and Clothing Extension.

Gaffney, G. (1997, March). Quick Response for everyone, Bobbin, pp. 52-56.

Goldman, S. L., Nagel, R. N., & Preiss, K. (1995). Agile competitors and virtual organizations: Strategies for enriching the consumer. New York: Van Nostrand Reinhold.

Henricks, M. (1997, October), Convergence 2: Vertical retail. Apparel Industry Magazine, pp. 38-46.

Jacobs, B. A. (1997, June). Customs presses importers to establish anti-transshipment controls. Bobbin, pp. 83-84.

Kunz, G. I. (1998). Merchandising: Theory. principles, and practice. New York: Fairchild

Made on Planet Earth (1996), DNR Special Publication.

McCarthy, E. J. (1978). Basic Marketing (6th ed.). Homewood. IL: Irwin.

Priestland, C. (1988, September). Trade classification system to change. Bobbin. pp. 192-193.

Wirtz, J. (1997. March). The ABCs of EDI. Bobbin, pp. 32-42.

Zimmerman, K. A. (1998, June 3). Retailers look beyond EDI for info exchange, DNR, p. 6.

Key Words

apparel manufacturing level availability hypothesis backward vertical integration better price classification bridge price classification budget price classification budgets Chapter 98 conglomerate conglomerate merger consumers contractor cooperative corporation countervailing duty designer price classification dumping electronic data interchange (EDI) embargo extrinsic cue fashion fashion business fashion change firm floor ready forward vertical integration

franchise global firms government subsidies growth Harmonized System of Tariffs (HS)horizontal integration internal growth international trade intrinsic cues intrinsic quality Item 807 low-end price classification market market power market share marketing mass customization merchandising merger mill level mission statement moderate price classification Multi-Fiber Arrangement (M-FA) North American Industry Classification System (NAICS)

operations

partnering perceived quality plant price classifications privately owned profit proprietorship publicly owned quality Quick Response (QR) auota retail level seasonal change specialty contractors sourcing stockholder strategic planning tariff time-based competition trade balance trade deficit transshipment U.S. Customs Service variety hypothesis vertical integration World Trade Organization (WTO)

Discussion Questions and Activities

- Go to the library and find the Census of Manufacturers. Examine the trends in levels of production for different classifications of apparel. Identify six classifications that are growing and six classifications that are shrinking in sales.
- 2. Divide the class into groups with five people in each group. Each group should organize itself into an apparel manufacturing business or an apparel contracting business. Give the business a name and location, and identify the target market and product line. Is your company a proprietorship, partnership, or corporation? Why?
- 3. Each member of the group is a manager in the company: merchandising manager,

- marketing and sales manager, operations manager, finance manager, and quick response. Make a list of job responsibilities for each manager. What will determine whether your company is successful?
- 4. Make a list of apparel manufacturers that you know. What trademarks do these firms use? Do they make primarily fashion or primarily basic products? How do the products differ?
- 5. Using the list from question 4, determine which firms are more marketing oriented and which are more production oriented. How can you tell the difference?

Marketing Strategies

OBJECTIVES

- Examine the role of the marketing division in apparel firms.
- Describe sales forecasting and the marketing calendar and their role in determining merchandising, production, and distribution schedules.
- Explore retail and wholesale marketing strategies and the apparel market system.
- Objects product differentiation through product labeling and licensing as a marketing tool.

For many apparel businesses, real growth in sales volume and profit is difficult to achieve. Intensified foreign and domestic competition, increasing production and transportation costs, and changing consumer demographics and lifestyles all provide a challenge for profitable growth. Annual consumer expenditures for apparel is over \$220 billion in the United States, but with an annual growth rate of less than 3 percent (Apparel Industry Trends, 1998). Approximately \$50 billion of apparel is manufactured in the United States and sold at wholesale. However, U.S. domestic apparel production peaked in 1995 and now is approximately equal to 1991 levels (Economic Intelligence Company, 1998). U.S. apparel firms have become global firms, using foreign sourcing when it is to their advantage. In spite of the competitive global scenario, the outlook for U.S.-based apparel firms is strong. Many U.S. apparel firms do a better job than their international competitors of appealing to their customers and meeting each customer's needs.

Marketing Responsibilities in Apparel Firms

In many firms, the marketing division, in cooperation with the other divisions, is instrumental in developing a firm's strategic plans. Marketing personnel are responsible for positioning the firm relative to target markets and the competition. The established market position provides the basis for the marketing division to set advertising and promotional objectives, recommend sales goals, create marketing programs, sell products, and provide feedback from retail buyers and consumers.

Responsibility for the planning, development, and presentation of apparel product lines may be shared by managers in the marketing and production divisions. Because of the speed of product change in today's markets, many apparel firms have created merchandising divisions to manage the product line. In the presence of a merchandising division, marketing personnel focus on the interface between the firm and the market and the development of new marketing opportunities. Marketing is also responsible for continually monitoring markets and recommending modifications when change in strategy is indicated.

Market Segmentation and Target Markets

In order to market products successfully, firms identify certain groups of customers as a target market(s) for their products. A **target market** is the select population to whom a group of products and the firm's marketing program are directed. In order to serve customers' needs, the firm must have a thorough understanding of the likes, wants, and needs of the target market. It is the responsibility of the marketing division to provide necessary data. A market profile provides data about a market segment that is the intended target market. A target market is described in terms of demographic characteristics such as age, sex, income, geographic location, and occupation. As shown in Table 2–1, lifestyle variables, such as type of residence, recreational activities, and modes of entertaining, are also used as descriptors.

Firms identify a particular group of target customers, a market segment they seek to serve with their products. They define and describe their core customers, customers who are the foundation of their business. Fringe customers occasionally shop or may be attracted to shop the firm's lines and offer potential for business growth. Understanding the core customer is a key step in developing a successful marketing strategy. Manufacturers seek retailers with similar core customers. Both manufacturers and retailers have their core customers in mind as they attend markets and plan assortments. Retail buyers usually create assortments from offerings of various manufacturers according to the buyer's perception of the core customers' needs and desires.

Table 2–1Lifestyle dimensions for market segmentation.

		the state of the s	
Activities	Interests	Opinions	Demographics
Work	Family	Themselves	Age
Hobbies	Home	Social issues	Education
Social events	Job	Politics	Income
Vacation	Community	Business	Occupation
Entertainment	Recreation	Economics	Family size
Club membership	Fashion	Education	Dwelling
Community	Food	Products	Geography
Shopping	Media	Future	City size
Sports	Achievements	Culture	Stage in life cycle
			그리는 그 나는 사는 일반에 살았다면 그 그리지? 그 그래요 그림 그림 그

Source: Plummer, J. (1974, January). The concept and application of life-style segmentation. *Journal of Marketing*, 33–37. Reported in McCarthy, E. J. (1978). *Basic Marketing*, 6th ed. (Homewood, IL: Irwin), p. 155.

The **market segment** a firm chooses to serve may be broadly or narrowly defined. A firm may choose to serve a mass market, a multiple-segment market, or a narrowly defined target market. If a firm wishes to serve a broadly defined market segment, it serves a mass market. A **mass market** usually includes all of the middle-income class and perhaps part of the lower- and upper-income class. For mass market product lines, marketing strategies are designed to appeal to a large portion of the total U.S. population. Retailers, such as Walmart and Target, have mass marketing strategies. Wal-Mart has a target market that includes nearly 80 percent of the U.S. population.

A mass market strategy by a retailer means that their manufacturer suppliers must also have mass market potential. Manufacturers must have adequate production capability and operating systems to supply hundreds of stores. Quality must be adequately monitored to provide consistent product serviceability. Timely deliveries are of particular importance to prevent stockouts. When an item a customer wants to buy is not immediately available, a lost sale is often the result. Mass marketers achieve success by having merchandise that customers want in stock.

Firms may develop **multiple-segment strategies** by directing their appeal to different target markets. For example, a line of junior apparel might be made in a different size range for the preteen market, or a men's sport shirt manufacturer may add a line of women's shirts. In each case, the apparel firm is able to utilize production and marketing capabilities while adding sales potential. Multiple-segment strategies provide a cushion for success because of the potential for some part of the merchandise mix to sell well when sales are down in other segments.

When the target market is narrowly defined according to demographic and lifestyle variables, the approach is sometimes called **niche marketing**. The

market may be segmented by type of product offered in relation to gender, price range, size range, and lifestyle variables. With a narrow target market definition, a firm might make a number of product lines for the same target market. Guess has built its business offering a variety of product lines, from jeans to sweatshirts and related products for a narrowly defined fashion-forward junior market. Guess's product lines provide an identifiable consistency in styling, color, fashion, and marketing strategy that clearly appeals to the same target customers.

Over time, a firm may change its conception of the target market because of demographic trends. Two key demographic changes among the U.S. population will impact apparel marketing during the next 10 years: (1) distribution changes among the age groups and (2) population shifts to the South and West. The U.S. population is expected to continue to increase. The largest increases in the number of people will be in the older age brackets (55-74 years of age). Households where people aged 55 to 75 or over reside spend between \$582 and \$1,833 per year on apparel. The size of the teenage population began to increase in 1992, after 16 years of decline. The number of teenagers is expected to increase until 2010, as kids of baby boomers expand the number of 12- to 19-yearolds to 34.9 million. The needs and wants of the older population segment differ markedly from younger consumers who have been targeted by most manufacturers and retailers over the last 30 years. These strong demographic trends are reflected in the focus on lifestyle variables and marketing strategies of firms that successfully market their products.

Changes in demographics and lifestyles are resulting in the recognition of many more market segments within apparel markets. Companies are positioning and differentiating their products in terms of styling, brands, sizing, service, and/or price to meet the needs of special market segments. For example, there has been a dramatic growth in the offering of petite and large size women's apparel and tall and large sizes for men. These segments represent up to one-third of the U.S. population, but until recently, have been largely ignored by the apparel industry. Effective service to an underserved market segment can be very profitable. For example, the women's petite size range was developed to serve one of these markets. Serving small market segments involves smaller production runs that may lack economy of scale; thus, good management is required to control costs.

Strategic Marketing Processes

The marketing strategy is the part of a firm's strategic plan that gives consideration to (1) marketing objectives, (2) analysis of the competition, (3) positioning and differentiation of the product lines, and (4) sell-through of the product lines.

Marketing Objectives

The purpose of a marketing strategy is to provide growth and profitability of the firm. Objectives of marketing plans include the following alternatives:

1. Market penetration: Expand sales of current products in current markets through effective advertising and promotion. The objective of market penetration is to have current customers buy current products more often. This might be achieved through price promotion, everydaylow pricing, developing brand/store loyalty, and/or convenient accessibility for purchase. The Internet is providing a means of penetrating both wholesale and retail markets. Apparel manufacturers are using web sites for business to business sales at wholesale as well as business to ultimate consumer at retail. The Internet provides firms another opportunity to serve their target market.

2. Market development: Seek greater sales of current products from new markets or develop new uses for current products. The objective of market development is to find new customers for the current product line. In today's global markets, that may mean reaching domestic customers more effectively and/or marketing in other countries. Finding new uses for current products is another opportunity for market development. For example, nylon net has commonly been used in formal wear and as a support fabric. During the 1970s and 1980s it was recommended as household scrubbers. In the 1990s it became popular with foam bath products

as a body sponge, new uses for an established product.

3. Diversification: Develop or obtain new products aimed at new markets. Diversification means learning a new business including needs and wants of the target market, supplier and customer patterns, and distribution systems. The dominance of Liz Claiborne in apparel is based on diversification. Liz Claiborne now accounts for 5 percent of all department store sales in the United States (Charron, 1998). Liz Claiborne started in the upscale misses market and systematically added new divisions to serve other female size ranges as well as males. For example, the Elizabeth division serves large sizes, Liz Sport serves a more casual market, and Claiborne serves the men's market.

Analysis of the Competition

Firms that offer similar products to similar target markets are competitors. To understand and analyze the nature of the competition in a market, the following points are considered:

- · Present and potential firms in the market
- Market positions of competing firms

- Missions and objectives of firms
- Typical patterns of competitive behavior among firms
- Strength of the resource base of competing firms
- · Competitive advantages of competing firms
- Key vulnerabilities of competing firms (Murray, 1984)

It is not difficult to determine which firms are already established in the market. Direct competitors can be identified by asking retail customers about alternative suppliers, reading the trade press, consulting industry directories, and participating in industry groups or trade associations. Obtaining specific information about the firm's objectives, size of its market share, and its financial condition may be more difficult, particularly if it is a privately owned company. Customers may be able to relay the competitive advantages and vulnerabilities of the firm's competitors and identify ways the competition is not meeting the market's needs. Knowledge regarding these vulnerabilities may be the key to establishing a market position that could make a particular apparel firm the preferred supplier in a particular market.

Determining potential competition is more difficult. The apparel business is characterized by low barriers to entry. Some firms enter, others change market strategies, and others leave the business everyday. It is difficult to predict which ones will be successful and in which markets. While most new entrants fail during the first 3 years (probably over 90 percent), some become very successful. The challenge is not only to meet the needs of the market for a selling period or a year but to continue to serve the market better than the competition year after year.

Market Positioning and Product Differentiation

In the apparel business, two of the greatest marketing challenges are positioning the firm in the market and differentiating the firm's products from the competition's. Most apparel markets have many firms with small market shares and thus a high level of competition. A new firm can become successful and an established firm can be even more successful by carefully developing a positioning strategy in the market. Effective market positioning means the firm is able to provide more benefits to the consumer than the competition. To make positioning decisions, the firm must know (1) purchase criteria of their target customers, (2) product performance expectations, and (3) customers' perceptions of competing products. Customers' purchase criteria are translated into specific benefits they expect to receive from the product. See Figure 2-1 for an example of analysis of the jeans market for the purpose of positioning a product line. The analysis includes sales trends, market share information, and relevant lifestyle dimensions as well as sources of information upon which the analysis is based. Notice that more pairs of jeans were sold in 1981 than in 1996. Conducting a market analysis using trade publications and other sources can be very frustrating because of great inconsistencies in the data reported. Good market analysis requires a knowledgeable, professional marketing organization.

Figure 2–1 Jeanswear market analysis.

U.S. Sales Trends				4
Year	1981	1985	1992	1996
Pairs of jeans sold (in millions)	510	430	385	500
Dollars of jeans sold (in billions)		\$6.5	\$6.8	\$10.0

Market Share

Overall jeans market:

- Levi's share has fallen from 22% to 20%; all national brands have slipped from 70% of the market in 1993 to 65% in 1997.
- Private label jeans have gone from a 16% market share in 1990 to 25% in 1997.
- Increasing portions of jeans market share are in foreign countries.

Men's Jeans:		Women's Jeans:			
 Wrangler & Lee 	31%	 Private label 	30%		
• Levi's	26%	 Wrangler & Lee 	16%		
 Private label 	19%				
 Designer 	5%				
Other	20%				

Key Lifestyle Dimensions for the Jeans Market

- The largest increases in the number of people over the next few years will be in the older age brackets (55–74 years of age).
- Households with people aged 55 to 75 spend between \$582 and \$1,833 per year on apparel.
- The size of the teenage population began to increase in 1992, after 16 years of decline; the number of teenagers is expected to increase until 2010, as kids of baby boomers expand the number of 12- to 19-year-olds to 34.9 million.
- Only 35% of office workers wear formal business attire on a daily basis; 70% of offices have at least once-a-week casual days.
- Jeans are frequently excluded as appropriate for casual wear days.
- Sales of men's casual wear bottoms increased 36% from 1990 to 1996 at the same time that jeanswear sales were increasing.
- Sales of Levi's Dockers and Slates brands are doing well and increasing in spite of increasing competition from other brands.

Sources: Elsberry, R. B. (1997, September). Clothes calls: Casual-dress days are breaking office dress code. Office Systems, 97, 14, 25+.

Irvine, M. (1997, November 6). Levi's market fades. San Francisco: The Associated Press. Retrieved February 13, 1998 from the World Wide Web: http://www.ocregister.com/news/1997/110697/levis.html

Levi's sales off 4% to \$6.9 billion in year to Nov. 30. (1998, February 11). DNR, 2.

McLean, B. (1996, January 13). Designer jeans: A fitting way to invest in fashion. Fortune, 135, 164.

Picard, D. E. (1998, February 11). VF net up 12.7% in fourth quarter. DNR, 2.

Stankevich, D. G. (1997, July). Fountain of Youth. Discount Merchandiser, 37, 76-78.

Steinhauer, J. (1997, April 9). What vanity and casual Fridays wrought. The New York Times, A1, D5.

The Kiplinger Washington Editors. (1997, December). The Kiplinger Washington Letter, 74(52):

Teenage Research Unlimited. (1997, December 11). Denim dish: dream jeans for teens. WWD, 174(113), 12(1). Zollo, P. (1995, November). Talking to teens. American Demographics, 17, 22–28.

Through **product differentiation**, a firm's products and services become distinctive and identifiable from the rest of the products in the market. Products are differentiated by using labeling, price, quality, customer service, fit, fashion, and distinctive styling. Advertising is a primary means of communicating product differentiation to target customers. Labeling, an important means of product differentiation, is discussed later in this chapter.

Product Sell-Through

Apparel manufacturers are concerned with sell-through of their products. Not only must retail buyers purchase an apparel manufacturer's product lines, but the ultimate consumer must promptly buy the merchandise from the retailer at "regular" price. When retailers are able to increase gross margin (the difference between cost of goods sold and net sales), they are more likely to continue buying the same lines from the same manufacturers for the next selling season.

Traditionally, textiles and apparel products have been marketed vertically through the trade matrix. Firms at each level of distribution have primarily directed marketing and promotional activities toward firms that are their customers at the next level of distribution. Firms at the mill products level have traditionally marketed their products to the firms at the apparel manufacturing level. Firms at the manufacturing level have marketed their products to the retailing level, which in turn promoted and sold the products to the consumer.

With this traditional marketing pattern, the manufacturer risks losing sight of the ultimate consumer's needs. Manufacturers may market the products they are able to produce most efficiently under the presumption that there will be a market for them. The result is a **push-through** type of system based on production convenience rather than market demand.

In recent years, many apparel firms have recognized the effectiveness of a pull-through marketing system. Pull-through strategies are the essence of Quick Response (QR). Pull-through strategies involve finding ways to make the marketing, production, and merchandising processes customer driven. Steps include analyzing customers' needs, developing products that are consistent with those needs, testing the acceptability of the products, and directing marketing and promotion efforts to differentiate the products in the mind of the ultimate consumer. Apparel firms use television, the Internet, and other advertising modia to create a demand for their products. As a result, consumers recognize styling, designer names, brand names, and trademarks and know what is being offered by various manufacturers. Retailers find it necessary to respond to the preconditioned desires of their customers. In effect, the consumer demand for specific products "pulls" the desired merchandise through the trade matrix for the manufacturer. The pull-through strategy gives the manufacturer power in the retail sector.

Apparel manufacturers in today's markets are involved in marketing at both the wholesale and retail level as well as preselling the product to consumers.

This requires broad and creative marketing expertise. Research regarding competition in the world market has found that apparel firms with strong marketing organizations are better positioned to compete in the global market. Not only must manufacturers be able to produce consistent quality merchandise efficiently, but they must also be able to sell the goods they make in highly competitive markets.

Sales Forecasting

Sales forecasts developed by the marketing division contribute to a firm's budgets and allocation of resources. "A sales forecast outlines expected company sales for a specific good or service to a specific consumer group over a specific period of time under a well-defined marketing program" (Evans and Berman, 1987, p. 218). Sales forecasts begin with the assumption that a relationship exists between future sales and one or more variables that can be measured or estimated. National economic forecasts and industry sales forecasts are prepared and publicized by government agencies, industry organizations, and trade press. These forecasts consider economic conditions such as inflation, interest rates, exchange rates, unemployment rates, and international political conditions.

Within a manufacturing firm, sales forecasts are prepared for the whole firm, for each product line, and sometimes for individual products in a line. Sales forecasts are usually stated in terms of units or dozens, dollars, and as percentage increases over the previous season. Sales forecasts reflect market potential rather than production capability. In a pull-through system, production capability is adjusted to meet opportunities in the market rather than adjusting the expected sales level according to production capability (pushthrough). Contracting may be used to supplement production capacity.

Both quantitative and qualitative research methods are used for sales forecasting. Qualitative methods are often used for new products or in situations in which background data are lacking. Qualitative techniques include consulting experts in the field, formation of consumer panels, and focus groups. Quantitative methods include market research using statistical analysis such as multiple-regression analysis and analysis of variance that will determine the relationship among variables. Time series and product life-cycle analysis also usually use quantitative methods that tend to be most effective for short-run forecasts.

Projections based on past sales is a common method of forecasting sales for established products. This method has an implicit assumption that past trends will continue into the future. To prepare **sales projections**, detailed analysis of sales records by individual products, specific market segments, sales territories, and months of sales are conducted. Sales representatives may project potential sales for their respective territories. These figures may be compared to the firm's projected sales total prepared by marketing researchers. Additional considerations before finalizing projections into sales forecasts include (1) national and international economic trends, (2) overall growth in demand within the target

market, (3) growth in the firm's market share, (4) marketing strategy for the product line, (5) production and marketing capacity of the firm, and (6) availability of supplies of raw materials for timely delivery. Consideration of these factors can help verify or modify the sales projections into sales forecasts.

Each type of sales forecasting technique has advantages and limitations. Because of this complexity, further discussion is beyond the scope of this text. Whatever the forecasting method, the ultimate decision comes down to managers' judgment to determine the best sales strategy for the firm. Reliability of the sales forecast is imperative because budgets and planning for QR are based primarily on these measures. Inadequate forecasting has been identified as the number one QR implementation problem.

Retail and Wholesale Marketing Strategies

The geographic market to be served by an apparel firm is determined by the description of the target market. An apparel firm might seek to serve a regional, national, or international market at the retail level, the wholesale level, or both. These decisions determine the focus of the promotional strategy and the selection of national and/or regional markets where products are sold. The lines offered in each market are edited to make them suitable for customers' needs and preferences in the particular geographic area. The options an apparel firm might choose as a means for distributing merchandise include (1) manufacturer-owned retail outlets, (2) mail-order distribution, (3) use of a road sales force for selling to retail buyers, (4) use of wholesale apparel markets, (5) marketing on the Internet, and (6) combinations of these.

Developing Retail Strategies

The use of manufacturer-owned retail outlets and mail or telephone order as direct outlets to consumers is a growing means of apparel distribution. Manufacturer-owned retail outlets may sell first-quality merchandise in a boutique-type setting and/or sell first- and/or second-quality and/or distressed merchandise through the manufacturer's outlet mall format. Manufacturers first used outlet malls to disperse distressed merchandise that was not salable through regular retail channels. **Distressed merchandise** includes seconds, samples, production overruns, last season's goods, retailer returns, and so forth. Manufacturers' outlets were so successful that some apparel firms are now manufacturing for their own outlet stores. For example, VF Corporation is using a dual distribution system in which it sells its goods in its own stores as well as in traditional discount, specialty, or department stores.

At the same time, firms such as Lands' End and J. Crew develop and distribute private-label merchandise and sell it directly to their customers

through catalogs. These firms assume the merchandising and marketing functions of manufacturers and merchandising and distribution functions of retailers. Many firms that started out strictly in the catalog sector now have established their own chains of retail stores. Most apparel, however, is still sold wholesale to retail buyers through a complex system of wholesale markets.

Developing Wholesale Market Strategies

The term *market* has multiple uses; therefore, it must be interpreted according to the context in which it is used. A common meaning of *market* is the sales potential for a particular type of goods. When estimating potential sales in a particular product market, marketers evaluate income levels, customers' preferences, and other factors to determine how many units might be sold and at

what prices.

Another use of the term *market* applies to the process of getting buyers and sellers together so that ownership of goods can be exchanged. Trade associations such as the American Association of Men's Sportswear Buyers (AAMSB) and other groups provide trade shows or "markets" where representatives of apparel manufacturers display merchandise and retail buyers have the opportunity to see the merchandise and select it for their stores. When a retail buyer says "I am going to market," it means that he or she is going to a place where a group of apparel manufacturers are showing their product lines for sale. The United States has a system of wholesale markets, organized according to product lines, that facilitates the sale of merchandise from both domestic and foreign apparel manufacturers to retail buyers. The functions of these markets include identifying prospective customers, working with current customers, introducing new products, enhancing corporate image, testing the acceptance of new products, gathering competitor information, and selling current product lines.

The Men's Apparel Guild of California (MAGIC) sponsors the largest apparel market in the world. Twice a year, 90,000+ people from over 100 countries attend MAGIC International in Las Vegas, Nevada. The show includes apparel for men (MAGIC), women (WWDMagic), and children (MAGICKids). The show in 1998 featured over 2,000 exhibitors and 5,000 brand names (Marlow, 1998).

Apparel firms often have permanent showrooms in major apparel markets and temporary showrooms in other apparel markets. Permanent showrooms serve the buyers on their regular buying trips. It is common for buyers to make buying trips about 1 week out of every month. Buyers also communicate with sales representatives or showroom managers by telephone on a daily basis regarding orders, fill-ins, delivery, prices, and other matters. Regional markets serve many buyers who might previously have relied on personal calls by sales representatives.

The development and administration of a wholesale market strategy is normally the responsibility of the marketing division. The wholesale strategies used by an apparel firm depend on the types of retail accounts served. If a firm has large corporate accounts, business is usually conducted in the home office

showrooms. Large corporate accounts might include mass merchandisers such as Sears or Kmart or department store conglomerates such as Federated, Daytons, or May Co. Lines may be created especially for these firms. Principals of the manufacturer and retailer may meet to refine the line to their market needs. Arrangements are made for exclusives, private-label, and other merchandise that will not be available to other retailers. Major accounts such as these are often regarded as corporate or "house" accounts so commission is usually not paid to sales representatives.

If a firm has hundreds or even thousands of smaller retail accounts, geographic territories are often the basis for selecting and organizing the sales force. The sales force may include both inside and outside salespeople. Inside sales representatives work in the home office showroom and/or permanent showrooms in apparel markets. Outside sales representatives travel and service a territory assigned by the marketing division. Outside salespeople commonly travel 30,000–60,000 miles a year calling on retail stores. Inside salespeople may be salaried; outside salespeople are usually paid on commission. Growth of the apparel market system in recent years has slowed as QR partnering arrangements have become more common and retailers have consolidated the number of suppliers they work with.

While the process of defining the target market involves development of an understanding of the ultimate consumer, the immediate target of the wholesale sales force is the retail buyer. The marketing strategy includes their target customers and the retailers who are best positioned to sell-through the merchandise. The best retail outlets for goods are growing and profitable firms that have compatible target markets and business strategies.

Maximizing the productivity of manufacturer's sales representatives is a marketing challenge. Sales representatives are challenged to maintain and build existing accounts and open new accounts for the firm. Manufacturers use financial appeals such as seasonal discounts, invoice dating, cooperative advertising, and markdown money among other incentives to encourage retail buyers and divisional merchandise managers to purchase their goods.

Even the best-designed and best-positioned products produce no revenue until they are sold. The contribution of the marketing function to the success of an apparel firm has created a need for professional manufacturers' representatives. Unfortunately, relatively few firms have sales trainee positions or sales training programs. Many firms rely on hiring salespeople who have gained selling experience with other companies.

The Marketing Calendar

Annual seasonal markets are held for different product categories in major cities across the country. The timing of these markets provides the basis for an apparel manufacturing firm's marketing calendar. A firm's sales representatives are challenged to meet the sales goals defined by the firm's budget within

the time frames specified by the marketing calendar. In the apparel business, timing of product development, production, and presentation are critical. A firm's marketing calendar provides the basis for the timing of all other schedules, such as the merchandising calendar, production schedules, and advertising and promotion plans. Sales forecasts provide the basis for financial planning and the marketing calendar sets the deadlines. The marketing calendar establishes the timeline for all the firm's activities.

Table 2–2 shows the dates that are often included in the marketing calendar. This marketing calendar is appropriate for a fashion firm that produces lines for six selling periods a year. **Selling periods** are determined by combinations of factors related to (1) the calendar year such as holidays and weather changes, (2) seasonal events such as beginning and ending of the school year, and (3) frequency of demand for fashion change.

Manufacturers of seasonal fashion products may have six selling periods per year and offer five lines for each season. Seasonal merchandise with a high rate of fashion change has a short selling life, often only 8 to 12 weeks. There has been a tendency recently for some manufacturers to have new items to sell on a weekly or biweekly basis rather than for specific selling periods. The advantage of this strategy is that new merchandise will always be available for the retail buyer and their retail customers. Thus, the merchandise stays fresher in the retail store.

Manufacturers of basic, staple products have only one or two selling periods a year. Manufacturers of staple, basic goods such as T-shirts and athletic socks may produce and promote only one line a year for a selling season of 52 weeks. Their product changes are minimal from one year to the next and focus more on color and trim changes than on basic styling.

Key marketing dates are established for each seasonal line including line preview, line release, start to ship, and season ship complete (Bertrand Frank Associates, 1982). Line preview involves presentation of the line to the sales staff by the merchandising and marketing divisions. Line preview is normally about 2 weeks prior to line release. Line release is the date when the full line and sales samples must be completed for the first showing in the wholesale

Table 2–2 Marketing calendar.

Selling Period						
Activity	Spring	Summer	Fall 1	Fall 2	Holiday	Cruise
Line preview Line release Start to ship Ship complete	Aug. 10 Sep. 14 Dec. 1 Dec. 30	Oct. 10 Nov. 2 Mar. 1 May 30	Dec. 10 Jan. 4 May 1 May 30	Feb. 10 Jan. 4 June 1 June 30	May 20 June 6 Sep. 1 Sep. 30	July 20 Aug. 3 Nov. 1 Nov. 30

market. Line release marks the conclusion of most of the line development activities carried on by the merchandising division for a particular season. In today's Quick Response markets, line release may really be **style release**. For some firms line release has evolved into an ongoing offering of individual styles. **Start to ship** is the time when a particular line or style release will be available for delivery to retail stores. This is a key date for production scheduling. **Season ship complete** indicates when retail orders are to be completely filled. Retailers sometimes require that start to ship and ship complete be within 3 weeks of each other.

Firms that are involved in Quick Response have radically revised concepts related to merchandise delivery. Use of multiple shipments with turnaround times of less than 2 weeks provides higher rates of sale because top-selling merchandise stays in stock. An added benefit is that the overall inventory investment is less. Implementation of Quick Response has significantly changed the activities and lead times identified by the marketing calendar.

In addition to the dates shown in Table 2–2, a marketing calendar also often breaks down the sales forecast, in units and dollars according to merchandising plans, to determine planned shipments per month for the year. These figures indicate the volume per month that production is able to generate. Comparison of the planned shipping by month and actual shipping by month at the end of the year provides an essential guide for setting goals for the coming year. The sales forecasts are compared with actual sales as the season goes along to evaluate the potential success of individual styles. If early sales do not meet expectations, the promotional plan may be modified or styles may be dropped from the line.

Global Marketing and Sourcing

Global marketing directs goods into multiple foreign markets. The process of directing products into global markets must be approached with considerable care and planning. The aggressiveness, method, and speed of the global marketing strategy depends on (1) whether the firm's products are known among consumers in the foreign country; (2) the customs, laws, and regulations in the foreign country; (3) the political stability of the foreign country; and (4) the expertise among management of the apparel firm. The wide variation in customs and trade practices among cultures must be explored before deciding to enter a foreign market.

Exporting means domestically produced goods are sold in foreign markets. **Indirect exporting** involves selling merchandise through a trading company that specializes in selling domestically produced goods in foreign markets. The primary advantage of indirect exporting is that the manufacturer gains the expertise of an exporting specialist. The greatest disadvantage of indirect exporting is that the manufacturer loses control of the promotion and distribution of the product in the foreign country.

If a manufacturer uses **direct exporting**, the goods are sold by the domestic manufacturer's sales representatives to retail buyers from a foreign country. Direct exporting gives a firm more control over the distribution of a product, but it also requires more expertise among the firm's management and sales representatives. Trade missions into foreign countries are sometimes organized by industry trade associations and local or state governments to establish exporting systems that many firms can then use. Sales might also be accomplished through export fairs or markets held in the United States or abroad,

where foreign buyers are invited to purchase goods.

If a firm's products are already known in the foreign country and/or the primary concern is control of the product, its quality, and distribution, the firm may take an aggressive approach to entering the market by using a joint venture, direct investment, and/or licensing. Joint ventures and direct investment require capital investment and transfer of technology to a firm in the foreign environment. Licensing means a foreign firm purchases the right to merchandising properties and/or the technology to produce certain goods. (Licensing is discussed at length later in this chapter.) Recognizing the demand for Levi's in foreign markets, Levi Strauss established manufacturing plants in Europe through direct investment, joint ventures, and licensing during the 1970s. Some foreign governments limit outside ownership to less than 50 percent, which severely limits the ability of the U.S. firm to determine management, marketing, or production policies of the firm.

Global sourcing determines where materials come from and/or where apparel is made that enters domestic markets. For the most part, global marketing results in exporting, while global sourcing results in importing. Global sourcing has become common practice for most apparel firms. Recent data indicate that about one-third of imported apparel is sourced offshore by apparel manufacturers, about one-third is sourced by apparel retailers, and one-third is marketed in the United States by foreign manufacturers. This suggests that two-thirds of apparel imports are the result of international sourcing by U.S.-based firms while one-third is the result of international marketing by foreign based firms.

Table 2–3 identifies 29 countries that were primary suppliers of apparel to the United States in 1997. The five major suppliers in square meter equivalents (SME) were Mexico, Peoples Republic of China, Dominican Republic, Hong Kong, and Honduras; three located in the Caribbean Basin, the other two in the Far East. These five countries represent 42 percent of the total apparel imports in SMEs and 41 percent in dollar value. Korea, formerly one of the largest exporters of apparel, has experienced a marked decline in import market share in recent years while Mexico, Dominican Republic, Honduras, and Bangladesh have had large percentage increases. The primary advantage of manufacturing in developing countries is the wage rate. U.S. apparel wages average more than \$8 per hour while workers in developing countries may receive less than \$1 per hour.

Because of many inconsistencies and uncertainties involved in international sourcing in recent years, many U.S. firms have reexamined their sourcing

Table 2–3
The 27 largest suppliers of imported apparel by millions of square meter equivalents (SME), millions of dollars (\$), and percent of total (%).*

Country	Millions SME	% of Total SME	\$ Value Per SME	Millions \$	% Total
Mexico	1,555	13.70%	\$3.25	\$5,050	11.79%
Peoples Republic of China	947	8.34	4.74	4,488	10.78
Dominican Republic	797	7.02	2.78	2,216	5.17
Hong Kong	736	6.49	5.35	3,935	9.19
Honduras	726	6.40	2.29	1,659	
Bangladesh	672	5.92	2.16	1,448	3.87
Taiwan	590	5.20	3.51		3.38
Philippines	445	3.92	3.59	2,071	4.84
El Salvador	433	3.82	2.43	1,597	3.73
Indonesia	394	3.47	4.05	1,052	2.46
Sri Lanka	322	2.84	3.74	1,596	3.73
Korea	320	2.82		1,204	2.81
India	316	2.78	4.74	1,518	3.55
Costa Rica	302	2.66	4.26	1,347	3.15
Thailand	284	2.50	2.78	840	1.96
Guatemala	237	2.09	4.43	1,257	2.94
Pakistan	194	1.71	4.06	962	2.25
Jamaica	194	1.71	3.19	618	1.44
Canada	186		2.43	472	1.10
Macao	176	1.64	6.47	1,204	2.81
Turkey	174	1.55 1.53	5.28	930	2.17
Malaysia	135		3.86	672	1.57
gypt	93	1.19	4.82	650	1.52
Colombia	84	0.82	3.30	307	0.72
Inited Arab Emirates		0.74	4.13	347	0.81
laiti	79	0.70	3.03	239	0.56
aly	78	0.69	1.76	137	0.32
ingapore	66	0.58	18.57	1,226	2.86
apan	61	0.54	4.72	288	0.67
	6	0.05	9.33	56	0.13
otal or Average Above	10,605	93.44%	\$ 3.71	\$39,386	91.97%
Il Other Countries	744	6.56%	\$ 4.63	\$ 3,441	8.04%
otal Imports	11,349	100.0%	\$ 3.77	\$42,827	100.0%

Adapted from 1998 Apparel Import Digest, American Apparel Manufacturers Association.

*Numbers may not sum exactly because of rounding.

strategies. The result has been some increase in domestic sourcing and somewhat more selective use of international sources. Use of Item 807/Chapter 98 operations has increased as a proportion of total imports (over 30 percent in 1997) while other forms of importing have proportionally declined. U.S. firms have developed combinations of direct investment, joint ventures, and licensing as sourcing strategies to increase the reliability of apparel producers in the

Caribbean Basin/Mexico 807 operations. Firms from Korea, Hong Kong, and Taiwan are also setting up 807 operations in the area. The real challenge to domestic apparel firms is to determine the best sources for each product in a line in terms of styling, price, quality, and timing.

Marketing at Wholesale and Retail on the Internet

Internet web sites provide access to a global market with a single marketing tool. In 1998, Internet marketers were reporting rapid increases in the sale of apparel. Previously, Internet shoppers were highly educated, young males that were highly involved in computer technology. By early 1998, the Internet shopping profile included 40 percent females from dual income families with income twice the national average. The result was a rapid increase in the sale of apparel, both at wholesale and at retail, on the Internet. Confidentiality of documents and financial instruments remain a concern of consumers and apparel professionals although Internet executives insisted it is not a problem.

The 1998 International Apparel Research Conference sponsored by the American Apparel Manufacturers Association focused attention on Internet marketing. Apparel manufacturers, reporting their Internet marketing experiences, identified two basic purposes of web sites: (1) to sell merchandise direct to customers and (2) to generate ultimate consumers for their retail customers.

Sara Lee Knits and Fruit of the Loom reported sales growth of basic/staple goods direct to consumers. Web sites offered complete manufacturer assortments and complete information about styles, sizes, and colors. A wide variety in product offering improved sales as customers had access to a greater assortment than offered by any retail store. The system reported whether or not a particular stock keeping unit (SKU) was available and when it could be delivered. Opportunity for immediate delivery, preferably the next day, was a priority for "immediate gratification" of the Internet shopper.

Firms offering fashion/seasonal goods reported successful use of the Web to introduce their product line to potential customers and to develop the image for their brand names. After receiving the customer's address, the location of the closest retail stores where the merchandise could be purchased was provided. Retail merchandisers also responded to these fashion oriented web sites expressing an interest in buying merchandise to be sold in their stores. Retail merchandisers saw this type of web site as a positive influence on developing their retail customer base.

Labeling and Licensing

Intellectual property is a general term that describes inventions or other discoveries that have been registered with government authorities for the sale or use by their owner. These include merchandising properties such as

trademarks, patents, and copyrights. Intellectual property also includes trade secrets that relate to know-how that may offer competitive advantage in a particular business. The United States was a major advocate for addressing, through the World Trade Organization (WTO) framework, deficiencies in the protection of **intellectual property rights (IPR)** that result in unfair competition. The U.S. objective was the negotiation of a comprehensive agreement on IPR that included (1) adequate substantive intellectual property standards; (2) effective means for enforcement of such standards, both at the border and internally; and (3) effective and expeditious dispute settlement procedures. The WTO agreement includes five IPR areas: copyrights, trademarks, patents, trade secrets, and semiconductor chips.

An apparel firm's trademarks and copyrights are a major source of value to the company. Use of labels is a primary means of product differentiation and customer loyalty in the textiles and apparel industry. Trademarks often outlive a firm; for example, the labels Sasson and Robert Bruce were sold for millions after the companies that owned them went bankrupt (Rutberg, 1990). A current trend is the development of **megabrands**, using a well-known brand name on the product for which it is known as well as on compatible merchandise. For example, the Lee Company is using Lee on its internationally known jeans as well as on shirts, sweats, and other casual wear products that are contracted by Lee from other companies. Lee is relying on the name and its well-known reputation of quality, value, and fit to attract customers to its related products.

A firm's marketing strategy determines its use of labels and licensing and its efforts to promote and protect these merchandising properties. Labels are merchandising properties whose presence may add to the value of the product or simply become litter on the fitting room floor.

Types of Labels

Labels on products may bear nationally advertised brand names or trademarks, generic names, private labels or trademarks, and information required by law. Labels are a primary means of conveying product identification and differentiation for consumers.

Brand Names and Trademarks Labels on products are the means of communicating brand names or trademarks to buyers. Retail buyers and consumers who develop brand loyalty, have confidence in the quality, performance, and/or fashion the products represent. Trademarks, including brand names, logos, mottoes, or product features, provide recognition and are distinctive means of identifying manufacturers of products. **Trademarks** assist in differentiating products of one manufacturer from their competitors and are protected by registration with the U.S. Patent Office. Owners of nationally advertised names, logos, or other trademarks seek to create a particular product identity and image through advertising and promotion and provide consistent quality, performance, and styling

to fit the image. These product differentiation strategies contribute to the cost of manufacturing and marketing the products bearing the brand names.

Because of the merchandising value of established brand names and trademarks, some firms have invested millions of dollars in efforts to prevent trademark infringement. **Infringement** is the reproduction or use of a trademark to mislead the public into believing the items bearing the trademark are produced by the owner of the trademark. For example, in the early battles related to trademark infringement, Levi Strauss took a number of firms to court for infringing on Levi's trademarks, including the arcuate stitched design on pockets, the cloth pocket tab, and the word *Levi's*. The court action was followed by a series of ads in *Daily News Record* and *Women's Wear Daily* warning other companies not to violate the trademarks of Levi Strauss (see Figure 2–2). Izod, a division of General Mills that owned the well-known alligator logo, investigated about 500 infringement cases in a single year. The company sued about 150 defendants and confiscated about 150,000 garments.

Products that involve trademark infringement are counterfeit. Issues related to counterfeiting are discussed later in the chapter.

GENERIC AND NO-NAME PRODUCTS Apparel without any sort of brand name to represent the manufacturer—generic goods—used to be commonly found in budget lines sold in variety stores, discount stores, and budget departments in department stores. These products might be considered "generic" because of a lack of obvious manufacturer identification. Even though generic products have lower marketing and product development costs, there has been a move away from generic apparel even in budget lines. Since the late 1970s, product differentiation by brand name or label has increased in importance because of the success of extensive advertising campaigns conducted by U.S. designers and other manufacturers. It has become unusual to find garments of any type or price range that do not have a brand name or trademark representing an apparel manufacturer or retailer.

PRIVATE LABELS **Private brands and labels, store brands,** and **house brands** all mean the same thing: they are labels owned and used by specific retail firms. The products bearing private labels are sold primarily by stores owned by or associated with the owner of the label. Mass merchandisers, such as Sears and J. C. Penney, have long had successful private-label programs, primarily for basic goods. For example, J. C. Penney developed "Plain Pocket Jeans" made to J. C. Penney's specifications. Plain Pockets were produced by some of the same contractors that made Levi's and Lee's and used similar specifications. Plain Pockets has now been replaced by the successful "Arizona" line. The Arizona line has been successfully diversified into tops, bottoms, and jackets serving casual wear needs of men, women, and children and now generates 5 percent of Penney's sales. Arizona is one of nineteen of Penney's private labels (Henricks, 1997, October).

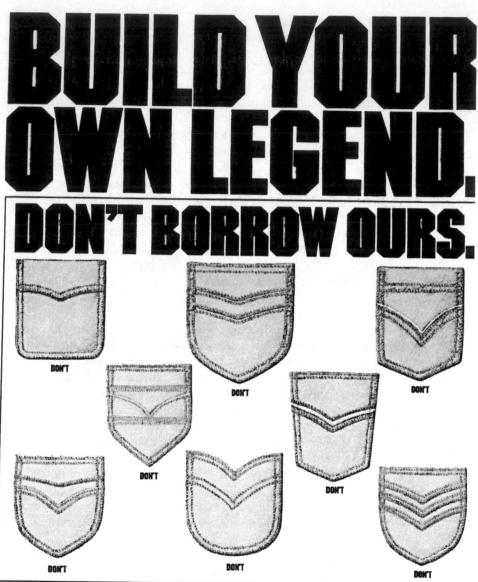

According to the United States Patent and Trademark Office, Levi Strauss & Co. is the only manufacturer entitled to use the double-curved "arcuate" design on a patch pocket Regardless of what color of thread is used.

Or whether it's a fabric insert, piping, a pocket

flap, or even printed onto the material.

The arcuate is our design trademark. And we will If you want to apply decorative stitching to a back pocket, more power to you. But please, just be sure you choose a different design.

Figure 2-2 Levi's anti-infringement ads. Source: Courtesy Levi Strauss & Co. Department, specialty, and discount stores use private-label merchandise to increase customer loyalty, increase exclusivity, decrease costs, and increase gross margin. Private-label goods may have lower marketing costs, lower production costs, and have greater variation in quality than brand-name goods be-

cause of less rigorous quality control.

Private labels provide brand names that will not appear in competing stores. The store name may be used as the private label, or a special name may be created. For example, Dayton-Hudson Department Stores has "Daytons" on some of their merchandise categories and unique labels such as "Boundary Waters" on other classifications. Target created the "Honors" label for their apparel, and it is now being used on diverse categories of merchandise. Honors is promoted along with other nationally advertised brands when a "brand-name sale" is held. Some types of Honors lingerie is made for Target by Jockey International, which has a similar line of Jockey For Her products. Merona is another example of Target's private labels.

Some manufacturers specialize in making merchandise especially for buyers of private-label merchandise. Manufacturers of branded goods also may offer special lines for private-label. An annual market for private-label goods called Private Label Expo is held in New York. The private-label exhibitors represented 46 countries. Customers at the show include most major U.S. department stores and catalog companies. Prices for goods sourced overseas were about 30 percent less than those produced domestically (Gellers, 1994).

To support the use of private labels, some retail firms have created "product development" divisions. Others have expanded the responsibilities of the merchandising division to include product development. For example, Paul Harris Inc. now calls their buyers and merchandisers "product development managers." These retailers may employ apparel designers, graphic artists, and international sourcing experts in addition to merchandisers. Product development divisions in retail firms are performing the merchandising functions that traditionally have been performed by apparel manufacturers. They also may hire production from the same contractors that apparel manufacturers might use to make similar products.

Some retailers are examining the possibility of selling their private-label lines to retail stores in noncompeting markets. This opens the possibility that a retailer might lease space in an **apparel mart** to sell goods to other retailers, thus competing directly with apparel manufacturers in the wholesale function.

LEGALLY REQUIRED LABELS A number of federal laws and regulations require specific label information. The Wool Products Labeling Act, Fur Products Labeling Act, Flammable Fabrics Act, Textiles Products Identification Act, Trade Regulation Rule on Care Labeling of Textile Wearing Apparel, and Country of Origin Rules all specify labeling requirements or performance regulations. The flammability standards mandated by the Flammable Fabrics Act (passed in 1953, amended in 1967 and 1972) prohibited marketing of dangerously

flammable materials. Compliance with children's sleepwear flammability standards is required to be on the label.

The **Textile Fiber Products Identification Act (TFPIA)** requires that a label identify the generic name of the fiber content, the manufacturer's name or number, and country of origin. Textile fiber trade names can be used, but only in association with generic names. A label can say "100% Hollofil polyester" but not "100% Hollofil." However, in the textile and apparel trade, fabrics made of manufactured fibers are widely identified by the trademark associated with the fiber content rather than by the generic name of the fiber. Fiber manufacturers have been successful in gaining acceptance of their brand names through advertising and promotion. Fabric and finish generic names are not required by TFPIA, although textile manufacturers widely advertise trade names for these products.

The TFPIA requires garment producers to be identified by trademark or registration number (RN). If there is no brand name present on a product or if the production of the product is contracted, the product is required to have a manufacturer's identification number such as "RN456852" on the label so the actual producer of the product can be identified. The manufacturer must register with the Federal Trade Commission (FTC) to receive this number. It must appear on a label in all products sold.

Permanent care labels are also required on most textiles and apparel products. The care labeling rule was originally passed in 1971 and amended in 1984. The new version of the care labeling rule requires specific wordings and definitions relative to care methods; \$10,000 fines can be levied for noncompliance to the rule. The move now is to global use of international care symbols on labels to overcome the language barrier. The United States is one of few countries that has required permanently attached written care instructions. The FTC, in cooperation with the American Society for Testing and Materials (ASTM) developed a care symbol system for the U.S. market. For 18 months, beginning July 1997, care symbols were required to be accompanied by written care instructions to familiarize U.S. customers with the new system. The U.S. system is similar to but not the same as the GINETEX system used in Europe. The symbol system was developed to simplify labeling for products sold in NAFTA countries that otherwise would have required care instructions in three languages (Wolf, 1997).

Country of origin is required information on permanently attached labels in the United States. In 1996, the definition of country of origin was changed to put the United States in compliance with the rules of the World Trade Organization (WTO). Previously, country of origin was determined by where a garment was cut; now country of origin is determined by where the garment is assembled (Wolf, 1997). Assembly is defined as the last significant transformation of the garment.

To carry a **Made in USA** label requires that "substantially all" of the garment is made in the United States. As the apparel industry has become more

globalized with several countries potentially involved in the manufacturing of a single garment, determining whether it is appropriate to say Made in USA is more complex. The U.S. Federal Trade Commission specifies that U.S. manufacturing costs must constitute at least 75 percent of the total manufacturing costs and that the product must be last "substantially transformed" in the United States to carry the label. If the product is made of foreign-made materials the label might say "Made in USA of foreign materials" (O'Brian, 1997).

Merchandising License Agreements

Licensing is a means of using intellectual property that belongs to someone else. Licensing merchandising properties such as brand names, trademarks, designer names, celebrity names, cartoon characters, and other things that have merchandising value is a proven marketing tool. A **licensing agreement** is a contract in which the licensee agrees to pay the licenser a royalty or fee for the use of a merchandising property. The **licenser** is the owner of the merchandising property. The **licensee** buys the right to use the property for identifying, advertising, and promoting its products. A **licensed product** is one that bears the merchandising property.

Table 2–4 shows the different types of property that uses licensing as a marketing tool by retail sales in 1995 and 1996. Clearly, the dominating property types are entertainment and characters, trademarks and brands, sports, and fashion. Among product categories apparel is most likely to be licensed with

Table 2–4Retail sales of licensed products in the United States and Canada by property type for 1995–1996 (dollar figures in billions).

Property Type	1996 Retail Sales	1995 Retail Sales	Percent Change 1995/96	Percent All Sales 1996
Entertainment/Character	\$16.70	\$16.19	3%	7%
Trademarks/Brands	15.11	14.20	6	21
Sports	13.79	3.39	3	19
Fashion	12.60	12.16	4	17
Art	5.20	5.08	2	7
Celebrities/Estates	2.57	2.54	1	4
Toys/Games	2.71	2.78	-1	4
Publishing	1.64	1.59	-1	2
Music	1.03	1.08	-5	1
Nonprofit	0.70	0.69	e establishe	1
Other	0.23	0.22		_
Total	\$72.28	\$69.93	3%	100%

Source: The lure of licensing. (1997, June). Discount Merchandiser, 37 (6), 3.

\$11.58 billion in retail sales in 1996 followed by toys and games with \$7.85 billion and accessories at \$6.83 billion.

Licensing is used at all price levels of merchandise. Professional marketers now conceive, develop, and promote properties with an eye on the needs and desires of the ultimate consumer and with the intent of marketing it through licensing. Licensing is growing faster than retailing as a whole; thus, licensed products are increasing as a proportion of total merchandise offered at retail. In addition, royalty fees as a proportion of sales are increasing because the percentages of sales to be paid in royalties have increased. Thus, licensers have gotten a larger portion of the increases in sales of licensed products than licensees (Gill, 1990).

Currently there is strong demand for upscale designer licenses. For example, the men's clothing trade believes there are not enough strong designer names to go around. Lauren by Ralph Lauren was well received at a recent trade show. Peerless International bought the right to sell Lauren suits at \$395 to \$550. Argo Clothing bought a license for Balenciaga suits to retail at \$1,000 (Gellers, 1998).

Licensers sell the rights to use their property because it is a source of revenue with little risk associated with it. The costs of licensing to the licenser depend on the contract and the level of involvement the licenser has with the licensee. Successful licensing agreements usually involve careful monitoring by the licenser to be sure products meet quality standards and that the terms of the contract are met.

Licensing contracts include descriptions of what is being licensed (label, trademark, logo, designer name, character, or manufacturing process), a description of the product that can bear the licensed property, the time frame the agreement covers, the responsibilities of the licenser and the licensee, the amount of royalty to be paid, the basis of royalty, the market coverage, and the guarantee and/or minimum royalty. Most licensing agreements are exclusive, meaning that the licensee is the only party that has the right to use the licensed merchandising property on a certain type of product. Therefore, the definition of the product is an important part of the contract. Careful product definition prevents the manufacture of competing products bearing the same label, especially since some licensers license 50 or more manufacturers for different products. Figure 2–3 shows the products of Londontown, the maker of London Fog coats.

Royalty rates run from 1 percent to 15 percent of sales. Royalties on toys usually run from 6 percent to 8 percent; apparel products usually have a slightly lower rate than toys. Items that sell for higher prices, for example, \$500 or more, may not have as high a royalty as a \$6 T-shirt. Royalties are usually based on net sales, which is the manufacturer's wholesale price less returns. The licensee is usually required to pay the licenser an advance against a guaranteed minimum royalty. The guarantee may be based on half of the licensees' projected sales. For instance, if a manufacturer planned sales for the licensed product of \$1 million, \$1.5 million, and \$2 million for three successive years of

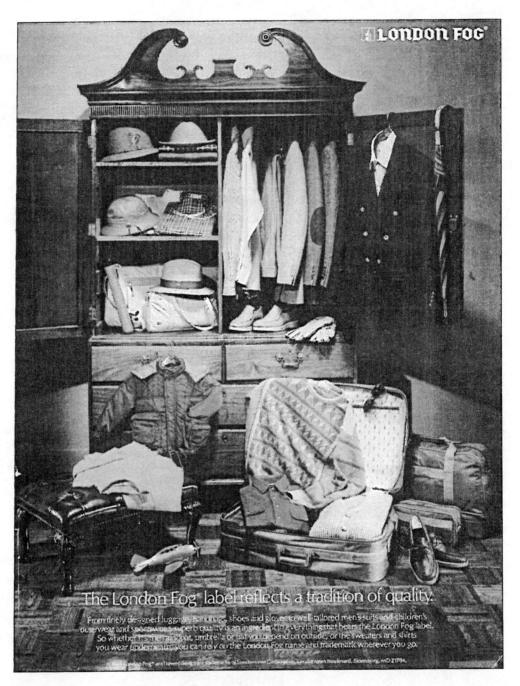

Figure 2–3 London Fog products. Courtesy of Londontown Corporation.

a 3-year contract, the royalty guarantee would be calculated on sales of \$500,000, \$750,000, and \$1 million, respectively.

Retail licensing volume reached \$72 billion in 1996 with an expected 6 percent increase in 1997 (D'Innocenzio, 1997). Fifteen years ago, licensing was regarded as a marketing bonanza, a certain way to increase profits. Licensing is now regarded much more realistically. Joint planning, between the licensee and licenser, is a key to success. A good licensing agreement provides benefits to both parties. Licensees and licensers have different perspectives when selecting cooperating firms. Table 2–5 identifies perspectives of licensing participants.

Licensing contracts often extend from 1 to 5 years with or without a renewal option. Since it often takes up to 18 months to plan, produce, and distribute a line, a 1-year contract is extremely limiting in terms of long-term planning. The most successful licenses are the ones in which the licenser of the property maintains some control over the program.

Counterfeiting

Counterfeiting is the act of making an imitation of what is genuine with the intent to defraud. Counterfeits result from infringement of intellectual property rights. Counterfeiting of brand-name products is affecting growing numbers of legitimate manufacturers. Cartier watches, Levi's jeans, Guess jeans, and other trademarks that are fashionable at any particular time are targets

Table 2–5Considerations of licensers and licensees when entering licensing contracts.

Licensers seek licensees with the following qualities:

- 1. Adequate market share
- 2. Compatible quality level
- 3. Production capability
- 4. Appropriate quality control program
- 5. Compatible target market
- 6. Established sales force
- 7. Sufficient financial backing to stay in business
- 8. Appropriate suppliers and customers
- 9. Complimentary products to the established product line

Licensees consider the following issues when seeking a licenser:

- 1. The prominence of the property with the target customer
- 2. The reputation of the licenser
- 3. The licenser's support of the property
- 4. The life expectancy of the property
- 5. Adequate protection by copyright or other legal protection
- 6. Media exposure of property
- 7. Types of guarantees required
- 8. Amount of royalties
- 9. Length of contract
- 10. Availability of renewal options

of counterfeiters. Copyrights as well as trademarks are vulnerable. Counterfeiting costs the apparel industry \$13 billion annually according to the International Anti-Counterfeiting Coalition (Henricks, 1997, September).

In the apparel business, copying is often regarded as the fondest form of flattery. After all, if a style is not copied it can never become a fashion. While knockoffs are widely accepted in the apparel industry, counterfeiting is not. The difference between a counterfeit and a knockoff depends on how the product is presented. A product is a **counterfeit** if it is presented as being produced and marketed by the owner of the trademark, copyright, or patent. A **knockoff** is an imitation of the original, but it does not carry the labels and trademarks of the original.

In 1978, 35 American and European companies established the International Anti-Counterfeiting Coalition to persuade governments to adopt a global code to combat the problem. Some of the members of the coalition included Cartier of France, Puma, Walt Disney, Levi Strauss, and VF Corporation. At that time, the Coalition developed an Anti-counterfeiting Code that could come under the administration of the General Agreements on Tariffs and Trade. Under the code, it was the responsibility of the manufacturers to alert customs officials of the possibility of counterfeit merchandise being imported (Salmans, 1981).

With current global sourcing strategies, counterfeiting is a serious international issue. Certain countries are particularly known for violations. The counterfeiting business has been described as "wide open" in east Asia: China, Taiwan, South Korea, and Hong Kong. To try to tighten enforcement of import regulations, the U.S. Customs Service created a New York task force to coordinate detection of textile fraud. Among the trophies of the task force were 100,000 counterfeit trademark emblems and 759 cartons of fake designer jeans. Customs agents estimate that fake designer jeans would come into the United States at a cost of \$8 and could be sold in the stores for \$60. Obviously, there are tremendous profits to be made in counterfeiting. Counterfeiting continues to be a concern of firms that hold highly marketable intellectual properties.

In U.S. markets, counterfeiting of athletic team logos is particularly a problem. A Coalition to Advance the Protection of Team Logos (CAPS) was formed by the National Football League, National Basketball League, National Hockey League, Major League Baseball, and the Collegiate Licensing Company. In an 18-month period, CAPS made 200 arrests and confiscated \$18 million in counterfeit merchandise and printing equipment. Most arrests take place at manufacturing plants or distribution centers but flea markets have also become a problem. Some states have now passed laws to make it a felony to possess more than 1,000 units of counterfeit goods (Salfino, 1994).

Protecting Rights to Merchandising Properties

Protection of rights to merchandising properties is fashioned from a patchwork of trademark law, copyright law, patent law, laws protecting against unfair

competition, and laws regarding misappropriation of property. Registration of copyrights, patents, and trademarks helps deter infringers. If suits are brought for infringement and supported by the courts, the owner is entitled to damages, an injunction (stopping the infringer from using the item), compensation for loss of profits, profits made by the infringer, attorneys' fees, and court costs.

The purpose of a **copyright** is to protect the work of an artist or author. Copyright protection is given to artistic and literary works and to the different ways in which they may be expressed. The copyright symbol, followed by the name of the owner and the year in which the work was first published, is the necessary notice of a copyrighted work. The copyright must be registered within 5 years of the first publication with the Copyright Office, Library of Congress.

Textile designs can be copyrighted and are closely monitored by artists. However, protection of apparel designs by copyright is particularly difficult. A substantial portion of a design must be copied in order to be identified as infringement. A knockoff is not usually regarded as an infringement because it is a modification of a design in a less expensive fabric and at a lower price point. A knockoff is usually not in direct competition with the original because it appeals to a different target market.

A **trademark symbol** (TM) or the word *trademark* can be used next to a name or symbol that has not been registered. The purpose is strictly to identify the trademark as owned by a firm. The trademark is protected under common law rights that arise from constant use. Names and symbols can be registered as trademarks with the U.S. Patent and Trademark Office.

A **registered trademark** is indicated by the registered name or symbol followed by R with a circle around it ($^{\textcircled{\$}}$). Trademark rights in the United States are based on use, not registration. In fact, registration with the Patent and Trademark Office requires that the property has first been used in interstate commerce.

A **patent** provides protection to processes, devices, equipment, and so on. It can also be given as a design patent to protect ornamental designs for articles of manufacture. Registration of a patent is indicated by including the patent number along with the product name or trademark. (For further information about copyrights and registration, write to Register of Copyrights, Library of Congress, Washington, DC 20559.)

Firms protect the merchandising properties that they own and the ones that they license through effective use of the legal system. The steps to legal protection of a merchandising property in the United States include the following:

- Determine whether another firm has rights to the property.
- Determine ownership of the property.
- Determine what property rights can and cannot be merchandised.
- Know what product categories can use the property.
- Establish trademark rights to the property by using it in the marketplace.

 Establish a protection plan for protecting the property, prevention of misuse of the property, detection of misuse of the property, and enforcement of property rights.

Register the property by filing for appropriate trademark, copyright,

and patent protections.

Monitor all use of the property.

The Omnibus Trade and Competitiveness Act of 1988 directs the U.S. trade representative (USTR) to develop an overall strategy to ensure adequate and effective protection of intellectual property rights (IPR), both at home and abroad. The so-called "Special 301" provisions brought the United States a new tool for upgraded protection of IPR, worldwide. USTR is to identify annually those countries that do not adequately and effectively protect IPR or fail to provide fair and equitable access to their markets. Countries on the priority watch list include Brazil, India, Mexico, People's Republic of China, Saudi Arabia, Republic of Korea, Taiwan, and Thailand (Main, 1989).

As time passes, the labels that are being counterfeited change, because primarily the "hottest" goods of the season are copied at any particular time. The counterfeit products are typically substandard; therefore, they damage the reputation of the owners of the trademarks in addition to denying the rightful owners the revenue from the sale of the products. It is impossible to accurately estimate the total value of counterfeiting in the apparel industry because only a small portion of counterfeit goods are confiscated. However, because of the investment that firms make in differentiating their products by using labels and trademarks, the fight against counterfeiting will continue.

Summary

Firms operate in an environment involving many uncontrollable factors, including climate, economy, culture, politics, fashion, competition, and international relations. Controllable factors include a firm's marketing strategy, relationships with suppliers and customers, and product lines. During the late 1970s and early 1980s, many apparel manufacturers recognized that success could be built on managing the controllable variables and anticipating the effects of uncontrollable variables. Apparel firms of all sizes and types have to perform similar functions, regardless of the sophistication of technology or management.

Marketing plays a central role in defining an apparel business and in deciding its product-market scope. Marketing has a unique focus on customers and on business's competitive environment. Strategic planning is a common foundation for marketing strategies. Sales forecasting provides the basis for budget

formulation and the firm's financial planning. Marketing strategies may include both wholesale and retail components. Product positioning, differentiation, and use of labeling and licensing are key factors in apparel business success. Infringement of intellectual property rights via counterfeits is an ongoing problem. The apparel firm's marketing calendar provides the time structure for product development, production, and marketing. There is a strong relationship between commitment to a marketing strategy and profitability for apparel manufacturers.

References and Reading List

Apparel Industry Trends. (1998, March). Economic Newsletter of American Apparel Manufacturers Association.

Bertrand Frank Associates. (1982). Profitable merchandising of apparel. New York: National Knitwear and Sportswear Association.

Charron, P. R. (1998, March 3). Realities of global manufacturing and sourcing: A sewn products perspective. Key note address at International Apparel Research Conference, Atlanta, GA.

D'Innocenzio, A. (1997, June 18). Licensing '98: Seeking a hit. WWD, p. 12.

Economic Intelligence Company. (1998, April).

American apparel manufacturers
association report: Economic indicators
for the apparel industry. New York:
Author.

Evans, J. R., and Berman, B. (1987). Marketing (3d ed.). New York: Macmillan.

Gellers, S. (1994, October 19). Private label draws major public stores. *DNR*, pp. 1, 8.

Gellers, S. (1998, February 18). New designer labels raise the bar for clothing companies. *DNR*, pp. 31–32.

Gill, P. (1990, June). Licensing: New heyday. Stores, pp. 11–13, 18–22.

Henricks, M. (1997, September). Harmful diversions. Apparel Industry Magazine, pp. 72–78. Henricks, M. (1997, October). Convergence 2: Vertical retail. Apparel Industry Magazine, pp. 38–46.

Main, A. (1989, September 25). Pursuing U.S. goals bilaterally: Intellectual property and "Special 301." *Business America*, pp. 6–8.

Marlow, M. (1998, June 5). It's in the mail—finally. DNR, p. 20.

Murray, J. A. (1984). Marketing management. Dublin: Gill & Macmillan.

O'Brian, K. (1997, October). Made (mostly) in USA? *Bobbin*, pp. 54–55.

Plummer, J. (1974, January). The concept and application of life-style segmentation. Journal of Marketing, pp. 33–37.

Rutberg, S. (1990, April 3). The bottom line: Before gauging its value, it's good to know the tricks of the trademark. *Daily News Record*, p. 7.

Salfino, C. (1994, August 29). Putting a cap on counterfeit licensed team-logo apparel. DNR, pp. 54–55.

Salmans, S. (1981, March 3). The pirating of brand goods. *New York Times*, p. D2.

Wolf, A. W. (1997, April). Making sense out of symbols. *Bobbin*, pp. 98–99.

Key Words

apparel mart care symbols copyright core customers counterfeit counterfeiting country of origin direct exporting distressed merchandise diversification exporting fringe customers generic goods global marketing global sourcing house brands indirect exporting infringement inside sales representatives intellectual property intellectual property rights (TPR) Internet web site knockoff

licensed product licensee licenser licensing licensing agreement line preview line release Made in USA manufacturer's identification number market development market penetration market positioning market segment marketing marketing strategy mass market megabrands merchandising properties multiple-segment strategies niche marketing outside sales representatives patent permanent care label

private brands and labels product differentiation pull-through push-through qualitative research methods quantitative research methods registered trademark rovalty sales forecast sales projections season ship complete sell-through selling period start to ship store brands style release target market Textile Fiber Products Identification Act (TFPIA) trademark trademark symbol U.S. Patent Office

Discussion Questions and Activities

- Make a list of trade associations that sponsor apparel markets. Where are markets held? Are they located in apparel marts? Are the markets national, regional, or local in scope? Use trade publications such as Women's Wear Daily or Daily News Record as sources of information.
- 2. Find out where apparel markets are held in your state. Who organizes the markets? What products are represented in each?

- How far do retail buyers travel to use the markets?
- Take a field trip to a local apparel market.
 Make appointments to talk with
 manufacturer's sales representatives; ask
 them to do a sales presentation for you;
 observe a market in action.
- 4. Refer to Figure 2–1 and Table 2–1. What other information could be included for a more complete market analysis?

- 5. Examine the advertising in WWD or DNR. Can you tell whether the products being advertised are licensed? Consider the ethics of licensing from the consumer viewpoint. Is licensing misrepresentation of products from a consumer's perspective?
- Examine the classified section of WWD or DNR. Find ads for licensers and licensees.
- What kind of information is specified in the ads? Why?
- 7. Research the marketing strategy of a large publicly owned apparel firm. Use annual reports, trade press, consumer publications, Internet, and observation of the merchandise presentation at retail.

Merchandising Processes

OBJECTIVES

- @ Examine the role of merchandising in an apparel firm.
- Obscribe the dimensions of apparel product lines including the merchandising calendar.
- Evaluate how Quick Response strategies impact the merchandising process.
- Examine the merchandising process including line planning, development, and presentation.
- Objects the relationship of merchandising to sourcing finished goods, materials, and production.

The primary concern of an apparel firm is to provide a product line that will meet the needs of the selected target market and produce a profit so the firm can grow. The product line is the primary responsibility of the merchandising division. **Merchandising** is the planning, development, and presentation of product line(s) for identified target market(s) with regard to prices, assortments, styling, and timing. Merchandisers may be involved in the **materials** manufacturing, apparel manufacturing, and retailing levels of the apparel business. Merchandising is the central coordinating point for the product line.

Context of Merchandising

Strategic **business planning** is recognized as an essential part of management in today's competitive markets. A firm's mission, goals, and policies reflected in their strategic plan provide the basis on which merchandising decisions are made. Merchandisers work within the context of the firm's strategic business plans that identify the primary product line(s), price range(s), size range(s), fashion emphasis(es), and quality level(s) appropriate to the firm's mission and target market. It is the merchandisers' responsibility to work creatively within the constraints of the firm and marketplace to meet the needs of the target market.

Merchandisers are charged with converting business strategies, including sales volume and profit goals, into product lines, individual styles, units of merchandise, and dollar values. The criteria used to evaluate the effectiveness of a merchandiser and merchandising functions include determining what merchandise will sell the best, cost the least, and make the most gross margin and profit. Traditionally merchandisers have worked with **gross margin** (GM), the difference between net sales and cost of goods sold, as an indicator of success. Gross margin can be calculated in both dollars and percent for total assortments, individual merchandise groups, individual selling periods, or an entire year.

Manufacturer merchandisers are involved primarily in the apparel manufacturing sector. They may plan and develop lines that are presented at wholesale apparel markets for sale to retail buyers. If a firm is vertically integrated, manufacturer merchandisers may be presenting directly to ultimate consumers in manufacturer owned retail stores. Retailer merchandisers work for firms that operate primarily in the retail sector and prepare lines for presentation to retail customers. Merchandisers may buy finished goods to develop assortments and/or use product development as a part of line development.

Impact of Quick Response on the Merchandising Calendar

Merchandisers have long been responsible for planning, developing, and presenting the firm's product line, the primary source of revenue. A mcrchandising calendar determines the timing and interaction of events required to provide merchandise for each selling period in the merchandising cycle. Merchandising calendars are based on a 52-week merchandising cycle, usually from the first week of February to the last week of January. Within the merchandising cycle are blocks of time called selling periods defined in weeks of sale for different types of products. The end of the selling period in a Quick Response (QR) system is determined by sales decline for a style. A selling period

may be 3, 6, 12, 26, 52 weeks, or as long as the style continues to sell. The merchandising calendar may also have strategically planned release dates for individual styles or merchandisable groups. This allows manufacturers to level production while providing their retail customers with an ongoing sequence of fresh merchandise.

According to the merchandising calendar developed in 1982 by the American Apparel Manufacturers Association, the time-line from evaluation of past selling periods to delivery of finished goods to the retailer was 56 weeks. The goal of QR systems is to cut that time in half or less. The benefits of working closer

to the time of sale to the ultimate consumer are enormous.

Under QR systems, merchandisers are also responsible for planning and coordinating complex delivery schedules. Historically, retail merchandisers have preferred that orders for merchandise be shipped complete before the beginning of or very early in a selling period. This provided retailers with maximum flexibility in presenting the merchandise on the selling floor. QR strategies have now shown the benefits of pretesting styles before the selling period and using small, multiple orders based on sales early in the selling period. Manufacturers set up for QR with lead times of 3 weeks or less can respond to customer demand by shipping reordered merchandise for hot selling styles. Brief **lead time**, the time between placement of an order and merchandise delivery, allows the replenishment process to be **customer driven**. The result is maximum merchandise turnover and minimum inventory investment for both the manufacturer and the retailer (Kurt Salmon Associates, 1997).

Quick Response has brought two measures of merchandising success to the attention of apparel firms in addition to gross margin (GM): gross margin return on inventory (GMROI) and adjusted gross margin (AGM).

GM = net sales - total cost of goods sold

GMROI = gross margin ÷ average inventory investment

AGM = GM - (inventory carrying costs + distribution costs)

While describing how apparel firms develop and use these formulas is not the purpose of this book, it is essential to recognize the complexity of generating a

product line that is the primary source of a firm's revenue.

With QR strategies the target market becomes an active participant in line planning and development by providing feedback just before or during the selling period. Feedback from customers, including point of sale data, during the selling period is only effective when electronic communication systems are in place among firms involved with the product lines. Cooperation; long-range planning; and investment in technology among materials vendors, apparel manufacturers, and retailers are essential to make QR programs work.

Concepts of Apparel Product Lines

In a general context, the term **product line** is used to refer to the total merchandise mix presented for sale by a firm. For a firm, a product line may be primarily shoes or gloves. This general product line often has several divisions, and each of these may also be referred to as a product line but is more specific. In this context, the term *product line* refers to a category of merchandise in the total merchandise mix that is (1) closely related because it satisfies certain needs, (2) used with other items, (3) sold to the same target market, (4) marketed within the same outlets, and/or (5) priced within similar price ranges. For example, within a shoe line, there are many categories of women's shoes, children's shoes, and men's shoes. Each category of shoes may be subdivided into classifications. The category of men's shoes might include classifications of dress shoes, casual shoes, and work shoes at moderate prices.

Within each line/category/classification of merchandise, the merchandiser builds an **assortment**, the range of choices offered at a particular time. The assortment is determined by the number of styles, sizes, and colors, in which products are offered. A **style** is an identifiable piece of merchandise characterized by a distinctive appearance. Styles may be modified from one selling period to the next. A **design** is a specific or unique version of a style that has not yet been accepted into a product line. Designs that are accepted into a line are given a style number and from then on are simply referred to by manufacturers and retailers as a "style," a "style number," or simply "number." A **style number** provides identification of the product throughout the manufacturing and distribution process.

The product line is an apparel firm's source of potential profit; therefore, its content, development, and production require constant analysis and planning. The wrong mix of products may not appeal or meet the needs of the specific target market and thus would limit sales and profits. The number of lines produced in a year and the number of styles in each line depend on the nature of the product(s) and the individual firm's objectives, strategies, size, and projected sales volume. Large apparel firms may have several product lines for each solling period. Each product line may be marketed at a different price range, under a different label, and targeted to a different market segment (Reda, 1994). This gives the firm broader market coverage. A smaller firm may offer a single product line focused on serving a few needs of a particular target market.

As discussed in Chapter 1, the North American Industry Classification System (NAICS) identifies the general product lines within the apparel business. An individual firm further refines the description of its product line (considering its business plan regarding quality, value, and fashion) by describing the

particular type of product (knit dresses), general price range (upper-moderate knit dresses), and the size range(s) offered (upper-moderate junior knit dresses).

Merchandisable Groups

The definition of the product line includes a concept of how individual units of merchandise relate to each other and to the line as a whole. Merchandisers and designers, when planning and developing product lines, usually think in terms of merchandisable groups rather than individual units of merchandise. A merchandisable group provides alternate solutions to solving the same apparel need for the ultimate consumer. Basic concepts of these merchandise groups include separates, coordinates, and related separates.

A firm described as a "separates house" may produce and/or distribute tops or bottoms or both. As **separates**, tops may be grouped as blouses, dressy blouses, and knit tops. Bottoms may be grouped as casual skirts, career skirts, and slacks. Within the dressy blouses group the line may have classifications based on common fabrication, trim, color, or style feature(s). Separates lines are merchandised for retail buyers and for consumers as groups of the same type of merchandise. For example, at retail, blouses from several vendors might be displayed on a rounder classified by size. Separates-type merchandising serves the customer who is looking for an individual item rather than a whole ensemble. Historically, discount and off-price retailers have been more likely to merchandise goods as separates rather than as coordinates.

A firm that develops and distributes **coordinates** presents groups of different types of products with common characteristics. For example a group of coordinates might include skirt, slacks, top, and jacket. The group of coordinates creates an ensemble unified by styling, fabric, trim, and/or color. Coordinates are presented at wholesale to show the multiple-sales potential of product groups. At retail, coordinates tend to be displayed on T-stands or other multiface units featuring related styles in the group. Styles in the coordinate set are sold individually, but the benefit of a multistyle purchase is very obvious.

Coordinates are different than multipiece styles. A **multipiece style** is a product such as a suit in which a jacket and skirt are included in the same style number, and the two pieces are merchandised for one price. Multipiece styles may serve the same purpose as coordinates but do not offer the consumer the same flexibility in selection of individual pieces. For example, a customer cannot buy a different size in a top and bottom or substitute slacks for a skirt.

Yet another concept related to merchandise groups is related separates. **Related separates** are conceived, displayed, and sold like a separates line, but coordination potential exists throughout the product offering because of use of common color palettes and materials. The advantage of related separates is the potential for multiple sales of compatible merchandise without the complexity of presenting the merchandise groups as coordinates. The Gap has made great success of offering related separates.

Sometimes a firm uses a multiconcept line strategy in which part of the line is offered as separates and other parts are presented as coordinates. The way the product line is conceptualized guides marketing strategies, merchandising processes, and production sourcing. In any case, in the apparel business, everyone must be prepared to deal with product change.

Dimensions of Product Change

Dealing with the demand for constantly changing products may be one of the most challenging and interesting aspects of apparel merchandising. Fashion results in customer demand for product change. "Fashion is a continuing process of change in the styles of dress that are accepted and followed by segments of the public at any particular time" (Jarnow, Judelle, and Guerreiro, 1981). A second aspect of product change, seasonal change, is often confused with fashion change. The terms seasonal goods and fashion goods are often used interchangeably, as are the terms basic goods and staple goods. However, when fashion change is separated from seasonal change, reasons for product change are clarified.

A Perceptual Map of Product Change

Some apparel products are highly fashionable, and others are highly seasonal. Some are both seasonal and fashionable; others are neither seasonal nor fashionable. The impact of these aspects of product change on merchandise planning and positioning can be visualized through the use of a perceptual map as shown in Figure 3–1. This **perceptual map** is a graphic representation of fashion/seasonal and basic/staple variation in consumer demand. It is based on a 52-week merchandising cycle, the time period commonly used for merchandise planning. A merchandising cycle is divided into **selling periods**, the number of weeks a particular style or merchandise group is salable to the ultimate consumer. The **rate of product change** is determined by the number of different selling periods in a merchandising cycle. Table 3–1 on p. 68 itemizes the definitions of terms required to understand rate of product change.

FASHION/BASIC CONTINUUM **Fashion goods** are products that frequently experience demand for change in styling. Fashion goods require frequent change in styling in order to have continued demand from consumers. **Styling** is the characteristic or distinctive appearance of a product, the combination of features that makes it different from other products of the same type. For example, the salable life of junior dress styles may be only about 8 weeks. This means that the junior dress line needs to be replanned, developed, produced, and presented six times a year (52-week merchandising cycle divided by 8-week

Figure 3–1
A perceptual map of product change defined by weeks in a selling period.

Adapted by G. Kunz from Kunz, G. I. (1987). Apparel merchandising: A model for product change. In *Theory Building in Apparel Merchandising*, Rita C. Kean, Ed. University of Nebraska Press, Lincoln, pp. 15–21.

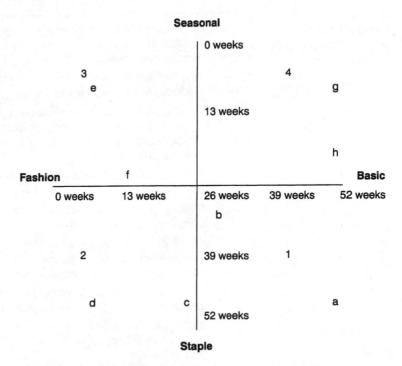

Types of Products in Each Quadrant

Sector 1 basic, staple products

a. men's white boxer shorts

b. golf shirts

Sector 2 fashion, staple products

c. designer sheets

d. teen blue jeans

Sector 3 fashion, seasonal products

e. junior dresses for teen market

f. misses skirts

Sector 4 basic, seasonal products

g. holiday decorations

h. thermal winter underwear

selling period equals 6.5 lines a year). In contrast, products that experience a comparatively long period of fashion acceptance are called basics. **Basic goods** have less frequent demand for style change than fashion goods. Basic goods may have a selling period of 52 weeks, a whole year, and perhaps for several years. Only one or at the most two lines have to be planned, developed, produced, and presented during a merchandising cycle.

In Figure 3–1, a **fashion/basic continuum** is created and plotted horizontally. At one extreme are products that are completely basic and enjoy a 52-week selling period. At the other extreme are high fashion or fad items where style change may be demanded every week. The fashion/basic continuum represents

Table 3-1

Definitions related to the perceptual map of product change.

Merchandising—the planning, development, and presentation of product line(s) for identified target market(s) with regard to prices, assortments, styling, and timing.

Merchandising cycle—52-week period from the first week of February to the last week of January.

Selling period—number of weeks a particular style or merchandise group is salable; combination of factors related to the product and the calendar year such as ethnic and cultural events, holidays, and weather changes.

Rate of product change—the number of selling periods in a merchandising cycle.

Styling—characteristic or distinctive appearance of a product, the combination of features that makes it different from other products of the same type.

Fashion goods—products that experience demand for change in the styling more than twice in a merchandising cycle.

Basic goods—products that experience demand for change in styling not more than twice in a merchandising cycle.

Staple goods—products that are in continuous demand throughout the merchandising cycle; the demand is not greatly affected by the time of the year.

Seasonal goods—products that experience changes in demand during the merchandising cycle related primarily to the time of the year.

the range of consumer demand for change in styling from the extreme of fashion, 1-week selling period, to the extreme of basic, 52-week selling period, over a merchandising cycle. The changeover from fashion to basic is at 26 weeks.

SEASONAL/STAPLE CONTINUUM Seasonal goods experience change in demand related to a combination of factors associated with the calendar year including ethnic and cultural traditions, seasonal events, and weather changes. Products may be seasonal because of events that occur consistently in the calendar year, social customs, or functional aspects of the garments relative to the weather. Holidays and the beginning and ending of the school year have a major impact on the demand for certain types of products. For example, well over half of all children's wear is sold at retail during about 10 weeks of the back-to-school selling period. The merchandising of coats offers another seasonal example. Coats are often sold year-round, but the types of coats offered vary. Lightweight coats and raincoats are offered for spring/summer, and down, wool, or fur coats are offered for fall/winter, about a 26-week selling period for each.

In contrast to these seasonal products, products that have little change in demand relative to the time of the year are called **staple goods**. Staple goods are stocked year-round at consistent inventory levels.

Change in demand related to time of year may or may not include a corresponding demand for change in styling. For example, demand for budget or moderate-priced girls' Easter dresses is highly seasonal. The selling period spans less than 8 weeks, ending with the Easter holiday. However, the preferred styling for the Easter dress may be quite traditional, including white collars, lace trim, and bows in the back. In this case, the merchandiser's primary concern may be planning for the highly seasonal demand of a basic product.

In Figure 3–1, the **seasonal/staple continuum** is plotted vertically. It represents change in consumer demand for products relative to time of year over a 1-year period. One extreme represents staple goods, such as natural-color pantyhose, that tend to be in relative continuous demand throughout 52 weeks of the year. At the other extreme are seasonal goods that experience dramatic changes in market demand that depend primarily on time of year. The four sectors that are created by the intersection of the basic/staple continuum and the seasonal/staple continuum are useful in describing product characteristics.

SECTOR 1—Basic/Staple Goods The intersection of the fashion/basic continuum and the seasonal/staple continuum creates four sectors in the perceptual map. Sector 1 represents products that are basic and staple. These products have selling periods lasting over 26 weeks without product change. The same or similar styles in similar fabrics and colors are stocked year-round. Manufacturers of basic/staple goods such as athletic socks may produce and promote only one line for each year with a minimum of a 52-week selling period. Product lines for succeeding years may be nearly identical. Athletic socks may be located at a in Sector 1. Another example of a basic/staple product is men's white boxer shorts. These might also be positioned at a in Sector 1. The growing demand for fashion fabrics in men's boxer shorts could move the demand along the fashion continuum to the left reflecting shorter selling periods. Basic/staple merchandise lends itself to standardized stocks, computer-based reordering systems, and sales direct to the consumer on the internet.

Products that experience subtle fashion change from one selling period to the next are sometimes called *fashion basics*. (This is an apparel industry term for what is commonly called *classics* in the fashion literature.) Golf shirts are examples of fashion basics that might be represented by b in Sector 1 with a 26-week selling period. The style changes in golf shirts may only involve fabric or color. The seasonal impact on golf shirts is also moderate since many products have only spring and fall versions. Selection of fabrications and color assortments are the primary merchandising tactics.

SECTOR 2—FASHION/STAPLE GOODS Sector 2 represents fashion/staple products. Selling periods might range from 1 to 52 weeks. An example is designer sheets. Most household textiles are basic/staple products; they are offered year-round and have relatively few changes in styling (52-week selling period). However, the creation of designer lines moves some household textiles

into the fashion category, to c in Sector 2 with a 26-week selling period, with designers doing two lines a year. An apparel example of a staple, fashion product is blue jeans for the teenage market. Blue jeans are purchased year-round by teenagers, but the popular styles and labels change frequently. Therefore, jeans for teens might be positioned at d in Sector 2 with a 10-week selling period.

SECTOR 3—FASHION/SEASONAL GOODS Sector 3 represents merchandise that is both fashionable and seasonal. Seasonal merchandise with a high rate of fashion change has a short selling life from 1 to 26 weeks. Each selling period's stock should start at zero and end at zero since merchandise is not normally carried over from one selling period to the next. Any fashion merchandise the firm has left over at the end of the period has to be sold at extreme discounts. This makes timing of planning, development, and delivery of the line extremely critical. Merchandisers monitor sales and inventory levels and have to make quick and risky decisions for reorders because of the short selling period. Thus, merchandise represented in Sector 3 experiences the most frequent demand for change. The junior dresses mentioned earlier might be positioned at ein Sector 3 with an 8-week selling period. Missy skirts are also a fashion/ seasonal product, but the rate of change may not be as intense as for junior dresses. They might be positioned at f with a 13-week selling period resulting in remerchandising the line 4 times a year. Fashion/seasonal merchandise means frequent change of fabrics, colors, styling, and inventory. Fashion/ seasonal goods require the most complex merchandiser decision making, involve the highest levels of risk, and provide the greatest potential for profit. With regard to internet marketing, fashion/seasonal goods may be shown on the manufacturer's web site and potential customers may be provided with retail sources where they can be bought.

Sector 4—Basic/Seasonal Goods Sector 4 represents basic/seasonal goods. Selling periods may range from 1 to 52 weeks. A product such as holiday decorations is highly seasonal but mostly basic in styling. Holiday decorations are sold only for selected weeks during a year, but the merchandise often has similar styling year after year. Thus, holiday decorations might be represented by g in Sector 4 with a 12-week selling period. Men's winter underwear (long johns) have seasonal demand, but styling remains basic. Thus, thermal underwear might be positioned at h in Sector 4 with a 20-week selling period. Merchandisers must decide when to offer the seasonal goods for sale and what prices and quantities will satisfy the seasonal demand to maximize profits.

USES OF THE PERCEPTUAL MAP Various classifications of merchandise might be more accurately placed on the perceptual map by analyzing sales figures that reflect changes in rate of sale during each week of the year. Clearly, the length of time that a particular style or classification is salable—the selling period—may be limited either by consumer expectation for fashion change or

by nature of the product related to the calendar year. Merchandisers must understand what aspect of product change limits salability of the product and

make merchandise plans accordingly.

Computerized data captured by both manufacturers and retailers can make appropriate analyses easily accessible to the merchandiser. Raw sales figures reflect two things: (1) the results of decisions made by merchandising and marketing personnel related to selection, presentation, and promotion of goods and (2) customers' preferences relative to the merchandise offered. The effects of seasonal and fashion change have to be sorted out of those figures. Analysis of rate of change in style numbers stocked in a department or offered by a particular firm might be used to indicate the rate of fashion change for particular merchandise. For example, if goods are basic but seasonal, the same or similar style numbers may be stocked for the same selling period the following year.

Fashion and seasonal changes are two aspects of product change that strongly influence merchandisers' decisions. Salaries and/or numbers of departments or classifications in merchandisers' assignments are often varied according to the "difficulty" of the merchandise (Kunz, 1998). "Difficulty" is highly related to the amount of change in the merchandise. The planning, development, and presentation of product lines are clearly demanding and intensive processes.

Nature and Timing of Merchandising Responsibilities

Merchandising processes differ for individual firms according to business strategies, product types, and technologies employed. Figure 3–2 is a **merchandising taxonomy**. The taxonomy identifies interactive, concurrent, and sequential components of the merchandising process. Components that may occur somewhat concurrently have a similar level of shading vertically. The components of the merchandising process that may occur somewhat sequentially are located horizontally.

The merchandising process, as defined in Figure 3–2, interacts with and may be limited by the business plan as described in Chapter 1 and the **marketing plan** as described in Chapter 2. The primary components of merchandising ac-

tivities include the following:

1. Line planning is the formulation of the parameters that guide line development and presentation and influences sourcing and production processes. Line planning has subcategories including evaluate merchandise mix, forecast merchandise offerings, plan merchandise budgets, plan merchandise assortments, and analyze and update merchandise plans. The line plan defines and limits the line.

Figure 3–2 Merchandising taxonomy detailing planning, developing, and presenting a product line. Based on Kunz, 1998.

Retail	Power of appeal display space fixtures lighting signage labels tickets pricing strategy customer service
-	Types specialty department discount off price manufacturer's outlet catalog television
Wholesale	Line/styte release • fashion shows • wholesale markets • trunk shows • trunk shows • ggy Customer service
	Line preview • fine concept • image strategy • style appeal • marketing strategy • pricing strategy • wisual merchandising
Internal	Review for adoption • fine concept • mage strategy • groups and designs • applications to line plan • design specs & costing • pricing strategy • visual merchandising

2. Line development has subcategories of line concept, creative design, line adoption, and technical design. Line development includes determining the actual merchandise that will fill out the line plan through some combination of product development and/or selecting finished goods at wholesale. Line development identifies merchandise that im-

plements the line plan.

3. Line presentation, with subcategories of internal (meaning within a firm), wholesale (meaning through interaction at wholesale markets or with personal calls by sales representative), and retail (including the many different retail formats and components of presentation). Line presentation involves processes required to evaluate the line and make the line visible and salable. Line presentation results in evaluation and sale of the product offering.

In apparel firms, the merchandising function is essential but not always performed by someone called a merchandiser. Some of the different job titles commonly used for merchandisers include merchandise manager, product development manager, product manager, designer, and buyer. A designer may perform the merchandising as well as the design functions for some firms. When both merchandiser and designer are present, the merchandiser is likely to focus on line planning and development, while the designer's primary responsibility is creation of merchandisable groups for the line. A product manager may be responsible for the product development process as well as coordinating production. In a large retail firm, a buyer is often in charge of line planning and development. In an apparel manufacturing firm, a buyer may be in charge of sourcing materials.

Large apparel firms may have a different merchandiser in charge of each product line or classification. In small companies the merchandising responsibilities may be carried out by the owner/manager. Regardless of the job titles or size of a firm, merchandising involves directing and coordinating development of product lines from start to finish. Line content, fabrications, styling, diversity of assortments, pricing, midselling period changes and revisions, visual presentations, timing, and budgets are all part of merchandisers'

responsibilities and decision making.

The following discussion of merchandising, including planning, developing, and presenting product lines is based on Case 3–1, CartWheels Manufacturing. It is easier to grasp the processes and relationships among the elements of the merchandising process if it has a context, consequently, CartWheels is used as a foundation of discussion throughout the rest of the chapter to illustrate principles of merchandising. Case 3–1 is an example of a simple line plan summary for a merchandise group. The **line plan summary** combines the key points considered in planning the line for a particular selling period. It includes the scenario within which the firm operates, its target customer, positioning in the market, socioeconomic and fashion trends, and parameters to guide line development, sourcing, product development, and line presentation.

Case 3–1 Line plan summary for girls' spring tops at CartWheels.

Line Plan Summary for CartWheels

Merchandisable group: girls' tops

Selling Period: spring

Year: 2000

CartWheels is an apparel manufacturer that specializes in children's apparel at good value. The firm's mission is to provide serviceable children's fashion goods at moderate prices. Size ranges offered include toddlers, boys, and girls. Annual sales for the firm are \$25,000,000. They have QR partnerships with their major retail customers. CartWheels has three major categories in their merchandise mix: tops (60 percent of sales), bottoms (30 percent of sales), and pajamas (10 percent of sales). Girls' tops are 55 percent of tops sales. The economy has been flat and competition strong but because of QR partnerships, sales are expected to increase 10 percent. A fashion trend away from wearing oversize tops has been observed.

The merchandising cycle is divided into four selling periods for girls' tops. The selling periods are approximately equal in length, about 10 weeks each in the 52-week merchandising cycle. The distribution of sales for girls' tops for spring 2000 were as follows: spring (15 percent), summer (10 percent), back-to-school (60 percent), and holiday (15 percent). The average list price for tops is \$20 with a wholesale price of \$10. CartWheels plans a 25 percent gross margin on wholesale.

CartWheels's Recommended Retail Assortments

CartWheels's complete assortment of girls' spring tops for spring 2000 includes 10 styles, 6 sizes, and 12 colors. The majority of CartWheels's goods are sold through QR partnerships and the wholesale market system. Based on the merchandise plans for the selling period, CartWheels's sales representatives commonly recommend A, B, or C assortments of girls' tops for 150, 100, or 50 square feet of retail floor space, respectively. Planned annual retail sales for each of these assortments is \$37,500, \$25,000, and \$12,500, assuming sales of \$250 per square foot. The sizes offered and the distribution of sales by size for spring 2000 were as follows: 6 (8 percent), 7 (25 percent), 8 (32 percent), 10 (20 percent), 12 (10 percent), and 14 (5 percent). CartWheels normally sells diverse assortments of girls' tops to retailers.

Line Planning

As indicated in Figure 3–2, the merchandising taxonomy, the primary elements of merchandise planning are to evaluate the merchandise mix, forecast merchandise offerings based on synthesis of fashion trends and socioeconomic issues, plan merchandise budgets, plan merchandise assortments, and analyze and update merchandise plans. This discussion follows the same format. In addition, use of merchandise plans is discussed.

EVALUATING THE MERCHANDISE MIX AND FORECASTING MERCHANDISE OF-FERINGS Line planning is a time-consuming, expensive process. Evaluation of the merchandise mix for the same selling period last year may begin by analyzing extensive records of past season sales. Issues to be examined include the relative rate of sale of merchandise groups, brands, individual styles, colors, and/or sizes. Managers from the firm's various divisions may meet to evaluate past performance of the line, review current market information, and brainstorm for ideas for the new season. World markets may be shopped for fashion direction, fabrics, design ideas, and sample garments. As described in Chapter 2, forecasting requires synthesizing quantities of information from diverse sources into relevant issues related to a particular product line and target customer.

PLANNING MERCHANDISE BUDGETS The merchandise budget provides the foundation for the merchandise plan. Total planned sales are determined by executive leadership with input from each of the functional divisions. In the case of CartWheels, the decision was made to plan a sales increase because of their QR partnerships (see Table 3-2). Consequently, planned sales for 2001 are 10 percent greater than 2000. Because of the stable market conditions and good relationships with their regular retail buyers, the proportion of sales allocated to total tops, girls' tops, and girls' back-to-school (BTS) tops is based on last year. List price (the manufacturer's suggested retail price) and wholesale price (the cost to retail buyers) also remain similar to last year. Manufacturers commonly provide incentives to retailers for buying their merchandise and for paying for it on time. In the CartWheels's budget, discounts and allowances to retailers are estimated at 6 percent. Consequently, 6 percent more merchandise must be sold in order to achieve planned sales. CartWheels's planned gross margin is 25 percent. Using the numbers in Table 3-2, total allowable merchandise cost and allowable unit cost can also be planned.

Table 3-2

Merchandise budget for CartWheels's girls' tops for back-to-school (BTS) 2001 along with calculation of each component based on Case 3–1. Total planned sales at CartWheels for 2001 = \$27,500,000 (\$25,000,000 sales last year + 10% sales increase)

Planned sales of tops = $$16,500,000 ($27,500,000 \times 60\%)$

Planned sales of girls' tops = $$9,075,000 ($16,500,000 \times 55\%)$

Planned sales of girls' BTS tops = \$5,445,000 ($\$9,075,000 \times 60\%$)

Discounts and reductions on girls' BTS tops = \$326,700 ($\$5,445,000 \times 6\%$)

Amount of girls' BTS tops to sell to achieve planned sales = \$5,771,700 (\$5,445,000 + \$326,700)

Planned gross margin = 25%

Total allowable cost of girls' BTS tops = \$4,328,775 (\$5,771,700 - 25%)

Number of units of girls' BTS tops to sell = 577,170 (\$5,771,700 ÷ \$10)

Unit allowable cost of girls' BTS tops = \$7.50 (\$4,328,775 ÷ 577,170)

PLANNING MERCHANDISE ASSORTMENTS Assortment plans are based on merchandise budgets. A summary of language used in assortment planning is included in Table 3–3. An **assortment** is the range of choices offered at a particular time, usually defined by assortment factors of style, size, and color. A **balanced assortment** matches the assortment plan to customer demand. Assortment balance is often based on the development of **model stock plans** identifying the number of styles, sizes, and colors in the assortment. The **variety** of an assortment is determined by the number of stock keeping units (SKUs) (number of styles × number of sizes × number of colors). The variety of the assortment encompasses the total number of unique items that must be produced and distributed to satisfy the line plan. **Assortment volume** is planned sales and/or the number of units of merchandise that must be sold to achieve planned sales.

Assortment diversity is measured by volume per SKU for the assortment (VSA). VSA is an indicator of the impact of the nature of the assortment on financial productivity. When average volume per SKU for an assortment is five or less, potential for increases in stockouts, lost sales, and high rates of markdowns result in lower gross margin (Rupe & Kunz, 1998). Planning more focused assortments whenever possible can result in better financial outcomes. Using as-

Table 3–3Definitions of dimensions of merchandise assortments.

Assortment—the range of choices to be offered at a particular time. **Assortment distribution**—allocation of volume across styles, sizes, and colors of the model stock.

Assortment diversity—volume per SKU for an assortment (VSA).

Assortment factors—dimensions identifying characteristics of a product for purposes of describing it; usually style, size, and color (Rupe & Kunz, 1998).

Balanced assortment—range of choices in merchandise offered matches customer demand.

Model stock—the planned combination of styles, sizes, and colors for an assortment; determines the variety of the assortment.

Stock keeping unit (SKU) —a unique piece of merchandise usually defined by style, size, and color.

Unit—a single piece of merchandise.

Variety—the total number of SKUs in an assortment.

Volume—planned sales and/or the total number of units in an assortment; planned dollars of merchandise to sell divided by average wholesale price.

Volume per SKU—number of units for each unique SKU.

Volume per SKU for an assortment (VSA)—average number of units for each SKU in an assortment; total number of units divided by total number of SKUs in an assortment.

sortment plans with model stocks at the individual store level and/or at the merchandise group level helps reduce the temptation to provide more diversity than necessary in a line. **Assortment distribution** is the percentage allocation of volume across assortment factors, usually style, size, and color, of the model stock.

ANALYZE AND UPDATE MERCHANDISE PLANS Merchandise plans are only as good as their relationship to demand from target customers. Consequently, good, functional merchandise plans must be dynamic. They must be developed using technology that can accommodate planning at the SKU level and allows examination of "what if" scenarios. When conditions change in the market, merchandise plans must be adjusted to effectively achieve the firm's goals. Unfortunately, most merchandising technology systems do a good job of inventory management but are much less effective for merchandise planning.

USING ASSORTMENT PLANS As mentioned in Case 3–1, CartWheels's sales reps commonly recommend model stocks to their retail buyers based on floor space allocation. Sharing of data in QR relationships make it possible for manufacturers to make realistic plans to assist their retail partners. By recommending model stocks, sales reps can influence how merchandise is bought in terms of number of styles, sizes, and colors. This increases consistency between how merchandise is planned and how merchandise is sold. From a manufacturing standpoint, the reliability of merchandise plans is improved and production can be started earlier with less risk of producing unsalable merchandise.

Table 3–4 provides examples of model stock and distribution plans for BTS girls' tops as CartWheels's sales reps might present them to retail buyers. Remember, planned annual sales is dependent on the retailer's planned square footage to be devoted to the merchandise group in a single store (in this case the options are 150, 100, and 50 square feet). BTS dollar volume is 60 percent of annual volume. Unit volume is BTS dollar volume divided by the \$20 retail price.

In its simplest form, a model stock does not identify any particular style, color, or size but only the number of each. For these assortments, model stocks are as follows:

- Assortment A, 10 styles, 6 sizes, and 12 colors = 720 SKUs.
- Assortment B, 7 styles, 6 sizes, and 6 colors = 252 SKUs.
- Assortment C, 4 styles, 6 sizes, and 5 colors = 120 SKUs.

The model stock determines the number of SKUs in an assortment. Merchandisers may limit the number of stock keeping units in lines in order to control variety of assortments and complexity of inventories. As described earlier, a single style, such as a T-shirt, produced in four sizes, four colors, would produce sixteen SKUs (1 style \times 4 colors \times 4 sizes = 16 SKUs). As any one of these variables increases, so do the SKUs and the variety of inventory to be sourced, managed, and distributed. Firms with a focus on basic/staple goods might control

Table 3-4
Assortment plans for retail model stocks for back-to-school (BTS) girls' tops developed by CartWheels.

	Assertment Plan A								
	Assortment Plan A			Assortment Plan B			Assortment Plan C		
Square Feet	150			100			50		
Average First Price	\$20			\$20			\$20		
Annual Volume	\$37,500, 1875 units			\$25,000, 1250 units			\$12,500, 625 units		
BTS Volume	\$22,500, 1125 units			\$15,000, 750 units			\$7,500, 375 units		
BTS Variety	720 SKUs			252 SKUs			120 SKUs		
BTS VSA	1.56			2.98			3.13		
	Style (%)	Size (%)	Color (%)	Style (%)	Size (%)	Color (%)	Style (%)	Size (%)	Color (%
. 1	30	9	22	30	9	30	40	9	
2	20	26	17	25	26	25	30	26	35 25
3	20	36	15	18	36	17	20	36	20
4	10	17	11	10	17	13	10	17	15
5	6	8	10	7	8	10		8	5
6	4	4	7	5	4	5		4	, ,
7	4		6	5					
8	3		4						
	2		4						
9	2					1			
9 10	1		2						
9 10 11			2						
9 10									

assortments by including only a few styles in the line. Because of minimal style variation, they might use multiple size ranges and colors to provide variety. For example, golf shirts may be offered in two styles in twelve sizes (small, medium, large, and extra large for men, women, and children) and fifteen different colors for each style $(2 \text{ styles} \times 15 \text{ colors} \times 12 \text{ sizes} = 360 \text{ SKUs})$.

Firms with a focus on fashion/seasonal goods tend to offer a wide variety of styles to meet consumers' seemingly insatiable appetite for style change. A coordinated set of shirt, jacket, and slacks, three styles, made in four colors and five sizes would have $60 \, \text{SKUs} \, (3 \, \text{styles} \times 4 \, \text{colors} \times 5 \, \text{sizes} = 60 \, \text{SKUs})$. A small-

to moderate-size fashion manufacturer commonly offers between 30 and 60 styles per line per period with four to eight selling periods per year. A firm with a comparatively simple product line consisting of 60 styles per line in five colors and five sizes with eight selling periods is dealing with 12,000 SKUs per year.

The number of sizes to include in an assortment is also an important variety decision. The size range for a line is basically determined by the merchandise classification and the target market. If a manufacturing firm is targeting the junior market, it may offer garments in the 3–15 size range but a retailer buyer of the line may not include all sizes in the retail assortment. Generally retail firms offer garments in five to seven different sizes for a particular merchandise group. The more sizes used in a line, the greater the number of SKUs. The majority of sales are usually found in the middle of a range. For example, manufacturing firms that offer the extreme sizes in the junior market, sizes 3 and 15, may make them available only by special order and retailer merchandisers may decide not to order them at all. Garments that can be made in small, medium, and large sizing have obvious advantages from the standpoint of SKUs.

Color selection relative to the assortment is equally important. Whether it is more important to offer a coordinated color system or a variety of colors depends on the assortment strategy. In any case, too many different colors may spread investment dollars over too many SKUs for both manufacturers and retailers. Consequently, sales may be lost at both levels because the most popu-

lar items are out of stock.

Table 3–4 also includes the percentage distribution of assortment volume across the assortment factors in the model stock. The model stock and assortment distribution plans are designed to reflect expected customer demand for each style, size, and color and provides the basis for a balanced stock in developing the line. Notice that styles and colors are listed from highest percentages to lowest while size distributions have the highest percentages in the middle. This is because it is common to sell the largest percentage of goods in the middle of the size range.

The trend away from oversized tops has caused CartWheels's merchandisers to adjust the rate of sale according to size as compared to last years' plans (2000) reported in Case 3–1. Proportion allocated to sizes 10, 12, and 14 were reduced and proportions to sizes 6, 7, 8 were increased in relation to last year. Planned sales for each size of girls' spring tops = 6 (9 percent), 7 (26 percent), 8 (36 percent), 10 (17 percent), 12 (8 percent), and 14 (4 percent). The distribution according to size is the same in all three model stocks, based on the assumption that the customer demand according to size will be proportionally the same in all markets.

Notice that, according to CartWheels's model stocks, variety (number of SKUs) increases as volume (number of units) increases. This provides a broader selection for customers in higher volume stores. As the number of units for each style, size, or color decreases, risk of stockouts and lost sales both at wholesale and retail increases. Table 3–5 shows the model stock plan with the addition of volume per assortment factor for each style, size, and color.

Table 3–5 Volume per assortment factor according to CartWheels's assortment plan C (375 units).

		r	Units per	Units per		
	Style (%)	Style	Size (%)	Size	Color (%)	Color
1	40	150	9	34	35	131
2	30	113	26	97	25	94
3	20	75	36	135	20	75
4	10	37	17	64	15	56
5			8	30	5	19
6			4	15		
Total	100	375	100	375	100	375

Table 3–6 Volume per SKU for CartWheels's assortment plan C, style 1 (150 units).

Color	Size 1	Size 2	Size 3	Size 4	Size 5	Size 6	Total
1	5	14	19	9	4	2	53
2	3	10	13	6	3	1	36
3	3	8	11	5	2	1	30
4	2	6	8	4	2	1	23
5	1	2	3	1	1	Ó	8
Total	14	40	54	25	12	5	150

A complete assortment plan can be taken one step further to determine the number of units for each style in each color and size, that is, the **volume per SKU**. Table 3–6 provides an example of a volume per SKU plan for a single style based on Table 3–4, Assortment Plan C, Style 1. The number of units for each combination of style, size, and color (SKU) are calculated by multiplying the total number of units for the style by the percentage allocation for each color and size. For example, for Style 1 Size 1/Color 1: 150 units \times 9% \times 35% = 4.7 units. Notice that numbers have to be rounded to whole numbers in a volume per SKU plan because only whole pieces of merchandise can be produced and sold to customers. Notice also that, according to Assortment Plan C for Style 1, several SKUs will have only one unit of merchandise and one SKU won't have any merchandise during the entire selling period because of how the assortment is defined.

Line Development

Line development includes all the processes required to translate a line plan into real merchandise. The length of time allowed for line development varies greatly from one firm to the next depending on the nature of the merchandise offered and the types of line development processes used. Sometimes the process is highly formalized, with numerous planning meetings involving a merchandising team. In other firms, the process may be almost haphazard in nature. The line plan summary is a guide for line development and is always

subject to review. Adjustments are often needed to make the line more mar-

ketable, producible, and salable.

If the line will be sold at wholesale, the line must be completed in time for presentation to the sales staff (in Figure 3-2, see line presentation, internal). If the firm is vertically integrated and sells all of its merchandise through its own retail outlets, the wholesale selling process is unnecessary. In that case, line development is completed with a final internal management review. The time line is determined by when the goods need to be on the retail sales floor.

The first phase of line development is formulation of the line concept (in Figure 3-2, see line development, line concept). Once the line concept is established, there are two primary methods to complete line development: finished goods buying/sourcing and product development. Line adoption processes are a part of both finished goods buying/sourcing and product development.

LINE CONCEPT A line concept includes the look and appeal that contributes to the identity and salability of the line. Line concept (see Figure 3-2) includes synthesis of current issues/trends and line direction. To synthesize current issues, merchandisers must research diverse sources related to economic, social, and cultural issues. What are predominate topics in world news that might influence customer choices over the next few years? What is happening in technology? What are demographic and lifestyle trends of target customers and those that might influence target customers?

Merchandisers/buyers/designers may shop world markets for fashion trends, ideas, materials, and finished garments to use as prototypes. To assist merchandisers in synthesizing fashion trends, apparel firms may subscribe to clipping services that examine fashion newspapers and periodicals published worldwide. The clipping services may clip and/or copy selected pictures and articles and distribute them to their subscribers. Many trade associations, such as Cotton Incorporated, provide color and style forecasts for the textile and apparel industry. Fabric and trims may be the source of the line concept. Or, the line concept may be developed from other sources, and fabrics and trims are then selected or developed to be consistent with it. Inspiration boards and/or concept boards may be developed to epitomize key ideas important for line development.

Establishing line direction requires making decisions among all of the issues and trends and deciding what target customers want to see in the new line. Two primary factors in line direction are color and styling. Establishing a color palette may be the first step. To make effective color choices, firms may subscribe to color forecasting services that research trends and forecast the popular colors for coming selling periods. Consistent use of a color palette throughout a line provides unity, continuity, and cohesiveness. Decisions may be made as to the values and intensities for each color in the palette. If coordination from one season to the next or one year to the next is important, consideration is given to past seasons' color systems.

Similar analyses are required to provide direction in styling. **Style features** such as length, silhouette, and fit may also be forecast. Identification of appropriate types of materials, textures, and print designs help complete line direction. Merchandisers and designers can then source worldwide for materials, finished goods, and/or accessories and communicate expectations for color and style consistency to executives and assistants.

Group concepts are factors that give continuity to merchandise groups and make them salable together. Group concepts are developed based on the line direction. Product lines consist of several groups of garments called merchandising groups, families, or collections. Each group has characteristics that are easily identifiable and that relate to each other. Group concepts may focus on style features; repetition of color, fabric, or trim; coordinated print designs; or a combination of these factors. These groupings are assembled to make a fashion statement when the line is presented, offer versatility for fabric use, provide variety and flexibility of selection by retail buyers and/or target customers, and encourage multiple sales.

Based on group concepts, sales history, and sales forecasts, the **current line** can be analyzed. Decisions can be made as to which styles from the past season's line should be carried over, modified, or replaced. To minimize product development costs and risks associated with introducing new styles, it is essential to identify high-volume styles that, with no change or minimal change, can continue to be top sellers.

FINISHED GOODS BUYING/SOURCING Retail buyers/merchandisers often travel to wholesale markets or work with manufacturers' representatives in their stores to select merchandise from apparel manufacturers' lines (in Figure 3–2, see line presentation, wholesale). Wholesale markets provide a setting for linking the work of merchandisers at the wholesale level with the merchandisers at the retail level. The result is the development of product lines that ultimate consumers see in retail stores.

Buyers/merchandisers for large retail firms may spend at least 1 week of every month visiting apparel markets in different parts of the world. Buyers for smaller firms may rely on a few regional markets that are held across the country or on personal calls by sales representatives. In any case, retail buyers need and expect to see new merchandise with every visit to market because many retail customers expect to see different merchandise every time they enter a retail store. Strategic visual merchandising can, to a limited extent, contribute to this effect for the ultimate consumer, but the fashion retailer needs a nearly continuous flow of new merchandise to continually stimulate consumer interest. This is why many fashion apparel manufacturers now offer new styles every few weeks. At the same time, merchandisers carefully plan merchandise deliveries to avoid investment in merchandise prior to the selling period.

Good coordination within merchandising groupings is critical to success. From a separates line, merchandisers may buy only slacks or skirts or blouses.

Slacks or skirts or blouses may also be purchased from other manufacturers. Separates from different manufacturers are mixed together for presentation to the ultimate consumer offering a variety of fabrics, colors, and styling. Lines described as coordinates are presented in groups often with recommended assortments. Purchase of coordinates requires a greater commitment on the part of retailer merchandisers because more SKUs may be invested in a single line from a single manufacturer. A manufacturer of coordinates also must ship all of the coordinating pieces at the same time, which may be made in different factories or even different countries. Coordinating pieces must arrive at the retailer's store or distribution center at the same time so they are available for retail sales.

The related separates line concept allows the retail merchandiser to pick and choose among coordinated garments, but it does not impose multiple purchase requirements. The better related separates mix, match, and complement each other, the greater the potential for multiple sales and high sales volume. A well-planned variety of styles is essential to make a fashion statement, inspire the retail buyer, and make an effective presentation on the retail sales floor.

Both manufacturer and retailer merchandisers may source finished goods in the global apparel market. For example, a women's wear manufacturer may have production capabilities only for tailored clothing, but the product line is offered as coordinates including blouses. For that firm, merchandisers may be involved in product development for the tailored goods as well as sourcing blouses from other manufacturers or contractors that specialize in those goods. The coordinated goods are offered with the same label so ultimate consumers may assume that the same manufacturer produced all of the coordinate parts. Some retailer merchandisers still have responsibilities similar to the traditional buyer. More often than not, however, merchandisers at both the wholesale and retail level are involved in some form of product development.

Product Development

Product development is the design and engineering required to make products serviceable, salable, producible, and profitable. Apparel product development, as an option in line development, requires two primary phases: (1) creative design which focuses on analysis, creativity, and the formation of merchandisable groups and (2) technical design which involves perfecting the style, fit, and patterns and developing detailed specifications and costs. Line adoption usually occurs between creative and technical design.

Product development may be planned, implemented, and managed by product teams consisting of members with multiple perspectives. Team members often include representatives of merchandising, creative design, technical design, quality assurance, sourcing, and production. The team may be responsible for the product line for each selling period from evaluation of merchandise mix and forecasting to delivery of finished goods to consumers. The team approach to

product development speeds decision making incorporating multiple perspectives and reduces duplication of effort. The merchandiser's role in a product development team is often planner, coordinator, evaluator, and negotiator. Since product development is the focus of the next three chapters of this text, only the key concepts of creative and technical design are discussed briefly here.

Creative design processes may be done simultaneously or in different sequences to reduce total product development time. Design development may involve sketching, draping, or computer-aided design (CAD). The rough design ideas can be precosted to determine whether they would cost about the same as, more than, or less than styles in the current line. The challenge is to keep product costs within allowable costs according to the merchandise plans so gross margin goals can be realized. First patterns are developed based on the design ideas. Design specifications including garment descriptions, detailed drawings, fit standards, and materials descriptions are completed so prototypes can be made. Designs are then revised based on evaluation of the prototypes.

The last 2–3 weeks before line adoption may be the most pressure packed and productive of the season for merchandisers and designers. Designs with the most potential are selected for specification development and sample making. Samples may be evaluated and materials tested for performance and compatibility. Designs that are presented for line adoption have more detailed specifications developed as a basis for detailed costing and compatibility with fit standards.

Technical design follows line adoption. Line adoption decisions determine which designs will become styles in the line and how the styles relate to the line plan. During the technical design phase of product development, styles are prepared for production. As indicated in the merchandising taxonomy, technical design processes include perfecting styling and fit, engineering production patterns, testing materials and assembly methods, developing style and quality specifications, testing materials, developing detailed costs, and grading patterns.

The time frame and actual sequence of events related to product development may differ considerably from one firm to another and from one product line to another. The process of product development involves planning, creating, copying, modifying, sampling, costing, testing, reviewing, adopting, and rejecting. Some steps may take weeks, others may take only a few hours, but a small time investment makes a process no less important. Designers must be knowledgeable about merchandising, marketing, and production processes in order to develop products that are marketable and cost-effective.

LINE ADOPTION Line adoption processes involve integration of line planning, line development, and line presentation. At **line adoption** meetings, merchandisers and designers present the proposed line or parts of the line to the management team (in Figure 3–2, see line presentation, internal). Heated discussion may ensue related to the relative merits of line plans and each proposed style, fabric, and color. Opinions on customer appeal, production costs, salability, profit potential, and coordination with the merchandise group stimulate

lively discussion. Negotiations take place related to design modifications, cost reductions, efficient use of materials, and sourcing. Designs that are accepted become styles in the line. They may be modified before technical design activities begin. With CAD systems and recognition of the cost of product development processes, many firms are trying to proceed with fewer sequential steps

in product development.

The line adoption phase of product development may be one of the most stressful periods for designers and merchandisers. In some firms line adoption occurs with a series of day-long meetings with elaborate presentations of line concept, group concepts with story boards, prototypes, design specifications, fit analysis, and cost estimates. In other firms line adoption is more of an ongoing series of short meetings in which a few designs in merchandise groups are evaluated at a time. In any case, designs may be accepted as styles, sent back to the design room for further development, or rejected. The designs presented are evaluated in light of the line plan and sales forecasts.

Line adoption includes a review of line balance as proposed in the line plan. Decisions about the styles accepted into the line are reviewed in relation to the line plan. Model stocks, gross margin projections, prices, and expected volume for each merchandise group and individual style are adjusted to improve line

balance.

Preparation of sales samples, which follows line adoption, is a key factor in presentation of product lines at wholesale markets and to retail buyers in their stores. In the final stages of line adoption, merchandisable groups are analyzed to determine which fabrics and colors should be used in preparing sales samples and which will be swatched. Usually the color that is sampled has the best sales potential. If the wrong color is chosen for the sample, the style may not sell at all. Styles and fabrications that are sampled are often used for promotional materials, advertisements, and brochures. If a firm is involved with mail order, decisions are also made for catalog copy. The sales force must be given adequate information and direction to enable effective representation of the line and assistance to retailers in making appropriate selections. Sales representatives may edit the line further by showing only what they perceive will sell in their markets.

Line Presentation

The power of appeal (Scheller & Kunz, 1998), also known as **hanger** or **shelf appeal**, attracts attention causing retail buyers and ultimate consumers to stop, take a longer look, and ultimately purchase. Successful merchandise groups have hanger or shelf appeal for retail buyers and target customers. Without hanger appeal, products may go unnoticed. A style can be extremely well done and fit perfectly, but without that initial hanger appeal, it will seldom get a closer look. This is especially true for the department, specialty, and discount stores that depend on self-service. Their customers find, evaluate, and

make merchandise selections without assistance from store personnel. Through the course of many seasons, there must be consistent appeal to target customers, whether it be fashion, quality, or price. Customer loyalty develops when expectations are satisfied from one season to the next.

In the merchandising taxonomy, line presentation has three components: internal, wholesale, and retail. Internal line presentation was discussed in association with line adoption. The following discussion focuses on line presentation at wholesale and retail.

LINE PRESENTATION AT WHOLESALE For lines to be sold at wholesale, line preview is the target date for culmination of all the line and product development activity. Line preview provides sales representatives with an opportunity to see the line, learn about its marketing and merchandising strategies and attributes firsthand, and become inspired with its sales potential. Responsibility for line preview is often shared by merchandisers and marketers. This includes preparations for the selling period that must be in place before the line is presented. Sales policies, support programs, pricing goals, and promotional concepts must be well defined and ready to present to the sales staff. This event provides merchandisers and designers with an opportunity to give information, inspire, and direct the sales staff for presentation of the new line. Designers may prepare and present the line to the sales force, orchestrate a fashion show, and/or make personal appearances at these events.

The primary purpose of line preview is for merchandisers and marketers to help sales people understand how to sell the line. The rationale behind the development of the line, the concept of the line, and how it can be translated into selling strategies are explained. The recommended model stocks are explained to the sales team for different merchandising groups. The benefits of the materials and styles to the target customer are described. In addition, features of the styles that provide the benefits are identified to assist in effectively selling the merchandise. For example, a benefit for a child's coat might be that it is soil-resistant.

Line release follows the line preview, although this date may have been the first to be set. **Line release**, which must coincide with wholesale market dates, is the target date for showing the line to retail buyers. For designers and high fashion houses, this is a greatly anticipated event when the line is revealed to the public and press. By this time, sales representatives have reviewed the line, have been inspired by its potential, and have a set of samples for presentation to retail buyers. Following line release, there may be some additional modifications in the line as a result of feedback from the sales staff and from the response of the trade press and retail buyers.

If the line will be presented in a catalog, a slightly different series of line presentation events ensue. Following line adoption, photo samples are prepared. Line preview consists of presentation of planned catalog layouts with justifications for use of space based on line concept, image, assortment plans,

sales potential, and so forth. Competition for catalog space for different merchandise groups is very strong.

If the apparel firm that is doing product development has its own retail stores, then line preview and line release may be unnecessary. Instead, merchandisers may get involved in planning visual presentations of merchandise groups for the retail level. Merchandisers may be involved in training department managers and retail sales associates about the merits of the product line.

PRESENTATION AT RETAIL Apparel manufacturers want "prime real estate" in retail stores for display of their merchandise. Manufacturers who have effectively positioned and differentiated their products and proven successful sell-through can pressure retailers for the best display space. For example, manufacturers such as Ralph Lauren, Liz Claiborne, Tommy Hilfiger, and Nautica can demand (1) boutique-type space (shop-within-a-shop) for their merchandise, (2) large minimum orders, and (3) purchase and use of manufacturer-designed fixtures for displaying their merchandise (Silverman, 1998).

Manufacturers may want to be involved in the visual merchandising of their lines at the retail level for a number of reasons: (1) it provides control over product presentation and helps to maintain a consistent look nationwide, (2) fixtures designed especially for their products should show off the goods better and provide better sell-through, (3) custom fixtures are the best defense against poorly trained retail merchandisers, (4) custom fixtures include signing and/or graphics that emphasize brand identity, (5) sales ranging from \$300 to \$1200 per square foot are the result far exceeding overall retail performance (Silverman, 1998). On the other hand, the going rate is sometimes \$60,000 for special fixtures to occupy 1,000 square feet of floor space for a particular line.

Retailers may welcome visual merchandising assistance. Fixtures may be supplied free, on a cooperative basis, or at cost to the retailer. Thus, when a manufacturer **fixtures** a department, it may cost less than when the retailer acquires fixtures through regular sources. However, many retailers object to having the manufacturer "interfering" in the visual merchandising of their stores. Only manufacturers with name-brand clout can convince retailers to adopt their fixturing programs.

Some major apparel manufacturers now have merchandise coordinators located in major retail divisions. A **merchandise coordinator** represents a manufacturer and its product lines in a retail setting. He or she may be paid by the manufacturer, the retailer, or a combination of the manufacturer and retailer. Merchandise coordinators are responsible for merchandise presentation, retail stock levels, sales training, handling complaints, and providing direct feedback to the manufacturer. They provide a direct liaison between retail merchandisers and wholesale merchandisers.

LABELING, TICKETING, AND PACKAGING The use of brand names, trademarks, designer names, and private labels is a key factor in hanger appeal and

product differentiation. Merchandisers and marketers must determine the size, type, quantity, and means of attaching labels, hang tags, and tickets and include the information in product specifications.

Labels are made of durable materials and are permanently sewn in garments. Label information includes fiber content, care, country of origin, and manufacturer identification, which are required by law. On better career-type garments sold by full-service retailers, jacquard labels may be sewn to the inside of garments and/or presented on simple hang tags. Materials manufacturers sometimes provide informative hang tags featuring brand names and performance benefits. Whatever the labeling technique, manufacturers and retailers want customers to recognize and identify with certain brands of merchandise to develop customer loyalty. The use of large, colorful hang tags may be an effective strategy for target markets served by self-service retailers. Large hang tags are easy for customers to find. Other target markets require more subtle presentation of brand names.

Tickets, which may be added by manufacturers or retailers, provide essential product information such as style number, size, color, and price. Tickets may include human-readable, machine-readable, or both human- and machine-readable information. Bar codes that can be scanned into computer systems are regarded as the most effective means of recording machine-readable information. Some machine-generated tickets are difficult for consumers to read and may result in lost sales. Tickets should be attached to garments where they are easy for customers to find and not covered by hangers or other display devices.

Most apparel is shipped ready for retailers' racks or shelves. Garments are folded and packaged or placed on hangers and covered with plastic bags. Packages and hanging devices provided by manufacturers often become part of retail displays. Dresses for babies may be placed on frame-type hangers and padded with multiple layers of tissue paper. Men's dress shirts may be boarded and pinned. Multiple supports are often used to maintain the perfectly formed appearance of collars. Fashion apparel may be placed on specially designed hangers to emphasize the silhouette or keep the garment from falling off the hanger. Hangers may be designed so as not to cover the neckline labels of garments. Successful visual presentation in the retail sector is essential to complete the merchandising process.

Sourcing Materials and Production

Merchandisers also work closely with and sometimes are responsible for business activities beyond those described as planning, development, and presentation of product lines. Sourcing is one of these where a merchandiser is the coordinator and may be responsible for some or all of the activities. **Sourcing** is determining the most cost-efficient vendor of materials, production, and/or finished goods at the specified quality and service level. Sourcing strategy determines how merchandise will be acquired recognizing the unique nature of the

firm's products, the most efficient means of acquisition of the products, the firm's production capacity, and/or intent to acquire production capacity. Sourcing determines where the goods will be acquired. Finished goods sourcing was discussed as a part of line development. (Sourcing materials is the focus of Chapter 8 and sourcing production is discussed in Chapter 9.)

Merchandisers continually review orders and/or retail sales, compare forecasted sales with actual sales, and evaluate gross margin for profit potential. If sales and profit figures are below the projected level, production of certain styles may be canceled. This frees production capacity to concentrate on those styles that are in greater demand and have greater gross margin. Dealing with product change, negotiating compromises, and meeting deadlines and delivery dates are constant parts of merchandisers' jobs. A merchandiser must coordinate these activities in order to present salable, profitable product lines.

Summary

Merchandising is a complex process of planning, developing, and presenting product lines. Planning apparel product lines often involves dealing with intensive change in styling, materials, and production processes. There are two primary sources of change in apparel products: fashion change and seasonal change. Apparel can be described as fashion, basic, seasonal, or staple. The perceptual map of product change contributes to understanding why selling periods are limited. The nature and timing of merchandising responsibilities are presented in the form of a merchandising taxonomy. The taxonomy identifies the major components of the apparel merchandising system (line planning, line development, and line presentation) and the primary elements of each component.

Line planning requires analysis of past season performance, evaluation of fashion direction, and assessment of new materials. Line planning includes evaluation of the merchandise mix, forecasting merchandise offerings, planning merchandise budgets, planning merchandise assortments, and analyzing and updating merchandise plans to reflect current needs.

Line development involves determining what specific merchandise described by style, size, and color will be used to satisfy the Line Plan. There are two primary methods, purchase of finished goods and product development. Line development includes development of a line concept, creative design, line adoption, and technical design.

Line presentation results in evaluation of the product line internally, at wholesale, and at retail. These days, manufacturers are often very involved in presentation of their product lines at retail. Selection of labels, tickets, and packaging materials is often crucial to the visual appeal of products to retail buyers and consumers. Considering the complexities of these activities and the

timing limitations, it is essential to have coordination and cooperation in working toward the firm's primary goals. Regardless of the type of merchandise, the merchandising function is critical to the coordination, efficiency, productivity, and profitability of the apparel firm.

References and Reading List

Friedman, J. P. (1994). Dictionary of business terms (2d ed.). New York: Barron's Educational Series.

Jarnow, J. A., Judelle, B., and Guerreiro, M. (1981). *Inside the fashion business* (3d ed.). New York: Wiley.

Kunz, G. I. (1987). Apparel merchandising: A model for product change. In *Theory* building in apparel merchandising, Rita C. Kean, Ed. Lincoln: University of Nebraska Press, pp. 15–21.

Kunz, G. I. (1998). Merchandising: Theory, principles, and practice. New York: Fairchild Publications.

Kurt Salmon Associates. (1997, June). A \$13 billion success story: Quick response. *Bobbin*, pp. 46–48.

Reda, S. (1994, January). Manufacturers develop labels for different retail tiers. *Stores*, pp. 34–38. Reda, S. (1994, March). Planning systems. Stores, pp. 34–37.

Rupe, D., & Kunz, G. I. (1998). Building a financially meaningful language of merchandise assortments. Clothing and Textiles Research Journal, 16(2), 88–97.

Scheller, H. P., & Kunz, G. I. (1998). Toward a grounded theory of apparel product quality. Clothing and Textiles Research Journal, 16(2), 57–67.

Silverman, D. (1998, February 5). Sparring for space: Big labels brandish their clout at retail. Women's Wear Daily, pp. 1, 4–5.

Troxell, M. D., & Stone, E. (1981). Fashion merchandising (3d ed.). New York: McGraw-Hill.

Key Words

adjusted gross margin (AGM)
assortment
assortment distribution
assortment diversity
assortment variety
assortment volume
balanced assortment
basic goods
business planning
concept board
coordinates

creative design
current issues
current line
customer driven
design
diverse assortment
fashion/basic continuum
fashion goods
fashion trends
fixtures
focused assortment

group concept gross margin (GM) gross margin return on inventory (GMROI) hang tags hanger or shelf appeal labels lead time line adoption line concept line development

line direction line plan line plan summary line planning line presentation line preview line release manufacturer merchandiser marketing plan materials merchandisable group merchandise coordinator merchandise mix merchandising merchandising calendar merchandising cycle

merchandising taxonomy model stock plan multipiece style perceptual map product development product line rate of product change related separates retail line presentation retailer merchandisers sales samples seasonal goods seasonal/staple continuum selling period separates sourcing

staple goods
stock keeping unit (SKU)
style
style features
style number
styling
technical design
testing materials
tickets
unit
variety
volume
volume per SKU
volume per SKU for the
assortment (VSA)

Discussion Questions and Activities

- Think about textile and apparel producers and how their products' characteristics relate to fashion and seasonal change. Consider work wear, oxford shirts, prom dresses, and carpets. Decide which sector in Figure 3-1 best represents the product's characteristics.
- 2. Compare the number of SKUs for product lines using sizing systems for men's dress shirts with collar and sleeve length and men's sport shirts sized small, medium, and large. Compare SKUs for lines of men's pants sized by waist and length and missy pants sizes 8-16. Why is the number of SKUs in a product line an issue?
- 3. Select a style that is part of a group of coordinates in a retail store. Determine the number of SKUs produced for the style and for the group of coordinates. How does this relate to merchandise planning for separates and coordinates?

- Develop a merchandise budget for boys' tops for the spring selling period using Table 3-2 as a model.
- 5. Develop a volume per assortment factor plan and volume per SKU plan for Assortment A, Style 1 in Table 3–4. How do your numbers compare with Tables 3–5 and 3–6? What causes the differences in the numbers?
- 6. Go to a department store. Select a boutique representing a single manufacturer's goods (e.g., Liz Claiborne, Tommy Hilfiger, Ralph Lauren). Evaluate the effectiveness of the manufacturer's presentation at retail. Determine the number of styles, SKUs, type of ticketing, hang tags, and signage. What does the manufacturer control? What does the retailer control?

PAIRT WALL

Product Development

© Chapter 4 Analysis of Product Development

Chapter 5 Product Standards and Specifications

Chapter 6 Creative and Technical Design

Analysis of Product Development

OBJECTIVES

- Oiscuss the role of garment analysis relative to meeting consumer and business needs.
- Relate garment analysis from professional perspectives to analysis from consumer perspectives.
- Obescribe a system of garment analysis that examines market positioning, sizing and fit, materials selection, component assembly, final assembly and finishing, and garment presentation.
- Consider a variety of professional perspectives toward garment analysis.

Apparel professionals are individuals employed in the apparel business who are involved in management, development, selection, production, presentation, and sale of apparel. Challenges to apparel professionals include providing target customers with products that satisfy customers' priorities and needs while making a profit. Apparel professionals are constantly faced with the responsibility for analyzing

- products produced by their factories and/or contractors,
- · products produced by their competitors,
- products made available by vendors, and
- products and processes developed by suppliers and chemical and equipment companies.

The process of conducting a systematic product analysis can be very extensive or limited, depending on the purpose and the desired outcome. Outcomes may be conclusions related to product positioning, quality, value, producibility, cost, and consumer appeal. Many concepts introduced in this chapter are discussed in more depth in the following chapters.

Role of Product Analysis

Most apparel professionals engage in some type of **garment analysis**, either formal or informal, as part of their job responsibilities. Garment analysis is often used with such frequency that the process is second nature to apparel professionals. Garment analysis procedures differ depending on who performs the analysis, the purpose of the analysis, and the methods of analysis that are employed.

Professional Garment Analysis

Consumers engage in garment analysis every time they shop for apparel. The thoroughness of the analysis depends in large part on the type of garment being sought and consumers' product knowledge. Consumers' perceptions of products may be based on intrinsic or extrinsic cues to quality and performance depending on personal preferences or priorities. Purchases made by customers determine the success of the decisions made by apparel professionals.

The ultimate goal of apparel professionals is to satisfy consumers' needs for apparel. What are the target customers' priorities among aesthetics, performance, price, and value? What aspects of apparel serviceability are of particular concern to consumers? Comfort? Durability? Care? Functional use? Do customers focus on intrinsic or extrinsic cues in making apparel choices? The answers to these questions provide apparel professionals with priorities for line development, product development, product on, and marketing decisions.

Professional apparel analysis involves the following goals, processes, and limitations:

- 1. Products are examined from a business perspective with the goal of positioning products to satisfy the needs of target customers.
- 2. Decisions are made in the context of the product line and the firm's strategic plan.
- 3. Products are developed and marketed to suit groups of target customers in terms of styling, fit, fashion, quality, and value.
- 4. Sound technical knowledge of materials and garment assembly is needed to determine product performance.
- 5. Alternative product development, production, and/or marketing processes are assessed.

- 6. The bottom line, the profitability of the product, is always considered in evaluating alternatives.
- Quality standards are based on perceptions of target customers' expectations.
- 8. Analysis may be focused on one particular aspect of a product such as production costs or specifications.
- 9. The results of professional analysis determine what will be available to consumers on the retail sales floor.

Apparel professionals are constantly faced with pressure to control costs of labor, materials, and overhead. These costs are often interrelated; reducing costs in one area may increase costs in another. The choice of less expensive materials may result in using materials with more flaws or handling problems, which thus raises spreading, cutting, and sewing costs. The choice of sourcing production in a developing country with lower labor costs may result in increased risks of nonconformance to specifications, more second-quality goods, higher shipping costs, and missed delivery deadlines. Production costs provide a baseline for determining the lowest price that will allow a reasonable profit.

Analysis may involve intrinsic and/or extrinsic factors depending on the purpose of the analysis. The tangible, intrinsic characteristics of garments include materials, methods of assembly, styling, fit, and pressing. Extrinsic aspects originate from outside the product and are not a physical part of the product itself. Price, brand name, reputation of the manufacturer or retailer, visual merchandising techniques, and advertising are common extrinsic cues to quality and value. Developing higher levels of intrinsic quality and performance requires increased investment in materials, equipment, skills, and time. A myriad of options differing in quality, appearance, performance, and cost have to be evaluated by apparel professionals in making decisions about the development of each product characteristic.

Methods of Garment Analysis

The purpose of garment analysis determines the methods and complexity of the analysis. Three different methods of analyses that could be used are

- visual inspection;
- augmented visual inspection, aided by simple tests, simple magnification and measuring equipment, and/or home laundry equipment; and
- laboratory analysis with standard test methods, specialized testing equipment, high-power magnification, and highly calibrated measuring equipment.

Visual inspection is the least sophisticated and least complex method of garment analysis. It is effective in evaluating overall garment appearance and aesthetics, estimating fabric quality, identifying stitch and seam types, and

Designer analyzing concept boards for new line development.

estimating numbers of stitches per inch. A skilled person can conduct a quick and reasonably reliable assessment of these product characteristics using visual inspection. Experience in garment analysis develops the ability to see and feel quality in products. Skills are developed through comparing similar characteristics and performance of a wide variety of products. Visual assessments may also be compared with more scientific analyses for verification. Visual inspection is frequently used by consumers and retail buyers when viewing product lines for the first time. The reliability of visual analysis is completely dependent on the skill of the individual conducting the analysis.

Garment analysis using **augmented visual inspection** provides more information and increases the ability to reach reliable conclusions. Less experienced analyzers or those requiring extremely consistent results need more than visual inspection as a basis of analysis. For example, simple burning or solubility tests might be used to verify fiber content. Use of microscopes or pic glasses increases the details that can be observed in fabric structures relative to interlacing patterns, yarn types, yarn twist, methods of color application, and so on. Use of home laundry equipment can provide insight into latent defects such as color bleeding and shrinkage. Both visual inspection and augmented visual inspection can often be performed without destroying the product. Use of tests and equipment increases the costs of the analysis but also the amount of information available.

The most scientific garment analysis involves laboratory tests of products and materials. Laboratory tests with standard test methods endorsed by the American Society for Testing and Materials (ASTM), the American Association of Textile Chemists and Colorists (AATCC), or other professional organizations and controlled laboratory conditions provide the most reliable results. Laboratory analysis with textile testing equipment may be particularly useful when concerned with performance aspects such as shrinkage, strength, abrasion resistance, air permeability, colorfastness, and shading. Analysis of these aspects can be used to determine the compatibility of materials and suitability to particular end uses. Tests are frequently destructive, and extra materials and garments must be sampled according to specified methods. Firms may establish and operate product testing labs or contract laboratory services. The time required to have the tests performed may be prohibitive given the intense, time-driven nature of the apparel business. In-house testing is less time-consuming but requires equipment, time, and personnel. Out-of-house testing requires more time.

Processes of Product Analysis

Professional garment analysis can be accomplished by evaluating six aspects of garments: product positioning strategy, sizing and fit, materials selection, component assembly, final assembly and finishing, and garment presentation. Garment analysis, conducted to meet particular business needs, may require extensive knowledge of certain aspects of the apparel business. For example, analysis conducted to cost a garment requires an in-depth understanding of apparel production and materials. The apparel professional is challenged to choose the best alternatives among many options based on the firm's strategic plan for product lines, cost structures, and quality standards.

Professional garment analysis is easiest if accomplished in small segments. Figure 4–1 presents a garment analysis guide that itemizes the six aspects of garment analysis, factors to consider, and criteria for analysis. Figure 4–1 continues with a garment analysis worksheet that provides an organizational structure for recording information about a product during garment analysis. Additional copies of some pages of the worksheet may be needed to actually complete a garment analysis. This garment analysis worksheet is an example of one method for collecting data relative to garment analysis. Other worksheets may be used for certain types of analysis or different types of garments. The purpose here is to provide an overview of the garment analysis process. Analyses designed to meet particular business needs may require a more indepth exploration.

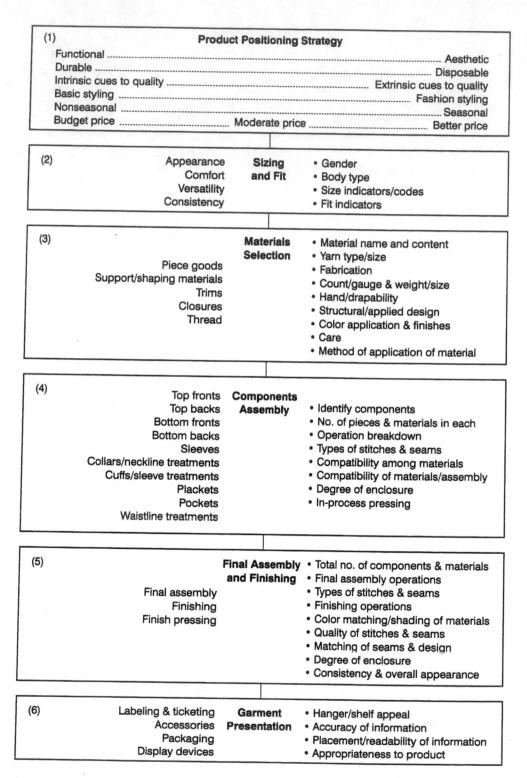

Figure 4–1
Garment analysis guide.

Product Positioning Strategy			Style	No
For each pair of criteria, circle one nur riority.)	mber that represents the rel	ative priority for	or this style; 0	shows equa
Brand Name Garment Description				
Functional	54321012345	Aesth	etic	
Durable	54321012345	Dispo	sable	
Intrinsic cues/quality	54321012345		sic cues/qual	ity
Basic styling	54321012345	Fashion styling		
Nonseasonal	54321012345			
Budget price	54321012345	Bette	r price	
2) Sizing and Fit			Style	No
(Circle or write in the appropria	ate indicators.)			
izing System Classification by Gen				
Unisex infant toddler	children	student	adult	
Male boys young me				
Female girls preteen	young juniors	juniors	misses	women's
pecificity of Size Indicator/Code				
	The state of the s			
General body size: small medium	n large extra large			
General body size: small medium 1x 2x 3x	n large extra large 4x 5x Other ————		2.0	V ²⁰⁰ 2 mm
1x 2x 3x	4x 5x Other			V 2 - 1.
1x 2x 3x Number code used to indicate garme	4x 5x Other			1 1 1 1 1 1 1 1 1 1 1 1 1 1 1 1 1 1 1
1x 2x 3x Number code used to indicate garmonicate gar	4x 5x Other	<u></u>		
1x 2x 3x Number code used to indicate garme	4x 5x Other	<u></u>		
1x 2x 3x Number code used to indicate garmonic discrete garmonic	4x 5x Other	<u></u>		
1x 2x 3x Number code used to indicate garmo Dimensional size: collar sleeve chest _ t Indicators	4x 5x Other ent size: waist inseam _	other _		
1x 2x 3x Number code used to indicate garmonic discrete garmonic	4x 5x Other ent size: waist inseam _	other _		
1x 2x 3x Number code used to indicate garmo Dimensional size: collar sleeve chest t Indicators Height:	ent size: inseam petite tall other	other _		
1x 2x 3x Number code used to indicate garmonic properties of the state of the stat	4x 5x Otherent size: inseam _	other _		
1x 2x 3x Number code used to indicate garmonic properties of the second properties of the secon	ent size: waist inseam _ petite tall other	other _		
1x 2x 3x Number code used to indicate garmonic processes and the second processes are second processes are second processes and the second processes are second processes and the second processes are second processes and the second processes are second processes are second processes are second processes and the second processes are se	ent size: inseam petite tall other	other _		
Number code used to indicate garmonic description of the state of the	ent size: waist inseam _ petite tall other stocky other : little moderate	other _		
Number code used to indicate garmonic process of conformance to body amount of fabric stretch:	ent size: inseam petite tall other	other _		
Number code used to indicate garmonic process of conformance to body amount of fabric stretch: Number code used to indicate garmonic process of conformance to body amount of fabric stretch: Number code used to indicate garmonic process of conformance to body amount of fabric stretch:	ent size: waist inseam _ petite tall other stocky other : little moderate little moderate	other _		
Number code used to indicate garmonic properties of conformance to body amount of fabric stretch: Lix 2x 3x Number code used to indicate garmonic properties Silmonic properties of conformance to body amount of fabric stretch: Components that limit fit: top front top back bottom front	ent size: waist inseam _ petite tall other stocky other : little moderate little moderate at bottom back sleeves	other _		
Number code used to indicate garmonic process of conformance to body amount of fabric stretch: Number code used to indicate garmonic process of conformance to body amount of fabric stretch: Number code used to indicate garmonic process of conformance to body amount of fabric stretch:	ent size: waist inseam _ petite tall other stocky other : little moderate little moderate at bottom back sleeves	other _		
Number code used to indicate garmonic properties of conformance to body amount of fabric stretch: Lix 2x 3x Number code used to indicate garmonic properties Silmonic properties of conformance to body amount of fabric stretch: Components that limit fit: top front top back bottom front	ent size: waist inseam _ petite tall other stocky other : little moderate little moderate at bottom back sleeves	other _		
Number code used to indicate garmonic properties of conformance to body amount of fabric stretch: Components that limit fit: top front top back bottom front collar cuffs plackets pocket	ent size: waist inseam _ petite tall other stocky other : little moderate little moderate at bottom back sleeves waistline hems	other _		
Number code used to indicate garmonic properties of conformance to body amount of fabric stretch: Components that limit fit: top front top back bottom front collar cuffs plackets pocket cucks darts tucks	ent size: waist inseam _ petite tall other stocky other : little moderate little moderate at bottom back sleeves waistline hems	other _		
Number code used to indicate garmonic properties of conformance to body amount of fabric stretch: Components that limit fit: top front top back bottom front collar cuffs plackets pocket Control of Fullness darts	ent size: waist inseam _ petite tall other stocky other : little moderate little moderate at bottom back sleeves waistline hems	other _		

(3) Materials Selection	Style No
(piece goods, support fabrics, trim, closures, thread)	
(Use this analysis process for each material in the garment.)	
Material name	
Material content	
Yarn type/size	
Fabrication	
Count/gauge	
Weight/size	
Hand	
Struct./appl. design	
Color application	
Finishes	
Care	
Application method	
Material name	
Material name	
Yarn type/size	
Fabrication	
Count/gauge	
Weight/size	P
Hand	
Struct./appl. design	
Color application	
Finishes	
Care	
application method	

Figure 4–1 (continued)
Garment analysis guide.

(top front, to waistline, he		tom back, sleeves, collar, cuffs	, plackets, pockets,	
Style No	Component	No. of Pieces	No. of Materials	
	0	perational Breakdown		
Operation 1				
spi			77 10 10 10 10 10 10 10 10 10 10 10 10 10	
stitch/seam ty	/pe	stitch/seam ty	pe	
Operation 2		Operation 8		
spi		spi		
stitch/seam ty	/pe	stitch/seam ty	/pe	
Operation 3				
spi		spi		
stitch/seam ty	pe	stitch/seam ty	pe	
Operation 4		Operation 10 _		
		spi		
	pe		/pe	
Operation 5		Operation 11 _		
		spi		
stitch/seam ty	pe	stitch/seam ty	/pe	
Operation 6				
spi		spi		
stitch/seam ty	pe	stitch/seam ty	/pe	
		Quality Summary		
Sampatability o	mong materials			
The first backets of				
Quality of stitch	es and seams			
egree of enclo	osure			

Total No. of Materials ment dyeing, postcuring, finish pressing) Finishing Operations Operation 1
Finishing Operations
Operation 1
· Control of the cont
Operation 2
Oporation 2
Operation 3
Operation 4
Operation 5
Operation 6
Finished Garment

Figure 4–1 (continued)
Garment analysis guide.

Analysis of Labeling/Ticketing Information		
ypes		
Placement		
Readability		
Completeness	3-14-5	
ppropriateness		
accuracy		
analysis of Hanger/Shelf Appeal		
ccessories		
icketing		
ackaging		
Display devices		
Other extrinsic cues to quality		
ppropriateness to product		

Product Positioning Strategy

Section 1 of the apparel analysis guide identifies criteria for a **product positioning strategy**. The foundation for garment analysis is the purpose or intended use of a garment. Factors that are useful in describing a product's purpose and styling include functional/aesthetic priorities, durable/disposable performance, intrinsic/extrinsic cues to quality, basic/fashion styles, nonseasonal/seasonal use, and low-end/budget/moderate/better/designer price ranges. Each set of factors forms a range of possibilities that can be selected to position a product to make it desirable for a particular target market.

FUNCTIONAL/AESTHETIC PURPOSE AND DURABLE/DISPOSABLE PERFORMANCE For a particular target customer, does a garment serve primarily a **functional purpose** or an **aesthetic purpose?** This is closely related to the level of intrinsic quality and durability needed in end use. An extreme in functional purpose is an astronaut's space suit. An astronaut's apparel must provide protection from highly hostile environments. Appropriate garment performance is accomplished through engineering, experimentation, and testing. Visual effect is of comparatively little importance as long as an extensive list of functional needs is accomplished.

An actor or actress is a target customer that requires an extreme of visual and aesthetic needs in stage costume. Visual effect is the primary requirement. Comfort and protection may be sacrificed for the appearance of the garment. Appearances of theater costumes are evaluated from a distance, therefore, quality of execution may also be secondary. Quality is judged, primarily, on whether the item accomplishes its visual purpose. However, stage costumes may also need to be durable enough to withstand the rigors of stressful use, rapid changes, and frequent cleaning. Apparel intended for general consumer use usually represents a blend of functional and aesthetic priorities.

Intrinsic/Extrinsic Cues to Quality Quality standards tend to be arbitrary in terms of meeting consumer needs. Sometimes what is perceived as high quality meets functional needs; other times it meets aesthetic needs. For some garments intrinsic cues to quality are more important; for others extrinsic cues to quality are more important. Profitable positioning and satisfactory performance can be accomplished at different levels of quality and durability, depending on the purpose of garments and the priorities of target customers.

Tangible **intrinsic cues** of quality include styling, fit, sizing, fabrics and other materials, stitches and seams, and finishing. Each characteristic represents a group of options that creates a range from high to low quality. Specifications are developed to ensure an appropriate combination of quality characteristics, maintain consistent quality throughout production, and control costs.

Many intrinsic characteristics that contribute to quality also contribute to costs of finished products. **Cost** is the value surrendered in order to receive

and/or produce goods or services. Costs of production include a combination of costs of materials, labor, equipment, transportation, and overhead. Developing intrinsic quality requires greater investment in materials, equipment, skill, and time. Normally, higher-quality goods cost more to produce than lower-quality goods. However, high-quality garments may not be producible within the price range of the target customer; thus, trade-offs must be made.

Intrinsic quality is built into garments beginning with product development and design. The desired intrinsic quality level determines the selection and use of materials, production methods, the processing sequence, and the degree of accuracy that is expected. Advanced technology and automation are means of reducing labor costs, and increasing production efficiency and accuracy while increasing intrinsic quality. For example, computer-aided design equipment may increase the accuracy of pattern development and efficiency of use of time and materials.

Some firms invest in product development by having designers and merchandisers travel all over the world for design inspiration and selection of unique fabrics and trims. Other firms invest in extensive product testing to determine the performance capabilities of their products. Still others "knock off" styles, that is, they copy styles from other firms' lines using lower-cost materials and production methods. Thus, a design may begin with making original sketches, draping fabrics on a body form, or making patterns from other firms' finished garments. The investment in creativity, uniqueness, and perfection of fit depend on the quality and fashion level acceptable to the target market.

The perception of quality in fashion goods depends more on extrinsic cues than intrinsic ones. Extrinsic cues include price, brand name, apparel firm's reputation, product presentation, and advertising. Selection and evaluation of fashion goods are often based on fashion advertising, acceptance by peer groups, and popular labels. Manufacturers and retailers use advertising to romanticize and glamorize products, price reductions to promote good value, and brand names and trademarks to promote consumer confidence. The product images created using extrinsic cues may or may not be consistent with intrinsic quality.

The most significant intrinsic cues for fashion goods may be styling and color. Other intrinsic factors such as quality of materials and construction may be overlooked by manufacturers, retailers, and consumers in favor of styling and effective fashion promotion. The wearable life of a fashion garment may be only a few weeks, therefore, intrinsic characteristics that affect durability are less critical to acceptable performance. On the other hand, basic garments with little change year after year depend on intrinsic characteristics for better performance.

Styling may be a vehicle for setting a higher retail price without increasing other intrinsic quality characteristics. Some consumers are willing to pay a higher price because of the value they place on styling. Effective merchandising and marketing programs can make it possible to sell a product at a higher price than the quality represents, thus, price may not be a reliable indicator of quality.

PRODUCT CHANGE How does the product relate to the fashion/basic, seasonal/nonseasonal continuums? For example, does the customer prefer a garment that provides basic, nonseasonal, functional service? Or, is the garment intended to provide fashionable styling at a budget price? What is the general price range at which the garment should be offered? Principles of design, seasonal color story, and current fashion are sources of criteria for analysis of the visual appearance of garments. Each garment or style has certain performance characteristics that are needed in order to meet performance expectations. These performance traits are the result of the characteristics of materials, assembly, and finishing processes. Analysis of these factors and matching product characteristics to preferences of the target market provides a framework for successfully positioning products.

PRICE AND PRICE RANGES The general price ranges of low-end, budget, moderate, better, and designer are deeply embedded in the apparel business. Firms establish their definitions of product lines to include the price range of merchandise and position products considering their competitors at similar prices. Thus, merchandise is developed and produced and/or selected to be marketable within the intended price classification. Unfortunately, high price does not always mean high quality or vice versa. Thus, analysis of the combination of price and quality can result in the relative value of the product.

Sizing and Fit

Apparel manufacturers, retailers, and consumers are concerned about sizing and fit. Consumers seek garments that provide an attractive appearance and comfort during wear, often within whatever current fashion suggests as acceptable fit. Manufacturers and retailers recognize that garments must be labeled in a manner that allows customers to find the right size. However, the apparel industry has no mandated or universally used sizing standards. The responsibility falls on manufacturers to develop appropriate systems of measurements to suit target customers. A firm's sizing system is a means of product differentiation.

The challenge is to offer consistency in sizing among styles, product lines, and seasonal offerings. Customers want to be able to select the same size for a new style of a favorite brand name and have it fit in a similar manner to products already owned. It is imperative for a firm to develop its own sizing standards with tolerances for variation consistent with consumer expectations. Manufacturers usually test the size and fit of garments on specifically designed body forms and live fitting models. However, consumers who buy the finished garments are seldom exactly the same size or shape as the body forms. Potential sales volume is higher for garments that have versatility in fitting a variety of body shapes.

SIZING SYSTEMS AND SIZE RANGES Body type is the fundamental basis of sizing systems. For apparel sizing, **body types** are classified by body proportions as related to age and gender. For example, the sizing terms *infants*,

toddlers, children, and preteens relate to age and common proportional changes during human body growth and development. Junior, missy, and women's sizing systems represent different proportional relationships among body parts of fully formed females. Sizes for additional body types are achieved by using petite, tall, or large variations. Commonly used body types are given in Table 4–1.

Several body types have been not been well served by the apparel industry. Adults who are small, tall, or full-bodied are frequently not included in a firm's size offerings. Research recently conducted in the Chicago market has revealed numbers of female customers by body type. See Table 4–2. Recent increases in availability of petite and large sizes for females are certainly justi-

fied by these findings.

A **sizing system** includes a range of sizes based on gradation of dimensions for a body type. Apparel firms identify body types that are representative of their target customers and develop what they perceive to be appropriate proportions for each size and graduations between sizes. Table 4–1 also identifies commonly used size ranges classified by gender and body type.

Table 4–1
Commonly used size ranges classified by gender and body type.

Infant—baby not mobile newborn and 3, 6, 9, 12, 18, 24 months Toddler—stocky, mobile

Foddler—stocky, mobile 1T. 2T. 3T, 4T

Girls—preschool and elementary school-age female 4, 5, 6, 6x, 7, 8, 10, 12, 14

Boys—preschool and elementary school-age male 4, 6, 8, 10, 12, 14, 16, 18, 20

Preteen—prepuberty female 7, 9, 11, 13

Junior—young, fully formed female figure 1, 3, 5, 7, 9, 11, 13, 15

Misses—mature female figure over 5' 4" 2, 4, 6, 8, 10, 12, 14, 16, 18, 20

Misses Petite—mature female figure under 5' 4"

2p, 4p, 6p, 8p, 10p, 12p, 14p, 16p, 18p, 20p

Women's Petite—full-bodied female figure under 5' 4" 14½ wp, 16½ wp, 18½ wp, 20½ wp, 22½, wp, 24½ wp, 26½ wp, 28½ wp

Women's—full-bodied female over 5' 4" 14 w, 16 w, 18 w, 20 w, 22 w, 24 w, 26 w, 28 w, 30 w, 32 w

Young Men's—young male 27, 28, 29, 30, 31, 32, 33, 34

Men's—mature male 32, 34, 36, 38, 40, 42, 44, 46, 48, 50, 52

Table 4–2Percent of females of different body types in the Chicago market.*

Percent of Sample		
16		
8		
15		
40		
23		
100		
1,822		

*Tigert, D. J., Reynolds, C. C., Cotter, T., & Arnold, S. J. (1996, October). The 1996 Chicago female research project. Chain Store Age, 72, 5B-31B.

INDICATORS OF SIZE The size of a particular garment is indicated by a word, letter, or number that represents general body size; proportional relationships among body parts; age, height, or weight; or dimensional sizes of body parts. For example,

- size small, medium, large (S, M, L) represents general body size;
- size 10, 12, 14 for misses or 7, 9, 11 for juniors represent proportional relationships among body parts;
- size 6, 12, 18, or 24 months for infants and size A, B, or C for pantyhose represent age, height, or weight; and
- size 15½-32 for collar and sleeve length of men's dress shirts and size 34-33 for waist and inseam of men's trousers represent dimensional sizes of body parts.

Indications of **general body size** include one-size-fits-all; small, medium, large, extra large (S-M-L-XL) within "normal" size ranges. Anyone who is larger or smaller than "normal" knows that one-size-fits-all does not always fit all. However, garments with a one-size-fits-all size indication are usually very loosely fitted or made of stretch materials, may be unisex, and include garments such as caftans or bathrobes. S-M-L is used to describe men's, women's, or children's body types. Garments that commonly have general body size designations include sweaters, T-shirts, men's sport shirts, and sweats.

Sizes for adult females usually consist of a number assigned to a particular set of unrevealed dimensions. It has long been believed that women do not want to be reminded of or reveal their body dimensions when shopping for clothes. Therefore, as ready-to-wear was developed for women during the 19th and 20th centuries, sizing systems were developed that used size designations unrelated to any specific garment dimensions. The actual garment dimensions are not indicated by the numbers.

For example, the 8, 10, 12 in the misses system represents the proportions of a more mature figure than the 7, 9, 11 sizes of the junior classification, but the

general size of people who wear a 7 or 8 may be similar. Firms that style garments to appeal to a broader age category may use 7/8, 9/10, and 11/12 size designations to indicate appropriateness for a broader target market. These designations are commonly used on basic pants/slacks, blouses, and shirts.

Size designations that indicate age, height, and/or weight provide specific information about suitability of garment size to certain body dimensions. Perhaps the only sizing system for women that uses body height and weight has been developed for pantyhose. Commonly used size indicators, such as size A, B, C, or D, do not specify body dimensions, but information is provided at point of sale about the range of height and weight that will fit within a given size. Pantyhose sizing systems may represent a breakthrough in size information for women's apparel.

Infants' garments are commonly offered in newborn, 3, 6, 9, 12, 18, and 24 months sizes. Labels may also indicate body weight. However, there is wide variation in infant body size related to age; thus, age is not a good indicator of garment size. Therefore, for an age/weight size designation to be meaningful, a sizing system must be developed that is based on body dimensions for a given age.

Sizes of men's apparel have long been based on dimensional measurements, that is, length or circumference of specific body parts including neck, arm length, chest, waist, and leg. Measurements specified by size relate to dimensions of a garment component relative to a particular body part such as collar or inseam. Examples of dimensional sizes used for men's wear are shown in Table 4–3. Garments with dimensional sizing tend to have more consistency in measurements among styles and brands. Garments tend to be more basic in nature and more varied size ranges tend to be offered.

FIT INDICATORS Size alone does not determine garment fit. Fit is how a garment conforms to or differs from the body. Fit is sometimes described as garment "cut." A well-cut garment conforms to the body in a comfortable and flattering manner. Fit or cut is determined by proportional relationships among measurements used in a firm's sizing system. Garments of the same size from

Table 4–3
Dimensional sizes for men's wear.

Men's Dress Shirts

Neck sizes: 14, 14½, 15, 15½, 16, 16½, 17, 17½, 18

Sleeve length: 32, 33, 34, 35, 36

Men's Pants

Waist sizes: 28, 29, 30, 31, 32, 33, 34, 36, 38, 40, 42, 44, 46

Inseam: 28, 29, 30, 31, 32, 33, 34, 36

Men's Suits or Sport Coats

Chest size: 36, 38, 40, 42, 44, 46, 48, 50, 52

Length: short, regular, long Body type: regular, trim, stocky

Large and tall versions are also available.

different manufacturers are unlikely to have exactly the same measurements because each firm customizes its sizing and fit according to its perception of fashion and its target customer.

The two sources of information about fit are labels and garment structure. Labels often describe the body type the garment was designed to fit. For example, a garment might be labeled short, regular, long, petite, or tall. Information about garment circumference may be indicated by descriptors, such as trim, slim, tapered, stocky, or husky. These indicators of fit provide a basis of judging appropriateness of garment selection for a particular body type.

Examination of **garment structure** reveals the general silhouette of a garment, number and location of limiting fit points, and amount, placement, and control of fullness. **Silhouette** is an indicator of how closely a garment conforms to the body. Generally, the closer the silhouette conforms to body shape, the more limited the garment is in accommodating varying body proportions. Stretch fabric may allow a garment to conform exactly to a greater variety of body shapes of similar size than rigid fabrics.

Limiting fit points include rigid garment components that do not readily expand or contract to accommodate different body shapes and dimensions. Collar length, shoulder width, waistband length, or hip circumference may provide fit limitations depending on the style of the garment. Garment components may be modified to allow more variance in fit. For example, waistbands sometimes have a small section of elastic, side tabs, or other adjustment built in to accommodate variance in waist size.

Fullness in a garment is controlled by darts, tucks, pleats, and gathers. Fullness allows for comfort and freedom of body movement within the garment. For example, pleats below the yoke on the back of a shirt allow expansion of back width with arm movement. Fullness also allows different body shapes to fit within the garment. Skirts with front pleats will accommodate a greater variation in hip circumference than fitted skirts. More extensive evaluation of sizing and fit requires analysis of pattern development and apparel production processes.

Why do garments marked the same size not have the same fit? Many factors contribute to the dimensions of a particular style of a particular size. Contributors to variance include (1) lack of industry-wide sizing standards, (2) factors that determine garment fit, (3) sizing standards used by individual firms, (4) production tolerances for garment dimensions, and (5) quality control.

INDUSTRY-WIDE SIZING STANDARDS There is no generally adopted industry-wide standardization of fit or sizing with mandated sets of dimensions specifying garment sizes. U.S. government standards are available for some body types based on data collected in the 1940s if apparel firms choose to use them. However, changing nutrition and exercise priorities have caused changes in body sizes and shapes over time. Many apparel professionals and consumers believe there is a need for a massive anthropometric study involving measurements of thousands of people of different ages and ethnic origins to provide a basis for

industry-wide sizing standards. Recently, the U.S. government has taken a position that the apparel industry should set its own sizing standards. Based on recent research, sizing standards are now available for infants, and research is under way related to a sizing system for mature females.

Researchers at Cornell University have developed a methodology for deriving a set of sizes that will provide the best fit for the greatest number of today's women. The procedure uses a database of more than 100 dimensions taken from nearly 3,000 women in the U.S. Army in the 1980s, and works with a computer algorithm based on cluster analysis. The research was commissioned by the U.S. Army because they were seeking ways to reduce the number of inventory items required to fit troops comfortably. The apparel industry has also expressed interest in this technique which could help them reach the largest possible segment of the target population, provide the best possible fit, and provide that fit using the smallest number of sizes in order to hold down inventory (Holzman, 1996).

Without widely used sizing standards, there is variation in the measurements used for different styles of the same size. Lack of consistency in fit of garments of the same size creates confusion for consumers. For example, a comparison of dimensions used by firms advertising on the Internet is reported in Table 4–4. Clearly, each of these firms provide garments that will

Table 4–4
Comparison of dimensions of misses sizes 10 and 12 as advertised on the World Wide Web.

	Comparison of Size 10			
Company	Bust	Waist	Hip	
L. L. Bean	36.5	28.5	38.5	
Eddie Bauer	36	28	38	
J. Crew	36.5	28	38	
Butterick	32.5	25	34.5	
Frederick's	35.5-36.5	25.5-27.5	37.5-38.5	
Hanna Anderson	36–38	28-29.5	38-39.5	
Lands' End	36	28	38.5	
Spiegel	36.5	27.5	38.5	
	Co	mparison of Size	12	
L. L. Bean	38	30	40	
Eddie Bauer	37.5	29.5	39.5	
J. Crew	38	29.5	39.5	
Butterick	34	26.5	36	
Frederick's	37-38	28-29	39-40	
Hanna Anderson	36–38	28-29.5	38-39.5	
Lands' End	37.5	29.5	40	
Spiegel	38	29	40	

Johns, M. J. (1998). The Web: A supplement for teaching apparel analysis. Annual meeting of the International Textiles and Apparel Association, Dallas, Texas.

fit differently because of differing proportional relationships among key measurements.

Firms that are extensively involved with direct mail, telephone order, or Internet distribution have greater needs for consistency in sizing than retail stores since customers are not able to try on garments before purchase. However, customers need to understand the firm's sizing system in order to acquire the appropriate fit.

Developing sizing systems to meet the apparel needs of the U.S. population is more complex than for some populations of the world. The population of the United States has a heterogeneous, multicultural, multiethnic heritage. The result is diversity of sizing and fit requirements for apparel. For example, females with Scandinavian origins tend to be taller than average height and have broad shoulders, Spanish and Italian females tend to be less than average height and full bodied, whereas females with Asian heritage tend to be small and slim. Since many ethnic types make up the U.S. population, apparel sizing systems that accommodate a variety of body types are required. The U.S. market presently offers over 50 sizes of women's apparel to meet the diverse needs of the population, and more are being developed. Some firms are specializing in sizing for individual ethnic groups as a niche marketing strategy.

Materials Selection

Section 3 of the apparel analysis guide identifies a list of types of materials and criteria that are commonly used for analyzing materials. Materials used in apparel manufacturing include fabrics and findings. Fabrics are cut and assembled into the shells of garments. **Findings** include all the rest of the materials required to complete garments including support/shaping materials, trims, closures, threads, labels, and accessories. In the apparel business, this category of materials has a number of common names including sundries, findings, trim, and notions. Table 4–5 provides a brief description of each of these types of materials. Proper selection and consistent quality of materials are important to apparel quality and performance. One incorrect or inferior material can impart a lower-quality level to the entire garment. The quality of materials must also be consistent with the product positioning strategy.

The technical nature of quality and performance of materials, such as strength, abrasion resistance, resiliency, pilling and snagging resistance, and colorfastness, is too complex to be completely discussed in this text. For garments in which intrinsic quality and durability are particular concerns, these properties may be analyzed in addition to the criteria listed here. These properties may be estimated through visual analysis or, more reliably, determined using standardized laboratory tests.

CRITERIA FOR ANALYSIS OF MATERIALS The criteria include material name, material content, yarn type and size, fabrication, count/gauge, weight/size, hand/drapability, structural/applied design, color application, finish(es), care,

Table 4–5Classification of materials.

Piece goods make up the outer shell of a garment. Piece goods analysis involves material content, yarn type/structure/size, fabrication, count/gauge, weight/size, structural/applied design, color application, finish(es), care, and quality. Piece goods are often the primary focus of materials analysis because of their role in garment aesthetics, performance, and cost. They are often the first target when cost reduction is desired.

Support materials are used on the inside of a garment to provide shape, shape retention, reinforcement, and/or durability. Included are linings, interlinings (interfacings), tapes, shoulder pads, collar stays, and so on. Factors to consider for evaluation of support materials include material content, fabrication, weight, stiffness, color, care, quality, and method of application. Interlinings are frequently intrinsic parts of collar, sleeve, and waistline treatments as well as pockets and hems. Compatibility of support materials and piece goods is essential to assure acceptable garment performance.

Trims are materials or stitching applied primarily for aesthetic reasons to provide decorative details. Trims may be dual purpose in providing both aesthetic focus and functional service such as a braid or tape that serves as an edge finish or hem as well as a decorative effect. Evaluation of trims may be based on material content, fabrication, size, color application, finishes, care, and method of application. Compatibility of trims with the piece goods is essential because of the potential for latent problems like bleeding or differential shrinkage.

Closures are devices that secure a garment around the body. Closures may be functional and/or aesthetic. The basic types of closures are buttons, snaps, hooks, zippers, hook-and-loop tape, elastic, and drawstrings or ties. A garment may have closures at the neckline, waistline, sleeve openings, pockets, hems, and so forth. Analysis of closures requires evaluation of the material content, fabrication, size, color, finishes, care, methods of attachment, effectiveness of operation, and quality. Functional closures are often combined with plackets in order to open and close garments and keep them closed.

Thread is a linear medium used to form stitches in fabric. It is a major factor in the strength and appearance of seams. Thread can be analyzed based on material content, type (structure), size, and finishes. Thread choice depends on the type of piece goods, findings, stitches, seams, and machines that are used, as well as where the thread is used and the durability needed.

and method of application. Each of these criteria represents a range of possibilities that relate to quality and performance. Sometimes these can be determined by general observation; other times lab analysis is required.

A material name should identify each material and where it is used in the garment. For example, shirt materials might include fabrics, thread for seams, top stitching, and embroidery.

Material content refers to the type and proportion of textile fibers, plastics, metals, or other substances that make up the product. Material content is a primary determinant of product performance including properties such as strength, resiliency, melting point, abrasion resistance, and absorbency.

Yarn type and size relate only to textile materials. Yarns are long continuous strands of textile fibers that make up most textile fabrics. Thread is a special type of yarn used for sewing materials together. Yarn type or structure and size are major factors in the hand, appearance, durability, and quality of woven and knitted fabrics. Yarns and threads might be smooth or textured filament, combed or carded, spun, plied, and/or core spun. Plied construction provides greater strength and durability. Yarns and threads are sized by denier, Tex, or cotton count. Precise type and size can only be determined by laboratory analysis, but useful and reasonable estimations can be made.

Fabrication refers to the process used to produce the material. Textiles are woven, knitted, or nonwoven fiber web. Specific characteristics are identified by fabric names such as denim, tricot, and gingham. Fabrication of zipper chain may refer to coils or scoops. Fabrication of other materials such as snaps or hooks may refer to whether the material is molded, cast, or stamped.

Count or gauge is used to describe textile materials. Count is the number of yarns per square inch in woven fabrics. Gauge is the number of wales per inch in knit fabrics. Count and gauge are factors related to fabric quality and durability.

Weight and/or size is unique to each type of material. Fabric is purchased by ounces per linear yard, yards to the pound, or ounces per square yard. Fabric weight is determined largely by fiber content, yarn size, and count. In lower-quality fabrics, finishes may make an important contribution to fabric weight. Weight and/or size of materials other than fabric frequently involves a special measuring system such as "lignes" for buttons.

Drapability refers to the manner in which a material hangs or bends over a three-dimensional object. These characteristics are particularly important in the choice of fabrics, support materials, trims, and closures when considering compatibility of materials and desired appearance of finished garments.

Structural or applied design refers to how the design is incorporated in the material. Structural design suggests the appearance is an intrinsic part of the material; the design is formed as the material is made. Applied designs may be printed, embossed, or added in some other way to the surface of the material. For example, labels may be produced by a jacquard weave or by printing fabric tapes. Structural designs are more expensive and require more lead time but are more durable for extended use and care.

Color application refers to the method that is used to add color to materials. Textiles may be solution dyed, fiber dyed, yarn dyed, piece dyed, printed, or product dyed. Solution dying of artificially made textiles, buttons, and molded zippers causes color to become an integral part of the material because it is added before the material is formed.

Finishes refer to mechanical or chemical processes that modify the appearance or performance of the material. Fabrics may be made resistant to wrinkles or moisture and printed or napped to create a particular appearance. Materials may also be starched, polished, buffed, or glazed to improve their texture or appearance.

Care refers to processes for garment upkeep, making garments suitable for continued wear. For most garments, care labels are required by law to describe appropriate renovation procedures for particular garments. Materials that are combined in a garment must be compatible in terms of laundry and/or dry cleaning procedures.

Method of application refers to the technique normally used to hold a particular material in place in a garment. Various types of materials may be stitched, tacked, fused, glued, clamped, or stapled. Costs and performance of application methods must be evaluated. Special equipment may be required for some application methods so choice of materials for the production of a particular garment may be limited by equipment availability.

Garment Structure

Sections 4 and 5 of the apparel analysis guide identify components of garment structure and criteria for analysis. *Garment structure* refers to the manner of assembling materials into garments. To meet the needs of target customers, garment structure must also be consistent with the product positioning strategy. Analysis of the formation of garment structure is divided into two phases: (1) assembly of garment components and (2) final garment assembly and garment finishing. The principles guiding analysis of garment structure are detailed in Table 4–6. **Methods of assembly** define the sequence of events and how each step in the assembly process is accomplished to create the garment structure.

GARMENT COMPONENTS A garment component is a garment part that requires one or more separate pieces to be processed as a unit. Garment components are the basic sections of garments including top fronts, top backs, bottom fronts, bottom backs, sleeves, collars/neckline treatments, cuffs/sleeve treatments, plackets, pockets, and waistline treatments. Hems may be completed as a part of a component or as part of final assembly or finishing. Stitches, seams, and/or bonding are used to assemble components and final garment structure. Components are usually assembled at the same time by different sewing machine operators. Table 4–7 provides brief descriptions of each component.

Table 4–6
Principles that guide methods of garment assembly and analysis of garment structure.

Use methods appropriate to materials that will achieve consistency of output.

Use methods that will achieve quality and performance standards.

Use appropriate machines, stitch, and seam types.

Use appropriate work aids.

Minimize handling and number of operations.

Keep garments so they will lay flat as long as possible.

Assemble small components before attaching to large components.

Operators are responsible for the quality of their own work.

Table 4–7Descriptions of garment components.

Top front, top back, bottom front, bottom back are the major sections of a garment. Fronts and backs may be one or more pieces depending on the styling of the garment. Left and right sections are frequently mirror images of each other but may be different if the garment is asymmetrical. Sometimes side seams are eliminated so that fronts and backs are one piece. Fronts and backs usually determine the basic shape, silhouette, and length of the garment. Fronts and backs often have other components attached to them before the garment is assembled.

Sleeves are a fundamental part of garment design, silhouette, and fit. They are functional in covering all or part of the arm. Sleeves also provide opportunities for creative styling, frequently with additional components, such as sleeve plackets and cuffs attached.

Plackets provide a finished opening in the garment to allow a body part to pass through. Types of placket formations and methods of assembly vary widely in cost, quality, and design. Plackets often require some type of closure.

Collars and other neckline treatments, such as facings and knitted bands, may finish, support, and provide aesthetic emphasis for the neckline of a garment. Neckline treatments may also involve closures and plackets to allow the head to pass through and still maintain a close fit at the neck.

Cuffs and other sleeve treatments are components used to finish the lower edges of sleeves. Cuff type varies with the style and function of the component and garment, materials used, and methods of assembly and attachment. Other sleeve treatments include casings, facings, and hems.

Pockets may be functional, aesthetic, or both. They may be sewn onto garment parts, cut into the body of a garment, or incorporated into garment structure. Pocket treatment may also involve a closure. Pockets are sometimes used as a means of differentiating brands of products, particularly on jeans.

Waistline treatments include components that serve to define the waistline of the garment, provide entrance to the garment, and/or hold the garment in place on the body. Waistline treatments may involve formation or application of bands, casings, facings, and elastic. They may or may not involve a waistline seam.

Components such as collars, cuffs, and pockets are small parts that are usually constructed independent of final assembly. Many small parts are attached to the major garment components (tops, bottoms, and sleeves) before final assembly. For example, sleeve plackets may be attached to sleeves prior to final assembly, but cuffs may be added after the sleeve is attached and the underarm seam is sewn. The particular treatment given a component involves consideration of functional use, aesthetics, quality, complexity, materials, component shape, sequence of assembly operations, time, and costs.

CRITERIA FOR ANALYSIS OF GARMENT COMPONENTS Part 4 of the garment analysis guide lists the criteria that may be used for analyzing the components of

garment structure. These criteria include identifying components, determining the number of pieces and number of materials in each component, the operation breakdown, types of stitches and seams, compatibility among materials, compatibility of materials and assembly methods, degree of enclosure, and pressing.

The first step is to identify the **components** used in the garment structure. The second step is to examine the structure of each component individually. The number of pieces in a component is a significant factor in labor costs, method and complexity of assembly, selection of seams, and amount of handling that is required. Each garment piece requires developing a pattern, marking, cutting, sewing, and handling, all of which contribute to the cost of production.

The larger the numbers of materials in components the greater the sourcing, inventory, and handling costs for the garment. Each material must be acquired and prepared for the assembly process. Different materials may be used in various components of the same garment because of different performance expectations. Within the garment structure different materials must complement each other.

Determining the operation breakdown is the next step in the analysis of components. An **operation breakdown** is a sequential list of the steps in the production process. Appropriate methods for each operation are determined to meet cost and quality requirements. The methods used to assemble components often determine the methods of final assembly.

Selecting **stitch** and **seam types** depends on the materials used, predetermined quality level, performance expectations, cost limitations, equipment available, and aesthetic requirements. Most stitch and seam types are identified according to ASTM stitch and seam standards. Stitch and seam quality depends on suitability of materials, thread selection and use, stitch and seam types, machine settings, and skills of operators.

Materials must be compatible within each garment, with assembly procedures, and performance expectations. The greater the number of materials in each garment the greater the risk of noncompatibility. Combinations of materials are successful when the appropriate appearance, hand, and performance are achieved initially as well as after use and care by the consumer. When materials are compatible, problems such as differential shrinkage are eliminated and appropriate care procedures are consistent for all materials.

Assembly methods and materials must also be compatible. For example, use of nonwoven interlining on facings that receive abrasion may be unsatisfactory due to pilling. Fabrics chosen for drapability may be lower in count and have a tendency to ravel. Particular stitches and seams need to be chosen to compensate for the less desirable fabric characteristics.

Degree of enclosure is usually an indicator of quality of garment structure. Garment structure may be enclosed by

- selection of specific seam types,
- · choice of overedge and cover stitches,

- · sequence of assembly,
- use of trim and/or bindings,
- · partial or full linings, or
- assembly methods that enclose seams.

The interior of a garment may be open, closed, or some combination of the two. Open construction reveals raw edges or exposed seams on the interior of a garment. Closed construction has all seams or edges enclosed on the interior of a garment. Enclosed seams enhance the comfort, appearance, and performance of a garment. The more enclosed the interior of a garment, the higher the quality tends to be. A seam covered with fabric may be higher quality and more durable than a seam covered with thread. For example, when setting a cuff to a sleeve the seam may be completely enclosed between the parts of the cuff, or the seam may be constructed with the raw edge covered only by an overedge stitch.

In-process pressing, also called underpressing, involves pressing component parts during the assembly process. It may involve pressing open (busting) seams, shaping pockets, or creasing hems in preparation for operations that follow. Underpressing is an added operation that increases processing and handling time, which, in turn, may increase production costs. It is used to make subsequent handling and placement of pieces easier and to increase accuracy of sewing. In most cases, it improves the appearance of garment components and finished garments. In-process pressing is generally regarded as an important part of component construction for higher-quality garments.

Final assembly includes the processes used to combine a garment's major components. Processes that might be included in final assembly include attaching collars, setting sleeves, attaching waistbands, inserting linings, closing side seams, and forming hems. Small components are attached to larger components such as pockets to fronts, plackets to sleeves, and plaits to shirt fronts. Combined components are assembled to make a complete garment by inserting linings and/or closing seams. Minimizing handling is a primary factor that may determine the sequence of final assembly. Operations may be planned so that sewing operators work on the smallest mass of fabric possible and so the product remains flat as long as possible for easy handling.

CRITERIA FOR ANALYSIS OF FINAL ASSEMBLY Part 5 of the apparel analysis guide identifies the garment structure criteria appropriate for final assembly. The analysis process addresses the operations used to achieve the finished garment as well as the overall quality of the finished garment. Criteria include total number of components and materials in the garment, operation breakdown for final assembly, types and quality of stitches and seams, matching of

seams and design, color matching of materials, shading, and degree of enclosure. Identifying the total number of components and materials contributes to understanding the complexity of garment assembly and the difficulty of materials management.

Final garment assembly operations, including operation sequence and choice of stitches and seams, make a major contribution to product quality and performance. Criteria for the analysis of stitches and seams are the same as when evaluating components.

Care in planning and accuracy of garment assembly are visible in matching corresponding seams and fabric design. The degree of matching is an indication of quality. For example, corresponding seams should align to maintain balance of a garment. The front crotch seam should match up with the back crotch seam as the inseam is sewn. If plaid fabrics are used, all parts may be matched or only specific seams may be matched. "One hundred percent plaid/pattern match" means every seam has fabric design perfectly placed for unity of appearance. Matching requires additional planning, extra materials handling, lower utilization of fabric, greater sewing skill, and more time. All of these factors increase costs; therefore, the amount of matching used is designated to meet cost and quality goals.

Shading in fabrics is another color-matching problem. **Shading,** an expensive problem for both apparel manufacturers and textile mills, is color variation that occurs within or among dye lots of the same fabric and color number. High standards for color consistency mean fabrics are carefully matched prior to cutting so there is little or no shade variation in a garment. Fabrics can be preshaded by electronic instruments at the mill to comply with rigid quality control standards. This improves quality of finished goods and reduces handling and production costs particularly in spreading and cutting. At the same time, extra care in the handling of cut parts also helps avoid assembling components of different shades.

Evaluation of the **quality of stitches** is based on the correct formation of the stitches as compared to ASTM stitch and seam standards and consistent stitch length. **Quality of seams** is judged on the selection of the stitch type, number of stitches per inch, seam width, finish, and appropriateness of the seam type for the fabric and styling.

Materials requirements and assembly methods determine the degree of enclosure that is achieved in the finished garment. Partial or full linings, if used, are usually added in the final assembly process. While linings are usually regarded as a quality feature, they sometimes cover poor quality in other aspects of garment assembly.

GARMENT FINISHING AND OVERALL QUALITY AND APPEARANCE Processes in garment finishing produce the desired final appearance of the garment. Potential steps in **garment finishing** include trimming, wet processing, garment dyeing, postcuring, and **final pressing** or **off-pressing**. Table 4–8 includes

Table 4–8 Garment finishing processes.

Trimming removes thread ends and loose threads and contributes to a neat appearance in the final garment. Trimming is another indication of quality and attention to detail in the production process.

Wet processing includes rinsing, washing, and/or bleaching and abrading of garments after assembly. Wrinkled, crinkled, flecked, or other fashionable looks may be created by special types of wet processing. Wet processing usually removes fabric sizing and may cause latent fabric defects to be revealed.

Garment dyeing provides an opportunity to use fashion colors as demand dictates and reduces risks associated with the use of fashion colors. Garment dyeing can result in shading problems among materials that may be visible only after processing.

Postcure durable press finishes on materials may be used to increase permanency of the finished appearance. Postcure finishes are activated by heat or steam after a garment is completed to permanently set the shape of the garment. Postcure durable press may limit alteration of garment fit, change hand of piece goods, and cause soil retention.

Final pressing (off-pressing) makes a major contribution to the finished appearance of a garment. Smooth seams are indications of quality assembly and final pressing. Pressing may be used to camouflage or cover up poor construction. Poor pressing can also distort a well-made garment.

Ticketing, tagging, and packaging prepare the garment for retail presentation. Tickets include UPC codes, style number, and price. Hang tags are added to identify the trademarks for materials or manufacturer. Products may be hung or folded and pinned to enhance shelf or hanger appeal.

brief descriptions of each of these finishing processes. Figure 4–2 shows a giant washer that may be used for various types of wet processing. Finishing processes contribute to a garment's final appearance and hanger appeal but may also reveal irregularities and latent defects of materials. Garment finishing may also create potential for additional latent defects such as differential shrinkage, color bleeding, and seam puckering. For example, the jean's challenge for Fall 1998 was "dark denim," to achieve the fashionable dark color without the wet bleeding and stiffness common to jeans "double dipped in dye" (Knight, 1998).

CRITERIA FOR ANALYSIS OF GARMENT FINISHING Part 5 of the apparel analysis guide identifies the criteria appropriate for analyzing garment finishing. The analysis process addresses the operations used to finish and achieve the final garment appearance. Criteria for analysis of garment finishing include operations breakdown, consistency, and overall appearance.

The operation breakdown for garment finishing identifies all the finishing operations used on the garment. Finishing operations may include finish pressing, trimming ends of threads, wet processing, garment dyeing, inspecting the

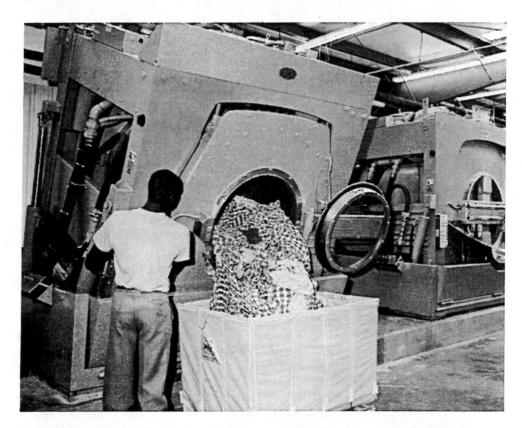

Figure 4–2 Industrial washer used in wet processing. This open pocket washer-extractor manufactured by Milnor reduces labor by tilting forward to unload 300 pounds. *Source:* Courtesy of Pellerin Milnor Corp.

garment, labeling, ticketing, and bagging. Criteria for analysis of finishing include appropriateness, effectiveness, and uniformity.

Consistency is a major factor in determining quality and value. Manufacturers establish quality standards that result in garments of a particular quality level. Garments of different quality levels serve different purposes. Not all garments need to be the highest quality, but garments should be of the highest quality for which the customer is willing to pay. Each item must be consistent with other similar products in a firm's line and provide adequate quality and performance to ensure serviceability in use and renovation.

Consistency is the primary indication of conformance to manufacturer's quality standards such as stitch and seam selection, size standards, material performance, and so on. For example, consistency of garment measurements is a major concern for some manufacturers. Measurements of different garments of the same style and size should be the same or within tolerances. Garments are rejected when they do not meet the firm's specifications.

Judgment of overall appearance requires consideration of purpose of the garment, materials, components, final assembly, and finishes. The question is whether the garment provides a salable appearance. The degree of color matching among materials indicates the attention paid to detail and the aesthetic quality of the garment. Accuracy of color matching depends on a firm's quality standards and effectiveness of sourcing. Matching thread, buttons, and zippers are found on better-quality garments unless design criteria dictate contrasting appearance. These factors are most obvious when a garment is considered as a finished whole.

Garment Presentation

Hanger or shelf appeal is critical for selling the product to the retail buyer and to the target consumer. The product must look attractive to the customer. Part 6 of the apparel analysis guide identifies criteria for analysis of garment presentation for effective hanger/shelf appeal. Garment presentation involves extrinsic cues to quality and value such as labeling, ticketing, accessories, display devices, and packaging.

Evaluation of labeling and ticketing involves examination of the availability, accuracy, and effectiveness of printed information attached to garments. Labels are tags sewn into garments that provide specific product information including brand names, trademarks, country of origin, and care information. Labels need to be durable enough to last the life of the garment. Insertion of labels may be included in the garment assembly process.

Tickets are removable tags that provide selling information including UPC codes, size, style number, and price. Tickets are usually added to finished garments. Some tickets are provided by manufacturers, others may be required by retailers. Many manufacturers now install retailer's tickets so the merchandise is shipped "floor ready." Some retailers do their own ticketing in their distribution centers.

Analysis of the effectiveness of labeling and ticketing involves answering the following questions. What types of labels and tickets are included with the garment? Are the labels and tickets intended for consumer use placed in locations where they are easily accessible? Are the types of information that consumers normally seek easily readable (e.g., size, fiber content, care, brand name, price)? Are legal requirements for labels met? Are the labels and tickets effective for marketing the product? Is there any reason to believe the information on the labels and tickets is misleading or inaccurate?

Merchandisers often add accessories, such as belts, scarves, bows, pins, or other objects, to garments to complete the aesthetic appeal or function of a product. These accessories are then sold with the garment, considered a part of the style, and included in the garment price. The accessories that are sold as part of the style are not to be confused with accessories added for display purposes at the retail level. Accessories that are part of the style may be evaluated

based on compatibility with the garment from both the aesthetic and performance perspectives. Accessories may make a small addition to cost while making a major contribution to hanger appeal and perceived value.

Packaging may provide functional protection and/or aesthetic appeal. Functional packaging protects garments during storage, shipment, or display. Aesthetic packaging includes the visual presentation of a garment including hanging, folding, padding, pinning, draping, and boxing. Display devices, such as collar supports, clips, skirt or sock hangers, and bubble packs, add to the appeal of the garment at point of sale. Display devices, such as fixtures, racks, and hangers, sometimes interfere with customers' access to label information. Are display devices appropriate to the garment? Do display devices interfere with being able to see the garment?

Effective presentation may determine the financial success of the product. All the efforts toward product positioning, materials selection, and the development of garment structure, assembly, and finishing may be in vain if garments are inappropriately presented.

Professional Perspectives on Product Development

Apparel professionals in many different roles are involved in making decisions that make garments serviceable, salable, producible, and profitable. This is a universal skill set that is required of all apparel professionals:

- 1. Understand the importance of consistency of product image.
- 2. Have a strong teamwork orientation.
- 3. Be able to contribute specialized technical expertise.
- 4. Have a priority for satisfying customers.
- 5. Be accountable for your priorities, decisions, and actions.
- 6. Have an entrepreneurial spirit.
- 7. Constantly seek new ideas, products, and processes.
- 8. Be proactive rather than reactive in addressing opportunities, issues, and problems.
- 9. Effectively manage time and other resources.
- 10. Organize and prioritize work flow.
- 11. Motivate team members and other associates to consistently do their finest work.
- 12. Communicate in a clear, direct, and persuasive manner to executives, peers, and other associates.
- 13. Effectively use computer technology and electronic communications to enhance effectiveness of decision making, presenting, and reporting (Hoskin, 1998).

In order to focus on the role of garment analysis in the planning, development, production, and presentation of apparel, consider the perspectives of the following apparel professionals:

apparel engineers
color managers
costing engineers
creative designers
fabric research and
development directors
laboratory technicians
marketing managers
materials buyers
merchandisers
print managers
product managers
production managers

production pattern makers
production planners
production sourcing specialists
quality assurance managers
quality control engineers
retail buyers
retail sales associates
sales representatives
specification writers
technical designers
textile technologists
trend directors
visual merchandisers

Apparel Engineers

Apparel engineers analyze, develop, and implement methods and procedures to produce apparel products that will meet the firm's standards for quality, efficiency, and productivity. Engineers are responsible for designing processes for materials handling and utilization to maximize efficiency. They design plant layouts to provide efficiency, safety, and effective use of equipment while minimizing costs. Method analysis and work measurement are engineering functions related to determining plant capacity and operator pay systems. Engineers analyze garments to determine appropriate methods of assembly, equipment required for garment production, and production capacity for individual styles.

Color Managers

Color managers are members of product development teams that need to have a good eye for color and may need to be able to pass a 100 hue test. They need knowledge of color, fabric, dyes, finishes, textile testing, and a college degree with a focus on textiles. Color managers are responsible for color quality from concept to consumer. They work with creative designers, product managers, textile technologists, and print managers to establish color palettes and carry them out in the chosen fabrics. They establish color standards and develop procedures and tolerances to assure color quality. Color managers super-

vise evaluation of lab dips and dye lots. They communicate with vendors and travel to dye houses for production checks. Color managers must stay on the forefront of opportunities provided by new textile technology.

Costing Engineers

Costing engineers determine anticipated costs for manufacturing various styles and the volume needed to make production feasible. Cost factors include quality of materials, number of garment pieces, number of sewing operations, difficulty of operations, types of equipment, amount of handling, types of finishing processes, and size of lot or order. Garment analysis to determine production costs involves a detailed breakdown of the steps in the assembly process. Each assembly operation is analyzed to determine its labor requirement, production cost, and most economical production source. The analysis may involve estimates of production time, time and motion studies, or use of standard data relative to production procedures. After analysis the costing engineer may recommend modifications in the cutting or assembly processes to reduce production costs or make the assembly process more compatible with plant equipment and routine assembly procedures.

Creative Designers

Creative designers usually have primary responsibility for the preadoption phase of product development. They are responsible for creative, aesthetic, and functional aspects of a line relative to fashion, styling, colors, variety, fit, sizing, and end use. Designers must create hanger and emotional appeal to sales representatives, retail buyers, and customers. A designer's priorities may focus primarily on garment appearance, customer preferences, and/or value depending on the firm's target customer. The designer's greatest challenge may be to "sell" the designs created to the merchandising, marketing, and production teams within the company.

The challenge to designers is to be able to create the desired appearance and function through combining structure and materials. The position of a firm relative to fashion and seasonality determines the amount and types of product change from the previous selling period. Designers may work with merchandisers in developing consistency among seasons and lines and coordination within lines. Designers and/or merchandisers determine product differentiation from the competition while providing continuity from one selling period to the next.

Designers also develop design specifications for garment assembly that require considerations of alternative materials and assembly procedures. Design specifications provide information required for precosting of sketches and cost estimation of designs to determine feasibility of production.

Fabric Research and Development Directors

Fabric research and development directors proactively work with the fashion office, product developers, quality managers, technical designers, and sourcing to develop and deliver fabrics to carry out merchandise plans. They maintain up-to-date industry information on fibers, yarns, fabrics, and finishes. They have an in-depth knowledge of color and fabrics and supervise textile technologists and laboratory technicians.

Laboratory Technicians

Laboratory technicians usually do not initiate garment analysis but rather carry out analysis procedures requested by other apparel professionals. They operate textile testing equipment and perform standardized tests on materials and garments to determine strength, durability, drapability, colorfastness, and so on. These tests produce technical descriptions of intrinsic performance characteristics. Tests may also identify patent and latent defects due to laundry or dry cleaning procedures. Results are reported to other company professionals as input for garment analysis decisions.

Marketing Managers

Marketing managers are concerned about promotional strategies, product differentiation, consistency of image, and the appearance and promotability of a line relative to the competition. They evaluate products from the standpoint of sales volume relative to the needs of target customers. Marketing managers tend to seek variety in a line in order to appeal to as many retail buyers and target customers as possible.

The limitations of the marketing calendar make timing of delivery a primary concern. Extrinsic aspects of apparel are important to the marketing manager because of the importance of brand names and product image in promotional campaigns. A marketing manager may be willing to sacrifice some quality characteristics in favor of timely delivery. Packaging and shelf/hanger appeal are important factors in sales performance.

Materials Buyers/Sourcers

Materials buyers/sourcers are charged with the responsibility of selecting and purchasing specific materials that are used in particular styles. They work in both domestic and international markets. The amount of analysis required of the buyer depends on the level of specificity desired. Buyers are concerned with performance, availability, quality, consistency, compatibility, and costs. The materials buyer must compare suppliers' specifications to style specifications to determine the most suitable product to buy. Buyers must also determine whether the materials received meet the specifications. Labora-

tory tests may be ordered to confirm acceptability of materials. Buyers negotiate price, delivery dates, and refunds and returns when merchandise or service is unsatisfactory.

Merchandisers

Merchandisers are responsible for planning and developing products and product lines at both the wholesale and retail level. They plan merchandise budgets and assortments and develop product lines by interpreting the product positioning strategy developed by marketing. Merchandisers use a broad perspective on garment analysis, considering both intrinsic and extrinsic factors. They analyze effects of cost reductions, materials modifications, and changes in production procedures on finished garments. At the same time factors such as salability, product differentiation, producibility, and profit are considered. Changes in materials or assembly procedures require collaboration between merchandisers and production managers.

Merchandisers make final product decisions and negotiate priorities between design, marketing, and production. Merchandisers must be prepared to develop, accept, or reject product modifications that accomplish certain objectives without compromising the firm's overall objectives and maintaining line integrity. Modifications might result from a need to reduce costs, use multiple contractors, upgrade or downgrade product quality, develop knockoffs, and so on.

Print Managers

Print managers have excellent color and design skills and translate fashion direction into fabric and trim print designs appropriate for target customers using computer applications. They design or buy artwork and identify and define prints, patterns, and graphics to support the line concept for all products in the line. Print managers evaluate and approve strike offs, knit downs, hand looms, and production.

Product Managers

The position of **product managers** has evolved to satisfy the need of having someone who is in charge of the entire product rather than parts of the product. Product managers oversee the product development and production of assigned products and categories. They work within the context of the product line and are members of the merchandising or product development team. Product managers need an understanding of the entire product development and production processes including materials characteristics, costing, and size and quality standards. Product managers work closely with production and frequently are liaisons with contractors.

Production Managers

Production managers manage the production of styles. They are primarily concerned with controlling production costs, evaluating production capacity, increasing productivity, maintaining a smooth work flow, and meeting production deadlines. Their goals for garment analysis are simplification of operations, reducing throughput time, and providing appropriate equipment and trained operators. Production managers' primary concerns are producibility with available equipment and operator skills, to meet quality standards and production deadlines.

Production managers are often involved in acquisition of new equipment. Capital investment in equipment has a long-term impact on finished products. Garment analysis relative to equipment purchases involves comparisons of available and new equipment relative to product quality, ease and cost of operation, and rate of output.

Production Pattern Makers

Production pattern makers are responsible for maintaining the integrity of designs while developing accurate patterns for cost-efficient use of materials and construction. They analyze the relationship of a pattern relative to fabrics, sewability, grain, fit, and the appearance of the finished garment. Many production pattern makers work on computerized pattern-making systems for greater accuracy and efficiency.

Production Planners

Production planners integrate plant resources with the demand for finished goods with consideration for forecasts, budgets, and customer orders. They coordinate plant capacity with style requirements, projected volume, and shipping dates. As work is scheduled, production planners effectively utilize owned and contracted plant capacity, maintain high productivity, and balance work flow. Production planners work with apparel engineers, technical designers, and production and plant managers.

Production Sourcing Specialists

Production sourcing specialists determine the most cost-effective vendors of production given quality standards and time constraints. They evaluate sourcing options including domestic, 807, and foreign. They assess vendor and factory capabilities and capacities against line plans. They negotiate agreements with vendors, contractors, and international agents related to prices, lead times, and minimums. They place orders and make arrangements for an ongoing supply of production capacity. Sourcing specialists work within international trade regulations, do the paperwork, and work with the Customs Service for importing and exporting goods.

Quality Assurance Managers

Quality assurance managers recognize that quality is built into a product. Quality cannot be inspected into a product. Therefore, if a firm is going to make products of consistent quality, concern about quality outcomes permeates everyone's responsibilities. The role of the quality assurance manager is to maintain everyone's awareness of the importance of quality to the firm and to coordinate efforts to produce and distribute the quality level desired. Quality assurance managers need a thorough understanding of the production process and its contribution to product quality. The more complete the quality manager's product knowledge, the better able he or she is to communicate quality priorities. Quality assurance managers work on site with vendors and factories to identify and resolve manufacturing problems.

Quality Control Engineers

Garment analysis as conducted by **quality control engineers** focuses on intrinsic aspects of quality. Quality control engineers may have three purposes for garment analysis: to establish garment standards and specifications, to determine whether garments meet established standards and specifications, and to establish standards and quality control procedures. Establishing standards involves interacting with specification writers, providing input on acceptable tolerances, and evaluating acceptability of garment specifications. Determining whether garments meet standards involves training and supervising inspectors, who evaluate materials, garments, or garment components against standards and style specifications.

Retail Buyers

Retail buyers perform garment analysis every time they look at a product line. Their garment analysis is concerned with the anticipated sell-through of the product, which is based on promotional appeal, anticipated quality level, price, and customer preferences. The types of analyses performed depend on employers' priorities for quality and styling. Buyers for Sears or J. C. Penney may send materials to their testing lab for verification of specifications and quality. Buyers for other firms may focus primarily on visual appeal and price of the line based on the assumption that product quality will be adequate to meet their customers' needs.

Retail buyers have limited budgets for each classification of goods they buy. Within their budget they must balance assortments to provide the customer with an adequate selection on the sales floor while minimizing the cost of goods sold and maximizing sales at first price. The results are higher gross margins and greater profit for their departments. Initially, garment analysis may focus on the coordination and compatibility of styles as they relate to the total assortment offered by their retail stores. Later, garment analysis may involve

products that had to be marked down. Buyers attempt to determine what intrinsic and/or extrinsic factors made the garments unsalable at first price and make appropriate sourcing changes for the next season.

Retail Sales Associates

Garment analysis required of **retail sales associates** often involves determining appropriateness to end use for each customer they help. The end use may include providing functional service, status, fashion, social acceptability, individuality, or conformity. Sales associates are frequently asked to evaluate garment appearance, fit, and care procedures. The ability of retail salespeople to provide answers to these questions depends on the information they have about the nature and use of the apparel products they sell. Retailers frequently neglect to train their salespeople to deal adequately with garment analysis questions.

Sales Representatives

Analysis of garments by **sales representatives** is likely to focus primarily on extrinsic factors. Their primary concern is the salability of the line. Sales reps are concerned with the coordination, methods of presentation, features, and versatility of a line. Advertising campaigns, use of trademarks and brand names, and the pricing strategy may also be based on garment analysis. Garments are analyzed relative to the characteristics of comparable garments produced or sold by their competition and the needs of their retail customers. Sales representatives may tend to assume that the intended level of intrinsic quality is represented in a line. They need to know the benefits of materials selection and style features. Sales samples may not be intrinsically the same as the mass-produced garments because they may not be made on the production floor or engineered to meet cost limitations. Thus, intrinsic analysis of sales samples is often not appropriate.

Specification Writers

Specification writers prepare detailed specifications from the brief descriptions and samples provided by designers, merchandisers, or product managers; however, specificity of specifications vary widely. Garment samples are analyzed to provide all the descriptive data needed by purchasing, production, marketing, and merchandising. The amount of detail and sources of data used in specifications vary for each firm. Some product specifications use suppliers' specifications for materials. Others may use laboratory analysis to determine and/or verify appropriate specifications.

Technical Designers

Responsibilities of **technical designers** are focused on postadoption product development processes. They may perfect the fit of new styles, supervise the development

opment of production patterns, grading, develop style and quality specifications, and assist with detailed costing. Technical designers work with sample makers, pattern makers, merchandisers, designers, cutting room supervisors, production sourcing specialists, and contractors. They are responsible for communication of technical information, verifications of measurements, patterns, materials usage, and assembly methods. Technical design is sometimes a senior-level position but may be an entry-level position in a merchandising or product development group.

Textile Technologists

Textile technologists need to graduate from an academic program with a focus in textile science of quality assurance and retail or manufacturing experience. They assist in the technical development and preproduction of fabrics. They work with quality assurance managers on all issues regarding quality of fabrics and other materials. Textile technologists are responsible for tracking the development and approval of fabrics. They also develop product specifications and performance packages and work with laboratory technicians who carry out testing.

Trend Directors

Trend directors interpret fashion dynamics, identify critical trends, and are passionate about fashion and satisfying customers. They have extensive experience in analysis, synthesis, and forecasting of fashion trends for different target markets. They identify, develop, and present fashion direction for color, fabric, and style. Trend directors partner with product development, merchandising, and marketing to integrate fashion focus and brand strategy.

Visual Merchandisers

Visual merchandisers create, develop, and supervise merchandise presentation for both apparel manufacturers and retailers. Manufacturer's visual merchandisers train retail department managers and salespeople, check merchandise assortments, and stock merchandise. Retailer's visual merchandisers design merchandise displays, select fixtures, and analyze productivity of merchandise presentation. Visual merchandisers work with sales representatives, retail buyers, department managers.

Summary

Garment analysis is a part of the everyday life of most apparel professionals. The purpose and depth of analysis vary greatly depending on professional responsibilities for garments. A garment can be evaluated by establishing the

product positioning strategy; examining sizing and fit; analyzing quality, compatibility, and appropriateness of materials; examining the components of garment structure; examining the processes of final assembly and techniques of garment finishing; and evaluating garment presentation. Professional uses of garment analysis depend on individual responsibilities for garments. Examples of apparel professionals who use garment analysis include merchandisers, designers, marketing managers, specification writers, costing engineers, materials buyers, production managers, quality control engineers, laboratory technicians, sales representatives, retail buyers, and retail salespeople, sourcing specialists, specification writers, and technical designers.

References and Reading List

Holzman, D. C. (1996, January). Fewer sizes fit all. *Technology Review*, 99, 19-21.

Hoskin, J. (1998, November). The fashion business: The process that makes excellence happen. Presentation at the International Textiles and Apparel Association Annual Meeting, Dallas, Texas.

Knight, M. (1998, June 1). Mecca DNM takes soft approach to dark denim. DNR, 25.

Lee, Y. T. (1994, February). A bibliography on apparel sizing and related issues. Gaithersburg, MD: U.S. Department of Commerce, NISTIR 5365.

Lee, Y. T. (1994, April). Body dimensions for apparel. Gaithersburg, MD: U.S. Department of Commerce, NISTIR 5411. Palaganas, D. (1991, September). Sizing standards underway in U.S. Apparel Industry Magazine, p. 88.

Tamburrino, N. (1992, April). Apparel sizing issues. Part 1. Bobbin, pp. 44–46.

Tamburrino, N. (1992, May). Apparel sizing issues. Part 2. Bobbin, pp. 52–60.

Tamburrino, N. (1992, June). Sized to sell. *Bobbin*, pp. 68–74.

Tigert, D. J., Reynolds, C. C., Cotter, T., & Arnold, S. J. (1996, October). The 1996 Chicago female research project. *Chain Store Age*, 72, 5B–31B.

Key Words

accessories
aesthetic purpose
apparel engineers
apparel professionals
augmented visual inspection
body types
bottom back
bottom front

care
closures
collars and other neckline
treatments
color application
color manager
components
consistency

cost
costing engineers
count
cuffs and other sleeve
treatments
degree of enclosure
designers
display devices

drapability durability extrinsic cues fabric research and development director fabrication final assembly final pressing findings finishes finishing fit fullness functional purpose garment analysis garment component garment dyeing garment finishing garment presentation garment structure gauge general body size hanger or shelf appeal in-process pressing intrinsic cues labeling labels laboratory technicians

laboratory tests limiting fit points marketing managers material content material name materials buvers / sourcers merchandisers method of application methods of assembly off-pressing operation breakdown packaging plackets pockets postcure durable press print manager product managers product positioning strategy production managers production pattern makers production sourcing specialists quality assurance managers quality control engineers quality of seams quality of stitches retail buvers retail sales associates sales representatives

shading silhouette 9170 sizing system sleeves specification writers stitch and seam types structural or applied design support or shaping materials tagging technical designers textile technologists thread tickets top back top front trademarks trend director trimming trims underpressing visual inspection visual merchandisers waistline treatments weight wet processing varn type and size

Discussion Questions and Activities

1. In groups of two or three, choose a simple garment, such as a T-shirt, and conduct a garment analysis using the garment analysis guide and garment analysis worksheet. Some of the information, such as stitch and seam types, have not yet been discussed in class. These factors are topics of subsequent chapters. But work through the garment analysis process and be sure you understand the process, the terminology, and the concepts. The information that you can provide through garment analysis will become more accurate as you learn more about apparel manufacturing.

2. Organize the class into groups of four or five people. Have each person in a group assume the role as one of the apparel professionals discussed in the chapter. For example, one person might be a merchandiser and another a costing engineer. Identify aspects of the garment analysis process that would be of primary concern to each apparel professional. Discuss potential conflicts that might develop between apparel professionals because of differing priorities.

Product Standards and Specifications

OBJECTIVES

- Discuss the development and use of product standards.
- Explore the relationship between product standards and specifications.
- @ Examine the content of product specifications.
- 6 Discuss the use of product specifications among vendors, manufacturers, contractors, retailers, and consumers.

Apparel manufacturers and retailers establish standards for quality, fit, and performance for the products they produce and distribute. **Standards** are a set of characteristics or procedures that provide a basis for resource and production decisions. Standards are used to guide product development, selection of materials, production methods, and finishing techniques. The framework for establishing standards is described in a firm's strategic business plan. The framework is based on preferences of target customers, profit goals, and production and sourcing capabilities. Standards reflect the quality level and quality characteristics that are important to a firm's target customers and incorporate a firm's need to make a profit while meeting consumer expectations.

Standards are used in developing specifications for each style in a firm's line. Specifications (specs) are brief, written descriptions of materials, procedures, dimensions, and performance for a particular style. Specifications are used to communicate standards and provide control of products during production. Product specifications are the basis of contracts between suppliers and buyers in the chain of production. They determine acceptability of materials and finished goods. Conscientious attention to specifications results in products that consistently meet a firm's quality standards.

Sources of Product and Quality Standards

There are at least four different sources of product standards: company standards, industry standards, national standards, and international standards. Conformance to some standards is mandatory, while conformance to other standards is voluntary. Standards that are mandatory for the textiles and apparel industry in the United States include those enforced by state, federal, or international law or regulations. A few international standards relate to textiles and apparel. One of the greatest frustrations of some firms is the lack of conformance of the United States to the metric system. The United States is the only major industrialized country that does not use the metric system, although it does have mandatory standards for fiber content and care labeling as well as safety regulations for some textiles and apparel products.

For firms in the textile and apparel business, compliance with product standards is, for the most part, voluntary. For example, the strength, durability, and shrinkage levels acceptable for sportswear fabrics are not mandated by federal law or regulation. However, voluntary industry standards are available if a firm chooses to use them. The development of company standards for quality,

fit, and performance is the primary topic of this chapter.

International standards are increasingly important for doing business in a global environment. The International Organization for Standardization (ISO) is comprised of the national standards bodies from 91 countries. ISO has developed a set of standards for quality systems, ISO 9000, that is required for quality certification.

ISO 9000 is a set of five individual but related international standards on quality management and quality assurance that have been developed by the agency. The published standards enable manufacturers to build and document an approved quality system that will allow them to be competitive at the highest level with manufacturers around the world. These standards have worldwide acceptance as the only official quality registration procedures. Implementation is not required by law; however, it is anticipated that as competition in the world market increases, so will the demand for certification.

The benefits of participating in ISO 9000 include marketing opportunities and reducing costs. Keeping existing business and acquiring new customers may be dependent on certification. For example, many large firms that may be customers of small firms require that all suppliers use ISO 9000. Lack of certification becomes a significant barrier to growth of market share in these circumstances. Reduction of costs is realized through improved process control by conformance to ISO 9000 standards. Firms may not address inefficiencies in manufacturing processes without an effective set of standards as guidelines (Pochop, 1997).

At the same time, implementation of ISO 9000 requires investment of time and expertise. Among other things, documentation must be upgraded, employees trained, and an independent auditor hired. Exact costs are difficult to estimate for a particular firm, but costs per employee may range from \$1,000 to \$4,500. For any company, finding ways to conform production processes to a set of external standards requires time, commitment, and money. The result of the improvement in quality standards, however, can be improvement in efficiency, market growth, and profitability (Pochop, 1997).

Standards for Quality, Fit, and Performance

Apparel professionals establish a firm's product standards based on predetermined preferences of target customers, costs, volume, price levels, and capabilities for production and sourcing. Each division of a firm contributes to the establishment of standards. The marketing division conducts market research and provides feedback from retail buyers regarding customer preferences. Quality control, which is often supervised by the operations division, evaluates returned goods and analyzes production processes. The production division analyzes the manufacturing capabilities of the plant(s) relative to skills, equipment, and costs. The merchandising division evaluates new products relative to customer preferences, plans the product line, and may source materials. Technical designers write specifications based on the standards.

As a result of the integration of this information, standards are established that reflect the quality characteristics, performance levels, and fit that a firm can produce and for which the target customers are willing to pay. A firm's standards are used to define the quality characteristics that become intrinsic parts of every garment. This contributes to a consistent image of the product line in the mind of the consumer.

Established standards are an integral part of all of the firm's operations. Standards are communicated to personnel in all divisions as well as to vendors, contractors, retailers, and consumers. All people involved with the organization must understand and support the organization's standards. Training of new

personnel includes indoctrination relative to the firm's standards and expectations of commitment to those standards. A manufacturer that wants to change its standards identifies the characteristics that are to be changed, develops new standards, adjusts wage rates, and retrains employees. Issuing new specifications notifies contractors and vendors of expectations for changes in quality, fit, or product performance. It may be necessary to hire different contractors or use different vendors if the specifications for the new standards cannot be met.

Quality Standards

Quality standards are part of a firm's "standard operating procedure," product development, and production planning. Standards reflect the overall intrinsic quality level the firm seeks to achieve. The fundamental purpose of using standards is to provide consistency between products and product lines. Quality standards may determine the amount of testing to be done on materials and prototypes. Some manufacturers test each fabric before it is ordered. Others rely on specifications from the vendor or visual inspection. Some firms also perform extensive tests and inspection after fabrics and materials are received. Some firms may inspect 100 percent of the incoming fabrics for flaws and color shade variations, while other firms inspect fabric only as it is spread for cutting.

Standards are the basis of product development decisions, specifications, and quality control. Fundamental quality standards may involve the use of color-matched thread and buttons. Many jacket makers use twill tape for retaining shape of the garment. Some firms use twill tape on shoulder seams, collar and lapel edges, and armholes. Others use it only for shoulder seams. Such quality standards affect the costs, intrinsic quality, materials used, and methods of production.

Size and Fit Standards

A firm's basic pattern blocks represent its standards for size and fit (discussed in Chapter 6). Using basic blocks for style and pattern development provides a basis for consistency among sample sizes for a variety of styles. Grade rules provide consistency in size variations from the standard fit of the sample size. A firm's standard grade rules establish differences in dimensions and proportions for each size within the size range produced. Grade rules, based on company size standards, indicate precise increases or decreases at specific points on the garment. Standards are also needed for production processes to maintain consistency of fit throughout assembly. Checking certain garment dimensions is often part of inspection of finished garments.

Performance Standards for Materials and Finished Products

The consumer is often concerned with performance related to aesthetics, end use, and care of finished products. Market research is used to identify the cus-

tomers' expectations, while company standards for materials and finished goods are developed to meet the customers' needs. An apparel company makes decisions based on its interpretation of the performance level expected by the consumer.

Apparel professionals are concerned about ease of handling materials, cutability, sewability, appearance, and end use of finished products. Each textile mill and apparel manufacturer develops its own standards for performance of its products related to end use. Materials and products are tested to verify that quality, fit, and performance standards are met. In many instances, however, merchandise returned by consumers met performance standards set by the firm but the products failed to meet consumers' expectations. To be valid, product **performance standards** must meet the needs of both the consumer and the firm(s) involved in the production and distribution of the merchandise. If consumer expectations are not met, then all the commitment to quality, development of specifications, testing, and quality control are not realized. The apparel firm is challenged to set appropriate standards and establish appropriate tests to verify that the products meet the standards.

Both textile mills and apparel firms are concerned that product performance meet customers' needs, thus, two types of performance standards are used in product development: (1) standards related to the performance of materials and (2) standards for performance of finished products. There are no industry or government-mandated standards for textile or garment performance, but voluntary standards are available for many products. These standards are used by many textile mills and apparel firms to evaluate performance of materials. Use of standard test methods is important to firms involved with a product so each knows how performance is evaluated. Standard test methods provide common procedures that both buyers and sellers use.

Two government- and trade-supported organizations have developed standard performance specifications for textiles and many other products. The American Society for Testing and Materials (ASTM) and the American Association of Textile Chemists and Colorists (AATCC) have established standard test methods related to performance characteristics and physical parameters of textile products.

ASTM is the world's largest source of voluntary standards for thousands of different types of products, including textile and apparel categories. It operates through more than 137 main technical committees with 1,935 subcommittees. The committees function in prescribed fields under regulations that ensure balanced representation among producers, users, and general interest participants. ASTM annually publishes books of standards for thousands of products. The textiles standards appear in the *Annual Book of ASTM Standards*. In 1983, ASTM published a series of recommended standards that can serve as guidelines for purchasing fabrics with performance acceptable for 42 apparel product categories. These standards are used as guidelines in specifying fabric requirements and negotiating purchase contracts.

AATCC is a technical and scientific society of 7,000 members from the United States and 50 other countries. Some 250 organizations in the textile, chemical, and related industries help support the association as corporate members. AATCC is internationally recognized for its standard methods for testing dyed and chemically treated fibers and fabrics. These standards are established to measure and evaluate performance characteristics such as color-fastness to light and washing, durable press finishes, shape retention, flammability, and the many other conditions to which textiles may be subjected. The standards and **test methods** provided by ASTM and AATCC often become a part of the materials standards and specifications used by manufacturers.

Many apparel firms do not use standardized tests to determine performance of materials. Some firms may rely only on visual inspection of the materials to determine conformance to company standards. Others may depend on performance specifications prepared by the textile manufacturer. Some firms may test materials for sewability, care, and other performance characteristics by performing simple tests on fabric samples or sample garments. Samples may be subjected to use and care procedures. Simple laundry tests may be used to ensure adequate performance during care by revealing shrinkage and color problems that make finished products unusable. Usually, any testing is better than no testing at all.

Using Specifications

Once a firm establishes quality, fit, and performance standards, specifications for individual products can be developed to be sure that standards are maintained. As the textile and apparel industries have become more globalized, the need for detailed and accurate specifications has increased. More firms are focusing resources on specification development than ever before. For some firms, specifications are the result of intense study, testing, examination, and integration of information from many sources within and outside the firm. Specifications that incorporate great detail require lots of time, information, and knowledge to write. Developing realistic specifications and implementing them are, many times, the catalyst that brings the manufacturer and supplier together with a feeling of mutual respect for each other's interests and needs.

For each style, specifications are prepared that provide control over acquisition of materials, their performance characteristics, and the production processes required to make the finished product. Performance characteristics of materials that might be specified include wrinkle resistance, colorfastness, and dimensional stability. Production processes that are usually specified include types of seams and stitches, machine settings, and processing sequence. Specifications are a means of (1) communicating specific product descriptions, (2) developing product consistency, and (3) negotiating bids and contracts.

Communicating Product Descriptions

Specifications are an important means of communicating product information at all levels of distribution in the textiles and apparel industry. They are used as a means of communication between buyers and sellers of products; between the manufacturers and contractors; between management and production workers; between designers, pattern makers, and sample makers; and among the divisions of an apparel firm. Inadequate specifications are the source of many problems.

Wholesale and retail catalogs are often used to communicate product specifications among buyers and sellers. For example, firms involved in direct marketing such as Lands' End or L. L. Bean use product specifications to describe their merchandise to consumers. Specifications are needed since the consumer cannot physically examine and try on the merchandise. Product specifications often include both intrinsic and extrinsic cues to performance, fit, quality, and value.

Suppliers or vendors of materials use product specifications to advertise product lines and services; communicate product availability, characteristics, and performance; and sell materials to apparel manufacturers. Supply catalogs, swatch books, or sample cards include specifications and prices for the products offered. When ordering materials from open stock, a garment manufacturer may rely on specifications for making selections. The specifications may include statements of physical dimensions, product capabilities, tolerances, and testing done to support the claims. Characteristics identified include physical properties, minimum standards, and test methods used to verify the property. Vendor or product specs that are based on extensive product testing provide information on a product's performance capabilities, appropriate uses, and specifics of application or installation. These product specifications provide the garment manufacturer with information to be used in relating product performance to end use.

Specifications may also be written by manufacturers or retailers for buying materials necessary for manufacturing products or product lines. These specifications are used to select goods from open stock or to order materials "made to specifications." Buyers may develop specifications based on expected performance and the projected end use of a product. Things such as fiber content, color, count, fabric construction, weight, width, and finishes might be specified. When a materials buyer uses specifications related to end use, the vendor is often able to make recommendations for appropriate products from its line based on product knowledge and product testing. If an unusual component is needed, the specifications can be used as a basis for developing and manufacturing the needed product. If several suppliers have comparable products, the buyer will be able to make comparisons for the best value.

Apparel professionals use specifications for communicating procedures and expectations to contractors and production workers. The general level of expectations may be part of a company's standard operating procedures and may

not be specified for each new style. However, specific details are needed when procedures vary from the typical product or standard operation. Methods and procedures are specified so that each employee knows exactly what is to be done and how it is to be done. All this information is essential to perform the processes correctly and produce consistent products.

Developing Product Consistency

Specifications provide the basis for maintaining consistency among products of the same type, among products in the line, and among product lines. Consistency of appearance, quality, fit, and performance is essential if the firm is to develop product differentiation and customer loyalty. Specifications interpret a firm's quality and performance standards for individual products, identify properties and characteristics desired for a particular product, and provide quality control with a basis for product evaluation.

Consistency of fit reflects a firm's commitment to performance and quality standards. A firm's **size standards** are the basis of finished garments that consistently fit the target customer. Specifications for fit are sets of measurements, allowable tolerances, and specific points of measurement for each size and style. A perfect production pattern reflecting the firm's size standards is the first step in achieving consistency of fit. In addition, production process specifications are critical for maintaining the size standards and consistency of fit throughout the production process.

Negotiating Bids, Contracts, and Licensing

Specifications are used to purchase a contractor's services and/or establish a basis for bidding for the sale of materials or services. The U.S. government has developed the most extensive and complete specifications used for contracting apparel production. Government specifications include the product's exact measurements, materials requirements, and processing methods. The specifications are made available to any firm that is interested in bidding on production of the product exactly as it is specified. Potential contractors submit their bids based on the specifications for the product, and the government issues a contract to the lowest bidder. The specifications and contract leave little doubt about the appearance, fit, and quality the final product should have. Products must meet specifications or they will be rejected.

Table 5–1 shows an example of specifications for one operation for a women's coat to be produced for the U.S. government. The specifications used by the federal government are highly detailed. Complete specifications for a single style may occupy numerous pages. The designations for stitch type and seam type are discussed in Chapter 13.

Contracts among apparel firms, suppliers, and contractors are usually based on much less complex specifications. Specifications identify the requirements of a style and serve as the basis of determining the price when purchasing sewing and related services from contractors. Services that are sometimes

Table 5–1U.S. government specifications MIL-C-44101 (GL) 1983 for one operation on a women's coat.

				Outshaa		Thread			
No.	Manufacturing Operations Requirements	Stitch Type	Seam and Stitching Type	Stitches per Inch	Needle	Bobbin/ Looper	Cove		
23.	Join back to side body. a. Stitch back to side body matching notches, working in fullness between back notches. b. Press seams open and flat. Avoid stretching waist.	301	SSa-1	10–14	50	50			
	or								
	c. 1/4 inch twill tape may be positioned and stitched to armhole as required in operations 17.c. and 22.c., across pressed open seam (23.b.) in one piece. Care must be taken not to stitch the front interlining to the tape.	301 401	SSaa-1 SSaa-1	10–14 10–14	50 50	50 70			

NATICK Form 903

Source: NATICK Form 903.

contracted include pattern making, cutting, screen printing, embroidery, belt making, and pleating. Specs provide a means of ensuring a firm that products will be made as contracted. Specs provide contractors, up front, with the requirements for the goods, the means of evaluating compliance, and a basis for preparation of a bid. Completed products are evaluated based on the specifications and accepted or rejected based on conformance.

Product specifications are particularly important when using contractors for production. Although contractors are usually selected that have quality standards similar to the apparel firm, production processes may differ. Without exact communication of standards, it is the contractor's decision as to how the garment is produced. The contractor may choose to assemble the garment in the fastest and least costly manner, which can create inconsistencies in appearance, performance, fit, and quality. This problem could be multiplied further if several contractors are producing the same style number. Without adequate communication of specifications, there could be different versions from different contractors, all sold under the same style number and label.

Specifications can also be used to itemize specific requirements for special, atypical products and make the product available for bids. Suppliers of materials can prepare bids for the goods or services based on the specifications. The manufacturer offering the contract can compare the bids since all bids are based on the same specifications. The specifications become part of the contract for the goods and are the basis of accepting or rejecting the goods that are delivered.

Licensing often involves a licenser granting the right to a licensee to use merchandising properties such as brand names and trademarks. In addition, it may be necessary to transfer a licenser's technology, standards, and manufacturing expertise so that products can be properly produced. **Product specifications** are the means by which standards and intellectual property related to the manufacturing process are described. For example, if Levi Strauss were to license the production of jeans in France, detailed specifications of product design, materials, technology, and production procedures would be included in the licensing agreement. Table 5–2 provides a detailed list of types of product specifications that might be included in a licensing agreement.

Table 5–2
Product specifications that might be part of a licensing agreement.

Merchandising

Fashion and color forecasting

Styling including garments designed for the specific market

Pattern alterations to meet manufacturing conditions, materials, and sizing for the market Patterns graded by size

Continuing supply of sample garments and materials

Marketing

Advertising, marketing, and promotional strategies

Sales training

Market research

Display designs and programs for retail stores

Materials

Material samples and color cards

Material costs

Material usage

Material specifications and characteristics

Supplier listings

Laboratory evaluations of materials

Dye formulas and instruction on dyeing processes

Inventory control

Equipment and production processes

Workplace diagrams and layouts

Machinery requirements including specialized attachments

Quality evaluation and control

Assistance in training sewing machine operators, technicians, sewing machine mechanics, and so on

Suppliers of machines and attachments

Information about how to perform patented processes

Research and computer applications

Updates on machinery and production methods

Warehousing and distribution techniques

Generally, the more geographically remote the licensee is from the licenser, the more complete the product specifications need to be. The more definitive the agreement, the more control the licenser has over production, and the more information that has to be communicated to the licensee. A good licensing agreement is frequently a long-term commitment that can lead to an ongoing partnership between the firms involved.

Writing Specifications for Apparel Manufacturing

Both manufacturers and retailers develop specifications for the products they produce and/or buy. There is a wide range in the specificity of information presented on a spec sheet. The extent that specifications are used and the detail included vary with each firm's commitment to quality and consistency. An overview of specifications is provided here with more discussion related to design and engineering specifications in Chapters 6 and 10.

Specifications might be as simple and routine as a grocery list, but grocery lists also vary in detail and specificity. For example, a list that reads "cereal" leaves a whole range of options from which to choose. "Dry cereal" would limit the options to a type of cereal and raisin bran would narrow the selection from rice flakes, corn flakes, and other cereals. A list that specifies "Kellogg's Raisin Bran, 6-ounce box" would eliminate all the choices of the shopper except the one exact brand and size.

The foregoing example represents two types of materials specifications that apparel manufacturers may use, open or closed. An **open specification** uses only generic terms—"cereal"—and identifies only the properties that are needed. This allows more flexibility in buying materials. A **closed specification** limits the product to a specific brand or vendor—"Kellogg's Raisin Bran, 6-ounce box."

Consider the following apparel example. A garment manufacturer needs to order batting for a ski vest. Specifications for this product may be written with several different levels of specificity. Some possible options are shown in Table 5–3. Batting is an open specification. Hollofil® polyester batting is a closed specification because the purchase is limited to DuPont's Hollofil® polyester and eliminates all competing products. The cost of the component depends on the contract that can be negotiated with DuPont, which may include the right to use the name and logos. Thus, the price may be higher than if competing products were considered.

Table 5–3Specifications for polyester batting.

Batting	Open
Polyester batting	Open
Bonded polyester batting	Open
Bonded polyester batting, 6 oz.	Open
Hollofil® polyester batting, 6 oz.	Closed

Phases of Apparel Specification Development

Specifications develop in phases as a product begins to evolve and take form. Specifications are often general at first and evolve into greater levels of specificity as the requirements for a product need to become more defined and exact. General specifications are based on the line plan summary and initial sample making and evolve into the first phase: **design specifications**. After line adoption, **style specifications** become very detailed as individual styles are prepared for production. The third phase of specification development is **engineering specifications**. These are developed during the production planning process. Figure 5–1 presents the sequence of specification development and the elements that are commonly a part of different types of specifications. These various types of specifications are discussed in more detail in later chapters.

Many individuals are involved with writing specifications: designers, pattern makers, quality managers, sourcing specialists, and others. Often these individuals are located around the world. Technology today allows input from all participants of a product team in a timely manner regardless of location and al-

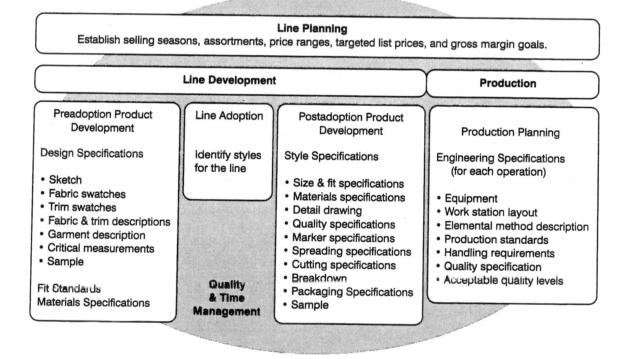

Stages of standard and specification development.

Figure 5-1

Source: Model developed by Grace I. Kunz and Ruth E. Glock based on Figure 3-2, Merchandising Taxonomy.

lows immediate dissemination of information. Specs can now be transmitted electronically and developed or modified by multiple individuals at the same time. Technical designers often coordinate specification development.

Each firm has its own system for developing specifications. Some specifications are nothing more than a few comments or expectations from the designer or production pattern maker. Some designers develop a design specification sheet that may indicate top stitching, detail placement, construction features, fabric treatment, cutting, and finishing instructions that need to be communicated to marker makers, cutters, sewing operators, or finishers (see Figure 6–4). Some firms employ specification writers who specialize in developing materials specifications, quality, or production specifications. Others may base production on very general design specifications.

A meeting including the designer, merchandiser, quality manager, cutting room manager, production manager, and/or production engineer is often the basis of further development of product specifications. Sample garments provide a visual model that should be accompanied by written specifications that describe procedures and dimensions for producing the finished garments. Sample garments, alone, are inadequate for communicating expectations.

Effective specifications are written documents that provide criteria for selection, production, and/or evaluation of a product or process. They need to be precise, accurate, and understandable. If garments are being produced in a foreign country, the specs need to be readable and understandable for those working on them. Sometimes specifications are presented in English when no one in the plant speaks English. Other times specifications are translated into another language. The translation may result in very confusing instructions.

Specifications establish **minimum requirements** and allowed variance for acceptability of materials and materials performance, procedures for production, characteristics of finished garments, size dimensions, and measurements for placement of garment components. Cost and product performance are major factors in determining the minimum requirements for a product. Not all characteristics can be quantified, but when performance can be determined by value, higher values elevate costs.

A specified value should reflect the minimum acceptable level considering the allowed tolerance. If the specified value exceeds the lowest acceptable level or if the specification is really not necessary, the product is **overspecified**. For example, to specify 100-count fabric when 60 count is adequate would significantly increase the cost of material and ultimately the cost of the garment. However, without a count specification, a 30-count fabric could be used that would be totally unsatisfactory for the expected quality and performance level. Values and tolerances are also used to specify and verify garment dimensions. Quality control personnel use specifications of minimums to determine whether a product meets the acceptable and specified criteria. When it doesn't meet the minimum specified, it is substandard and unacceptable. The product would be declared second quality.

Meeting Quality and Performance Standards

Tolerances allow variation from the specified value in the specifications. The more specific the specification, the less variation is allowed and the more consistency there will be in finished products. Specified minimum values vary by the amount of the allowed tolerance; therefore, the specification writers must determine what is the very lowest value that can be used. For example, a specification for 60-inch fabric width with a tolerance of "+ 0.5 inch" would mean the fabric would be acceptable if it was 59.5 or 60.5 inches wide. Anything above or below that could be rejected because of noncompliance with the specification. Tolerances are included only when variations are acceptable. Tolerances are a means of loosening restrictions and making the specifications less rigorous, but they should never go beyond what is acceptable for **first quality**.

Rigid specifications mean zero tolerances; no variance from the specifications is allowed. With a rigid specification, there is little room for variation in properties, quality, size, or performance. In some cases, suppliers or contractors indicate they cannot meet the specifications for the product if tolerances are too restrictive for their production methods. Rigid specifications are critical to the manufacturer of hard goods since there is no flexibility or room for variation.

For soft goods, materials are flexible and somewhat elastic; therefore, a variation in size of 0.1 inch may not make the product unusable. The more rigid the tolerances, the more costly the materials and processes. Requiring exactly 18 spi with no tolerance means that all seams would have to be sewn with 18 spi. It is difficult to be that precise with stitching, and, based on that specification, there would be a high percentage of seconds or rejects. Thus, rigid tolerances inflate the cost of production. The cost of producing unsalable garments that do not meet specifications has to be incorporated in the cost of the salable products.

As quality standards increase, tolerances are reduced; less variance from specifications is allowed which thus produces more consistent products. In most cases, apparel products are more satisfactory when **realistic tolerances** are strictly enforced than when rigid tolerances have uneven enforcement. AATCC and ASTM standard test methods and quality control sampling are means of enforcing specifications. Quality control is responsible for monitoring procedures and checking fabrics and garments for compliance to specifications.

When a product does not meet specifications, it is considered a **second** or **reject** depending on the seriousness of the defect. **Defects** or **flaws** are variations from allowed minimums and tolerances. Randomly selected finished garments are checked by quality control personnel to determine whether the dimensions are within the tolerance range of the specific set of measurements for the style and size. Consistency is a major reason for establishing a quality control program. The primary means of controlling variation is developing complete and adequate specifications and monitoring their compliance.

When verifying materials specifications, a firm uses standard test methods to determine the allowable variance for compliance to specifications. Specifications often include the test methods or procedures used to verify the

performance criteria. As shown in Table 5–4, methods of testing are included in the specification so both the buyer and seller will understand the evaluation criteria for satisfactory product performance. Using established test methods helps both the buyer and seller understand the procedure and the level of expectation for the product. Many large manufacturers and retailers in the United States have their own testing labs or use laboratories that contract testing services. When verifying stitch and seam types and assembly methods, visual analysis is done based on the specifications.

Acceptance sampling refers to the acceptance or rejection of products based on a system of inspecting a representative sample of fabrics, components, operations, or finished garments. Each firm establishes its own system for specific products. In some cases, 100 percent inspection is used while in other cases products are checked on a random sample basis. Procedures vary with the reliability

Table 5–4Minimum performance standard for knit fabrics.

			Ca	tegory							
Property		1	II	III	IV	Test Method					
Bursting strength (PSI)		60	90	90	60	ASTM D 3786-80a Hydraulic Diaphragm Bursting Test					
Dimensional change (matching (Length \times Width)	ax. %)	7×7	7×7	3×3	7 × 10	AATCC 135-1978 (II B Wash) 1 Laundering					
	С	olorfastne	ess Rat	ings—All	Categories						
		Dry		4.0							
Crocking		Wet		3.0	AATCC 8-1	981					
		Shade		4.0	4.4700.04	1000 (II A W - 1)					
Colorfastness to washing]	Stain		3.0	AATCC 61-	1980 (II A Wash)					
		Shade		4.0	A ATOO 400	1.1070					
Colorfastness to dry clea	ning	Stain		3.0	AATCC 132	2-1979					
Colorfastness to light-20	Hours		4.0		AATCC 16A	A-1982					
AATCC Rating System:	7 / 7 / 7	xcellent			NEWS TO SE						
	4 = G										
	3 = F										
	2 = P										
	1 = V	ery poor	20.00	3.0 AATCC 132-1979							

of vendors or with the consistency of operators and the number of seconds or faulty products that may have previously been found. For example, fabrics from a mill that has a good record and few defects may not be inspected at all, while incoming fabric from other mills may be checked on a random sample basis. If a fabric lot shows extensive defects, the entire order may be inspected.

Specifications should be realistic and meaningful and deal with the properties and specific values that will meet the firm's standards. Written specifications may not constitute a complete list of all product characteristics (as with U.S. government specs) but still provide the criteria that is of primary concern to the purchaser. The supplying firm remains responsible for providing materials or services that meet recognized performance requirements in the industry, whether or not enumerated in the written contract. At the same time, specifications should not exceed what is needed to meet performance requirements and quality standards of the target customer.

Floor-Ready Specifications in Retail Purchase Contracts

A recently developed requirement by major retailers is for manufacturers to ship merchandise "floor-ready." This means that garments will arrive at the store ready for display. Garments will be folded and packaged or on the hangers specified by the store. All labels and tickets will be in place including bar codes and prices. Retailers have developed telephone book size lists of specifications communicating their floor-ready requirements. If manufacturers do not meet the specifications the retailers take chargebacks when the bills are paid. Deductions are taken from the amount paid for the merchandise—sometimes the manufacturer is dropped as the retailer's supplier (Applegate, 1997).

Some retailers believe it is more efficient for the manufacturer to prepare the garments for display before they are shipped than to use the traditional process where garments were shipped to the retailers' distribution center where garments were sorted for shipment to individual stores. Hangers were changed or garments were hung and the price tickets etc. were added when the merchandise arrived at the store. The traditional process took from one to three weeks after arrival at the distribution center for the goods to be ready for display at the retail store. With floor-ready preparation by the manufacturer, merchandise may be on display within a few hours of arrival.

The problem with the manufacturers preparing goods to be floor-ready is that retailers are often not willing to pay for the service. In addition, manufacturers may have to stock hundreds of styles of hangers, labels, and tickets to satisfy the retailers' specifications for floor-ready merchandise. In response to this problem VICS (Voluntary Inter-industry Communications Standards) developed voluntary standards for floor-ready merchandise. The biggest challenge was developing agreement on hanger styles so that the number of styles required of manufacturers could be reduced. From a manufacturing standpoint, the other problem is that use of the standards is voluntary so many manufacturers still are stocking hundreds of styles of hangers to satisfy their retail customers.

Summary

Standards are sets of characteristics or procedures that provide a basis for resource and production decisions. Conformance to some standards is mandatory, while conformance to other standards is voluntary. The communication of product standards is accomplished through the use of product specifications. Specifications are brief, written descriptions of materials, procedures, dimensions, and performance for a particular style. They vary in detail and specificity. Specifications establish minimum requirements for acceptability of materials, products, and performance.

Tolerances allow variation from the minimum value specified. The more specific the specification and the less variation allowed, the more consistency there will be in the finished products, and the higher the cost of production.

Specifications uphold a firm's standards by communicating product information, providing consistency in finished products, and offering a basis for quality control. Adequate specifications result in fewer garment seconds, less fabric waste, reduced labor costs in handling, warehousing, cutting, and sewing, and more satisfied customers.

References and Reading List

AATCC Technical Manual. (Current ed).
Research Triangle Park, NC: American
Association of Textile Chemists and
Colorists.

Annual Book of ASTM Standards. (Current ed). Philadelphia: American Society for Testing and Materials.

Apparel Quality Committee of American Apparel Manufacturers Association. (1985). Elements of an apparel quality control program. Arlington, VA: Author.

Applegate, J. (1997, August 11). Apparel manufacturers hurt by picky retailers. The Des Moines Register, p. 14B.

Cedrone, L. (1992, January). Performance wear paradigm restructures. *Bobbin*, pp. 36–40.

Ott, E., and Chipps, E. (1985). Licensing in worldwide apparel markets. Panel presentation at American Apparel Manufacturers Association Annual Meeting, Maui, Hawaii.

Pochop, M. (1997, Fall). Cost and benefits of ISO 9000 registration. CIRUS News. p. 3.

Scheller, H. P. (1993). Apparel quality through the perception of apparel production managers and operators. Unpublished master's thesis, Iowa State University, Ames.

Technology Applications Center. Answers to the most frequently asked questions about the ISO 9000 (ANSI/ASQC Q90). N.p.: Author.

acceptance sampling
American Association of Textile
Chemists and Colorists
(AATCC)
American Society for Testing
and Materials (ASTM)
bids
closed specification
contracts
defects
design specifications
engineering specifications
first quality

flaws
International Organization for
Standardization (ISO)
ISO 9000
licensing
materials specifications
minimum requirements
open specification
overspecified
performance standards
product testing
production specifications
quality standards

realistic tolerance
reject
rigid specification
second
size standards
specifications
standard test methods
standards
style specifications
test methods
tolerances
variation
zero tolerances

Discussion Questions and Activities

- 1. Read product specifications for oxford shirts and polo shirts included in two or three direct-mail catalogs such as Lands' End, J. Crew, or L. L. Bean. What materials are described? What product characteristics are identified? What quality level is implied? What performance expectations are established as a result of the product specifications?
- 2. What is the fundamental purpose of design specifications? Style specifications? Engineering specifications? Materials specifications?
- 3. What is the relationship between standards and specifications?

Creative and Technical Design

OBJECTIVES

- Examine the factors that influence the nature of the design process and product development.
- Examine preadoption processes in relation to creative design.
- Discuss sizing and fit as related to the design process.
- Examine postadoption processes in relation to technical design.

The ultimate objective of the design process is to create styles for the firm's product line that will meet the needs of the target market and produce a profit. Apparel designers are responsible for the aesthetic appeal and functional service of a firm's product line as well as the technical development of adopted styles. Designers perform most of the creative and analytical processes involved in developing fashion direction, line concepts, new designs, and new styles. The design function of an apparel firm may be a separate division, part of the merchandising division, or designers may be members of product development teams. In any case, designers are engaged in line development via product development processes. The creative design process is related primarily to the innovation aspect of product development and proceeds in the context of the line concept and line plan. Technical design processes result in perfected styles that are ready for production. Designers can be more effective in their product development decisions when they understand the whole manufacturing process.

Influences on the Design Process

In today's apparel firms, designers may be expected to develop line concepts and line plans as well as the styles that make up the line. Designs created for the firm's target market need to have sufficiently wide appeal to meet planned sales volume or a firm cannot afford to produce them. The objective is to create a line that will sell-through to target customers at planned gross margin and volume. A designer must evaluate the demand for design innovations and product features in relation to the price the target customer would be willing to pay. Potential production costs must be monitored to keep the price within range of the target customer. Factors that influence a firm's design process include the fashion focus of the product line, size and organization of the firm, licensing agreements, and the merchandising calendar.

Fashion Focus of the Product Line

In general, the stronger the fashion focus of a product line, the more important the design function is to the product development process. A firm that places heavy emphasis on original and fashion-forward apparel gives a great deal of power, status, and influence to their designers. Designers for this type of firm will be expected to generate a steady flow of new, original ideas and sketches that can be developed into styles for four or more lines a year. Creation of these new designs may receive a great deal of recognition in the trade press and consumer publications. Designers for these firms are closely involved with merchandising decisions and content of the lines.

Manufacturers with a more moderate fashion image place less emphasis on originality and creativity. The role of designers in these types of firms are usually less influential. They are expected to create some original styles, modify styles from the previous season's line, and may use knockoffs or ruboffs. **Knockoffs** are adaptations or modifications of styles from other firm's lines. **Ruboffs** are line-for-line copies of other firm's styles.

In a firm that makes primarily basic or staple products, the design process takes on a different focus. In these firms creativity and originality may be secondary to efficiency and cost effectiveness. The design function may be carried out by the owner, merchandisers, marketing or sales managers, product managers, or engineers. These individuals may perform the design function in addition to other responsibilities. In this scenario, people who are called "designers" may develop patterns and production samples. Basic, staple products have longer selling periods and therefore require fewer lines per year. They also have less product change from one selling period to the next. For

this type of product line, design innovations may only involve changing fabrications or trims.

Size and Organization of the Firm

The size of an apparel firm affects the number of product lines and the number of people with design responsibilities. A large firm may employ several designers or operate a design room with a designer and several assistants, stylists, first pattern makers, and sample makers. The designer's responsibilities may include managing the workforce in the design room, creating new styles, and maintaining the design focus of the firm.

Small firms that gross less than \$15 million are common in the apparel business. Success or failure of a single merchandise group has a greater effect on profitability if the firm is small. Because of the limited size of the product line, limited financial resources, and relatively small volume, small firms are constantly in risk of bankruptcy. These firms have few people in management positions; therefore, managers have broad responsibilities. In these small apparel firms, the designer may be the figurehead or owner of the company. In that role, the designer may be responsible for design innovation as well as merchandising and marketing decisions. Pattern development and costing may also be the designer's responsibilities.

Both large and small firms may use outside sources for their designs. Free-lance designers and outside design studios are contractors who sell design services. Sketches that a freelance designer sells to a manufacturer may be original designs or adaptations that reflect a manufacturer's specifications. A freelancer's job may end with delivery of sketches to the manufacturer or a set of completed patterns for approved styles. Some freelance designers follow a product through production. Many outside design studios offer specialized services such as providing original art, researching fabric and trim markets, and international and domestic sourcing (Rudie, 1989).

A disadvantage of using a design contractor is that the design consultant may not be adequately familiar with the firm's target market, fashion image, or production capabilities. On the other hand, a firm does not have to pay a designer for full-time work if the service is needed only periodically. As the need arises, a firm can select a design contractor with expertise for a certain type of product or product line to bring fresh ideas.

Merchandise presentation on the retail selling floor is important to design development. For example, private label designers need to develop merchandise groups appropriate for the fixtures that will be used on the retail floor. If four-way fixtures are used extensively, the designer will develop groups that consist of coordinates or compatible color ways that hang well together. Designers of name brand apparel also plan for merchandise presentation but each retail customer may have different layouts and fixturing unless fixtures are supplied by the manufacturer.

Use of Licensing

Licensing designs and designer names has tremendous impact on the design process. Many apparel designers and celebrities grant the right for manufacturers and retailers to use their names and trademarks on a wide variety of products. For many designers, licensing income equals or exceeds income received from the sale of their own apparel lines. The level of involvement the designer or celebrity has with the firm depends on the terms of the licensing contract. The licensee is usually required to supply the licenser with a certain quantity of sketches each selling period. The designer or the designer's assistants may also be actively involved in approval of styles, final development of the product line, and quality control.

A growing type of private label for retail stores is an **exclusive license** between a retailer and a celebrity or designer. Jaclyn Smith for Kmart is an example of this type of license. How much she is involved in product design is not clear, but she is very involved in visual merchandising and product promotion. Licensed private-label merchandise reduces the possibility of having the merchandise appear in off-price stores and gives the stores an exclusive, prestige label.

Merchandising Calendar

Firms commonly establish a merchandising calendar that guides the timing of the product development process and/or the purchase of finished goods for line development. A line development calendar includes weeks of the year in relation to product development activities. It also defines product development in relation to the selling periods the firm has defined.

Figure 6–1 is a line development calendar for a children's wear company that sells the line at wholesale and in outlet stores. According to the calendar, the firm has four selling periods—spring, summer, fall, and holiday. The product development cycle for a selling period is about 30 weeks. The calendar identifies 49 activities required to develop the line. The numbers 1, 2, and 3 represent the development of three different merchandise groups that will be made available to vendors sequentially to keep fresh merchandise on retailers' shelves during a single selling period.

Designers are key players in the product development process. Responsibilities for product development are discussed here from the perspective of creative design and technical design.

Creative Design

Creative design decisions center around groupings or families of garments that have some common visual elements such as fabric, trim, color, silhouette, or structural details. The commonality in a grouping should be very visible at first

1	2	velo B	•	5 6	7	В	P	10	11	12	13	14 1	5 16	17	18	19 20	21	22		25	26 2	7 28	29	30 3	1 32	33	34	36 36	37	38	39 4	0 41	42	43	44 45	46	47	48	49 5	0 5	1
velopment ks	Sp	ting Of		1	1	1	1		1	1	Ditario.	HER DI		1				Pall 61										(citate)	SH.			I				I			\top	\top	
iness lysis	1		ar		1	1	1	1	1	1		-	1	1	Ш		1	Ц	_			1															20				
us group	-	-			+	+	+	+	-	+				+	Н	au	+	H		-		1	1					1		П						4				\perp	
ail analysis	-	8.F		-	+	+	-	-	-	-				-	H		+	Н	4			-	1	-	_				4.	Н						_	-		1	1	
diseas with	1			1		1	1	1	l.,	L		- 1		1.	Ш							L		1		1	Ш		Г	П	1		П								
ct rs/themes		5 P	7		P 84		T	T	П			- 80	1 31			T	T		7						T	T		T	7		- 14	T			\top	T		П	T	T	-
elop cs/prints		3P			F 25							100	T S				T		ľ	Т	П				T				1	m	7	T			1	+		П	\top	\top	-
tify ders/key		100	F	* *	7		T		Г				1 60	N.	П		T		7	T	П	T			\top		П		*	FT	7	T			\top	T		П	\top	+	-
s	+	20	a	F (6)	1 10	+	+	-	-	+	-	-	7 20	dis.	H	+	+	H	4	-	H	+	+	+	+	+	+	+	4		-	+	+	H	+	+	+	Н	+	+	_
pare pept ds				1	1								1	1			\perp													Ш											
elop new gns ct thread rs/types				5 to										200																		*			T	T		П			_
ct thread s/types				T	ar	Ľ	L						1 50	200																		1			\perp	I					
ir wed!				1			f	35			1		1			1			1	11					Т	Г	П	Т		П					Т	T	П	П	Т	T	
	27000	200	*	*57 25	-	+	400	170,0	27	1 1	7	+	+	1		o T	11	+	+	Ħ	***	t	\Box	+	+	+-	1-1	+	\vdash	H	7000	-	+ 1		+	i deng	1-1	PC2	-	+	ė
couse	_		4	4	4,	_	4				4	Ц,	-			4		Ц	1	Ш		_	4			L	Ц	1		Ц	4	L	1.4			丄	Ш	Ш	1	1	
dye	-		+	1	-								-																	П										1	_
rmine ery lence	1		1		1					ſſ	ľ	1	ſ			T		1	ľ					ľ	T.	ſ					1				1	f	1	ľ			
rapeats			\top	T	T	1	7			1	1	-	1	17				-	9	3		T		7		-	1	+	3	•	1	T	1	1	+	1	1	1	12	1	-
fy yarn lovens			T	T	T		T	10		1	3	T	T		2				T			T	П	2 10		1	M	T	T		1	+	П	12	2	1	3		T	1	-
fy plece			T	T	1	8	1			F		1	2	3	7	1		T	3	•		T		T		1		3		\Box	1	+	H	1	2	1	П	7		+	-
ify piece ns/yarn tripes				1								1																												1	
fy piece										-	F		1	P					18					T									П				2	T	7		
fy trims			1	1	-	_				2 2	Ľ,	L	4				Ш	П.	1	Ш				1	L			E	3			I			I		П		I	I	
piece strim			1	1	+	-		Ц			_	100	13		1	1	Ц	4	2.5		1	1			72			3 222	ř.					1	12		2.5	3 6	3 8	1	00000
cost \$ in								ľ		1	ľ	1	Ĺ				П	ıŤ	ľ	ľľ					П			Î.	n			1	11	1	f	f	r	ľ	1		
ove photo			I	I	I						I	I	L		I			I	E								Ħ	I						7	丁	1	Ħ	7	丰	1	
nit cideries	Ш		1					Ц	1	1	Ĭ.	I.	I.		I	L	Ц	1	Ľ	П	1							H		1					\mathbf{I}	F	П		F	1	
epideries	Н	1	1	1	1					4	_f_	L.	L	Ц	I.	Ţ.	Ц	1	Ĭ.		L.	Ľ.						Ť.			1				1	Ш	Ш		P	ľ	ă
n cost ates	Н	1	1	1	1				4	4	Ţ.	1	Ţ		ľ	1	Ш	4		Ш	Ţ.	1						ŧ.		Ľ	1				L				I	L	
op nandise line data nputer		1	1					' [1	ľ	Ť		ľ									1		1					2					1					•		
fine data	3		+	T	1		П	7	7	7	*	*	•	9	19				-	1	1							+	•	1		+	H	-	+	+		7	-	-	
it screen			T	T				7	7	7	P	*	†	7	T	-	1		1	**	*	-			T		1	T	1	r þ			T		+	Ħ	2	7	*	*	ě
fication		7	7		Т	П	П	T		1	T	1	P		1	P	P		7		3 2	2/5				z	1	7	Ħ		-	7			7		r t	1	7	*	ě
e plant ment			I									E			Γ		П			М	•							7	П		Т	T		1	1	П	F	1	T	3	-
trikeoffs		-						1	1	_		I			I			I			I		F 3	1	1						I		T		I		1 1	1	2	2	-
le piece ready at	ff	ľ	ľ	ľ					1			1	r I	ı	f	P	ľľ	f	ľ	Ħ	Ť.		f P	P	M		1	1	M		ř	ľ	7		T		1	1	2	2	Ī
e piece in	* *	ħ	*	1	3	П		+	1	1	1	7		iast.	*	7	1	-	1	11	\$		* *	3	Ħ			+	Ħ	T.	+	*	-	•		\forall	1	1	1	2	-
	k - k	4	Ļ	ļ	ļ		-	+	+	-	+	-		-	4	4	-	1	<u> </u>	\mathbf{H}	4		Щ	4	Ш			4	Щ	4	4	<u>. </u>	Щ	4		Ц	\perp	1	1	1	
cut es	H	1	Ļ	L			4	4	+	+	+				4	Į.,	Ц	4.	L	Ц	1		L.	1	Ш			4_	Ш	4	1		Щ		1					L	
se price tickets			-	-			1	+	+	+	+	-		4				1	-								-	1								Ш		1		L	
prints	H		-	-	<u> </u>		1	1	+	+	+	+	H	4	4	ļ	H	Ţ.	-		-		4	-				-	Ш	4	4		H	_[_				1	-	4	
amples v prices	+	-	-	-		H	+	-	+	+	+	+	H	-	+	80	H	+	-	H	+	20	-	+	H		4	-	H	4	-			4	4			+	+	-	10000
ordo no	+	+	4			H	+	+	+	-	+	-		1	+	102	+		-	-	+	SU	+	+			+	-						+	+	H	1	+	+	+	
tristica;		+	1			\Box	-	+	+	+	1	1			1		1	-	5/	\forall	1	\Box	+	1	bil	+	+	1	1	+	+	11	-+	+	+	H	+	-	-	+	97
g S		T	1				T	1	T		T	T		T	T			T	T	更	1			1		(1)	1	1		1	1		1	7	1	H	7	+	+	1	
ste plan		I						I	1		I	I			T					9							W T	T							T		1	1	1	1	-
porder	I						I	*	F					I	I					SP 80				I			il.										1	1	T	T	•
p sale ps	T						1	1	F		Γ				T			T	32	SP S			T	T			W.	T		T	T	П			1		1	1	T	T	
tation s reps	1	+	+	H	H	1	-	+	+	H	-	-		+	+	+	+	+	89	150 BI	+	H	+	+		IU I	NU I	+	1	+	+	H	+	-	+	-	+	+	+	+	-
s reps oduct iale	+	+	+	H	H	+	+	+	+	+	H	-	H	+	+	+	+	+		5	+	H	+	+			10	+	H	+	+	+	+	-	+		+	+	+	+	-
ale	-	-					+	+	+	+	-		4	+	+		+	+			+			es.	1	-	-	+		+	+			-	+		-	+	+	+	

Figure 6–1 Line development calendar for children's wear.

glance and make a statement about the line. The elements that are featured in any group are often related to the fashion of the time. Figure 6–2 provides an example of a merchandise group with common visual elements. These groupings may be separates, related separates, or coordinates depending on how the firm defines its merchandise classifications. The merchandise groups are an essential aspect of merchandise presentation for both manufacturers and retailers.

As discussed in Chapter 3, product development is a means of line development and evolves in three phases: preadoption, adoption, and postadoption (see Figure 3–2). Designers have different roles in each phase. **Creative designers** are most directly involved with preadoption processes that include development of line concepts, creation of new designs, and presentation of merchandise groups for line adoption. Other key considerations when developing a line include characteristics of fabrics, establishing fit, developing patterns and prototypes, and design costing and specifications.

Developing the Line Concept

In the line development calendar, (Figure 6.1) line concept development is included in development tasks 1, 2, and 3. Designs are inspired by many different sources and influences, many of which are intangible. A good designer often develops a feel for fashion and the demands of the marketplace and is attuned to different influences and sources of inspiration. Many look to social and cultural influences that affect the lifestyles and attitudes of their target

Figure 6–2
Merchandise group presentation for retail environment.
Courtesy of Pendleton Woolen Mills.

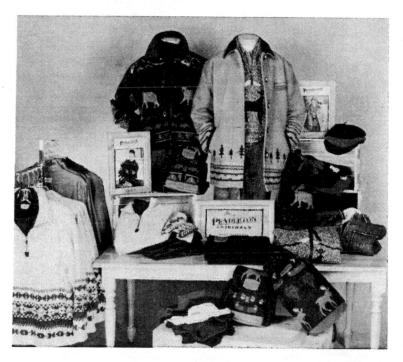

market, while others look to historic events. Some look to ancient history or art for inspiration. Others observe people on the street or certain trendsetting groups such as celebrities, rock music stars, or other entertainers.

Many designers use fabrics as a source of design inspiration. Some shop foreign and domestic apparel and fabric markets to keep abreast of the latest trends and influences in the marketplace. Feedback from marketing and sales representatives provides an excellent source of buyer and consumer expectations and information about the competition. In addition, many fashion houses subscribe to research/forecasting services that help isolate colors, fabrications, and styles that will be used in upcoming selling periods. The design inspiration phase of concept development often culminates in the development of an **inspiration board**, a collage of selected sources of fashion, cultural, and technological ideas.

The development of line concept and line direction is often represented in the form of **concept boards**. These display boards present color ways, textures, and the visual direction for the line being developed. Concept boards are used as a means of integrating ideas from inspiration boards and developing a particular idea or look for merchandisers, designers, and buyers. The boards help to conceptualize the fashion direction or look. Concept boards are often created from a collage of tear sheets from fashion magazines, photos, yarn and fabric swatches, or whatever is needed to represent the concept or line direction.

Development of a color palette for the line for the selling period is an important step in developing line concept. The color palette represents hue, value, and intensity for the products in the line and provides a number of important functions for line development:

- color consistency among merchandise groups for purposes of multiple sales;
- guidance in selection and development of fabrics, print designs, embroidery, and trims; and
- · a limit to the number of colors used in the line to control inventory.

Creating Designs for Merchandise Groups

Design creation is reflected in the calendar in line development tasks 4 through 21. Line concepts and direction are converted into fabric and apparel designs through the creative design process. New merchandise groups evolve from several different methods of design: creation of new and original designs, modification of last season's styles, and knockoffs and ruboffs of other firm's styles.

CREATING ORIGINAL DESIGNS A particular designer's approach to creating original designs depends on personal preference, abilities, resources, and philosophy of management. Some begin with dozens or even hundreds of **croquis**, sketches that visualize styling ideas and the use of fabrics. Some designers use **flats**, two-dimensional detailed drawings, to visualize the designs for a merchandise group (see Figure 6–3). It is possible to save a great deal of

Figure 6–3
Computer-generated flats for a merchandise group.
Courtesy of Nicole Bakley.

sample-making time and cost by analyzing sketches before samples are made. Sketches and flats may be done by hand or on the computer. Selected sketches are developed into more detailed drawings that are later translated into patterns, fabric, and trim by a sample maker.

Some designers prefer to **drape** directly on a fitting form. This makes it easier for a designer to analyze the hand and drape of the fabric as it is formed into a garment. Although this process is slower and more costly, the styles produced can maximize the effectiveness of the fabric in the design. In many cases, a design is revised many times before it is presented for line adoption. Some designers go directly from a sketch to creating the first pattern by using drafting techniques and pattern manipulation.

MODIFICATIONS OF STYLES The previous season's line and the previous year's line are often evaluated for possible styles to carry over as a part of developing line direction. Styles that sold through early in the previous selling period and made a profit are considered for inclusion in the coming line. A hotselling style may offer a body that can be used for the next selling period. A

body is the perfected pattern for a style that has been fitted and graded. A good body fits the target customer and provides distinctive appearance that can be used with different details, fabrications, and trims over several seasons. Many styles may be based on the same body.

When a body is carried over to the next season, many of the costs of design and product development have already been covered. The design and pattern work are complete, and usually only minor revisions are made. Much of the guesswork is eliminated as the body has already proven its sales potential. The same body may be kept in the line for several seasons, as long as the styles made from it are salable.

COPYING STYLES Knockoffs and ruboffs are common ways of making use of another firm's design ideas. They are usually offered for sale at lower prices than the original. This is a very common practice throughout the apparel industry. Designers, merchandisers, pattern makers, and retailers of better, moderate, budget, and low-end merchandise are involved in knocking off styles and adapting them to their needs. Many firm's that specialize in tall or petite collections knock off other fashion apparel and modify proportions to fit their specific market segment. Garments to be knocked off may be purchased at retail, disassembled, and copied. The resulting pattern can be quickly perfected and graded. This bypasses the creative design process and eliminates most of the product development cost and preparation time. Producing knockoffs is one method of meeting the competition and one reason that manufacturers carefully guard their lines until market time.

Role of Fabric in Design Decisions

Fabric selection and development is among the early decisions in developing a line and certainly one of the most costly. Fabrics may account for one-half or more of the total production cost of a merchandise group and can be much higher if poor decisions are made. Fabric selection may be done by the merchandiser and/or the creative designer. Fabrics may be purchased from or developed in cooperation with textile manufacturers in domestic and foreign markets. Finished fabrics may be ordered from open stock or unfinished greige goods may be ordered and finished as needed. More flexibility can be achieved by purchasing unfinished fabrics, which also allows color decisions to be made later in the product development process.

Exclusivity of fabric design can be accomplished by confinement of a specific print or fabric design with the mill or converter or by creation of exclusive fabric designs. **Confinement** means that the use of a specific fabric design is restricted to one apparel firm. Exclusive fabric designs may be created by apparel designers, textile designers, or as combined efforts. The amount of lead time and the volume required for confinement vary among the fabric suppliers. Many confined fabrics are purchased offshore because of lower minimums. Minimum yardage requirements may limit an apparel manufacturer's ability to use unique fabrics.

Basic cost per yard of fabric varies widely and can rapidly elevate garment costs. For example, a dress requiring three yards of fabric may vary in cost from \$6 to \$45 for the fabric alone, depending on whether the fabric cost is \$2 or \$15 per yard. In the same line, less expensive fabrics may be used for styles that are trendy and require large yardages, while more expensive fabrics may be used for classic styles that require less yardage. Fabric costs increase with performance expectations, poor quality control, excessive inventory, inefficient use, bad selection, and poor planning. Sometimes the most aesthetically pleasing fabric or trim is very expensive, and use of it would elevate the price beyond the resources of the target customer. Some of these factors can be controlled by the designer and some by merchandisers or quality control personnel.

Handling costs escalate rapidly with certain fabrics. They include inspections for irregularities and flaws, shading for color match, and storage. A designer must know the cost of materials, components, and trim as well as the cost of their inclusion and application to garments. In many cases, the application can be the most costly part. Designers may not do the final costing but must be aware of the effect that the fabric and trim decisions have on the cost of the garment.

An understanding of marker making and the problems associated with layout, grain tolerances, fabric utilization, and costs will help reduce the amount of reshaping and adjusting of patterns that may be needed to reduce yardage requirements, reduce handling, and control costs. A **marker** is a diagram of a precise arrangement of pattern pieces for the sizes of a specific style that are to be cut at one time. Fabrics with long repeats or large designs may require extra fabric and increase wastes, which also raises costs. Too much fabric waste may cause cancellation of a style or require redesigning and change of pattern lines. Often the amount of required fabric can be reduced considerably with minimal adjustments to pattern shapes. One inch of wasted fabric can make a tremendous difference when cutting 50,000 garments over the course of a season. Designers that are able to anticipate some of these problems can produce more cost-effective garments.

Patterned and one-way design fabrics must be given careful consideration before selection. **One-way fabric design** requires the fabric to be laid in one direction and patterns to be placed in only one direction on the marker. This often creates more fabric waste and therefore is more costly to use. Fabrics with large-scale patterns may be used only for certain silhouettes with limited seaming without creating unpleasant visual affects. Large repeats create excessive waste and are very costly to use if a company's quality standards require matching.

A patterned fabric that is suited to only one or two styles may be costly. If the style should be dropped or canceled before the run is completed, the fabric may not be adopted for another style and therefore becomes a loss to the manufacturer. Patterned fabrics are rarely carried over to the next season. Designers develop several related styles for merchandise groups to be made from the same fabric in order to compensate for the cancellation of one or more individual styles.

If quality standards require matching stripes or plaids, the additional costs of using these fabrics will have to be considered at all stages of production. Cutting a plaid garment for matching requires more handling at all stages of pro-

duction from pattern making to the final sewing. Fashion sometimes dictates the use of a particular type of fabric or pattern. It is a designer's responsibility to use the fabric in the most efficient manner to satisfy the target customer

while meeting the firm's objectives for revenue.

Garment dyeing is a process in which apparel products are made up in greige goods, sold to retail buyers, and dyed to order. Garment dyeing reduces lead time and increases production efficiency for both fabric producers and garment producers. Fabric producers make up large quantities of greige goods designed for use in garment dyeing. Garment manufacturers stock "white styles" that can be dyed or printed to retail order instead of made to retail order. Products such as pantyhose have long been garment dyed. Garment dyeing is also being used for a wide range of casual and sportswear. When garment dyeing is a viable option for a particular merchandise group, it can offer real benefits to both the manufacturer and the retailer.

FABRIC CHARACTERISTICS AFFECTING UTILIZATION Designers need to consider five fabric characteristics because of their impact on the level of utilization: (1) differences in the face and back, (2) differences in lengthwise symmetry, (3) differences in crosswise symmetry, (4) need for matching the design, and (5) width of the fabric. Placement of the **face** of the fabric is a major factor in planning markers and spreading fabric. On many fabrics the face is very apparent as with prints, jersey knits, and pile weaves. Other fabrics have a less distinct face. Subtle differences may exist because of unbalanced weaves or finishes applied only to the face.

A second characteristic that affects fabric utilization is **lengthwise symmetry**, which is commonly referred to as *up and down*. When a fabric has an **up and down**, it means that when viewing the fabric with the warp yarns vertical, the fabric is different in structure or appearance than when the fabric is turned 180 degrees. See Figure 13–4. Fabrics that do not have an up and down are called **nondirectional** or **symmetric**. Lengthwise symmetry or lack of it is created by fabric structures, fabric designs, and fabric finishes. Consider these points:

- 1. Unbalanced interlacing patterns in woven fabrics and loop formation in knits create lengthwise directionality.
- 2. Printed or woven designs that are asymmetric in the lengthwise direction, such as flowers, trees, people, and some plaids, have an up and down.
- 3. Fabric pile, nap, and other finishes frequently have lengthwise directionality.

For an acceptable garment appearance, lengthwise directionality requires that all pattern pieces be placed on the fabric in the same direction. With some fabrics, there may be only one direction that is acceptable.

A third fabric characteristic that affects fabric utilization is **crosswise** symmetry. When viewed with the warp yarns vertical, fabrics that have mirror images from right to left are crosswise symmetric. Asymmetric designs

lack a mirror image from right to left and require one-way placement of pattern pieces on the fabric. Asymmetric fabrics also may require special placement of pieces so the fabric design will match in the finished garment.

A fourth factor that may affect fabric utilization and preproduction processes is the scale of the fabric design and the firm's standards for matching. When matching is required, the prominence and **scale of design** are major factors in fabric utilization and handling. Designs that are symmetric and small in scale may not require matching for acceptable appearance. Larger-scale designs with prominent figures whether they are floral, plaid, or other motifs usually look better when matched. As the design increases in scale, fabric utilization declines because of the necessity of matching the repeats.

Fabric width is a fifth utilization factor. Many firms prefer 60-inch fabric over the traditional 45-inch fabric because better utilization is possible. New technology in looms and knitting machines has made wider fabrics economical to produce, and thus wider fabrics are available in more fabrications. For apparel manufacturers, use of wider fabrics may require investing in new markers and changing cutting and spreading equipment to accommodate the wider fabric. Knitted goods may be used in tubular form. Tubes may be knitted in the specified circular dimensions needed to produce a specific garment size such as the body of a T-shirt.

Establishing Fit

Fit is how a garment conforms to or differs from a body. For many firms, fit is a means of product differentiation and is always important to design development. A designer's understanding of body proportions, movement, and the target customer's fit preferences is important to the success of a firm's product line. Consumers may develop brand loyalty based on their experiences with fit. Some consumers will buy nothing but Levi's because of the fit, while others purchase only Wrangler or Lee's because of the way those jeans fit. It is essential for firms' products to provide consistent fit to maintain their loyal customers. The elements used in developing fit are balance, ease, and positioning.

A well-balanced garment maintains stability on the body with normal movement and activity. Balance is the first factor in developing fit because all other proportions and positioning depend on it. **Balance** of a garment is its physical equilibrium on the body. It affects both appearance and comfort. Designers determine the **fulcrum** or point of balance between front and back which is usually in the shoulder area. Placement of the shoulder seam determines where the front of a garment begins to fall forward and the back of a garment falls over the back of the body. Gravity determines the fall of a garment. The **center of gravity** is the center of mass that varies with body type and posture. If a garment is properly balanced on the body, gravity will cause center and side seams to hang perpendicular to the floor. If a garment is not properly balanced

the grain will be distorted and the drape of the garment altered. Designers determine the center of gravity for each style in relation to the body type it is de-

signed to fit.

Cye seams are also impacted by balance. Cye seams are cylinder type seams (armhole and crotch seams) that behave differently than other curved seams. The position of the inseam in slacks and the underarm seam of a sleeve should be aligned with the center of gravity for the body. This determines the distribution of the seam between front and back. An armcye seam that is too short in back in relation to the front will cause the garment to pull toward the back of the body. An individual wearing a garment that is out of balance may find the neckline pulling away from the back of the neck and the front of a shirt or jacket may creep up in front forcing the wearer to constantly pull the garment down in position. An inseam positioned too far forward on the crotch seam may force extra fabric into the back of the pant and make them feel baggy.

Ease is the difference between garment measurement and body measurement. There are primarily two types of ease, comfort ease and design ease. Wearing or comfort ease, which allows for body flexing and movement, depends on manufacturers' size standards. Styling or design ease includes, in addition to wearing ease, whatever is built into a style to provide the look the designer wants. Structural features such as pleats, gathers, or the oversized "big shirts" are examples of ease created by styling. Use of styling ease is dependent on a designer's interpretation of fashion for the firm's target customer. For example, for a customer with a 36-inch chest, a basic oxford shirt may have a chest size of 41 inches. An oversize, fashion oxford shirt may have a 44-inch chest. The difference between the body measurement (36 inches) and the basic shirt measurement (41 inches) is 5 inches of comfort ease. The difference between the basic shirt (41 inches) and the oversize, fashion shirt (44 inches) is 3 inches of styling ease.

Other factors affecting ease include type of fabric and garment use. Rigid fabrics require more comfort ease than stretch fabrics. Highly elastic fabrics may require negative comfort allowances. For example, a leotard intended to fit a customer with a 36-inch chest may have a 30-inch chest measurement. For the same customer, a raincoat intended to be worn over several other garments

may have a 44- or 46-inch chest measurement.

Positioning relates to the designers' decisions on where to place pockets, trims, hems, and connecting seams for components. Positioning decisions affect the comfort and aesthetic appearance of a garment. Positioning decisions are subjective judgments that evolve from the designer's perceptions of body proportion and garment proportion, shape, and line. Both balance and ease affect the decisions that are made. Designers and pattern makers often work with fitting forms to ensure appropriate proportions and positioning. To help assure consistency, fitting forms may be ordered specifically to body dimensions of the sample sizes appropriate for the target customer. Fit is dependent on pattern size and shape.

PATTERNS AND SAMPLES Basic patterns or blocks are developed to reflect the firm's sizing standards and fit. A basic block pattern is a set of pattern pieces for the simplest garment of a particular type that reflects a set of measurements in the sample size. The terms basic block, sloper, and master pattern may be used interchangeably. Firms have basic blocks for each type of product in their product line—skirts, pants, shirts, jackets, etc. The basic block includes balance and comfort ease but not seam allowances. Basic blocks are used to maintain consistency in sizing and fit among styles across seasons.

Style blocks are variations of the individual pieces of the basic block that have been modified to include styling ease. Style blocks contain both comfort and styling ease. For example, a puffed sleeve is one style block, and a tailored shirt sleeve is another. Both could have been developed from the same basic block. Both have the same comfort ease, but the puffed sleeve has more design ease than the shirt sleeve. Previously developed style blocks can be a fast and efficient way to create the first pattern when originality is not a major requirement. Basic and style blocks are the basis of pattern design for both manual and computerized pattern making. They may be stored as computer data or made of durable materials that pattern makers can manually manipulate.

Patterns may be made by designers or professional pattern makers. Patterns are two-dimensional templates or guides for cutting fabric to form a garment. A first pattern interprets the designer's sketch into two-dimensional shapes for each garment component. A first pattern may be developed by manipulating a basic block or a styled block, drafting or draping. Drafting is a method of pattern development that builds pattern shapes from specific measurements. Pattern makers may use a computer-aided design system (CAD) to draft patterns or manipulate blocks. (In the apparel industry, pattern development through flat pattern or drafting techniques may be called drafting. The term flat pattern is seldom used.) Draping involves developing a pattern by manipulating fabric directly on a body form. To reduce costs, some firms prefer to have their designers work with muslin first before fashion fabrics are draped since the pattern may be draped several times before it is finalized.

A design prototype is cut and sewn from the first pattern to evaluate the styling and fit. Multiple experiments with the pattern and prototypes may be needed to perfect the design. Most apparel firms employ sample makers. Sample makers work with designers, first pattern makers, merchandisers, product managers, and/or production pattern makers. It is not unusual for a design to be sampled four or five different times during design development. Using pattern blocks and computer technology increase consistency and reduce the number of samples that are developed to perfect the design. A final design sample may be prepared for presentation of the line for adoption. As many as four other kinds of samples may be produced in the process of design and style de-

velopment: sales samples, photo/catalog samples, style samples, and production samples. For the most part, samples are prepared during postadoption phases of product development.

A firm that uses previously developed bodies or knockoffs may limit the number of samples that are used to evaluate styling and fit. The cost of samples in both time and dollars is exceedingly high. The number of samples commonly used depends on the priorities of the firm and the effectiveness of the designer. When fewer samples are made, the fit of style blocks is exceedingly important. When fast turn around is essential there may not be time during preadoption for patterns to be refined multiple times.

Design Costing and Design Specifications

Costing and writing specifications are an essential part of the design process and may be executed initially for selected sketches that have potential for line adoption. **Precosting** or **quick costing** based on a sketch may be done to determine whether a garment is producible within the targeted price range (refer to Figure 10–1). Precosting includes estimates of yardage and trim, costs per yard, special processing and handling requirements, and projected assembly costs based on data for producing previous styles. Assembly costs may also be estimated by comparing the complexity of new designs with styles previously included in the line. Would the new design cost more to produce? Would it be sold at the same price point or could it be sold at a higher price? Design modifications may be made to reduce costs while maintaining a comparable appearance. If it is not feasible to produce a specific design within cost limitations, it may not be sampled or it may be dropped.

Design specifications developed during the preadoption phase initially provide guidelines for the first pattern maker and sample sewer to produce design prototypes. Specification development is both time-consuming and costly; thus the initial specifications are brief providing only information needed by sample makers. The designer simply describes the materials to be used in the design, information for assembly, position of design details, and any special treatment that may be needed. If stripes or plaids are to match or prints are to have special positioning, this must be specified. When sample makers work in close proximity to designers, simple design specifications are adequate. As designs are finalized for presentation at line adoption, more detailed design specifications are developed to provide a basis for final design samples and cost estimating. See Figure 6–4 for an example of design specifications.

Cost estimating is based on final design prototypes and specifications. It provides a comparison with recommended prices and gross margin potential that is a part of the presentation for line adoption. Cost estimating includes estimates of costs for materials, direct labor, and overhead based on standard cost data.

REVISIONS:			DES		1: Pane	1 Dirne	Il Skiri	-
CAUT		N	FAE	ES: 4- BRIC: RENTENT: NTERN MA	liable	S#: 446/ I	cebound 50% R	d Payon
MARKERS FOR SEWING: Pock	ket Fu	sible	707					
FABRIC ON ROLL: Fusible	301 Sti	aight	3/8" ;	20"	_			
SELF FABRIC	COI	MBINATIO	r poc		ING		INTERLI	MING
							III I ENCII	41140
BACK 2			_		2	_		
SIDE			_			_		
FRONT /			_					
POCKET			-		4			
FLAP	_		-					
WAISTBAND /	_		_			_		
LOOPS			_					
ZIPPER REINFORCEMENT			_			_		
POCKET FACING 2	71	4 total						
	4	1 /0/0/						
			_					
			-					
			_					
	-		_					
TOTAL PIECES 6	-		-			_		
TOTAL PIECES	ONS:	pray	with	edge /	ock at	cutti	ng tab	le
OUTSIDE WORK NECESSARY TO	PRODUC	E GARME	NT					
SPECIAL ATTACHMENTS:								
TRIM INFORMATION: SEE TRIM STOCK :	SHEET		4 1					
AREAS TOPSTITCHED: 74 TOP	ostii ch	Waist	pana					
BUTTONHOLES: On angle 1/24	o inside	waistba	nd; (2)	4/24 he	riz. on	front	waistb	and
MEASUREMENTS:	2	4	6	8	10	12	14	16
WAIST RELAXED	1	241/4	251/4	261/4	27 1/4	281/4	293/4	3/1/4
WAIST EXTENDED								-, /,
HIGH HIP 3%" DOWN (%"/PETITE)	+-							
HIP 7%" DOWN (7%"/PETITE)	+	36 1/2	371/2	381/2	391/2	401/2	42	43/2
SKIRT LENGTH FRONT SKIRT LENGTH BACK	+-/	263/4		271/4	-	_	_	-
SWEEP BACK	+-	26 1/2	263/4	27	-	_		_
HEM - ALL SIZES SAME	+-	38 1/2	391/2	40 1/2	411/2	421/2	44	451/2
RONT RISE 1/2" ABOVE	+	-		2" w	./ribbo	n		
BACK RISE WB SEAM	+ +							
HIGH - ON FOLD	+	 				-		
EG OPENING	/-							
NSEAM	+ /							
IPPER LENGTH	1							
						-		

Figure 6-4

Design specification sheet.

Source: Courtesy of J. H. Collectibles.

PART	SELF	LINING	ADDITIONAL INFORMATION
CENTER BACK	1/2	1/2	S.N. lockstitch press open
SIDE SEAMS	1/2	1/2	S.N. lockstitch, merrow together self Safety stitch
CENTER FRONT		1111111	
SET ZIP			
CLOSE WAISTBAND	1/4		3/8" seam, merrow of 1/8"
BELT LOOPS ·			
SET BELT LOOPS			
SET WAIST BAND	1/2		
POCKET		1/2	Safety stitch
POCKET FLAPS		300	
POCKET WELT			
FRONT CROTCH			
DARTS SIDE	4/2"	long	begin stitch "8" outside notch, extend 1" below punch
DARTS FRONT		7	
YOKE BACK			
YOKE FRONT			
INSEAM	100		
OUTSEAM			
BOTTOM HEM	2"	11/2"	w./ ribbon w./ fold
			(self) (lining)
WAISTBAND WIDTH: /3/4"	finish	ed	

WRAP THE SHANKS OF <u>ALL</u> BUTTONS WHICH ARE LOCATED AT STRESS POINTS (ie: WAISTBANDS, JACKET CLOSINGS, ANY BUTTONS WHICH ARE <u>USED</u>)

Designer's Role in Line Adoption

In the line development calendar (Figure 6–1), line adoption relates primarily to development tasks 22 and 23 and then 36 to 39. As discussed in Chapter 3, **line adoption** decisions may take place through a series of meetings in which designers and/or merchandisers present the proposed line to the management team. Relative merits of each merchandise group and design are presented. The creative designer often presents merchandise groups for adoption in the line. Intensive negotiation often takes place as a part of the line adoption process. The decision to adopt a particular design or merchandise group may involve voting based on established criteria relative to sales potential, gross margin, and visual presentation of the group. Sometimes adoption is an independent decision by the owner of the company, merchandiser, or designer. In any case, strong negotiations are the norm. Adoption of individual styles may also occur in a less formal environment as designs are developed to ensure a continual flow of new products.

Many aspects of a design are analyzed before it is included in the line. Designers and merchandisers evaluate aesthetics, fit, and styling to be sure they are correct for the target customer and consistent with the firm's image. Production managers analyze materials, processes, and equipment to determine production capabilities. Costing engineers analyze materials and labor to ensure cost effectiveness and achieving quality standards. Marketing specialists analyze the total garment to determine its suitability to the specific target market at a price the customer is willing to pay. Operations personnel evaluate total costs, break-even points, and proposed volumes. Merchandisers seek support for the merchandise plan while negotiating differences among perspectives of personnel in the various divisions.

A design becomes a style when it is accepted into the line. An accepted design, a new style, is assigned a **style number** that is used as an identifier throughout postadoption product development, production, and marketing. Costs, sales, inventory, and deadlines are tracked by style numbers in a line.

Acceptability of new styles may be pretested by introducing them in a few retail markets just prior to or very early in the selling period. Firms may conduct consumer research with focus groups or show the designs to retail buyers before line adoption. This is the norm with Quick Response (QR) systems. New styles are made up in short production runs and included in selected retail offerings prior to the selling period to assess their sales potential. Based on the response, styles may be included as tested, modified, or dropped from the proposed line. Style testing provides substantive evidence of salability of designs prior to major investment in materials and production.

With pretesting, merchandisers and designers receive more accurate evaluation of customer preferences. Unacceptable styles can be modified or eliminated before additional investment in product development and production. Pretesting increases the reliability of sales forecasts, which in turn improves the effectiveness of inventory and production planning. Styles can be more ac-

curately matched to target markets. Information gathered in pretesting can also be used as a part of product promotion.

Technical Design

In the line development calendar (Figure 6–1), technical design is related primarily to development tasks 24 to 35. Technical design includes a group of processes required to perfect a design into a style and make the style producible at the quality level desired by the target customer. While creative design tends to focus on development of merchandise groups that can be merchandised and marketed together, technical design focuses on perfecting individual styles and interpreting quality standards as they relate to each style. Technical design processes are detail-oriented and time-consuming, therefore it is important to verify the acceptability of a style before investing in perfecting it for production.

Technical designers specialize in specific product categories and serve as the coordinating point and communication hub for most postadoption activities related to product development. The role of technical design has become more important as firms have sourced production from multiple contractors around the world. Consumer expectations for quality and consistency in product offerings pressure firms to improve product management. Many problems that emerge and must be resolved on the production floor could have been avoided with effective technical design. "... it is the technical designer who coordinates with everyone in order to achieve the expected quality level in production. He or she sends out the initial specification package, reviews and approves counter samples for production, reviews sizing requirements and troubleshoots with the factory to maintain the same level of quality during production" (Trautman, 1996, p. 152).

Technical designers' decisions focus on the newly adopted individual styles in each merchandise group and their salability and producibility. Salability issues include evaluation of the aesthetic and functional aspects of the style and evaluation of fit. Producibility depends on perfecting and grading patterns and developing detailed specifications so apparel engineers will clearly understand the intent of the designer when the style is produced. Effective specifications contribute to consistency in production. Detailed costing provides a foundation for updating merchandise plans including pricing plans, gross margin plans, and planned sales.

Perfection of Style and Fit

Evaluation of style and fit is essential to complete the product development process. The level of attention given to perfection of styling and fit depends on the quality expectations of the target customer and the standards of the firm.

The definition of product development identifies four factors that are expected outcomes of the process: salability, serviceability, producibility, and profitability. For the most part, profitability is dependent on successful execution of the first three factors. Table 6–1 lists the items to consider when evaluating a style before it goes into production.

Table 6–2 itemizes issues that can be considered when perfecting garment fit. Many firms use live fit models for postadoption fit analysis. Fit models are selected because their body type is representative of the target customer. It is important to evaluate fit on a live body that can bend, stretch, and move. Professional fit models are able to provide consistent information on comfort, appearance, and performance of a style during normal body activity (see Figure 6–5). Firms try to use the same fit models over an extended period of time to maintain fit consistency. Body forms are always available, never gain weight,

Table 6–1 Checklist for style evaluation.

Salability	Seminophilib.		
	Serviceability	Producibility	
Will the style appeal to the target customer?	Are assembly methods suited to desired quality level?	What is the lead time for ordering fabric and trim?	
Is the fashion image appropriate?	Will materials perform as expected?	Will there be problems in handling materials?	
Do fashion features communicate the intent of the designer?	Are care requirements appropriate to customer expectations?	Is necessary technology and equipment available for assembly and finishing?	
Is the silhouette appropriate for the style?	Is the weight of the fabric appropriate to the style?	Are assembly methods appropriate?	
Is the silhouette appropriate for the body type(s)?	Do functional features adequately serve their purpose? Are materials compatible with each other? Is fabric shading likely to be a problem? Is bleeding or crocking likely to be a problem?	Do sewing operators have appropriate skills?	
Is there a pleasing relationship among garment components?		Are stitches and seams appropriate for materials?	
s the design of the fabric appropriate to the style?		What are potential construction problems?	
Are structural details appropriately positioned?		Is adequate oapacity available to meet the quantity and timing	
Are the colors and color combinations appropriate?		of the merchandise plan?	
Does the style contribute to a merchandisible group?		1	
s the style salable in the quantity planned?			

and do not have to be paid, but they cannot make judgments on comfort and ease of movement like fit models can.

Technical designers must have a thorough understanding of the target customer's style preferences, body type(s), and comfort expectations as well as the firm's size standards to effectively evaluate styling and fit. They must also be able to communicate modifications based on style and fit analysis to pattern makers and graders. A style may be sampled several times until the styling and fit are approved. When quality standards are high, style samples may be made from each color of each fabric to check fit, drape, sewability, and compatibility. When quality standards are less specific, an approved preadoption design prototype may be regarded as representative of all other similar materials.

Table 6–2
Checklist for fit evaluation

Balance	Ease	Positioning
Is the garment balanced on the body?	Is styling ease appropriate for the silhouette of the style?	Do hems fall at appropriate body landmarks?
Do side and center seams hang perpendicular to the floor?	Is comfort ease appropriate for the style?	Are structural details appropriately positioned?
Do sleeves hang freely and slope forward?	Is comfort ease appropriate for body movement?	Are components appropriately aligned left to right?
Is the slope of the shoulder appropriate for the style and body type?	Is there adequate ease to accommodate body dimensions up to the next	Is the curve of cye seams appropriate for the body type and style of garment?
Are horizontal seams and hems parallel to the floor?	size? Are there horizontal, vertical, or diagonal folds that form? Is there gapping between with buttonholes? Is the re complete with the complete with t	Is the relationship among components appropriate?
Are grainlines appropriate for the style?		Are components compatible with body proportions?
Is there hiking in the front, back, or sides?		Does any part of the garment seem restricted?
Is the collar balanced on the body?		Are proportions of components appropriate for the style?
Does the back of the collar or neckline fit the neck?		Do curved seams follow the contours of the body?
Does the neckline opening lie		Are darts appropriately placed?
flat against the body?		Do gathers lie flat?
Do plackets, pleats, vents, and openings lie flat and hang closed?		Does the garment maintain its position on the body with movement?
		Is there grain distortion?

Figure 6–5
Fitting session with a live fit model.

Production Patterns and Grading

Once a design has been accepted into the line and styling and fit have been perfected and approved, production patterns are made. **Production patterns** are accurate, final patterns that meet all fit, quality, and production requirements. Production patterns are eventually graded into all the sizes that a manufacturer intends to produce. Meeting quality and production requirements includes adapting the pattern to the firm's cutting and assembly methods and equipment. Appropriate hem widths and seam allowances must be provided to fit the firm's folders, attachments, and standard methods of operation. If an automated pocket setter requires a specific size seam allowance for folding, it is the responsibility of production pattern makers to include this on the production patterns. Adjoining seams and markings are verified to ensure proper alignment of parts, and length of corresponding seams are checked for identical measurements.

Production pattern makers need to be aware of fabric design and dimensions in order to utilize the fabric and effectively place the design in each garment component. This also requires a good understanding of grading and how it changes the shape and dimensions of individual components and garments.

Finalized production patterns are graded into specified sizes. Pattern grading is the process of increasing or decreasing the dimensions of each pattern

piece according to a firm's grade rules of proportional change. The proportional difference in measurement between sizes at a specific point of measurement is a **grade rule.** The result of applying grade rules is a set of patterns for one style for each size. It is important that the proper fit and style sense of the original design be retained as the garment dimensions change for different sizes. The basis of pattern grading is the specific detailed set of measurements for each size within a firm's targeted size range.

Graders begin by determining **grade points** or specific points of measurement for each pattern piece. Specific points of measurement are in locations where the body proportions change. Grade rules are applied to the grade points, which will increase or decrease the measurement of a specific pattern piece at a specified point. Each piece must be graded so the completed pattern will fit the body dimensions for a different size. A skilled grader is able to assign specific grade points to pattern pieces that will maintain the integrity and fit of a style. Grade rules are consistent but grade points vary with each pattern piece of each style and size. A grader is responsible for consistent fit across sizes.

Graded patterns are used to make markers. A **marker** is a diagram or an arrangement of the pattern pieces for sizes of a style(s) that are to be cut at one time. Pattern pieces that fit together well in a marker allow better fabric utilization and reduce costs of material. Fabric utilization is affected by many factors, such as pattern shape, interlocking of pattern pieces, and fabric selection and width.

Postadoption Samples

As indicated in the previous discussion, samples make an important contribution to perfecting designs into styles. In addition, when styles in the line will be sold at wholesale, **sales samples** are prepared. Sales samples shown by manufacturers' representatives may not be exactly the same as the mass-produced garments that will be delivered to the retailers. Because of time pressures, sales samples may not be made from production patterns. They may be made by sample sewers or a special sample-making line rather than the mass production line. **Photo/catalog samples** are required if the line has an advertising campaign or if it will be sold in a catalog. Their purpose is for advertising photographs or catalog layouts. Photo/catalog samples may be the same as design, sales, or style samples depending on their timing in relation to the product development process.

Style samples are based on perfected production patterns and style specifications. A series of style samples may be required to perfect fit and styling of the garment and the production pattern. The final style sample is an accurately made representation of the style specifications. Style samples provide the model for production samples. They are particularly important if the style will be made in multiple plants or in other parts of the world. **Production samples**, sometimes

called counter samples, are sewn by the contractor or plant to verify quality and production capabilities. If a firm has its own production plants or well-established relationships with contractors, both style and production samples may not be necessary. Sample making is a costly and time-consuming process. The investment that apparel firms make in sample making depends on their commitment to quality of design and consistency of fit.

STYLE SPECIFICATIONS AND DETAILED COSTING Style specifications and cost estimating are much more specific than design specifications and costing. Style specifications represent merchandisers' and technical designers' expectations for finished, salable garments. Postadoption cost estimation is based on style samples and specifications. **Detailed costing** includes an estimate of amounts and costs of materials and labor required to produce each style (refer to Figure 10–1). A complete discussion of cost estimating is included in Chapter 10. Complete style specifications are sent to potential contractors as a bid package. See Figure 6–6. Contractors use the bid package as a basis of estimating necessary plant capacity, technology, and cost of production.

During the postadoption phase, designers, merchandisers, and product managers are involved in developing style specifications. **Style specifications** are the communication tool for fabric sourcing, development of production patterns, and materials handling in spreading, cutting, sewing, and finishing. Style specifications identify materials, dimensions, and methods which include specific descriptions and special handling needed to produce the finished product at the quality level desired. They provide a basis of quality control. Tolerances may also be included to indicate the amount of variation that is allowed. See Figure 6–7 for an example of postadoption style specifications.

Materials specifications identify the vendor, fiber content, fabrication, color, and width. Special instructions for spreading and cutting may be included to ensure appropriate treatment of materials such as centering stripes or matching plaids. Swatches are included for quick verification of fabrication and color. Materials performance expectations are commonly verified through laboratory testing.

Size specifications identify critical measurements for each size of the style and the methods of measurement. These specifications are based on final fit measurements and dimension changes established in grading. Size specifications may include tolerances or allowable variations in measurements that occur as a result of the manufacturing processes. Size specifications are used by quality control to verify the dimensions of finished garments and ensure production consistency and quality.

Structural style specifications include technical drawings of the style, garment components, and/or trims. These are often accompanied by specific dimensions or descriptions that will assist with the trim placement, component assembly, and decorative stitching.

Product Specification Bid Package Style: TD Contact: Spring 2000 Buver: Date: S(6-8)-XL(18) June 22, 1999 June 22, 1999 Modified: 8:21 am Country of Origin: Page 1 of 5 Pointelle Gown w/Yoke

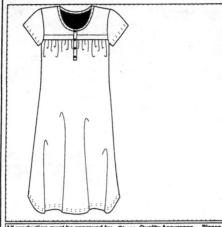

All production must be approved by Store Quality Assurance. Please see ShopKo Apparel Quality Manual for details.

FLOOR READY STANDARDS

All product must be in 100% compliance to Store's floor ready standards. Any non-compliance will result in punitive chargebacks to the vendor/agent.

It is the wendor/agent's responsibility to contact Product Development or the Buyer to determine which method of packing will be used for this style. If the wendor is unsure they may quote prices both hanging and folded.

HANGING GARMENT REQUIREMENTS

-Correct hanger purchased from A & E or Batts

-Correct size clip purchased from A & E or Batts

-Integrated Hangtag, correctly placed on garment, purcha

from Store approved supplier

-Noven Care Label, Store format, correctly placed on

oven Main Label purchased from Store approved supplier

FOLDED GARMENT REQUIREMENTS Integrated Hangtag, correctly placed on garment, Store

-Woven Care Label, Store format, correctly placed on -Noven Main Label, purchased from Store approved supplier -Pold as detailed by Store : Quality Assurance -Size strip, purchased from Store approved supplier, correctly placed on garment

Specifics per style will be sent once the order is confirmed. For further details, please refer to the Softlines Floor Ready Standards Manual.

Construction/Make Details Bid Package TD Contact: Spring 2000 Date: Modified: Buyer: S(6-8)-XL(18) June 22, 1999 Size Rang Modified: July 06, 1999 Vendor: 11:30 am Country of Origin: Page 2 of 5 Pointelle Gown w/Yoke

FARRIC DETAILS

SELF:
FARRIC WEIGHT: 5.0 oz/yd2 = 170 g/m2
FIBER CONTENT: 60% Cotton 40% Polyester
FABRICATION: Pointelle Knit
MAXIMUM SERINKAGE: 781 x 58W
DYE CLASS: Reactive/Disperse

SATIN TRIM:
FABRIC WEIGHT: Compatible with Body
FIBER CONTENT: 100% Polyester
TARRICATION: Satin Weave

FIBER CONTENT: 1008 Folyester
FABRICATION: Satin Weave
DYE CLASS: Disperse
Care instructions are determined by the Store Quality
Assurance Department based upon fiber content,
fabrication, and garment type. These care instructions
are given to the vendor after an order is placed.
The vendor is responsible to purchase
fabric that conforms to these care instructions.
If upon receipt of final garment testing the care
instructions are determined to be unacceptable the
vendor is responsible to othange the care instructions to
the testing lab's recommendation.

Lab dips and strike-offs, in all colorways, must be
submitted for approval before production of piecegoods.
Production piecegoods, in all colorways, must be
submitted to Shopko designated testing lab for approval
prior to garment production.

All raw edges must be overlocked and safety stitched if not enclosed

COMPONENT DETAILS

All novelty components must be submitted to Store QA for approval prior to production.

Color: DTM body color Construction: polyester core, cotton wrapped

Twill Tape Width: 1/4" Color: white

Construction: Satin Beaded Color: To be Determined

Buttons:

Interfacing:

Ouantity: 4
Size: Ligne 24
Construction: 2-Hole, Plastic
Color: DTM body
Finish: Pearlized

Interfacing:
Weight: 68 oz/yd2= 23 g/m2
Color: White
Construction: Lightweight, fusible, nonwoven

Stitches per inch: 10-12 spi stressed seams, 8-10 unstressed seams Seam widths: 3/8" for all seams

diagnote 05 Apr 95

Copyright (C) 1990-1995 Gerber Garment Technology, Inc.

Figure 6-6

Bid package.

Courtesy of Donette Ambrosy.

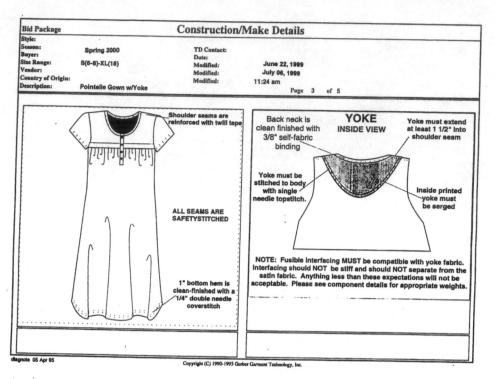

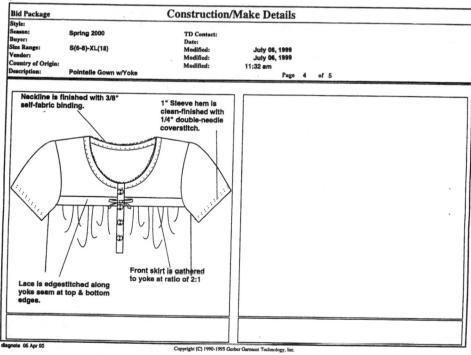

Figure 6–6 (continued)
Bid package.
Courtesy of Donette Ambrosy.

7	L. Control of the con
	Sketch: JKTBK.WMF Cost:\$ 52.76 or special instructions Topstitch the front piped method for the
3 C's Dominican Republic Peter Chen September 01, 1993 September 20, 1993 4:35 pm	Seetch: JKTFT.WMF See Send Out: Y Cost:\$ 52.76 1. See Susan Hawkins for special instructions on the turn back front. Topstitch the front diagonal seams. 2. Please use two-piece piped method for the bound buttonholes.
3 C's Dominican Peter Chen September September	1.79 1.79 1.179 1.15 1.15 1.15 1.15 1.15 1.15 1.15 1.1
Fabric: Group: Approved: Date: Modified:	23.6 2.5 1.1 1.1
Fabric: Group: Approv Date: Modiffe	MRWD 57.5 59.5 59.5 59.5 59.5 69.5 80.0tside Inside Inside May Black Turq Green
	SeeBlw White SeeBlw White Black Black Black White
	2848 2841 912 832 832 832 832 832 1/4" Miss Miss 114" #50 3.1 1.1 1.5 25 26 Wine Nawy Black Turquoise Green
	CONTENT 100% Wool 100% Polyester 100% Polyester 100% Polyester 100% Polyester 50% Wool 50% Poly EU BU
9,600	
Estimate: Sizes: acket 27	DESCRIPTION Lightweight 2748 Fus Medium Weight 2748 Fus Medium Weight Eschip Cord Plping Lgwt Collection label Care instructions Black
JACKETB93 WOMEN FALL Fitted long jacket 7 27	SOURCE Belks Belks SLR Text SLR Text Number Navy Black Green
Style: Division: Season: Description: Page:	FABRIC BUDY Self Interlinin Canvas Interlinin Canvas Buttons Buttons Buttons ShdrPds Piping Thread CareLab CareLab Tape Col.OR Wine Wine Wany Black CareLab GareLab Ga

Figure 6-7
Example of one part of a style specification sheet.
Reprinted with permission from Gerber Garment Technology, Inc.

Special sewing and finishing specifications relate to any instructions related to sewing operations, wet processing, pressing, and packaging. This may include information related to stitch and seam types, equipment, and procedures. Packaging specifications may include floor-ready requirements of the retail customer.

Product Quality and Consistency

A primary purpose of postadoption style specifications is to provide a basis for product quality and consistency. Size consistency is a major issue related to product quality. Quality control inspectors may use specified measurements as a basis for determining acceptance of garments during production and final quality inspection. The number of measurements that are specified for a style depends on the complexity of the style and quality standards of the apparel firm. The following discussion identifies issues related to maintaining consistency of fit throughout the production process.

Production tolerances are established for variations in dimensions that occur during garment production. Some dimensions, such as a collar on a dress shirt, may have zero tolerance. Others may allow up to one-half inch. Smaller tolerances allow less variation in size dimensions of finished garments. Factors that can cause changes in fit during the production process are:

- · Tolerances allowed in cutting and sewing:
- Fabric distortion during spreading, sewing, and pressing:
- Inaccurate cutting and sewing;
- · Shrinkage from heat, steam, and fusing; and
- Notches incorrectly placed.

Technical designers establish tolerances that are reasonable and acceptable for the finished garments. Tolerances are established because of the realities of potential size variation that can be caused at different stages of the production process. For example, if fabric is spread and cut under tension, the resulting garment pieces will relax and become smaller than the pattern piece. If garment pieces are cut inaccurately, variation in size can occur. Some machines trim as they sew. The amount trimmed is specified in the production standard. Inaccuracies of sewing may not become apparent until the garment is finished. Pressing can also cause size distortion. Unskilled handling of garments during pressing may cause distortion or stretching. Excess heat on some fabrics causes shrinkage. Finally, a garment must have the correct size label installed. If a garment meets the size specifications but has an incorrect size label, it will not fit the customer.

Meeting sizing standards and maintaining the accuracy of garment dimensions are even more difficult if a style is produced by several different contractors or in foreign countries. Apparel firms may supply production patterns to the contractor and evaluate production samples for consistency of sizing and

fit. However, it may not be possible to evaluate size and fit of finished garments until the entire shipment is received in the distribution center.

Each style has special production requirements based on design characteristics, fabrics, trims, methods of assembly, and quality desired. Technical designers often determine the methods to be used, assign the styles to plants with required capabilities, and follow up with plant visits to ensure appropriate production. This often involves international travel and effective communication skills to achieve the product quality desired.

Apparel Design Technology

Many apparel firms are seeking faster and more efficient methods of product development. Computer technology can reduce the time required and increase the accuracy of many of these processes. Computer systems are now available to serve the needs of both the small and large apparel firms.

Capabilities of CAD Systems

Computer-aided design (CAD) is the application of computer technology to the development of a garment up to the point of production. CAD systems offer significant benefits in time reduction, improved quality, and cost control, but each system has a specific function. CAD systems for design, pattern making, grading, and marker making have been available for many years. Emphasis is now on integration of free-standing systems to speed overall data processing and reduce errors implicit in rekeying and reformatting. Efforts are also being made to make systems more user friendly by integrating window environments that include commonly used icons. One of the greatest challenges is the development of 3D product development systems that can take a product from concept to the fashion runway using computer graphics (Greco, 1997).

Fabric Design Systems There are basically two types of fabric design systems, those that simulate the look that is desired and those that technically develop detailed layouts that plot each row of a knit or weave. Simulation systems allow the designer to experiment with various color ways, scan images, modify designs as needed, and simulate the look of the desired fabric. Flat fabric designs can be simulated without having to thread a loom or produce a sample. These systems provide a quick visual analysis without a great investment in time and costly fabric samples. Some highly sophisticated systems enable highly skilled technicians to simulate the three-dimensional drape of fabric onto photographs of garments or furniture designs to show how a fabric will look in the finished product. This allows an apparel firm to

produce high-resolution prints of catalog-ready art in varied colorations without having to produce expensive samples. Output of this system is more realistic and can provide an accurate visualization of fabric and style. New technology can now reduce the 3-D sculpted garments into flat pattern pieces to be used for first patterns for making prototypes. It has generated first pattern accuracy within 1/32nd of an inch.

Technical fabric design systems are available for development of knits, wovens, and printed fabrics. Technicians must be highly knowledgeable about fabric structures, yarns, and the specific production equipment. With technical systems the final fabric design structure can be fed directly to the equipment producing the fabric. Knit design systems require input of gauge, yarn size, stitch types, maximum number of colors per row, and knitting machines to be used. Woven designs require manipulating yarn size, interlacing patterns, thread count, warp and weft layout, and specifics of the equipment.

For printed designs, designers and technicians must know the specific method of printing that will be used. Screen printing and direct roller prints require development and preparation of a different screen for each color in the print. Screen size, the number of colors in a design, repeat length, and layout are all variables that can be manipulated with computer technology. Specifics of digital printing are discussed in Chapter 18.

Apparel Design Systems

While the traditional CAD system operates primarily in the postadoption, technical design, phase of product development, more newly developed apparel design systems function primarily in the preadoption, creative design phase. Design and styling software that operate on CAD systems were introduced to the apparel industry in 1984, and they are now used for line development and product development, merchandising, and sales. Apparel design systems make it possible to create or modify a line or a style quickly. Apparel design and styling software systems allow designers and merchandisers to develop designs through electronic sketching or use of templates of flats. Flats can be colored or filled with a pattern to determine what a style will look like in a specific fabric.

Electronic sketching systems allow designers to create garments on the computer screen. These software programs enable designers to trace or free-hand sketch with a stylus pen and data tablet or scan sketches, photographs, motifs, and fabrics into the system. Once entered, it is possible to experiment with style lines, colors, and fabric combinations, or sizing and positioning of motifs without having to create samples. Designers can develop a new season's line by recalling and modifying styles from a prior season's line that were stored in the computer memory. Finalized designs can be used as images for catalog copy, story boards, and merchandising materials.

Template programs, such as Snap Fashun™ and Style Manager, consist of libraries of garment components that can be combined in countless ways to rapidly design a garment or line. These programs require minimum sketching abil-

ity and are a quick way to develop a concept or merchandise group. Firms may also develop their own library of bodies or component parts that can be manipulated in various ways.

The most significant benefit of garment design systems is the speed with which a design or a group can be developed, permitting merchandisers, designers, and buyers to work closer to the selling season. As private-label lines evolve, merchandisers, designers, and buyers are able to develop together on the computer the visual concepts of a line and specific design details that are desired. The visualization of designs assists merchandisers and buyers in making final selections for line adoption without having to wait to have numerous samples developed. Printer output can be used to build story boards for new collections, sent to fabric and label suppliers as a production guide, and provided to the sales department to facilitate customer visualization of color and style.

Pattern Making, Grading, and Marker Making

Pattern making on CAD systems is based on the block pattern concept described earlier. Basic blocks are entered into the computer system using a digitizer or scanner that converts pattern shapes into coordinate data. Using a graphic display screen, experienced pattern makers can create patterns for new designs from basic blocks much faster and with greater accuracy than with manual methods. A CAD system can be used to create first patterns, production patterns, style revisions, and pattern changes. Any pattern stored in the system can be used as a block. The operator can move and modify each line in a pattern independently.

Computer pattern grading reduces time required and increases accuracy as compared to manual grading methods. To check for accuracy, the computer operator can view each pattern piece as a nested set consisting of a single pattern piece graded to each size in the range. Using manual methods, this is a process requiring a great deal of time and skill; thus it is not surprising that pattern grading was one of the first processes of apparel production to be computerized.

Computerized marker making allows manipulation of pattern pieces to determine the most efficient layout considering sizes of garments to be produced, spreading methods, cutting equipment, and fabric width. The computer conveniently calculates the percentage of fabric utilization allowing the operator to seek a more efficient layout if necessary. Major advantages of computerized marker making include accuracy, improved fabric utilization, and less dependence on skill of a marker maker.

Specification Programs

Specification programs collect and integrate the information that has evolved for a specific style. The data is organized for each style and made accessible to those that need the information. Data may include design sketches, pattern shapes and dimensions, size specifications, grade rules, fabric and trim details,

vendors for material, finished measurements, assembly methods, costs of materials and production, quota restrictions, and delivery information. Information is gathered and delivered electronically anywhere in the world. Data input and access to information may be limited to specific individuals or departments as determined by the technical designers or merchandisers. Programs of this type allow quick modifications and immediate availability of accurate information without extensive photocopying and lost delivery time.

Made-to-Measure

"Less than sixty percent (60%) of the population can purchase pre-sized apparel and obtain the desired fit. Almost half the population would be potential customers for made-to-measure apparel" (Early, 1992, p. 10). Traditionally, the term made-to-measure is used to describe apparel that is custom made to fit an individual's unique body size and shape. Measurements are taken by a dressmaker or custom tailor, and the garment is designed and fitted for the individual.

A recent trend is strong demand for upscale made-to-measure services for men's tailored clothing. Personal measurements are taken by a retailer and submitted to a manufacturer along with the customer's choice of fabric and style. The manufacturer's patterns for the style are adjusted to suit individual measurements, and the specified garment is cut, sewn, and delivered to the individual (Schneiderman, 1998). This service has met with some measure of success; however, a lack of consistency in taking measurements, time-consuming pattern adjustments, and cutting and sewing of individual garments make the process labor-intensive and expensive.

New make-to-measure (MTM) technology has potential to revolutionize the sewn products industry. MTM systems use body scanning computer technology to determine body size, dimensions, and shape. For body scanning the customer puts on a close-fitting elastic body suit and steps into a small measurement booth. Several different technical systems have been developed for body scanning, but basically a curved gradient is projected onto the subject and the body image is captured by video camera connected to image capture boards in a computer. The computer generates a critical measurement table for the individual. Measurement time is approximately 1.5 seconds. See Figure 6–8.

The customer selects style features, fabrics, and colors for the desired garment. Customer preference information is then merged with the critical measurement table that is transmitted to the manufacturing site. Key body measurements are applied to the nearest standard size pattern for adjustment. The computer generates a file of cutting data that can be communicated to a single ply fabric cutter. For the quickest response time, flexible manufacturing is used to assemble the garment. The made-to-measure garment can be delivered directly to the customer.

The Computer Clothing Research Group at Nottingham Trent University in England began using virtual reality in 1993 for product development aspects of

Figure 6–8
Facility for 3-dimensional body scanning using a structured light pattern projected on the body.
Courtesy of Textile/Clothing
Technology Corporation.

made-to-measure apparel. Their system is built for apparel design professionals, not consumers. The goal is to enable a designer in Milan, Italy, to work with a retail merchandiser in New York to develop a product line without making any samples. They want the proposed designs to be virtually displayed on models that reflect the measurements of the firm's target customers. To provide a database for body dimensions the Nottingham Research Group has analyzed the shape of over 7,500 women. The sizing research focuses on the relationship between body size and body shape, an issue not addressed in other apparel sizing research (Gray, 1998 & 1994).

Because of replacement of many of the traditional processes with computer technology, high-quality, customized garments will be made available at reasonable prices. Custom fit is something few budget and moderate price customers have never experienced. Full development of an MTM market is dependent on integration of technology as well as development of a customer base.

Summary

The roles and responsibilities of designers depend on the fashion orientation and the seasonality of the product line and the size of the firm. Design is the creative portion of product development. Designers work within a framework established by a strategic plan and merchandising and marketing strategies. Specifics are defined in the line plan summary. The better the entire production and marketing process is understood by those responsible for design, the more effectively new styles can be created.

Designers have many options and avenues of inspiration that will stimulate creativity and originality of design. Styling, sizing and fit, fabric selection, coordination within the line, and timing of offering are all critical factors. All of these factors are important at the creative level but the bottom line remains sales volume. Designers are evaluated on the success of the styles they create, which translates to the amount of sales and profit they produce. Design and designer licensing have tremendous impact on textile and apparel merchandising. Apparel designers grant the right for manufacturers and retailers to use their names and trademarks on a wide variety of products. CAD systems are widely used tools in the design and pattern development process. Make-to-measure technology has the potential to revolutionize the process of design and the apparel business.

References and Reading List

Early, J. (1992, November 10–11). Projects Sponsored by Textile/Clothing Technology Corporation. Apparel Research Conference, Atlanta, GA.

Gray, S. (1998, February). Virtual reality in fashion. *IEEE Spectrum*, pp. 18–25.

Gray, S. (1994, January). Formula for a fashion show. *Bobbin*, pp. 54–58.

Greco, M. (1997, May). CAD/CAM offers valueadded services to apparel industry. *Apparel Industry Magazine*, pp. CS-3—CS-11.

Grudier, A. (1994, July). Making sense of the CAD marketplace. *Bobbin*, pp. 68–71.

Lee, Y. T. (1994, February). A bibliography on apparel sizing and related issues. Gaithersburg, MD: U.S. Department of Commerce, NISTIR 5365.

Rudie, R. (1989, August). Design studios: The new wave. *Bobbin*, pp. 86–88.

Schneiderman, I. (1998, June 17). Clothing is getting "better" all the time. *DNR*, p. 10.

Trautman, P. (1996, September).

Manufacturing quality: The role of technical design. *Bobbin*, p. 152.

Key Words

balance basic block basic block pattern blocks body center of gravity comfort ease computer-aided design (CAD) concept board confinement

cost estimating creative design croquis crosswise symmetry cye

design ease design prototype design samples design specifications designer licensing detailed costing drafting drape electronic sketching systems fabric face first pattern fit fit model flats freelance designer fulcrum garment dyeing grade points grade rule inspiration board knockoffs lengthwise symmetry licensing

line adoption make-to-measure (MTM) technology marker master pattern materials specifications nondirectional one-way fabric design outside design studio pattern pattern grading photo/catalog samples positioning postadoption product development preadoption product development precosting production patterns production samples production tolerances quality specifications quick costing

ruboffs sales samples sample makers scale of design size and fit specifications sizing standards sloper special sewing and finishing specifications structural style specifications style style blocks style number style sample style specifications styling ease symmetric technical design template programs up and down width

Discussion Questions and Activities

- 1. Go to a retail outlet and select a style of slacks or jeans that is stocked in-depth so a number of identical garments are available in your size. The brand, style, and fabric must be the same but the color could vary. Try on three garments and compare the fit. Did they all fit exactly the same? Why did they fit the same? If there were differences, in what specific ways were they different? What could have caused these differences?
- 2. Select a basic style of pants or jeans that can be found in several different stores at different price ranges. Choose three different stores that carry these garments in different price ranges. Try on the style of pants that you selected in each store. Be sure the style is as similar as possible
- and the same size. Compare the fit. Did they all fit the same? Was one brand cut fuller or longer than the other? Was the same basic block used by each firm? Which one fit the best? How might the differences in fit be related to differences in price?
- 3. Using a mail-order catalog, select three styles that have been made from the same body. How have the garments been modified to give different visual impressions?
- 4. Visit a retail department store and examine the content of a manufacturer's line as represented in the retailer's assortment. How many styles are in the line? How many sizes are in the line? How many colors are in the line? How many

- styles use the same fabric? How many styles use the same body?
- 5. Select two garments, an original design and a basic style, and list the product development steps required for each. Compare the number of steps, potential time required for each. Which one potentially took longer to develop? Which one has more potential for next season?
- 6. Select a garment and identify the preadoption process it went through. Summarize the reasons it was included in the line. (Examine market needs and expectations, coordinates, sourcing, and profit.) What steps were required in postadoption?

PART WASS

Dimensions of Apparel Management

Chapter 7 Management of Quality

© Chapter 8 Materials Sourcing and Selection

Chapter 9 Production Planning and Sourcing

Chapter 10 Costs, Costing, Pricing, and Profit

chapter /

Management of Quality

OBJECTIVES

- Explore the nature of the global textile and apparel industry and its role in product quality.
- © Examine organizational structures for quality management.
- © Explain the concept, purpose, and language of quality assurance.
- Explore product variation and defect classifications.
- Analyze the costs of quality.

The global textile complex includes manufacturing and distribution of materials and finished goods. Components of the textile complex in various countries around the world have differing levels of technical sophistication, capital intensity, vertical integration, market concentration, foreign investment, and government involvement. Management of quality is dependent on understanding the interrelationships of the global textile complex.

The Global Textile Complex

The global textile complex includes a combination of highly interactive manufacturing and marketing firms. The many segments of production and marketing in the textile industry are represented in Figure 7–1. In this diagram, the dotted-line boxes represent industry segments that have primarily marketing or distribution functions. The solid boxes represent segments that perform production as well as marketing functions. Aspects of the textile complex that are not represented in this diagram are the developers, producers, and suppliers of machinery, equipment, and communications technology. These firms serve every segment of the textile complex and are frequently principal sources of research and development.

Producer and Consumer Goods

Within the textile complex, **producer goods** are products and materials that are used in the production of other goods. Fiber, yarn, greige goods, finishing, and findings businesses all operate in what is known as producer goods markets. (Greige goods are fabrics just off the loom or knitting machine in the unfinished state. The term may be spelled *greige*, *griege*, *gray*, or *grey* depending on the author.) **Consumer goods** are end products produced by manufacturers and distributed by retailers. Producer goods markets are represented by the top half and consumer goods markets, the bottom half of Figure 7–1. There are many brokers, wholesalers, and jobbers that facilitate the transfer of ownership from producer goods (materials) markets to consumer (finished) goods markets when firms are not vertically integrated.

There is a strong trend toward **vertical** and **horizontal integration** in both producer and consumer goods markets. **Mergers** between mills, between mills and converters, and between converters mean fewer firms are involved in fabric production in the world market. Textile sourcing options for apparel firms are more limited and competition among textile firms is reduced. There are far more firms involved in consumer goods markets than in producer goods markets. For example, in the United States in producer goods markets, there are about 15 natural fiber trading companies, less than 20 manufactured fiber producers, and about 5,000 textile mills and converters. In consumer goods markets there are about 15,000 apparel manufacturing firms, while the city of Chicago alone has over 5,000 retailing firms.

The materials manufacturing component of the United States textile complex is the largest textile producer in the world although deficits in textile trade have been common since the late 1970s. Production has become increasingly capital-intensive, employment has declined, and there is a strong trend toward vertical integration (Cline, 1990). For example, around 1960, capital invest-

Figure 7–1
Diagram of the international textile industry.
(Developed by Grace I. Kunz.)

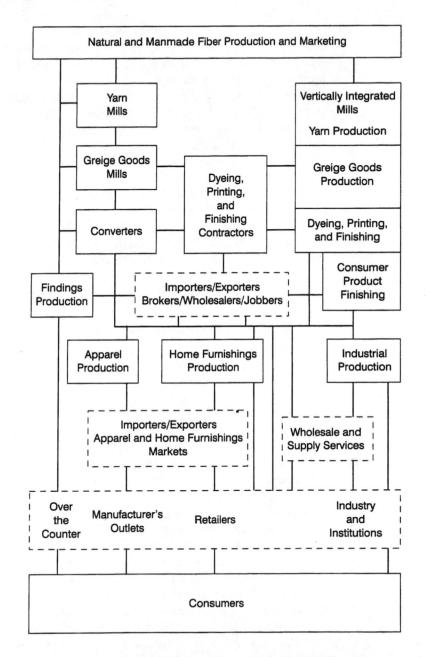

ment in a new spinning and weaving mill was about \$50,000 per employee; by 1975, it was about \$250,000 per employee (Woodruff and McDonald, 1982). Textile machinery continues to increase in sophistication, automation, productivity, and cost, with some modification of the production focus. Until 1980, capital improvements focused on producing fabric at a faster pace and a lower price.

As a result, many textile firms increased the size of order minimums and focused on the production of moderate-quality goods. More recently textile firms have tried to respond to demand for more flexibility to meet the needs of consumer goods manufacturers.

The three principal segments of consumer (finished goods) markets are apparel, home furnishings, and industrial textiles. Most of this book is focused on apparel, which has been the largest end use for textile producer goods in the United States, while home furnishings and industrial textiles are growing segments of the industry. Apparel firms have been experiencing increased demand for (1) fashion goods requiring short production runs, (2) variety in fabric selection, and (3) quality in materials. Some U.S. textile manufacturers and suppliers now recognize their customers' needs for greater variety of higher-quality textiles with shorter turnaround times and have redirected capital investments toward these needs. Most textile firms still have not developed systems to provide the levels of flexibility many Quick Response apparel manufacturers prefer. The following discussion describes the producer goods parts of the textile complex that relate primarily to quality and sourcing of apparel.

Fiber Production and Marketing

Production and marketing of textile fibers are the first steps in the textile manufacturing process. There are two major types of fibers used in textiles, natural and manufactured cellulosics and synthetics. In the United States, manufactured fibers represent over 75 percent of the total fibers consumed. The production of natural fibers is a worldwide agricultural endeavor related to the production and harvesting of cotton, wool, flax, ramie, and other fibers. Government subsidies for agricultural production are common in many countries around the world. However, they distort the self-regulating nature of supply and demand and interfere with a classic economic case of pure competition in natural fiber production.

Marketing of natural fiber is concentrated in the hands of a few worldwide trading companies. For example, by 1981, the number of major trading companies involved in cotton marketing was reduced to 15, including two giant European corporations, five Japanese conglomerates, and eight U.S. public and private corporations (Clairmonte and Cavanagh, 1981). The number of cotton trading companies has continued to decline. The highly concentrated nature of cotton marketing contrasts with the more competitive nature of cotton production by thousands of cotton farmers around the world. The tightly structured organization of the natural fiber marketing system means that textile and apparel producers must source natural fiber from among a few large trading companies.

Both cellulose and petroleum-based manufactured fibers are produced by a few giant chemical companies. Contrary to natural fiber production, manufactured fiber production is a highly capital-intensive business. Requirements for large capital investment in technology and equipment provide a significant

barrier to the entry of new firms into manufactured fiber production. The chemical companies involved in manufactured fiber production and the Manufactured Fiber Producers Association are major sources of research and development for textile products.

The marketing process for manufactured fibers is also very different than natural fiber marketing. Manufactured fiber producers frequently introduce a new fiber or fiber modification by trade name through an extensive advertising and promotion campaign. The new fiber is usually integrated into a media blitz directed toward the textile and apparel producer as well as the ultimate consumer.

In contrast, a comparatively small amount is spent on natural fiber research, development, and promotion. Cotton Inc. and the Wool Bureau are two industry-supported natural fiber organizations that engage in these activities. Cotton Inc. supports a major research and development center and serves as a resource for cotton fabric innovation. However, the economic investment is small compared to the economic power of the chemical companies that dominate manufactured fiber production.

Fabric Production and Marketing

There is a strong trend toward vertical integration in fabric production. A growing proportion of fabric production in the United States is dominated by huge vertically and horizontally integrated textile companies. This trend is illustrated in Figure 7–1 by linking the four major stages in textile production. As indicated on the left side of the diagram, the stages in production are also performed by smaller companies that specialize in one stage of textile production for certain types of fabrics.

Apparel firms source fabrics and linings from mills, converters, and jobbers. A mill is a company that owns textile machinery and makes yarn and/or fabric. Textile mills produce woven, knitted, or fiberweb materials. A mill is vertically integrated when it also makes yarn for its own use and/or converts the

greige goods by dyeing and finishing.

Converters are finishers. They buy greige goods from a mill and sell the finished goods or contract the dyeing or printing and finishing. Converters may also buy finished fabrics to supplement their inventory or diversify the product line. They frequently contract fabric finishing according to orders from finished goods manufacturers. Converters have more flexibility to respond to market and fashion changes than mills because converters have no investment in machinery restricting the types of fabrics they handle. Converters are more likely to experiment with new designs and tend to be the best sources for special and fashion fabrics or novelty fabrics.

Fabrics are sometimes categorized as *fancies* or *staples*. Special and fashion fabrics are often called **fancies**. Fancies are usually made in shorter runs than staples and tend to be less economical to produce. Fancy fabrics are characterized by fiber- or yarn-dyed construction, dobby and jacquard weaves or knits,

unique yarn structures, embroidery or special finishes, or goods manufactured to buyer's specifications. Fancy fabrics are marketed by the mills' sales representatives using sample books to display the aesthetic appeal of the goods or swatch cards that allow analysis of hand and drape. Mills may also give sample yardage of new fabrics to their customers. This is a stark contrast to the marketing process for staple goods using standardized product descriptions.

Staple fabrics are made continuously, year after year, with little or no change in construction or finish (Pizzuto, Price, and Cohen, 1980). Most staple fabrics—such as print cloth, sheeting, osnaburg, duck, sailcloth, drill, tricot, taffeta, and linings—are sold by the mills as greige goods and purchased by converters for finishing. Market prices for staple greige goods, cotton, manufactured fibers, and yarns are published weekly in the *Daily News Record* (DNR). In DNR, fabrics are described according to width, count per square inch, and weight in yards per pound. Price quotations are accompanied by an explanation of the buying trends and the role of international supplies. The market for staple greige goods is a world market and prices fluctuate according to supply and demand.

Quoted prices are based on mill sales of average quality fabrics or yarns. In the article accompanying the market price chart in DNR, prices for print- and dye-quality fabrics are often discussed. Standards differ for print-quality fabric and dye-quality fabric. Printed patterns tend to camouflage fabric irregularities; therefore, print-quality fabric does not have to be as uniform as dye quality. The prices quoted are **spot prices**, the prices at which the fabrics can be immediately delivered. Large apparel firms or converters may commit for greige goods several quarters (a quarter is one-fourth of the business year) in advance when it appears that supplies will be tight or prices may increase. One or two cents a yard is a major concern when thousands of yards are purchased.

Manufacturers of textile products tend to focus their business on certain segments of consumer goods markets. As with the apparel firm, a fabric firm must identify a target market and develop suppliers and customers that are involved in that market.

Primary and Secondary Sources of Fabrics

In textile trade jargon, there are primary and secondary sources of fabrics. **Primary sources** include the mills and converters that are actually involved in producing or finishing fabric, while **secondary sources** are firms involved in resale of the materials. A secondary source is a company that buys fabric and then sells it (Pizzuto et al., 1980). Secondary sources of materials include jobbers, brokers, wholesalers, retail stores, and apparel manufacturers.

Usually, **jobbers** buy fabric from mills, converters, and apparel manufacturers in comparatively small quantities. **Brokers** differ from jobbers in that brokers do not take ownership of the goods but rather facilitate the transfer of ownership from the manufacturer of the materials to the manufacturer of the finished goods. Apparel manufacturers use brokers to search out sources of fabric to meet specific

needs. Wholesalers assemble broad assortments of fabrics and/or findings and sell to small apparel manufacturers and/or over-the-counter fabric retailers.

Jobbers buy mill **overruns** or **tailings** that are available because of extra fabric production as allowances for damaged goods. Short pieces are also created by cutting out mill defects. These short pieces are often unacceptable to the mill's regular customers so they are sold to a jobber. Jobbers also buy excess

or unused fabrics from apparel manufacturers.

For apparel manufacturers, jobbers function both as a source of materials and an outlet for excess inventory. A jobber is often a source for specialty fabrics, hot fashion fabrics, and other materials that are needed in small quantities. Jobbers sometimes try to anticipate demand for fashion goods in order to have appropriate materials on hand when the fashion is hot. The potential problem when an apparel firm uses a jobber as a fabric source is lack of continuity of supply. Reorders are seldom possible because a jobber carries limited inventories.

Apparel manufacturers do not source fabrics from the retail sector; however, retail stores are considered a secondary source of fabrics because they buy and sell materials. As indicated in Figure 7–1, fabrics purchased in retail stores by home sewers are called "over-the-counter" sales by the textile industry. Mills and converters often offer separate lines for over-the-counter sales. Fabric wholesalers are important sources for small fabric stores. Fabric retailers may also use jobbers as sources in order to offer the same fabrics that are available in ready-to-wear.

Worth Street Textile Market Rules

The traditional mode of operating in the cotton textile business was first codified in 1926 as the **Worth Street Textile Market Rules.** The rules were named for Worth Street in New York City where the textile trade was centered. Twelve major textile associations joined together to establish definitions, performance standards, physical testing procedures, and rules of conduct pertaining to the purchase and sale of cotton textiles and allied lines (Kolbeck, 1984).

The rules were revised in 1941, 1964, and 1986. Over the years, they have been expanded to cover a variety of textile fibers as well as finished textiles. The 1986 version of the Worth Street Rules was approved and endorsed by the American Textile Manufacturers Institute, the Textile Distributors Association, and the Knitted Textile Association. As with the original rules, the new rules reflect what are considered to be common and fair business practices. The 1986 version of the Worth Street Rules describes definitions of terms, buyer's rights, seller's rights, common terms in contracts, and tolerances for quality in the textile business.

For production and marketing purposes, the 1986 Worth Street Textile Market Rules have classified fabrics into five groups: fine fancy goods, fine cotton and blended greige goods, carded cotton and carded blend greige goods, smooth and bulked filament and filament/spun greige goods, and goods for coating and

laminating. Marketing and trade practices and contract terms are specified in the Worth Street Rules for each of these classifications of goods. Factors specified relate to quality, width, yarns per inch, weight, lengths of cuts, and acceptable levels of defects.

Findings Production and Marketing

Manufacturers and wholesalers of findings use the fiber, yarn, and fabric markets as well as markets outside the textile trade for materials, as indicated in Figure 7–1. Linings and interlinings may be specialties of certain textile mills. Interlinings are specialties of firms such as Pellon Division of Freudenberg Ltd. Braids, tapes, and other trims are made by mills that specialize in narrow goods. Snaps, hooks, and other metal and plastic findings require materials from outside the textile market.

Many apparel manufacturers buy findings direct from the producers. Findings can be purchased from open stock or made-to-order for special fabrications or color match. A few wholesalers specialize in providing assortments of findings, which make it possible for the apparel firm to purchase the necessary findings from fewer vendors.

Findings firms not only market the products they make but also develop and sell equipment for installing or attaching the product. For example, snap and zipper manufacturers may sell or lease machines for installing their products. Many findings manufacturers assist in matching the appropriate product to available equipment and end use. Many offer services for testing prototypes. For example, one interlinings vendor has offered over 80 style numbers of interlining varying in color, fabrication, fiber content, and weight. It has a complete product testing lab to evaluate the suitability of the interlining to the end product. Findings manufacturers also provide product information, installation specifications, and hang tags to identify their products and verify their quality.

Systems for Quality Management

Consumers want products that meet their needs. They also want protection from product failure in the form of exchanges or guarantees. These consumer attitudes have significant implications for the domestic apparel industry. Some apparel firms have always had a strong focus on quality. Even so, in the U.S. market, there is wide range in the quality offered within product lines and price ranges. Expectations for Quick Response business systems include reducing variance and eliminating repetitive inspection of materials and garments. More effective application of quality management systems is essential to meet quality standards and reduce turnaround time.

Quality Concepts

In Chapter 1, quality is defined as a perceived level of value (Scheller and Kunz, 1998). Using this concept, quality can be visualized as a range of intrinsic product characteristics and extrinsic quality cues, any combination of which might satisfy a particular customer's needs. Product quality can be evaluated from two different perspectives: (1) by comparing the intrinsic and extrinsic product characteristics to other similar goods in the marketplace and (2) by comparing the consistency of a product's intrinsic characteristics to the firm's standards and specifications. Ultimate consumers and often retail buyers often use the first method, that is, they compare the relative quality of one firm's products with others that are available in order to determine which offers the best quality, meets needs, and offers the best value relative to the price. Apparel manufacturers use the first method when selecting fabrics and also use the second method to assure fabric quality and performance.

Apparel firms consider the quality preferences of their target customers in establishing quality standards and product specifications. See Table 7–1. A firm that targets the budget market reduces costs by establishing quality standards and specifications that allow for the use of inexpensive but serviceable materials and simple production processes. A firm that targets the better market establishes standards and specifications that require better materials and fit, more complex garment assembly, more stitches per inch, in-process pressing, and better finishing techniques.

Once a firm's quality standards are established and product specifications are developed, quality is measured by conformance to the specific standards and specifications for particular parts, materials, or processes. Specifications establish the intrinsic quality of a product. From a firm's perspective, acceptability of a product is based on the firm's quality standards and whether the product has the characteristics it was intended to have as described in the specifications. Regardless of the overall quality level available in the marketplace, within a firm a product of acceptable quality is one that conforms to the product's specifications and the firm's standards.

Product Variation and Classification of Defects

Product variation is a normal result of the manufacturing process. It is impossible to make each product exactly like the previous one. Factors that contribute to variation include the materials, equipment, operators, manufacturing processes, the environment, and the inspection system. As a result of these factors, variation may occur within a single piece of a garment, between pieces of the same type, within a garment, between garments of the same type, and between products in the line. Quality management programs seek to separate chance or normal variation from variation that has identifiable causes that can be corrected. In order to establish acceptable levels of variation, tolerances are stated as a part of product specifications. The variations in attributes are

Table 7-1

Content of complete garment specifications.

Date:

Style number:

Model number:

Sample number:

Complete garment description:

Detailed line drawings of front and back:

Materials including fabric name(s), vendor, fabrics structure(s), weight(s), width(s), color(s) finish(es); interlining(s); zipper(s) length, type, color, chain type; button size(s), type(s), number; button hole size(s) and types(s); thread size(s), color(s), type(s); labels, type(s), size(s), shape(s)

Breakdown of pattern(s) including pattern piece numbers, names, and number of cut parts

Marker instructions:

Spreading instructions:

Cutting instructions:

Breakdown of assembly sequence including stitch and seam types, stitches per inch, top stitching placement, tolerances

Machine types(s) and attachments:

Method description:

Finishing instructions including wet processing if any, pressing, ticketing, folding, and packing

Finished dimensions for each size such as chest, waist, back length, inseam of sleeve or pant, bottom width; location of each measurement

evaluated to determine whether the amount and type of variation are within tolerances.

Variations that exceed tolerances or do not meet specifications are called **defects.** For example, materials defects are measured by size and length (Kadolph and Langford, 1998) and may be classified into three categories:

- 1. Critical—will prevent usability or performance,
- 2. Major—may affect usability or may interfere with performance,
- 3. Minor-will not affect usability (Besterfield, 1986).

As a result of evaluating attributes, products are (1) accepted as adequate to meet quality standards or (2) rejected because they are defective. If the quality of a garment is evaluated as acceptable, it is "first" quality. **Defectives** are evaluated as seconds, thirds, irregulars, or scrap depending on the number and

type of defects. Defects may occur in materials, components, assembly, or in processes. An average rate of defective garments is 10 to 12 percent. Goals for defect reduction may be targeted at less than 5 percent. Prevention of defects early in the process reduces production of unsalable garments.

Concept of Quality Assurance (QA) or Total Quality Management (TQM)

Successful quality management requires an orientation toward quality that permeates the entire organization. Many psychological and emotional as well as physical and mechanical factors contribute to the production of high-quality goods. Top executives must establish quality management as an ongoing part of the organization and provide the equipment, supplies, personnel, and budget to support its existence. Continual improvement in quality comes only with the commitment of managers and employees to consistent, high-quality perform-

ance in all aspects of the business.

Firms that have adopted this total concept of quality often use the terms Quality Assurance (QA) or Total Quality Management (TQM). The term QA is used throughout this discussion. Under a QA system, evaluation of conformance to standards involves performance of all the company's divisions as well as the products and services that are produced by the firm. It is recognized that production of quality products depends on the quality consciousness of the entire organization including merchandising, marketing, finance, operations, and production. Employee involvement throughout the firm is normally a part of a QA strategy. Employees receive training on how to identify causes of product defects and how to resolve the problem so defects do not continue to occur. Some studies have shown that fewer than 20 percent of rejected garments have defects dependent on the sewing operator, which is often the focus of more limited quality control programs (Jacobsen, 1985). Quality control (QC), a more limited form of quality management, is the process of assuring that products are made according to standards. QC activities tend to focus directly on the production process rather than on quality as a responsibility of the entire firm.

QUALITY ASSURANCE POLICIES AND RECORDS A necessary tool for understanding and communicating a quality program is through the development of a written quality policy and a quality manual. The **quality policy** establishes priorities relative to materials, processes, training, product development, and customer service. The **quality manual** provides documentation of the quality policy and all related standards and procedures. Table 7–2 shows the range of topics that may be included in a complete quality manual. The quality policy and manual are essential for firms located in multiple sites in one country and/or in multiple countries.

While it is often the responsibility of a QA team to develop and implement quality policy, all employees need to have total understanding of and commitment to

Table 7-2

Topics included in a quality manual.

Company quality policy

- Statement of quality objectives
- Organizational chart
- · Instructions for the use of the manual

Product standards and tolerances

- Materials production processes
- Finished products
- · Defect classification standards

Inspection, testing, acceptance procedures

- Receiving
- Preproduction
- In process
- Finished goods
- Distribution center
- · Measuring instructions
- · Identification of non-first-quality goods

Quality audit process

- Procedures
- Sample plans

Quality responsibility, qualification, and training

- Quality control personnel
- Production managers
- Line supervisors
- Operators
- Others

Supplier control

- Supplier evaluation
- Packaging requirements
- Source inspection
- · Certification requirements

Documentation

- Forms
- Reporting systems
- Quality audits

the quality program and its objectives. Writing a quality policy requires a great deal of thought and synthesis of ideas from a wide range of employees, all of which contributes to the development of an effective system. The quality policy provides a means of communication both within and outside the firm. All of a firm's employees and business partners should be made aware of priorities and implications, supplied with a copy of the policy, and have the policy explained and discussed. The quality policy is also essential when negotiating with the firm's suppliers and customers. A summary statement of the quality policy may be made available to customers so they better understand the firm's priorities.

One of the essential parts of a quality policy is a list of the **objectives** of the QA program. Objectives should be stated in measurable terms and "what and when" aspects of issues should be specified. Clearly stated objectives help to unify the quality effort, motivate action, and promote harmony among the managers and workers because they all understand they are working toward the same goals. The objectives also provide a basis for evaluation of the firm's qual-

ity program.

Clearly communicated objectives contribute to the development of quality consciousness among suppliers, customers, managers, contractors, supervisors, and sewing operators. Quality consciousness helps in the development of better workmanship, early detection of irregularities, prevention of seconds and rejects, minimization of repairs, and elimination of the need for 100 percent inspection. Objectives should reflect a determination to minimize the production of nonconforming goods. This can be accomplished through identification and correction of primary sources of quality variation so that unnecessary inspection and testing can be avoided.

Another essential part of the quality policy is a statement of **quality standards**. As defined in Chapter 5, standards are a set of characteristics or procedures that provide a basis for resource and production decisions. Standards reflect the overall quality and performance level the firm seeks to achieve. Quality standards are the basis of product development decisions and specifications. The statement of quality standards should cover minimum standards and tolerances for materials, production processes, and finished goods. This includes definitions of critical, major, and minor defects, and forms for recording the results of the various tests and inspections. A statement of a firm's quality standards often constitutes a major portion of the quality manual.

In addition to a written quality policy and standards, documentation of quality procedures, inspection systems, and quality analysis reporting are required. Without documentation, it is difficult to trace quality problems to the source. A QA system reduces the focus on finished goods inspection and increases the fo-

cus on quality within the entire organization.

Establishing a Quality Management Team

There are many different types of organizational structures for implementing quality management. Four possible ones are briefly described here: independent quality management groups, teams of divisional managers, product development teams, and teams of production workers. Some combination of these or other organizational structures may be the best for the management of quality in a particular firm.

An independent quality management group is recommended by many quality consultants. When the quality management function is a separate division that reports directly to the firm's chief executive officer, conflicts of interest can be avoided. For example, if quality management personnel reported to the vice president of manufacturing, quality issues might be set aside in favor

of cost control measures. By making the quality management function independent of the company's functional divisions, the quality professionals avoid influences by other vested interests in the organization. The independent quality management group can be very effective in setting policy, but implementation of the policy must be carried out by others.

When organized as a separate division, quality management is a staff function. In a staff role, quality specialists are able to make recommendations to managers throughout the organization. Quality management staff would not have any direct authority in any division or responsibility for the "bottom line" in any department. A problem with the independent quality management division is that quality appears to be the responsibility of the quality management specialists rather than the responsibility of every company employee. To be fully successful, the need to achieve quality standards must be regarded as each individual's responsibility.

A second type of organization for quality management involves a **team in- corporating management representatives** from each of the company's divisions. This type of organization may be particularly helpful in communicating the broad responsibility for quality to all divisions and employees,
particularly in small firms that have less specialization. Special training for
quality management is essential for the firm's managers. Educational efforts
are essential in order to provide a basic understanding of quality and to emphasize personal responsibility for it (Krantz, 1989).

Outside sources of expertise would probably be necessary in order to launch a new quality management program of this type. Use of consulting services can be especially helpful in creating a workable quality policy, developing a quality organization, and establishing quality objectives. Internal resistance to change can be absorbed by the outside party allowing internal managers the opportunity to implement quality programs. Table 7–3 lists colleges and universities that offer workshops, seminars, and consulting related to quality. Apparel firms

Table 7–3Colleges and universities offering consulting services.

Auburn University, Auburn, AL
Clemson Apparel Research Center, Clemson, SC
Fashion Institute of Technology, New York, NY
Georgia Tech, Atlanta, GA
lowa State University, Ames, IA
North Carolina State University, Raleigh, NC
Philadelphia College of Textiles and Science, Philadelphia, PA
Southern Technical Institute, Marietta, GA
University of Tennessee, Knoxville, TN
University of Wisconsin Stout, Menomonie, WI

frequently rely on consulting services for assistance in planning and imple-

menting quality programs.

The third type of quality management team is a **product development team.** Product development teams are often responsible for the quality of goods produced, from concept to consumer. The team may include a technical designer or quality manager who works with creative designers, merchandisers, and product managers to assure that products will meet quality standards. Technical designers are often responsible for analyzing designs and materials and identifying potential problems prior to writing specifications and sourcing. Issues they might address include differential shrinkage of materials, color loss, and sewing difficulties. Production managers analyze sewing and finishing problems to assure that garments produced meet quality standards.

A fourth possible type of quality organization is **teams of production** workers. The use of teams of production workers to solve production problems is based on the assumption that production workers are in the best position to understand and analyze production processes. Production teams have been used a long time. Levi Strauss initiated an "Employee Participation Group" (EPG) in 1983. They reported, before the program had been in effect for a year, the savings from the EPG projects exceeded the costs of the program five times over. The groups were organized according to the follow-

ing guidelines:

1. Groups meet once a week for one hour during work hours.

2. Membership is voluntary.

- 3. Training for group leaders and group members is provided.
- 4. Brainstorming and other group process techniques are emphasized.
- 5. The group selects a specific problem (within their area) to study and gathers meaningful data using surveys, observations, and so on.

6. The group studies and analyzes the gathered data.

- 7. The group proposes a solution to management in a formal presentation.
- 8. A follow-up study is done comparing pre- and post-implementation (Jennings, 1983).

Many firms are now using teams of sewing operators that are responsible for many aspects of the production process including quality. The teams are operated using guidelines similar to those outlined above.

Regardless of the organization of the quality management function, the tasks to be accomplished are similar. The quality management team establishes a quality policy including quality objectives for each of the firm's divisions, quality standards, measurement criteria, documentation, systems for communicating those requirements, methods of testing and evaluating levels of success, and feedback to the quality management team and the firm's management. This takes a lot of time, but the investment is worth it in terms of productivity and profitability of the firm.

Methods of Assuring Quality

Quality management involves integrated systems of checks and balances among a firm's suppliers and customers and within the firm's functional divisions to assure that finished products meet quality standards. A combination of visual inspection, measurements, laboratory tests, and wear tests may be used to evaluate conformance to standards. Goods are accepted or rejected based on the evaluation. Results are recorded, analyzed, and reported to management. Sources of defects are identified and steps are taken to reduce variation including evaluation of materials before production, evaluation of the products during production, and postproduction evaluation.

Preproduction Quality Assurance

Preproduction planning for quality assurance requires the cooperation of designers, merchandisers, production managers, and quality specialists. Decisions are made that determine aesthetic appeal, performance, and intrinsic quality of garments. Designers and/or merchandisers, quality management, and production/engineering personnel need to understand each other's roles with respect to product evaluation. This ensures that new styles will be both marketable and producible according to the firm's quality standards. Technical designers are frequently responsible for checking patterns, evaluating specifications, checking materials specifications, and production samples. Materials quality and performance is frequently assured by laboratory analysis.

LABORATORY TESTING FOR QUALITY AND PERFORMANCE Manufacturing efficiency, garment quality, and percentage of defective garments are directly related to the quality of the materials used. For example, when the required volume for a particular fabric is very large and the sale of the style extends over many months or even years, it is not unusual for the same fabrics to be manufactured by several different plants. When the resulting garments are marketed under a single style number, it is imperative that the fabrics are manufactured to the same specifications. Laboratory testing may be essential to assure consistency of materials used for the style throughout the selling period.

Methods and extensiveness of laboratory analysis vary widely among apparel firms. The primary reason for laboratory testing is to determine the level of performance needed, establish quality standards, or determine, scientifically, whether products conform to standards. The amount and type of testing used on materials and finished goods is dependent on the time frame for product development and a firm's emphasis on quality. A product's performance can be

judged by (1) relying on the tests conducted by materials suppliers, (2) using the services of commercial laboratories, (3) establishing the firm's own testing laboratory, or (4) using a combination of testing services. Regardless of the source of testing, the use of standardized tests is essential for correct interpretation of the results and for accurate communication within the firm, with sup-

pliers and customers, and with regulatory agencies.

Laboratory services have to meet the needs of a specific apparel firm and the laws and regulations governing the firm's market. The type of laboratory services desired depends on a number of factors: warranties and guarantees the firm offers, the size of the company, the amount and types of testing conducted by suppliers, the quality level of goods being produced, and types of tests that need to be conducted. Guarantees are more likely to be offered by producers of basic goods than by producers of fashion goods and more likely to be offered by large companies than small companies.

Testing sample yardage, materials received for production, garment components, and finished goods are often responsibilities of apparel testing laboratories. It is often beneficial to verify fiber content and care recommendations that are specified on materials. Analysis of performance characteristics and quality facilitates the identification of potential performance problems. Items that

might be tested include

- · fabrics and findings,
- design prototypes,
- · product assemblies and components,
- · conformance to specifications,
- · evaluations of customer requests and feedback,
- · returned merchandise, and
- · competitors' goods.

Some materials vendors have excellent testing laboratories with well-trained personnel. Other vendors have no testing facilities and rely on "eye-balling" the product to determine its match with product specifications. In the absence of its own testing lab, when a problem occurs, any apparel firm may make use of **commercial testing services** to find a solution.

Commercial testing services may be more economical than establishing an in-house testing lab. Testing needs may be perceived to be intermittent and not at a sufficient level to utilize the investment. Commercial testing labs often rely on standardized tests developed by ASTM and AATCC. Table 7–4 lists some of the commercial testing labs that are available in the United States. Time may be the greatest limitation in the use of the commercial laboratories. An apparel firm often needs test results in a matter of a few hours or a few days.

Establishing an in-house testing laboratory means a considerable financial investment on the part of an apparel firm. Specialized testing equipment, laboratory space, and trained personnel are required. However, if the lab is used

Table 7–4Examples of commercial testing laboratories.

Better Fabrics Testing Bureau, Inc.	
101 West 31st Street	
New York, NY 10001	

Industrial Testing Laboratories, Inc. 2350 Seventh Boulevard St. Louis, MO 63104

University of Massachusetts Lowell Research Foundation 450 Aiken Street Lowell, MA 01854 Philadelphia College of Textiles and Science Schoolhouse Lane and Henry Avenue Philadelphia, PA 19144

United States Testing Company 291 Fairfield Avenue Fairfield, NJ 09004

University of Louisville Institute of Industrial Research Louisville, KY 40208

effectively, the investment may be easily recovered in reduced costs, better product performance, and customer good will. The end use of the products produced, the quality requirements and expectations of customers, and the price level of the product are critical factors in determining testing needs. An apparel firm must decide what it wants to test, when it wants to test, and how the data will be utilized before a lab is established. Many tests can be performed with an ordinary washer and dryer. Some firms may do wear tests before making an investment in new materials or production processes. Wear tests provide consumers' views of extended use and care.

Testing should always have a purpose, and some action should be taken as a result of performance of tests. Information about laboratory testing of fabrics, findings, and apparel is available primarily from American Association of Textile Chemists and Colorists and American Society for Testing and Materials.

Quality Assurance During Production

Assuring quality during the production process requires additional strategies. Firms that use a number of contractors for production in geographically dispersed locations often have a group of quality assurance (QA) engineers or field quality managers. These QA engineers are responsible for communicating quality expectations to the production managers, working with the supervisors and operators during production, monitoring output, and accepting or rejecting the finished goods. QA engineers are often based at headquarters but spend several days a week involved in source inspection in the plants. Occasionally, they are stationed in a particular plant for weeks at a time particularly if a new product is being produced in a remote factory. The importance of product standards, specifications, production samples, and quality manuals increases since these are the primary tools for communication of expectations for product quality. It is often not possible to maintain close supervision of the actual production process.

Quality management personnel may evaluate outgoing specification sheets and incoming production samples. If necessary, field quality managers oversee the production of samples in the plants to ensure that every feature meets specifications. Field quality managers may live in the country where the product is sourced. Source inspection may take the form of visits prior to committing to production, occasional visits during production, and/or a quality audit prior to shipment. It facilitates the process of assuring that products with repairable defects are corrected before they leave the factory. Source inspection expedites the flow of the product into the distribution centers or the retail stores. Field quality managers also evaluate prospective plants for their ability to fulfill production and quality expectations.

Inspection Inspection is the process of examining materials, garment parts, or finished garments to determine acceptability against a standard and to accumulate information about product quality (Rosenberg, 1983). According to a study conducted through *Bobbin* magazine, finished goods inspection remains the most frequent type of quality control in apparel plants, followed by supervisory inspection, random inspection, and statistical quality control. Inspection has three purposes: to determine whether (1) products have been made according to specifications, (2) products meet standards, and (3) products are acceptable.

Some apparel firms still use quality control systems that depend on 100 percent inspection of finished products. Unfortunately, even firms that inspect 100 percent of the finished goods still ship defective merchandise. Inspection systems break down because of human and mechanical errors. If visual inspection is used, the process is dependent on human judgment. If the inspector loses concentration or is distracted for some reason, the consistency of the inspector's work may suffer. Measuring devices may be inaccurately read, incorrectly used, or information may be inaccurately recorded. For these reasons, even with 100 percent inspection, defective goods may be shipped as first quality.

The inadequacies of 100 percent inspection of finished goods have stimulated improvements in quality control systems. Effective competition in the world market requires the use of more sophisticated and cost-efficient means of quality control. The production and inspection of defective goods require just as much material and labor as the production of first-quality goods, but the value of the finished product is less. If the defects are corrected, costs of producing defective goods are higher than making first-quality goods. Thus, if the production of defective goods is reduced, production costs are less and there is greater opportunity for profitability.

Quality cannot be inspected into products—it has to be built into products. The trend is toward proactive instead of reactive approach to quality management. Modern quality management programs seek to prevent errors so that products that meet standards are made right the first time. Inspection may

take place before materials are shipped from the supplier, upon receiving materials, during garment assembly, or after garments are completed. The goal is to assure the quality of input, production processing, and output. Some firms keep their seconds rate as low as 0.5 percent of production. If the seconds rate is higher, 2 percent or more, a quality management program is likely to provide cost savings (Jacobsen, 1985).

STATISTICAL QUALITY CONTROL One hundred percent inspection is tedious and costly because of the time and labor involved. Statistical quality control (SQC) is a means of reducing the amount of inspection. Instead, a specified sample of goods is inspected based on the probability that the proportion and type of defects found in the sample are representative of the proportion and type of defects in the total production run or lot. In the apparel business, the term lot tends to refer to a group of goods making up a single transaction. At any given time it may be a bundle, a box, an order, or an entire production run. Statistical sampling for quality control is based on a specified lot. If more numerous or more serious defects are found than are allowed by the quality standards, additional steps are taken to inspect the lot. The cause of the defects must be identified and corrected.

Statistical quality control has been used in Europe since the 1920s. The first broad use of SQC in the United States was during World War II, to provide consistency and compatibility of weapons and ammunition. Many U.S. firms did not adopt statistical quality control strategies until after the Japanese had established themselves as the quality experts following World War II. W. Edwards Deming, formerly a U.S. government statistician, is often credited with the efficiency of Japanese quality control systems. Deming used statistical concepts to show "firms how to measure the variation in a production process in order to pinpoint the causes of poor quality and then gradually how to reduce those variations" (Main, 1986, p. 31).

After the Japanese used Deming's expertise so successfully, U.S. firms began to adopt SQC programs. The success of Japanese firms in improving quality and efficiency of production has resulted in increased focus on quality worldwide. Some firms now pay quality control experts \$3,000–\$6,000 a day (when they hired Deming the fee was \$10,000 a day) to evaluate their production systems, evaluate quality problems, and develop quality control programs.

ACCEPTANCE SAMPLING Apparel firms frequently use a statistical quality control process called **acceptance sampling**. Acceptance sampling is a commonly used method of statistical sampling (Besterfield, 1986). It is a way of determining whether to accept or reject a defined lot of goods on the basis of the evaluation of a selected sample. It can be the basis of determining the number and type of defects per unit and/or the number of defective units per lot. Acceptance sampling is used for evaluation of incoming materials, in-process inspection, and inspection of finished goods. Statistically, in-process inspection

reduces the number of defects that appear in finished goods and reduces the dependence of the quality program on 100 percent inspection of finished goods.

Traditionally, Federal Military Standards 105D (MIL-STD-105D) and later 105E (MIL-STD-105E) were often used as a guide for statistical quality control and acceptance sampling. However, in 1995, the U.S. Air Force canceled the use of the military standards so many firms now use the commercial standard ANSI/ASQ Z1.4-1993 (Kadolph, 1998). Although the names have changed, the standards are actually nearly identical. Among apparel professionals, it is still common to refer to MIL-STD-105D as the source of statistical quality control because it is the best known name. In order to use the commercial standard, whatever it is called, the following information must be known:

- 1. the acceptable quality level;
- 2. the lot size;
- 3. whether single, double, or multiple sampling will be used; and
- 4. the number of inspections that will be performed.

The acceptable quality level is determined by the standards and specifications for the product. The lot size determines the population from which the sample is selected. Lots should be as homogeneous and as large as possible. The sample, in order to be representative of the entire lot, is selected using random sample techniques so that every piece in the lot has an equal chance of being chosen.

Three types of **sampling plans** are commonly used: single, double, and multiple. A single sample plan means the decision to accept or reject the lot is made based on a single sample. A double sampling plan means that, based on the first sample, the decision may be made to accept, reject, or select another sample from the same lot. A multiple sampling plan is a continuation of the double sampling plan in that three or more samples may be the basis of the acceptance decision.

Acceptance sampling is an appropriate quality control technique when

- 1. required tests are destructive,
- 2. costs of 100 percent inspection are high in relation to costs of passing defective items,
- 3. there are many similar items to be inspected,
- 4. information concerning suppliers' quality is not available, or
- 5. automated inspection is not used.

There are many advantages of acceptance sampling over 100 percent inspection. The most obvious is that inspection costs are less because fewer units are inspected and less handling is required. Fewer inspectors are required, and therefore less hiring, training, and so on is needed. The inspection job itself is upgraded due to the impact of decision making. Instead of making piece-by-piece decisions, the inspectors determine the acceptability of entire lots through inspection of a few units. If destructive tests such as tearing or breaking strength

are required, sampling has to be used, or all of the products produced would be destroyed during inspection.

Acceptance sampling provides greater incentive to managers and production workers to improve their work. Under 100 percent inspection, individual items are rejected. Under acceptance sampling, entire lots of goods are rejected, which puts much greater pressure on sewing plants and sewing operators to produce first-quality goods every time. There are two major disadvantages of acceptance sampling. The first is the risk of accepting defective lots and rejecting good lots. The second is the time and effort required for planning and documenting the findings of quality control evaluation (Besterfield, 1986).

Monitoring the Garment Assembly Process In-process quality management means checking at key points throughout the manufacturing sequence using the product's specifications as the quality standard. Operators may receive detailed quality specifications for the particular operation performed at each machine. The operators may also be actively involved in the quality management process by being instructed not to sew over unacceptable work. Having operators check the work of previous operators and their own work reduces time-consuming repairs that may be required on finished garments. Line supervisors are frequently trained in quality evaluation and are expected to monitor operations in their area.

In addition, quality management check stations may be established at key points in the production process. Acceptance sampling techniques are often used to reduce the amount of in-process inspection and minimize the interruption of the production flow. In-process sampling allows early detection of out-of-tolerance operations and helps prevent costly rework. Sources of defects can be identified and corrections made to minimize the number of defectives produced. The goal is to do it right the first time.

For example, in a basic jeans plant, quality check stations may be established in three strategic locations during the production process. These stations are treated as manufacturing operations in that they cannot be overlooked or skipped. Statistical acceptance sampling techniques are established for each station with the size of the sample varying according to the level of defects normally produced in that area. In addition to examining the operations covered by that station, the inspectors look for fabric defects, shaded parts, spots and stains, and so on. Acceptance numbers are established for each quality station. The acceptance number is the largest number of defective items that can be found in the sample and still allow the lot to pass. For example, if the acceptance number at a particular station is zero, one defective item means the bundle is rejected. Another station may accept minor defects and reject the entire bundle if three items have major or critical defects.

The first-quality check may be located in the small parts area where operations such as assembly of zipper plackets, pocket bags, watch pockets, and pocket stitchings are completed. Inspectors work with one bundle at a time and select a specified number of pieces at random. The selected items may be evaluated for consistent measurements, evenness of stitching, width of hems, and so on. The second quality station may inspect fronts and backs after the pockets, front join, and seat seams are finished. The third quality station may examine side seams, inseams, and waistbands.

Inspectors use a standard form to record the number of defects found for each operation in each bundle. Each successive inspection station evaluates work that has been added since the last inspection. When finished goods are evaluated, reinspection of certain operations occurs. This type of inspection plan minimizes duplication of effort.

If fabric defects, soiling, or other problems are found, the defect is flagged as a potential irregular with a plastic tag or some other device so successive operators will know that the problem has been identified. In some cases the part may be recut or the garment may be processed as an irregular.

If the bundle is rejected because of poor sewing, it goes back to the operator who created the defect. The operator at fault is expected to reinspect the entire bundle for accuracy of the operation performed and to repair all of his or her unacceptable work.

Taking time for repairs results in a decline in the operator's overall productivity. This is believed to provide incentive to do the work correctly the first time. Defects caused by faulty machines or materials may be sent to a repair station for correction. If nonrepairable defects are found, the garment might be downgraded to a second, sold as scrap, or discarded. Repaired garments are returned to inspectors for reinspection.

FINISHED GARMENT EVALUATION Some firms use 100 percent inspection, some use statistical sampling, and some firms use both 100 percent inspection and statistical sampling. Finishing processes such as trimming threads and pressing may also assist in identifying glaring defects that have not been previously found. When effective quality management systems are used throughout the manufacturing process, the reliance on finished goods inspection may be reduced.

In the jeans example, in addition to in-process inspection, quality management may involve inspection of finished goods before and/or after wet processing. Wet processing involves rinsing, bleaching, garment dyeing, stonewashing, and so on. These processes frequently damage the garments. Final inspection usually involves inspection of fabric, sewing, wet processing results, consistency of labels, and measurements according to size.

MILL FLAW AND GENERAL REPAIR Garments with defects caused by failure of equipment or materials may be sent to special repair stations for correction. These defects may be attributed to problems such as defective thread, zippers, and malfunctioning machines.

As mentioned earlier, fabric flaws may be flagged during in-process or final inspection. When fabrics are repairable, garments may be sent to a special station called **mill flaw repair** where fabric flaws may be corrected by pulling extra fibers out of yarn slubs, pulling knots to the back, and recoloring exposed fibers. These relatively simple processes require special training for operators but may allow seconds to be upgraded to first quality. Fabric flaws are discussed in more detail later in this text.

Postproduction Quality Assurance

QA programs continue while goods are stored at production plants, in manufacturers' distribution centers, and in retailers' distributions centers. Important means of quality assurance of finished goods include quality audits and analysis of finished goods.

QUALITY AUDITS Distribution centers are commonly used as a location for auditing, monitoring, and reporting quality of finished goods and quality of packing and shipping. (Unannounced quality audits are also used during production particularly when production is contracted.) A quality station in a distribution center provides the opportunity to evaluate consistency of goods produced in a number of different plants, both domestic and foreign. Quality management personnel are often responsible for training the receiving personnel in the distribution center. Products that come into a distribution center may be 100 percent inspected or inspected on a sampling basis depending on the reliability of the contractor.

Quality audits are used to determine the defect level of the output of a particular plant and to prevent defective goods from entering the distribution system. For a quality audit, the lot may be the total number of units of a particular style that are ready to ship or are being received. The auditor records major and minor defects and evaluates the finished appearance of the specified number of garments. Key measurements, based on style specifications, are recorded. Garment measurements, to be sure sizes are consistent among garments, are often a critical component of quality audits.

If sampling indicates a need for more extensive inspection, the costs of that inspection may be charged to the plant. If the number of identified defects exceeds the standards specified in the quality control manual, the lot is rejected. Handling the rejected lot depends on the quality policy. The rejected lot may be 100 percent reinspected, defects corrected, or garments may be reclassified as seconds or irregulars. If lots are rejected, the goods may be returned to the source to be repaired or credited to the firm's account, or the goods may be downgraded to seconds and the lost value charged back to the source. If the defective goods were imported, serious problems could be created between the plant and its manufacturer or retail customer.

Another distribution center quality audit examines shipping. The purpose is to be sure that the correct lot numbers are going out and that the goods are packaged correctly and shipped to the right place. QC supervision of the shipping room is difficult because pickers and packers have different work rules and may belong to different unions. A conflict in authority sometimes develops between quality management and distribution management.

The distribution center quality management stations may also be responsible for evaluating sales samples before they are shipped. Inspection of sales samples differs from a regular finished goods inspection or audit. It is not a detailed sewing examination but rather an overall check of the outside appearance of the garment. Inspectors check to be sure labels are correct, the right finishing or wet processes were used, and no streaks or other glaring defects are present.

ANALYSIS OF RETURNED MERCHANDISE The final stage in the quality management process is analyzing defects in garments that are returned by customers. Some firms perform extensive performance evaluations on returned goods to determine the source of the problem and take steps within the production process to be sure similar problems do not continue to occur. Analysis of returned merchandise may take place in the distribution center or in a space set aside in the company headquarters.

Quality management can be a time-consuming and expensive process. The payoff is in reduced production costs and satisfied customers who buy goods season after season.

Costs and Benefits of Quality Programs

In general, efficient manufacturing of higher-quality goods costs more than efficient manufacturing of lower-quality goods. It costs more to make a higher-quality, better dress than a lower-quality, budget dress. Higher-quality goods tend to require more expensive materials, more time-consuming operations, a larger number of operations, more handling, and greater consistency based on smaller tolerances. (The price that the consumer pays for higher-quality garments, as has been said many times before, may or may not accurately reflect the production costs because the retail price depends on many factors in addition to production costs.) Table 7–5 lists factors that contribute directly to costs of garment production. In general, higher-quality construction requires more, better, and slower . . . (whatever variable you want to insert).

Generally, higher-quality products cost more than lower-quality products, however, as quality improves for a given product, overall costs are reduced

Table 7–5Factors that contribute to the cost of garment production.

Mat	-		10	0	-	-
IVIA	ler	ıaı	3	C	151	3

- 1. Number of materials used
- 2. Amount of materials used
- 3. Consistency of materials used

Labor Costs

- 1. Time involved in cutting
- 2. Time involved in assembling
- 3. Number of pieces in garment
- 4. Amount of handling
- 5. Types of stitches used
- 6. Number of stitches per inch (stitch density)
- 7. Types of seams used
- 8. Length of seams
- 9. Automation used
- 10. Skill of operators

(Besterfield, 1986). This is the quality paradox. The concern of each apparel firm tends to focus on improving processes to minimize the cost of production at whatever quality level the firm intends to produce. The production of defective merchandise is very expensive regardless of overall quality level. Defective merchandise is evidence of inconsistency in the manufacturing process. Increasing consistency means improving manufacturing processes. Many studies have shown that investment in quality assurance improves consistency and is more than recovered in manufacturing cost savings. Informed apparel managers recognize the costs associated with the production of defective merchandise.

Overall costs are reduced when quality is increased for a given product because consistency increases, that is, more desired products are produced whether they be budget, moderate, or better quality. More products can be sold at regular price. Less defective products are produced; fewer products are unsalable or sold at less than regular price. The salable value of consistent products is greater than the salable value of inconsistent products.

Overall, there are four types of quality-related costs: defect prevention, defect detection and appraisal, internal failure, and external failure. See Table 7–6. Firms that use only finished goods inspection will have high internal and external failure costs such as repair (internal) and frustrated customers (external). Firms that have more comprehensive quality management will have higher prevention and appraisal costs but lower costs related to defective finished goods. Effective quality management programs account for all of these costs and the processes related to them.

Table 7-6

Costs of quality.

Defects prevention—costs associated with design, planning, and execution of a quality assurance program

- · Quality administration and systems planning
- · Development of quality standards
- · Development of product standards, specifications, tolerances
- · Quality training; instruction manuals
- · Procurement planning
- · Quality engineering; special process planning
- Preventive maintenance
- · Sampling plans and audits
- · Quality reporting systems

Defects detection and appraisal—costs involved in direct appraisal of quality

- · Quality data analysis
- · Quality laboratory, measurement, and control equipment
- · Equipment calibration and maintenance
- · Materials and services consumed in destructive tests
- · Inspection and testing of incoming material
- · Quality histories of suppliers
- · In-process and final inspection and testing
- · Product quality audits
- · Special studies of quality problems

Internal failure—costs associated with production and correction of defective goods

- Coordination with purchasing, merchandising, and production
- Scrap or net loss in labor, material, and overhead from unusable products
- · Rework, repair, salvage, labor, and materials for correcting defective products
- · Analysis of cause of failure
- · Reinspection and retest of products reworked
- · Unrecovered losses that were fault of supplier or vendor
- Additional handling and inspection because of defectives
- · Downgrading of product value because of defects
- · Product and/or process redesign

External failure—costs associated with failure of a product in the hands of distributor or consumer

- Coordination with customer relations
- · Adjustments for complaints
- · Handling, repair, service, and/or replacement of rejected or returned products
- · Warranty charges or costs
- Replacement costs and inventories
- · Liability litigation
- · Customer dissatisfaction costs
- · Loss of customer goodwill
- · Reduced customer confidence, loss of reputation costs

Quality Cost Index

The cost of quality or lack of it is underestimated by most people, including quality professionals. Realistic estimates range from 10 to 35 percent of product costs. Quality costs have been broken down in the following manner:

- 1. Inspection: 2 to 15 percent of labor costs
- 2. Scrap: 2 to 10 percent of material costs
- 3. Excess material made but not used: 0 to 5 percent of material costs
- 4. Rework: 0 to 5 percent of labor and material costs
- 5. Field service: 0 to 20 percent of labor and material costs
- 6. Customer dissatisfaction: not estimated but potentially more expensive than all of the above (McKee, 1983)

Break-even analysis can be used to analyze the cost effectiveness of quality management programs. As quality increases, fewer defectives are produced and thus production costs decrease. As quality increases, the costs of the quality program increase. At break-even, the production of fewer defectives reduces production costs to the point where the costs of administering the quality management system equals the savings that are generated. As quality improves, the need for quality control is reduced. But the commitment to quality production must remain or production quality will decrease. Each apparel firm and production plant must strike a balance between costs of the quality program and savings generated by the production of first-quality goods.

According to Besterfield (1986), the value of quality management might be determined by using a series of quality cost indexes. Each index provides a different perspective on trends in quality cost. The measurement base might be direct labor costs, manufacturing costs, defective rate, sales, returns, and/or unit costs. Quality costs per direct labor hour or dollar is a common index. The required information is readily available, but this index is influenced by the level of automation in a plant. Quality costs per manufacturing dollar is another common index. Manufacturing costs are composed of direct labor, direct materials, and overhead. These data are also readily available, and this index is not influenced by automation.

Quality cost per dollar of sales is the most common quality index. This index is commonly used by top management for long-term planning but is less useful in the short run because it is subject to seasonal variations. Quality cost per unit is useful when products and product lines are similar. Thus its usefulness may be limited for fashion apparel manufacturers.

It is sometimes possible to compare a firm's quality indexes with other firms in similar businesses. This may give managers an idea how well they are doing with the costs of their quality assurance programs. A firm can also compare its own quality indexes over time to identify trends, necessary improvements, or increases in costs.

Trends in Quality Management

Quality in the 21st century will be different than it is today. Increased use of automation and robotics will reduce product variation. An increased emphasis on building quality into products has put greater emphasis on defect prevention through effective product development. Partnering and more effective communication with materials suppliers and retail customers will make quality expectations and performance more consistent. One hundred percent inspection should disappear and statistical quality control is likely to have less significance. Process measurement and automated inspection will partially replace it. Wider use of quality certification programs between buyers and vendors will assure quality of materials and finished goods, reducing production of unacceptable goods, and reducing product costs related to quality. The role of quality specialists will be to plan and to take action to avoid quality problems. A quality program acceptable under ISO will likely be required to do business in most international markets.

Summary

The textile industry is a global industry that varies in technical sophistication in different countries. The U.S. textile industry has become increasingly capital-intensive in recent years. Materials manufacturers make producer goods and finished goods manufacturers make consumer goods. Fiber producers include huge chemical companies that produce manufactured fibers and farmers who produce natural fibers. Textile mills, converters, and contractors produce and market yarns and fabrics. Apparel, home textiles, and industrial textiles are finished goods industries. Worth Street Textile Market Rules is a codified system of textile trade regulations that are regarded as common and fair trade practices.

Quality is the perceived value of a product. Two different aspects of quality must be identified in order to manage quality: (1) perception of quality of a product relative to other similar products offered in the market and (2) conformance of a product to a firm's quality standards. In the first context, retail buyers and consumers evaluate quality of the array of goods offered in the market. In the second context, products are judged as acceptable or unacceptable according to a defined set of quality standards. Product variation is normal but must be controlled to fall within a firm's tolerances.

One hundred percent inspection is still the most common form of quality control used in apparel firms. Unfortunately, quality cannot be inspected into a garment. It has to be built into the garment. Many apparel firms are upgrading their quality control procedures in order to be more competitive in the world

market. In general, better quality garments cost more to produce than budget quality products. However, for a given product and quality level, improving production processes consistency of output and thus improves product quality at lower cost.

References and Reading List

Besterfield, D. H. (1986). Quality control (2nd ed.). Englewood Cliffs, NJ: Prentice-Hall.

Clairmonte, F., and Cavanagh, J. (1981). The world in their web: Dynamics of textile multinationals. London: Zed.

Cline, W. R. (1990). The future of world trade in textiles and apparel (rev. ed.).

Washington, DC: Institute for International Economics.

Jacobsen, D. M. (1985, August). Fabric inspection savings: Fact or fiction? Bobbin, 26(12), 70–78.

Jennings, S. (1983, August). Quality control through participation. *Bobbin*, 24(12), 30–32, 34.

Kadolph, S. J. (1998). Quality assurance for textiles and apparel. New York: Fairchild Publications.

Kadolph, S. J., and Langford, A. L. (1998).

Textiles (8th ed.). Upper Saddle River, NJ:
Prentice-Hall.

Kolbeck, W. B. (1984, April). The receipt and inspection of fabric: A primer. Bobbin, 25(6), 45–49. Krantz, K. T. (1989, September-October). How Velcro got hooked on quality. *Harvard Business Review*, pp. 34-40.

Main, J. (1986, August 18). Under the spell of the quality gurus. Fortune, pp. 30–34.

McKee, K. E. (1983, August). Quality in the 21st century. *Bobbin*, 24(12), 47–50.

Pizzuto, J., Price, A., and Cohen, A. (1980). Fabric science. New York: Fairchild Publications.

Rosenberg, J. (1983). Dictionary of business and management (2nd ed.). New York: Wiley.

Scheller, H. P., and Kunz, G. I. (1998). Toward a grounded theory of apparel product quality. Clothing and Textiles Research Journal, 16(2), 57–67.

Vendor-Vendee Technical Committee of American Society for Quality Control. (1985). How to establish effective quality control for the small supplier. Milwaukee, WI: Author.

Woodruff, J. L., and McDonald, J. M. (eds.) (1982). *Handbook for textile marketing*. New York: Fairchild Publications.

Key Words

100 percent inspection acceptance sampling ANSI/ASQ Z1.4-1993 commercial testing services

consumer goods converters defectives defects fabric brokers fabric jobbers fabric wholesalers fancies horizontal integration independent quality management group inspection lot mergers MIL-STD-105D mill mill flaw repair objectives overruns

primary sources

producer goods
product development team
quality
quality assurance (QA)
quality audits
quality control (QC)
quality cost indexes
quality manual
quality policy
quality standards
sampling plans
secondary sources

spot prices
staples
statistical quality control (SQC)
tailings
team incorporating
management representatives
tolerances
total quality management
(TQM)
vertical integration
Worth Street Rules

Discussion Questions and Activities

- Develop an inspection procedure for a simple product such as a T-shirt. How many times should it be inspected during the production process? Who should be responsible for quality control of the Tshirt? Identify the product standards that are needed in order to evaluate the quality of this product.
- 2. What is the basis of acceptable quality during quality control inspection?
- Identify and discuss advantages and disadvantages of 100 percent inspection of finished goods as the primary technique for quality control. Identify and discuss the

- advantages and disadvantages of acceptance sampling as the primary basis of quality control.
- 4. What is the role of the lot in acceptance sampling? How is the lot determined?
- 5. How can a quality program that requires investment in planning, people, space, and equipment reduce costs and increase profitability?
- 6. Quality management is the effort applied to ensure that end products/services meet the intended requirements and achieve customers' satisfaction. Who is responsible for quality?

Materials Sourcing and Selection

OBJECTIVES

- Explore the role of sourcing within an apparel firm.
- Examine materials sourcing processes.
- Explore the responsibilities of buyers of materials.
- Examine fabric selection in relation to garment aesthetics, performance, and quality.
- Discuss sources of product information.

Sourcing is the determination of the most cost-efficient vendor of materials and/or production at a specified quality and service level. Sourcing processes are rapidly changing to take advantage of improvements in communication technology and business partnerships. International trade regulation is ever present in sourcing decisions. This chapter introduces basic concepts of sourcing and focuses on issues involved in selecting and sourcing materials, particularly fabrics. Chapter 9 continues with a discussion of sourcing apparel production.

The Role of Sourcing in an Apparel Firm

As previously discussed, the strategic business plan provides direction and financial objectives for an apparel firm's functional divisions. Figure 8–1 shows the relationships of key business functions to materials and production sourcing. Merchandise plans determine the numbers of styles, sizes, and colors that are appropriate according to sales forecasts and other data. Production capacity estimates are translations of merchandise plans into numbers and types of plants, machines, and operators required to produce the line. The combination of sales forecasts, merchandise plans, product specifications, and production capacity estimates provides a basis for developing an effective materials and production sourcing network.

Make-or-Buy Decisions

A basic decision in sourcing either materials or production is whether to make or buy the desired product. Making involves producing the materials and/or finished products in the firm's own production facilities. Buying involves contracting with another firm to produce the product. **Make-or-buy decisions** arise as the result of the development of new products, need for specialized equipment and skills, unsatisfactory supplier or contractor performance, and increase or decrease in demand for established products.

Figure 8–1 Organization of sourcing systems for apparel firms.

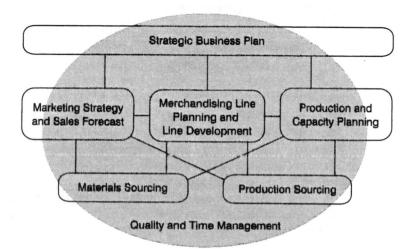

Considerations that may favor making materials and/or finished goods include the following:

- 1. less expensive to make it,
- 2. availability of excess plant capacity and specialized equipment,
- 3. need to exert direct control over production and/or quality,
- 4. unreliable service from vendors or contractors,
- 5. desire for design secrecy,
- 6. desire to maintain stable workforce in period of declining sales,
- 7. volume requirements too large or too small,
- 8. desire to integrate phases of production, and
- 9. limited lead time with Quick Response (QR) systems.

Considerations that may favor buying the materials or finished goods include the following:

- 1. less expensive to buy it,
- 2. small volume requirements,
- 3. short product life,
- 4. close supervision of quality is less important,
- 5. own inadequate production facilities, equipment, or capacity,
- 6. need for supplier's expertise and know-how,
- 7. desire to maintain stable workforce in periods of rising sales,
- 8. desire to develop or maintain a multiple sourcing strategy (adapted from Dobler et al., 1984).

Four factors stand out above all others when considering make-or-buy alternatives in the apparel business: (1) costs, (2) production capacity, (3) quality, and (4) timing.

COSTS The first tool a manager needs when making sourcing decisions is product specifications in the form of a bid package. The bid package is the basis of negotiating price, delivery, and direct cost estimating. These provide the basis of the make-or-buy decisions. The direct cost estimate includes costs of materials, direct labor costs, and variable costs of factory usage such as start-up costs and training. Only direct costs and variable overhead are variable costs. Nonvariable overhead is an expense that continues to accumulate whether the product is made or not and should not be included in the make-or-buy decision.

The cost estimate for making the product is compared with a price quote from the prospective **supplier** or contractor. A **price quote** is the estimated purchase price of the product given certain quality standards, quantity, and delivery dates. A potential contractor/supplier uses the product specifications to

determine the price quote for the product. To give a realistic picture of buying costs, the item's total cost must include agent or broker fees, quota and/or tariffs, insurance, transportation, receiving, and quality management costs. The make-or-buy cost comparison provides the economic basis for consideration of plant capacity and other issues.

PRODUCTION CAPACITY There are two aspects of production capacity to consider when making sourcing decisions: required capacity and demonstrated capacity. **Required capacity** is the total *need for output* of materials, product parts, or finished goods in a specified period of time at the expected quality level. Required capacity may be determined for quantities of materials, parts of products, individual styles, or product lines. **Demonstrated capacity** is the volume of output that a plant, work center, or machine is *capable of producing*. Operator skills and equipment determine types of goods that can be produced. The number and type of machines, labor hours, and productivity determine volume of output.

Materials and finished goods production plants tend to specialize in specific types of products. Equipment, technical skills, and quality control procedures are often specific to the product type and quality characteristics. Specialization of equipment and expertise limits a plant's flexibility relative to changes in materials or styling. When a firm's production capacity or capabilities do not match up with market demands or the approved new styles, alternative sources of production must be found.

QUALITY Quality standards are often factors in sourcing decisions. Selection of sources that provide goods that match the quality standards desired is an important part of sourcing. Types of equipment, skills of operators, and quality control tend to be geared to a particular quality level. Some plants are set up to produce budget-type goods; other plants are set up to produce better-priced goods and have different production and quality standards. Selecting a source that normally produces goods at the quality and cost level desired is more expedient than attempting to change the plant's mode of operation. It is easier to monitor or assume part of the quality control function if a manufacturer or contractor is located in close geographic proximity to the sourcing organization.

TIMING Timing is critical to both manufacturers and retailers. Timing affects placement and volume of orders as well as production deadlines. As proportions of fashion goods increase in retail assortments and competitive pressures reduce gross margins, retailers have increased their expectations in terms of delivery. Retailers want to place smaller initial orders closer to the time of sale on the retail floor and get fast replenishment of "hot items." This is the major impetus to the QR programs. Retailers prefer less investment in inventory for a shorter period of time; assortments are tailored to customer demands. The ap-

parel firm who can provide the fast and dependable timing for the merchandise has the opportunity to establish lasting, cooperative relationships with its retail customers.

For technologically advanced apparel firms, sourcing networks involve electronic communication systems including electronic data interchange (EDI) and the Internet. Electronic communication makes it possible to reduce the time between order placement and delivery. For example, the normal in-process time after receipt of an order for woven labels is 2-6 weeks. Adding mailing time for the order and delivery time for the labels means a required time of 4-10 weeks before delivery (Smarr, 1987). Manufacturers and suppliers use electronic communication to eliminate mailing time, to transmit designs and specifications, to evaluate test runs and samples, and to provide an access to each other's inventory data in order to anticipate needs and to eliminate delays for such things as order confirmations. Electronic communications makes it possible to reorder after test marketing and/or sample production instead of having to order total quantities long before production begins. Reduction of inventory throughout production and distribution cycles has a profound impact on the overall profitability of apparel firms.

Make-to-Stock or Make-to-Order

A fundamental business policy reflected in a sourcing plan is the decision to make-to-stock or make-to-order. Basic goods have traditionally been made-to-stock, while fashion goods have been made-to-order. An apparel firm may use either or both inventory strategies depending on its product line(s) and target market. Make-to-stock planning involves relating sales forecasts to inventory levels while make-to-order relates sales forecasts to order backlog.

The sourcing plan for make-to-stock goods is based on the following formula:

sourcing plan = forecast + (desired ending finished goods inventory - starting finished goods inventory)

The total inventory on hand may be expressed in terms of days, weeks, or months of supply. The firm using a make-to-stock system often has a large investment in inventory of finished goods. With a make-to-stock system, production can be scheduled to maximize use of production capacity, equipment, and labor. Accuracy of the sales forecast determines how well the inventory on hand satisfies the orders for goods.

For **make-to-order** planning, the goal is not to maintain finished goods inventory. QR systems are based primarily on make-to-order sourcing plans. The goal is to have zero inventory at the beginning and end of each selling period. Make-to-order reduces the risk of creating an inventory of unwanted colors or

styles. It is common for apparel manufacturers to delay the actual production of fashion goods until after orders from retailers are received. Private-label lines are also made-to-order.

Customized goods may involve a combination of make-to-stock and make-to-order. With some products the manufacturer may assemble the products up to a certain point and finish them to the buyer's specifications when orders are received. For example, the firm may offer a line that includes screen-printed designs or custom logos that are applied to T-shirts before the order is shipped. The T-shirts are made-to-stock in a specified assortment of fabrics, sizes, and colors. When orders are received, the appropriate designs are applied and the order is packed and shipped.

The sourcing plan for make-to-order goods is based on the following formula:

sourcing plan = forecast + (starting order backlog - desired ending order backlog)

Order backlog refers to all orders received and not yet shipped. (Some companies use the term *backlog* to refer to orders with shipping dates that are past due. That is not the use of *backlog* for this discussion.) As with inventory, backlog may be stated in terms of days, weeks, or months of supply.

The concept of order backlog is controversial among the marketing, merchandising, and production divisions of an apparel company. Production prefers a higher level of backlog before initiating production because start-up costs cut into profits. On the other hand, marketing views the backlog from the stand-point of customer service. Marketing wants low levels of starting and ending backlog so that customers are supplied with complete orders as promptly as possible. Merchandising is concerned with the shipment of complete coordinated groups or related separates. Complete assortments must be on the retail selling floor to maximize sell-through.

Many firms **produce against forecast** on a make-to-order system. Orders are anticipated instead of waiting for an order backlog before beginning production. Their ultimate goal for the end of the season is zero stock, but a number of factors may cause the firm to begin production early. The anticipated volume may be greater than can be effectively produced or sourced during the regular season. Producing against forecast makes possible early delivery to retailers who want the goods first in their markets. Merchandisers may also use early production to test new styles for acceptance in the market and then forecast sales accordingly.

Both make-to-stock and make-to-order systems for materials and finished goods are under pressure to reduce the time required for the total production cycle. One advantage that domestic producers have over foreign producers is proximity to the market. Domestic manufacturers are now trying to exploit this advantage by providing faster turnaround time.

Materials Sourcing Processes

Materials sourcing seeks and negotiates the acquisition of fiber, yarns, fabric, interlining, buttons, zippers, and so forth. Strong, supportive relationships with materials vendors are essential to successful execution of the merchandising process. Materials supply determines the availability of fabrics and findings for production of finished goods. Materials development, selection, and sourcing are often a responsibility of creative designers, technical designers, and or merchandisers when product development is part of the line development strategy.

Materials include fibers, yarns, fabrics, and findings. Sometimes fibers and yarns are sourced to be made into fabrics desired for the product line. Fiber and yarn orders must be placed well ahead of line development for a particular selling period. Fabrics are the materials that are cut and assembled into garments. Fabric orders are often committed very early in line development, especially if the yardage is to be used for prototype garments. Not only does the fabric have to be appropriate and suited to the garment design and end use, but it also must be available at the precise time that it is needed. Deliveries of all materials required for a style must be coordinated for production to begin on time.

Orders for materials may be placed before styles have been tested, thus imposing considerable risk with each order. Merchandisers must consider the anticipated sales volume for each style since repeat orders are often not possible. Lines are often planned with several styles or a group from the same fabric. Styles that do not sell at wholesale in adequate numbers are canceled and do not go into production. The fabric is committed to other styles in the group that do sell in adequate volume ("hot numbers"). If the entire group does not sell, the manufacturer may take a loss on the fabric, but a loss on fabric is less than a loss of fabric plus garment production costs. Fabrics from canceled styles may be used for different styles or sold to jobbers, fabric wholesalers, or retailers.

Findings are all the materials other than fibers, yarns, and fabrics that are required to make garments. Examples of findings include interlinings, trim, zippers, buttons, thread, and labels. Findings sourcing requires the same careful planning as sourcing fabric. Compatibility with other materials, for both wear and renovation, is a major consideration that must be examined and resolved before purchasing. Lines that require a wide variety of decorative trims can create costly inventories of materials. Trims are also more difficult than fabrics to sell at the end of a season. Ordering materials for delivery as close to production as possible reduces inventory costs associated with early commitments. On the other hand, other types of costs are incurred when deliveries are late and materials are not available when styles are scheduled to go into production.

Materials Sourcing Responsibilities

Sourcing involves a series of strategic management decisions that includes merchandising, production, and marketing managers. The people responsible for acquisition or procurement of materials may include buyers, designers, merchandisers, sourcing specialists, or purchasing agents. (For convenience in this discussion the sourcing agent, whatever the title, is simply called a buyer.) Decisions are based on product requirements, production capabilities, lead time, quality, and cost. Product specifications provide the detailed information the buyer needs to make decisions. The amount of latitude the buyer has in product selection depends on the specificity of the product specifications and the time frame for acquisition. Buyers determine exactly which products are purchased, vendors, delivery terms, methods of transportation, and the price. Buyers also are responsible for negotiation of price adjustments if materials or service is unacceptable. Table 8–1 itemizes the responsibilities of materials buyers.

Materials buyers must ensure that suitable materials are available at the appropriate locations when production is scheduled to begin. The quantities of fabric and findings that buyers must make available for apparel production at any particular time and place are determined by a group of interdependent managerial decisions. These include sales forecasting, preseason style testing, merchandise line planning and development, production capacity estimating, minimums, and whether reorders are possible. The amount of flexibility in sourcing depends on whether product specifications are open or closed. If product specifications are closed (product and vendor are identified by brand name), the buyer negotiates with the specified vendor for quantities, delivery terms, and price for the product. If the apparel firm's product specifications are open (a brand name is not used), the buyer searches the market for a product that is the best value to meet the specifications.

Table 8–1Responsibilities of materials buyers.

- Provide an uninterrupted flow of materials and services necessary for maximizing the efficiency of the manufacturing process.
- Buy materials that are suitable to the purpose at the best possible prices.
- 3. Minimize inventory investment.
- 4. Minimize inventory shrinkage and losses due to theft and unusable, damaged, or obsolete materials.
- 5. Develop good vendor relationships and sound, continuing supplier relationships.
- Develop reliable alternative sources of supply.
- Develop personnel and execute policies and procedures that provide materials at the lowest possible costs.

Source: Adapted from Dobler, D. W., Lamar, L. L., Jr., and Burt, D. N. (1984). Purchasing and materials management. New York: McGraw-Hill. Vertically integrated apparel firms may have the option of producing some of their own fabrics or findings when they have appropriate equipment. A buyer may compare the relative cost and timing of making the product in-house to acquiring it from an outside supplier. Thus, materials sourcing involves the make-or-buy decision. Often, better-quality and lower-cost materials can be purchased from outside suppliers that have highly specialized equipment and expertise and are capable of high-volume production at low unit cost.

RETAIL BUYERS VERSUS MATERIALS BUYERS Responsibilities of materials buyers differ from retail buyers. Retail buyers are usually involved in consumer goods wholesale markets. The chief responsibility of the retail buyer is to form a select assortment of finished goods to offer the store's customers. Retail buyers visit apparel markets and manufacturers' showrooms to (1) select from their product lines, (2) work with manufacturers and contractors to develop unique, private-label merchandise for their firms, and (3) often attend fashion shows and designer openings to review product offerings and fashion trends. Fashion shows help retail buyers understand fashion trends, silhouettes, and color systems. Apparel manufacturers use fashion shows to promote their product lines.

Materials buyers are usually involved in purchasing producer goods in primary markets at the mill level. In general, markets for producer goods have less fashion and seasonal influence than markets for consumer goods. Materials buyers tend to make higher-volume purchases from fewer suppliers. Materials buyers often make decisions a year in advance of the retail buyers regarding the same product lines. Decisions made by the materials buyers limit the assortments offered to the retail buyers. Materials buyers, designers, and merchandisers may attend fashion shows presented by manufactured fiber producers or major fabric mills. Some materials buyers attend semiannual fabric shows held in the United States, Germany, Italy, Japan, and other foreign countries. National and international fabric markets, such as Interstoff in Germany, provide opportunities for mills and converters to display their new lines to apparel merchandisers, designers, and materials buyers.

Both materials and retail buyers are limited by budgets, contract terms, and inventory space. Traditional systems for contract negotiation and terms for materials purchasing are reflected in the Worth Street Rules. In spite of the fact that the Worth Street Rules have been codified since 1929, it is not unusual for an industry participant to have never heard of them. However, the customs and method of doing business represented by the Worth Street Rules are widely used. Retail buying practices have not been codified in a similar manner.

Oral contracts between apparel manufacturers and textile firms are common. Agreements are reached over the telephone or electronically for purchases of thousands of yards of fabrics. The oral contract is later confirmed with a written contract or E-mail (electronic mail), but perhaps not until after the goods are shipped. In contrast, apparel manufacturers often do not regard orders as

confirmed until after they have "paper," a written copy of the order signed by a retail buyer, except when electronic communication is in use. The satisfaction with the purchase is dependent on the appropriateness of the materials for end use, their quality, aesthetics, performance, and timely delivery.

Selecting Fabrics

The international textile market system provides the environment within which fabrics are designed and produced. According to the Worth Street Textile Market Rules, it is the apparel manufacturers' responsibility to determine suitability to end use. It is the fabric manufacturers' responsibility to provide serviceable products and information about the quality and performance of their products. Designers and merchandisers select and combine fabrics and findings that meet cost limitations and perform according to the expectations for the style and of the firm's target customers. Materials buyers carry out the process of acquiring the desired materials.

The fabric selection process is carried out in a number of ways. For fashion goods, the primary concern may be aesthetic factors such as color and texture, while performance characteristics such as count and fabrication may be secondary considerations. Designers and merchandisers may go to major fabric markets to collect ideas, check trends, examine new products, and seek sample yardage. Expectations for lead times for fashion goods are often short because of rapidly changing product lines.

For basic goods, priorities for aesthetics and performance may be reversed. The buying process for basic goods may be more systematic with more analysis of performance characteristics before the buying decision. Fabrics may be designed and developed by apparel designers or merchandisers and ordered from mills or converters according to the apparel manufacturer's specifications. Acquisition of fabric is accomplished after fabric samples and product specifications have been examined and lead times, minimums, delivery dates, put-up, and price have been negotiated.

Product Identification

Appropriate fabrics are identified based on product information and testing provided by fabric vendors and/or testing and product development conducted by apparel manufacturers. Sources of information include fabric samples, specifications, and certification.

FABRIC SAMPLES Apparel manufacturers' designers and merchandisers work with sample lengths of about 5 yards. Fabric samples are frequently accompanied by specifications and other product information as an indication of prod-

uct quality, aesthetics, and suitability to end use. When styling and innovation are high-priority criteria, samples are essential. Swatch books are frequently used by fabric and garment sales representatives to promote and sell their products. Fabric specifications provided by fabric vendors may or may not include fabric samples.

FABRIC SPECIFICATIONS The amount of information included in a style's fabric specifications varies from basic fiber content to complete descriptions of the material and results of standard performance tests. Specifications provided by a fabric vendor may include product name, style number, fiber content, finishes, dyes, performance evaluation, methods of manufacturing, and quality standards. Figure 8–2 provides an example of product information a vendor might provide for a materials buyer to evaluate in relation to style specifications.

FABRIC CERTIFICATION Some vendors provide certification of product quality. **Fabric certification** is a statement of compliance to specifications. Certification is intended to provide assurance to the buyer of the quality of goods shipped and eliminate the need for receiving inspection. In these days of QR and Just-in-Time production, certification of fabric quality can cut days or weeks from the apparel manufacturer's production process by eliminating the need for fabric inspection and reducing production delays because of inconsistent materials.

Certification data include

- documentation of flaws and their locations, number of splices, and width of fabric;
- reports of evaluation of compliance to specifications including types of tests performed, methods used, and the results;
- identification of the laboratory or facility, operators, and dates when the evaluations and tests were performed; and
- documentation of traceability of purchase order numbers, lots, markings on the materials.

A major jeans manufacturer and its denim supplier have established a unique partnership whose heart is fabric certification. The denim mill both supplies and cuts fabrics for the jeans maker's 807 operations. This is not a common practice in the industry, but it has worked so well, they have planned to use only certified vendors in the future. This means that the jeans maker depends on the vendors to ship the quantity and quality of goods they have agreed upon.

Lead Times

Lead time varies with point of origin, shipping methods, whether materials are open stock or custom designed, and whether products are performance tested before production begins. Imported fabrics or other materials may require 6–9

RAVEN®

Setting the Standard for Outdoor Protection

Military Approved Gore-Tex® All Weather Parka and Trouser – A High-Tech Extreme Cold Weather Clothing System (ECWCS)

Lightweight, versatile, and durable, the intrared resistant ECWCS outer garments are constructed of an exclusive 3-layer laminate of GORE-TEX® and rugged, abrasion resistant Taslan, Jr. cloth treated to resist water and stains. Used in combination with the layering concept, the ECWCS will provide protection from +70° to -50° F. Guaranteed windproof, waterproof, and snowproof - plus "breathable" for comfort during warm weather and active use. Designed to prevent leakage, all seams are heat sealed for unbeatable protection.

GORE-TEX® parka, trouser, and fabric covered by the following specifications: Parka, Extended Cold Weather Camouflage – MIL-P-44188; Trouser, Extended Cold Weather Camouflage – MIL-T-44189; and Fabric, Cloth. Laminated, Waterproof and Moisture Vapor Permeable – MIL-C-44187.

Underarm zippers provide ample ventilation, essential during active use.

interior drawcord pulls hood tight giving you extra warmit

18-inch zippers let pants slip easily over boots. Velcro strips

ECWCS PARKA - MAWP-8201/2 - (Commercial equivalent to NSN 8415-01-228-1313) Woodland Carnouflage

- 3-Layer Tasian Jr. GORE-TEX* tabric construction with factory sealed seams.
- Hung nylon tatteta liner with access slot.
- Internal storm skirt
- Doubled storm flap tront body zipper with snap down outer flap.
- Underarm ventilation zippers for body cooling.
- Polyester coil zippers for ease of operation in coid temperatures.
- Two storm flapped front pockets with Velcro* closures and snaps.
- Two large breast pockets with Velcro* closures accessible without unzipping.
- · Sleeve pocket with Velcro* flap.
- Reinforced double layer elbows.
- Veicro[®] closure cuffs.
- Peripheral vision oversized hood with visor and drawcord.
- Drawstring waist & hem.
- Badge/Insignia holder.
- Oversize cut to accommodate layering.

ECWCS PARKA - (2.5 LBS.)

Unisex Sizes	XXS	XS	S	M	L	XL	XXI.
To Fit Women	6-8	8-10	10-13	12-14	14-16		
To Pit Men	30-32	32-34	35-37	38-40	42-44	46-48	50-52
Sized to fit over a	down po	urka If i	n doubt	choose	a smaile	r size	

ECWCS TROUSER - MAWT-8202/2 (Commercial Equivalent to NSN 8415-01-228-1342) Woodland Carnoutlage

- 3-layer Tasian Jr. GORE-TEX® tabric construction with tactory sealed seams.
- Double layer reinforced seat and knee.
- Polyester coil zipper fly.
- Drawstring waist.
- 18" polyester coil leg zips with bellows bottom. Velcro® cuff closures to seal out weather.
- Side pocket access to inner wear and also providing ventilation.
- Suspender loops.
- Oversized cut to allow layering.

ECWCS TROUSER - (1.5 LBS.)

Unisex Sizes	XXS	XS	S	M	L	XL	XXI.
Waist*	21-24	24-27	27-30	30-34	34-38	38-42	42-46
Inseam	25	26	28	30	32	32	32

^{*} Actual waist size, measure yourself with layers on.

RAVEN® industries, inc P.O. Box 1007 205 East 6th Street Sloux Falls, SD 57117 606-338-2750

for quality outerwear you can trust

Figure 8-2

Product description, performance, and quality information provided by vendor.

months' lead time, while domestically produced fabrics may require a few days to 3 months depending on availability and additional processing. Lead times for materials may be reduced significantly when QR programs are put in place.

Open-stock materials have shorter lead times and are usually lower priced than goods made to the apparel firm's specifications. Open-stock materials are often available for immediate delivery and can be reordered because mills and converters make them to stock in anticipation of demand instead of making them to order. Open-stock fabrics consist of common fabrications such as gingham, poplin, and chambray. They are offered in basic colors such as red, blue, black, white, and the fashion colors of the season. Mills develop sample yardage, swatch sets, and sample garments of open-stock materials that are displayed at trade shows for potential buyers. Sales reps may also show them to potential customers.

Converters often develop printed fabrics and offer them for sale as open stock. Greige goods may be purchased and stored by a converter in anticipation of fabric orders. Greige goods can then be printed or finished to order. This provides flexibility and delays decision making on the final fabric.

Fashion firms that specialize in **unique original designs** may employ their own fabric designers, use computerized fabric design systems, and/or they may purchase prints from a fabric design studio and adapt then to their own needs. Fabric design studios employ artists that create hundreds of different designs each season either freehand or on the computer. A manufacturer or retailer that is shopping for a special print may review available art or have a specific print developed. The purchaser of the print may work with the studio to modify the design or may make his or her own modifications. Fabric prints are copyrighted by the artist or studio but when a print is purchased the new owner controls the copyright and can modify it as desired. An apparel firm can also get an exclusive **confined print** design by purchasing a full production run from a mill or converter. Confined prints are available only to the firm that purchases the fabric design.

Special structural designs in woven and knitted fabrics may be developed by working with fabric mills. For example, knit designs are charted and interlacing patterns are determined for wovens. To be producible, fabrications must be compatible with equipment available at the mill. Frequently mills or trade associations, such as Cotton Inc., maintain libraries of new fabrications that designers use in making fabric decisions. Fabrics ordered to specifications may take extra time because they have to go through the sample approval process before the goods are produced.

Apparel firms with basic product lines often place large orders with mills for basic greige goods, like print cloth, and use converters to print or finish the fabric as needed. Prices of greige goods are based on conditions in the market. For example, cotton prices are affected by favorable or unfavorable growing conditions, a major insect infestation in one of the major producing countries, or unusually high or low demand for cotton fiber in the world market. If prices are expected to rise, orders may be placed many months ahead of the actual need.

This locks in the price and guarantees the manufacturers that the fabric is available for garment production.

When large quantities (millions of yards) of greige goods are purchased by an apparel firm several months in advance, the apparel firm warehouses the fabric and has smaller quantities (several thousand yards) printed in fashion colors and fabric designs close to the time of cutting the garments. Manufacturers work closely with converters to develop the designs and colorations planned. Buying fabric based on supply and demand is high risk business but the potential savings are great if the buyer is really on top of trends in world markets.

Large firms often place huge blanket orders with a mill to guarantee their commitment to a certain fabric volume during the course of a year. Delivery is made in quarterly or monthly shipments. This practice guarantees the firm's business with the mill so the mill can plan its production and additional sales.

Order Minimums

Order minimums are another factor affecting materials selection. An **order minimum** is the smallest quantity a vendor will sell on a single purchase order. Minimums established for vendor efficiency may be inconsistent with an apparel firm's needs for variety in materials or finished goods selection. Textile, apparel, and retail firms often disagree as to what is a reasonable minimum order. Many fashion firms want to buy fabrics and other materials in small quantities of a variety of fabrications and colors. However, materials vendors establish minimum quantities that are feasible to produce and distribute. Imported goods may require longer lead time but often have lower minimums than domestically produced materials. Minimums also relate to availability, order processing, packaging, and shipping costs. Start-up costs for a single run can be prohibitive if the volume is small.

Open-stock fabric is usually available with smaller minimums than custom-order fabric. With open-stock fabrics, production costs including start-up costs are spread over a large quantity of fabric. With custom fabrics, all costs have to be covered by the limited amount a single firm can sell. Special-order fabrics usually have larger minimums, more exclusivity, and are often higher priced. Special orders may require special lab dips to verify color match. Made-to-order printed goods may require several strike-offs or test runs to check the colors and print quality with the print designers or fabric buyers. One hundred yards of fabric may be required for one strike-off of a roller print.

Converters may offer quicker delivery and smaller minimums than fabric mills. Some U.S. textile mills have open-stock fabrics available with 500-yard minimums for both prints and solids. For special prints, 6,000 yards may be the minimum, with a 5,000-yard minimum on special solid colors. Some Far East textile vendors offer confined or exclusive prints for 3,000 yards per design with a 1,000-yard color minimum.

An order minimum of 5,000 yards will produce excess inventory if only 3,000 yards is required to meet projected orders. Fabrics used for fashion apparel have

a short market life and usually cannot be carried over to the next season; therefore, the shelf life of fabric also becomes a factor in determining costs. Often excess fabric from fashion goods ends up being sold to a jobber much below cost.

Fabric Put-Up

Fabric **put-up** is the manner in which the fabric is folded and/or rolled by the vendor. An apparel firm usually buys woven fabric that is rolled full width on a cardboard tube. Tubular knits may be put up in rolls or flat folded. Flat knit goods are usually rolled. High-pile fabrics such as velvets may be wound and hung from a creel that keeps pressure off the surface of the fabric. Fabric characteristics and put-up determine the type of markers that are used and how the fabric is spread and cut. A full roll is usually 60–100 yards in length. Some firms may specify that fabric be put up on large rolls up to 300 or more yards in total length. The firm may also specify the maximum number of pieces, perhaps no more than three, that can make up the total yardage in the roll. This minimizes the number of fabric splices, amount of waste, and amount of handling in the spreading process.

Shorts, tailings, and remnants are fabric less than 40 yards in length. Shorts and tailings may result from experimental fabric runs, removal of defects, ends of rolls, and overruns. Some manufacturers may use short spreads using these short yardage pieces. Shorts are also retained for recuts of damaged or missing pieces. In Levi's 807 operations these are often sent with the cut goods to the sewing plant in case there is a problem.

Fabric jobbers are often the buyers of shorts, tailings, and remnants that are not kept. Shorts and tailings are sold as "20s to 40s" or "10s to 20s" and are more likely to be put up as flat folds. **Remnants** are less than 10 yards in length and may be sold by the pound.

Apparel firms may specify how fabric is to be packaged for shipping. Traditionally, rolls of fabric have not been covered except for tape to prevent unrolling. The first 3 or 4 yards of each roll were often discarded because of damage or soiling. Imported goods are packaged in plastic for protection. Many domestic fabric vendors now provide the option of plastic or paper packaging.

The put-up of fabric for over-the-counter sales differs from put-up for apparel manufacturing. **Over-the-counter** fabric is less than 30 yards in length and doubled and rolled on a flat bolt. Shorts and tailings may be purchased by fabric jobbers and sold to fabric retailers as flat folds.

Materials Testing

The amount of **materials testing** performed by the apparel manufacturer is another factor in determining the lead time. Inadequate performance testing of materials can result in poor performance and unsatisfactory finished garments. Testing is usually done to sample yardage before major purchase commitments are made. Apparel manufacturers' quality control procedures determine whether the performance of materials is tested prior to garment assembly. Some

merchandisers depend on specifications provided by fabric producers; others develop their own specifications for the materials they need. It is safer to do some performance testing before ordering large quantities of fabrics rather than finding out after the fact that fabric or trim is not colorfast, washable, or compatible with other materials.

Prices, Price Adjustments, and Costs

Fabric buyers are responsible for sourcing the specified quality of particular fabrics at the most favorable prices. Buying decisions are only as good as the accuracy of information, consistency of products, and judgment of buyers. For the most part, production of higher-quality goods costs more than the production of lower-quality goods, since higher-quality goods usually require more expensive materials and more steps in processing.

There are additional price-related factors for buyers to consider such as advertising support, guarantees, and adjustments for defective merchandise or late deliveries. The buyer is responsible for securing discounts, credits, or refunds on unsatisfactory goods or services. Some suppliers offer cooperative advertising programs in which they provide a share of an advertising campaign that includes the names of both the materials supplier and the apparel manufacturer. Fabric certification and guarantees may reduce the hassle involved in negotiating price adjustments on defective or late delivery.

Actual fabric costs are affected by many factors such as availability, selection and quality, handling, processing, and utilization. Many of these factors affecting costs are discussed in other sections of this chapter and other parts of the textbook. Actual costs are continually compared with allowable costs for fabric and components according to the merchandise plan. If fabric is flawed, off grain, or difficult to handle, costs can increase dramatically, causing actual costs to be substantially greater than budgeted costs. Defects have to be removed, the fabric spliced, and the defective yardage and splicing accounted for in the costing process. Costs increase as the number of defects increase. In some instances, actual costs may show that it is less costly to purchase more expensive fabric with a guarantee of fewer defects than to use the less expensive but more defective fabrics. Fabric storage and obsolescence are also cost factors that should be included in fabric costs.

Professional Credibility of Suppliers

When an apparel firm has established productive relationships with materials vendors, the regular suppliers are always the first sources considered. If a buyer wants to make price or quality comparisons or needs to source a new product, additional vendors may be considered. One of the difficulties materials buyers have is finding vendors that are able to supply particular products. This is especially true for new manufacturers that have not established a sourcing network in the marketplace. A number of directories and source books are

published for different types of products. In addition, a firm may subscribe to one of several commercial computer databases that provides vendor information. Many of these are now available on the Internet.

Buyers often use referrals from other firms as a reference in locating a supplier for a particular product. A vendor's reputation in the trade is often a strong factor in determining whether the materials buyer will seek a firm as a supplier. The buyer may consult a vendor's advertising and evaluate the quality of information supplied about its products or look for information about product specifications, testing, and quality control. A Dunn and Bradstreet credit rating is also a common reference to verify professional credibility.

The quality of service offered by a vendor is an important consideration. What is the vendor's history in terms of product quality and timing of delivery? What is a vendor's production capacity and who are the vendor's major customers? What testing services are offered? What is the turnaround time from order to delivery? Do vendors have appropriate labor practices? Does the vendor use compatible communication technology? If the vendor has several large, established customers that require most of the vendor's production capacity, it may be difficult to get delivery. New orders may not have the same priority as those for established customers.

The services and products of both potential suppliers and established suppliers need to be evaluated on a regular basis. Factors that are considered in evaluating potential or past performance of suppliers are listed in Table 8–2. Priorities for supplier performance may differ for different products and product lines. For some budget lines, price may be the overriding factor. For some fashion lines, innovation, minimums, and timing of delivery may be the most important factors. For some lines, the cooperation of the supplier in assisting with product development may be important.

Predicting Aesthetics and Performance

Fabrics are selected, purchased, and cut to form shells of garments. Criteria for determining acceptable quality of fabric is based on aesthetic and performance needs of particular styles. It is often difficult to judge relative quality of a material. Skills for judging fabric quality develop with experience. Fiber content, yarn types and sizes, fabrication, count or gauge, weight, hand and drapeability, structural or applied design, color application, finishes, and care all contribute to aesthetics, performance, and quality of fabrics.

Fiber Content

Inherent properties of textile fibers determine the fundamental performance potential of fabrics. For example, for sheer, lightweight fabrics, strong fibers are

Table 8-2

Materials supplier performance evaluation.

Professional credibility

History

Market information

Quality management program

Communication/follow-up

Technical assistance

Reputation in the trade

Personalities

Credit rating

Production and delivery capabilities

Production capacity

Confinement/exclusivity

Minimums

Lead time

Proximity to apparel production facilities

Delivery

- · Lab dips
- Sample vardage
- · Sales sample production
- Production

Shortage/overage

Quality

Production specifications

Market grades

Commercial standards

Samples

Color matching, shading, print clarity

Styling/innovativeness

Production standards

Testing and inspection processes

Price factors

Quality relative to value

Advertising support

Guarantees and warranties

Adjustments for defects or late delivery

important. For warm fabrics, bulk and loft are important. Textile fibers are generally classified into three groups: synthetic, manufactured cellulosics, and natural.

The petroleum-based **synthetic fibers** such as nylon, polyester, and acrylic differ fundamentally in performance characteristics from manufactured cellulosics and the natural fibers. Synthetic fibers tend to be high in strength, abrasion resistance, heat sensitivity, and resiliency and low in absorbency. Natural and cellulose-based manufactured fibers tend to be higher in absorbency and lower in strength, abrasion resistance, and resiliency.

Manufactured synthetic and **cellulosic fibers** are marketed in hundreds of different chemical and structural variants, each with slightly different properties. Brand names are used as a means of identification and differentiation among the many variants.

Descriptions of **natural fibers** like cotton and wool may include indications of market grade. **Market grades** are used as a basis of determining a product's suitability for end use and for establishing market prices for raw fibers. For example, natural fibers such as cotton and wool are graded according to quality standards for fineness, whiteness, cleanliness, and length of fiber. Fineness and whiteness vary with the variety or breed of the plant or animal. Cleanliness is determined by the effectiveness of processing. Cotton fiber ranges from 0.5 to over 2 inches in length; wool fiber from about 1 inch to over 5 inches. In general, the finer, whiter, cleaner, and longer the fibers, the higher the grade, quality, and price.

The market grade of the raw fiber may be included as a part of fabric descriptions with statements such as long staple, Pima cotton, or Merino wool. Higher-quality natural fibers make stronger, smoother, finer, more uniform, and more expensive yarns.

Yarn Quality and Size

Yarn quality is a primary determinant of fabric quality. It is related to yarn type and based on fineness, smoothness, and consistency. Contributors to yarn quality include fiber quality, amount of twist, type of yarn, and method of processing. Yarn production or finishing processes such as combed, mercerized, or worsted are indicators of quality. High-quality yarns make high-count, fine, smooth, lustrous, durable fabrics possible. Two or more strands twisted together to form **plied** yarns give increased strength and quality to yarns. Yarns might also be plied to create special or novelty effects, but novelty and special yarns are not always plied.

Yarn sizing systems may be very confusing because yarn size or yarn number, as it is commonly called, is defined using several different systems based on fiber type and in what country the yarn is produced. When yarns of the same fiber content are compared, **yarn number** is an indication of yarn diameter. In the United States, filament yarn size is determined by **denier**, which is the weight in grams of 9,000 meters of yarn or fiber. In many countries, the Tex system has replaced other yarn numbering systems. ASTM has also endorsed the **Tex** system, which determines yarn number by the weight in grams of 1 kilometer (1,000 meters) of yarn. Denier and Tex are both direct numbering systems; that is, the yarn number gets larger as the yarn diameter increases.

Woolen and worsted yarns use special sizing systems. Woolen yarn is measured by the number of 300-yard hanks per pound. Worsted yarns are measured by the number of 560-yard hanks in 1 pound of yarn. The higher the yarn count, the finer the yarn.

The traditional **cotton count** system is also an indirect numbering system. Cotton yarns are numbered by measuring the weight in pounds of one 840-yard hank of yarn. Cotton yarn numbers are reported as the number of single strand, 840-yard hanks weighing 1 pound. For example, a cotton yarn count of 40's or 40s means 40 single-strand hanks weigh 1 pound. The larger the number, the finer the yarn. Yarns for cotton shirtings might have the following yarn numbers:

20s—for singles yarns for lower-quality oxford cloth 40s—for two-ply yarns for medium-quality oxford cloth 50s or 60s—for singles yarns for medium-quality broadcloth 80s—for two-ply yarns for higher-quality, pinpoint oxford 100s—for two-ply yarns, fine cotton shirting

An example of a fabric that requires high-quality, long-staple, fine yarn is Liberty Lawn, a fine lightweight cotton fabric made in England. Liberty Lawn is very lightweight but opaque and durable because of extremely fine-plied yarns and high count. A lower-quality fabric of similar weight can be made with larger yarns and lower count. Lower-quality fabric may be less durable, less expensive, and more transparent because of lower yarn quality, lower fabric count, and more space between the yarns.

Fabric Weight

Fabric weight is a primary consideration in suitability to end use. Two general classes are often used to describe fabric weight: top weight and bottom weight. From a performance perspective, lighter-weight fabrics are more appropriately used on the top of the body above the waist and heavier-weight fabrics on the bottom of the body, below the waist, because garments on the lower half of the body receive more abrasion and stress. However, fashion sometimes dictates the use of top-weight fabrics in skirts or bottom-weight fabrics in shirts for a particular fashion look. Lighter-weight fabrics can be used below the waist when garments are appropriately styled.

More specifically, fabric weight is indicated in ounces per linear or square yard or yards to the pound. For example, the weight of denim generally ranges from 6 to 16 ounces per square yard. Weight is varied through the use of fiber content, yarn size, and/or fabric count. Most jeans used for general wear are made of 14-ounce denim. A manufacturer that wants to cut material costs or wants a softer fashion look may use 10- or 12-ounce denim. When severe forms of wet processing are used on finished garments, 16-ounce denim may be used because of the wear and tear of finishing.

Eight ounces per square yard and heavier is generally regarded as bottom weight. The following lists provide some examples of weights of fabrics and appropriate end uses as indicated by garment descriptions in L. L. Bean, J. Crew, and Lands' End direct mail catalogs.

Woven cotton or cotton/blend fabrics:

4.5-ounce chambray for work shirts

5.5-ounce oxford for shirts or robes

5.5-ounce seersucker for pants or shirts

6-ounce denim for shirts or fashion skirts or pants

6.5-ounce corduroy for shirts or dresses

7-ounce chamois cloth for shirts

6- to 8-ounce twill for casual slacks or shorts

9-ounce canvas for pants

9.5- to 14-ounce corduroy for jeans

10- to 16-ounce denim for jeans

14- to 18-ounce canvas for luggage or sneakers

Natural fiber and blended knits:

6.5-ounce jersey for sweats

10.5-ounce jersey for rugby shirts

11-ounce fleece-backed jersey for sweats

11.2-ounce mesh for polo shirts

16-ounce terry-backed jersey for sweats

14- to 18-ounce wool/blend jersey for ragg sweaters

Hand and Drapeability

The hand and drapeability of fabrics and other materials are important contributors to satisfaction with fabric aesthetics and performance. While hand and drapeability are related, **hand** refers more to tactile qualities, while **drapeability** relates to how fabric falls when it hangs, its ability to form graceful configurations. Hand and drapeability of a particular fabric are the result of the combination of fiber content, yarn type, fabric structure, and finishes. Analysis of acceptable hand and drapeability is usually subjective, based on the skills of the observer.

However, technology is being developed to objectively evaluate hand, drape, and related performance characteristics of apparel fabrics. The Kawabata Evaluation System for Fabrics (KES-F) is being used in Japan to correlate the subjective evaluation of hand with the objective measurement of mechanical fabric properties. One of the goals of the KES-F system is to predict behavior of fabrics in apparel manufacturing so objective purchasing specifications for hand and drape can be established.

The KES-F system was the basis of a group of research papers presented at the Second Australia-Japan Bilateral Science and Technology Symposium held in Japan in 1983. Researchers evaluated the correlation of mechanical properties of the fabrics as determined by the KES-F system with the fabric's behavior in sewing acceptable seams and in producing smooth curved surfaces, such as shoulders, collar, and lapels (Fortess, 1985). While the technology is being developed for an objective evaluation of hand and drape, the subjective evaluation remains the responsibility of apparel professionals.

Application of Color

The two basic types of substances used to color textile materials are dyes and pigments. **Dyes** are soluble and penetrate to the interior of fibers to bond with chemical structures. **Pigments** are particles of color that are not soluble and must be added to fiber-forming solutions or affixed to the surface of fibers with resins or bonding agents. The stages of production where color is commonly added include fiber dyeing, yarn dyeing, piece dyeing, and product or garment dyeing. Dyeing generally produces solid, all-over color on the material. Printing localizes the application of color to create a pattern or design. The earlier in textile production that color is added, the more uniform the color penetration and the more permanent the color would be.

Structural or Applied Design

Structural designs are intrinsic parts of materials. They are created through manipulation of yarns, fabrication, color, or texture. Novelty yarns included in knit and woven fabrications add interest and texture. Structural design created through fabrication depends on the use of color and texture in the yarns forming loops or interlacing patterns in the fabric. In general, structural designs are more permanent, better quality, and more durable than applied designs. Structural designs are more expensive to produce than applied designs due to slower production and longer setup time. The knitting machines and looms must also have the technology for varying fabric structure.

Applied design is created by printing, embroidery, quilting, appliqué, or other forms of fabric decoration. Some applied designs are mass-produced and very economical. Others are individual creations that are highly labor-intensive. Roller and screen printing are probably the most commonly used forms of applied design. Problems that are sometimes associated with printed designs are fuzzy patterns where edges of patterns are not clear and off-register prints where colors are not properly aligned.

Fabrication

The basic **fabrications** commonly used for fabrics are wovens and knits. Fabrics are often identified by names customarily used in textile trade. The

Table 8–3 (continued)Woven textile goods classified for marketing.

Filament (smooth) and textured (bulked) filament and filament/spun greige goods (Specification FFGG):

Taffetas

Ninons

Twills

Marquisettes

Satins

Voiles

Dobbies

Tri-blends

Pongees

Bi-blends

Print cloths

Batistes

Crepe de chines

Poplins

Georgettes

Oxfords

5. Goods sold for rubberizing, coating, and laminating

(Specification P.1):

Broken twills

Print cloths

Drills

Sateens

Enameling ducks

Sheetings

Osnaburgs

Source: Worth Street Textile Market Rules. (1986). Washington, DC: American Textile Manufacturers Institute, Inc.

design, and general use classification of fancy or staple. The quality of woven fabrics is generally based on fiber content, yarn size and type, fabric count, color application method, and whether design is structural or applied. The highest-quality fabrics are not necessarily the most durable fabrics.

- Class 1—"fine fancy goods and cotton and synthetic yarn mixtures and blends"; includes lightweight, yarn-dyed, combed and mercerized cottons and blends, that are special or fashion goods. Fabrics in this class have structural designs.
- Class 2—"fine cotton and blended greige goods"; includes light-weight, combed and mercerized, loom state, staple fabrics. These fabrics are prepared for piece or garment dyeing and/or applied designs.

Worth Street Rules include a classification system for woven fabrics as they are commonly sold in textile markets. The classification system includes categories of fabrics, recommended specification abbreviations, quality standards, and lists of fabric types and/or fabric names for the categories (see Table 8–3).

Notice the criteria listed here that provide the basis of the classification system including fiber content, yarn type, fabric weight, structural or applied

Table 8–3Woven textile goods classified for marketing.

Fine fancy goods and cotton and synthetic yarn mixtures and blends (Specification FF):

Combed handkerchief cloths

Plain combed and blended staples using color in warp or filling Piques and bedford cords using color in warp or filling

Other dobby weaves and jacquard weaves, carded or combed, or blended

Combed and blended shirtings and dress goods manufactured to buyer's specifications

Cotton and synthetic yarn mixtures manufactured to buyer's specifications

2. Fine cotton and blended greige goods (Specification FS):

Combed broadcloths

Poplins

Lawns

Voiles

Longcloths

Synthetic print cloths

Organdies

Piques and bedford cords

Challis

Sateens all or partly combed

Oxfords

Twills all or partly combed

Pongees

3. Carded cotton and carded blended greige goods

(Specification G):

Broadcloths

Paiama checks

Clothing twills

Pocketing twills

Drills

Print cloths

Four-leaf twills

Sheetings

Osnaburgs

Sateens

- Class 3—"carded cotton and carded blended greige goods"; includes lower-quality, heavier-weight, general use staple goods. These fabrics are prepared for piece or garment dyeing and/or applied designs.
- Class 4—"filament (smooth) and textured (bulked) filament and filament/spun greige goods"; includes staple goods made with filament or filament and spun yarns. These fabrics are finished primarily with piece dyeing or applied designs.
- Class 5—"goods sold for rubberizing, coating, and laminating"; includes
 a variety of staple goods such as fiber webs and lower-quality woven
 and knit goods. These fabrics are used as a substrate for additional materials such as plastics, vinyls, foams, and/or adhesives. Finished fabrics include special-purpose materials such as oilcloth and imitation
 leathers.

Worth Street Rules also include quality standards for knitted fabrics. There are two basic types of knits: filling knits and warp knits. Knits generally provide more elasticity than woven fabrics although some warp knits are stabilized both lengthwise and crosswise. Worth Street Rules include quality standards for four classifications of knit fabrics. Each fabric classification has certain appearance and performance characteristics associated with it (see Table 8–4). In place of or in addition to the customarily used fabric names, fabric vendors commonly assign brand names or trademarks to fabrics as a means of product differentiation and as an indicator of quality.

Table 8–4Knitted fabrics classified for quality standards.

1. Circular knitted fabrics

Basic fabrics—single-knit, rib, terry, double-knit, interlock
Face finished fabrics—velour, sanded, brushed, sueded, napped,
sheared, printed, bonded
Novelty fabrics—fabrics with surface interest yarns and stitches

2. Raschel knitted fabrics

Basic, flat finished raschel fabrics
Fabrics with a textured (raised) surface produced either in knitting
or by finishing procedures
Novelty fabrics

3. Tricot fabrics

Plain, flat finished tricot fabrics without raised fiber surfaces Tricot fabrics having a raised fiber surface produced either in knitting or finishing processes

 Sliver knitted pile fabrics (excluding those for furniture upholstery)

Source: Worth Street Textile Market Rules. (1986). Washington, DC: American Textile Manufacturers Institute, Inc.

The classes for knit fabrics are as follows:

- Class 1—"circular knitted fabrics" are sometimes called filling or weft
 knits. Circular knitted fabrics tend to be somewhat elastic in both directions with more crosswise than lengthwise stretch. Filling knit fabrics vary widely in function and appearance depending on knitted
 structure, yarn type, and gauge.
- Class 2—"Raschel knitted fabrics" are warp knits that may be produced in a wide variety of fabrications. Raschel knitting machines are often regarded as the most versatile fabric-forming machines available. Novelty yarns are frequently used for interesting fabric textures.
- Class 3—"tricot fabrics" are warp knit fabrics made from very fine filament yarns. Fabrics tend to be lighter in weight and more stable in both directions than circular knits.
- Class 4—"sliver knitted pile fabrics" are filling knits that have a yarn sliver laid into the knitted structure as the fabric is formed.

Finishes

Finishes may be classified as aesthetic or functional. Aesthetic finishes modify the appearance or hand of the fabric, while functional finishes improve the performance of fabrics for certain end uses. Examples of aesthetic finishes include calendering, polishing, and napping. Examples of functional finishes include treatments for wrinkle resistance, antistatic, flame retardancy, soil release, and dimensional stability. Finishes may be specified when purchasing fabrics to meet performance needs in end use.

Finishes vary in degree of permanence: durable, semidurable, or temporary. Durable finishes require chemical change in the textile fibers, while temporary finishes are removed or negated with the first laundering or dry cleaning. Finishes may not be visible, so label information is necessary to be able to evaluate the types and permanence of finishes that have been applied to particular fabrics, but labeling of finishes is not required by law.

Evaluating Fabric Quality

Selecting the appropriate fabrics is only the first step in providing serviceable fabrics for apparel manufacturing. When goods are delivered, the conformance to specifications must be verified. Fabrics may also be inspected to evaluate quality and mark defects.

Receiving and Inspecting Materials

Materials buyers are frequently in contact with fabric suppliers, as many as three times before acquisition of fabrics for a single style. The first contact is to acquire a sample length of fabric, often about 5 yards. The merchandiser or designer may handle this transaction. The second contact, after the decision to use the fabric for one or more styles in the line, is to purchase yardage for sales samples.

When the decision is made to put a style into production, yardage is purchased against the sales forecast. A **fabric buyer** is likely to handle the negotiation of the contract. Production yardage may be purchased and delivered all at once or purchased with delivery spaced out over time to minimize inventory investment and storage requirements. Sequential deliveries of a single order may also be more consistent with the production capacity of the fabric mill. Spreading out delivery increases the risk of color variation and shortage of materials for production deadlines, but it levels out inventory.

Fabrics and trims included in a style must be ready for cutting at the same time. Color shading must be correct and all the components compatible in terms of use and care. If these products are produced in-house or by the same manufacturer, timing and compatibility may be less of a problem. There is potential for production delays, however, if any of the materials are delivered late or do not meet specifications.

Many apparel manufacturers use a combination of domestic and foreign suppliers. Apparel manufacturers frequently change suppliers and types of materials in response to fashion change. This constant change increases the possibility of inaccuracy of shipments and variation in quality of materials received.

To ensure correct shipments, apparel manufacturers verify that (1) goods are received as specified on purchase orders by style numbers, colors, and product descriptions; (2) goods arrived on time; (3) width and length of the goods correspond to the specifications; (4) goods meet quality standards; and (5) goods are free of exterior damage. Any variation in these criteria requires a conference among fabric buyer, merchandiser, and receiving manager to determine appropriate action.

"Most apparel manufacturers never inspect the fabric they buy until it is laid out on the cutting table" (Powderly, 1987, p. 27). The inspection that occurs during spreading is often a cursory viewing by the spreading operator. Some managers in the apparel industry believe that the relatively low cost per yard of fabric precludes the expense involved in materials inspection prior to spreading. These managers may rely on the fabric vendor to ship goods as specified in the contract. Others recognize that the quality of the finished product can be no better than the quality of the goods that go into it; thus, costs of inspection are justified. With more expensive fabrics and reduced yardages, the risk of defects can impose greater losses, which increases the need for inspection.

Purchasing by specifications provides a basis for material evaluation. One hundred percent inspection of fabric prior to spreading is rarely used; therefore, some sort of statistical sampling plan may be implemented. The amount of fabric inspected from a particular shipment depends on past experience with the supplier, cost of goods, and the amount of time available for inspection. Use of inspection and testing provides verification of the length and width, identification of size, number, and types of fabric defects, shade matching, performance evaluation, and acceptable or unacceptable quality ratings. Fabric evaluation requires trained personnel, specialized equipment, and standardized procedures. Figure 8–3 shows a fabric inspection system that a garment manufacturer might use to inspect incoming fabric.

Planning for marker making, spreading, and cutting takes into consideration the quantities and qualities of fabric that will be used for each production run. Receiving inspection minimizes spreading and cutting problems due to defects and variations in widths and lengths. Receiving inspection also minimizes cutting defective goods, finished goods rejections, and returns by customers. Expensive recutting, repairs, and refunds can be avoided. It is estimated that repairing finished garments costs five to ten times as much as early detection of fabric defects (Jacobsen, 1985). Table 8–5 itemizes the advantages and disadvantages of materials inspection.

In spite of new sophistication in inspection equipment, human judgment is still required for the decision to accept or reject a particular lot of goods (Jacobsen, 1985). Automatic inspection equipment can now accurately measure the length of a piece or roll and monitor width on tensionless or variable tension equipment. Optic sensoring equipment can determine color and shade, and robotic and laser inspection with video cameras can supply computer readouts of variations and locations of defects. Identifying and marking fabric defects are some of the most important outcomes of receiving inspection. Computerized marker making, spreading, and cutting equipment can be used to plan markers and/or spread and cut materials to avoid fabric defects.

Figure 8–3 A fabric inspection system. Courtesy of Joseph Dernick Manufacturing Corp.

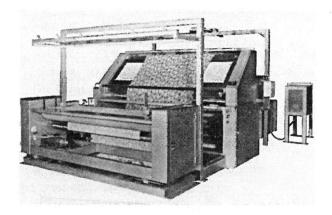

Table 8–5 Advantages and disadvantages of materials inspection.

Advantages

- Shortages are immediately detected.
- 2. Claims against suppliers can be processed immediately.
- Suppliers can be evaluated.
- Fabric utilization can be improved because exact cuttable measurements are known.
- 5. Material wastes and overages can be reduced.
- 6. Preproduction and production stoppages are reduced.
- 7. Production productivity is improved.
- 8. Costs are reduced by avoiding recuts, reworks, and repairs.
- Losses are reduced because of markdowns on seconds and customer returns.
- 10. Customer satisfaction is increased.

Disadvantages

- 1. Time must be committed to the inspection process.
- 2. Specialized machines and personnel are expensive.
- 3. Space has to be allocated for inspection.
- 4. Receiving inspection may duplicate supplier inspection.

Source: Adapted from D. Jacobsen. (1985, August). Fabric inspection savings: Fact or fiction. *Bobbin*, 26(12), 70–78.

Fabric Problems

There are two general types of fabric problems: patent defects and latent defects. Most spreading operators are concerned with **patent defects** that are visible such as shading and fabric flaws such as holes, streaks, stains, and slubs. Other patent defects include bow and skew, barré and streaks, inconsistent width, and wavy selvages. Almost every fabric has patent defects that occur as the fabric is made. Patent defects can be readily seen or detected.

Manufacturers of fashion apparel differ from manufacturers of basic apparel in prioritizing patent defects. For basics manufacturers, inconsistent width is as serious a problem as shading and flaws. Basics producers make few style and pattern changes and are more likely to reuse markers. Basics producers often work on a smaller profit margin, which makes fabric variations of any kind less acceptable. Larger companies (those with sales over \$50 million) are more likely to have written quality standards for materials.

Latent defects cannot be detected by simply viewing the fabric. They appear after the fabric has been further subjected to processes such as steaming, wet processing, and/or pressing. Common latent defects include shrinkage or stretching, colorfastness, and sewability. Latent defects in materials, such as color loss or shrinkage, may appear during the apparel production process. Wearing, laundry, or dry cleaning by the consumer may also reveal latent defects. Some firms take more responsibility for latent defects than others. Some take the position

that it is impossible to tell what a consumer might do with a fabric, and therefore latent defects are not the responsibility of the manufacturer. Others regard the evaluation of potential latent defects as the responsibility of the fabric producer. Still others believe the apparel firm is responsible for the performance of the products they produce. The Federal Trade Commission supports the latter position since the care labeling law states that the apparel manufacturer is responsible for determining how a garment will perform when it is cleaned. Simple wash-and-wear testing may reveal many latent defects.

Consumers deal primarily with latent defects such as shrinkage and color loss because patent defects have already been removed. Consumers also experience problems with snagging and pilling that are not often serious problems in manufacturing. The following discussion describes issues associated with selected patent and latent defects from the apparel manufacturer's perspective. Table 8–6 describes these common fabric patent and latent defects.

Table 8–6Common fabric problems for apparel manufacturers.

Patent Defects

- 1. Shading and shade variation: variation in hue, value, or intensity as measured against some standard
- 2. Fabric flaws: knots, stains, broken warp and filling yarns, holes, and so on that occur by accident during fabric production
- 3. Barré and streaks: a bar or striped effect, usually in the filling direction, creating a difference in color or shade; may be caused by irregularities in fiber or varn processing
- 4. Width variation: variation in the crosswise dimensions of fabric because of relaxation, tension, or application of water, heat, steam, laundry, or dry cleaning processes
- 5. Bow and skew: distortion in warp and filling alignment due to improper tensioning of fabric in weaving, knitting, or finishing. Bow has filling yarns even at the edge but arched across the middle. Skew has filling yarns that are straight but are angled across the width of the fabric. It is possible for a fabric to exhibit both bow and skew.
- 6. Wavy salvages: uneven edges because of poor tension, tentering, or handling during finishing

Latent Defects

- Shrinkage and stretching: a change in the physical dimensions of fabrio booduse of relaxation, tension, or application of water, heat steam, laundry, or dry cleaning processes
- 2. Sewability: yarn severance because of needle cutting, strength of seam, yarn slippage, raveling, or seam efficiency. Other problems include seam puckering and fusing because of needle heat.
- Colorfastness: color change due to heat, atmosphere, light, perspiration, or abrasion; crocking, bleeding, or fading during handling or renovation

Patent Fabric Defects

Patent defects detailed in the following discussion include shading, fabric flaws, width variation, and bow and skew.

Shading is variation in hue, value, or intensity as measured against some standard. Shading may occur side to side, side to middle, or end to end in the same role; between rolls and between lots for the same style number and color. Apparel firms often face the challenge of creating coordinated or matching groups from a variety of fabrications and fabric suppliers. A color system is established for each season, collection, or group. All garments in the group must match. This means fabrics must conform to the shade as purchased, and the amount of shade variation that can be allowed should be determined and agreed on in advance. Apparel firms and suppliers must agree on the technology that will be used to determine conformance to shade.

Shading problems exist at all quality levels and with all types of fabrics. Nearly every variable in the fabric manufacturing process can cause variations in the shade. The generic fiber, its diameter, length, age, and yarn manufacturing procedures influence a fabric's ability to take color. Fabric density, weight, and finishes also influence color, as do selection of dyes and dyeing processes. With present technology, it is impossible to eliminate color shading. Fabric suppliers seek to minimize variations and inform customers of shades of fabrics as shipped. This assists manufacturers in planning layouts and markers to maximize the efficiency of using the fabrics.

Traditional shading systems were based on "commercial match" or "acceptable variation." When shade is determined by visual examination, potential exists for conflict between the apparel firm and its suppliers. Modern colorimeters and spectrophotometers are color-measuring instruments that eliminate human judgment in evaluating color. However, a person still has to decide whether two colors have adequate match. Instrumentation can be used to (1) set shade standards and tolerances, (2) monitor incoming shipments, (3) determine whether coordinating fabrics match, (4) plan cuttings by shade groups, and (5) assemble finished apparel items that will "match." Use of instrumentation for fabric shading provides a common language between the apparel firm and its suppliers.

FABRIC FLAWS **Fabric flaws** include knots, stains, broken warp and filling yarns, holes, and so on that occur by accident during fabric production. Apparel manufacturers can deal with fabric flaws in four ways:

- Cut and sew all fabric; sell garments with fabric defects as other than first-quality.
- 2. Premark defects or mark defects as the fabric is spread; recut defective garment pieces.
- $3. \ \ Remove \ fabric \ defects; produce \ garments \ only \ from \ first-quality \ goods.$
- 4. Use some combination of the preceding three options.

The appropriate strategy depends on the types of products being produced, the relationship of materials costs and labor costs, and the firm's quality standards. Option 1 may be appropriate when fabric flaws tend to be small or infrequent and/or labor costs are comparatively low since a proportion of finished garments may be sold at less than regular price because of fabric flaws.

Option 2 is appropriate when fabrics are relatively costly and production is labor-intensive. Shading problems are a risk. A manufacturer of dress suits may use this strategy. Option 3 may be preferable when fabrics are comparatively inexpensive, quality standards are high, and production is labor-intensive. Cutting out all defects significantly reduces fabric utilization and thus increases fabric costs. Option 4 may be implemented by removing major defects and producing garments from the remainder of the fabric.

WIDTH VARIATION **Width variation** is variation in the crosswise dimensions of fabric because of relaxation, tension, or application of water, heat, steam, laundry, or dry cleaning processes. Traditional widths of fabrics are 36, 45, 60, 72, and 120 inches. Handwoven and imported fabrics may be 39 inches wide. Fabric width is frequently related to fabrication method. Modern technology makes it possible to weave wider fabrics at lower cost, so the trend in apparel fabrics has been toward wider widths. Cotton fabrics have increased in width from 36 to 45 inches, and now 60- and 72-inch widths are common. Some of the imported cottons and wools made on traditional looms are still 36 inches wide. Cutting utilization may be better on wider fabrics, but there is an optimum width for each type of product. Manufacturers must use fabric widths that are compatible with their equipment and facilities.

Width as ordered is intended to optimize manufacturing procedures and markers. The apparel manufacturer is concerned with cuttable width, thus width is measured between the selvages or between the tenter-frame marks. Mills charge for fabric according to width and length specifications. Sometimes fabrics vary in width. For example, a fabric that is supposed to be 60 inches wide may measure anywhere from 59 to 61 inches wide at different places along the length. If fabric is narrower than the established minimum, different markers have to be developed. If fabric is wider than specified, the fabric may be less dense or lower in count. Wider fabric results in waste unless markers are developed to use the full width. All this results in increased expenses for the apparel manufacturer; therefore, the fabric buyer may seek price reductions on nonconforming goods. Fabrics my be sorted and cut based on width.

Bow and skew are distortion in warp and filling alignment due to improper tensioning of fabric in weaving or finishing. Bowing and skewing are common defects in fabrics and pose problems when they are excessive. Some mills and apparel manufacturers use standards that limit bow and skew to a third or less of the fabric width or to 1.5 inches in a 45-inch fabric (Powderly, 1984). Bow and skew are problems when matching fabric designs partic-

ularly with geometric patterns. They also can affect drapeability and dimensional stability. Bow and skew are also common problems with circular knits. Skirts may hang at an angle or sag in an unsightly manner because of bow or skew in the fabric. Roped hems and twisting of garments after care or product dyeing may also be caused by bow or skew.

Latent Fabric Defects

Since wet processing of finished garments has become more common, some latent defects such as color change and shrinkage have become obvious problems for apparel manufacturers. Previously, these latent defects did not appear until garments were in consumers' hands. Now, latent defects often appear during wet processing and are evaluated during final inspection of finished garments. When latent fabric defects make garments salable only as seconds, the apparel firm may go back to the fabric suppliers for price adjustments. This may or may not be achieved depending on the firm's relationship with the particular mill or converter. Shrinkage is the most common latent defect.

SHRINKAGE Fabric **shrinkage** is reduction in the physical dimensions of fabric because of relaxation or application of water, heat, steam, laundry, or dry cleaning. It is caused by numerous factors, some of which are inherent in the structure, finishing, or handling of fabric. Fabric shrinkage problems may not be apparent until the fabric is cut or garments are finished. Shrinkage of any type is seldom consistent, which makes it difficult to compensate with changes in pattern measurements.

Snap back occurs in cutting. When rolled fabric is spread and cut, it may snap back to a relaxed state and thus become smaller than the pattern piece used for cutting. This is especially true of knits. The result is undersized garments. It is the result of fabric being under too much tension when it is placed on the roll or spread for cutting.

Other fabrics may shrink when interlining is fused to garment pieces or when steam is applied during pressing processes. If some components are pressed or fused and others are not, there may be a change in dimensions. Some firms may try to preshrink their fabrics prior to cutting or assembly or enlarge the garment pieces to be fused to accommodate the shrinkage. This may be done by application of heat or steam. Thorough testing of assembled garment parts and documentation of results can determine whether there are potential problems.

Obviously, there are many fabric problems that can interfere with apparel manufacturing. Consequently, fabric grading systems are necessary to assess fabric quality.

Fabric Grading

A number of **fabric grading** systems have commonly been used to assess or **grade** the quality of fabric. There are three commonly used systems for wovens,

two for knits, and a number of proprietary systems developed and used by individual manufacturers. Each system places emphasis on different aspects of fabric defects so it is possible that a fabric could be graded first-quality by one system and second-quality using another. All of the systems are concerned with the size or length of defects and the number of defects in the lot.

The three systems commonly used for grading woven fabrics include the following:

- The Ten Point System was published in 1955 by the Textile Distributors Institute and the National Federation of Textiles. This system is designed to consider every imperfection according to size, regardless of type. The cause of the defect is not a consideration.
- 2. The Four Point Grading System was published in 1959 by the National Association of Shirt-Pajama-Sportswear Manufacturers and the American Society for Quality Control. This system is endorsed by the American Apparel Manufacturers Association and the Department of Defense. The Four Point System differs from the Ten Point System in assigning penalty points. There is a tendency to classify more fabrics as first-quality (Powderly, 1987).
- 3. The **Graniteville System** or 78 System was established in 1978 by the Graniteville Manufacturing Company. It is frequently used by jeans manufacturers and their denim suppliers.

Four Point and Ten Point Systems are also available for knitted fabrics. The Four Point System is the one most commonly used and was endorsed by the Worth Street Rules in 1986, but there is no standard, industrywide system for grading fabrics. A fabric purchase contract may specify the evaluation system to be used for grading fabric and also set an agreed-on point value for first-quality.

The Four Point System assigns penalty points for woven fabrics, as shown in Table 8–7, based on penalty points per 100 square yards with a maximum number of four penalty points per linear yard. Forty penalty points or less per 100 square yards is usually regarded as a first-quality fabric (Powderly, 1985, October).

Table 8–7Four point piece goods grading system.

Size of Defect	Penalty Points	Tolerance for First Quality		
Up to 3 inches	1 point	50 points/100 yards 45 inches wide		
3–6 inches	2 points	25 points/100 yards 45 inches wide		
6–9 inches	3 points	17 points/100 yards 45 inches wide		
Over 9 inches	4 points	Rejected for first quality		

Source: Adapted from C. Moore and L. M. Gurel. (1987). Fabric defect tolerances in first quality piece goods. *Journal of Home Economics*, pp. 49–51.

Apparel firms and their fabric suppliers must agree on the kind of grading system to be used and the number and type of defects to be allowed. These standards are included in the specifications for the product. The number and type of defects that are acceptable may vary with the end product. For example, a 1-inch defect (one-point defect) is the most common cause for marking a man's shirt a second (Powderly, 1983). A one-point defect is a slub, nub, knot, small hole, or any defect less than 1 inch in length. Small defects often do not make a fabric unusable, but they may affect garment appearance. Garments that tend to be basic and made out of solid-colored, smooth-textured fabrics require better-quality fabrics than garments that have more styling emphasis and use fabrics with more texture and pattern. Garments made to higher-quality specifications also require fabrics with fewer and less obvious defects.

Textile Performance Standards

Apparel firms may determine performance standards for each of their products by doing extensive laboratory testing, or they might adopt voluntary standards that were developed and are generally accepted within the industry. During the 1950s the American National Standards Institute published the L 22 Performance Specifications for Textile Fabrics based on fabric end use. L 22 provided a group of industry standards an apparel firm could choose to use. Usage of L 22 was not mandated by industry or the federal government but was available for use on a voluntary basis. The L 22 Standards have not been published since 1968.

During the 1970s, the American Society for Testing and Materials (ASTM) took on the task of updating the L 22 Standards so that they would reflect new technology and performance expectations. The 1983 ASTM Annual Book of Standards contains the first publication of the new fabric end-use standards. Table 8–8 shows the 42 garment categories included in the ASTM Performance Standards for Textile Fabrics. The standards are still being developed and refined and are subject to review every 5 years. Men's and boys' apparel end uses are usually separated from women's and girls', and different standards are provided for wovens and knits. Standards are available for nonapparel categories as well.

The ASTM performance specifications include

- product performance aspects desirable for each end use such as dimensional stability, yarn slippage, fabric smoothness, flammability (this is mandated for some categories such as children's sleepwear), and color-fastness;
- 2. performance requirements for each characteristic; and
- 3. designated test to determine conformance.

ASTM standards address fabric performance. ASTM acknowledges that it may not be desirable for the products of a particular firm to meet the standard

Table 8-8

Garment categories in ASTM D-13.56: Performance specifications for fabrics.

Men's and boys' garments, woven fabrics

Dress topcoats and dress overcoats

Rainwear and all-purpose, water-repellent coat fabrics

Dress suits, sportswear jackets, slacks, trousers

Flat lining fabrics

Dress shirts

Beachwear, sport shirts

Coveralls, dungarees, overalls, shop coats

Underwear

Bathrobes, dressing gowns

Pajamas

Men's and boys' garments, knitted fabrics

Rainwear and all-purpose, water-repellent coats

Dress suits and sportswear jackets, slacks, trousers

Dress shirts

Beachwear, sport shirts

Bathrobes, dressing gowns, pajamas

Women's and girls' garments, woven fabrics

Dry cleanable woven dress coats

Rainwear and all-purpose, water-repellent coats

Flat lining fabrics

Dress glove fabrics

Dresses and blouses

Sportswear, shorts, slacks, suits

Coveralls, dungarees, overalls, shop coats

Robes, negligées, nightgowns, pajamas, slips, lingerie

Corsets and girdles

Brassieres

Women's and girls' garments, knitted fabrics

Sportswear

Blouses, dresses

Dress glove fabrics

Robes, negligées, nightgowns, pajamas, slips, lingerie

Corsets, girdles

Brassieres

Men's, women's, and children's garments

Feather-filled and down-filled

Sliver-knitted overcoats and jackets

Knitted career apparel, dress and vocational

Woven neckties and scarves

Knitted neckties and scarves

Woven swimwear

Knit swimwear

line by line because of fashion, technical limitations, or costs. However, the standard does provide a basis for writing specifications for materials and negotiating with fabric suppliers. Combined use of ASTM standards for latent defects and the Four Point Inspection System for patent defects maximizes apparel firms' control over fabric quality.

Summary

Materials and finished goods sourcing have become increasingly sophisticated with the development of Quick Response business strategies. The textile industry is a global industry that varies in technical sophistication in different countries. It is the responsibility of sourcing departments in apparel firms find appropriate materials, define quality for suppliers, and communicate expectations with regard to service.

The make-or-buy decision is fundamental to sourcing and takes place within the firm's policy related to make-to-stock and/or make-to-order. Buyers establish delivery places and dates, negotiate prices, and evaluate vendor's efficiency. Many materials inventory systems are now computerized. Effective management of materials can make a significant contribution to the profitability of the firm.

Worth Street Market Rules provide a framework for organizing fabric marketing, quality evaluation, and fabric specification writing. The evaluation of fabric quality and performance is a complex process. Selection priorities for fashion and basic fabrics differ. Fashion priorities may focus on aesthetics, while performance is more important for basic goods. Many factors are included in predicting fabric performance including fiber content, yarn quality and size, fabric weight, hand and drapability, application of color, structural or applied design, fabrication, and finishes.

Cooperation between fabric vendors and apparel manufacturers can improve the quality and performance of finished garments. Lead time and minimums may be sources of conflicts between fabric and apparel manufacturers. The quality of fabrics can be verified by using visual or computerized inspection techniques. Both patent and latent defects affect garment quality and performance. ASTM Standard Performance Specifications may be used as guidelines for selection of appropriate fabrics for various end uses.

References and Reading List

Dobler, D. W., Lamar, L. L., Jr., and Burt, D. N. (1984). Purchasing and materials management. New York: McGraw-Hill.

Fortess, F. (1985, June). Objective evaluation of apparel fabrics. *Bobbin*, 130–138.

Jacobsen, D. M. (1985, August). Fabric inspection savings: Fact or fiction. Bobbin, 26(12), 70-78.

Powderly, D. (1983, March). First or second quality? A fabric grading overview. *Bobbin*, 24(7), 126–130.

Powderly, D. (1984, January). Bow and bias fabric problems. *Bobbin*, 117–122.

Powderly, D. (1985, October). Making the grade. Bobbin, 150.

Powderly, D. (1987). Fabric inspection and grading. Columbia, SC: Bobbin International.

Smarr, S. L. (1987, May). The latest link is SAFLINC. *Bobbin*, 28(9), 134–143.

Worth Street Textile Market Rules. (1986). Washington, DC: American Textile Manufacturers Institute.

Key Words

applied design
bow
cellulosic fibers
confined print
converters
cotton count
defects
demonstrated capacity
denier
drapeability
electronic data interchange
(EDI)
fabric buyer
fabric certification

(EDI)
fabric buyer
fabric buyers
fabric certification
fabric count
fabric grading
fabric weight
fabrications
fiber content
findings
Four Point Grading System
grade

Graniteville Grading System hand latent defects lead times make-or-buy decision make-to-order make-to-stock market grade materials materials buyers materials sourcing materials testing mills natural fibers open stock order backlog order minimum over-the-counter patent defects pigments plied yarns price quote

produce against forecast

purchasing agents put-up remnants required capacity retail buvers shading shorts shrinkage skew snap back sourcing sourcing specialists structural designs supplier synthetic fibers tailings Ten Point Grading System unique original design Worth Street Market Rules varn number yarn type

Discussion Questions and Activities

- Examine a yard of fabric. Identify irregularities in the fabric that might be classified as defects. What type of defects are present? Use Table 8-6 for ideas of possibilities. How large are the defects? How many penalty points might the fabric be assigned according to the Four Point System?
- 2. Select a particular product category and determine the ranges of fabric quality and weight offered for the category. Direct-mail catalogs that provide extensive product descriptions can provide a basis of information. What measures of weight and quality are given?

- 3. What is the relationship between capacity and a firm's resources?
- 4. List four indications of product quality that may be available to a materials buyer. Make a list of four indications of quality that may be available to the consumer of the finished product. How might decision-making processes differ based on information about quality?
- Material buyers sometimes seek price adjustments after materials are received. Identify five reasons that a buyer might seek a price adjustment from the supplier.
- 6. Why are fashion goods usually made-toorder instead of made-to-stock?

Production Planning and Sourcing

OBJECTIVES

- Examine production strategies and concepts.
- © Explore the relationship among production standards, capacity, and production planning.
- Explore production sourcing options and requirements.

Drucker (1990) identified four underlying conflicts that have inhibited the progress of manufacturing plants: standardization and flexibility, time and money, people and machines, and functions and systems. These conflicts are inherent to apparel manufacturing by its very nature as a labor-intensive, cost-competitive, function-driven industry. These issues impact the use of resources, productivity, and profitability of an apparel firm and are of particular importance to planning and sourcing activities.

Production planning and sourcing in a demanding market environment pose many challenges. Today's customers require a more diverse product mix, smaller volume per production run, and more frequent shipments. Flexibility is essential to meet customer needs. Automation and technology are essential but the nature of soft goods also makes it labor-intensive. Manufacturers must carefully analyze investments in equipment and technology with low labor costs off shore and the fast turns on production that are needed for customer service.

Production Strategies and Concepts

Production—along with marketing, merchandising, operations, and finance—is one of the essential functions in apparel manufacturing. Apparel **production** involves the conversion of materials (**input**) into completed, salable garments (**output**). Flat piece goods are cut, shaped, assembled, and trimmed as they are converted into specific styles to meet customer needs. Production processes may be carried out in a firm's own plants or sourced from other firms located anywhere in the world. Production plants specialize in certain types of materials and finished goods because of the limitations of equipment, skills, and expertise available. **Production managers** are responsible for managing a firm's styles through the conversion processes. Managing production in owned facilities involves people, processes, equipment and facilities. Managing production through vendors involves evaluation of production facilities, negotiation of price, quota, and delivery, and monitoring quality.

In today's apparel industry, production is market-driven. To meet market demands and generate a profit, firms must fully utilize their resources (inventory, people, and equipment) and successfully expand their productivity. Consumer demand for timely fashion, quality, and value has caused manufacturers to rethink their production strategies. The demands of today's market require the flexibility and fast throughput implicit to Quick Response (QR) strategies. A number of terms have been used to identify the evolving strategies over the past 10 years including flexible manufacturing, value-added manufacturing, and agile manufacturing. Mass customization is the most recent interest.

Production Strategies

Flexible manufacturing strives to be responsive to customer demand for small orders and short lead times. For the apparel manufacturing plant, **flexible manufacturing** means the capability to quickly and efficiently produce a variety of styles in small production runs with no defects. Adopting flexible manufacturing may require philosophy changes, new performance criteria, effective use of new technology, and better development and use of resources than with traditional production systems. The underlying philosophy is that the manufacturing firm will operate with the flexibility needed to meet the demands of its customers and the inherent ability to adapt to immediate changes in the apparel market (Technical Advisory Committee, 1989). Although flexible manufacturing involves the entire firm, much of the focus for improving flexibility has been on the production function. Value-added manufacturing and agility require more comprehensive involvement of the entire firm.

Value-added manufacturing is a quick response strategy that focuses attention on eliminating any unnecessary operations or handling that do not in-

crease the value of a product and that may cause undue delay in production. The rationale of this strategy is that each operation performed on a style should add value and bring it closer to the market. Operations such as inspection, bundle marking and sorting, and warehousing require extra time, handling, and personnel and do not add value. To operate in a value-added environment firms need to evaluate processes and find more efficient ways to produce a product.

Agility is the dynamic ability of a firm to strategically use change as a vehicle to growth in new markets, with new products, and to develop new competencies. It requires an openness to change and the flexibility to pursue change. An agile manufacturer is a firm that precipitates change and strategically profits from it. It reflects a mind set of openness to new business relationships in a rapidly changing, highly competitive environment. The real strength of an agile company is its ability to anticipate customer needs and through innovation lead the emergence of new markets. Agility needs to be an integral part of a firm's goals.

Four strategic dimensions for being an agile competitor are:

- 1. Enable the customers to perceive that they are being enriched,
- 2. Develop internal and external cooperation to bring innovative products to market through use of cross-functional teams, empowerment, virtual companies, partnerships with competitors;
- 3. Develop a flexible organization that thrives on change and uncertainty; and
- 4. Develop an entrepreneurial company culture that rewards innovation and shares responsibility for success (Goldman, Nagel, and Preiss, 1995).

In the transition to agility all the paradigms of mass production must change. Orders are small; change is rapid; innovation is commonplace; customers' perception of value is vital. The extreme of agility is mass customization.

Mass customization is the integration of information technology, automation, and team-based flexible manufacturing to produce a wide variety of products and services. The goal of mass customization is to be agile enough so products can be made-to-order rather than made to plan. Product life cycles are short and niche markets diverse. Mass customization requires processing single orders with immediate turn around. Considering the complexity of many apparel products and the number of processes that a style may require, the equipment, skills, information, and processes must be highly integrated. This may involve single ply cutting, single piece continuous floor manufacturing, and integrated information technology.

Automobile production, when made to order, incorporates some mass customization concepts. An automotive customer selects a model, color, upholstery, and other customizing features and the vehicle is made to his or her specifications. Actually, only a few features of the automobile are customized and delivery time may take weeks or months.

Apparel customers will soon have the opportunity to have garments fully customized, including style, fit, fabric, and trim with delivery direct to their home in a few days at a price similar to mass-produced garments. A customer will be able to select a style from a planned group, modify certain aspects of the style, select fabric, color and/or print design, and have the garment made according to his or her personal measurements. Body scanning technology will be the basis of custom fit. A combination of computer-aided design, single ply cutters, and team-based assembly will facilitate shipping the garment the same day it is ordered. Mass customization will reduce the risk associated with trying to anticipate customer demand months ahead of point of sale to the ultimate consumer.

Production Concepts

Regardless of the production strategy three factors impact the planning and management of the conversion process. Throughput volume, throughput time, and work in process are measures of productivity and production capability. **Throughput volume** is the amount of work that can be completed in a specific amount of time. The time block may be an hour, day, or week. Throughput volume provides a means of evaluating the performance of a manufacturing unit and is a measure of a plant's production capability. Production of goods to fill orders can be planned, based on throughput volume that a plant or machine can complete in a specific time period.

Throughput time is the amount of time it takes for a single unit of a style to go through the production process, cutting to shipping. This includes the actual processing time plus the time a style waits to be processed ahead of each operation. Manufacturers plan production schedules to meet delivery dates based on projected throughput time. Throughput time impacts lead time and the total cost of producing a garment. The longer a garment is in production, the greater the risk of increasing costs and decreasing cash flow.

Throughput time may be minutes, days, or weeks depending on the firm's priorities and commitment to market responsiveness and agile manufacturing. If throughput time is in minutes, orders can be shipped to customers the same day they go into production. A very large order may not be completed in one day, but a significant portion of it could be shipped if needed. If throughput time is several weeks, filling and shipping an order could take several months. Short throughput times and low work in process are critical for mass customization and Quick Response business systems.

Work in process refers to the number of garments that are under production at any given time. Throughout conversion, garments are at different stages of completion, but all are considered work in process. When work accumulates as backlog ahead of operations, throughput time increases. Some work in process is planned to keep the plant operating smoothly, but excessive amounts increase required lead times, reduce productivity, and limit a firm's flexibility

and market responsiveness. High work in process means large amounts of inventory on hand, increased carrying costs on the investment in inventory, and reduction of cash flow. High work in process is common with traditional production systems.

Production Planning

Production planning is an integrative process of coordinating the demand for finished goods with available resources. Production planners may work many months ahead of planned delivery to ensure that specific materials, production capacity, and reliable quality management are available when needed. Long-term production planning (months or selling periods) is based on forecasts, merchandise plans, and budgets; short-term production planning (days or weeks) is based on customer orders.

Production planning at corporate level is usually longer term. Corporate production planners analyze potential sourcing strategies, types of styles in the line, labor intensity of the line, planned volume per style, reorder expectations, expected delivery dates, and the resources available. Firms may decide to produce a product line in their own plants and/or use international or domestic vendors to execute production.

Long-term production planners at the plant level are concerned with having appropriate equipment, trained personnel, available capacity, and establishing start dates appropriate for promised delivery dates. New styles may require a change in processes, equipment, and a longer conversion time. All of this must be built into the required production time for a style. When operators are required to change styles frequently, extra time must be built into the production schedule to allow them to make mental and physical adjustments in handling a new fabrication or process.

Short-term production planning at the plant level relates required production times for styles on order (production standards) with available production time in the plant. Style specifications and samples supplied by technical designers describe the sequence of operations, materials to be used, and special skills and procedures required for production. Engineers may modify assembly methods to make the product more producible, identify equipment to be used, and determine production times for each operation.

Production planners who work for firms that do not own production plants may oversee the work sourced from vendors. Some firms may turn short-term production planning and management functions over to an agent if products are to be produced in a foreign country. As these functions move farther from the firm's management, less control is maintained over the processes, quality, and delivery times.

Production planning involves coordinating plant capacity with style requirements, projected volume, and shipping dates. Coordinating a plant's resources and activities requires teamwork and an integration of operating systems. New technology that provides integrated systems throughout the manufacturing process supports more accurate planning, scheduling, and management of resources. As work is planned and scheduled, production planners are expected to effectively utilize plant capacity and maintain high productivity. The discussion of capacity was introduced in Chapter 8 and is expanded upon here.

Production Capacity

Capacity refers to the productive capability potential (output) of a plant, machine, or work center in a given period of time. Capacity is created from the availability of resources such as machines, time (labor), space, and facilities that require capital investment by the firm.

Capacity is frequently measured in units of output (number of garments or garment parts) but may be expressed in terms of input (number of hours or days). Many factors affect **output capacity** including variations in (1) space utilization and limitations; (2) equipment type, configurations, and uses; (3) the size, skill, versatility, and productivity of the labor force; and (4) product variation. Each style has different time and equipment requirements. A labor-intensive style will require more time (capacity) to complete. Product variations such as types of materials, materials handling methods, processing time, and processing methods also impact the capacity required for a specific product. Output may be increased or decreased with a change in any one of these variables. A change in one variable may also cause a change in others. Implicit to capacity is rate of conversion of inputs to outputs.

Use of the term *capacity* has many dimensions in relation to production planning. See Table 9–1 for a group of definitions that is used in the following discussion.

Table 9–1Definitions related to production capacity.

Maximum capacity—total hours available under normal conditions in a given period of time

Potential capacity—maximum capacity adjusted for efficiency Committed capacity—total hours previously allocated for production during a certain time period

Available capacity—difference between potential capacity and committed capacity for a certain time period

Required capacity—SAHs (standard allowed hours) necessary to produce a specified volume in a certain period of time

Excess capacity—difference between potential capacity and required capacity

PLANT CAPACITY Plant capacity is a projection of the total hours available for production in a given period of time for a certain facility. Firms may use an efficiency factor to adjust the maximum capacity to a realistic level of potential production capacity. Although 100 percent efficiency may be a goal, realistically efficiency is often somewhat less (90 percent for many firms) because of down time, plant or team meetings, absenteeism, and other demands in a work day.

Maximizing use of plant capacity has a significant impact on a firm's profits; therefore, firms seek commitment of orders well in advance of production time. Committed capacity, total of hours previously allocated for production during a given time period, ensures the plant of a continuous flow of work and employment. Committed capacity also affects potential start and completion dates of succeeding orders. Available capacity, the difference between potential capacity and committed capacity for a given period, is what sales representatives can work with in promising delivery on new orders.

Required capacity is the time required to produce a specified volume of a specific style in a given time period. Required production capacity is based on SAM (standard allowed minutes indicated by the production standards) for the operations required to produce the style. The total SAM for one unit of a style is multiplied by the number of units ordered to determine the time requirement of the order. Total SAM are often converted to standard allowed hours (SAHs) for capacity planning.

An apparel firm, contemplating the use of a particular vendor or plant, analyzes the plant's potential capacity. If the potential capacity is adequate, negotiations can be made to use available capacity. A key to effective capacity planning is to make necessary resource decisions in advance to ensure that the required capacity and available capacity are compatible. A plant's expertise, skill level, and equipment also must be compatible with assembly requirements of the style. Table 9–2 provides a simplistic example of how capacity dimensions are determined and their relationship to production planning and management.

INDIVIDUAL OPERATION CAPACITY Each individual operation contributes value to the product, has measurable capacity, and may be part of the work flow. Each operation is dependent on the previous one. One operation does not determine throughput time of a style unless it is a constraint operation. Some operations are constraints; others are nonconstraints.

The slowest operation in a production line is the **constraint operation**, the **bottleneck**, which can determine throughput time and limit capacity. No matter how fast or efficient other operations may be, they only build inventory of parts if a product can't get through the constraint. If throughput or capacity need to be increased, then changes must be made in the bottleneck that limits the number of products that can be completed in a given time frame. An improvement in the slowest operation will likely improve throughput but shift the bottleneck to another resource or operation. Making better use of available

Table 9-2

Example of relationships among capacity dimensions.

Stitch Taylor operates a small apparel contract sewing business that employs 10 operators who work 7 hours a day. The plant has a 90 percent efficiency factor.

A customer brought in an order for 6,000 units of Style A that needs a 10-day turnaround. The plant has the appropriate equipment and skills available to make the style. The plant has a committed capacity of 300 hours for the 10-day period. Style A has a production time of 5 SAM (see text p. 274). The order for 6,000 units (500 dozen) requires 30,000 SAM or 500 SAH. What factors should be considered in deciding whether to accept the order?

What is the potential capacity of Stitch Taylor's plant for the 10 working days? 630 hours

70 working hours per day \times 90% efficiency = 63 potential production hours per day 63 potential production hours per day \times 10 days = 630 hours potential capacity

What is the required capacity for the order? 500 SAH 5 SAM per unit \times 6,000 units = 30,000 SAM/60 minutes per hour = 500 SAH for the complete order

Is there adequate potential capacity for the order? Yes630 hours potential capacity — 500 hours required capacity = 130 hours excess capacity

What is the available capacity in the specified time frame? 330 hours

630 hours potential capacity -300 hours committed capacity =330 hours available capacity

Is available capacity adequate to accept the order? No 330 hours of available capacity - 500 SAH of required capacity - 170 SAH

What adjustments might be made to make adequate capacity available?

- Expedite the new order so it would have priority over previously committed orders.
- 2. Require operators to work overtime to get order completed.
- Offer operators a bonus if the group can average over 100 percent efficiency for 10 days.

resources or changing the resources available can increase capacity of an operation. This might be done by continuous operation through breaks, using multiple shifts, or adding additional equipment or operators.

It is feasible that nonconstraint operations and machines may have excess capacity. **Excess capacity** is based on resources or input not being fully used. Excess capacity of an individual operation may not be needed. If well managed,

excess capacity is not wasted production time, as only constraint operations need to be producing all the time. When capacity is maximized, excess capacity is not available. Excess capacity is potential for increased production and expansion. Production managers level production by allocating the excess capacity from one operation to another.

RELATIONSHIP OF PRODUCTION STANDARDS TO CAPACITY A production standard is a rate, stated in standard allowed minutes (SAM) or standard allowed hours (SAH), that reflects the time required for a normal operator to complete one operation using a specified method. The production standard is also an indicator of how many times the operation can be completed in an hour. A total of the production standards of each style indicates the time required (minimum throughput time) to produce a specific style. Production standards are the basis of planning and controlling production. The rate setting process is discussed in Chapter 11.

Production standards are used in production planning to do the following:

- estimate the rate or time for completion of each operation,
- · determine the required capacity for an order or style,
- · determine production start dates and completion dates for orders,
- · plan the daily volume that should be completed,
- · determine the backup inventory needed to support the work flow,
- determine how many operators and machines should be performing each operation,
- · schedule specialized equipment,
- balance work flow between departments and work centers,
- · monitor production delays, and
- assess the performance of individual operators.

As mentioned earlier, production standards also provide indicators of which operations may have excess capacity and which operations may have potential to be constraints. Examine the production standards (SAM) for assembly operations for Style A in Table 9–3.

Based on the production standards in Table 9–3, Operation 6 is the potential bottleneck that requires the most time. If two operators and machines were assigned to Operation 6, it would no longer be the bottleneck. Operation 4 might then become the bottleneck. Production standards used with volume requirements enable planners to determine equipment and operator requirements, load the plant, and schedule production.

Managing Plant Capacity Routing, loading, and scheduling are systems often referred to as *shop floor controls*. They involve the input of styles into the production process and provide managers with information necessary to make timely decisions related to activities on the sewing floor.

Table 9–3Style A assembly operations and production standards.

Operation 1	=	0.35 SAM
Operation 2	=	0.45 SAM
Operation 3	=	0.50 SAM
Operation 4	=	0.75 SAM
Operation 5	=	0.55 SAM
Operation 6	=	0.90 SAM
Operation 7	=	0.60 SAM
Operation 8	=	0.50 SAM
Operation 9	=	0.40 SAM
Total production time	=	5.00 SAM

Routing provides the bridge between long-range production planning and execution. It establishes the path a style follows during conversion. The operations are identified for each style and coordinated with work centers where those operations are performed. Routings may include information about the machines and equipment required for each operation and the time required to complete each operation.

Plant loading is concerned with weekly and day-to-day actions that get the work done in accordance with orders or master production plan. **Loading** specifies the work centers that will be used and the volume that is to be processed in a specific time period. Factors necessary for plant loading are routing, standard minutes per operation or work center, available machine and/or labor hours, efficiency factors, and deadlines. Effective loading requires a thorough knowledge of the product, skills of the plant's labor force, and equipment capabilities.

Balancing the work load is essential to utilize both labor and equipment to maintain an effective level of productivity. Components and subassemblies should flow into work stations and along the production line at a rate equal to their use. Load assignments are compared to capacity and available, applicable equipment for specific work centers.

Plant loading assigns specific jobs to production lines, work centers, and machines, but the sequence of processing the orders for priority control and allocating labor resources is determined by scheduling. **Scheduling** is the process of assigning start times and completion times to jobs or orders. Starting times determine the sequence in which orders are to be processed. Assignments are made for each stage of the production process. Back scheduling is often done to ensure meeting shipping deadlines. Back scheduling begins with the order due date and calculates backward from the last operation to the first to set the start date.

Even the most precise scheduling can meet obstacles in production. In monitoring work flow, expediting often is necessary to keep priority orders on schedule. **Expediting** involves tracking a specific bundle or order and reprioritizing orders to get the specific order completed on time. Expediting usually re-

sults from follow-up to customer inquiries or as special treatment of certain customers.

The means of managing each of these tasks varies as new priorities and technologies emerge. New technology provides more data collection and better integration of information, which allows better tracking and a smoother flow of goods through conversion. New systems have the capability to provide regular and consistent feedback, indicate the current schedule status, compare actual versus planned production, and indicate potential scheduling conflicts.

LEARNING CURVE APPLICATION The learning curve, also called an experience curve, start-up curve, or progress function, is a factor in production planning and scheduling (see Figure 9–1). The **learning curve** is a scale on which proficiency in completing a task is related to the frequency of completing a task. An operator learns a task by doing it; proficiency increases with the repetitions. After a few repetitions, proficiency increases rapidly, but the rate of increase slows as the number of repetitions becomes greater.

When an operator is inexperienced or an experienced operator is introduced to a new operation, a decrease in productivity can be predicted based on the learning curve. Applying a learning curve to an operation adjusts capacity expectations to a reasonable level, makes productivity goals seem more attainable, and adjusts compensation for learning a new task.

The learning curve is established for a period of weeks depending on the estimated time required for an operator to be able to work at a normal pace. Short-term or weekly goals establish the productivity or learning rate of the operator. Each week expected production rates are higher. Operators can judge their progress by their ability to meet the production goals. During the learning period, compensation rates are adjusted to the learning curve so an operator is compensated according to performance relative to the learning curve, not

Figure 9–1
Diagram of a learning curve.

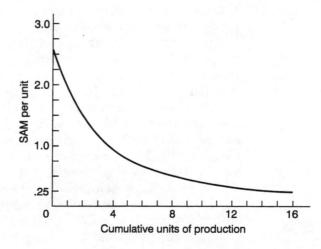

solely according to output. During the learning period, potential capacity for the operation needs to be adjusted as output from the operation is expected to follow the projections of the learning curve.

Determining Sources of Production

Apparel can be sourced anywhere in the world there is a labor supply and a transportation system. Determining where, when, and how goods will be produced is the purpose of production sourcing. Materials sourcing may be a companion process to production sourcing. Geographic location of key material sources is sometimes the deciding factor in determining where the garment will be produced. Effective production sourcing requires extensive information about the product, production processes and equipment, and business requirements. Sourcing has a language of its own. Key terms used in describing production sourcing processes are itemized in Table 9–4.

In today's markets, both manufacturers and retailers source production. Learning to source effectively is a great challenge. If international sourcing is planned, knowledge of the business culture and climate, trade regulations, international finance, and overseas shipping are also essential. A primary social concern today is fair treatment of production workers. This concern is addressed through use of codes of conduct. Sourcing firms also have to consider many financial options associated with sourcing. A third consideration is whether products will be sourced domestically or internationally.

Codes of Conduct

Human rights issues and exploiting labor is a major concern of all U.S. apparel firms, but it is also difficult to monitor labor practices, especially when plants are in remote locations. The apparel industry particularly has received some bad publicity in this regard and responsible firms are developing policies and practices that seek to prevent this type of behavior. Vendor compliance on human rights issues is a major concern to anyone wanting to source production whether in the U.S. or internationally. The first step is for the sourcer to have a written **code of conduct** or company policy that defines the firm's expectations on human rights issues. It should state the conditions under which the sourcer will do business such as conditions of employment, minimum work age, health and safety standards in plant, and wages. This needs to be translated into the language of the vendor and then signed by the vendor.

The second step and probably the most difficult is monitoring compliance. Factory conditions and human rights practices must be monitored based on the code of conduct. It does little good to have a policy if compliance is not verified. Child labor, substandard working conditions, and violation of basic human

Table 9–4 Sourcing terminology.

- **Agent**—representative of sourcing company in country where product is sourced.
- Audit—methodical quality and/or quantity examination applying pre-established company guidelines.
- Certificate of origin—a document which certifies that the identified goods were manufactured in a specific country.
- **Compliance**—in accordance with international trade regulations.
- **Contractor**—a vendor providing a service such as cutting, sewing, or finishing.
- **Counter sample**—a duplicate of the prototype garment made by the vendor.
- Customs broker—expert in international trade that facilitates moving a sourcing company's goods through Customs.
- Cut-make-trim (CMT)—vendor cuts and sews garments; sourcer provides fabric and findings.
- **Development package**—basis of counter sample and costing; sketch and fabric descriptions or prototype and swatches along with sample size specifications and size range.
- Full package sourcing (FPS)—vendor provides everything needed to make the garment including materials, findings, and production labor.
- Garment purchase agreement (GPA)—legal contract to purchase a stated quantity of goods, at a certain price, within specified dates, and on stated terms and conditions.

- Landed cost—the cost of goods up to the time they are delivered to the distribution center of the sourcer.
- Letter of Credit (LC)—written document issued by a bank at the request of a buyer authorizing a seller to claim payment in accordance with certain terms and conditions; may or may not be irrevocable or transferable.
- Off shore—U.S. term for beyond the boundaries of East and West coasts.
- Quota—quantitative restraint on the quantity of products that can be imported from specified countries.
- **Sourcer**—firm that requests and pays for specific services.
- Subcontractor—firm hired by a vendor or contractor to assemble part or all of a sourcing company's goods; may complete a special operation.
- **Trade advisor**—consultant that provides advice on international sourcing; specializes in specific geographic areas.
- **Transshipment**—illegal movement of finished goods from one country to another to avoid quota restraints; product is incorrectly identified as to country of origin.
- U.S. Customs Service—Federal agency responsible for monitoring importing of goods and application of appropriate quotas and tariffs.
- Vendor—supplier or contractor of products or services.

rights are violations that have received a great deal of negative publicity and firms need to guard against these practices. External auditors, internal auditors, or a combination can monitor a vendor's practices. The difficult problem comes when a third party such as a buying agent or subcontractor is used and the sourcer does not have control of where and under what conditions the products are produced.

Liz Claiborne's code of ethics is evident in its sourcing priorities summarized in Figure 9–2.

Figure 9–2 Sourcing priorities at Liz Claiborne.

According to Paul Charron, Chairman and CEO of Liz Claiborne, "in 1998, Liz Claiborne Inc. [planned to] produce nearly 90,000,000 units of apparel with a roster of approximately 250 manufacturing partners in about 30 countries around the world. To achieve maximum quality, accuracy, and efficiency, our network of contractors must integrate seamlessly with our internal system and processes—and do so in an extremely challenging retail environment.

Though sourcing is often noted as one of Liz Claiborne's core competencies, our operation has made some key changes in order to secure competitive advantages and address the sourcing world of the future. Generally, the factors that drive our sourcing decisions can be summarized as the "Five Cs"—configuration, consolidation, certification, concern, and cost.

Configuration relates to the strategy behind where we make our products. Certain countries offer advantages such as closeness to the U.S., quota availability, and labor force with the skills to manufacture particular products. But no matter why we select a particular country, there is always a risk that unforeseen circumstances, like the Asian currency crisis, will arise and present us both with challenges and opportunities.

Consolidation allows us to decrease the number of factories we work with, thus developing more meaningful relationships with fewer suppliers and becoming more important to them. This ensures that our partners can make the business investments necessary to be responsive to our needs, such as the deployment of technology.

Certification ensures that the vendors we select are capable to servicing us, now and in the future. Under the Vendor Certification Program, we will buy the product as a whole package, rather than purchasing manufacturing processes. Vendors will be responsible for supplying us with finished goods which meet our quality criteria, irrespective of where, when, or if we inspect the actual product.

Concern refers to our position with respect to human rights and our commitment to being part of the long-term solution to better working conditions around the world. We believe that good working conditions are productive working conditions, and ensuring the fair and decent treatment of workers is both the right thing to do and the smart thing to do.

Cost The structure of our sourcing base has as great an impact on a product's costs as the fabric with which it is made. We believe fair prices will result naturally when the other four "Cs" are in order. When we pay a fair price, so does the consumer. And that is what value is really all about—giving the consumer the very best product at the very best price" (Charron, 1998).

Figure 9–2 reports the sourcing priorities of Liz Claiborne as reported by Paul Charron, President and CEO, at the 1998 Apparel Research Conference in Atlanta, GA.

Financial Options

The financial options in sourcing production for both manufacturers and retailers include the following:

- 1. own the manufacturing capacity (direct or joint investment),
- 2. purchase the materials and have manufacturing done on contract,
- 3. have the vendor source materials and produce finished goods,

- 4. generate part of production and contract the rest,
- 5. purchase the finished goods from an independent supplier, or
- 6. license the production.

Retailers who choose option 1 are vertically integrated because they are providing both manufacturing and retailing functions. Manufacturers who select option 1 are performing all the functions required to be a manufacturer including merchandising, marketing, and production. Both manufacturers and retailers engage in Option 2. Option 3 means the sourcing firm only develops the designs and specifications. The vendor develops patterns, makes samples, sources materials, and produces and ships finished garments. Option 4 is consistent with manufacturing with an Item 807 (9802) operation. Garments are cut in the United States, garment parts are exported and assembled in a foreign country (usually located in the Caribbean Basin or Mexico), and assembled garments are imported with tariff assessed only on value added. Option 5 reflects the traditional relationship between manufacturers and retailers and the means for manufacturers to supplement their lines. Option 6 involves transferring the right to use the trademarks and technology so products can be most economically produced.

The terminology used to refer to different kinds of vendors and production facilities is often confusing. Firms that own their own production plants and those that source production capacity from contractors are both called manufacturers. Firms that supply sewing and specialty services are called vendors, contractors, subcontractors, or sometimes jobbers. Cut-make-trim (CMT) contractors normally cut the garments from patterns supplied by the manufacturer and provide sewing operators, machines, and thread to make garments. CMT services are commonly supplied by U.S. domestic contractors. With CMT, the sourcing firm also sources the materials and has them shipped to the contractor. Both manufacturers and contractors may use specialty contractors, who provide specialized services such as grading patterns, cutting, embroidering, making belts, pleating fabric, screen printing, and wet finishing.

The many retailers engaged in product development also source production from contractors. This bypasses costs of many services normally performed by apparel manufacturers that sell finished goods at wholesale. Many retailers prefer what is known as full package sourcing that is typically done in the Far East. With **full package sourcing**, the contractor not only provides production services but sources the materials and oversees all the details of producing a style. Retailers are asking contractors in the Caribbean Basin countries to provide more full package sourcing instead of CMT.

Apparel producers in more developed countries are moving from being contractors to being manufacturers. They are taking on the responsibilities for marketing and merchandising their product lines in addition to production. The contractors-now-manufacturers are designing and developing their own product lines that may be marketed in their own countries or

marketed in competition to the lines developed by U.S. manufacturers. They want to sell their finished goods to U.S. retailers and manufacturers rather than just providing production services. The money realized from development and sale of finished goods is far greater than from only the sale of production services.

LETTER OF CREDIT (LC) Banks also play an important role in sourcing operations. In the apparel industry a **Letter of Credit (LC)** is used as a method of payment by the **sourcer** (buying firm) to the **vendor** (contractor) in an international sourcing operation. An LC outlines the purchase arrangement and the agreements between the parties. Two banks are involved, the sourcer's bank and the vendor's bank. The vendor can use the sourcer's LC to secure funds from the local bank to operate the business.

An LC is an extension of the Purchase Order and becomes the primary document for terms of purchase. The LC spells out the details of the purchase—product, sizes, colors, delivery dates, first cost, any special processing, quality criteria and need for a quality certificate, documents needed for entry into the U.S. purchase terms, and consignee. If the vendor satisfies all the terms of the LC and presents the documents to his bank, the LC must be paid. If the terms of the LC are not met, the order can be canceled at once, or shipment can occur with discrepancies. Both parties have to agree to any actions that impact the LC and payment by the bank. (Technical Advisory Committee, 1998.)

Domestic Sourcing

In spite of great increases in international sourcing over the past 20 years, approximately half of apparel sold in the United States is still made domestically. Use of **domestic sourcing** is sometimes called *speed sourcing* or "quick response" because of easy access to the manufacturers and potential for minimum turnaround time between placing the order and delivering the merchandise. U.S. domestic manufacturers produce more apparel than any other country in the world (Cline, 1990). Domestic production had shown some decline between 1992 and 1996 but rebounded in 1997. Advantages of using domestic sources include flexibility, short lead time, nearness to markets, well-developed distribution system, availability of sophisticated technology, and up-to-date skills and techniques. Domestic sourcing eliminates many language and cultural barriers as well as tariffs and quotas.

Because of higher labor costs, in order to compete successfully in a global market domestic sources must upgrade planning systems, operating methods, and technology to minimize lead time and keep best selling products on the retail shelves. U.S. manufacturers are seeking to improve their cost position by maximizing their advantages in lead time, styling, flexibility, quality, and delivery. Success depends on the quality of management and the ability to adapt to complex and sophisticated marketing environments.

Finding domestic contractors can be a challenge for the sourcing firm depending on their needs and priorities. Location is often a priority for shipping and if a sourcer wants to be able to work closely with the contractor. Contractors specialize in certain types of products because of the equipment and skill of their workforce. Contractors offer different types of services. There are full service contractors that produce patterns and source materials as well as subcontractors that specialize in just one aspect of production. There are directories and Internet contacts that list contractors, locations, and their specialized operations. There are also Apparel Contractor Associations in states such as Alabama, California, Missouri, and New York.

A good contractor is an extremely valuable resource and often partnerships are formed to ensure both parties of continuing business. Names of contractors in some cities may be a well-guarded secret in some areas to ensure that they will not get overscheduled. This is especially true if they operate a sweatshop and employ illegal workers.

Contractors often sew for several firms at the same time. A firm that produces dress shirts may produce shirts for their own label and shirts for several other firms as well. Each firm will have their own styles and specifications for their products. The difficulty for the contractor is managing the capacity to meet their own production needs and those of their customers.

International Sourcing

Potential challenges with **international sourcing** include (1) communications, (2) culture, (3) financial, legal, and political issues, (4) quality, (5) lead times, and (6) selection of international contractors. Developed apparel-producing countries generally offer more reliable service, production skills, and quality control than developing countries. They also have higher wages; thus, when price is the most critical criteria, one of the developing countries may be the best choice.

When sourcing internationally, apparel firms may use **agents** who know the trade laws, language, culture, and production capabilities of apparel manufacturers and contractors in their country. Agents are residents of the countries where products are being sourced and should know the comparative abilities and performance records of the contractors in their country. Agents are hired to direct U.S. sourcing managers to the most appropriate sources considering the costs, quality, and styling desired. Firms that source large quantities of goods in certain areas of the world often establish regional sourcing offices to work with sourcing agents. Although an agent may be extremely beneficial in developing and working with contractors in a particular country, the sourcing manager or representative of the firm should make an on-site evaluation of the factory producing their products. All factories should be visited before a contract is established for doing business.

Most 807 (9802) operations are located in close proximity to the United States; thus, turnaround time may be less than when sourcing in the Far East.

It is more convenient to supervise production and quality control and tariff is assessed only on value added. As reduced turnaround time becomes more essential, 807 (9802) operations are expected to increase. The sourcing firm must develop patterns and cut garments so the garment parts can be exported for assembly. However, to take advantage of the Caribbean Basin Initiative, U.S./Canada Free Trade Agreement, and the North American Free Trade Agreement (NAFTA), domestically produced fabrics must be used.

Problems involved in working with some of the countries in the Caribbean Basin include lack of a trained workforce, inadequate technology, poor quality control, and problems meeting deadlines. In some cases, potential for Item 807 (9802) sourcing depends on patience related to bringing vendors up to quality and service standards. These same problems commonly exist when sourcing in any developing country.

Licensing can be used as a means of importing or sourcing goods. Licensing may be used in combination with Item 807 (9802) in order to provide close proximity to the production. Licensing of contractors is commonly used when extensive training of production procedures is required in order to make products consistent with particular product specifications. For example, producers of Levis are licensed for production in foreign countries. The licenser faces the risk that the licensee will learn the technology and then become a competitor of the licenser.

International Trade Assistance **Trade advisors** are one of the best sources of current information on world trade. They are often former government employees of the Commerce Department based in Washington, DC, who know key people from exporting countries and their trade ministries. They can offer insights into trade agreements, developing trade actions, quota usage, potential transshipment violations, and upcoming trade negotiations. As international trade becomes more complex and changes in regulations evolve, a trade advisor can be an extremely valuable resource.

Legal counsel is essential for the complicated sourcing process. Attorneys that specialize in international trade law can assist with contracts and agreements, letters of credit, and purchase order terms. Many complications can be avoided with appropriate legal interpretations and documentation for Customs. Large firms have in-house attorneys that handle all of their issues and documents while others seek counsel from law firms that specialize in international trade. It is always better to anticipate legal issues and be appropriately prepared rather than to be surprised and have to seek solutions to problems that could have been avoided.

Customs brokers are licensed third parties used to generate the transactions and interface with Customs on behalf of the sourcer. "The customs house broker is a needed partner and experienced resource for all import activities" (Technical Advisory Committee, 1998). They serve as an intermediary between the vendor and Customs. Customs brokers can help determine product classi-

fications for quotas and tariffs, provide documentation for Customs, make payment of duties, and execute other transactions that Customs may require.

Quality auditors (located in major sourcing regions of the world) can be hired to provide independent evaluations of fabric and finished goods. When starting up a sourcing program and working with an agent for the first time, it is often recommended to use an outside auditor to monitor quality of the goods. Quality auditors may also test for fiber content, flammability, care, etc. When fabric comes from a source close to the contractor, verification testing should be done in that country since it is time-consuming and costly to ship it to the United States. Once a sourcer develops confidence in an agent, an outside auditor may not be needed as much. Many firms continually use a combination of in-house quality personnel, agents, and independent quality auditors.

Production Sourcing Priorities and Processes

Sourcing production can be a profitable way for a firm to do business but it requires a great deal of advanced preparation, knowledgeable individuals, attention to detail, careful planning, and timing. Losses can be minimized if the sourcing firm is well prepared. Prior to sourcing decisions, locations, plants, and potential contractors should be visited and evaluated.

Selecting a Vendor

Factors that drive sourcing decisions include cost, product quality, specialization, and timing. A firm's priorities will often determine where, what, and how products will be sourced. For some firms sourcing involves extensive research and analysis of countries, agents, and contractors especially if the goal is the development of a long-term business relationship. Other firms are opportunistic and develop business connections that will meet their immediate needs for product.

Firms need to determine the level of risk they are willing to assume and the level of involvement they wish to maintain. A trade advisor can be extremely helpful with initial investigation and determining the business climate, legal restrictions, and potential advantages and disadvantages of sourcing in a particular country.

Firms that choose to source in remote areas and those that do not require involvement with the product may decide to work with an agent. This method of sourcing involves a certain amount of risk but it is relatively easy and requires minimal involvement. A reputable agent can facilitate the sourcing process while an unethical agent can compound the problems and risks.

The assistance of a trade advisor should never replace a first-hand evaluation of the contractor and production plant. There are many issues that need to be evaluated by a knowledgeable person from the sourcing firm. It is essential

to evaluate business practices, ethics, and services relative to the firm's priorities and needs.

At the plant level the sourcing firm needs to evaluate a facility's capability to produce the product desired at the determined quality level. There are also many human rights and health and safety issues that a socially responsible firm will want to monitor. A sourcer needs to verify firsthand that the code of conduct is being honored. Violations are easy to overlook especially with just one visit. Some sourcing firm's evaluate plant sites and activities as if they were being taped by 20/20 or 60 Minutes.

The check list in Table 9–5 provides some key elements that should be considered in evaluating sites and facilities prior to making a sourcing commitment. It is much easier to make a wise decision based on first-hand information and analysis of capabilities than to enter into an agreement and find major violations of human rights and safety issues and a contractor's inability to produce the volume and quality product needed. Surprises need to be avoided.

Product Preparation for Sourcing

Once a good match between product and contractor is determined, the manufacturer can prepare the style for production. Technical design specifications and costing are developed. Specifications include materials, sewing methods, operational breakdown, production standards, and measurements for each operation. If the contractor is in a different country, the specifications and rates (production standards) need to be appropriate for the country. Costing should include allowances for differences in equipment. Some firms use a 5–10 percent increase in rates (SAM) because operations may be more manual, equipment may be slower and less automated, and productivity below U.S. factories. This could be determined during a plant visit and an analysis of constraints and specific operations. Costing should also take into account the potential for additional unexpected operations such as additional pressing that may be needed or label changes that are common. Unexpected addon operations are fairly common with international sourcing and they definitely increase costs.

Correct style samples are made using the materials, procedures, and similar equipment to that used by the contractor. Style samples are a blueprint for production and a verification of the rates. The sourcer sends a sample for each style to the contractor and retains one of each for reference. When both parties have an identical garment available it facilitates communication when problems occur and changes have to be made. Changes may be required because of different equipment or methods used by the contractor. If changes are required, the contractor submits revised samples for approval. If changes are approved, all documents including costing must be revised to reflect the changes.

Table 9-5

Checklist for evaluating production contractors.

Country Level

- Does the country have a minimum legal age for manufacturing employment?
- 2. Does the country have a minimum wage?
- 3. Does the country have a standard number of hours for a work week and standard practice for overtime pay?
- 4. Is there political unrest in the country?
- 5. Is the economy stable in the country?

Agent Level

- 1. What is the relationship between contractor management and agent?
- 2. Is communication good between contractor and agent?
- 3. How much time does the agent or agent's representative spend in the plant?
- 4. Who manages the operation on a day-to-day basis?

Vendor Level

- 1. Is the company financially stable?
- 2. Is the company vertical?
- 3. Does the contractor subcontract work?
- 4. Does the company provide housing and meals for employees? If so, is it clean and safe?
- 5. Does the company enforce legal restrictions such as minimum age and wage requirements?
- 6. Does the company have a policy for paying overtime?
- 7. Does the company keep good employee records for citizenship and number of hours worked?
- 8. Does the company provide transportation assistance to the plant?
- 9. Does the company operate in a free trade zone?
- 10. Can the company provide pattern-making support?
- 11. Does the company have good communication, especially from headquarters to production plants?
- 12. What is the contractor's product strength?

Plant Level

Product

- 1. What types of garments are currently being produced?
- 2. Who are the plant's primary customers?
- 3. How many workers are employed?
- 4. What type of equipment is being used?
- 5. Are machines properly maintained?
- 6. What is the degree of automation in cutting? In assembly?
- 7. Is there a good workflow through the plant?
- 8. What are the bottleneck operations?
- 9. Does plant have required capacity?
- 10. How were operators trained?
- 11. Is skill level of operators adequate?

Quality

- 1. How is quality monitored?
- 2. Are specifications available to operators?
- 3. Are specifications in the appropriate language?
- 4. How many inspectors do they have?
- 5. Are in-line inspections performed?
- 6. Are final statistical audits performed?
- 7. What percent of product is audited?
- 8. How have they been rated on previous audits?
- 9. What is the plant's audit pass rate?

Human Rights

- 1. How many workers are in a room?
- 2. What is the age of the workers?
- 3. Are there children present?
- 4. How many hours do they work per day?
- 5. Is the level of compensation appropriate for the country? Community?
- 6. Are the workers allowed break time?
- 7. Is there forced overtime?

Plant Safety and Health

- 1. How many exits are there?
- 2. Are there fire safety exits? Sprinkler systems? Fire extinguishers?
- 3. Are safety codes being met?
- 4. Are safety regulations posted?
- 5. Is the level of lighting adequate?
- 6. Are workers attentive to their work?
- 7. Are the aisles clear for emergency evacuation?
- 8. Is the plant clean?
- 9. Are appropriate housekeeping procedures in place?
- 10 Are there enough rest rooms?
- 11. Is the ventilation adequate?
- 12. Is the drinking water safe?
- 13. Are electrical outlets grounded?

Shippina

- 1. How will products be shipped?
- Will additional processing be required in the distribution center?
- 3. Does the plant have EDI capability?
- 4. How do they insure against theft?
- 5. What precautions are taken to prevent drug smuggling?
- 6. How safe is transportation from the plant to the port?

Environmental Responsibility

- 1. Are products disposed of appropriately?
- 2. Are materials recycled or reused?
- 3. Are their practices environmentally friendly?

Construction methods for each operation should use diagrams or technical drawings as much as possible. Illustrations bridge language barriers and are less likely to be misinterpreted than a verbal description. See Figure 6–7 of Chapter 6 for an example of a technical drawing that might be used to describe the method for a single operation.

Measurement specifications for size and patterns have to be appropriate for the country. These include the unit of measure and illustrations of how to measure the specific style. Some firms submit a videotape of measurement techniques so there is no mistake of how a finished garment will be measured. Measurement information accompanies all styles that are to be produced by a contractor. It is important for the contractor to know how a style will be measured in a quality audit.

Once a contractor has been approved and a style assigned to a facility, a **pre-production sample** (also known as *counter sample* or *design approved sample*) is produced exactly as it will be manufactured in the plant including labels, tags, and packaging. Some firms may request a pilot lot (multiples of a style) or a size range sampling. Any changes or modifications must be made prior to final approval of this sample. For some firms this is the final set of samples while other firms expect a sample lot of production samples to be made in the actual factory where the style will be assembled. This is the final check on quality and assembly methods before a style is mass produced.

Regardless of the sampling process, a minimum of two samples must be kept by the sourcing firm and an approved sample returned to the production facility. All approved samples should have written verification permanently attached so quality inspectors can use the sample to monitor production. The contractor should retain production samples for at least 6 months after an order has been shipped in case there are any quality issues that arise once a style reaches the retail floor.

Quality Management of Sourced Goods

A well-researched facility and a structured quality management program are essential to receiving the goods desired and specified. Long-term partnerships between sourcer and contractor may have many parts of the process already in place but if a sourcer uses a wide variety of contractors or if a contractor is being considered for the first time, it is essential to use sound procedures.

Quality instructions must be precise and understandable to the contractor. Quality instructions include method descriptions, tolerances for each operation, and step-by-step inspection procedures. These are part of quality manuals and/or videotapes that are shared with the vendor. These form the basis for quality audits and inspection procedures. According to many quality standards, there should be in-line quality auditors that monitor styles while they are being produced to identify problems before products are completed. Final inspection verifies that garments meet specifications before leaving the plant. If us-

ing international sourcing a post-inspection final audit may be used to detect defects before the goods leave the country. If defects are found before garments are shipped the problems can be corrected at the factory that was responsible. It is extremely difficult and costly to have to make repairs in the United States after faulty goods have been shipped.

Sourcing firms may handle the quality inspections and audits in a variety of ways. Some firms may use in-country independent quality audit firms. Larger firms may set up a regional quality audit center in the country where production is done and train the quality auditors to the system used by the firm. Some firms use U.S.-based quality managers to do quality reviews on a routine basis. Many firms use a combination of an independent quality auditor and periodic reviews by the U.S. quality manager. The Technical Advisory Committee of AAMA (1998) suggests that once every three weeks is a good rule of thumb. The volume of goods being sourced in a particular country and the quality level desired are primary considerations in determining the quality management system used.

If full package sourcing is used, quality inspections may be left to the agent or the sourcer may use some combination of quality management components to ensure delivery of a specified product. More responsibility for quality can be placed on the contractor if the sourcing firm specifies the acceptability requirements for quality audits in the Letter of Credit. If products do not meet the sourcer's standards the contractor is not paid. This is not as simple as it sounds as many stipulations must be identified and documented, but problems can be averted if provisions are made up front.

Managing Production of Sourced Goods

The Merchandising Calendar and Production Schedule may be shared with contractors so the flow of goods will be on time. If contractors are brought into the firm's information and planning network they are more likely to understand the implications of late delivery and work harder to meet delivery schedules. Production schedules should be monitored on a weekly basis so any delays can be determined immediately.

Reliability of off shore production schedules and on-time delivery is a major concern particularly with new vendors. Some sourcing experts recommend building in as much as 50 percent extra lead time simply to avoid costly surprises and missed delivery to retailers. Over time a reliability factor can be built into scheduling. Agents or full package suppliers are expected to maintain their own production schedules.

FABRIC AND TRIM It is essential to have all fabric and trim items for a style available before production starts. This is often a problem when styles are produced in a firm's own plants but it is an even greater problem when sourcing is done off shore. The first issue in managing fabric and trim is to determine

where it will be sourced. Will U.S. fabric be cut and shipped to the contracting country? Will fabric be ordered in the producing country? Fabric being shipped from one country to another should be inspected and lab tests done before it is shipped out of the producing country.

Any fabric produced outside the United States must have a statement of origin, value statement, and shipping documents attached in order to satisfy Customs. Complications can arise with styles that include several different fabrics. Duty is different on different fabrics.

Extra trim should be allowed for all contracted garments. The primary concern of contractors tends to be efficient use of time and little priority may be given to economically using fabric and trim. Firms frequently use a 5–8 percent trim allowance when using domestic contractors. When using international contractors this allowance should be doubled. Production delays due to lack of trim can be extremely costly in terms of delivery.

Trim may be ordered in the producing country, shipped as a bulk order ahead of fabric, or sent as trim packages with cut goods. Trims ordered in the producing country should be tested for performance requirements in the country where purchased and any substitutions should be monitored closely. Substitutions often can cause a garment to become defective.

Cut orders identify the styles, sizes, and quantities that are to be cut from a specific fabric. Sourcers may choose to cut garments and have a domestic contractor do the assembly. Cut orders are issued for 807 type sourcing when garments are cut in the states and assembled in Central America or Mexico. Where a style is cut often depends on where the fabric is purchased. Cut orders are important documents to verify the number of pieces being cut, shipped, sewn, and returned through customs. The actual assembly of a style is in the hands of the contractor. A thorough initial evaluation of the plant and its operation is a critical step to successful production. A sourcer should not rely on operations continuing the same as during the initial visit, thus it is important to continually monitor the operations with periodic visits.

Finishing and packaging may be done by the sourcer or vendor. If the vendor is expected to do the finishing, specifications should be developed specifically for these operations and a finishing sample should be available in the finishing department. It should be tagged, folded, and packaged in the approved method. Special precautions should be taken with international sourcing in subtropical areas to ensure that garments are thoroughly dry. Mildew can ruin garments if they are not thoroughly dry when packaged. Often there is little if any air circulation in shipping containers and garments may be stored for several weeks at high temperatures.

As long as appropriate quality specifications, methods, samples, and a quality program are in place there are controls to manage production. None of these provide a guarantee that all products will meet a sourcer's expectations but the more information that is made available the less guesswork is involved.

Managing Logistics and Customs Issues

Packing is a critical element in getting the product to the distribution center or customer in good condition. The type of containers used and how the goods are packed in those containers affects the condition of the merchandise and the efficiency of the shipping process. Utilization of container space can impact shipping costs for international shipping. A firm pays to ship a full container and if it is not full the cost is the same.

The packing department is responsible for getting an accurate count of finished goods. This must be compared to cut orders to ensure that specified goods have been assembled and shipped. Shipping complete orders and accurate counts are critical for both domestic and international sourcing. All shipping containers or cartons, whether from domestic or international sites, should be appropriately bar coded so they can be tracked during shipping.

Shipping method is a consideration in determining lead time and total product cost. Shipping can be arranged by the vendor or sourcer. Many vendors have routine pickup by specific freight carriers. Importers have two choices for shipping products, ocean freight or air freight. Each has advan-

tages and disadvantages.

Ocean freight is the way most apparel is shipped. Freight consolidators and forwarders are used to move containers to ocean ports and to factories or distribution centers. This can be a major challenge if plants are located in remote areas. In most cases the vendor arranges transportation from the factory to the port. A nonvessel operating common carrier is often used to arrange, manage, and track shipping. They will book ocean transportation and overland shipment, assist with customs clearance, and expedite shipments.

Air freight is faster, more costly, and subject to some major problems. It is commonly used to transport quick response garments and high margin fashion apparel. Problems occur because perishable goods usually have priority with air freight and apparel is not a perishable product, therefore it could get left behind. It is possible that all cartons may not be placed on the same plane and thus have to wait for the rest of the order before it can clear customs and be released. Another complication occurs if an order arrives prior to the paperwork, it cannot be released. Orders are assigned to the banks issuing the Letter of Credit (LC) and possession cannot be transferred until the credit process is complete.

According to the Technical Advisory Committee of AAMA (1998), "More shipments are delayed or returned due to improper paperwork than for any other reason." This is good reason to use a qualified customs broker that will establish procedures and ensure that all paperwork is correct and properly documented. Although it is advantageous to use a customs broker, firms should have someone in their organization delegated to handle customs processes, documentation, and information.

Summary

Production planning involves utilization of resources to maximize throughput and productivity of the firm. Capacity is a means of judging whether a firm has adequate resources (machines, labor, and facilities) to manufacture a product. Production standards for specific styles are used to determine the required capacity for an order, throughput time for the style and order, and equipment and labor needs. Plant capacity is managed through routing, loading, and scheduling. Long-term production planning is based on forecasts, merchandise plans, and budgets. Short-term plant capacity is managed through routing, loading, and scheduling.

The goal of production sourcing is to produce or acquire the goods in the most cost-effective way in order to maximize return on investment. Effective production sourcing results in salable, profitable products with the desired styling and quality characteristics. Firms may source from domestic and/or international contractors depending on their needs and priorities. Before using international sources it is critical to visit the country to assess the available labor force, potential language difficulties, cultural differences, plant productivity, shipping opportunities, quality of management, and political risks. Communication among merchandisers, technical designers, engineers, and production planners is essential for effective planning and sourcing.

References and Reading List

Charron, P. R. (1998, March 3). Realities of global manufacturing and sourcing: A sewn products perspective. Key note address at International Apparel Research Conference, Atlanta, GA.

Cline, W. R. (1990). The future of world trade in textiles and apparel (rev. ed.).
Washington, DC: Institute for International Economics.

Drucker, P. F. (1990, May–June). The emerging theory of manufacturing. *Harvard Business Review*, pp. 94–102.

Goldman, S. L., Nagel, R. N., and Preiss, K. (1995). Agile competitors and virtual organizations: Strategies for enriching the consumer. New York: Van Nostrand Reinhold.

Goldratt, E. M., and Cox, J. (1992). The goal: A process of ongoing improvement (2nd rev. ed.). New York: North River.

Technical Advisory Committee of American Apparel Manufacturers Association. (1989). Making the revolution work. Arlington, VA: Author.

Technical Advisory Committee of American Apparel Manufacturers Association. (1998). Sourcing without surprises. Arlington, VA: Author.

Key Words

agent agile manufacturing air freight apparel computer integrated manufacturing (A-CIM) available capacity balancing base rate bonuses bottleneck brokers capacity certification code of conduct committed capacity computer integrated manufacturing (CIM) configuration consolidation constraint constraint operation contractor contractor compliance cross-trained

customs customs broker

cut-make-trim (CMT) cut order demonstrated capacity domestic sourcing excess capacity expediting flexible manufacturing full package sourcing (FPS) input learning curve legal council letter of credit (LC) loading long-term planning mass customization output plant capacity potential capacity price quote produce against forecast production production capacity production capacity estimates production managers production planning production samples

production sourcing production standard production strategies productive capability purchasing agents quality auditor auota required capacity routing salaries scheduling short-term planning sourcer specialty contractors standard allowed hours (SAH) standard allowed minutes (SAM) style samples subcontractor throughput time throughput volume trade advisor value-added vendor work-in-process

Discussion Questions and Activities

- 1. What is throughput? Why is it a primary concern of engineers and production managers? How does it impact business? How is it achieved?
- 2. Consider the situation in Table 9–2. Would it have been feasible for the contractor, Stitch Taylor, to hire more operators in order to complete the order on time?
- 3. If you were the manufacturer and wanted to source shirts in Mexico, what would you need to know before you would begin? What would you have to do? How would sourcing in Mexico be different from sourcing in Asia or in the United States?

- 4. How do production standards affect production planning and capacity?
- 5. How does a constraint operation affect inventory, capacity, and throughput?
- 6. How does the production plan relate to a firm's strategic plan, merchandising calendar, and sales forecast?
- 7. Assume you are an apparel entrepreneur who has a unique idea for a fashion product such as a special design for casual shorts. List all the steps you would have to take to have the product mass-produced for you by an apparel contractor.

Costs, Costing, Pricing, and Profit

OBJECTIVES

- © Explore the relationships among costs, costing, pricing, and profit.
- Examine various strategies and stages of costing.
- Evaluate the purposes, uses, and processes of determining product costs.
- Examine the relationship of costs to pricing, volume, and profit.
- Discuss policies and procedures related to pricing.

Distinguishing between cost and price is fundamental to understanding profit and loss. **Cost** is the total dollar amount invested in a product. **Price** is the dollar amount asked or received in exchange for a product. The difference between the price and the cost of a product is profit or loss on that product. For a firm, revenue minus costs equals profit or loss. **Revenue** is the total of all receipts from the sale of the firm's products during a stated time period. In order to make a **profit**, revenue must exceed costs. When costs exceed revenue, a loss is incurred.

Integration of the concepts of cost, price, and profit is shown in Table 10–1. This example shows how the manufacturer's costs and profit are combined to become the manufacturer's price, which is the retailer's cost, when the goods are purchased. The retailer's costs plus profit is the consumer's price.

Table 10–1 Relationship of cost, price, and profit.

Manufacturing costs + Operating expenses + Profit = Manufacturer's price MC + OE + P = MP \$7 + \$4 + \$1 = \$12
 Manufacturer's price = Retailer's cost MP = RC \$12 = \$12
 Retailer's cost + Operating expense + Profit = Retailer's price RC + OE + P = RP \$12 + \$10 + \$2 = \$24

Costing is the process of estimating the total resource investment required to merchandise, produce, and market a product. Product costs accumulate from all functional divisions of a company. **Pricing** is the process of determining the exchange value of goods that are made available for sale. Pricing is based on data produced in the costing process, the value customers place on the product, and the competition in the market. The pricing process is discussed later in this chapter.

Costs and Profits

Costs have a major impact on a firm's success and thus need to be managed. The key to successful cost control is information and the ability to use that information to manage a firm. Advanced computer technology has expanded the amount of cost data collected and increased the speed and complexity of analysis. Financial statements and performance reports that used to take hours of recording and calculating can now be ready in a matter of a few hours or minutes. Performance reports provide comparisons of actual costs against budgeted costs. Effective managers utilize this information to make appropriate business decisions for the firms.

An **income statement** is a financial statement that relates revenue (sales) to costs to determine profit. An *income* or *profit and loss statement*, as it is sometimes called, is a summary of revenue and expenses for a specific period of time. Values may be shown both in dollars and as a percentage of sales to help in understanding the relationships between sales and costs and the relationships among cost and expense categories. In the following discussion, the sections of a simple income statement and the impact that each of these categories of costs has on profit is examined (see Table 10–2). A detailed version of an income statement would have each of the sections more finely differentiated for

Table 10–2 A simple income statement.

Net sales	\$10,500,000	100%
 Cost of goods sold 	\$ 6,300,000	60%
Materials costs		
Direct labor		
Overhead		
Gross profit margin	\$ 4,200,000	40%
 General operating expense 	\$ 3,150,000	30%
Net profit or loss (+ or -)	\$ 1,050,000	10%
1917 M. H. B. STONE LEFT BUT OF THE SECTION OF A STORY AND A SECTION OF THE SECTI		

a more thorough analysis of income, costs, expenses, and potential for increased profit.

An income statement has three sections: revenue (sales), cost of goods sold, and general operating expenses. **Cost of goods sold** represents all expenditures associated with the manufacture of the product line including material costs, labor costs, and overhead expenses. The **gross profit margin** (also called *gross profit* or *gross margin*) is the amount of income remaining after cost of goods sold is covered. When general operating expenses are deducted from the gross profit margin, the "bottom line" becomes profit or loss.

Managers are always concerned as to how positive or negative the bottom line will be. In the business community, many references are made to the "bottom line" as the deciding factor when making business decisions. In the long run, the bottom line has to be positive so a firm can stay in business.

The different parts of the income statement identify basic areas of profit potential. Careful examination of an income statement can help identify where improvements or changes need to be made in order to improve profits. For example:

1. An increase in sales without an increase in cost of goods sold or operating expenses would result in an increase in income and profit. This might be attained by an increase in price.

 A reduction in the cost of goods sold without a change in net sales would mean an increase in profit. Cost of goods sold may be affected by

changes in costs of materials, labor, and/or overhead.

A reduction in general operating expenses would result in larger profits if income and cost of goods sold remain constant. This could occur from a reduction in administrative salaries or expenses of clerical and record-keeping services.

While the income statement is useful in identifying the overall status of a firm, it does not clarify the sources of profits or costs among the products the firm offers. Each style needs to be evaluated separately on its contribution to profits.

Manufacturing Costs

Manufacturing costs include all the expenditures that are incurred in making a finished product available. These costs are summarized as cost of goods sold on the income statement. Cost concepts used in this discussion are shown in Table 10–3. Manufacturing costs are subdivided into three basic areas: (1) direct materials, (2) direct labor, and (3) overhead. Direct materials costs include fabric, thread, trim, and findings used in garments. Direct labor costs include wages of employees who work on the product in the plant, including cutters, sewers, and finishers. Direct materials and labor are direct variable costs. The cost varies with the quantity of goods produced.

Overhead consists of both nonvariable and variable indirect manufacturing costs. Overhead costs are unique to each firm, but they generally are subdivided into (1) indirect labor, (2) occupancy, and (3) other overhead. Indirect labor costs consist of service personnel, quality control, material handlers, mechanics and maintenance workers, and security. The work of these individuals

Table 10–3
Definitions of costs.

Contribution—the amount of revenue remaining to cover overhead and profits after variable costs have been deducted from sales revenue

Contribution margin—difference between sales revenue and variable costs

Direct costs—costs incurred by increasing the value of a product
Direct labor—first-line supervisors and factory employees who work
on the styles being manufactured

General operating expense—indirect costs including the expenses of operating the general offices and departments that are not part of the manufacturing process but are essential to the operation of the firm

Gross (profit) margin—amount available to cover general operating expense and profit as determined by subtracting manufacturing costs from net sales

Indirect costs—costs not associated with specific units of production

Indirect labor—workers in the manufacturing area who do not work on the product such as repair and maintenance in the factory, materials handlers, and janitorial people

Nonvariable costs—costs that remain unchanged despite changes in volume. (In the short run, many costs are nonvariable. In the long run, all costs are variable.)

Overhead—variable and nonvariable manufacturing costs that cannot be traced to specific units of production

Variable costs—costs that increase or decrease in direct proportion to a change in the volume of production

is essential to efficient manufacturing of a product line, but none of them work directly on the product. **Nonvariable overhead costs** include rent, depreciation, insurance, property taxes, and security. Examples of **variable overhead costs** are machine parts and repairs, marker paper, and needles. Other overhead costs include materials management, machinery and equipment costs, and cost of compliance with regulations.

In the income statement (Table 10–2), general operating expense is deducted from the gross profit margin to determine profit or loss. General operating expenses or administrative overhead are indirect costs that include the costs of operating the general offices and departments that are not directly involved with the product line but are essential to the operation of the firm. Administrative overhead includes engineering, merchandising, marketing, accounting, management information systems (MIS), secretarial and clerical staff, and personnel office.

Systems of Costing

Cost information is the basis of a firm's decision making. Decision making is usually related to a time span of activity that may be **short range** (days or weeks) or **long range** (months or years). When viewed in the context of a time span, costs that are variable and nonvariable change. For example, labor costs and factory costs, when viewed long range are variable costs that increase or decrease as the demand for product fluctuates. Plants can be opened or closed and employees hired or laid off. The same costs when viewed for short-range decisions become nonvariable costs as the investment has been made in the factory and the labor force employed. Short-range decisions are limited by the type of plant, skill level of the workers, and the type of equipment that is available. Decisions impacting the short range should determine how to achieve the most output with the investment that has been made.

When viewed long range, labor, materials, and factory overhead are variable costs. When these same costs are reviewed for immediate decisions they are nonvariable. Long range, priorities change and variable costs can be changed

with appropriate decisions.

There are several different types of cost systems that firms use and each has its benefits and drawbacks. Managers need to determine the cost information needed and how the information will be used. Some of the systems generate good product cost data for external reporting but are not relevant for internal management decisions needed by the firm and others provide incomplete information for accurately differentiating the costs of various products.

The costing process includes assembling data on (1) variable and nonvariable costs of materials and labor required to produce a product, (2) overhead

necessary to operate the factory, and (3) general operating expenses required to run the firm. To be effective, cost data must be specific, accurate, and timely. The more accurate the costing, the better the business decisions and the greater the potential for business success.

Product costing requires in-depth understanding of product development, materials, production processes, and plant and business operations. Three product costing systems commonly used in the apparel industry are direct costing, absorption costing, and activity-based costing.

Direct Costing

Direct costing is a concept that considers only the variable costs, such as production labor, material costs, and sales commission, to be product costs. Nonvariable costs, both manufacturing and nonmanufacturing, are treated as time period costs. Because individual product costs are clearly identified, direct costing makes it possible to determine the contribution margin for each product. A contribution margin is the difference between the price of a product and the cost of goods (variable costs). The contribution margin is the amount of revenue available to cover nonvariable costs and profit. Direct costing makes it possible to compare the cost of production and the contribution each product makes to nonvariable selling and administrative costs and profit. Direct costing also makes it possible to identify individual styles and their level of contribution. It is useful in determining whether to make or buy a product.

Absorption Costing

Absorption costing is a costing system that recovers overhead costs by assigning a percentage to some element of direct labor. It considers all manufacturing costs, both variable and nonvariable, to be product costs that can be allocated to products. An **overhead application rate** is a percentage determined to be representative of all the overhead costs. It would be applied to a measurable direct cost driver such as labor hours or machine time. Determination of a realistic overhead application rate is difficult, especially in today's plants when direct labor may only be 15 percent of a product's cost. Firms often project the expected total overhead for the period based on the past year's costs and expected changes. The overhead application rate may be determined by dividing the total **factory overhead** by the total direct labor costs for the period.

Absorption costing makes it difficult to focus on the actual variable costs and to analyze specific nonvariable costs as overhead costs are generally allocated from a single cost pool. The profit potential associated with a particular product or product line is often distorted by the overhead application rate. Figure 10–1 shows the factors that can be included in absorption costing and their relationships. In Figure 10–1, the garment has sewing costs of

\$3.230 (line 7). The overhead application rate for management and clerical expenses is 25 percent (line 18). The overhead costs are .8075 per garment $(3.230 \times 0.25 = 0.8075)$.

Several risks are associated with using absorption costing. Are direct labor costs accurate? Is the overhead application rate accurate? Does the overhead application rate really reflect true product costs? The first risk is the dependency of the costing system on the accuracy of costing direct labor. The second risk is the determination of the overhead application rate, which is arbitrary.

The outcomes and uses of direct and absorption costing are quite different. A comparison of income statements resulting from each process is presented in Table 10–4. Using absorption costing becomes unrealistic as the percentage of

direct labor is reduced.

Activity-Based Costing

Activity-based costing (ABC) is a costing system that treats all costs as variable elements of product cost. "Virtually all of a company's activities exist to support the production and delivery of today's goods and services. They should therefore all be considered product costs" (Cooper and Kaplan, 1988). Activities create costs and products consume activities. Costs that can be associated with certain products, customers, or suppliers should be allocated accordingly. What would be considered indirect product costs with another accounting system, are allocated based on utilization of these activities. See a summary of activity-based costs allocated to individual product categories in Table 10–5.

ABC builds realistic product cost data by determining the demands of particular styles on what, in other costing systems, is regarded as indirect resources. The result is a comprehensive product cost that provides a realistic basis for making long-range business decisions. All factory overhead, administrative overhead, and any other organizational resources used in support of a product line are first assigned to activity centers such as design, merchandising, MIS, quality assurance, and distribution. Costs of using these resources are then assessed to the styles, customers, or suppliers that create the demand for these resources. Under an ABC system, a line or style that consumes a lot of a designer's time is assessed for the time spent. A carryover product that is already developed and does not require any design involvement would not be assessed for design service.

Most factory overhead and support costs can be traced to specific products. All costs are budgeted, both direct and indirect. Notice in Table 10–6 the mechanics, maintenance, pattern making, and so forth all have a line in the budget. This figure is based on the projected hours to be worked multiplied by the average hourly wage. Table 10–7 shows a further breakdown of these costs by assessing them to old styles and new styles. This also makes each activity center accountable for time and productivity. "Only traceable costs can be controlled, and ABC

Figure 10–1
Basic absorption costing sheet.

				Basic C	Basic Cost Sheet				
Date	11/5/98		Style #	48511		Garment Type		Classic Wool Skirt	
Line	Category	Item							Total
	Piece	Description				Yards/Unit	Cost/Yard	Cost/Unit	Cost
		Worsted 800 Freight				0.875	8.000	7.000	
	Trim and Findings	Description		1 2		Yards/Unit	Cost/Yard	Cost/Unit	7.011
		Lining Label & Tag Zipper				1.125	1.250	1.406	
	Direct Labor	Cost Center				200	0.000	0.600	2.014
		Cutting Sewing Finishing		S.A.H. 0.0134 0.3800 0.0400	Rate 10.00 8.50 6.00	Cost 0.1340 3.2300 0.2400	Variances -21% -18% -14%	Tot. Dir. Lab. 0.1621 3.8114 0.2736	7404
	Manufacturing Overhead	Cost Center					Exp. Rate	Tot. O.H.	
9 11		Indirect Labor Cutting					200%	0.2680	
		Finishing					35% 35%	1.1350	
4		Factory Expenses					19%	0.1369	
							%12	0.1513	

Line	e Category	Item	Total Unit Cost
5 5 7	Total Mfg. Costs	Cost of Contractor CMT Work Total Cut Make and Trim Costs (Total Lines 5, 8, 14) Total manufacturing Costs (Total of Lines 2 & 16)	8.032
8 6 8 5	Admin. Expenses	Management & Clerical (Line 7, Cost of Sewing Labor \times 25%) Computer & MIS (Line 7, Cost of Sewing Labor \times 7.5%) Shipping Labor (incentive .010 plus excess) Shipping Overhead (incentive .010 \times 300% exp. rate)	0.808 0.242 0.014 0.030
888	Selling	General Selling Expense (Line 17 \times 2.5% exp. rate) Allowance for Close-outs and Seconds (Line 17 \times 0.9% exp. rate) Cost to Make & Sell (Total Lines 17 through 33)	0.376 0.135 16.648
28 27 88 82	Profit Analysis	Variable Selling Cost (7.2% of Line 27) Total Cost to Make & Sell (Total Lines 24 and 25) Wholesale Price (Net of discounts after customer terms) Gross Margin (Line 27 – Line 26) Gross Margin % (Line 28 divided by Line 27)	2.160 18.808 30.000 11.192 37.3

Table 10–4
Comparison of direct and absorption costing income statements.

Nonvariable selling and administrative expenses

Total selling and administrative expenses

Net income

Direct Costing Ir	ncome Statement		
	Product 1	Product 2	Total
Sales	\$1,000	\$1,000	\$2,000
Less: Variable costs			4-,000
Direct materials	300	500	800
Direct labor	400	200	600
Variable overhead	200	100	300
Variable selling and administrative expenses	50	30	80
Total variable costs	950	830	1,780
Contribution margin	50	170	220
Less: Nonvariable costs			
Nonvariable overhead	100	50	150
Nonvariable selling and administration costs	50	20	70
Total nonvariable costs	150	70	220
Net income	\$ (100)	100	\$0

Product 1 Product 2 Total Sales \$1,000 \$1,000 \$2,000 Less: Costs of goods sold Direct material 300 500 800 Direct labor 400 200 600 Variable overhead 200 100 300 Nonvariable overhead 100 50 150 Total costs of goods sold 1,000 850 1,850 Gross profit margin 0 150 150 Less: Operating expenses Variable selling and administrative expenses 50 30 80

Absorption Costing Income Statement

makes overhead traceable" (Barbee, 1993, p. 64). ABC makes it possible to analyze each activity area to determine the amount of resources (capacity) available for a specific activity and how much of the resource has actually been used. Determining the amount of used capacity or slack in the activity area can provide justification for increasing or reducing the resources for a specific activity area.

50

100

\$ (100)

20

50

100

70

150

0

Activity-based costing can be used as a diagnostic tool that allows focus on overhead cost reduction as well as reductions in direct labor. For example, with ABC engineers can justify projects based on overhead savings. Benefits of new automated equipment may be the improved quality of products and reduced machine downtime. The cost of the new equipment often cannot be justified

Table 10–5Summary of activity-based costs assessed to product categories.

Caps	Shirts	Jackets
\$0.58	\$0.17	\$ 3.62
0.19	0.19	0.19
0.26	0.13	0.40
2.26	0.64	4.88
0.48	0.30	0.72
0.24	0.26	0.31
1.42	1.42	1.42
0.32	0.28	0.35
\$5.75	\$3.39	\$11.89
	\$0.58 0.19 0.26 2.26 0.48 0.24 1.42 0.32	\$0.58 \$0.17 0.19 0.19 0.26 0.13 2.26 0.64 0.48 0.30 0.24 0.26 1.42 1.42 0.32 0.28

Source: Gene Barbee & Associates Ltd., Management Consultants.

Table 10–6Labor summary for budgeted activity-based costs.

Sources of Labor Cost	Rate/Hour	Budgeted Hours	Total Wages	Old Styles	New Styles
Management	Salaried		\$44,000	\$40,600	\$3,400
Department Heads					
Cutting foreman	Salaried		27,560	24,380	3,180
Sewing manager	Salaried		28,600	25,300	3,300
Shipping supervisor	Salaried		23,400	22,500	900
Supervisors					
Sewing 1	\$7.25	1,964	14,239	12,596	1,643
Sewing 2	7.00	1,964	13,748	12,173	1,575
Sewing 3	7.75	1,964	15,221	13,471	1,750
Other Indirect Labor					
Mechanic 1	12.00	2,160	25,000	22,930	2,990
Mechanic 2	10.50	2,160	22,680	20,060	2,620
Clean-up 1	7.00	2,160	15,120	15,120	
Clean-up 2	5.50	1,964	10,802	10,802	
Service 1	6.25	1,964	12,275	11,803	472
Service 2	6.00	1,964	11,784	11,331	453
Service 3	5.75	1,964	11,293	10,858	435
Recuts	6.25	1,964	12,275	10,859	1,416
Repairs	6.00	1,964	11,784	10,878	906
Quality	7.00	1,964	13,748	12,691	1,057
Patterns	5.75	1,964	11,293	9,553	1,740
Office 1	Salaried		15,000	15,000	
Office 2	5.75	1,964	11,293	11,293	
Total			\$352,035	\$324,198	\$27,837
Direct Labor					
Cutting 10	6.25	1,964	122,750	96,973	25,777
Sewing 85	5.75	1,920	938,400	800,554	137,846
Shipping 4	5.75	2,004	46,092	34,569	11,523
Total Direct			\$1,107,242	\$932,096	\$175,146

Source: Information made available courtesy of Bob Lowder, Principal, Charles Gilbert Associates, Marietta, GA.

Table 10–7Activity-based labor and expenses.

Category	Original Budget	Old Styles	New Styles
Sewing standard	\$823,160	\$721,220	\$101,940
Sewing excesses	115,240	79,334	35,906
% excesses	14	11	35.22
Cutting direct	122,750	96,973	25,777
Shipping direct	46,092	34,569	11,523
Total direct	\$1,107,242	\$932,096	\$175,146
Indirect labor	352,035	324,198	27,837
Total direct & indirect	\$1,459,277	\$1,256,294	\$202,983
Expenses	368,162	368,162	
Fringe benefits (17.52%)	255,664	220,103	35,561
Total overhead*	975,861	912,463	63,398
Grand totals	\$2,083,103	\$1,844,559	\$238,544
Overhead % of Direct	88.13%	82.41%	36.20%

^{*}Total overhead includes: indirect labor, expenses, and fringe benefits. Source: Information made available courtesy of Bob Lowder, Principal, Charles Gilbert Associates, Marietta, GA.

with traditional costing methods that focus on improved efficiency and payback based on direct labor savings. With ABC new equipment may be justifiable based on a reduction in nonproducing time due to improved product quality, less training, and dependability of machines.

Firms can also determine the products and customers that contribute higher gross margins and those that do not. Activity-based costing is designed to provide realistic information about support activities and product costs so that managers can focus their attention on the products and processes with the greatest potential for increasing gross margins. ABC is frequently referred to as a cost management tool.

Stages of Costing

Managers use costing to determine (1) the producibility of a design within an established price range, (2) the profit potential in a design, and (3) whether a design should be added to the line. Inaccurate costing may cause cancellation of a style with good profit potential or allow sale and production of styles that ultimately prove too costly to manufacture. Once a style is included in a line, specific cost information is used to plan line budgets and to establish a base for the selling price. Costing may be done by cost estimators, industrial engineers, designers, merchandisers, production managers, or a combination of individuals involved with the product line.

Costing may be done at several different stages throughout manufacturing: (1) preliminary or **precosting** is done during the preadoption phase of product development before samples are made, (2) cost estimating is done prior to line adoption, (3) detailed costing is done during the postadoption stage prior to production, and (4) actual costs are determined during and following production. Figure 10–2 shows the integration of pricing and costing stages as related to merchandising and production.

Preliminary Costing for Creative Design

Manufacturers of fashion goods may use preliminary costing early in the development stage to determine whether the designers' sketches are producible and marketable within the established price range. **Preliminary costing** is a rough estimate of costs of producing a particular style. Fabric type, yardage, and quantities are estimated as are trims and other material costs. Labor costs are estimated based on production of similar styles. Costing at this early stage of product development is particularly necessary for the fashion manufacturer because of the broad range of styling ideas a designer may use. Preliminary costing helps weed out designs that would be too costly for the line before additional time and resources are invested. If it appears a design has potential but is too costly to produce, it may be modified to meet cost limitations. Preliminary costing may save time and sample costs that can range from \$50 to \$300 per sample.

Costing at this stage may not be a formal process for all firms. A knowledgeable designer can edit ideas and sketches based on cost information from past experiences and current market information. Previous experience will help a designer focus on fabrics and processes that are realistically suited to the firm's particular price point.

Cost Estimating for Line Adoption

Cost estimating may be done just prior to line adoption. Cost estimating determines the expected investment in materials, direct labor, and overhead required to produce a single unit of a style. Specific materials have been determined and fabric yardage requirements need to be refined. Labor costs are estimated based on the time required to produce a style and the average hourly wage. Decisions relating to producibility at a specific price point rely on cost estimates. It requires more detail and greater accuracy than preliminary costing. Costing, at this stage, is based on a firm's samples and standard data. Cost information is often justification for accepting or rejecting a style in the line.

Detailed Costing for Technical Design

Detailed costing is done after styles are adopted into the line and refined for production. It provides the opportunity to pick up any costs that may have been missed during cost estimating such as an overlooked label or an extra button. It also picks up changes that were made by technical designers such as fit

Establi	ish selling seasons,	assortments, price ranges, targe	Establish selling seasons, assortments, price ranges, targeted list/first prices, and gross-margin goals.	rgin goals.
	Line Development		Production	Line Presentation
Preadoption Product Development	Line Adoption	Postadoption Product Development	Assembly and Finishing	Wholesale/Retail
Precosting of Sketzhes (rough estimates) Product development costs Materials costs Production costs Gross-margin potential Cost Estimating of Designs (based on samples and design specifications) Materials Direct labor Overhead Gross-margin potential	Establish listfirst price for each style accepted in line. Establish gross-margin requirements for line. Management	Detailed Costing of Styles Product development costs Materials costs Piece goods Trim Other Production costs Cutting costs Start-up costs Start-up costs Equipment amortization Subcontracting Overhead Subcontracting Overhead Subcontracting Overhead Shipping costs Administrative costs Administrative costs Marketing expense Evaluate Gross-margin potential Merchandise assortment	Actual Costs Determine actual costs and cost variance related to • Marketing • Marketing • Production • Overhead • Administration Reevaluate • Merchandise assortment • Pricing • Product line	First price Premium price Selling price Job off price Mark up Mark down Cost of goods sold Gross margin Gross-margin return on investment Adjusted gross margin

Figure 10-2 Integration of pricing and costing stages as carried out in apparel firms. Source: Model developed by Grace I. Kunz, 1994.

changes that reduced the amount of fabric needed or a complex operation that may have been simplified. It requires more accurate cost estimates. Detailed costing is tedious and time-consuming but essential if a firm wants an accurate account of product costs. Detailed costing is based on specific production methods and production standards in standard allowed minutes (SAM) that are determined for each component or operation required for the style.

A production standard reflects the normal time required to complete one operation or cycle using a specified method that will produce the expected quality. Production standards are the basis of establishing standard labor costs and managing available production time. They set a consistent work rate or time for completing each specific operation. Production standards are developed from work measurement techniques such as predetermined time, standard data, and time studies. The time values specified in the production standards are usually expressed in standard allowed minutes (SAMs), which may be translated into standard allowed hours (SAHs) if a firm chooses to work in dozens per hour. Firms frequently use their own standard data or commercially available, predetermined time systems as a basis of determining time requirements which are converted to labor costs.

As a result of detailed costing, changes may be made to modify fabric requirements and reduce the number of operations. Minimarkers are made to provide more accurate material costs. Detailed costs provide the basis for establishing production budgets and specification sheets that accompany styles being sourced.

Determining Actual Costs

Actual costs are determined by the collection of data from production. Once a style reaches the sewing floor, an engineer may find some rates are too tight and that more time is needed to complete specific procedures. If a rate adjustment is needed, it will inevitably affect costs. Actual costs need to be monitored throughout production; and if a style exceeds budgeted costs, it may need to be reengineered or dropped from the line. Actual costs of materials may increase if there are excessive flaws or shading problems while at the same time costs could decrease if fabric utilization was better due to large multisize markers.

Determining Product Costs

Determining direct costs of materials and labor for individual styles is an important part of accurately costing a product line. A **Bill of Materials** is developed for each approved style. This includes a precise list of all the materials, exact quantity for one unit, and the cost of each unit. A manufacturer can use this list to determine quantities and costs of producing one, a dozen, or ten

thousand. Material costs are the largest part of product costs. Labor costs are based on time. Labor costs, although a lower percentage of total product costs, are closely monitored for reductions.

Materials Costing

Direct costs of materials for a style, including piece goods, trim, and findings, are based on estimates derived from an approved style sample. The first step in costing materials is to determine the specific products to be used and the number of units of each required for one garment. Unit specifications and putup are specific to the type of material. Commonly, fabric units may be yards or pounds, trims may be yards per roll or each, buttons may be sold by the gross or package, and sets of snaps may be sold as a gross or package (see Table 10–8). It shows unit costs of materials broken down to costs for an individual style.

Fabric is usually the material that is most costly and most difficult to determine precise yardage requirements. Garment samples represent only one size. Larger sizes take more fabric; smaller sizes take less fabric. Therefore, some firms may use a weighted average to accommodate all sizes that are to be produced. In cost estimating before line adoption, firms with computer-aided design (CAD) systems may use the dimensional data available for each style to determine the required fabric yardage for a single garment. In detailed costing after line adoption, firms may make minimarkers of a standard mix of sizes based on assortment plans to determine more precise fabric requirements. See Figure 10–3 for an example of a style cost sheet including materials and labor.

Materials are usually priced and sold in minimum quantities such as 1,000 yards, 1,000 sets, or 100 dozen. When the merchandise plan includes 500 units of a style that requires 1.7 yards per style and the piece goods minimum is 1,000 yards, excess piece goods may be bought if a vendor with a smaller minimum cannot be located. The excess materials cost, in this case, relates to 150 yards of piece goods (500 units \times 1.7 yards = 850 yards required; 1,000 yards minimum - 850 yards required = 150 yards excess).

Material costs are affected by the percentage of utilization. Utilization depends on how much of the material is actually used compared to the amount that

Table 10–8
Materials cost worksheet.

Garment Component	Material	Qty/Gmt	Units	\$/Units	\$/Gmt
Waistband	Curtain, plain/cream	1.17 yd	1,000 yd	195.85	0.29
	Hook & eye	1 each	1,000 sets	32.00	0.038
Belt loops	Fusible, white	0.833 yd	1,000 yd	13.75	0.0115
Flys	Right fly lining, cream	0.389	1,000 yd	158.20	0.0615
	Zipper tape	0.264 yd	200 yd	37.60	.0496

Style: 389	Date: Sep-91	Customer: BIG BUCKS	Season: SPR92
Description:	BASIC T SHIRT, HEMM	MED SLEEVE, RIB NECK,	
	LARGE TUBE SIZE 22	OII	

LABOR:

EXTENSION PER GARMENT

1.36	SAMS	\$6.25 ,	Wt. Avg. Base Rate	Standard	\$0.012
12.0%	Excesses, Cu	tting	12 Gmts. / Unit	Excesses	\$0.001
31.21	SAMS	\$5.75 ,	Wt. Avg. Base Rate	Standard	\$0.249
14.0%	Excesses, sev	wing I	12 Gmts. / Unit	Excesses	\$0.035
0.00	SAMS	\$0.00,	Wt. Avg. Base Rate	Standard	\$0.000
0.0%	Excesses, sev	wing II	1 Gmts. / Unit	Excesses	\$0.000
0.00	SAMS	\$0.00 ,	Wt. Avg. Base Rate	Standard	\$0.000
0.0%	Excesses, Fin	ishing	1 Gmts. / Unit	Excesses	\$0.000
0.00	SAMS	\$0.00 ,	Wt. Avg. Base Rate	Standard	\$0.000
0.0%	Excesses, Pre	essing	1 Gmts. / Unit	Excesses	\$0.000
1.43	SAMS	\$5.75 ,	Wt. Avg. Base Rate	Standard	\$0.011
10.0%	Excesses, shi	pping	12 Gmts. / Unit	Excesses	\$0.001
	12.0% 31.21 14.0% 0.00 0.0% 0.00 0.0% 0.00 1.43	12.0% Excesses, Cu 31.21 SAMS 14.0% Excesses, set 0.00 SAMS 0.0% Excesses, set 0.00 SAMS 0.0% Excesses, Fin 0.00 SAMS 0.0% Excesses, Fin 1.43 SAMS	12.0% Excesses, Cutting 31.21 SAMS \$5.75 , 14.0% Excesses, sewing I 0.00 SAMS \$0.00 , 0.0% Excesses, sewing II 0.00 SAMS \$0.00 , 0.0% Excesses, Finishing 0.00 SAMS \$0.00 , 0.0% Excesses, Pressing 1.43 SAMS \$5.75 ,	12.0% Excesses, Cutting 12 Gmts. / Unit 31.21 SAMS \$5.75 , Wt. Avg. Base Rate 14.0% Excesses, sewing I 12 Gmts. / Unit 0.00 SAMS \$0.00 , Wt. Avg. Base Rate 0.0% Excesses, sewing II 1 Gmts. / Unit 0.00 SAMS \$0.00 , Wt. Avg. Base Rate 0.0% Excesses, Finishing 1 Gmts. / Unit 0.00 SAMS \$0.00 , Wt. Avg. Base Rate 0.0% Excesses, Pressing 1 Gmts. / Unit 1.43 SAMS \$5.75 , Wt. Avg. Base Rate	12.0% Excesses, Cutting 12 Gmts. / Unit Excesses 31.21 SAMS \$5.75 , Wt. Avg. Base Rate Standard 14.0% Excesses, sewing I 12 Gmts. / Unit Excesses 0.00 SAMS \$0.00 , Wt. Avg. Base Rate Standard 0.0% Excesses, sewing II 1 Gmts. / Unit Excesses 0.00 SAMS \$0.00 , Wt. Avg. Base Rate Standard 0.0% Excesses, Finishing 1 Gmts. / Unit Excesses 0.00 SAMS \$0.00 , Wt. Avg. Base Rate Standard 0.0% Excesses, Pressing 1 Gmts. / Unit Excesses 1.43 SAMS \$5.75 , Wt. Avg. Base Rate Standard

\$0.272 TOTAL STANDARD

0.037 TOTAL EXCESSES

OVERHEAD PERCENT 88

88.1%

TOTAL LABOR & OVERHEAD

\$0.583

MATERIALS:

Description BODY	TUBE, 100%	COTTON, 22"	, PURCHASED AS I	POUNDS.	
5.750 Units	\$2.750 ,	Cost / Uni	3.00% Waste	12 Gmts. / Unit	\$1.357
Description COLLA	AR RIB, 100%	COTTON, PU	RCHASED AS POU	NDS.	
0.220 Units	\$2.750 ,	Cost / Uni	10.00% Waste	12 Gmts. / Unit	\$0.055
Description THREA	D, TEXTURIZ	ED POLY, PUF	RCHASED BY CONE	E, 26000 YDS.	
0.015 Units	\$4.000 ,	Cost / Uni	10.00% Waste	12 Gmts. / Unit	\$0.006
Description LABEL	, TWO-COLO	R, PRINTED, V	W. CARE, PER 1000)	
1.000 Units	\$3.250 , 0	Cost / Uni	10.00% Waste	1000 Gmts. / Unit	\$0.004
Description SHIPP	ING CARTON	S, PER 100			
1.000 Units	\$110 ,	Cost / Uni	5.00% Waste	7200 Gmts. / Unit	\$0.016

\$0.583 LABOR & O.H. 1.438 TOTAL MATERIALS TOTAL COST \$2.021

20.0% MARK-UP PERCENTAGE COST PLUS MARK-UP \$2.425

Figure 10-3

Style cost sheet including materials and labor. Source: Information made available courtesy of Bob Lowder, Principal, Charles Gilbert Associates, Marietta, GA.

actually becomes part of the product. For example, a specific short-sleeve blouse requires 1.3 yards of fabric. Computer calculations show the actual fabric to be consumed by the blouse is 0.95 yards. The 0.35 yards of fabric that is not used is considered waste even though it is required for cutting the garment. This may be the result of a poorly engineered design, patterned fabric, or an inefficient marker. If a style is being sourced from a contractor extra fabric and/or trim allowances may need to be added to orders even though it may result in waste.

Many firms have established standards for fabric utilization, but some waste is inevitable. Each firm develops its own policy for costing material waste. Many firms use a percentage of the cost of each material to cover waste. Three to 10 percent is common. This figure may vary with the item based on past history of the material and vendor. The materials cost in Figure 10–3 shows a percentage to cover waste being added to the unit cost of each material. Poor utilization produces waste. Wastes may also result from poor-quality materials, inconsistent fabric width, splicing, and recuts.

Other costs associated with materials such as inspecting and shading of fabrics may be figured on a per-yard basis, treated as an activity cost, or included in the total cost of the product. Freight costs may also be calculated for each unit of fabric or trim.

Labor Costing

Two aspects of the role of labor costing are discussed here: budgeting for production and labor costing for individual styles.

BUDGETING FOR PRODUCTION The basis of labor costing is time. Labor costs, both direct and indirect need to be budgeted in order for a firm to examine its financial commitments, and evaluate its capacity to produce a product.

Direct labor includes all factory employees that are directly involved with the cutting, sewing, finishing, and pressing of styles. Total direct labor cost is determined by the following:

 $\textit{Total direct labor cost} = \frac{\textit{number of operators} \times \textit{hours per week}}{\times \textit{weeks per year} \times \textit{average hourly earnings}}$

Total direct labor cost represents a firm's financial commitment to employing a predetermined number of operators for a specific period of time. Total direct labor costs are used to establish budgets, schedule work, and hire employees. Determination of total direct labor cost is shown in Table 10–9. Direct labor cost consists of standard labor costs and excess labor costs.

 $Total\ direct\ labor\ cost = standard\ labor\ cost + excess\ labor\ costs$

Standard labor cost is compensation for producing the firm's product line. It is earned money or piece rate earnings. Standard labor cost is estimated by the following:

Table 10–9
Excess cost worksheet.

Pla	nt or Department	Plant # _	1
	Direct Labor		Budget
A.	Number of operations		150
B.	Hours per week		36
C.	Weeks per year		48
	Average hourly earnings Total annual direct labor		\$7.50
	$(A \times B \times C \times D)$		\$1,944,000
	Standard Labor		Budget
F.	Percentage efficiency		90%
G.	Weighted average base rate per hour Total annual standard labor		\$6.00
	$(A \times B \times C \times F \times G)$		\$1,399,680
I.	Excess cost percentage		
	(E - H) / H		38.9%

Source: Courtesy of Textile/Clothing Technology Corporation [TC]2.

 $standard\ labor\ cost = \%\ plant\ efficiency \times number\ of\ work\ hours \ \times weighted\ average\ base\ rate$

Estimates of standard labor costs are needed to determine the cost of producing each style and excess costs for each style. Estimates of standard labor costs are based on plant efficiency and the firm's weighted average base rate.

Plant efficiency is determined by the volume of production relative to the input of work hours. This figure for budget purposes is based on operational history of a plant. A base rate (BR) is an established dollar compensation for one hour of work. Firms may use one flat base rate for all operators or a different rate for each skill level. For budget purposes, a weighted average provides sufficient accuracy.

Excess labor cost is compensation for time spent on the job but not producing a product. It is the difference between the total earned and the total paid to direct employees.

 $excess\ labor = direct\ labor - standard\ labor$

Excess labor may be the result of machine downtime, attending meetings, being out of garments to work on, or taking inventory (see examples in Tables 10–6 and 10–7 and Figure 10–3). Excesses can vary a great deal from year to year and need to be budgeted as close as possible.

COSTING INDIVIDUAL STYLES Labor costing for individual styles begins with a breakdown. A **breakdown** is a complete sequential list of all operations involved in assembling a style. A single assembly process, such as attaching a pocket, is called an operation or cycle. Figure 10–4 includes a breakdown used

RUN: 05/04/88 07:36

LEADTEC UTAH STYLE LISTING

PAGE 91

STYLE NUMBER: 9G460 GIRBAUD INVERTED PLEAT SHORT VERIFIED? : YES STD. BUNDLE: 4 CONTROL NBR : C06 OK FOR USE? : YES DATE ENTERED: 04/11/88 SUB/ADD RULE: OUTSTN. CUTS : 0

	Q **		BASE *****		RATE/UNITS	STA ****	SEC ****	NEXT	LOC ****	UNT/8.00	
1	0	86-3 MAKE LOOPS	- 002	0. 00164	0. 00722#	002	01	49	Υ	4878	
2	0	50-2 MAKE FLY LOOF	- 002 P	0. 00145	0. 00638#	002	02	12	Υ	5517	
3	0	51–3 – – MAKE TAB	- 003	0. 01258	0. 05787	404	03	4	Υ	636	
4	0	51–6 – – B/H TAB	- 001	0. 00290	0. 01218	006	03	19	N	2759	
5	0	78–8 – – JOIN BANDS	- 002	0. 00320	0. 01408	327	04	6	Υ	2500	
6	0	83–5 – – SERGE BAND	- 002	0. 00463	0. 02037	110	04	7	N	1732	
7	0	65-0 SET LABELS ON	- 004 I BAND	0. 01042	0. 05002	206	04	40	N	768	
8	0	50-4 SERGE LEFT FL		0. 00268	0. 01179	480	05	9	Υ	2996	
9	0	50-6 ATTACH ZIPPER		0. 00360	0. 01584	059	05	36	N	2222	
10	0	50–8 – – ST/TURN FLY ST		0. 00355	0. 01562	482	06	11	Υ	2254	
11	0	04–2 – – SERGE RT FLY	- 002	0. 00333	0. 01465	068	06	40	N	2410	
12	0	10-A SHADE PANELS	- 001	0. 00106	0. 00445#	001	07	13	Υ	7619	
13	0	52-4 FLY LABEL LOOF	- 004 P&YOKE	0. 01307	0. 06274	483	07	30	N	612	
14	0	65-7 CS FACING	- 004	0. 00966	0. 04637	484	80	15	Υ	828	
15	0	93-1 VOID VOID	- 003	0. 00000	0. 00000	326	80	16	N	0	
16	0	67–4 – – OL PKT BAG	- 004	0. 00855	0. 04104	069	80	32	N	936	

Figure 10-4

Portion of a style costing sheet.

for detail costing. Each operation is listed in the order in which it will be performed along with the production standard. The style can be broken into component parts and subtotaled, or the production standards (SAM) for each operation can be added together for the total garment.

Production time can be converted to cost dollars by determining the dollar value of each minute. For example if the standard rate is \$6.00 per hour, each minute of actual production is worth \$0.10 (\$6.00/60 minutes). A garment that required 5.5 minutes of production would have a \$0.55 direct labor cost. This example assumes that every operation is paid the same rate. In reality some operations require more skill and attention by the operator; thus, firms may use variable base rates to compensate operators for different skill levels. In a plant that pays hourly wage, production may be based on production standards representing what an operator is expected to complete in a specified time period.

As with budgeted costs, excess labor is a part of style cost. It is sometimes referred to as *off standard*, which means operators are working, but not being compensated according to a production standard. Each firm may establish its own policy for compensating for excess labor time.

Cost/Volume Relationships

Production costs per unit increase with lower volume per style. As firms seek to meet customer demand for more variety in product lines new challenges arise in producing and costing products. Firms that continually change products and produce small production runs must take into account the difficulty of constantly doing different operations and handling different materials. In costing products allowances need to be added for short runs and a diverse mix of products.

Direct labor costs tend to increase as the volume of a style decreases. Producing 50 of a style will take longer proportionally than producing 5,000 of the same style. Proficiency in performing an operation increases with the number of repetitions and new products often have many new operations. New products have start-up costs that have to be considered each time a new style goes into production.

Start-up Costs

Start-up costs include costs and expenses of putting a new style or new version of an old style into production. This may include new equipment, changeover of machines, new methods, training, and make-up pay. If ABC is used, start-up costs are included as product costs. Additional time and cost is involved just in changing thread colors when a style goes into production.

Production standards are used to determine time and labor costs for normal operators to complete an operation, but when a new product is put into production the operators are not able to work at the normal rate. It may take

several weeks to several months for an operator to learn a new operation, use new equipment, or learn new methods or handling techniques for certain materials. Learning curves are established based on the anticipated number of weeks before an operator will be able to work at a normal pace. During this start-up period production costs escalate. Two factors impact costs and must be taken into consideration when developing budgets and planning production.

1. Compensation for operators is expected to remain constant with their previous earnings while they are learning a new operation,

Productivity of the operators will be low until they learn the operation and build their skill level.

Operators may receive hourly compensation or compensation based on their productivity related to the learning curve while they are learning the operations. The difference between what they are paid and what they earn based on the products they produce is considered a **make-up cost**. Make-up costs will be high the first weeks and decrease as proficiency increases. Start-up also affects capacity planning as the plant will not be able to fill orders at the projected level until productivity increases.

Some plants choose to shut down and force employees to take a week vacation while changeover for new styles occurs. This enables engineers and mechanics to move equipment, change the plant layout, and make whatever adjustments are needed without disrupting the production flow. Even if the plant makes the transition to new styles during shutdown, operator productivity will follow a learning curve when start-up begins.

PRODUCTION COSTS AT ATHLETIC JACKETS UNLIMITED Athletic Jackets Unlimited (AJU) produces and markets several different groups of athletic jackets to dealers. The styles are exhibited at trade shows and the product line is presented through dealer catalogs. They do not maintain an inventory of finished goods nor does the dealer. Styles are produced to order and are personalized with embroidered logos for the specific team or individual. Team logos and special artwork are developed as specified by the customer and must be verified by the customer. Styles are produced to order and shipped direct to the dealer. The complexity and costs of introducing new products at AJU can be examined in Tables 10–10, 10–11, 10–12, and 10–13.

The focus of this discussion is on one group of four styles. Style A has been in the line for five years and is available in a new fabric this season. Style B is a repeat style with the addition of knit cuffs or a waistband. Style C is a totally new style for the firm, and Style D is new but has been purchased from a vendor and Athletic Jackets Unlimited's label is being added.

Table 10–10 shows how the calculation of wholesale price and gross margin are determined for the merchandise group. The allowable cost of producing a style is budgeted at \$30.66. This is intended to cover cost of labor, materials, val-

Table 10–10Deriving wholesale price and gross margin for jacket styles A, B, C, D.

Wholesale Price		Gross Margin	
Labor	\$ 5.63	Wholesale Price	\$45.76
Materials	19.91	Selling Costs	4.58
VOH (L × 56%)	3.16	Production Costs	30.66
FOH (L + M × 22%)	4.96	Gross Margin	\$10.52
Production Costs	\$30.66	Gross Margin Percent	23%
Markup on Wholesale	15.10		
Wholesale Price	\$45.76		

idation overhead (VOH), and factory overhead (FOH). They use a 33 percent markup on wholesale (\$15.10) which establishes a wholesale price of \$45.76. The wholesale price (\$45.76) covers the allowable cost of goods (\$30.66) and selling costs of \$4.58 which leaves a gross margin of \$10.52 for administrative expenses and profit. Although the wholesale price is the same for each style, product development costs and start-up manufacturing costs vary considerably.

Table 10–11 compares the product development and validation costs for each style. The firm uses activity-based costing (ABC) to assign product development and validation costs to each style. **Product development costs** include all the activities needed to prepare a new product for the line. This includes pattern development; refining style and fit; grading; selecting and sourcing materials; establishing assembly methods; determining stitch and seam types and placement of zippers, snaps, and labels. Notice the difference in product development costs between Style A and Style C. This reflects the difference in amount of work that must be done on a completely new style (C) as compared to an established style (A).

Validation costs include checking fit and garment measurements, checking each set of graded patterns to verify seam alignment and correct notch placement, costing, specification development, data entry for bill of materials, and verifying it as a new style number in the line and computer system. This also includes customer approval of artwork that will be used for embroidery on the completed jacket. The multiplication factor is determined by the firm and is based on the number of samples required and the labor costs consumed in producing them.

Compare differences in costs of the styles. What caused the increase in validation costs among the styles? Why are there validation costs associated with Style D when there are no product development costs? Why is the multiplying factor higher for Style C?

Table 10–12 compares the total costs of introducing a line of four new styles. The costs of development and validation are itemized in Table 10–11. Samples for dealers and the catalog photo shoot are also a notable cost, especially for the new style that initially requires more samples to be refined and perfected. Manufacturing start-up for each style includes training costs, make-up labor costs,

Table 10-11 Time/costs using activity-based costing for style development and validation for four styles.

	Style A Same as existing style, but different fabric		Same as existing style, but has cuffs or waistband; minor change		St	Style C		Style D ³	
Cost Categories					New style construction; nothing like it exists		Purchased product; new style number; sew in label		
	Develop ¹	Validate ²	Develop	Validate	Develop	o Validate	Develop	Validate	
Pattern Making	0.83	6.16	3.08	6.16	15.75	6.16	0.00	0.00	
Labor Costing	0.00	3.00	3.25	4.00	7.25	79.75	0.00	3.00	
Mfg. Specifications	0.50	0.15	1.000	0.50	6.00	0.50	0.00	0.00	
Material/Style data entry	0.00	2.60	0.00	2.75	3.25	0.00	0.00	0.75	
Administrative Dev	0.00	0.50	0.00	1.00	0.00	4.00	0.00	0.00	
Spreading/Cutting Bundling	0.00	0.50	0.00	1.00	0.00	2.00	0.00	0.00	
Sewing	0.00	0.50	0.00	1.00	0.00	4.00	0.00	0.00	
Findings/Trim/Pack	0.10	0.20	0.10	0.50	0.10	0.50	0.00	0.10	
Artwork Dev/Specs	3.50	0.00	4.50	0.00	8.50	0.00	0.00	3.50	
Standard Cost Determination	0.50	0.00	0.50	0.00	2.00	0.00	0.00	0.50	
Total Hours	16.01	3.03	18.51	10.83	30.26	39.50	0.00	7.85	
Combined Hours per Style		19.04		29.34		69.76		7.85	
Total Cost@\$10/hr	\$160.10	\$30.03	\$185.10	\$108.30	\$302.60	\$395.00	\$0.00	\$78.50	
Combined Cost		\$190.04		\$293.40		\$697.60		\$78.50	
Number of Versions (Multiplication Factor) ⁴		1.3		1.5		2.7		1.1	
Adjusted Total Cost	\$160.10	\$39.39	\$185.10	\$162.45	\$302.60	\$1,580.00	\$0.00	\$86.35	
Combined Adjusted Cost		\$199.49		\$347.55		\$1,882.00		86.35	

¹Development costs—research and development required to determine what and how things need to be done to make the product, determine stitch types, seam types, zippers, placements, and fit for marketing approval, assembly methods.

²Validation costs—includes checking grade increments; determining that adjoining seams align; checking placement and alignment of notches; checking grain and internal markings; data entry on product style #, pattern #'s, bill of materials, specifications for style.

There are no product development costs for Style D because it was a purchased style.

⁴The multiplication factor is related to the number of samples developed therefore the labor cost.

Table 10–12Cost analysis comparison: Break-even point for manufacturing a new style.

	Style A	Style B	Style C	Purchased product; new style number; sew in label	
	Same as existing style, but different fabric	Same as existing style, but has cuffs or waistband; minor change	New style construction; nothing like it exists		
Development & validation cost	\$ 199.49	\$ 347.55	\$ 1,882.60	\$ 78.50	
Samples (salesman/photo)	500.00	500.00	3,500.00	500.00	
Manufacturing start-up (Make-up/training cost)	14.69	117.22	23,916.90	0.00	
Break-even cost to introduce New style	714.80	964.77	29,299.50	578.50	
Minimum sales dollars to break-even (9 weeks)	\$3,109.92	\$4,197.48	\$127,475.10	\$2,516.92	

equipment setup, and other costs incurred in starting the production of a new style. Evidence of make-up labor costs is shown in Table 10–13.

A total of all start-up costs shows the initial investment and break-even cost required to put a merchandise group in the line. The **break-even cost** is the dollar amount that must be recovered from sales of a style before there is any contribution to profit. Break-even sales dollars are determined by dividing break-even cost by the gross margin (\$10.52). This provides the required units of sales that are needed to break-even and when multiplied by the wholesale price (\$45.77) it provides a break-even dollar amount. Notice there are start-up costs for all style changes even if some of the changes seem insignificant.

Table 10–13 provides data on start-up labor costs. Notice that Style D is not included. When a style is sourced, the firm does not have to consider start-up labor costs. This is the responsibility of the contractor. Start-up costs are part of the contractor's charge for producing the product.

The production standard is 0.92 (SAH) for all three styles and a projected labor cost of \$5.63. Operators averaged 0.97 hours production time per jacket instead of the standard 0.92. For Style A this results in 41.3 units per week instead of the 43.4 that were scheduled. This means they are a little slow, perhaps as a result of the fabric change. This means that each jacket is costing \$0.29 more to produce which means a loss to the firm of \$12.24 per week and they are falling behind on production by 2.1 jackets per week on that particular style.

Style B has cuffs or a waistband added to the style instead of the hem that was used on the original style. Ten percent of the operations are new. The production time for the first week of production averaged 1.36 hours per jacket which cost an average of \$8.30. This incurred losses of \$2.67 per jacket and \$78.69 for the

Table 10–13
Analysis of start-up labor costs.

		Week 1	Week 2	Week 3	Week 4	Week 5
Style A	operations 100% old, 0% new					
	Total SAH/unit 0.92	0.97	0.97	0.97	0.97	0.97
	Units to be produced per wk 43.4	41.3	41.3	41.3	41.3	41.3
	Ave cost per unit \$5.6366	5.9333	5.9333	5.9333	5.9333	5.9333
	\$ diff per unit	0.2967	0.2967	0.2967	0.2967	0.2967
	\$ loss per wk	12.24	12.24	12.24	12.24	12.24
Style B	operations 90% old, 10% new					
	Total SAH/unit 0.92	1.36	1.23	1.18	1.16	1.15
	Units to be produced per wk 43.4	29.5	32.4	33.9	34.6	34.7
	Ave cost per unit \$5.6366	8.3066	7.5504	7.2188	7.0743	7.0480
	\$ diff per unit	2.6700	1.9138	1.5822	1.4377	1.4114
	\$ loss per wk	78.69	62.05	53.65	49.75	49.02
Style C	operations 40% old, 60% new					
	Total SAH/unit 0.92	3.30	2.55	2.23	2.09	2.06
	Units to be produced per wk 43.4	12.1	15.7	17.9	19.2	19.4
	Ave cost per unit \$5.6366	20.1731	15.6359	13.6465	12.7793	12.6217
	\$ diff per unit	14.5365	9.9993	8.0099	7.1427	6.9851
	\$ loss per wk	176.40	156.55	143.69	136.83	135.48

week. Notice what happened in weeks 2–5. There was still a loss each week but the losses began to diminish. What allowed this to happen? Each week the operators became more skilled and the operations took less time. Notice also that there is very little change between week 4 and 5, which shows that the greatest learning occurs in the first weeks of the operation. The numerical data is evidence that a learning curve does impact production scheduling and costing.

Compare the production time and costs of producing Style C, a new style with 40 percent old and 60 percent new operations with similar data for the other styles. Answer the following questions.

- 1. Why does it take so much longer to produce Style C?
- 2. Will Style C ever be profitable?
- 3. Should they increase the price of Style C?
- 4. Will they be able to catch up with orders?
- 5. Why do firms try to limit the number of new styles in a line for a selling period?

Cost Control

Budgets reflect comprehensive financial plans that establish the expected route for achieving the financial and operational goals of the firm. **Budgets** are

based on sales projections, cost containment goals, and profit objectives. Analyzing the effect of cost behavior on revenue can be valuable in the planning and control of a firm's activities and profit potential. The firm must manage product output to meet the profit objectives expressed in the budget.

Performance reports compare budgeted and actual costs for materials, labor, overhead, or volume of production in order to determine cost variances. **Cost variance** is the difference between budgeted costs and actual costs. Costs are monitored and controlled in an effort to maintain favorable variances. If the variance is negative, meaning that actual costs exceed budgeted costs, action may be taken to reduce the variance. This may involve changing a design, revising production procedures, or stopping production of a style. Excessive variance can result in production bottlenecks, failure to meet deadlines, loss of profits, and eventually business failure.

Performance reports provided by the accounting division provide managers with a realistic view of plant productivity for a specific period of time. These reports show the amount of production for each plant, product, and operator and serve as a basis of evaluation. Performance reports help managers and supervisors identify production problems, areas needing additional training or staffing, and areas that need to be made more cost-efficient.

Pricing Strategies

Prices for commodities and standardized goods such as precious metals are set by the impersonal market forces of supply and demand. Because apparel products are differentiated, there are few standardized goods in apparel markets. Apparel prices are set and administered by the firms that manufacture the products. **Administered prices** are prices set or "administered" by the firms in the market rather than by impersonal market forces.

Basic Pricing Decisions

The prices on a manufacturer's products must first cover costs and then meet the profit and volume goals of the firm. Cost estimating provides the basis for pricing, but many other factors such as discounts, allowances, and pricing strategy must be considered before establishing the list price and the wholesale price. Most wholesale price structures are based on list prices. The list price is the suggested retail price identified in a manufacturer's catalogs and price sheets. The list price is often an estimate of the value of the product to the ultimate consumer. The differences between list prices and wholesale prices are discounts and allowances. **Discounts and allowances** are reductions from the list price that are granted by a manufacturer to a firm that performs some marketing or distribution function.

Basic questions a manufacturer must answer to develop a pricing strategy include the following:

- 1. At what estimated gross margin level will the list prices be set?
- 2. Will the prices be cost-based or demand-based?
- 3. Will the firm use price lining and/or even dollar pricing?
- 4. What terms will be negotiable as a part of sales agreements?
- 5. Will the firm's pricing strategy fall within legal restrictions on pricing?

Clearly, the process of establishing wholesale prices and negotiating sales contracts with retail buyers is not a simple one. Manufacturers must have a clear understanding of product costs and the influence of negotiated "terms" in sales contracts before developing their pricing strategy.

Price Level

As a part of defining their business, apparel manufacturers identify what general price range of merchandise they will produce. As discussed in previous chapters, the general price ranges in apparel markets include low-end, budget, moderate, better, bridge, and designer. Firms position themselves within the general price range in order to appeal to their target customer and respond to the competition in the market. For example, a firm may be positioned as an upper-moderate producer of professional career women's apparel. Given this general range, prices are determined for each product in the line.

Under most pricing strategies, it is desirable to establish a markup that is sufficient to cover variable and nonvariable costs, profit, and subsequent price reductions. The first step in setting prices is having an accurate knowledge of costs, thus the emphasis on the costing process earlier in this chapter.

In general, firms operate in markets where fundamental economic concepts apply. Firms face **downward sloping demand curves** indicating that as prices increase, the quantities taken from the markets decrease (see Figure 10–5). A firm cannot usually expect to increase its prices and maintain sales volume at the same time. The **elasticity of demand** curve determines the impact that price-volume relationships have on total revenue. A steeper curve reflects **inelastic demand**, meaning that a price decrease results in comparatively little increase in quantity sold. A flat curve indicates **elastic demand**, meaning that a decrease in price results in a greater quantity purchased. A firm is challenged to find a price-volume combination that achieves the goals of the firm and maximizes profits.

Cost- and Demand-Based Pricing

When setting prices, managers take into account the firm's goals and strategic plan. Over the long run, a firm must sell its products at prices that will cover costs and provide a profit. In the short run, however, pricing strategies may be designed

Figure 10–5
Elastic and inelastic demand curves.

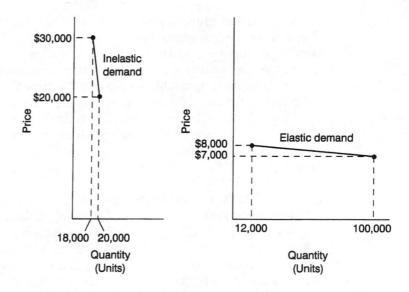

to impact a particular phase of the firm's growth, development, or profitability. Determining an appropriate pricing strategy requires careful evaluation of the market including positioning of competitors and product demand. There are two types of pricing strategies discussed here: cost-based and demand-based.

COST-BASED PRICING STRATEGIES Cost-based pricing strategies involve determining manufacturing costs and adding some amount of markup to determine the wholesale price. The cost-plus method of pricing and return on investment pricing are discussed here.

For **cost-plus pricing**, wholesale price is determined by multiplying unit cost by some "reasonable" markup. With the cost-plus method, accuracy of costing is critical. Costing processes must accurately reflect unit costs so that wholesale price will be sufficient to provide the firm a profit. The cost-plus method of pricing can be misleading. The problem is that this method does not adjust for cost variations at different levels of output. There may be economies of scale that are realized when volume increases. However, if demand increases beyond plant capacity, additional costs may be incurred because of hiring contractors or purchasing additional equipment and production space.

If a firm has unused production facilities, as a short-run strategy, the markup may actually be set to cover less than total costs. If a plant or a portion of a plant is closed, many nonvariable costs remain. Thus, if the price covers variable costs and makes some contribution toward nonvariable costs, the firm might be better off than when facilities are idle. The challenge the firm faces is to find a price-volume combination that will achieve the firm's goals and maximize profits.

Whatever the pricing strategy, managers and stockholders are usually concerned about the rate of return on investment (ROI), which is the amount

earned in direct proportion to the amount invested. Some companies eliminate divisions or drop products that do not yield adequate ROI. Target ROI is often somewhere between 10 and 20 percent ROI after taxes. Target ROI might be accomplished by setting a percentage return on investment or identifying a specific total dollar return. The desired target return is added to the total cost to determine the list price. Some firms use a long-run target return method based on the assumption that plants do not consistently run at full capacity. On an average over several years, plants may produce at 80 percent of capacity. That level of production would be used as a basis for setting prices that yield the desired target return. A long-run strategy tends to produce more stable prices.

DEMAND-BASED PRICING STRATEGIES Companies that base their list prices solely on costs, rather than on values placed on the product by their customers, may lose profits. Three types of **demand-based pricing strategies** are discussed: status pricing, penetration pricing, and market pricing.

A status pricing strategy uses a demand-oriented approach to pricing rather than a cost-oriented approach. Status pricing means the list prices may be set well above costs of production. This strategy may be effective in fashion markets where successful product differentiation has created inelastic demand. A status price reflects the intrinsic and extrinsic values the customer places on the product. Status pricing may also be used to maximize profits at the product introduction stage when costs are high and demand may be fairly inelastic.

Market penetration pricing means prices are set slightly above costs to maximize sales volume. Penetration pricing has a positive effect on profits when demand is fairly elastic and there are economies of scale in production. The strategic plan may call for an increase in market share through sales growth at the expense of profits. A larger market share contributes to a firm's overall resource base as well as increasing its visibility in the market. There may be long-run payoffs for short-run limitations on profits.

Market pricing means product prices are set to match competitors' prices. Market pricing tends to maintain the status quo in market share and profits. A firm may be operating at optimum capacity where further growth could involve prohibitive investment in production facilities or management. Complacency is a risk associated with this strategy, which may reduce an apparel firm's ability to compete. Firms that use market pricing may use nonprice competition such as cooperative advertising, special packaging, customer service, brand names, trademarks, and celebrity endorsements to build market share while not being directly price competitive.

Price Lining and Even Dollar Pricing

The price lines offered by a manufacturer often fit within one of the general price ranges (low-end, budget, moderate, better, bridge, designer) since apparel

markets are organized around these categories. Within the general price categories, price lining is sometimes used. **Price lining** means grouping several items of varying costs together and selling them all at the same price. When price lining is used, the firm has a system of prices at distinct list price level(s). Price lining simplifies inventory records and simplifies the selection process for the retail buyer and the ultimate consumer.

For example, in an extreme case of price lining, a dress manufacturer may offer only one price line that will have a list price of \$79.99. The costs of styles in the line will vary, but because of the manufacturer's pricing policy, all the styles have the same list price. More typically, a manufacturer may offer dresses in three price lines: \$59.99, \$69.99, and \$79.99.

Manufacturers and retailers in the United States have commonly used **odd price endings** on their prices such as \$3.95, \$7.98, or \$9.99 instead of **even dollar pricing** of \$4.00, \$8.00, and \$10.00. The origin of the practice of using odd price endings is sometimes traced to a psychological advantage of making products seem cheaper. The practice of using odd price endings is still common for low-end and budget prices but less common for better and designer goods. Manufacturers must decide whether they will use only one price ending when they set up their price lists. Using one price ending reduces errors throughout the record-keeping process.

Discounts and Allowances

Many types of discounts and allowances are granted to a manufacturer's customers depending on the services offered by the buyer, volume of purchases, time of delivery, geographic location, type of payment, and so on. Retailers frequently negotiate "terms" of the purchase contract to get the best "price."

TRADE DISCOUNTS Manufacturers offer their product lines to retail buyers at list price less a trade discount. The **trade discount** is the basic discount allowed to a member of the distribution chain; list price less the trade discount equals wholesale price. An apparel manufacturer grants a retail buyer a reduction from the list price because the retailer markets the goods to the ultimate consumer. The commonly used trade discount varies from one product line to another. Manufacturers of women's apparel have traditionally used price lists formulated with a 50 percent trade discount. This means the manufacturer's wholesale price to the retailer is half of the recommended retail or list price.

In addition to the trade discount, the list price is surrounded by a complex series of negotiable add-ons, discounts, and allowances. The multitude of terms that might be negotiated, if not carefully controlled, can totally erode the manufacturer's profit margin.

OTHER DISCOUNTS AND ALLOWANCES Wholesale prices may be adjusted up or down by special "terms" that are identified or negotiated in the purchase

agreement. The terms can determine the profitability of a particular sale. Contract terms might include quantity or seasonal discounts, payment terms, cash discounts, or dating. Most terms represent costs to the manufacturer. These costs are usually figured into the total cost structure of the manufacturing firm as a part of administrative overhead.

Quantity discounts are used to induce the retail buyer to purchase larger quantities in a single order. This enables the apparel manufacturer to acquire a larger portion of the retailer's total business and reduces the manufacturer's selling, shipping, and inventory costs. Some of the storage function may also be transferred to the retailer.

Some firms allow cumulative quantity discounts throughout the selling season to encourage the retailer to reorder. This improves the visibility of the manufacturer's merchandise on the retail selling floor. When retailers reorder, the merchandise remains available to the customer throughout the selling season.

Seasonal discounts or selling cycle pricing recognizes differences in price elasticity at different stages of the selling season or product life cycle. As the product moves through the selling cycle, demand may become more elastic and therefore prices may be lowered to maximize sales through the use of seasonal discounts. Pricing stages in the selling cycle might be called early purchase price, main season price, late-season price, and clearance price. Discounts offered ahead of the selling season stimulate early commitments by retailers. This levels production schedules and allows the manufacturer to make more efficient use of machinery and labor. Discounts may also be offered late in the selling season to increase total volume. End-of-season discounts stimulate clearance of unsold merchandise to help cover variable costs. Price reductions, such as the use of seasonal discounts, are regarded as a form of sales promotion that is built into the total pricing system.

Payment terms, cash discounts, and dating determine when and how much of the invoiced value will be paid by the retailer. Most sales by manufacturers to retailers are made on credit. Invoice terms are intended to stimulate early payment by retailers. Traditionally, terms differ for different product lines. For example, discounts in men's wear tend to be "2/10 net 30" while discounts in women's wear tend to be "8/10 net 30." The term "2/10 net 30" means a 2 percent discount on the face value of the invoice is acceptable to the manufacturer if the payment is made within 10 days of the date on the invoice. Otherwise, the face value of the invoice is due within 30 days. These terms are a source of controversy between manufacturer and retailer when the retailer automatically deducts the "accepted" discount, whether or not the terms are stated on the invoice.

Retail buyers may negotiate for 8/10 net 60 or even 90, meaning the net value of the invoice is not due for 2 or 3 months after the date of the invoice. A manufacturer may use *forward dating* of the invoice to make the cost of the merchandise more favorable to the buyer without changing other terms. The invoice date is advanced to the next month or to the end of the season when the stated terms are applied. This allows the retailer to take the discount as long

as the invoice is paid within 10 days of the forward date. Sometimes special arrangements are made for cash payment from the retailer before the merchandise is delivered. This reduces the need for the manufacturer to borrow money to pay expenses, therefore discounts are allowed for early payment.

Shipping terms are also negotiated. Invoices specify something like "FOB shipping point." Free on board (FOB) means the manufacturer takes responsibility up to the shipping point. At that point, the buyer assumes responsibility for the merchandise, damages, losses, and freight costs. Cash, insurance, freight (CIF) terms mean the manufacturer pays all the costs of delivery, and the buyer does not assume responsibility for the merchandise until it reaches the store, warehouse, or distribution center.

Many other terms might be negotiated in a purchase contract. A manufacturer may establish minimum order quantities and minimum areas for display in the store. They may also require special fixtures and merchandising techniques. A buyer may negotiate for markdown allowances on goods that do not sell by a certain time in the selling season. Some buyers want guarantees of refunds on damaged or defective goods. Other buyers want guarantees of shipping dates and discounts on late shipments. Many retailers use chargebacks to penalize manufacturers for late shipments, unsatisfactory quality, and/or poor service.

Some manufacturers provide inducements to retail buyers, such as free or cooperative advertising, point-of-purchase displays, special goods for price promotion, and offers of free goods. "Push money" or prize money allowances are sometimes given to retailers to pass on to retail salespeople in return for aggressive selling of particular items or lines. These funds may also be used to support sales contests or commissions.

Legal Restrictions on Pricing

In the United States, pricing legislation is designed to help the economy, business, and industry perform more effectively in the consumers' interests. Laws and regulations regarding pricing practices are in effect at the federal, state, and local levels. Some of the issues addressed in the legislation include price fixing, unfair trade practices, and price discrimination. **Price fixing** was allowed by "fair trade" or "resale price maintenance" legislation until 1976. Manufacturers could establish retail prices and require that retailers sell the goods at those prices. Price fixing is no longer allowed by federal law.

Unfair trade practices acts, passed in more than half the states in the United States, prevent selling below costs to deter unfair competition. It is possible for large firms to sell below costs for a period of time and drive their smaller competitors out of business. The large firm then has less competition in the market and can set higher prices.

Price discrimination is unlawful in the United States. Purchasers of products of like grade and quality must be offered the same price. Price differences must be based on cost differences related to quantity or other terms.

It is in the firm's best interest to be informed about both federal and state legislation relative to pricing. They must comply with the laws in any states or countries where they do business.

Summary

Profits are essential for the survival and growth of any business. Profits must be planned and strategies established to achieve the profit goals desired. For the manufacturer this means measuring, controlling, and managing the investment in materials and labor required to produce the products. Cost is the total dollar amount invested by the manufacturer in the product. Price is the dollar amount that is asked or received in exchange for a product.

Manufacturing costs include all the direct costs and expenses that are incurred in producing a finished product. Accurate costing of the investment in a specific product provides a basis of cost management, pricing, and evaluation of market and profit potential. Firms may use direct costing, absorption costing, or activity-based costing to determine the cost of individual styles. Costing is done at various stages of product development and production. Budgets and performance reports are used to monitor and control costs.

Apparel prices are set and administered by the firms that manufacture the products. Firms may use cost-based or demand-based strategies. The sales volume, actual costs, and selling prices determine the "bottom line" or profit produced by the investment in the firm and product.

References and Reading List

Barbee, G. (1993, August). The ABCs of costing. *Bobbin*, pp. 64–68.

Cooper, R., and Kaplan, R. S. (1988, September-October). Measure cost right: Make the right decisions. *Harvard Business Review*, pp. 96-103.

Curry, J. C. (1997, September). Is your product costing as good as you think? *Textile World*, pp. 100–107.

Fritzsch, R. B. (1997). Activity-based costing and the theory of constraints: Using time horizons to resolve two alternative concepts of product cost. *Journal of Applied Business Research* Vol. 14, #1, pp. 83–89.

Key Words

absorption costing activity-based costing (ABC) actual costs administered prices administrative overhead base rate (BR) bill of materials breakdown break-even point budgets cash discounts cash, insurance, freight (CIF) contract terms contribution contribution margin costcost estimating cost of goods sold cost variance cost-based pricing strategies cost-plus pricing costing dating demand-based pricing strategies detailed costing direct costing direct labor costs

direct materials costs discounts and allowances downward sloping demand curves elastic demand elasticity of demand even dollar pricing excess labor costs factory overhead free on board (FOB) general operating expense gross profit margin income statement indirect labor costs inelastic demand list price long range make-up cost manufacturing costs market penetration pricing market pricing nonvariable costs nonvariable overhead costs odd price ending overhead overhead application rate payment terms performance reports

plant efficiency precosting preliminary costing price price discrimination price fixing price lining pricing product development costs production standard profit quantity discounts return on investment (ROI) revenue seasonal discounts shipping terms short range standard allowed hours (SAHs) standard allowed minutes (SAMs) standard labor cost start-up costs status pricing

trade discount

validation costs

wholesale price

variable costs

unfair trade practices

Discussion Questions and Activities

- 1. List the advantages and disadvantages of direct costing and absorption costing. Why is activity-based costing currently being recommended?
- 2. Examine Table 10-4 very carefully. What is the difference between contribution margin and gross profit margin? What is an example of nonvariable overhead? What is an example of variable overhead? Why is net income the same with both costing systems?
- 3. What is the difference between cost and price?
- 4. Which style described in Tables 10–11 through 10–14 will be the most profitable?

- 5. Why would a firm continue to produce styles when they can source styles and not have any of the start-up costs or problems? What other factors does a firm have to consider?
- 6. Would Style C in Tables 10–11 through 10–14 be a good choice to source?
- 7. How would costs change if a style were sourced? Would there be fewer costs? Additional costs?
- 8. Why would a firm not put all new styles in a line every season?
- 9. What factors are negotiated in determining how much a retailer actually pays a manufacturer for a product?

PAIRIC WALV

Focus on Production

- Chapter 11 Apparel Engineering
- Chapter 12 Production Management
- (a) Chapter 13 Preproduction Operations
- Chapter 14 Stitches, Seams, Thread, and Needles
- Chapter 15 Equipment for Assembly and Pressing

Apparel Engineering

OBJECTIVES

- © Examine the role of apparel engineering in garment production.
- Evaluate the factors that affect work flow.
- Second Examine characteristics of different types of apparel production systems.
- Discuss the role of work measurement in the development of production standards.
- @ Examine ergonomics and its effect on the work environment.

For many years, manufacturers used **push through production** that focused on high efficiency by forcing large volumes of inventory through production based on anticipated demand. High-volume production, long runs, and minimal variations in products were strategies used to increase efficiencies and cost-effectiveness of operations. Efficiencies were based on the maximum output for each unit of input (hour, machine, material) and managers were accountable for the efficiency of each operation. Some firms still operate under the belief that efficiency is the primary measure of performance. Over the past 10 years new modes of thinking have filtered into the apparel industry.

Changing customer demand has forced some firms to change their paradigms and develop new strategies and philosophies for doing business. This has created a need for new approaches and new measures of performance. Goldratt's Theory of Constraints (TOC) (Covington, 1993) focuses on policies of the firm as the constraint for success. A constraint limits the firm's performance in achieving their goals. Constraints may be vendors or materials, processes, or the market or approach to the market. A constraint will impact all parts of a system that are dependent on the resource or process. Constraints are not planned but they inevitably appear. The primary focus in this chapter is on the systems and processes required to convert materials into apparel and how the components of processes (people, materials, methods, machines, environment) can become a constraint on the system.

Work Flow

Many parts of garment assembly are sequential, therefore, each operation is dependent on the previous operation. This has significant implications in planning work flow and assembly. **Work flow** is the movement of materials and garment parts through the conversion processes. It can be impacted by any part of a production process and the constraints that develop. A slow operator, a machine that malfunctions, or flawed fabric may all be constraints to work flow.

Balancing is the process of planning a smooth work flow with a steady supply of work for each operation. Balancing involves planning and scheduling input based on the demand for finished parts and products. Demand originates from both internal and external need for parts and finished goods. External demand is established by customers outside the firm and internal demand is created by succeeding operations as parts and components are needed to assemble products. Pull through production is customer driven which means that the next operation is an internal customer. Products or parts are produced as needed but not in anticipation of future use.

An inventory buffer is often needed ahead of some operations to guarantee a smooth and consistent work flow. A **buffer** consists of a planned backlog of work that is available for processing for each operation. Theoretically, if operations are planned and scheduled so that each takes the same amount of time, there would be a smooth, even flow of the parts. This situation seldom happens even with the most precise planning and methods development because people and machines do not always work at the same speed.

A work delay at one operation for whatever reason will impact succeeding operations. When work is not completed at the rate expected, all other operations are delayed. In seeking to maintain a steady work flow, it is essential to determine the operation that is consistently the slowest. If all work on a particular style must go through the specific slow operation, that operation will dictate the rate of work flow and the volume of finished goods that can be completed in a specific time period. This operation is often referred to as a **bottle**-

neck, a constraint to throughput, because it limits the volume of work that can be completed in a work day. **Throughput** is the volume of work that can be completed in a given amount of time.

Often excessive work in process will build up ahead of a bottleneck. Work in process is the number of garments under production at a given time. Once a bottleneck is determined, engineers study the operation to determine whether it can feasibly be improved. It may mean operating during breaks and lunch, adjusting routings, using other methods, scheduling the operation a second shift, buying an additional machine, or changing to new technology for the operation. Other factors that affect work flow are plant layout, materials handling, the production system, and operator skill and training.

Plant Layout

Plants provide the environment for the conversion processes. Plants may be crowded or spacious; cluttered or clean; well ventilated or stuffy. Whatever the conditions, it will impact the productivity of the employees and the facility. The goal is to maintain an environment that will maximize productivity.

Plant layout is the spatial arrangement and configuration of departments, work stations, and equipment used in the conversion process. Layout of an apparel production plant directs the flow of materials and work in process from start to completion and integrates materials handling and equipment. A good layout has the flexibility to be changed to meet requirements of the product line, delivery schedules, and anticipated volume. Safety is a major consideration in plant layout. Fire and safety codes, accessible exits, and open traffic areas must all be part of layout plans. It is often difficult to bring older buildings up to standard, especially if conditions are crowded.

The two basic types of plant layouts that have traditionally been used in apparel manufacturing are (1) line or product-oriented layout and (2) skill center or process-oriented layout. There are also many variations and combinations of these that have been developed by garment manufacturers. Each facility also has its own unique features that require special consideration.

LINE LAYOUT A **line layout** operates on the principle that each unit is produced exactly the same and that operations are performed in a specified sequence. Work often flows from the back of the facility to the front and work station to work station until the garment is completed. Line layout is most efficient with long runs (high volume of identical products) when the sequence of operations and equipment does not have to be changed frequently. Depending on the volume required, a plant may have several lines making the same style or several lines each making different styles.

Line layout does not necessarily mean each machine is different. There may be several operators performing the same operation. The goal is steady work flow through succeeding operations. If a style requires only one operator to hem the pockets and three operators to set pockets in order to keep work in process moving, then engineers will build that into the layout.

Advantages of line layout may be less work in process than a skill center configuration and less handling between operations. This means faster throughput time and less build up of parts between operations.

Disadvantages of a line layout include potential bottlenecks (work buildup) and work imbalance. Each operation depends on the previous one, and down time, absenteeism, and slow operators may interrupt the work flow. To counteract these problems, some operators may need to be cross-trained to perform more than one operation, and substitute machines need to be readily available for immediate replacement if equipment breaks down. New trainees may be expected to meet production standards before being placed in a line position. Failure to meet production schedules for whatever reason may create a need to reroute work, shift personnel, or reschedule to avoid further delays. (See Figure 11–1 for a diagram of a line layout and skill center.)

SKILL CENTER The skill center or process-oriented layout may be used when the production sequence varies with each style put into production. For a skill center layout, garment parts are bundled by operation and machines are grouped ac-

Figure 11–1 Flow chart showing skill center and line layout.

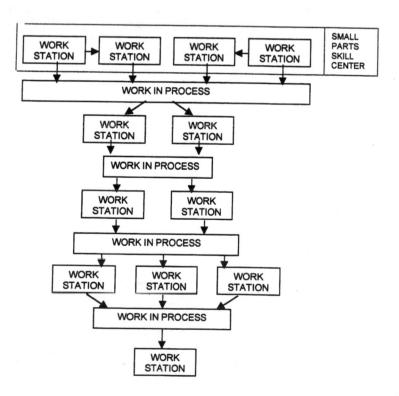

cording to the type of operation to be performed. Bundles are moved from one operation to another based on the needs of the style, not the sequence of equipment. Bundles often accumulate between operations while waiting to be processed.

A skill center may consist of similar machines that perform a similar function or a cluster of very different machines with specialized functions. One skill center may have a group of overedge machines used for serging edges or a group of blind stitch machines used for hemming operations. Often more than one operator is performing the same operation. Another skill center may consist of a specialized machine and other machines that support its operation. For example, a welt pocket maker may be supported by several lock stitch and safety stitch machines that are required to complete pocket assembly and attachment.

Automated equipment is often located in specific skill centers. The specialization of a skill center makes it easy to justify the purchase and use of automated machines. Some firms have small parts areas that are a type of skill center where a variety of specialized operations are completed on garment components. Small parts areas are often highly automated to produce collars, cuffs, belt loops, pockets, or trims. Because parts are bundled by operation, it is possible that all the components could be worked on at the same time. Routings and bundle tickets enable the completed parts to come together again for final assembly.

Depending on production needs there are advantages to a skill center layout. Supervisors are able to plan work for their particular center based on the amount of direct labor needed for the work available. Absenteeism and low productivity can be covered by other operators in the center, and style changes can usually be handled by moving garment bundles from one skill center to another without making large transfers of equipment or operators. Trainees can be put directly into a center and allowed to work at a comfortable pace while learning an operation, without affecting sequential operations.

Disadvantages include potential buildup of work in process and more floor space to accommodate it. It is more difficult for supervisors to detect poor quality work as poor workmanship may be hidden in large bundles. More service personnel are needed to move bundles between operations, and throughput time may be extensive depending on the waiting time at each center. Matching stations are often needed to bring completed parts together for assembly, and it is difficult to track orders and monitor production schedules.

Many plants use a combination of line and skill center layouts. Highly specialized machines and small parts assembly may be combined with some configuration of a line arrangement for final assembly. Whatever type of plant layout a firm develops, it should be designed to optimize quality, throughput time, and flexibility.

Materials Handling

Materials handling is concerned with the efficient movement of goods through the conversion process. From the time fabric is unloaded from the

truck until finished garments are packaged and shipped, storage and movement of materials and work in process must be planned and tracked to facilitate throughput. Handling materials does not add value to a product, but it affects work flow and productivity.

Handling costs can be reduced by eliminating as much handling as possible and reducing the distance materials are moved. Three aspects of materials handling need to be planned and evaluated: (1) handling and processing of incoming goods, (2) movement of work in process, and (3) distribution of the finished product.

Handling incoming goods may involve unloading trucks, inventorying, tagging, moving, shading, testing, and storing. Each firm has its own procedure for handling materials as they are received. Efficient materials handling and management in the receiving stage can reduce costs during production. Materials that are adequately labeled, inspected, and tested for verification of specifications can be accessibly stored for immediate use. Large inventories of materials increase the handling required and storage costs.

Just-in-time (JIT) delivery is an operational strategy that coordinates arrival of goods with immediate use and minimal handling. Materials are unloaded from the truck to the cutting room floor all prearranged in the planned order that they will be spread and cut. With JIT delivery, fabrics are not sorted or stored before going to the cutting room because of certification from the mill. This strategy has a certain amount of risk of not having the required materials when needed. Firms often plan a buffer of several days supply to ensure continuous cutting and assembly.

In many plants, work in process is moved by service personnel manually carrying bundles between processes. Carts, tubs, or rolling racks may be used to transport and store the work in process. These require floor space that must be provided in the layout plan if the system is to work properly. Other systems include conveyers of various types that operate overhead, along the floor, or off a central runway that feeds to production lines on either side of it. A well-planned and efficiently used materials handling system can decrease throughput time, minimize handling, and improve control of work in process.

Materials handling methods used at work stations depend on how garment parts are presented to the operator, the degree of automation, and the disposal system used. Materials handling procedures are incorporated in the production method for each operation. Work aids such as slanted tables for positioning parts, folders and binders for positioning trims, and automated cutters are some of the many ways an operation may be simplified and handling kept to a minimum. Handling time may account for up to 80 percent of sewing operation time.

Handling finished goods requires accessibility to the distribution area and shipping. Finished goods may be routed through inspection, final pressing, ticketing, and packaging with an extension of the materials handling system that is used on the sewing floor. Actual handling of output depends on whether a

firm makes-to-order or makes-to-stock. A firm that makes-to-order may box or load shipping containers as styles come off the production line. With some product lines, coordinated garments must be grouped before they can be shipped. A firm that makes-to-stock will collect garments in a distribution center according to style, color, and size. This requires a complex system of inventory control, product movement, and storage rails.

Apparel Production Systems

An apparel **production system** is an integration of materials handling, production processes, personnel, and equipment that directs work flow and generates finished products. Three types of production systems commonly used to mass produce apparel are: *progressive bundle, unit production,* and *modular production*. Each system requires an appropriate management philosophy, materials handling methods, floor layout, and employee training. Firms may combine or adapt these systems to meet their specific production needs. Firms may use only one system, a combination of systems for one product line, or different systems for different product lines in the same plant.

Progressive Bundle System

The **progressive bundle system** (**PBS**) gets its name from the bundles of garment parts that are moved sequentially from operation to operation. This system, often referred to as the traditional production system, has been widely used by apparel manufacturers for several decades and still is today. The AAMA Technical Advisory Committee (1993) reported that 80 percent of the apparel manufacturers used the bundle system. They also predicted that use of bundle systems would decrease as firms seek more flexibility in their production systems.

Bundles consist of garment parts needed to complete a specific operation or garment component. For example, an operation bundle for pocket setting might include shirt fronts and pockets that are to be attached. Bundle sizes may range from two to a hundred parts. Some firms operate with a standard bundle size, while other firms vary bundle sizes according to cutting orders, fabric shading, size of the pieces in the bundle, and the operation that is to be completed. Some firms use a dozen or multiples of a dozen because their sales are in dozens.

Bundles are assembled in the cutting room where cut parts are matched up with corresponding parts and bundle tickets. **Bundle tickets** consist of a master list of operations and corresponding coupons for each operation. Each bundle receives a ticket that identifies the style number, size, shade number, list of operations for routing, and the piece rate for each operation. Operators retain a corresponding segment of the bundle coupon for each bundle they complete. At the end of a work day, bundle coupons are turned in, and the earned time from completed

bundle tickets is totaled to determine the operator's compensation. Firms may use electronic bundle tickets or smart cards that accompany each bundle and that are swiped at each work station along with their own identification card. This reduces paper work, facilitates access to information, and eliminates lost bundle tickets.

Bundles of cut parts are transported to the sewing room and given to the operator scheduled to complete the operation. One operator is expected to perform the same operation on all the pieces in the bundle, retie the bundle, process the coupon, and set it aside until it is picked up and moved to the next operation. A progressive bundle system may require a high volume of work in process because of the number of units in the bundles and the large buffer of backup work that is needed to ensure a continuous work flow for all operators (see Figure 11–2). The firm's materials handling system facilitates bundle movement between operations.

The progressive bundle system may be used with a skill center or line layout depending on the order that bundles are advanced through production. Each style may have different processing requirements and thus different routing. Routing identifies the basic operations, sequence of production, and the work centers where those operations are to be performed. Some operations are common to many styles, and at those operations, work may build up waiting to be processed.

Figure 11–2 Plant using the progressive bundle system.

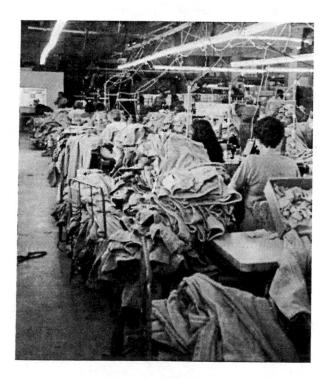

The progressive bundle system is driven by cost efficiency for individual operations. Operators perform the same operation on a continuing basis, which allows them to increase their speed and productivity. Operators who are compensated by piece rates become extremely efficient at one operation and may not be willing to learn a new operation because it reduces their efficiency and earnings. Individual operators that work in a progressive bundle system are independent of other operators and the final product.

Slow processing, absenteeism, and equipment failure may also cause major bottlenecks within the system. Large quantities of work in process are often characteristic of this type of production system. This may lead to longer throughput time, poor quality concealed by bundles, large inventory, extra handling, and difficulty in controlling inventory.

The success of a bundle system may depend on how the system is set up and used in a plant. This system may allow better utilization of specialized machines, as output from one special purpose automated machine may be able to supply several operators for the next operation. Small bundles allow faster throughput unless there are bottlenecks and extensive waiting between operations.

Unit Production System

A unit production system (UPS) is a type of line layout that uses an overhead transporter system to move garment components from work station to work station for assembly. All the parts for a single garment are advanced through the production line together by means of a hanging carrier that travels along an overhead conveyor. The overhead rail system consists of the main conveyor and accumulating rails for each work station. The overhead conveyor operates much like a railroad track. Carriers are moved along the main conveyor and switched to an accumulating rail at the work station where an operation is to be performed. At the completion of an operation the operator presses a button, and the carrier moves on to the next operation.

Most unit production systems are linked to a computer control center that routes and tracks production and provides up-to-the-minute data for management decisions. The automatic control of work flow sorts work, balances the line, and reduces claims of favoritism in bundle distribution. Electronic data collection provides payroll and inventory data, immediate tracking of styles, and costing and performance data for prompt decisions. Figure 11–3 shows a photograph of a UPS transporter system.

Processing begins at a staging area in the sewing room. Cut parts for one unit of a single style are grouped and loaded directly from the staging area to a hanging carrier. Loading is carefully planned so minimal handling is required to deliver garment parts in precisely the order and manner that they will be sewn. When possible, operations are completed without removing the parts from the carrier. Varied sizes and types of hanging carriers are available for different types of products. Automated materials handling replaces the traditional system of

Figure 11–3 UPS transporter system moves individual garment parts.

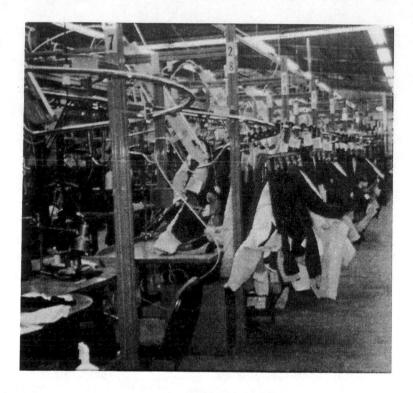

bundling, tying and untying, and manually moving garment parts. Unit production systems eliminate most of the lifting and turning needed to handle bundles and garment parts.

The need for bundle tickets and processing operator coupons is also eliminated when an integrated computer system monitors the work of each operator. Individual bar codes or electronic devices are embedded in the carriers and read by a bar code scanner at each work station and control point. Any data that are needed for sorting and processing such as style number, color shade, and lot can be included.

Integrated systems have on-line terminals located at each work station to collect data on each operation. Each operator may advance completed units, reroute units that need repair or processing to a different station, and check their efficiencies and earnings. Operators may signal for more inventory or call for a supervisor if assistance is needed. The terminals at each station enable the central control center to track each unit at any given moment and provide management with data to make immediate decisions on routing and scheduling.

Operators of the UPS control center can determine sequences of orders and colors to keep operators supplied with work and to minimize changes in equipment, operations, and thread colors. A unit production system can control mul-

tiple routes and simultaneous production of multiple styles without restructuring production lines. The control center may perform routing and automatic balancing of work flow, which reduces bottlenecks and work stoppages. Each operator as well as the control center is able to monitor individual work history. Data can be collected on the amount of time an operator works, time spent on each individual unit, number of units completed, the operator who worked on each unit, and the piece rate earned for each unit. The system will calculate the earnings per hour, per day, and the efficiency rate of each operator.

Unit production systems have varied options and capabilities, some of which are incorporated with real-time production control. **Real time** is actual time. Real-time reports provide immediate information on the status of a specific style or order at the time of inquiry. Real-time systems record each completed operation and provide up to the minute information for tracking the production process. Managers can monitor numerical data on actual production activities.

Benefits of a unit production system depend on how a system is used and the effectiveness of management. Throughput time in the sewing room can be drastically reduced when compared to the progressive bundle system because work in process levels are reduced. Clemson Apparel Research Center found that operator productivity increased an average of 18.4 percent and "direct labor excesses were reduced by an average of 33.8 percent" (Hill, April 1992, p. 48). Direct labor costs are reduced because of prepositioned parts in the carriers and elimination of bundle processing. Indirect labor costs may be reduced by elimination of bundle handling and requiring fewer supervisors. Quality is improved due to accountability of all operators and immediate visibility of problems that are no longer concealed in bundles for extended periods of time. The central control system makes it possible to immediately track a quality problem to the operator that completed the operation. Other benefits that have been realized are improved attendance and employee turnover and reduced space utilization.

Considerations for installing a UPS include costs of buying equipment, cost of installing, specialized training for the system, and prevention of downtime. Down time is a potential problem with any of the systems, but the low work in process that is maintained makes UPS especially vulnerable.

Modular Production System

A modular production system is a contained, manageable work unit that includes an empowered work team, equipment, and work to be executed. Modules frequently operate as minifactories with teams responsible for group goals and self-management. The number of teams in a plant varies with the size and needs of the firm and product line. Teams can have a niche function as long as there are orders for that type of product, but the success of this type of operation is in the flexibility of being able to produce a wide variety of products in small quantities.

Many different names are currently used to identify modular apparel production systems, including modular manufacturing, cellular manufacturing units, compact work teams, flexible work groups, self-directed work teams, and Toyota Sewing System (TSS). The basic premise is similar among these systems, although the organization and implementation may vary.

The number of employees on a team, usually 4 to 15, vary with the product mix. A general rule of thumb is to determine the average number of operations required for a style being produced and divide by three. Team members are cross-trained and interchangeable among tasks within the group. Incentive compensation is based on group pay and bonuses for meeting team goals for output and quality. Individual incentive compensation is not appropriate for team-based production. Teams may be used to perform all the operations or a certain portion of the assembly operations depending on the organization of the module and processes required.

Before a firm can establish a modular production system, it must prioritize its goals and make decisions that reflect the needs of the firm. Factors that need to be evaluated before installing a modular production system include:

- 1. Is upper management totally committed to team-based manufacturing?
- 2. Can management relinquish control of production to empowered work teams?
- 3. How much specialized equipment is needed?
- 4. Can the firm afford to install special equipment in each module?
- 5. How much training is needed for productive modules?
- 6. How much training is needed on a continued basis?
- 7. How much flexibility is needed?

Management and Team Training for Empowerment Modular production systems operate with an empowered work team approach to production. **Employee empowerment**, which distinguishes modular production from traditional systems, is a management strategy that transfers authority and responsibility for completing a task from management to the production team. Teams are empowered with decision making related to the operation and performance of the module. Managers and supervisors serve as resource people and facilitators. Relinquishing production control is usually contrary to traditional management philosophy and often the most difficult part of establishing a modular team-based system.

With a **team-based system** operators are given the responsibility for operating their module to meet goals for throughput and quality. The team is responsible for maintaining a smooth work flow, meeting production goals, maintaining a specified quality level, and handling motivational support for the team. Team members develop an interdependency to improve the process and accomplish their goals. **Interdependency** is the relationship among team members that utilizes everyone's strengths for the betterment of the team.

Because of the vastly different work environment and increased responsibility of operators, special training in interpersonal skills and team work is essential prior to establishing a team-based system. The success of a team-based system depends on the continued cooperation of its participants thus firms commonly encourage weekly meetings for teams to deal with operational issues and problem solving.

Topics for team training include the following (adapted from Hill, April 1992):

- Adaptability to change
- Brainstorming
- Communication skills
- Conflict resolution
- · Effective listening skills
- Effective meeting organization
- Safety principles
- Ergonomics factors

- Industrial engineering principles
- Line balancing techniques
- Preventive maintenance of equipment
- Problem solving
- · Quality principles
- Success visualization principles

Team members operate as a minifactory that assembles styles assigned to the module. This includes the direct labor that goes into a style and the indirect support functions that are required to operate a module. They may be expected to perform routine service on machines, sweep the module area at the end of the day, and do any other activities that might be required in support of the operation. When sewing operators assume additional responsibilities, direct costs increase and indirect costs decrease. Management needs to monitor the total cost of producing a style and not just the direct costs. Some of the cost savings come in the decrease of service personnel and fewer supervisors.

Giving teams full responsibility for a finished product encourages group ownership of the product and its success, which includes the product's quality, throughput, and methods of assembly. Responsibility for the completed product builds a sense of accomplishment and motivation for team members. Quality becomes a team responsibility and therefore is monitored all through production. Research shows a significant improvement in quality when the team, not inspectors or supervisors, is responsible for the quality of finished products. Some firms use auditors and statistical quality control to check the quality of work from all modules. If defective garments are found the work is returned to the module for the team to repair.

Management sets production and quality goals based on methods, production standards, and volume of orders. Team members assist with methods analysis, handling, and executing the production process. Team members meet to solve work flow, quality, communication, and operation problems related to the effective function of the team. Different firms have different approaches to team empowerment but it is generally agreed that team meetings and continued training are essential.

Operator compensation in most team-based systems is group wages and bonuses based on production goals for quantity and quality of output of the work team instead of the traditional piecework system. Various aspects of compensation and bonus rewards are being explored by many organizations. There is no general consensus for a preferred system. Issues related to compensation are discussed in Chapter 12.

WORK FLOW IN MODULAR PRODUCTION In a modular setting, the work team may establish the work flow and specific methods of handling and executing an operation. Engineers and supervisors are facilitators and provide expertise and support. The ultimate criteria, regardless of the methods used, is that each operation be completed to meet its quality specifications.

A modular production system operates as a pull system, with demand for work coming from the next operator in line to process the garment. Work in process is minimal, and work flow is continuous and does not wait ahead of each operation. This increases the potential for flexibility of styles and quantities of products that can be produced. A horseshoe configuration is a common modular arrangement (see Figure 11–4).

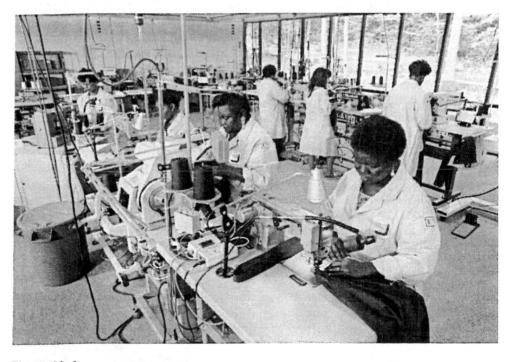

Figure 11–4
A team-based production system.
Courtesy of Textile/Clothing Technology Corp. [TC]².

Teams usually operate as stand-up or sit-down units. Most firms use stand-up teams in which operators stand to perform several different operations and move among them as needed. Walking is a healthy way of working because it increases circulation and reduces stress on the lower back. Stand-up units require elevated machines and work surfaces and special foot controls that are easy to operate from a standing position. Not all employees are able to work in a stand-up environment so sit-down units may also be used. In sit-down units operators usually do not move as freely between operations and may work with small bundles of six to twelve pieces. Team work and cross-training are essential regardless of how the operations are performed.

A module may be divided into several work zones based on the sequence of operations and the time required for each operation. A **work zone** consists of a group of sequential operations. Operators are trained to perform the operations in their work zone and adjacent operations in adjoining work zones so they can move freely from one operation to another as the garment progresses.

Figure 11–5 is a diagram of a module that completes 10 operations for an underwire bra style. The 10 operations are divided among four work zones and a team of four operators. The production standard for each operation is provided in the box. The times on either side of the X indicate the split of time for the operation at the end and beginning of a new work zone. Operator 1 will complete all of Operation #1 and 7.91 minutes of Operation #2. Operator 2 will complete 2.39 minutes of Operation #2, all of operations #3, 4, and part of Operation #5 before handing it off to Operator 3.

Work flow within a module may be with a single-piece hand-off, Kanban, or bump-back system. If a **single-piece hand-off** is used, machines are arranged in a very tight configuration. As soon as an operation is completed the part is handed to the next operator for processing. Operations need to be well balanced as there is usually only one garment component between each operation. Some modules may operate with a buffer or small bundle of up to ten pieces of work between operators. If a small bundle is used, an operator will complete the operation on the entire bundle and carry the bundle to the next operation. An operator may follow a component or bundle for as many operations as they have been trained or until the adjacent operator is ready to assume work on the bundle.

A Kanban uses a designated work space between operations to balance supply with demand. The designated space will hold a limited number of completed components (two or three) in queue for the next operation. If the designated space is full, there is no need to produce more until it is needed or the space empties. This limits build up of product ahead of the next operation. When the space is full the operator can assist with other operations that may be slow.

The bump-back or TSS (Toyota Sewing System) approach was developed by the Toyota Sewn Product Management System and is probably the most widely used type of team-based manufacturing. It is a stand-up module

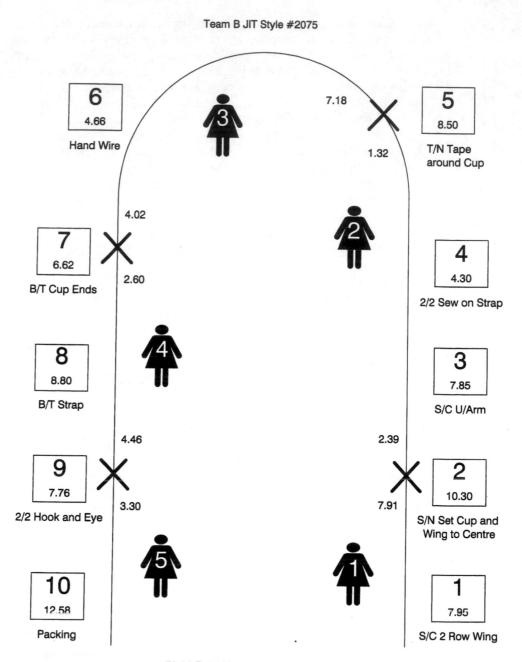

79.32 Total Mins = 100% per dozen

Figure 11–5
Diagram of work zones for team production of bras. Teams work on bundles of twelve.
Courtesy of Courtaulds Lingerie Limavady, Ireland.

with flexible work zones and cross-trained operators. Operators may be cross-trained on up to four different successive operations. This enables operators to shift from operation to operation until the next operator is ready to begin work on the garment. The operator needing work steps to the beginning of the zone and takes over the processing at whatever point it is in the production process. The operator who has been relieved of the garment will then move back to the beginning of the work zone and take over work on another garment. This approach enables continuous work on a garment and allows each operator to perform several different operations. This arrangement frequently uses a 4-to-1 ratio of machines to operators.

Because of the fast throughput time with modular manufacturing, there is less need for real-time production control. Because of additional training, operators are knowledgeable about all the processes performed in the module and are empowered to make decisions and solve problems regarding the products they assemble. Peer pressure and support encourage a team effort to meet quality and production goals and discourage absenteeism.

Advantages of a modular production system include high flexibility, fast throughput times, low work in process, reduced absenteeism, reduced repetitive motion ailments, employee ownership of the production process, empowered employees, and improved quality. Disadvantages include a high capital investment in equipment, high investment in initial training, and cost of continued training.

Combinations of Production Systems

Some firms may use the progressive bundle system for producing small parts combined with modular production for garment assembly. This reduces the investment in specialized equipment and reduces the team size needed. Some industry consultants believe that a modular system combined with a unit production system provides the most flexibility, fastest throughput, and most consistent quality. This would be particularly useful for large items such as coveralls or heavy coats. The UPS would move the garment instead of the operators. Each manufacturer needs to determine what is best for its product line and production requirements.

Production Processes

The plant and production system create the environment for executing production processes. A **process** is a procedure required to convert materials into a specific product or style. The type and sequence of processes required for conversion is unique to each style. Use of inputs to the process (including materials, methods, machines, and skills) is determined by the expected output.

Process Analysis and Control

Process analysis begins with examination of each style to determine its requirements for production. Style requirements are discussed at product planning meetings, determined through analysis of samples and specifications, and evaluated based on a firm's standard operating procedures and cost constraints. Production skills, production time, equipment needed, and the anticipated volume are evaluated for each style.

The basic breakdown of operations for a style is often identified by technical designers while engineers develop detailed specifications, methods, and production standards necessary for consistently executing the processes. An **operation** is one of the steps in a process that must be completed to convert materials into a finished garment. An **operation breakdown** is a sequential list of all the operations involved in cutting, sewing, and finishing a garment, component, or style.

Engineering specifications provide criteria for each operation and a means of measuring consistency. They include: quality specifications, a diagram of the work station and description of the standard conditions for the work place, the method description, and production standard for each operation. Engineering specifications are based on style specifications provided by the technical designer, production samples, and work measurement data. They should be provided to all supervisors, operators, and production teams involved with the style.

Quality specifications interpret and illustrate the final appearance expected for each operation. This includes stitch and seam type, stitches per inch, equipment requirements, and critical dimensions and tolerances for placement and alignment of stitching, seams, trims, and parts for each operation. Technical drawings identify details and points of measurement.

Standard conditions describe how the work will be received at the work station, how the work station will be prepared for the operation, and the position of the operator. Consistency in performing an operation is dependent on having a consistent work environment where equipment, people, and work are always in the same location.

Method descriptions identify the elements of the operation and describe the procedures that an operator is expected to follow in performing each part of the operation. An **element** is one of many sequential steps required to perform an operation. A **method** describes how each element of the operation should be completed. It is specific to the equipment to be used, work station arrangement, and required motion sequence. Method descriptions provide consistency in the procedure and a framework for measuring the time and equipment usage for each element. If the specific method is followed, each time that an operation is completed the results should be consistent providing that other inputs are also consistent. Figure 11–6 provides an example of an engineering specification for applying the bartack on a front slash pocket.

Operation: Bartack front slash pocket Page: 4 of 12
Operation No: 340–01 Date: 2/8/89
Equipment: Juki lk 1852–5 RPM: 2350

Attachments: Thread wiper, throat plate guide, eye shield

Attacriments. Thread wiper, throat plate guide, eye shield

28

Stitches per inch: Stitch Type: Seam Type:

301 SSa-1

Quality Specifications

Top tack is 9/16"
From band seam edge
Tack width 1/16"
Tack length 3/8"

Tack is 1/32" onto facing

Elemental Description:

A. Pick up the next, left, front panel: Using the right hand, the operator will bring the top of the next panel to the left hand. Grasp the top of the pocket with the left hand and hold.

B. Position the assembly to the presser foot: With both hands, the operator will position the top of the pocket assembly under the presser foot using the guide stop mounted to the rear of the throat plate for ascertaining the correct depth. Depress the foot pedal to the first position in order to lower the presser foot onto the assembly. The center of the foot should be directly over the edge of the front pocket for correct placement.

C. Sewing cycle: The operator will depress the foot pedal into the second position in order to activate the sewing cycle. During the sewing cycle, hold the garment with the left hand while the right moves to regrasp the bottom of the pocket. This grasp will be achieved by picking up the cloth between the thumb and forefingers with the outlet of the pocket. At the end of the cycle, the machine will automatically lift the foot and clear the thread.

D. Reposition for the bottom tack: Once the foot lifts away from the goods, remove the assembly from under the foot and reposition to the bottom of the pocket. Using both hands, position the bottom of the pocket at the front pocket attachment notch so that the bartack will cover the notch from the topstitch seam toward the outseam. Lower the presser foot.

E. Sewing cycle: Depress the foot pedal to engage the machine. While it is sewing, remove the right hand from the part and drop it into the lap for the subsequent pickup of the next piece.

F. Aside the left front: Immediately upon the end of the machine cycle, remove the front from the needle area with the left hand and toss it to the left over the top of the clamp truck. The right hand will form its grasp on the top of the right front panel.

G. Pick up the right front panel: The right hand will pick up the right front panel and carry it to the left hand as it returns from the previous maneuver. The left hand will grasp it at the top of the pocket and using both hands smooth out the top of the assembly.

H. Position to the presser foot: Position the assembly under the presser foot following the directions given in element B. For this pocket, however, note that it be positioned with the outseam to the left. Lower the presser foot.

I. Sewing cycle: Sew the bartack. While the machine is sewing, move the left hand to a new grasp at the bottom of the pocket. The right pocket is handled as a mirror image of the left.

J. Reposition for the bottom tack: Immediately after the machine finishes its cycle, remove the part to the right and reposition to the bottom tack as in element D.

K. Sewing cycle: Depress the foot pedal to engage the machine. While it is sewing, remove the right hand from the part and drop it into the lap for the subsequent pickup of the next piece.

L. Toss aside the right panel: Using the left hand, toss aside the right front panel.

M. Bobbin changes and resews: Time incurred to remove the empty bobbin from the machine; exchange it with the full bobbin from the bobbin winder, and load the empty bobbin onto the winder and engage the winder. This also permits the resewing of the interrupted bartack.

Figure 11-6

Methods to take into account:

- · characteristics of the style
- materials to be used
- · specifications for the style
- quality standards
- · expected performance of the product
- material handling procedures
- · equipment to be used
- work station layout
- skill of operators
- fatigue factors
- time required to execute the process

Documentation of methods and data collected relative to performance of the method can become the basis of change and improvement. A change in equipment requires development of a new method. Methods need to be tested prior to establishing their use as an inappropriate method can create a faulty product. There are many ways to achieve the same result but the key factor is to manufacture a product that meets production specifications with the least time and effort possible. Engineers constantly analyze methods and specific inputs to make quality more consistent and increase productivity. The elements identified in a method are the basis of establishing production standards and assigning predetermined time values to segments of an operation.

PRODUCTION STANDARDS **Production standards** are a means of controlling time and labor costs by establishing a reasonable time for completing each operation. They provide a basis for determining whether the actual production time and costs are acceptable. Production standards are used to plan and schedule production, analyze capacity, and serve as performance criteria for workers. Production standards provide management with a numerical base (quantitative base) for making decisions and managing plant production. In comparing actual performance with a production standard, trouble spots can be identified, productivity evaluated, and adjustments can be made.

Firms with piece rate systems use production standards as the basis of operator compensation, while firms that use modular production use a total of the production standards for the style to establish production goals and compensation for teams. Management and labor often have different opinions as to where production standards should be set. Management often strives for high efficiency at the lowest possible cost, while workers seek less exhausting work and higher wages. If rates, based on production standards, are too loose (too much time allowed per operation), labor costs will be excessive and the manufacturer may not be competitive in the market. If rates are too tight (not enough time allowed per operation), operators are not able to earn a fair income.

Fair rates are important for each operation. Dissatisfaction may occur if a rate for one operation is set low and a rate on another operation of equal difficulty is set much higher. Operators working at the low rate are able to earn more money and not have to work as hard, which can create discord within a work force.

A rate change may be initiated by complaints of inequity in work or pay, or a new rate may be developed for a change in method, equipment, product, or work station. A rate change will affect the amount of time allowed to complete an operation and ultimately the compensation the operator receives. Selling a rate change to operators is difficult. Frequently it means that operators performing a particular operation will have to produce more for less pay. To install a new rate requires justification of the new method or rate based on extensive work study and thorough documentation of work measurement.

Work Study

Work study is the analysis of the operations required to produce a style. It is primarily the responsibility of plant engineers. Effective work study requires both methods analysis and work measurement. Methods are studied, analyzed, and the elements of the method measured in terms of time consumed. Data are collected, analyzed, and used to support decisions on rates and methods. Work study is also important to ergonomic decisions, job design, and work station development. Decisions must be based on extensive study and documentation that is developed with work measurement procedures. Unsubstantiated opinions are not adequate justification for change.

Method Analysis

Method analysis determines the most effective means of executing each process. Each operation is broken down into elements or sequences of motions that are required to execute the operation. It is a tedious, time-consuming process that requires a knowledgeable and skilled observer. No one factor can be studied separately. When methods are studied, they cannot be looked at in isolation as each operation is affected by the operation before it and the one after it.

ANALYSIS OF MOTION During method analysis apparel engineers study factors affecting stress and fatigue, productivity, throughput time, production capacity, and effective use of resources. In establishing a method, engineers strive to (1) reduce the motions required, (2) shorten motions, (3) simplify motions, and (4) reduce the amount of control needed to complete a motion or element of an operation.

A **motion** is an act of moving a body part. Fewer motions decrease the time and energy required to complete an operation. Motions can often be eliminated by using work aids or changing the method. For example, a folder in front of the needle can fold a binding and position it for immediate sewing. All an operator needs to do is position the garment part and depress the machine treadle. An operator may not need to handle the trim at all. Motions can be shortened by arranging the work station so all parts are easily accessible and as close to the operator as possible. The farther an operator reaches, the longer it takes and the more fatiguing it is.

Effective motion patterns are rhythmic. Motions should be as symmetric and fluid as possible. Short jerky movements often appear to be faster, but they are tiring. Simultaneous movement of two body parts is often more efficient. Both hands should be doing useful work and hand movements can be carried out while an arm or body is moving. Motions can be simplified by using the lowest-class motions possible. Finger motion is the lowest-class motion. Using only finger action is much less taxing than if upper-arm action was required. The basic classes of motions are as follows:

Class 1: Motions by fingers only

Class 2: Motions by fingers and wrist

Class 3: Motions by fingers, wrist, and forearm

Class 4: Motions by fingers, wrist, forearm, and upper arm

Class 5: Motions using shoulders and trunk

When establishing a method, confine motions to the lowest class possible to complete the task because

fewer body parts are involved,

· motions provide the least amount of stress on the body,

· motions are less fatiguing, and

motions are faster.

Motions may require **low control** (only muscle control), **medium control** (both visual and muscle control), or **high control** (muscle, visual, and judgment) to complete an operation. Disposing of completed parts by pushing them off the table into a box is an example of a low-control motion sequence. It can be done very quickly and without looking. If an edge guide is used as a part of a method, an operator only needs to slide the fabric against it during sewing. The operator does not have to make an evaluative decision. This is an example of medium control as the operator uses both visual and muscle control but does not need to make a judgment whether the piece is placed appropriately. If markings need to be aligned, a high level of control is required. The operator must align the notches and make a decision whether the match is correct.

Based on method analysis, methods may be changed or new methods developed to (1) increase efficiency and work flow, (2) reduce fatigue factors and stress on body parts, (3) utilize new work aids and equipment, (4) improve quality, and (5) reduce the training time required for a specific operation. When a method is performed consistently, it is possible to measure the elements for data collection and analysis. Method analysis is followed by work measurement.

Work Measurement

Work measurement is used to determine the time required to complete one element or one operation, the amount of work that can be performed by one operator in a specific segment of time, and to substantiate or change a production standard or rate. Work measurement techniques used by garment manufacturers include (1) time studies, (2) judgment or past experience of the engineer or production manager, (3) predetermined motion/time systems, (4) standard data, (5) operator reporting, and (6) work sampling. Each work measurement technique has advantages and disadvantages for specific applications.

TIME STUDY **Time study** is a work measurement technique commonly used by apparel engineers to determine the rate at which a specific operation is performed. The objective of a time study is to develop and check production standards. An operation is studied by time analysts while a style is in production. A time study requires a method description for the specific operation to determine the work elements involved, the order in which they occur, the time required to complete each element, and the rate a particular operator is working. Time studies are an appropriate method of work measurement for high-volume operations with a high degree of repetitiveness. They are frequently used to establish production standards for operations performed in a progressive bundle system.

To prepare a time study, analysts break the operation down into elements. Each element involves a group of motions with a definite beginning and end that can be identified and timed. Potential elements for a sewing operation may include picking up and positioning parts, matching and aligning parts, positioning parts to the needle or presser foot, sewing, and disposing of parts. Machine-controlled elements are separated from manually controlled elements on cycle machines because they are always constant.

Examine the time study shown in Figure 11–7. In this operation, piece wool pockets, leather welts are being attached to the pocket bag that will be inserted into an award jacket. Elements of the operation are listed in the left column of the time study sheet. A **time analyst** records readings from a stopwatch or digital time board at the completion of each element. (Times are recorded for each element for 20 cycles or operations.) A minimum of 10 cycles should be timed to provide a fair representation of the operation. These readings are recorded on the T line. If readings are taken from a time piece that shows continuous time

M = MECHANICAL	P = PERSONAL		T=1	HREA	ND.	R	= REF	PAIR				F				D	100	,	late		Tu			1971		
I = INSTRUCTION	B = BOBBIN			DEFEC			= FUI					1	7117	PERA		2000	AUL	7.797		ONE	_	CK	ETS DA		# 330	_
ELEMEN	ITS	Г	1	1 2	3	4	5	6	7	8	9	10	111	12	13	14	15	16	17	18	19	T 20	TOTAL	_	LEVEL	S.M.
GET WELT !	FACING U.F.	1	T K	150	208	212	IUI	194	F	151	163	153	215	160	198	199	173	18/	191	Ke4		1/43	3.01		100%	.1775
SM - SEW W	ELT-SM	2	T 094	1013	102	221	097)	023	01.9	100	099	104	06)	065	788	0/27	07	17/	103	93	P	100	1,499		90%	.0794
GET 2nd WEL	F FACING U.F.	3	T 1/13	159		191						213				2/2	1:07	6	F	151	112	15	3.03	4.1783	100%	.175
SM - SEW WE	ELT-SM	4	R	100			083					07										1	1.45	7.0856	90%	.077
CLIT THREAD!	ITURN	5		135	074	065	072	103				079											7.32	7.0782	100%	.0782
GET FACING/POCK	ET BAG U.F	6		190		141	081	A70	P	254		124											2.73	1.1611	100%	.1611
SM - SEW FA		7			100	11.2	UKI	101	VEF	150		1067			120								2.62	7.0713	100%	.0773
GET 2" FAUN	IG BAGU.F.	8 A			059	A7/	NA	OES		_			100											1.1485	100%	. 1485
	ING -SM	9 R			073			7				-	A79	A27	17.	007	DAZ	037	WS	ATI	APO	M	1.24	.0690	105%	.0725
CUT THREAD !		10 R	10%		116		///					1089	119	120	129	089	095	141	183	123	135	129	2.114	.0782	100%	.0780
GET WELT/POCK		12 T	1/13	083	T	07/	08.2	067) [8	08	072	10%	097	092	099	093	06/	078	022	068	179	081	1,443	1174	95%	.///6
GET 2nd WELL	T BAGUE	13 T	P	125	100	34	111	13)	(3)	113	106	696	099	104	109	101							1.887	.0849	100%	.084
SM-SEW WEL		14 T	097	105	094	लश	099	087	044	087	098	108	102	110	ाव्य	106	108	599	021	084	I	<u>a</u>	1.657	.0975	95%	1/22
CUT A PART /OISI	,	15 T	249	209	222	F	220	28/	21	222	298	250	7.2	2/3	213	233	207	219	ומ	29	201	2/3	4.107		100%	.0926
SIZE '	ALL	-	PLACE	LAYO	TUC	_			_	_			_		SKET	CH O	F PAR	_				_		TOT. STD. M		1.7808
	WARD JACKET													1										ALLOWANCE	19%	.3384
FABRIC	WOOL													-		1	-		-	-		1		STD. ALLOW	ED	21192
MACHINES I C	ONSEW				Г					=	_	7		J		ţ		-	-	-	-	1		STD. ALLOW	ED .	25.4304
	3500					٢	7	П	C			\parallel				1	1				Í			DOZ. PER DAY		18.8750
SPI	8				L	_	<u></u>	П		_	_			1		•					1			PIECE RATE	\$/PC.	\$.1925
														APPROVED ENG.		me										
							1							1	PLANT MANAGER	DR.										
	1:05 am						Ш		`															ENG. MGR.		C-
L.O.S.			CUTT		A TW	ON N	Ë	_			_		_	1	EMAR	KS -	منيز	<u>, H</u>	N	ER	Но	LDS	-	PRESENT		6-
				-										1	2.90	A.E.	15		AIR	7	_			RATE SAM	- 1.9817	E. 1800

Figure 11–7a
Time study sheet.

and does not show the amount of time that elapses for each element, readings are recorded on the R line. When this is the case, each reading is subtracted from the previous reading in order to determine the actual amount of time that lapsed while each element is completed. The amount of lapsed time is averaged for each element. This is called **observed time**, which is the average amount of time that the analyst determined was used to complete each element.

The pace at which the observed operator worked may be above or below the rate that a normal 100 percent operator can perform. Operators do not perform at the same speed or with the same level of skill each time they repeat an element. Some operators may work faster or slower because they are the subject of a time study. To level the observed time to what a **normal operator** could do, the operator's performance is rated by the analyst. The **per**-

CODE	DETAILED ELEMENT DESCRIPTION	STANDARD MINUTES		5-16-59	STUDY NO.	APPROVED-P M.	APPROVED-IE.				
#1	GET POCKET WELT AND FACING. ALIGN.	./775	OPERATION CODE 330 STYLE AWARD JO SIZE/RANGE								
	POSITION UNDER FOOT.		OPERATION PIEC	E WOOL	POCKETS						
#2	START MACHINE, SEW 10", STOP MACHINE	.0794		ERGE PAT.	BAG OPERATION	ET WICKE	7				
#3	GET 2nd POCKET WELT AND FACING.	.1783	CONSEW & CLASS / CLASS								
	ALIGN. PASITION UNDERFOT.		SPECIAL TOOLS & ATTACHMENTS	NA							
#4	START MACHINE, SFW 10" STOP MACHINE	.0770	STITCH 30/ STITCHES/ 2 LOS ACTUAL 350								
#5	CUT THREAD FROM MACHINE. TURN	.0782	FACE UP DOWN FACE TO FABRIC WOOL BUNDLE / DO								
	PONKETS TO SET-UP FOR NEXT ELEMENT		THREAD NOLON	THREAD NUL BOTTOM 32	WT. SPEC #						
#6	GET FACING SEWN TO WELT. ALIGN TO	.1611	REMARKS PIECE	POCKETS	OPERATION	IS DON	E				
	POCKET BAG. POSITION LANDER FOOT				RACKS WHI						
#7	START MACHINE. SEW 10" STOP MACHINE	.0773	INA HAN	GERS. C	NE COAT	IS CON	SIDERFD				
#2	GET 2" FACING / POCKET BAG UNDER FOOT	. 1485					POCKETS				
#9	START MACHINE. SEW 10" STOP MACHINE.	.0725	ARE, PIE				POCKETS				
#10	CUT THREAD. TURN FOCKETS	.0782	IN CHAIN								
#11	GET POCKET WELT POCKET BAG, AUGN.	.1116	CUCLE.	7							
	POSITION UNDER FOOT.	11.0	9								
#12	START MACHINE. SELL 10 " STOP MACH	. 0849									
#13	GET 2 WELT/BAG POSITION UNDER FOOT						57				
#14	START MACHINE. SEW 10: STOP MACHINE.			1. 14.1							
#15	CUT POCKETS APART. DISPOSE FINISHED		1 1								
-15	PACKETS TO HANGER GET NEXT POCKETS.	110	ign each								
111	WORKPLACE LAYOUT	11	ППП	ПП	SKETCH OF PART	ППП	ППТ				
+++	 	HH	HHHH	++++	TITI	HHH	++++				
+++	 	++-1			++++	+++++	- War				
+++	╎╎╏╎╎╎╎╎ ╒ ╪╪╪╪┪	+++	111117	++++			HH				
+++	THE MACHINE	HH	FACING Y								
POLKET	┤┽╏╎╞╣ ┞ ╏ ┼┼┼┼┦┼╏┼┼	HH	 		++++	 	HHH				
BA	*	++-	 	++++	+++++		++++				
CEE	WELT	+	 	++++	+++++		PAGE				
+++	 	HH	 	++++	+++++	111	771				
ACK WIT		HH	111111	++++		HHM	HHH				
HANG	ERS	HH		1111	++++	11/1	++++				
		Ш		XIII							

Figure 11–7b
Time study sheet.

formance rating of the observed operator is used to adjust the observed rate up or down to what the analyst believes a normal operator would be able to do. This is why the production standard is stated in "normal" time or standard allowed minutes (SAM). (Note: in Figure 11–7a SAM is identified as SMs.) Examine the last three columns in Figure 11–7a to see how ratings affect the average observed time. A rating below 100 percent reduces the time allowed for each element to be completed as the observed operator is working slower than what a normal operator is capable of doing. A rating above 100 percent increases the time allowed for an element to be completed as a normal operator would not be working that fast.

Rating must be consistent; thus, analysts must be well trained if time studies are to be fair and reliable. The performance rating, which depends on the judgment of the analyst, is the most difficult and controversial part of a time study.

Allowances are made in production standards to include nonproductive time that occurs as part of the production process. An allowance factor is a percentage of time added to the normal time to cover the short delays and interruptions in work that are part of the operation. Studies are made of the delays that occur while a time study is conducted. Interruptions that occur as a normal part of an operation are considered delays and compensated through a delay allowance. Delay (D) allowances vary with the operation and machine. Some machines, such as the lock stitch, require more downtime than others to wind and replace bobbins while automated equipment has little downtime. An allowance is also provided to cover personal (P) needs and fatigue (F). P and F allowances are determined by each firm to meet the needs of their employees. Breaks are usually compensated through P and F allowances and included in production standards.

An advantage of time study compared to other work measurement techniques is the breakdown and analysis of the method prior to time measurement. Time studies measure actual performance thus they provide realistic data on the materials, equipment, and method being performed. Disadvantages are the time and training required for an analyst to become skilled in conducting time studies and the fact that operators have to be experienced in the operation before time studies can be done. Another disadvantage is the subjectivity of performance rating that must be done by the time analyst.

Because of the wide variety in products being produced, many manufacturers use a less detailed type of time study or cycle check that simply records time upon the completion of an operation or product. The focus of this type of study is to determine the time to complete the operation and not each element of the operation. This provides a check on production standards, monitors problems that may occur, and provides management with a realistic figure for costing and production planning.

JUDGMENT For some apparel manufacturers, time studies may be too time-consuming and costly. For small fashion manufacturers with rapidly changing product lines and short runs or small custom orders, a style may not be in production long enough to conduct time studies. Small firms may find it economically unfeasible to employ a time study analyst. Instead, they may rely on the judgment of managers or supervisors for time estimates. This method can provide only approximate time values, and it is not advocated if there is another more accurate means of gathering the needed information.

PREDETERMINED MOTION/TIME SYSTEMS **Predetermined motion/time** systems are used by many firms to establish production standards for new styles before the style goes into production. The basis of these systems is his-

toric data for hundreds of replications of basic motions and elemental times that have been averaged and converted to standard times for a specific motion. This method of work measurement produces the most consistent production standards and the most in-depth examination of motion.

With predetermined motion/time systems, rates are based on the time to execute a method. This forces engineers to examine equipment, layout of work stations, and handling of parts at the work station. The method or motion sequence is established first, and the time value or rate is identified for the motions specified. Engineering specifications identify the specific method that an operator is expected to follow. Generally this causes more effective use of direct labor and thus more accurate rates.

There are a number of different motion-time systems. General Sewing Data (GSD), MODSEW, KARAT, and other similar systems identify time values for specific motions required in garment production. These are available as computer software that manufacturers can purchase. Engineers that use these systems need to be well trained in identifying the specific motions that are involved in each operation.

STANDARD DATA Frequently firms collect their own data for repetitive operations with similar characteristics and develop their own **standard data** sets for specific operations. These data are used in the same way as predetermined motion-time data except the data sets are specific to the firm's quality standards, equipment, and procedures. A firm must have an adequate database before trying to use its own standard data. Standard data may be developed for operations, components, and styles and used for preliminary costing, design decisions, cost estimating, and rate setting.

OPERATOR REPORTING **Operator reporting** relates to the volume completed during the time spent. Operators report the amount they complete in a specific time period. There are no specified methods or output expectations; therefore, it is difficult to use operator reporting as a basis of production standards or for capacity planning. Cost figures are determined by dividing the number of units completed in an hour with the hourly wage. The amount of work completed in a specific time frame is often inconsistent and may be unreliable. This type of work measurement provides very little information and little incentive for increasing work efficiency. It may be the method used by firms that produce customized products in small volume and a wide variety.

WORK SAMPLING **Work sampling** is a work measurement method that is not concerned with how fast a unit is completed but rather which machines are used and the activities pursued in executing the job over an established period of time. It is based on simple random sampling techniques derived from statistical sampling theory. When production standards are needed for operations that are not highly repetitive, work sampling is a good choice. The analyst determines

the activities involved, amount of time spent on the various activities, equipment used, and number of units processed during an established time period. This type of work measurement is particularly useful in examining the productivity of nonproduction areas such as the shipping room. The manager can estimate the proportion of time a worker is engaged in work activity. This proportion can then be used as a performance standard.

Ergonomics

Ergonomics is the study of the interaction of workers and their work environment. The word *ergonomics* is derived from two Greek words: *ergos* and *nomos*, which translates into "work laws." Ergonomics is an interdisciplinary field integrating the study of human anatomy, psychology, physiology, anthropometry, biomechanics, and industrial engineering. The **ergonomist** seeks to optimize the relationship between the worker and the work environment thus improving productivity and the worker's well-being. The **work environment** includes all factors that affect the workplace and job performance even though they may not be directly involved in the operation itself.

Background

Prior to World War I there was a labor surplus and workers were often considered replaceable. Firms felt little obligation for their workers' well-being until a labor shortage developed during the war. This labor shortage focused new interest on improving individual productivity. Following the war Frank and Lillian Gilbreth, the co-founders of industrial engineering, began to study methods and motions. They found that as motions were made easier, productivity of the worker increased. However, ergonomics did not emerge as a distinct field until the urgencies of World War II and the need for more effective use of military equipment became a priority.

Today, the strong interest in ergonomics has been stimulated by the Occupational Safety and Health Administration (OSHA). Established in 1970, OSHA is a federal agency that develops and enforces health and safety standards for the workplace. OSHA standards regulate a wide range of factors, from allowable noise levels to design of equipment. Firms are required to keep accurate documentation of illness and injury that may occur on the job. Unannounced inspections and record checks determine adherence to OSHA standards, and violators are subject to substantial fines.

OSHA uses the Bureau of Labor Statistics (BLS) Annual Survey of Occupational Injuries in the Workplace to determine high incidences of injuries. The BLS calculates an injury or illness rate for every industry based on Standard Industrial Classification (SIC) code. If an OSHA inspection finds the injury rate

for an individual firm to be higher than the industry average, investigators may probe deeper to find probable causes. OSHA does not presently have specific rules on ergonomics; however, the "General Duty Clause" has been used to enforce a safe work environment.

CUMULATIVE TRAUMA DISORDERS Cumulative trauma disorders (CTD) are injuries that over time cause pain or disfunction of body parts. These may also be referred to as repetitive motion disorders (RMD). Repetitive motion is common to the apparel manufacturing process although not all workers are susceptible. Other activities may also cause CTD such as tennis and knitting. If motions are performed incorrectly for extended periods of time, it may result in trauma to the body. Ergonomists need to help workers understand and avoid the positions and motions that have a high risk factor. Risk factors include repetition, force, posture, vibration, pace. Teaching workers to use smoother movements, less pressure, and better posture can help reduce the incidence. Workers that are unfamiliar with a job are likely to apply more force and put themselves at greater risk.

The most common of these disorders is **carpal tunnel syndrome** (CTS), which is caused by pressure on the medial nerve in the carpal tunnel of the wrist. If tendons in the carpal tunnel swell from improper use, they put pressure on the nerve and cause pain and numbness. OSHA has identified CTS as the second highest occupational injury that draws workers compensation, with back injuries being first (Tyson, 1989).

Ergonomic factors have become a prime target of OSHA because of the high increases in worker's compensation claims and the high cost of insurance premiums. Ergonomically designed work areas increase human comfort. Comfort increases productivity of the worker and reduces stress and fatigue. Ergonomic factors that need to be considered include human factors, environmental conditions, job design, work station design, and equipment design and use.

Human Factors and Environmental Conditions

Human factors include both physiological and psychological factors, all of which can be impacted by the work environment. Humans are unique individuals that vary in size, shape, proportion, strength, and abilities. In order to fit a job to the worker, the ergonomist must first study the individuals performing the job and then seek ways to make the jobs, tools, and work stations fit the workers.

Anthropometrics, the study of human dimensions, is essential for effective development and use of equipment and arrangement of an individual's work station. An individual worker's dimensions are important when clearance, reach, posture, and strength are considerations in job design.

Physical injury of any type can impact work performance, but the musculoskeletal system has received the most attention from ergonomists because these injuries are the leading cause of disability on the job. Muscles, joints, and tendons are essential for body movement. Good circulation is required to supply nutrients to muscles and eliminate lactic acid, a byproduct of metabolism. When muscles are used, they require adequate time to readjust and recover between repetitions to prevent fatigue. The result of muscle fatigue is discomfort, pain, and intolerance for work.

Cognitive factors also affect job performance and fatigue. A lack of stimuli, feedback, and autonomy are often causes for psychological stress and poor performance. Stress, regardless of the cause, is often related to injury and illness.

Environmental conditions such as lighting, sound, vibrations, temperature, humidity, and air quality may affect how workers perform on the job. When these conditions are controlled at desirable levels, they can assist workers with their jobs. Undesirable levels can distract, inhibit, or be damaging to workers.

Environmental factors are measurable and controllable as firms seek to improve working conditions. Sound, which is measured in decibels (measure of loudness), needs to be monitored for worker safety. OSHA has rules governing sound over 85 decibels that can be unsafe. The type, volume, and placement of lighting are factors that may affect an employee's productivity and quality of work. Some firms may install individual ventilation systems above work stations in order to improve worker comfort. This is often found in pressing areas when heat and humidity are excessive.

Job Design

If a **job design** is to truly consider the worker, a wide range of anthropometric characteristics such as age, sex, ethnic, and developmental differences need to be taken into account. Also, a thorough understanding of the job is essential if it is to be ergonomically sound. This may include the type of work to be done, the type and range of motions, strength requirements of the operation, equipment and attachments available, and the relationship of the operation to other operations.

Jobs or tasks may require a dynamic or static effort. **Dynamic efforts** require body movement, muscle contraction, and relaxation. Dynamic activity increases circulation and reduces the load on the heart. **Static efforts** require a sustained position, which puts excessive stress on body parts, impedes circulation, and does not allow adequate muscle recovery. Static postures promote muscle fatigue, often centered in the lower back, neck, and upper extremities.

Rapid repetition is characteristic of many sewing operations. Sewing operators must move their hands very quickly and precisely. Some highly skilled operators may make as many as 50 different movements a minute with each hand. Potentially, the high repetitions of very fast hand and wrist movements can cause fatigue, pain, weakness, and injury, especially if done with force. Poor job design and lack of training are often cited as underlying causes.

Another issue of job design that is often debated is the **sit/stand approach**. As more firms explore modular manufacturing systems, the decision to sit or stand operations impacts the whole module. There are definite advantages and disadvantages to either approach. Sitting to work provides better fine-muscle coordination and more control over extensive hand manipulations if strength is not a factor. Sitting also distributes body weight to the seating device instead of the feet and legs. Disadvantages of seated work include the limited range of motions that can be covered and the reduced mechanical advantage of the body. Sustained repetitive work in a seated posture also concentrates fatigue in fewer muscle groups.

Standing allows the worker to have greater control over the work area. The principles of motion economy and ease of movement are easier to apply to work methods. Standing provides a mechanical advantage and more fluid momentum, which makes it easier for operators to develop a working rhythm. Legs act as levers, a source of power and strength. Disadvantages of standing include increased energy consumption, increased load on feet and legs, and circulatory

problems that can develop from static positioning.

Probably the most desirable arrangement is a module that includes multiple work stations with low work-in-process levels that keep operators moving from work station to work station. Combining the sit/stand approach is also desirable but not often suited to the operations required. Jobs that incorporate both sitting and standing allow workers to move and use different muscles.

Work Station and Equipment Design and Use

A work station should be designed for the individual operation to be carried out and the worker performing it. Adjustable equipment makes it possible to adapt equipment to individual measurements. Considerations for the design of a work station include height of the work surface, placement of work and the reach required, forced posture, and the design and relationship of all the

parts.

It has been determined that workers perform most effectively if the work surface is at elbow height or 2 inches below. If the work requires a close visual field, it may be necessary to elevate the surface 2–4 inches above elbow height, but this will place added strain on muscles. Work should be performed with elbows down and close to the body most of the time. Elbow height varies with individual stature; thus, an adjustable machine table or work area will be the most effective. A work station just 2 inches too high can result in a 20 percent reduction in performance (Ortiz, 1993).

Placement of the work affects the reach that is required in performing the operation. The forearm has a range of 14–16 inches that dictates the placement of materials. The worker should be able to reach for materials with only the forearms. Excessive arm extension increases muscle strain and fatigue. The

layout of the work station should also avoid positioning equipment or materials that will cause the worker to use unnatural posture or motions. All the equipment in a work station should work together to create a well-coordinated system with a smooth work flow.

Manufacturers of many types of tools and equipment are making greater efforts to develop flexible and ergonomically sound products. Equipment should have flexibility so that it can be adjusted to individual workers in the workplace, and devices should not force the worker to use an unnatural posture or motion. Specially shaped handle grips, control boards, tilt-top tables, and rounded edges on flat surfaces are all potential solutions to ergonomic problems.

Improved equipment is not enough. Workers need to be trained in how to select, adjust, and use the equipment effectively and safely. For example, a well-designed ergonomic chair is not adequate unless it is adjusted to the proper height for the worker and the work surface. One of OSHA's expectations is evidence of a training program that assists workers in learning new methods and using equipment more effectively.

Summary

Apparel engineers are facilitators for the throughput of a firm's products. They are concerned with work flow, production systems, production processes, and creating a safe work environment. Work flow is impacted by plant layout and materials handling. Production may be executed with a line layout or skill center configuration. The ultimate criteria for manufacturing a product for today's markets is to maintain production flexibility. The production systems most used by apparel manufacturing firms are progressive bundle systems, which require high-volume work in process, unit production systems that allow production and tracking of single garments, and team-based production that encourages a teamwork approach to manufacturing.

Apparel engineers are responsible for establishing and monitoring processes essential to maintain product consistency, on-time production, and fair treatment of workers. Effective work study is required to establish methods and production standards.

The work environment has a major impact on the health, safety, and productivity of workers. Ergonomic factors are considerations in all job design and work station design. OSHA has established specific standards for the work environment that apparel firms are expected to meet to ensure workers' health and safety of workers.

References and Reading List

Covington, J. W. (1993, June). Understanding the theory of constraints. *Apparel Industry Magazine*, pp. 42–46.

Hendrick, T. E., and Moore, F. G. (1985).

Production/operations management (9th ed.). Homewood, IL: Irwin.

Hill, E. (1992, February). Flexible manufacturing systems. Pt. I. *Bobbin*, pp. 34–38.

Hill, E. (1992, March). Flexible manufacturing systems. Pt. II. *Bobbin*, pp. 70–78.

Hill, E. (1992, April). Flexible manufacturing systems. Pt. III. *Bobbin*, pp. 48–50.

Moore, L. (1995, January). K-Products walks fine line of modular production. *Apparel Industry Magazine*, pp. 64–70. Ortiz, D. J. (1993, April 6). Ergonomics implementation. Seminar presented at Iowa Textiles and Apparel Association, Des Moines.

Technical Advisory Committee of American Apparel Manufacturers Association. (1993). The changing apparel plant: Responding to the new realities of manufacturing. Arlington, VA: Author.

Teel, D. R. (1997, April). Modular sewing: Are you prepared for the long haul? *Bobbin*, pp. 58–64.

Tyson, P. R. (1989, September). OSHA grows up. *Apparel Industry*, pp. 46–48.

Key Words

allowance factor allowances anthropometrics average observed time balancing bottleneck buffer bump-back bundle bundle system bundle ticket carpal tunnel syndrome (CTS) cumulative trauma disorders (CTD) dynamic efforts element elemental description

employee empowerment engineering specification environmental conditions ergonomics ergonomist high control human factors interdependency job design just-in-time (JIT) Kanban line layout low control materials handling medium control method method analysis method descriptions

modular production system motion normal operator normal time observed time Occupational Safety and Health Administration (OSHA) operation operation breakdown operator reporting performance rating plant layout predetermined motion-time systems process controls process-oriented layout product-oriented layout

production standard production system progressive bundle system (PBS) pull through production push through production quality specifications real time routing single-piece hand-off

sit/stand approach
skill center layout
standard conditions
standard data
static efforts
team-based production
system
Theory of Constraints (TOC)
throughput
time analyst

time study
Toyota Sewing System (TSS)
unit production system (UPS)
work environment
work flow
work in process
work measurement
work sampling
work study
work zone

Discussion Questions and Activities

- 1. Compare the three different types of production systems. When would each be used? How would work flow and materials handling differ in each of them?
- 2. What is modular manufacturing? What are some variations in operation of a module?
- 3. Why is production control essential to the successful operation of a firm? How are production controls used?
- 4. How is a production standard established?
- 5. How do allowances and ratings impact a production standard?

- Select a garment and prepare an operation breakdown for it. Prepare a quality specification for one of the operations.
- 7. Observe someone performing an operation at a sewing machine or at a computer terminal. Analyze the ergonomic factors of the work environment. What factors should be changed or modified? What anthropometric factors should be considered in this work environment?

Production Management

OBJECTIVES

- Examine factors that impact productivity and measures of productivity.
- Discuss the impact of resource management on plant productivity.
- © Explore management issues related to human resources, inventory, and equipment acquisition.

Resources provide the input for the conversion process and the tools to achieve goals. Goals establish the expected outcome or output of the production process. The relationship between inputs and outputs determines productivity. A firm must manage their resources to meet the immediate and future needs of their target customers. Knowing their customers' expectations for products and service allows a firm to establish goals and priorities for managing their resources including people, inventory, and equipment and technology.

Productivity Concepts

Productivity is measured by achievement toward established goals based on relationships between inputs and outputs. Management strives to increase productivity through more effective use of resources. Productivity is an indicator

of whether a firm is meeting its objectives. Management monitors productivity and makes both routine and strategic decisions based on productivity data. Smaller runs may be scheduled to meet customer demand and more market research or merchandising changes may be required if styles are not selling. Style changes might be made if throughput time is long; more education and training may be provided to assist employees; new technology and equipment might be added to increase production of more first-quality goods.

Productivity may be determined for a plant, center, machine, or individual; however, individual goals must support the goals of the firm. For example, the goal for an automatic pocket setting operation may be to run at 100 percent efficiency per work day. This supports an operational goal for a high-efficiency, low-cost work center. However, the plant's goal is to respond to customer de-

Table 12–1

Measures of performance in relation to productivity of three major resources.

Human Resources	Inventory	Facilities & Equipment
percent daily/monthly/annual absenteeism indirect labor as a percent of direct labor average direct labor operators per supervisor annual labor turnover Direct Labor dollar cost per clock hour dollar cost per SAH earned excess cost per SAH returns per 100 units in-process defects per 100 units out-going defects per 100 units raining training cost per hire training cost per operator average success rate per hire	Turnover material inventory turns per year work in process (hours, days, weeks) finished goods inventory turns per year total inventory turns per year Distribution Center Customer Services SKUs stocked, picked, shipped per day per employee shipping cost per dozen average time to process and ship orders unit volume per cubic foot percent order accuracy percent of complete shipments percent of on time shipments	Space average production space per SAH average production space per dollar sales average production space per employee distribution space per SAH distribution space per dollar sales building costs per dollar sales per SAH rental cost per dollar sales per SAH per square foot Equipment investment per dollar sales investment per SAH produced Material Utilization percent marker efficiency spreading efficiency losses at ends, splices, and

mand for quick response and a diverse product mix. Thus, high efficiency on one operation (pocket setting) feeds excess inventory into the system, reduces flexibility, and lessens the plant's ability to respond to the market. When patch pockets are needed on only one style in the line, it is unrealistic to schedule volume just to meet the operation goal. If the pocket setter only runs half the time, its efficiency goes down; but when consumers do not want styles with patch pockets, then a high efficiency at the pocket setting operation does not contribute to the goals of the firm.

Table 12–1 identifies some of the different measures of performance that impact plant productivity. By measuring each of these factors, goals can be set and productivity toward meeting these goals can be determined. Maximizing productivity in all of these areas will provide the firm's total productivity in meeting their goals. The following discussion focuses on the productivity and management of human resources, inventory, and equipment.

Human Resource Management

People are a firm's greatest resource. Employees and their degree of motivation have more to do with the success of a firm than any other single factor. Motivation may be compensation for completed work, recognition by peers or management, a feeling of accomplishment, a desire to learn. It is not the same for all persons, and one person is not always motivated by the same factors. Trainers and managers need to be aware of motivational factors in developing training programs and compensation systems. Motivation is very closely aligned with job satisfaction. When job satisfaction is high, motivation is easy; when job satisfaction is low, motivation can be very difficult.

People, unlike machines, become more valuable to a firm with time as they become better trained and more experienced. Machine capabilities can expand only within their mechanical limitations; eventually they become worn-out or outdated and need to be replaced. People have the ability to grow and improve in the right environment. This requires motivation, training, experience, and reinforcement.

Employees of a manufacturing firm are hired on one of several employment tracks: direct labor, management, and support staff. **Direct labor** are those employees who work directly on the products being produced such as cutting, sewing, and finishing operators. They add value to products and convert materials into finished products. **Management** is responsible for the leadership, organization, and decision making related to operation of the firm, facilities, and product line. Managers include floor supervisors, plant managers, merchandisers, engineers, and so forth. **Support staff** are those employees that provide services for management and assistance with the product line. Support staff

include quality control, mechanics, and clerical workers. All three areas are essential to the operation of a firm, but the focus of this chapter is on direct labor.

Hiring the right person for the job is the first step in developing a valuable employee. There must be a fit between the job requirements and the employee's abilities. Expectations of both the firm and the person being hired need to be compatible if the relationship is to prosper. Firms evaluate applicants' skills and abilities, and the applicants evaluate the job descriptions, wages, and employment opportunities to determine whether their expectations are compatible. Job descriptions identify the position, describe the work to be performed. and identify the physical and mental requirements to perform the job. Job descriptions need to be complete and accurate so the position is not misrepresented. The American Disabilities Act has forced firms to formalize job descriptions. If it is later determined that an applicant cannot perform the operation described, they can be terminated without recourse. If the employee was not informed of the job requirements, they can claim prejudice and discrimination. It is essential that job descriptions are well defined and explicit about the work and expectations of the firm to communicate job requirements to potential employees.

Developing accurate and appropriate job descriptions is difficult and time-consuming but essential for screening applicants and meeting legal requirements for hiring or rejecting an applicant. Evaluation tools that support the job description such as dexterity tests or skills assessments may be useful for screening applicants, but they must apply to the skills required for the position. Many legalities are involved with hiring practices and violation of any of these can lead to severe penalties and legal action.

Compensation

Compensation, payment for time and service provided to the firm, is wages or salary and fringe benefits. An established fair compensation system is essential for good management rapport and labor relations. Management salaries are a set sum that compensates for all activity required for executing the responsibilities of the position. Support staff may be salaried or compensated with an hourly wage. Unless service can be associated with a specific product or customer, salaries are considered operational expense and indirect costs.

Compensation systems commonly used for apparel production workers (direct labor) are (1) hourly wage or payment for a unit of time worked, (2) incentive systems or payment for units produced, and (3) performance-related systems or bonuses. Firms adopt variations or combinations of these systems in an effort to increase productivity and improve fairness to employees. Operator wages are a direct cost, and fringe benefits are an indirect cost.

An **hourly wage system** is often used in plants with limited production runs and a wide variety of products. This approach provides little incentive to produce more at a faster pace. Hourly wages are often used to compensate op-

erators who are learning methods or by firms that specialize in custom production or high-fashion goods. It may also be used to compensate workers who are expected to perform a wide variety of operations such as utility operators. Firms that use a team-based production system may use hourly wages as the base of their compensation system bonuses. In most plants, production standards are used as the basis of compensation systems for direct labor.

Payment per unit of production is common in the apparel industry. It is often referred to as the piece rate wage system or individual incentive system. Workers are paid for each unit they complete. The common belief is that this provides incentive for operators to consistently perform at maximum ability. Piece rates are based on production standards. Production standards are compared to an hourly base rate to determine the value of each completion. One advantage of the piece rate system is that the operator knows exactly how much is earned with each completion and management is able to cost the product more exactly.

Consider the example of Style A in Table 12–2. The production standard for operation #3 is 0.5 SAM. This means a normal operator should be able to complete 120 operations in 1 hour (60 minutes \div 0.5 minutes per operation = 120 operations). The base rate for operation #3 has been set at \$7.00 per hour. The compensation for each completion of operation #3 is \$.058 (\$7.00/120 = \$.058). If the firm used a single base rate, compensation for all operations in the style would be based on \$7.00 per hour.

In an attempt to keep the compensation system more fair, many firms use variable base rates. This system allows operators performing a more difficult task to earn more. It also recognizes the fact that it took longer to learn the more difficult operation; thus, there is an opportunity to earn more on a difficult job. Base rates may be based on experience, difficulty of the operation, training time required, or skill required. Some firms use a variable base rate system with increases at specific levels of productivity.

Table 12–2Style A assembly operations and production standards.

			_
Operation 1	=	0.35 SAM	
Operation 2	=	0.45 SAM	
Operation 3	=	0.50 SAM	
Operation 4	=	0.75 SAM	
Operation 5	=	0.55 SAM	
Operation 6	=	0.90 SAM	
Operation 7	=	0.60 SAM	
Operation 8	=	0.50 SAM	
Operation 9	=	0.40 SAM	
Total production time	=	5.00 SAM	

The piece rate system rewards outstanding individual performance and encourages operators to work as entrepreneurs in the plant. The more pieces an individual completes, the higher the earnings. This compensation system is widely used with the progressive bundle system. "More than 90 percent of U.S. apparel firms use the Individual Incentive System as the method of employee compensation in the stitching department" (Hill, 1993, p. 1).

Other compensation and incentives are often used in combination with wages to maximize production, skill, attendance, and quality. They may be used to reward individual or team productivity. Compensation may be in the form of bonuses, gain sharing, and profit sharing. **Bonuses** may be offered for exceeding production quotas, producing a higher percentage of first-quality garments, and not being absent.

Gain sharing is a group incentive system that allows employees to share additional bonuses based on an established standard of productivity and time frame. Common base standards may be related to hours worked, dollars spent on labor or material, and rejects. The dollar value of gains can be determined based on specific standards and distributed between workers and the company. This system encourages employees to focus on productivity goals of the firm and to take some ownership in the firm's success. Team bonuses and gain sharing are used with team-based production systems.

Profit sharing is an incentive system that shares a percentage of profits with employees. Many factors impact profits; thus, there is no guarantee of a bonus. A firm may show excellent productivity gains but still no profit.

Fringe benefits are provided in addition to wages. They are considered overhead cost or an indirect cost. They may include health insurance, social security, worker's compensation insurance, unemployment compensation, retirement benefits, sick leave, and vacation. Each state has required fringe benefits that every employer must provide. Required benefits may run as high as 15 to 17 percent of an individual's wages. In addition, firms decide what additional benefits (extended coverage of various types of insurance or retirement packages, more vacation days, etc.) they can afford to provide their employees. Benefits also may be in the form of special on-site facilities such as a special dining area or cafeteria, a fitness center, an employees' store with deep discounts, onsite day care, or special educational privileges. The larger the benefit package, the more enticing it is to employees and the more costly it is for the firm to execute and maintain.

Productivity of Direct Labor

Direct labor cost is often used as a key measurement of a firm's productivity. **Direct labor** includes first line supervisors and factory employees who actually make the products. Labor costs of a product are affected by two dimensions: the clock hours it takes to produce the product and the productivity of labor. Labor productivity can be evaluated based on a number of criteria, such as units

of output per labor hour, value of finished goods per labor hour, and units of production per labor dollar.

One source of data for evaluating labor productivity is the daily time sheet for each operator or an equivalent electronic spread sheet. A daily time sheet describes what and how much production an operator generated during the working day. If a piece rate system is used to compensate operators, bundle ticket information is transferred to a time sheet. The daily time sheet reports

- · Style or job number
- Minutes worked on production standard
- · Minutes worked off standard
- Quantity produced

From this information, earned minutes are calculated for each operator and department. Earned minutes are calculated by multiplying the number of units produced by the production standard for each operation. These data are available upon request with a real-time data collection system.

Real-time data collection systems collect data at the source as it occurs and provide immediate accessible information. Real-time systems eliminate the need for piece rate coupons, gummed sheets, time clocks, and manual data collection on inventory and payroll. Each operator has an individual terminal used as a time clock for inputting the traveling coupon from each bundle that an operator completes. Some of the real-time systems have electronic card readers at each work station. Real-time inventory tracking is helpful in scheduling work, expediting orders, monitoring quality, and providing prompt customer service. Real-time systems are often integrated with other programs and activities such as UPS bundle tracking.

Earned time can be used to calculate a productivity index for an individual, work center, or plant. Table 12–3 shows the calculation of earned minutes. A **productivity index** shows how well an operator or department worked

Table 12–3
Calculation of earned time and productivity index.

4/27/00			
Operation	Standard	Quantity	Minutes Earned
Sew sleeves	0.774	216	167
Sew sleeves	0.774	240	186
Sew sleeves	0.676	156	105
Sew sleeves	0.676	156	<u>81</u>
inutes earned			539
inutes available			480
	Operation Sew sleeves Sew sleeves Sew sleeves	OperationStandardSew sleeves0.774Sew sleeves0.774Sew sleeves0.676Sew sleeves0.676inutes earned	Operation Standard Quantity Sew sleeves 0.774 216 Sew sleeves 0.774 240 Sew sleeves 0.676 156 Sew sleeves 0.676 156 inutes earned 156 156

against the performance standard during the time work was being produced. The productivity index for the operator in Table 12–3 is 112 percent (normal efficiency is 100 percent).

Another aspect of productivity that a production manager monitors is utilization of the work day. **Labor utilization** is an indicator of the percentage of time operators actually were producing when compared to the total time available. Evaluation of labor utilization helps production managers determine how well a department or work center is converting the total hours that are available into production.

Workers are on the premises for a set number of hours each day, usually 7 or 8 hours excluding a lunch break. The total time to work may be 420 minutes per day, but a worker may not be producing on standard the complete 7 hours. With a piece rate system, on standard means an operator is producing against the production standard for the operation that he or she is assigned. Off standard means the operator is being compensated, usually with an hourly wage, but not producing a product. Off-standard time may appear to contribute to a reduction of plant efficiency.

Operators work off standard during the course of the working day for many reasons. Power failure, machine breakdowns, conferences with a supervisor, and training meetings interrupt production. Operators are still on the job but not producing. When long delays occur, operators clock out, which means they switch over to an hourly rate instead of piece rate. Operators often clock out to work on production samples as they may be experimenting with methods, performing new or unfamiliar operations, or using new fabrics with which production standards may not be established. Off-standard costs become excess costs.

First-quality products are essential to achieve a high level of productivity and low excess costs. Rework by operators when quality does not meet specifications can cause major reductions in productivity and increases in excess costs. Doing it right the first time means training and motivating operators to produce top quality all the time and never passing along poorquality work to the next operator. This approach, if well executed, produces minimal defects. Low volume of work in process also helps to increase the output of first-quality garments. Poor quality is much more visible and easier to contain.

Quality should be measured objectively and statistically to know the impact it has. Quality audits are used to determine the percentage of first-quality products that are produced in a plant. Random statistical quality checks may be done at any point during production or distribution.

Productivity in Other Areas of the Firm

It is common to focus on productivity of direct labor but other areas of the firm need to be equally productive. Examples discussed briefly here are cus-

tomer service including distribution center services and sourcing materials and production.

CUSTOMER AND DISTRIBUTION CENTER SERVICES Productivity of customer service measures how well an apparel firm meets the needs of its customers. One critical aspect of productivity is delivery performance and whether a firm is able to ship complete and on time. If a goal is improvement in shipping on time and complete orders, the firm needs to determine the current percentage they ship complete and on time. Its productivity in meeting this goal for improvement can be determined by comparing the new percentage to the original figure. Kurt Salmon Associates surveyed 50 of the larger apparel firms and found that only 17 were able to ship over 90 percent of their orders complete and on time (Vought, 1990). This is a clear indicator of an opportunity for improved customer service.

Efficient distribution centers are essential to effective customer service. Effective production is negated when products sit for days or weeks waiting for sorting and packaging for shipping. Established work standards serve as a basis for determining distribution center productivity and targets for improvement. Measures may include the volume processed in a day per employee or cost per dozen processed. Each measure can serve as a standard for comparison and a measure of productivity. When cost per dozen processed is a measure of productivity, distribution center automation is much easier to justify.

Sourcing Materials and Production The productivity of a firm's sourcing options may change over time. Firms need to assess whether the cost of using owned and contracted sources and/or foreign and domestic sources is optimum for a particular period of time for different merchandise groups. Labor costs in certain geographic areas may increase, shortages of labor and supplies may occur, freight rates may increase, quota costs and tariffs may increase or disappear, and reliability of contractors may change. The optimum location or source of products that prevailed two or three years ago may no longer be the most productive source to provide the best margins.

Training and Development

Hiring a new employee is the beginning of a building process that should be mutually beneficial to both the individual and firm. The success of a hire can often be traced to the effectiveness of the orientation and training programs and the follow-up with the individual. **Orientation** is the process of integrating a new employee into the firm. **Training** is the process of imparting jobrelated knowledge to employees.

Orientation programs help new employees adapt to company culture, job expectations, and coworkers. New employees need to know what is expected of

them, the skills they are expected to learn or bring to the job, how long the training should take, and what they can expect from the firm at the conclusion of their training. All policies and information should be in a manual or some written format to eliminate second guessing.

Training programs are designed to (1) prepare employees for the specific job they are expected to execute, (2) develop involvement with the firm, and (3) provide opportunities for personal and professional growth. With appropriate training, employees should be able to provide a service to the firm that will help it to meet customer needs and grow.

Effective training requires a commitment from management to make it happen. Time, cost, facilities, and expertise are all essential to a training program. A trainer should be hired whose primary responsibility is to work with new employees. Supervisors have too much to do and the favoritism factor can become an issue. Management also needs to be accepting and open to new ideas. Productive employees are often the result of good training programs.

Firms have different missions, goals, and expectations, all of which should be considered in customizing a training program to fit the firm's needs. Every training program should have a goal and method of measurement. Costs can be justified if results can be measured. Goals may relate to performance and professional development and do not necessarily have to relate to productivity and efficiency. Management's commitment should enable continuing education to become an ongoing effort for employees at all levels. Establishing training programs for new hires is just the beginning.

Job skills are often the dominant focus of training programs. Skill training prepares an employee for the specific job or task he or she is expected to perform. Operators learn the procedures and produce against a learning curve until they reach a certain level of competency. Operator efficiency remains high with continued focus on one operation, but being competent in one operation is not enough in a flexible manufacturing environment. Operators need to be cross-trained to do more than one operation. In some modular systems, all the operators on a team are trained on all the operations that are performed by the module. Cross-trained operators build flexibility into a system, but the training takes longer, and they probably never reach the same efficiency level as an operator performing just one operation.

Firms have different levels of commitment to job training. In a firm that seeks only to get the job done and lacks commitment to development of employee potential, job training may be as simple as showing the new hires what they are expected to do and providing a walk-through or map of the facilities. The employee may be given a task and left to figure out how it will get done. Other firms will provide extensive specifications and methods training to make sure operations are done precisely. Many weeks of training may be invested to ensure that operators consistently meet quality standards.

Training for involvement with the firm depends on management's philosophy and how employees are valued as a resource. If employees are viewed as pairs of hands to do various jobs, then they are replaceable and training focuses primarily on job skills. If employees are viewed as a valuable resource, then every effort is made to integrate individuals into the firm and encourage personal and professional growth.

Firms that strive to help employees feel welcome, encourage involvement in plant activities, and develop an understanding of the corporate philosophy and culture of the firm are likely to have less employee turnover. Job satisfaction and whether an employee stays often depend on the employee's relationship with the firm. Job satisfaction, though difficult to measure, is often overlooked in the effort to develop productivity. It builds on employees' perceptions of their recognition and acceptance by management and other employees and their ability to develop a support system within the plant.

Certain aspects of training programs may also seek to integrate employees with the firm's mission and policies. Some firms use in-depth training programs to develop a basic understanding of the operation of the firm, its customer, and product line. Such programs help employees see the relationship between specific operations and the finished product or goals of the firm. A knowledgeable employee is better able to make suggestions that may improve the operation or product. Each aspect requires more time and cost, but long-range employees are able to function at a much higher level.

Workers who have the opportunity to learn more about the interrelationships among operations, the company's needs and goals, customer wants, and product costs are likely to become more active, participative employees. This type of training has become a major priority in some firms as teamwork and employee empowerment have evolved. Many total quality management programs are targeted to developing greater interest and participation among employees. The result is a team effort in producing better-quality products.

According to Jim Hamiter, manager of Apparel Manufacturing Technical Training for Russell Corporation:

We have to teach more of the fundamentals of our particular business, such as what our current customers expect from us and how that impacts the way we do what we do... Make no mistake, the more understanding an employee has of the business, the more qualified that employee is. (Education Committee, 1994, pp. 83–84)

Workers who have the chance to learn continuously become more active, participative employees. Continuing education enables employees to contribute more to decision making and problem solving. As a result, the employee's sense of pride, belonging, accomplishment, and job satisfaction grows.

Moving the training program beyond the technical level to education for personal advancement and life skills is a major commitment of a few U.S. firms.

These firms realize the value of developing the whole person and see the long-range benefits to their company. Many firms are reluctant to invest in this type of training, however, for fear their investment will be lost when employees leave or are laid off.

Firms committed to this type of educational program have created opportunities for employees to take classes toward a high school degree and/or continuing education classes in computer technology, communication skills, and so forth. Russell Corporation's Star Learning Van, for example, takes microcomputers to its various plant sites to teach basic reading and math skills to employees.

Each firm executes its training programs differently. Some start their operators on the production floor under the guidance of a supervisor or trainer. Others do **vestibule training** in an area removed from the production line where similar equipment is available and trainers can function without disturbing the other workers. Some firms are able to combine these approaches to provide an environment in which employees are able to concentrate on the task at hand and later move to the production floor when they have reached a certain level of competence. Whatever the environment, it should facilitate learning.

Firms are constantly seeking new innovations to facilitate training. Firms have found interactive video training programs that allow trainees to interact directly with the computer to be helpful in imparting basic knowledge on machine operation and maintenance. Videotaping operations is another innovative method of training. Videotapes are used for both demonstration and analysis. Demonstrations of each operation in a style may be videotaped for operators, especially those who work in remote sites, to view and study. Trainers use video segments of an operator performing a specific task to analyze and help them develop better and faster methods. The visual presentation is also helpful in bridging language barriers.

COSTS OF TRAINING AND CONTINUING EDUCATION Employee turnover is a costly problem for many employers. "For a new hire in an average apparel plant, a fair ballpark dollar amount for training would be \$3,000 including wages, material usage, machinery utilization, supervisory time and the off-quality goods created during the training curve" (Education Committee, 1994, p. 83). This is a sizable cost, especially if the employee does not stay. Most employee turnover occurs among employees that have been employed less than one year. This may say something to hiring practices or the new employee's introduction to the firm.

The Education Committee (1994, p. 82) stresses the importance of continuing education: "The cost of providing continuing education programs to your employees is not a central issue in itself. Rather, the issue is what it costs your company in the long run if it doesn't promote education." Training costs are considered excess costs and easily accountable. The actual costs of inadequate

training programs are difficult to determine and document. Costs of inferior quality, poor performance, and customer dissatisfaction can be significantly higher than any training costs. The high cost of employee turnover and lack of job satisfaction ultimately affect costs also.

Inventory Management

Inventory is defined by Goldratt and Cox (1992, p. 60) as "money the system [i.e., firm] invests in things that it intends to sell." Units of inventory have value based on the total investment in the item that may be well above the original cost. Value is added to materials throughout the production process, and the value remains in the system until the style is sold.

Inventory includes all the items that have been purchased for conversion and sell through that are in the system at any given time including materials waiting to be processed, work in process, and finished goods. Once items enter the system, they are counted as inventory until they are sold or written off the books as a loss. This includes damaged goods that are not salable, trims that were not used and have been carried over for several seasons, and materials or finished goods whose orders have been canceled. Inventory contributes to success only when it has been sold.

Inventory has both volume and value. It is measured, managed, and controlled in both stock keeping units (SKUs) and dollars. Units of inventory compose the volume of goods that is available to use or to sell. Materials and finished goods are often stored in anticipation of future use and sales. Certain stock levels may be planned and maintained to meet customer needs. **Excess inventory** occurs when procurement and production exceed consumption.

Market value of items may decrease with prolonged storage. Fashion goods tend to become obsolete rather quickly. When this happens, the dollar return at the time of sale may be considerably less than the inventory value or amount invested in the product, which will negatively affect profitability and return on investment.

Three cost factors must be considered in evaluating inventory: (1) the original cost of the goods, (2) the cost of maintaining the inventory including interest on borrowed money and restricted cash flow, and (3) the value added to the original materials. The value added to the cost of materials is the investment in labor required to produce the product. Many firms only consider the former, which is a direct cost, and treat carrying costs as overhead, thus never really knowing what it costs to maintain their inventory.

Inventory management has become a more sophisticated field because of computerization of inventory data, production planning, real-time production control, and costing systems. It is common for investment in inventory to represent from 15 to 30 percent of a firm's invested capital. In addition, annual inventory carrying costs may range from 20 to 40 percent of inventory value. For example, a firm with \$1 million worth of inventory may spend \$300,000 a year maintaining that inventory. Managers recognize that profitability can be increased by better controlling inventory acquisition. Materials buyers face the conflicting requirements of investing as little as possible in inventory while having materials readily available for efficient production.

Materials are a major cost factor; therefore, effective use of materials may have a significant impact on plant productivity. Standards for material utilization are essential if a firm expects to control usage and costs. Firms are concerned with the quantity of materials that are actually used relative to the amount purchased and the waste generated. A manufacturing firm must have accurate, current, and comprehensive information on availability, volume, and complete costs of all materials. This information is essential for production planning, scheduling, inventory management, and determining unit costs of production.

Excess inventory, whether materials or work in process, increases costs, but a shortage of inventory will sharply curtail production. Manufacturers have realized sizable cost savings by reducing the amount of inventory carried, but reductions should be made relative to throughput. Only so much cost can be cut until it negatively impacts throughput. Materials must be available before cutting orders are initiated, but the less time materials sit in the warehouse, the less cost accrues. Many large manufacturers operate on just-in-time delivery of piece goods in order to reduce inventory carrying costs.

Many factors affect the amount of lead time needed for orders and the volume purchased. "Constraints govern both throughput and inventories" (Covington, 1994, p. 77). If materials are released at the rate they are used, a large build-up of work in process can be avoided. The release of materials for production should be synchronized with the constraint as it controls the pace of the manufacturing process. Constraint operations also need a planned buffer of inventory to ensure a smooth work flow and enough work to keep the constraint running in case of unpredicted down time on preceding operations. A buffer is planned work in process not accumulated inventory.

Reconsider Style A described in Table 12–2. If materials are released so Operation 1 is able to work at 100 percent efficiency, then inventory (work in process) is increased in the system, but Operation 1 does not affect throughput. The constraint operation, Operation 6, determines throughput and should determine release of materials. Operation 6 plus buffer inventory should also determine delivery of materials in a QR system.

Inventory Control and Turnover

Inventory control is an effort to maintain stock levels and costs within acceptable limits. Inventory levels must be high enough to maintain a steady work flow, keep inventory investment at a minimum, and provide good customer service.

Models and computer simulations are available that determine how much and when to have inventory delivered as well as systems for monitoring inventory.

Real-time inventory information provides managers with the exact location of each order and style at any given moment. Managers know what styles are in process, how many operations have been completed, who performed the operations, and exactly where the bundle is on the production floor. The control center of a unit production system provides this information, but there are other computer systems that track batches through production.

One common way to measure productivity of an apparel company's inventory is to determine how frequently it turns. In a 1993 survey of 25 top apparel manufacturers conducted by Charles Gilbert & Associates (Survey, 1993), the average inventory turn was 4.9. One company reported achieving 9 turns, and the lowest was 2.2 turns. An **inventory turn** of 2.2 means that, on the average, the firm had investment in each piece of inventory for 23.6 weeks per year (52 weeks \div 2.2 turns = 23.6 weeks). In contrast, with an inventory turn of 9 the firm has investment for only 5.8 weeks per year. The savings in interest on borrowed money becomes obvious.

Inventory is a controllable element that has a major impact on productivity and is key to the success of the firm. Firms use inventory to adjust to the peaks in demand. It does not add value to the product and only restricts cash flow. Inventory turns and productivity can be improved through better forecasting, more accurate production scheduling, and controlling work in process. Low work in process leads to higher inventory turns.

Equipment Management and Plant Modernization

A firm's strategic plans, financial base, merchandising and sourcing strategies, and commitment to modernization determine the needs and priorities for technology and equipment. By industry interpretation, modernization means use of integrated systems technology and automated equipment. The cost of this modernization may be high. Computerized cutting equipment is in the \$500,000 range, marking and grading equipment runs about \$80,000 to \$200,000, software programs and the equipment to run a factory loading- and material-scheduling system cost \$25,000 to \$100,000.

The firm's investment in owned plants and the availability of labor are primary considerations in equipment planning. Some issues that a firm must address before making a commitment to modernization of technology and equipment include the following:

- 1. What are the firm's long-range plans?
- 2. What is the firm's commitment to production?

- 3. What are the financial risks of capital investment in modern equipment compared with other sourcing options?
- 4. Will modernization increase productivity?
- 5. What degree of modernization is realistic?
- 6. What amount and skill level of labor are available in the area of the plant?
- 7. Is there enough capital or borrowing power to make the necessary investment?

Equipment needs are as varied as the firms and product lines they produce. Each plant operates with a set of characteristics unique to its existence. Reasons for equipment purchases include the following:

- · Replacement of essential worn-out equipment
- Replacement of existing equipment to increase productivity and reduce costs
- Acquisition of new equipment to expand production capacity and/or improve quality
- Acquisition of equipment to produce new product line(s)
- Acquisition of new equipment to improve safety and environmental factors

Although new technology and equipment hold great potential, they may not be the answer to all of a manufacturer's problems and needs. New technology may impose certain limitations and risks. Technology may discourage expansion into new areas and limit production to specific products. Investment in expensive equipment may also limit cash flow, depress plant morale, and require extensive training, maintenance, and remodeling. Equipment may restrict the variety of materials that can be used, limit styling to designs that can be produced on specific machines, and limit diversification of products.

Simulation to Support Decision Making

One way to test a change before investment and installation is through computer simulation. **Simulation** is a problem-solving tool that enables modeling of a real object or a real process. Process simulation involves making a flow-chart of a process and sending imaginary parts through the process. This can be done by hand or with a calculator or computer program. Now computer technology uses animation to carry out the process, thus creating a visual impact as the results are monitored.

Simulations are used to plan purchases, analyze proposed changes, and predict outcomes based on specific data and information supplied to the program. Simulation programs allow managers to test a change and analyze the potential results without actually installing it in a plant. Potential "what if" scenar-

ios can be created to explore potential solutions. Various options can be analyzed to predict what will work best for the particular plant.

Simulation is an accepted methodology for solving problems, but it must be flexible and easy to implement. Simulation models are available that can be easily adapted to a variety of manufacturing facilities and operations so reprogramming does not need to be done with each scenario. By providing the system with appropriate data, manufacturers can plan for the number of machines needed to meet customer demand, determine the unit output from these machines, and plan the buffer that might be needed for the type of production system used.

A number of large firms such as Hartmarx, Sara Lee Knit Products, and Russell Corporation have developed their own simulation programs to meet the specific needs of their firms. Simulation is also being developed by some of the major apparel research and technology centers.

Apparel Technology Centers

Three major organizations, Clemson Apparel Research, Textiles/Clothing Technology Corporation [TC]², and the A-CIM Center at the University of Southwestern Louisiana have made significant commitments to the revitalization of the apparel industry. They are nonprofit, industry- and government-sponsored organizations that provide demonstration sites, education programs, and research projects that benefit the apparel industry in the United States.

Clemson Apparel Research (CAR) Center in Pendleton, South Carolina, is affiliated with Clemson University. Formed in 1987 as a demonstration site for the U.S. government Defense Logistics Agency, it has since become a major apparel center with an integrated focus on applications of advanced technology and better management techniques. Its numerous research projects and seminars seek to expand the knowledge base of the industry and to disseminate information to apparel managers.

The basic premise of **Textiles/Clothing Technology Corporation** ([TC]²) in Cary, North Carolina, is advancement of the apparel industry through research, technology, and education. State-of-the-art technology is available at [TC]² for manufacturers to analyze and evaluate based on the unique characteristics of their own product lines and manufacturing facilities. This center provides faculty fellowships and student internships each summer in addition to a wide list of specialized seminars for apparel professionals. It is also highly involved with research and development of equipment and technology systems. At the 1993 and 1994 Bobbin shows, [TC]² exhibited a high-speed laser cutter developed as a joint effort with Gerber Garment Technology.

Computer integrated manufacturing (CIM) focuses on computer and communications technology to integrate people and machines involved in a manufacturing process. The Apparel Computer Integrated Manufacturing (A-CIM) Center was established at the University of Southwestern

Louisiana as a joint research effort with the AAMA for the development and implementation of communication standards and protocol to support computer network communication. (A protocol is a set of conventions that enable various functions to take place.) A common protocol will enable communication among different computer systems. With a common protocol, different machines and systems have the potential to send and receive messages from a central control center or communicate with other systems in the plant.

The common language that A-CIM is developing, Apparel Manufacturing Protocol Suite, will enable communication among various technologies and systems in the plant and with others outside the plant using the same protocol. A manufacturer can determine the dimensions for a collar shape, then send it electronically to the equipment producer that can produce and ship the die or template without other communication or having to reenter the data at different levels. A common language allows direct and faster communications among systems.

Product-Related Issues

Equipment needs are likely to be closely aligned with a firm's product line. Equipment needs evolve as a firm establishes its product line, quality standards, and productivity goals. Product characteristics such as the materials used, styling, quality requirements, cost restrictions, and delivery deadlines define the need for equipment and processing methods. Product specifications determine the specific methods, assembly sequences, and equipment needed to produce the products.

Sewing and pressing equipment are often specific to certain fabric characteristics. Some types of equipment are designed to handle light- to medium-weight fabrics, while others are built for heavy fabrics. Knits often require special needle types and feed systems; denim and canvas may need other mechanisms. Development of a new product may indicate a need for additional or specialized equipment. Management must explore a product's marketability, profit potential, longevity, competitive products, and additional use of the proposed equipment before making an investment.

Answers to the following questions help determine the appropriate type of equipment for a particular use:

- 1. What is the specific use of the equipment?
- 2. What type of operation is desired?
- 3. What level of productivity is required?
- 4. What types, weights, and thickness of materials are to be used?
- 5. How much flexibility does it have?
- 6. What automatic features and work aids are needed?
- 7. What quality level is desired?

QUALITY ASSURANCE As discussed in preceding chapters, quality is an important means of developing product differentiation. Specific quality characteristics are identified by customers as adding value to a product. For a particular firm or brand name, these characteristics need to be consistent over time. At some quality levels and for some operations, it is not enough to be consistent; operations must also be accurate and correct. Equipment that will provide greater accuracy at high speeds is an important consideration for many product lines and operations.

An obvious example of inconsistency and inaccuracy occurs in safety stitching the leg seams of slacks. The amount of seam allowance removed with manual sewing may vary from 1/8 to 1/2 inch in extreme cases. These discrepancies are not noticeable with visual examination of the finished garment, but they are noticeable to the consumer when trying on the garments. If two garments of the same exact style and size are tried, one will fit much tighter than the other if more seam allowance was removed during stitching.

Automated equipment, if properly managed, is an effective means of maintaining product consistency and accuracy. Automated equipment can continuously perform the same operation in precisely the same way with great regularity. Greater accuracy and consistency can also reduce production time of later operations.

Even with automated equipment, quality control is still essential. Equipment malfunction or breakdown rather than operator inconsistency is likely to be the cause of defects. Proper maintenance and operation of equipment, combined with automation, improve consistency and reduce the number of seconds and irregulars produced, which reduces production costs.

Job Skills

One expectation of modernization is a reduction in labor costs and improved consistency by lowering dependence on the manual operation and material handling skills of the operator. As equipment becomes more automated, operator involvement changes. Less manual dexterity and handling may be required, but operators will need to be more knowledgeable about technology, operation of the equipment, and complete assembly processes. Some operations can be almost entirely machine controlled as the operator only needs to position the item and engage the machine. With some equipment, operators may be able to operate more than one machine. A decrease in labor content increases the potential for faster throughput time and cost reduction.

Training is a major factor affecting cost and productivity of equipment. A well-trained operator can work faster, be more accurate, and produce a better-quality product. Equipment that is easy to operate, requires minimal operator control, and allows the operator to reach production standards with limited training can be very cost-efficient. The sooner an operator reaches the production standard, the less it costs the firm, and the more satisfied the operator is likely to be with his or her performance.

Some automated equipment may require different aptitudes and skills than manually operated equipment, which can create new challenges in hiring, training, and cross-training operators. With automated equipment, the requirements for high dexterity and skilled manipulations may decrease, but technical knowledge and problem-solving skills may be needed to keep the equipment performing to expectation. The amount of training or retraining time required for operators to utilize equipment effectively is an important issue in the selection of new equipment. In many instances the supplier provides the specialized training needed, initially, in order to put the equipment into operation.

IMPROVING EFFICIENCY Improved efficiency is a major factor in justifying equipment purchases. Cost reductions may occur as equipment reduces labor requirements and increases output volume. Automated plants often maintain higher levels of efficiency over extended periods of time.

Downtime is a factor that affects the efficiency of equipment. **Downtime** is the period of time that a machine is not operational because of setup, making adjustments, maintenance, or mechanical failure. Equipment that is not operating is not productive. This is a critical issue with special-purpose machines for which there is usually no backup available. Downtime of one special-purpose machine can cause work stoppage of other machines in the production line.

Mechanics that are well trained on the operation and maintenance of the equipment are necessary to minimize repairs and downtime. Much of the new automated equipment requires special training for preventive maintenance in addition to normal maintenance operations. This can also contribute to the cost of equipment installation and operation. In some cases, the supplier provides the initial training; in other cases, it is the responsibility of the purchaser. In either case, servicing machines can escalate costs. The ideal equipment purchase requires limited setup time and minimal maintenance that can be performed by operators and mechanics.

Equipment Acquisition

When developing or purchasing equipment, a firm should consider such factors as the equipment manufacturer's reputation, performance record of previous equipment used in the plant, amount of training provided, quality of repair service, and cost of service contracts. Equipment can be acquired through development by a firm's research and development (R&D) division, contracted to an outside R&D center, purchased direct from an equipment manufacturer, or ordered according to specifications. Trade shows are frequently used as a source of information about new equipment and an opportunity to see it demonstrated.

The primary goal of R&D is to improve productivity through development of machines, equipment, production systems, work stations, and work aids. An R&D program can provide a competitive edge by developing means for improved efficiency and cost reduction procedures. Research and development de-

partments may be organized and managed as separate profit centers of a firm. This allows for justification of their existence based on the savings generated from producing new equipment and labor-saving devices.

Research and development of equipment may consist of several phases: R&D of new equipment and production systems, securing patents, manufacturing the equipment, field testing, selling equipment to other manufacturers, and

servicing. Any one phase or all phases may be subcontracted.

Large firms that develop unique production equipment for particular products may choose not to make the technological developments available to other firms. Some firms have not made their R&D developments available to the industry at large because they believe the equipment provides a strategic edge in the market.

Only the very large firms can afford to maintain specialized research divisions, but in smaller firms the same function may be carried out by the firm's industrial engineers. In smaller firms the goal is often not to develop machines but to improve the efficiency of the existing machines through the use and/or development of attachments and work aids. Shaving seconds off a procedure can mean sizable savings when utilized over several seasons or years.

EQUIPMENT MANUFACTURERS Equipment manufacturers are the primary source of new equipment, technology, and automation for most apparel firms. Equipment development and manufacturing are global businesses. The United States, Germany, and Japan are leaders in both technological development and utilization of technology. Catalogs provided by major equipment manufacturers such as Union Special, Singer, Durkopp, Sussman, and Veit detail the features of the hundreds of models of machines that they produce. Information in the catalogs may be presented in several languages. Equipment described in the catalogs is often modified for each plant's individual needs. Equipment manufacturers are also important suppliers of educational information about machines and production processes.

TRADE SHOWS, EQUIPMENT DEMONSTRATIONS, AND ADVERTISING **Trade shows** and the trade press are good sources for current information on advanced technology, equipment suppliers, and new products. Most equipment and industrial suppliers advertise in the trade press and exhibit their products at the trade shows. Common trade publications for the apparel industry are *Bobbin, Apparel Industry Magazine*, and *Daily News Record*. They provide an opportunity for manufacturers to stay current on the latest issues, technology advances, and events that affect the apparel industry both nationally and internationally.

Equipment trade shows consist of exhibits, demonstrations, and seminars presented by equipment manufacturers and trade associations for apparel industry participants. There are three major trade shows where major equipment manufacturers exhibit: Bobbin World in the United States,

International Clothing Machine Fair (IMB) in Germany, and Japanese International Apparel Machinery (JIAM) Exhibition in Japan. These rotate every year. Bobbin World is the largest trade show held in the United States. The annual Bobbin America (a smaller version of Bobbin World) and Contexpo are two smaller trade shows held annually in the United States. Many other shows are more specialized for specific product lines or specific areas of the country.

Trade shows provide an opportunity for participants of the apparel industry to share concerns, needs, advancements in technology, and information. An equipment trade show provides a common location and date for all equipment manufacturers and suppliers that are interested in showing, demonstrating, and promoting their product lines to apparel manufacturers. Because of the magnitude of the exhibits, information, and opportunities to see and learn about the latest technology and trends and to make valuable contacts, trade shows attract top management from apparel manufacturing and related firms. Equipment firms often make sales, contacts for follow-up after the show, and provide information to interested firms that may be potential customers. A trade show is also an opportunity for equipment producers to see what the competition is promoting.

For the apparel manufacturer, trade shows offer the opportunity to see the newest technology, learn about sourcing opportunities, compare various types of equipment and product lines, learn technical capabilities that their competitors may have purchased, and find new sources of supply. There are also special informational seminars that are of interest to most attendees that provide insight into industry trends, problems, and opportunities.

Summary

A firm's resources, inventory, personnel, and equipment are managed and controlled to maximize a firm's productivity. People are a firm's greatest resource. Employee compensation systems have many variables. Whatever the system, it must be a fair reward for time worked or for a completed task. Training programs that seek to develop individuals as well as their job skills foster participative employees that make valuable contributions to the firm.

Inventory includes all items purchased for conversion and sell-through that are in the system at a given time. Inventory has both volume and value that must be managed to achieve desired profit margins. Plant modernization is a big issue in today's apparel industry. It plays a major role in productivity, efficiency, and quality. Integrating computer technology is the central focus for increasing flexibility and effective management of resources.

References and Reading List

Covington, J. (1993, June). Understanding the theory of constraints. Apparel Industry Magazine, pp. 42–46.

Covington, J. (1994, April). Getting your company in sync. Pt. 2. *Bobbin*, pp. 76–78.

Education Committee of American Apparel Manufacturers Association. (1994, June). If you think training is expensive, consider ignorance. *Bobbin*, pp. 82–85. Goldratt, E. M., and Cox, J. (1992). The goal: A process of ongoing improvement (2nd rev. ed.). New York: North River.

Hill, E. (1993, June). Dram-Buffer-Rope. Unpublished paper, Clemson, SC.

Survey: 9 inventory turns per year possible. (1993, March). Apparel Industry Magazine, pp. 14–15.

Vought, K. (1990, February). Total productivity. Apparel Manufacturer, pp. 74–81.

Key Words

Apparel Computer Integrated
Manufacturing (A-CIM)
base rate
bonuses
Clemson Apparel Research
(CAR)
compensation
computer integrated
manufacturing (CIM)
cross-trained
direct labor
downtime
excess inventory
fringe benefits

gain sharing

hourly wage system incentive system inventory inventory control inventory turns job description job skills job training labor utilization management off standard on standard orientation program

orientation
orientation program
payment per unit of production

piece rate wage system
productivity
productivity index
profit sharing
salaries
simulation
support staff
Textiles / Clothing Technology
Corporation [TC]²
trade shows
training programs
variable base rates
vestibule training

Discussion Questions and Activities

- 1. What are three primary resources that require productivity measurements?
- 2. What are the fundamental differences in compensation systems for direct labor?
- 3. How does training influence productivity?
- 4. How is a base rate used with a piece rate compensation system?
- 5. How does inventory impact profitability?
- 6. How is productivity of inventory measured?

- 7. How is productivity of equipment measured?
- 8. What issues need to be considered when deciding on the purchase of new equipment?
- 9. What are the primary sources of new technology for apparel production?

Preproduction Operations

OBJECTIVES

- Oiscuss the importance of cut order planning and fabric utilization in preproduction operations.
- Explore the relationships among the major preproduction operations: marker making, spreading, and cutting.
- Examine the factors affecting quality, costs, and productivity of preproduction operations.
- Explore the variety of methods and equipment used to complete the preproduction operations.

Changing market demands and varied production strategies are creating diverse needs for preproduction processes. Small orders, increased flexibility, and Quick Response expectations are creating the need for fast turns on markers, low-volume spreads, and high-speed low-ply cutters. In contrast, the growth in 807 production in Central America and Mexico has increased demand for electronic markers, high-speed spreading, and large volume cutting. Numerous cutting contractors that specialize in preproduction activities for 807 (HS 98) operations have developed in southern Florida. Many of these firms are running three shifts a day to produce needed markers, spread and cut U.S. fabric, and ship it to sewing contractors in participating countries.

Another significant change in preproduction has evolved from team-based production units. Some manufacturers have expanded the team approach to include spreading and cutting operations. One preproduction team spreads and cuts for two or three team-based sewing modules. It creates a pull system where cutters must have the work ready for the module on time and presented in the manner needed. If cutting is not accurate the sewing team knows with whom they need to work to improve the process. If a part is damaged and it holds up sewing production, the sewing team can immediately go to the preproduction team and have another piece cut. If the sewing team makes its production goal, this means the cutting team does also. This system can work effectively if teamwork is a priority with management.

Because of proportionately high fabric costs and the increasing costs of managing waste, firms have increased their focus on ways to increase the utilization of material. **Material utilization** is the process of optimizing the use of materials during product development and production. All preproduction operations—cut order planning, marker making, spreading, and cutting—impact material utilization.

Initiation of Preproduction Operations

Preproduction operations are dependent on perfected patterns. Technical designers and production pattern makers develop the patterns for styles accepted into the line, perfect them, and grade them into appropriate sizes. All the patterns in each size of a style are verified, that is, checked very carefully before sending them to cut order planning. Pattern verification includes checking the following:

- Correctness of grade increments
- · Compatibility of grading with style specifications
- Length and alignment of adjoining seam allowances
- Notch placement and alignment with adjoining pattern pieces
- · Placement of internal markings
- Placement of grain markings

Cut Order Planning

Cut order planning translates customer orders into cutting orders. It is the process that coordinates customer orders with all the variables of marker making, spreading, and cutting to minimize total production costs and meet customer demand for timely products. It seeks the most effective use of labor, equipment, fabric, and space. Cut order planning involves the following responsibilities:

- · Examining incoming orders and width and availability of piece goods
- Determining volume, size ratios, and sectioning procedures for marker making
- Determining whether file markers are available or new ones are needed
- Developing specifications for optimum marker making and fabric utilization
- · Determining most effective use of spreading and cutting equipment
- · Issuing orders for marker making, spreading, and cutting

Cut order planning can be done manually or by computer. New computer technology is much faster, more accurate, and supported with more data on all the variables. Computerized cut order planning allows experimentation with alternative cutting plans to develop the most efficient options. Cut order planning is a prerequisite to tight markers.

A key aspect of cut order planning is to analyze available information (defect maps provided by the mill) on the rolls of fabric to be spread and the firm's existing sectional markers. **Defect maps** identify locations of breaks and flaws, width variations, and length of pieces on a role. They can be sent electronically ahead of the goods so cut plans will be ready when the fabric arrives. Based on the defect maps the planner can estimate the number of plies and cuttable garments from each roll. Some firms refer to this as **chart spreading.** It is helpful to spreading operators to know the order in which rolls should be used to minimize remnants.

As many as fifty different variables, in addition to fabric information, may affect cut order planning. Some of the most common considerations are these:

- · Number of sizes in order
- Number of colors in order
- Maximum/minimum number of sizes allowed in marker
- Maximum spread length
- Maximum ply height
- Percentage of overcut or undercut units
- Fabric cost per yard
- Usable cloth width
- Width variation
- Common lines among pattern pieces
- Costs of making markers
- · Costs of spreading
- Costs of cutting
- Costs of bundling
- · Fabric roll change time

The results of cut order planning are cutting orders that direct marker planning and lay planning. Optimum use of material and cutting systems are

important considerations in planning cutting orders as more firms incorporate new technology. The purpose of **marker planning** is to determine the most efficient combination of sizes and shades for each order and to produce the best fabric yield and equipment utilization. One cutting order may require several markers to achieve optimum efficiency. Usually one of these is a **remnant marker** for the short pieces and ends of rolls left over. This helps to reduce fabric waste. Each marker requires a lay of fabric.

A lay is a stack of fabric plies that have been prepared for cutting. Lay planning is the basis of managing cutting room labor and table space. Spreading and cutting schedules are affected by table length, type of equipment, spread length, spreading time, and cutting time. The cutting room manager must minimize throughput time by efficient use of equipment, table space, and personnel. The following discussion describes the preproduction operations supported by cut order planning: marker making, spreading, and cutting.

Marker Making

A marker is a diagram of a precise arrangement of pattern pieces for a specific style and the sizes to be cut from a single spread. Marker making is the process of determining the most efficient layout of pattern pieces for a specified style, fabric, and distribution of sizes. The process of arranging pattern pieces in the most efficient manner requires time, skill, and concentration. Markers may be made by manually tracing master patterns onto fabric or paper or by manipulating and plotting computerized pattern images.

Manually produced markers may be created by arranging full-size pattern pieces on marker paper or directly on the top ply of fabric in a spread. Pattern pieces are traced using a pencil or tailor's chalk. Manual methods of marker making are time-consuming and require a great deal of space. Full-size pieces must be manipulated, adjusted, and readjusted on normal fabric widths. Manually made markers are also subject to errors and inconsistencies that may occur in grain variations, poor line definition, placement and alignment of pieces, and omission of pieces. Accuracy of a manually made marker depends on the skill of the individual who laid out the marker and traced it.

Computerized marker making is more accurate and provides the greatest opportunity for pattern manipulation, marker efficiency, reuse of previously made markers, and shortest response time. Production patterns may be developed on the computer and/or digitized or scanned into the computer. In addition, parameters for markers are entered into the computer from cutting orders. These might include style numbers, size distribution, and fabric width. Technicians manipulate pattern images on computer screens and experiment with various configurations to determine the best fabric utilization for the

marker. See Figure 13–1. Protective devices are built into the programs to ensure grain alignment and prevent overlapping or omission of pieces or other errors. Once markers have been planned and stored, they can be printed or recalled and modified for new cutting orders.

With newer marker-making software, markers can be automatically created. A computer can automatically develop up to seven different markers according to the criteria set by a technician. Automated marker making may be used to determine yardage requirements and fabric costs for designs prior to line adoption. Other firms use automated marker making to generate their markers. With automatic marker making, a fifty-piece marker can be generated on the computer screen in less than a minute.

Plotting is the process of drawing or printing pattern pieces or markers on paper so they can be reviewed or cut. Computer-driven plotters may draw pattern pieces, graded nests of patterns, and/or markers with complete annotation, depending on the needs of the apparel firm. New multihead jet plotters are much faster and can print variable line density and width, text identification information, and bar codes. Some garment manufacturers have devices to copy original markers when multiple copies are needed. Plotting is often the bottleneck in the preproduction processes, especially if a firm runs a lot of copies. Many firms run their plotters 24 hours a day to keep up with demand. Firms using computerized cutters may not need paper markers to guide the cutting process and therefore may only print identification information for bundles.

Figure 13–1 Marker being generated on a CAD system.

Cut order planning determines how many markers are needed, how many of each size should be in each marker, and the number of ply that will be cut with each marker. Size distribution in a marker depends on the volume of orders for specific sizes, fabric width, how the pieces fit together, and the firm's standard practices for marker making. An efficient size ratio is often 1:2:2:1. For example, an order for one marker may contain one small, two medium, two large, one extra large. Additional markers may include only medium and large, depending on the assortments in the line plan or orders from merchandise buyers. Cutting orders may require making new markers, copying previously made markers, or modifying previous markers.

Dimensions of Markers

Markers are made to fit specific widths of fabric and quantities of sizes. If a marker is narrower than the fabric, the unused fabric is wasted. If a marker is wider than the specified fabric, garment parts located on the edge of the marker will not be complete. Fabric is purchased by width but often it runs wider than the required width. When fabric width is grossly inconsistent, fabrics in a lot may be grouped by width and different markers produced for each width. Using the extra width in planning markers can save significant yardage.

Markers may be produced in sections or blocks or be continuous. **Blocked** or **sectioned markers** contain all of the pattern pieces for one style in one or two sizes. Sections may be used separately or joined together to form an extended multisize marker. Blocked or sectioned markers are easier to visualize, plot, and handle, but they may not produce the best utilization of fabric.

Sectioned markers may be used to adjust the volume requirements for various sizes or as a remnant marker. High-volume blocks can be placed on one end of the marker and low-volume blocks placed at the other end so the fabric can be spread to correspond with the volume needed for each block. Blocking keeps garment parts for one size in close proximity, which facilitates bundling and handling. Sectioned markers are advantageous if there is end-to-end shade variations of the fabric. Figure 13–2 shows a spread that could be used with a sectioned marker and an unequal distribution of sizes.

Figure 13–2
Diagram of a stepped spread.

A **stepped spread** for a sectioned marker may consist of plies of varied length, spread at different heights. The most frequently used configuration for a stepped spread consists of a group of plies that are spread the full length of the marker and another group of plies beginning at the section line. Stepped spreads are used to adjust the quantity of piece goods to the number of garments to be cut from each section of the marker (see Figure 13–2).

Continuous markers contain all the pattern pieces for the all sizes included in a single cutting. They may be lengthy and often require more juggling of pattern pieces. Pattern pieces are grouped by size and shape of the pieces rather than by garment size. Continuous markers often have better utilization because there is more flexibility in grouping and maneuvering large pieces and small pieces. Splice marks are planned into continuous markers to avoid excessive fabric waste and incomplete pieces.

Splice marks are points in a marker where fabrics can be cut and the next piece overlapped to maintain a continuous spread. See Figure 13—3. Splice marks may be one inch or several inches depending on the overlap needed to accommodate the pattern pieces in the area of the splice. The rectangular box indicates the amount of overlap needed. The lower ply should be cut at the end of the box and the new ply of fabric should be aligned with the beginning of the box. If fabric needs to be cut before there is a splice mark, the cut should be made at the last splice mark and the extra fabric used for recuts or smaller markers. Splice marks are inherent when markers are planned in blocks. Piece goods may be spliced at any point where the sections of a marker are joined together. Splices are needed when flaws are removed, a roll change is made, or a short length of fabric is used.

Figure 13–3 Mini marker with a splice mark.

Marker Efficiency

Marker efficiency is determined by fabric utilization, the percentage of the total fabric that is actually used in garment parts. The area not used in garment parts is waste. Marker efficiency depends on how tightly the pattern pieces fit together within the marker. The total surface area of the pattern pieces is compared to the total area of the marker to calculate the percentage of fabric that is used. This is determined automatically by marker-making software. If marker-making technology is not available, the area of each pattern piece may be determined by a planimeter—a mechanical device that calculates the surface area as the outline of the pattern is traced. Factors that affect marker efficiency are fabric characteristics, shapes of pattern pieces, and grain requirements.

FABRIC CHARACTERISTICS Fabric characteristics that affect utilization include differences in face and back, lengthwise directionality, crosswise symmetry, need for matching the fabric design, length of design repeat, and fabric width. These fabric characteristics frequently limit the arrangement of pattern pieces. Matching fabric designs requires special marker preparation and extra piece goods. Stripe or plaid lines must be indicated on pattern pieces and markers for accurate alignment and matching to corresponding pieces. The greater the length between repeats increases the potential for fabric waste.

CHARACTERISTICS OF PATTERN PIECES Characteristics of pattern pieces may limit fabric utilization. Generally the fabric utilization percentage increases when a variety of garment sizes are used in the same marker and when the marker contains both large and small pieces. Smaller pieces can often be nested with larger pieces. The shape of the pattern pieces determine how close they can be fit together (interlock). Irregular shaped pieces are difficult to fit together with other pieces. Large pattern pieces are less flexible and often dictate the placement of other pieces.

Patterns are sometimes modified to increase fabric utilization although modification may not always be feasible. Some pattern adjustments that may be used to improve fabric utilization are:

- Splitting pattern pieces and creating a seam
- Rounding or slanting corners
- Reducing seam allowances and/or hem width
- Adjusting pattern dimensions without noticeable change to fit and style
- Adjusting grain lines for hidden garment parts
- Modifying grain lines specified by the designer

Both marker and cutting efficiency may be improved by using a common line between pattern pieces. For example, several waistbands in juxtaposition could share a common cutting line and be cut with one pass with a cutting knife. A common line needs to be a smooth, clean cutting line for both pieces so inaccuracies do not occur.

GRAIN ORIENTATION Grain line markings determine the placement of the pattern relative to the warp yarns in wovens or wales in knit fabrics. Pattern pieces with a similar **grain orientation**, if grouped together on the marker, generally produce better utilization. Combining several bias pieces and straight grain pieces may not fit together as well and create more fabric waste. Markers usually have good utilization when all pattern pieces are on the bias or all pieces are cut on straight grain.

The firm's standards for grain tolerance may also affect marker efficiency. Tilting specific pattern pieces 1 or 2 percent may not be noticeable, and it may increase fabric utilization noticeably. This practice can impact the fit and drape of the finished garment but it may not be noticeable to the untrained eye. Computer marker-making programs will lock in the grain orientation of each piece unless an override function is used to adjust them. This can be done on a piece by piece basis.

FABRIC UTILIZATION STANDARDS Firms often establish fabric utilization standards. Firms producing basics may strive for 90 to 97 percent utilization, while fashion firms may be able to achieve only 80 to 85 percent. It is important for firms to document material utilization and variances from the standards to monitor improvements or factors that impact the utilization. Better utilization is normally developed for basic styles because optimum fabric widths are used consistently and more time invested in cut planning and manipulating pattern pieces in the markers to reduce waste of materials. Markers for basic styles are used to cut large volumes of piece goods and may be kept on file and used repeatedly; thus, the time invested in improving utilization results in greater savings.

Markers for fashion styles and Quick Response strategies may be used only once or for a limited number of spreads and few ply. Fashion garments are subject to constant changes in styling and materials and tight deadlines that limit the time available to develop efficient markers.

Marker Quality

Accuracy is a major factor in marker quality. Complete data and precise lines are essential for cutters and sewers to process the garment parts correctly. Information needed for each pattern piece includes size, style number, and piece name or number. Lines must be accurate, consistent, fine, smooth, and a precise image of the production pattern. Computerized marker making is more precise and eliminates many of the mistakes that occur with hand-drawn markers. CAD systems are one of the first areas for investing in technology

because of the time savings and accuracy they provide. Lines are always consistent, pieces are not omitted, and pieces are always on grain and facing the designated direction unless an override command is used.

Depending on quality standards, pieces may be overlapped slightly or have corners rounded in an effort to conserve fabric. These economies frequently cause problems when operators try to align two corresponding pieces for sewing.

The omission of even the smallest piece from the marker can create major problems in recutting. A missing piece may not become apparent until the garment parts are prepared for sewing. By this time, it is difficult to find the specific pattern piece and identical fabric to recut the piece. Scraps may have been discarded, or remaining fabric may be a different dye lot. If the fabric can be found, special handling and separate cutting are required. This is a common problem with manually made markers.

Planning the knife path for cutting is an important quality consideration. There needs to be space for the cutting knife to maneuver without cutting into adjoining pieces. It is easy to cut straight into a lay but to turn and change directions requires space in the marker where this can happen without damaging other pieces. If manually cut, consideration must be given to the position of the cutting operator as they are not able to maneuver as freely as a computer-controlled knife.

Types of Markers

The form of the fabric and whether it is symmetrical and/or directional determine the appropriate type of marker for a style. Markers may be open or closed depending on the form that the fabric is presented for cutting. Rolled fabrics are open and flat when spread. Markers for this type of spread require full-pattern pieces for each part to be cut. Markers made with full-pattern pieces are called **open markers**. Tubular knit fabrics are closed on both edges and therefore require pattern pieces that utilize the folds. Figure 13–9 shows a diecut shirt body that has center front and center back on the folds. Markers made with half-pattern pieces for laying along the folds of the tube are called **closed markers**. Garment parts must be symmetrical if half-pattern pieces are used.

Marker makers must also consider the symmetry (side-to-side) and directionality (end-to-end) differences in fabrics. Symmetric fabrics are the same side-to-side. Asymmetric fabrics, such as border prints are different side-to-side. Nondirectional fabrics are the same end-to-end. Directional fabrics are different end-to-end. Examples of directional fabrics include knits, napped fabrics, and prints with flowers all growing in one direction.

The **marker mode** is determined by the symmetry and directionality of fabric. There are three types of marker modes: nap-either-way (N/E/W), nap-one-way (N/O/W), and nap-up-and-down (N/U/D). In this case, the term nap is used to indicate the fabric is directional—it is different end-to-end. In marker jar-

gon, the **nap** of a fabric is created by its structure (corduroy or an unbalanced plaid), a finish, or a directional print. With symmetric, nondirectional fabrics, pattern pieces can be placed on a marker with only consideration for grainline. This marker mode is called **nap-either-way** (N/E/W). Pieces are placed for best fabric utilization.

With asymmetrical and directional fabrics the orientation of pattern pieces is extremely important to the consistency and quality of the product. These fabrics require that all pattern pieces be placed on a marker in only one direction. This is called **nap-one-way** (N/O/W). With this type of layout, pattern pieces do not interlock as closely and thus it usually requires more fabric and reduces fabric utilization.

On some directional fabrics, such as corduroy, it may be possible for all the pattern pieces of one size to be placed in one direction and another size placed in the opposite direction. This is called **nap-up-and-down** (N/U/D). With this type of marker, the nap of corduroy jeans may run down for a size 7 and up for a size 9. The critical factor is that the nap must run the same direction in all the pieces of one garment. Napped fabric such as corduroy will appear shaded if the pieces in one garment have the nap running in different directions. Generally N/U/D will yield a better utilization of fabric than N/O/W.

A marker is made for a specific style, fabric, and number of sizes. The length of the marker determines the length of the lay that will be spread. Completed markers are sent to the cutting room electronically or in hard copy for the spreading and cutting processes.

Spreading

Spreading is the process of superimposing lengths of fabric on a spreading table, cutting table, or specially designed surface in preparation for the cutting process. A **spread** or **lay-up** is the total amount of fabric prepared for a single marker. A spread may consist of a single ply or multiple plies. The height of a lay-up or spread is limited by fabric characteristics, size of the order to be cut, cutting method, and the vertical capacity of the spreader. The number of plies in a spread may range from 1 to 300.

Spreading may be done manually or by computer-controlled machines. One person or two, depending on the width and type of fabric, type of equipment, and size of spread, may be involved with the spreading process. Two people may be used for manual spreading unless the spread is very short. One person may work each side of the table in order to keep the fabric flat, smooth, and tension-free. With automatic spreading, the equipment controls the tension, fabric placement, and rate of travel. The spreading operator monitors the process and removes fabric flaws as needed.

Overview of the Spreading Process

Two aspects of spreading that affect spreading efficiency are the setup and actual layout of fabric. Setup involves loading and threading fabric through the spreader and positioning the machine and related equipment. The actual process of spreading involves laying out fabric in the desired number of layers. Fabric may be spread face up, face down, or face-to-face.

SPREADING MODES A **spreading mode** is the manner in which fabric plies are laid out for cutting. The spreading mode is determined by the fabric characteristics, quality standards of the firm, and available equipment. Two fabric characteristics that determine the spreading mode are the direction of fabric face and the direction of fabric nap.

DIRECTION OF FABRIC FACE The fabric face may be positioned in two ways: face-to-face (F/F) or with all plies facing-one-way (F/O/W), face up or face down. Face-to-face (F/F) spreading may be continuous as the spreader moves up and down the table. This is the fastest method of spreading, the least costly, and generally results in the lowest quality. With this method of spreading the face is up on one ply and down on the next ply as the spreader goes back and forth. Often symmetric, nondirectional fabrics are spread continuously, which places alternate plies face to face or back to back. Quality is affected because the operator is only able to monitor the face of fabric half the time. Figure 13–4 shows a diagram of spreading modes.

Figure 13–4
Spreading modes.

F/O/W spreads, face up or down, are more time-consuming and expensive because fabric must be cut at each end of the spread and the new end repositioned. If a rotating turntable is used to turn the fabric roll 180 degrees at the end of each ply, the fabric can be spread from both ends of the table without a wasted trip. F/O/W spreading may be done with the fabric face up or face down. When the fabric faces up, the operator is able to monitor the face for flaws and imperfections as the fabric is being unrolled. This is particularly helpful when spreading prints. Pile fabrics, corduroy and velvet, are often spread face down, other high-quality fabrics are spread face up.

DIRECTION OF FABRIC NAP A second consideration in selecting the spreading mode relates to the direction of the fabric nap. Placement of the nap may be nap-one-way (N/O/W) or nap-up-and-down (N/U/D). See Figure 13–4.

Asymmetric and directional fabrics must have the nap running the same direction, nap-one-way (N/O/W). This spreading mode is the most time-consuming to lay-up but it generally produces the best quality. N/O/W fabrics may be spread F/F and F/O/W. If napped fabrics are to be positioned F/F the fabric needs to be cut and the role turned at the end of each ply so the nap will lay in the same direction on facing plies. This is suitable for directional fabrics and to pair garment parts for the sewing operation. This is sometimes referred to as pair spreading.

Symmetric, nondirectional fabrics allow flexibility for spreading. These fabrics can be spread with the nap running both up and down the spread. This spreading mode is called **nap-up-and-down** (N/U/D). This type of fabric may be spread face-to-face or face-one-way with the nap running up and down. Table 13–1 summarizes the potential combinations for fabric, style, marker modes, and spreading modes.

Spreading Quality

A firm's standards for spreading quality may be consistent across all products or may vary with the specific product being produced, the targeted price range, and the quality standards and specifications of the buyer of the finished goods. Standards for spreading ultimately affect the succeeding operations of cutting, assembly, finishing, and the final fit and quality of the finished products. Spreading operators have many factors to monitor during the spreading process. A high-quality spread is free of noticeable defects in the fabric; tension-free; flat; selvages accurately aligned at least on one edge; free of static electricity; accurately spliced with minimal waste; and be the precise length, mode, and number of plies specified. In many cases firms are doing less formal inspection when fabrics are received which increases the responsibility of the spreading operator.

Fabric defects can have a major impact on the quality of a lay-up and the products to be cut. It is the responsibility of spreading operators to identify

Table 13–1

Appropriate marker and spreading modes considering symmetry and directionality of fabric.

Fabric		Marker Mode	Spreading Mode Face Nap	
wwwww				
**********	Symmetrical	N/O/W N/U/D	F/F	N/O/W
**************************************	Directional		F/O/W	
++++++++ ++++++++++	Symmetrical	N/E/W	F/F	N/U/D
+++++++++	Nondirectional		F/O/W	
W				
vvvvvvv vv	Asymmetrical	N/O/W	F/O/W	N/O/W
w w	Directional	14/0/44		
w				
++ +++++++ ++	Asymmetrical	N/O/W	F/O/W N/U/[
++	Nondirectional			N/U/D

fabric defects and make a decision on how to handle them. With certified fabric, many defects are identified by the mill or fabric inspectors but spreaders still have to make decisions on how defects should be treated. It is also not a safe assumption that all defects have been identified.

As flaws appear, the spreading operator determines the severity of the flaw, where in the spread the flaw is located, and whether it needs to be removed. Minor flaws may be left, depending on where they are located, where it will fall in the cut garment part, and the desired quality level in finished goods. Considering that 5 to 15 percent of the fabric will be marker waste and another 5 percent will be seam allowances, it may not be necessary to remove the flaw. Some firms mark flaws by covering them with crossed strips of narrow tissue paper that run the approximate length and width of the cut piece. The tissue paper alerts bundlers, and the cut piece with two strips of paper on top of it will be recut if needed. Many firms label and save short pieces of fabric in case recuts are needed. The more expensive the piece goods, the more likely that flawed parts will be recut. Flaws that are not removed in spread-

ing may appear in the finished garment, which creates a second or reject. A finished garment with flaws has a large investment in materials and labor; therefore, the loss may be greater than if the fabric flaw had been removed or recut during spreading.

A rule of thumb suggested by W. R. Cole, industry consultant, would be to cut out only full width or 4 point defects. He also suggests that fabric savings will outweigh labor costs for recutting on fabrics costing more than \$2.50 per yard (Cole, 1995).

Computer-controlled spreading systems can be equipped with flaw management systems that use information provided by mills relative to piece length, flaws, and width variation. Electronic monitoring also makes the spreading operator's work easier so spreading can be done at a faster rate and more attention given to monitoring the fabric surface. These systems show where flaws will appear in the cut parts so the operator can determine the appropriate strategy for handling. Flaw removal is costly. It is nonproductive time for spreading operators and fabric waste due to splicing.

Tension or tightness of a spread is a major factor that will ultimately affect garment fit and quality because of the reaction of the fabric. Fabric should be as tension-free as possible when spread. Fabric under too much tension as it is spread may be stretched or elongated. A tight spread will contract in length and the ends may tend to draw inward. This may occur while the fabric is waiting to be cut, which may result in a spread that is shorter than the marker. If the fabric contracts after it is cut, garment parts will be smaller than the pattern, which creates problems in assembly and garment fit. This trait is often referred to as snap back. To avoid excessive tension, fabrics may be spread manually, or spreading equipment may synchronize fabric unrolling with the rate of spreading. Tension can be a problem with any fabric but it is a special concern for knits and fabrications containing spandex.

Slack tension is a lesser problem, but it still needs to be monitored. A slack spread contains excess fabric in each ply that may create billows and ridges in the spread. Operators are able to monitor slack tension better than high tension because slack tension is more visible. As other plies are positioned over loose folds, creases form that may distort the cut garment parts. Cutting a slack spread may create oversize pieces, cause inaccuracies in assembly, and waste fabric.

The **flatness of a spread** may also be affected by the finish and behavior of the selvage. Selvages may shrink excessively or be stretched during fabric finishing. If either edge of the fabric draws together, it will cause the fabric to pucker. In most instances the only solution is to remove the problem selvage prior to spreading. Flatness may also be an issue with tubular goods that is skewed. When the skewing is excessive, the tube will twist and distort.

Ply alignment relates to the accuracy with which fabric edges, both length and width, are aligned during spreading. Ply alignment affects fabric waste and accuracy in cutting garment parts. If there is no width variation in the piece goods, both edges will be aligned, but if variation occurs within a roll or between

rolls, it is essential to keep one edge accurately aligned. Aligned edges of piece goods are matched with one edge of the marker for accurate cutting and effective fabric utilization.

Static electricity may result from friction among materials and spreading equipment. Particularly fabrics made of manufactured fibers may have a static problem. Static may cause fabric plies to cling to machinery or other fabric plies, which creates problems with flatness and accuracy of alignment.

Setup for Spreading

Setup for spreading involves the same basic steps for each cutting order issued: (1) verifying cutting orders, (2) positioning materials, (3) preparing cutting table(s), (4) preparing machine(s), and (5) loading machine(s). Verification of cutting orders and fabric positioning includes interpreting the cutting orders, identifying the designated fabric and marker, and moving the fabric to the spreading area. Depending on the degree of automation, roll goods can be delivered to the spreading area in the precise order that it will be cut, and verification is done by scanning UPC codes.

Preparing the spreading table for each spread includes marking off the table for the precise length of the marker, lengths of the various sections and/or specific splice points, and placing the spreading paper. This protects the fabric from any rough spots on the table surface, enables the lay-up to be moved if needed, and prevents the base plate of the cutting knife from distorting lower plies of fabric.

Machine setup may involve moving the spreader to loading position, loading the fabric roll or rolls, registering fabric data (length, width, vendor, UPC code), threading the fabric through tensioning devices, cutting the beginning edge so it is straight, moving the machine to the spreading position, and positioning the fabric. Loading large fabric rolls onto the spreader often requires two people or some type of mechanical assistance.

Basics manufacturers may use larger rolls, with some weighing as much as 1,650 pounds. Larger rolls are heavier and more difficult to lift and may require stronger, heavier spreading machines. Using larger rolls reduces the loading and threading time and often the number of splices that are needed as the fabric is spread. Manufacturers may specify the maximum number of pieces that are acceptable in a roll.

Rolled piece goods are mounted on spreading machines and unrolled as the spreader travels up and down the table and aligns plies. The spreading operator monitors the fabric for flaws and irrogularities during the spreading operation. Other responsibilities of the spreading operator depend on the type of equipment being used. Manually operated equipment requires that the operator monitor many other aspects of the operation such as edge alignment, counting plies, and moving the spreader. Plies are counted, and, in some spreads, layers of colored tissue paper are spread after a specific number of plies. This helps identify quantities of garment pieces and/or separate shades of piece goods.

Reloading the spreader requires many of the same steps as the initial start up. The empty roll has to be removed or unused fabric returned to inventory. The operator must register the number of yards spread, change the unrolling bar, and load a new roll of fabric. Reloading and delay time may use up to 70 percent of the time required for the entire spreading operation (Jung and Heyn, 1987). The more often rolls are exchanged, the more delay there is in the spreading operation. Some machines can carry multiple rolls, which eliminates the return trip to the loading area each time a roll runs out. This is especially helpful for long spreads.

The final step in the spreading process is placing the marker on the lay, unless it is to be cut with a computer-driven knife. The marker may be held in place with an adhesive, weighted, or stapled onto the spread to prevent shifting during the cutting process. Large straight pins or long staples (2–3 inches), sometimes as long as the spread is deep, may help hold the marker in place. Spreads set up for computer-controlled cutting are covered with a thin sheet of plastic film. This restricts movement of the spread and maximizes fabric compression when vacuum tables extract air to compact the spread prior to cutting.

Spreading Equipment

Basic **spreading equipment** consists of spreading surfaces, spreading machines, fabric control devices, and fabric cutting devices. Many firms operate productively with manually operated equipment, while other firms find the automated, high-tech equipment to be cost-effective for their operations. Understanding the parts and complexities of spreading equipment provides insight for troubleshooting problems and better preparation for the process.

SPREADING SURFACES The appropriate type of spreading surface is determined by the fabric type, spreading equipment, cutting method, cutting equipment, and the firm's quality standards. Spreading requires a flat, smooth surface. If the spreading surface doubles as a cutting surface, it also must be level. Spreading and cutting may be done on the same surface, but automated cutting often requires spreading and cutting to be done in adjacent but separate locations.

Spreading and cutting surfaces are available in standard widths that correspond to fabric width. Table width cannot be expanded, although narrow fabric can be spread on a wider table. A spreading surface needs to be about 10 inches wider than the fabric. Spreading tables may have tracks or rails placed along one or both sides of a tabletop or just a few inches off the floor. This track helps guide and control the spreader as it moves up and down the length of the table. With some types of equipment, the table tracks are geared to synchronize the movement of the spreading machine with fabric unrolling, in order to regulate tension.

Spreading tables may also be very specialized for certain types of fabric and cutting equipment. Pin tables have rows of pins located below the surface that can be extended through slats to hold fabric in a precise location for accurate

matching of pattern repeats. Vacuum tables are used to compress the lay-up and prevent shifting or movement during cutting. A spread is covered with a plastic film that forms a seal over the lay-up when a vacuum is applied. A lay-up of quilted fabric can be compressed as much as 75 percent when the vacuum is used. This allows more plies in the lay-up and restricts the movement of slip-pery fabrics for more accurate cutting.

Cutting equipment may be moved to a lay-up as another lay-up is prepared further down the table, or fabric can be spread on one surface and then transferred to the cutting surface. Air flotation tables, when activated, allow easy movement of a lay-up onto an adjacent cutting area. A layer of air between the table surface and the bottom layer of paper reduces friction and allows a lay-up to be moved easily without putting stress on the fabric or the operators.

Spreading tables with conveyorized surfaces carry the fabric to the cutting machine so that no time is wasted. Ideally one lay-up can be cut while another is being spread. Conveyors may be used with computerized cutting systems, large die presses, and laser cutters.

SPREADING MACHINES The fundamental purpose of a spreading machine is to superimpose layers of fabric in a smooth, tension-free manner for accurate and efficient cutting. Manually operated spreading machines can be as simple as a roll bar mounted on four wheels that is pushed up and down a spreading table by an operator. Manual spreaders travel only as fast as an operator moves them, while some of the faster automated machines can spread 100–150 yards per minute. Spreading speed can only be utilized on long spreads with few defects. Spreading speed may affect productivity, quality, and cost of the operation, but it should not be the primary focus for purchase of new equipment. Manual spreading machines may be used by small firms as the primary spreading device and by large firms for short spreads. As spreading machines become more sophisticated, they are motor driven and have fabric control devices included to increase productivity, decrease variability, and make spreading more cost-efficient (see Figure 13–5).

FABRIC CONTROL DEVICES At higher rates of travel, it is difficult for an operator to monitor more than one aspect of the operation; therefore, edge-sensing devices, lap counters, width monitors, and out-of-cloth sensors simplify the operation so the operator's primary concern is the fabric being spread. Fabric control devices are mechanisms that control fabric as it is carried up and down the table and unrolled by the spreading machine. These devices include tensioning mechanisms, positioning devices, and end treatment systems.

Tensioning involves synchronizing the rate of spreading with the rate fabric is unrolled. A positive feed system utilizes a covered roller that is driven and timed to the movement of the machine. It prevents the momentum of a large roll from continuing to unwind when the machine slows down or stops. Roller covers of different materials may be used to give better gripping power for different types and weights of fabric.

Figure 13–5
Automatic spreading machine with fabric control devices.

Positioning devices and sensors monitor position and control fabric placement during spreading. These devices improve the quality of a spread. Electronic edge sensors monitor selvages as fabric is spread. A deviation from the proposed alignment triggers a motor that shifts the roll to the correct position. Alignment can be held to one-eighth inch tolerance with these devices.

Width indicators may sound an alarm to alert the operator whenever fabric becomes narrower than the established width. Width variations are analyzed to determine where in the marker they fall, whether the fabric will still fit the marker, or whether the variation should be treated as a defect and removed.

End treatment devices are used with spreaders but are separate and placed at the end of the spread. The specific end treatment equipment needed depends on whether the spreading mode is face-to-face or face-one-way. A face-to-face spread utilizes an end catcher and folding blade that work together. These are mechanical parts, mounted at opposite ends of the marker to catch and hold the fabric as the blade shapes and creases the fold. An overfeed device may be built into the spreading unit, which automatically feeds extra material when a fold is to be made. End treatments have a major impact on fabric waste. There must be enough fabric at the end of a lay to retain it in place, but any fabric beyond the end of the marker is wasted.

For F/O/W spreads, a knife box is needed along with an end catcher. A **knife box** contains a cutting unit (usually a small rotary knife) that operates in a track and cuts across the fabric width when engaged. With face-one-way spreads, each ply must be cut from the roll at the end of the marker. The catcher simply holds the fabric end in place for cutting. As multiple plies are spread, the fold blade and/or knife box must be elevated to the height of the top ply in

order to fold or cut the fabric. The vertical positioning of knife boxes may involve mechanical gears, ratchets, or electronically operated elevating units.

Spreading Costs

Costs of the spreading process can be focused on three areas: labor costs including setup time and spreading time, fabric waste, and equipment purchase and operation. Spreading costs per garment are based on the number of garments to be cut from a single spread and the labor costs incurred in setup and spreading the fabric. Setup costs change very little from one size cutting order to another; therefore, spreading costs per garment decrease as cutting orders get larger.

LABOR COST Labor cost reduction focuses on reducing demands on operators and reducing the amount of labor needed to set up and perform the spreading operation. A large part of the labor required for the spreading process is involved in machine setup and delay time during reloading. Variables such as fabric type, roll size, machine capabilities, and degree of automation may affect the efficiency of the setup and reloading processes. Setup for the spreading operation is usually more time-consuming and physically demanding than spreading the fabric. As the size of the spread decreases, the setup time as a percentage of the spreading operation increases dramatically (Stevenson, 1987). Spreading costs rise when manufacturers work with small lots and/or shaded fabrics that must be handled in separate spreads.

Automation, if fully utilized, can reduce the amount of setup and delay time to less than the actual spreading time. As more automation is used in spreading, there is less operator involvement and more consistency in spreading rates. Power-driven spreaders travel faster, reduce operator fatigue, and carry heavier loads. Many power-driven spreaders have a platform attached to the side of the machine for an operator to ride as the machine moves up and down the table. This places the operator in a better position to monitor and inspect fabric.

Spreading speed is only a minor factor affecting productivity. Achieving maximum machine speed is nearly impossible because of slowdowns or stoppage for direction change, flaw removal, roll change, rethreading, and so on. Every time a flaw is removed, the spreading machine must be stopped and the fabric cut and spliced. This results in lost spreading time as well as wasted fabric; therefore, the fewer flaws removed, the faster and less costly spreading will be. Other problems such as curled edges and puckered selvages also may increase downtime. Manual spreading may require two operators to manipulate fabric evenly in order to produce a smooth lay.

The rate of spreading is also related to a firm's standards for quality and the spreading mode. Spreading costs increase as more operator involvement and judgment are needed. Specifications that demand matched fabric patterns and surface designs may increase spreading time significantly. Spreading modes and the type of equipment determine how much fabric manipulation is re-

quired during spreading and whether the spreader travels for repositioning without spreading.

Compensation for spreading operators is often based on the number of yards spread, therefore, there is incentive to spread as many yards as possible in the work day. This method of compensation encourages high-volume spreading but it does not encourage high-quality standards, or effective material utilization practices. Low labor costs may result in higher product costs.

FABRIC WASTE Fabric waste in spreading occurs with flaw removal, splicing, end loss, and width loss. Flaw removal not only removes the flaw but any good yardage on either side of it. A two-inch hole could end up wasting several yards of fabric depending on where the splice marks are located.

Splicing loss occurs with excessive overlap at splice marks. Although splicing is essential, too much overlap or not enough overlap could cause additional waste if pieces aren't cut properly. Excessive lapping at splice points may be the result of a poorly trained or careless spreading operator.

Because splicing must be done at precise points, short fabric pieces may be created. Some manufacturers may use short fabric pieces to create a short spread for a single section marker, use them for recuts, or sell them to fabric jobbers. In many cases the remaining pieces that are sold by the pound to a jobber end up as flat folds in fabric stores.

End loss occurs when the spreader reaches the end of the marker and the fabric must be cut from the roll or folded back for the return lap. End loss occurs at each end of a spread. Losses may be 1–2.5 inches at each end and for a spread of 100 ply the waste can be significant. The shorter the spread the higher the ratio of loss. Precaution is needed to minimize the amount of fabric allowed at the end of a spread and to cut the fabric straight. A slanted end cut can waste fabric at both ends of a spread. The amount of end loss varies with the spreading mode and equipment. Excessive end loss and careless spreading can create inventory shortages and poor utilization that will ultimately increase production costs.

Width loss occurs when fabric is wider than the marker and the extra fabric is not used. Often fabric is sorted by width and markers made for the cuttable width of fabric. A 2-inch difference in fabric width can significantly increase fabric utilization of a marker.

EQUIPMENT PURCHASE Equipment purchases are usually justified on a cost-savings basis. Material utilization and labor savings can be quantified, but the payback is often more difficult to establish when trying to improve the quality of a spread. Because preproduction operations are so closely related, it is difficult to determine cost savings related to a single innovation. Apparel manufacturers have been slower to adopt high-tech equipment for spreading than for other areas of manufacturing. Cutting contractors that operate multiple shifts find it much easier to justify the purchase of new innovative spreading equipment.

Cutting

Cutting is the preproduction process of separating (sectioning, carving, severing) a spread into garment parts that are the precise size and shape of the pattern pieces on a marker. The cutting process may also involve transferring marks and notches from the marker to garment parts to assist operators in sewing. Chopping or sectioning a spread into blocks of piece goods may precede precision cutting of individual pattern shapes. This is often done to allow for accurate matching of fabric design or easier manipulation of a cutting knife.

Fabric pieces may be cut to predetermined lengths for matching patterns or for additional processing such as screen printing. Spreads of plaid fabric may be presectioned into blocks so the design of the fabric can be perfectly matched before cutting to the shape of the pattern piece. Presectioned pieces may also be garment parts knitted to specific finished lengths such as sweater bodies. Presectioned pieces such as leather or other specialty fabrics may be spread and cut as a single ply or laid up and cut as a multiple-ply spread.

Cutting Quality

Preceding operations affect the cutting process just as cutting contributes to the quality, efficiency, and costs of subsequent operations including handling, fusing, and sewing. Precision use of appropriate cutting equipment is a major factor in determining the quality of the cut parts. Cutting quality can be judged by the accuracy and condition of cut edges and the precision of cut garment parts.

ACCURACY Accurate cutting facilitates sewing and improves garment quality. Inaccurate cutting may cause sewing operators to compensate by stretching or easing to make adjoining parts the same length. Manipulation of this sort increases sewing time and assembly costs and may cause defects and poor fit. When automated sewing equipment is used, garment parts must be cut accurately as there are no operators to make adjustments.

Factors that cause cutting inaccuracies are

- · Wide or vague lines on the marker
- Imprecise following of lines on the marker
- Variation in the cutting pitch
- Shifting of the spread or block
- · Allowing fabric to bunch up or push ahead of the knife
- Using improper equipment
- Using improper cutting sequence as parts are cut

The **cutting pitch** is the angle at which the cutting device contacts the spread. Cutting pitch determines the size uniformity, top ply to bottom ply, of pieces cut from in a single stack. Maintaining the cutting device in a perfectly vertical position, a 90-degree pitch, and accurately guiding the knife through the spread creates uniformity. Preventing the spread from moving during cutting also contributes to uniformity. Materials may bunch up in front of the cutting device as it moves through the fabric if it is moved too fast.

Many of the factors mentioned above are reduced or eliminated with the use of new marker making and cutting technology. Although computerized cutting is widely used in the industry, manual cutting is still used by most small and midsized manufacturers. Many large firms use both manual and computerized cutting.

CONDITION OF CUT EDGES Smooth edges and precise corners are easier to align and position during sewing operations. Edges that are frayed, jagged, scorched, or fused are difficult for operators to pick up, align, and sew accurately. This can cause problems meeting seam tolerances and size specifications. The condition of cut edges is affected by the appropriateness of the cutting equipment for the fabric, the shape being cut, and the condition of the equipment.

Cutting equipment must be suited to the depth of the spread and density of the piece goods. The thickness of each ply and the number of plies in the spread determine the depth of the spread. Density of material relates to the fabric weight and is determined by fiber content, yarn size, and count. For example, spreads of heavyweight synthetic materials are more difficult to cut than spreads of lightweight natural materials. Heat buildup may cause fusing of the edges of synthetic materials. Lightweight or slippery materials may shift or slip during cutting, causing inaccuracies.

Using an appropriate cutting knife for the type of cutting operation needed and the condition of the knife blade has a major impact on cutting quality. The knife has to be appropriate for the material to be cut and it needs to be sharp so it cuts instead of tears.

There are many different types of cutting systems and cutting equipment available. Knowing the basic operation and variables of this equipment enables better decisions and choices for improved quality.

Operator-Controlled Cutting

Manually operated systems depend on the skill of the cutting operator to position, manipulate, and guide the fabric or cutting device. Operator-controlled cutting equipment may be portable or stationary. Operators control the speed of cutting, the sequence, and the shape being cut. With the exception of shears, most cutting devices have an external power source that controls the speed of the cutting blade, and an operator controls the lateral movement of the cutting

device while propelling it into the spread. Stationary cutters require the operator to position and control fabric blocks in relation to the blade.

PORTABLE CUTTING KNIVES **Portable knives** can be moved to and through a spread by an operator. There are two main types of portable knives: vertical reciprocating straight knives and round knives. Structurally and mechanically the two types of machines share many similarities. Structurally, both types of knives have a base plate, power system, handle, cutting blade, sharpening device, and blade guard. Round knives operate with a one-way thrust as the circular blade makes contact with the fabric, and vertical knives cut with an upand-down action.

Vertical straight knives with reciprocating blades are the most versatile and commonly used cutting devices (see Figure 13–6). Reciprocating blades have a vertical cutting action. Blades vary in length from 6 to 14 inches. Blade length and the adjustable height of the blade guard are factors in determining the spread depth that can be cut. The 90-degree angle of the narrow, thin blade to the cutting surface makes this knife a good choice for accurately cutting sharp corners, angles, and curves.

Vertical straight knife machines make only lateral cuts into a spread and therefore cannot be used to cut out areas from the center of garment parts. To remove a section of fabric without cutting into the area requires a slasher,

Figure 13–6
Vertical straight knives.
Source: Courtesy of Wolf Cloth
Cutters.

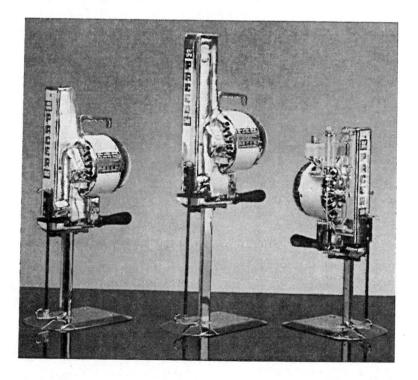

which is an adapted version of a vertical knife. A slasher cuts into the spread from above much the same as a jigsaw and cuts around the section of fabric to be removed.

Rotary or round knives can be identified by the round blade that cuts with a downward turn at the leading edge (see Figure 13–7). The cutting capacity or spread height is determined by the radius of the blade, motor size, and speed. Because of the flat, round blade, it cannot be manipulated around tight curves and sharp angles. This type of knife is used primarily for straight cuts and large radius curves.

Basic Components of Portable Knives—Blades are mounted in a vertical position at a 90-degree angle to the cutting surface. Blades vary in shape, size, cutting action, and fineness of the cutting edge. A straight blade contacts the spread at a 90-degree angle; assuming the blade and spread are kept vertical, all plies are cut at the same time. A rotary blade does not cut all plies evenly at the same time. A round blade contacts the spread at an angle; thus, the top ply is cut before the bottom ply.

Knife blades can have a major affect on the quality of the cut. Factors that affect the performance of a blade are the blade edge, surface texture of the blade, coarseness or fineness of the blade edge, and blade composition. Blade edges may be straight with a flat surface, saw-toothed, serrated, or wavy with

Figure 13–7
Portable rotary knife.

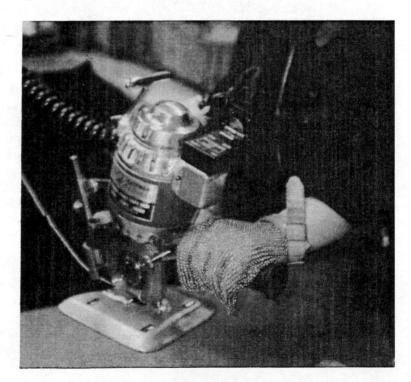

a striated surface. Straight-edge blades with a flat surface are general-purpose and the most widely used, while the other types are more specific to certain types of fabrics. Striated blades are used to reduce heat buildup during cutting, wavy edges are used for plastics and vinyls, and saw-type blades are used for cutting canvas.

The base plate is the foundation that supports and helps balance the cutting mechanism. Bases vary in shape and size, depending on the size and weight of the knife it supports and the maneuverability needed. The base plate guides the knife in relation to the table surface and elevates the spread off the cutting table for contact with the blade. Base plates are supported by bearing rollers to facilitate maneuverability and ease of movement. Edges of the plate are sloped and the front curved to easily slide under the bottom ply and provide less fabric distortion and drag as it is maneuvered during cutting. The base plate helps maintain the position of the blade at a 90-degree pitch.

The **power system** controls the motor and the potential cutting speed. The amount of power needed to cut a spread depends on the height of the spread and the density of the fabric to be cut. The horsepower of the motor determines the amount of thrust or cutting power of the blade. Motor size may be selected for the type of fabric and spread height that is typical for the plant. Higher speeds allow operators to move knives faster. Greater horsepower increases machine power, but it also may increase weight of the motor, which must be balanced by the blade housing and base plate. Larger, more powerful knives, which may weigh approximately 35 pounds, are often more cumbersome, heavier, and harder to manipulate and maneuver. Motors with variable speeds provide more versatility.

Sharpening devices appropriate for the specific blade type are found on almost all mechanized cutting equipment. Blades dull quickly when cutting a deep spread or dense fabric. As a blade becomes dull, it creates friction and may cause rough, frayed, or fused edges. Sharpening devices may be stone or emery wheels or abrasive belt sharpeners. Cutting blades are sharpened frequently during the cutting operation simply by touching the control.

All manually operated cutting devices have a **handle** for the operator to grip, guide, and propel the knife through the spread. The operator's other hand is used to stabilize the plies ahead of the knife to prevent bunching of fabric. A **blade guard**, when positioned at spread height, rests on the top ply to help stabilize the spread and to protect the operator's hand. Metal mesh gloves are available as a safety device for cutters using vertical knives.

STATIONARY CUTTERS **Stationary cutters** are those cutting machines that have blades or cutting devices that remain in a fixed position. The two basic types of stationary cutters are band knives and die cutters. Operators must move the fabric or lay up to the machine and engage the cutting action.

Band knives have fine blades that rotate through a slot in the cutting table while cutting. The operator positions, controls, and guides the fabric block around the knife. A band knife can be used to make only lateral cuts into a

spread as the operator must propel the fabric into the rotating blade. Band knife blades are finer and narrower than reciprocating blades, which makes it easier to manipulate tight curves and intricate patterns. Band knives are more accurate than vertical knives when used to cut small blocks or shave small amounts off precut blocks. Templates of plastic or heavy cardboard may be placed on top of a sectioned block to provide a guide for cutting specific shapes. Some manufacturers use band knives instead of die cutters because they are faster and less labor-intensive. Band knives are used to trim precut blocks of small or midsized pieces. They would not be used for cutting a whole spread or large pieces because of having to maneuver the block around the blade. There are also safety concerns with an open blade similar to using a band saw in a wood shop.

Die cutting is the most accurate means of cutting because each and every piece is cut to the exact same shape. *Dies* are preshaped metal outlines with one cutting edge. Die cutting involves use of a die to cut out a specific garment part or trim from a single piece or small block of fabric. The die-cutting operation involves placement of the fabric, positioning the die on the fabric, and engaging the machine to press the die into the fabric.

The basic parts of a die-cutting machine consist of a table block, ram head, motor, and ram drive system. When an operator engages the machine, the ram head moves into place above the die, applies tons of pressure to the die, releases, and returns to position. The cutting action is vertical as the ram presses the die into the surface of the fabric. Dies are frequently used to cut small pieces that require high accuracy, such as collars, pocket flaps, and appliqués. Leather goods are frequently die cut. Gloves with their fine detail are usually die cut as are shoes that require consistency of parts. Figure 13–8 is an example of a die cutter used to cut leather.

Figure 13–8
Die cutting is used to cut leather and other small parts. It is accurate and labor-intensive.

Dies can also be used to cut shapes from the center of a garment part. The accuracy and consistency of die cutting can be affected by irregular surfaces, improper placement of the die, and damaged or dull dies. Die cutting is laborintensive when dies are manually placed. Only a small area of fabric can be cut at one time, and the die must be repositioned each time unless the operation is computer-controlled. If cutting the same number of ply, die cutting can be faster for small parts with more periphery relative to area used.

Die cutting can be automated for continuous line cutting. Bierrebi systems are able to feed multiple lengths of tubular fabric onto the table block to be cut by a die and ejected for bundling. A single die for a T-shirt would contain a single-piece body utilizing a fold at center front and center back dovetailed with a sleeve shape. This type of system has the capability of cutting 1,200 complete T-shirts or 2,400 pairs of briefs per hour. It is both fast and accurate. A Bierrebi die-cutting system is shown in Figure 13–9.

Folded tubular fabric frequently retains a crease line and distortion along the folds. Cutting with closed patterns or dies requires that the full width of tubular knit fabric be used. Some firms spread the fabric as it is unfolded, while others draw the fabric over a frame to rotate the fabric a quarter turn. This creates new folds and moves the distorted fold to the center of the flat folded piece. The distorted lines end up where side seams would be located, not center front and center back. (See Figure 13–9 for a picture of fabric being rotated.)

Servo Cutters The bridge between computer-controlled and manual cutting is the **servo-cutting system.** This type of system has an overhead servo motor with adjustable speed and a suspension system that supports the knife perpendicular to the cutting table. This reduces problems with tilting the blade and inaccurate cutting. The knife is mounted on a swivel arm, which is extended above the cutting table. It also has a small base plate and narrow blade guide for easier maneuvering by the operator. It can make tighter turns with less distortion in the lay. It combines vertical cutting and band knife cutting into one machine. This type of system enables the operator to cut deeper spreads with greater accuracy than with a freestanding straight knife and for a lesser investment than computerized cutting, which is discussed later in this chapter.

SPECIALIZED CUTTING MACHINES Many types of specialized cutting machines are designed for specific operations and specific products. An example is a **strip cutter,** which may cut or cut and roll strips or bindings from knit tubular yardage, cut bias strips from wovens, or cut strips from vinyls or other fabrics. There are also strip cutters that measure and cut lengths of materials such as ribbons, tape, elastic, and strapping. The cutting device on a strip cutter may be as simple as a rotating blade that cuts as the product is forced against it.

Too many specialty cutting devices exist to mention in this text, but it is important to recognize the specificity in this type of equipment, the importance of

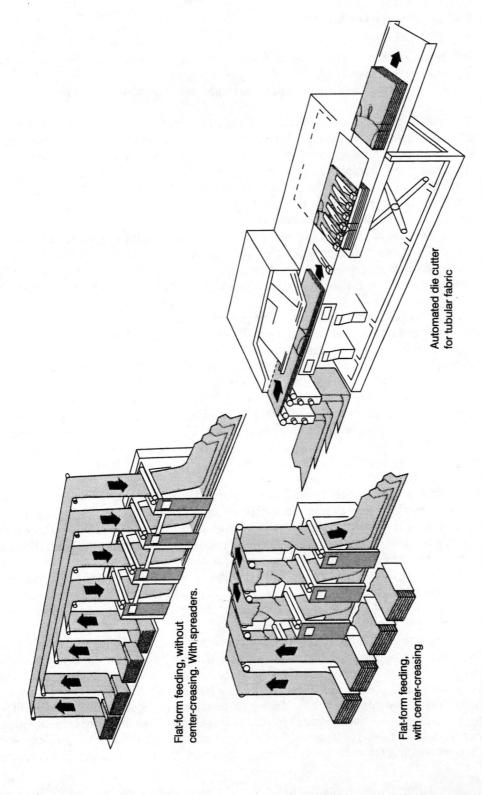

Figure 13–9
Bierrebi die-cutting system.
Source: Courtesy of MJL Corporation.

this equipment to specific product lines, and the type of technology available. These specialized cutting devices may be used by a manufacturing plant or by specialty contractors that provide a service for other manufacturers.

Transferring Marks Marks and notches are transferred from markers to the perimeter or internal surfaces of garment parts to facilitate the sewing operation. Operators depend on marks for alignment, placement of parts, and special treatment during the assembly process. When using operator-controlled cutting equipment, it is the cutter's responsibility to transfer the marks accurately to the cut garment parts. Computer-controlled cutters mark garment parts during the cutting process.

Marks should not damage or discolor the visible parts of a garment. This is especially true with internal marks, but edge marks if incorrectly done can also cause seam damage. Marks must be accurately placed and readily visible for sewing operators until the specific sewing operation requiring the mark is completed.

Edge marks are made in a variety of ways, but a vertical straight knife or hot notcher is commonly used. A small lateral cut into the lay with a straight knife is best suited to firm, smooth materials that do not ravel easily. This method of marking requires a perfectly vertical lay with no sloping; otherwise some pieces will be marked too deep, while others will not be marked at all.

A hot notcher is a hand-held device with a vertical electrical element that scorches fabric at the point of contact. Temperature and notch depth are adjustable for the fabric. A hot notcher is a good choice for edge marks on natural fiber and knit fabrics as it makes clearly visible marks that do not disappear. When used properly, it does not cut, pucker, or ravel the fabric. It is not a good choice for thermoplastic fibers.

Internal marks are needed for alignment and positioning pieces such as pockets, overlays, and appliqués. Drills are used to mark an entire lay-up at one time. A drill is positioned on top of a lay-up. A motor rotates the needle, which penetrates the top ply and drills its way through to the bottom ply. Penetration is made by needles of varied diameter (3/64 to 3/8 inch) and point types. Some points actually cut a hole in the fabric, which is easy for operators to locate but can cause problems in finished garments. Other types of drills carry a marking fluid or wax substance that will disappear in pressing. In some cases hot needles are used for marking.

The major problems confronting the manual-marking operation are accuracy and retention of marks until needed. If the needle enters the lay at a slight angle, there can be considerable difference in the position of the mark on the top ply and the position of the mark on the bottom ply. The needle must maintain a 90-degree angle to the lay for accurate marking. Sloping or shifting of the lay can also cause discrepancy of marks. Mark retention is a problem on thick, textured, loosely woven fabrics. As garment parts are handled in bundling and the first sewing operations, yarns may shift and the hole or marked area may

close up so sewing operators are unable to find the marks. Drills may be used cold or hot, depending on how easily holes may close in the fabric and the heat sensitivity of the fabric.

Firms that choose not to use drills for fear of damaging fabric may use mechanical thread-marking machines. These are slower but not as hard on the fabric or as messy. Another alternative is marking individual pieces or garments with a template and wax pen. This is the most time-consuming approach but it may be the most accurate.

Automated, Numerically Controlled Cutting Systems

The four types of **automated cutting** systems are blade cutting, laser cutting, water jet cutting, and plasma jet cutting. Electronic microchips control the cutting device, travel pattern, and speed. Computer-generated markers are stored and used to guide the operation of the cutting head. Printed markers are not required for cutting but may be used to assist with bundling. The primary advantage of computerized cutting systems is the accuracy of the process.

AUTOMATIC BLADE CUTTING Automatic blade cutting is the most highly developed and widely used computerized cutting system. Systems are specific to the standard volume to be cut. There are high ply cutters for firms consistently cutting a large number of plies, medium ply cutters, and low ply cutters. Numerically controlled knives cut multiple plies with great accuracy and speed. Information can be downloaded directly to the cutting system when needed. Easy data entry and instant communication with the main control unit allow technicians to preprogram multistep commands, set parameters, and start the process with a single keystroke.

The central control unit operates the components of the system such as the cutting head, cutter carriage, knife sharpening, and conveyorized cutting table. A cutting head is a sophisticated mechanical component with the capacity to cut, mark, and drill as dictated by the computer. Automatic knife sharpening is done at preset intervals during the cutting operation. The cutter carriage moves the cutting head and provides lengthwise and crosswise motion during the cutting operation (see Figure 13–10).

The reciprocating blade can be adjusted to the height of the spread and density of the fabric. Knife speed automatically adjusts to the forward speed of the cutting head. As the cutting head slows for corners, curves, or notches, the reciprocating blade also slows to reduce heat and possible fusing.

Most reciprocating knife systems use a bristle cutting surface (except for the low-ply system) and a vacuum to hold down the fabric. Bristle squares consist of 1.5-inch bristles that allow the computer-directed knife blade to cut down through the fabric into the bristle squares without being deflected, resulting in a perfect cut. Perforations in the base of these blocks allow the vacuum to be applied to the lay from under the table. Placement of plastic film over a spread helps

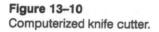

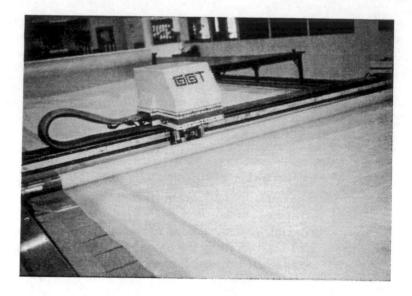

compress the fabric into a firm stationary lay-up when the vacuum is applied. The effect of the vacuum is to reduce the height of the spread and eliminate fabric movement during cutting. An intensified vacuum force is automatically applied to the area directly under the knife to further restrict material shifting.

LASER CUTTING Laser cutting focuses a powerful beam of light projected onto a minute area to cut fabric by vaporization. The fine, V-shaped beam is only 0.004 of an inch. The beam cuts without pressure on the fabric, which is a major advantage for some types of fabric. The fabric remains immobile during the cutting operation.

Lasers cut with incredible speed (twice that of automatic knife cutting), accuracy, and multidirectional ability, but with some heat emission. Laser-cut edges are sharp and clean. The heat produced tends to seal fabric edges, which can be an advantage for fabric that ravels and a disadvantage for cutting multiple plies as edges may fuse together. Laser-cut garment parts are easier to assemble as they are consistent in size with smooth sharp edges to align.

Laser cutters operate without any mechanical parts except for the conveyor and plotting system, which operates at a cutting speed of 3 feet per second. The operator calls up the appropriate cutting order, which is communicated to the laser cutter. Fabric is advanced through the roller assembly unit and onto the cutting surface, which thus eliminates the traditional fabric-spreading process. Laser cutting enables complete utilization of fabric width, regardless of discrepancies in width measurement. The handling operation following laser cutting is labor-intensive as all parts must be handled individually.

Lectra Systems Inc., one of the leaders in developing laser technology, has added robotic spreading and flaw detection to the cutting operation. A camera extended on an arm above the spread monitors the fabric for flaws and reads

the width. When a flaw is found, the operator can reposition the pattern pieces to avoid the flaw, which ensures a defect-free garment or a perfectly matched

plaid or pattern.

Lasers have been recognized for versatility in cutting small runs. Single-ply laser cutters also make it possible to cut by color or shade rather than by style. Multiple styles can be cut from one color and routed through the sewing room as one color. Lasers can be used to cut through a single ply of a bonded fabric such as would be used for shadow lettering. (See Figure 13–11). Laser cutting does not suit the needs of all manufacturers, but it may be used for samples and low-volume cuts along with more conventional blade cutters for other needs. Laser cutters offer applications for firms wanting to produce on a make-to-measure or just-in-time basis. The continuous, rapid cutting of lasers helps to smooth out the flow of production and reduce in-process inventory. Widespread use of laser systems is still limited due to the high cost of investment.

OTHER CUTTERS **Water jet cutting** is another computer-operated, multidirectional method that has limited usage at this time. Water jet cutting is performed by propelling a tiny jet of water (0.0010–0.0015 inch) through fabric at very high pressure (70,000 pounds per square inch). The forward edge of the jet stream shears the fabric as it moves along the cutting line but does not wet the fabric, generate airborne contaminant, or exert an appreciable force on the material (Technical Advisory Committee, 1992). The water jet will cut multiple plies without fusing, but it may fray and tangle the yarns of some fabrics, which makes it difficult to separate the plies. It is used when heat build up must be avoided and water absorption is not important. At the present time its use is limited to cutting leather and vinyl fabrics.

Figure 13–11
Laser cutter being used to cut script letters from synthetic twill fabric.

A plasma jet is a computer-operated, high-speed, single-ply cutting device that offers many of the same features of a laser cutter but at a lower price. Along with the plasma jet cutting system, Investronica has developed a Matching System for automatic matching and cutting of striped, checked, or printed fabric. A TV camera reads the fabric on the conveyor, and a digital image processor decides the best way to match and lay out the pattern pieces based on predetermined matching rules. Matches can be made among different pieces, prints, selvages, and fabric characteristics. This system eliminates recutting parts for more precise matching.

Investment in Cutting Equipment

New or additional cutting equipment may be purchased to increase productivity and improve quality while reducing direct labor. Many interrelating factors should be considered. The firm's goals, specific product lines, and commitment to quality and service may be the basis of decision making. A comparison of cutting systems should be based on the speed of the system as a unit, required employees, product quality, efficiency, required floor space, material utilization, versatility, and rate of return on investment.

Factors that may affect the productivity of cutting are (1) cutting speed, (2) spread height, (3) cutting method, (4) equipment type used in cutting, and (5) fabric characteristics. Each of these factors may have an effect on the number of garments cut and rate of cutting but cannot be isolated as a reason for change. The fastest-cutting equipment is designed for single-ply spreads. For volume cutting, high-ply spreads are needed. "Automatic single-ply, laser cutting has speeds almost double that of the automatic multiple-ply knife cutting. However, . . . multiple-ply knife cutting is over 12 times faster than single-ply cutting when the cutting of a large number of plies is taken into consideration" (Heyn and Jung, 1987, p. 82). Comparisons must be made among costs of systems, cutting speeds, cutting versatility, maximum spreading height, accuracy, and quality of cut edges.

Off Loading

After cutting, garment parts must be prepared for the sewing operation. **Off loading** is the process of removing cut parts from the cutting table, counting, ticketing, and grouping them. The method and sequence this follows depend on the production system, how the materials are to be transported to the sewing facility, and any additional operations that may be completed in the cutting room. This also provides an opportunity for monitoring the quality of preproduction operations.

Cut parts are considered work-in-process inventory and are counted and tracked throughout the rest of the production processes. This is usually done through bundle tickets that originate with cutting orders. The purpose of bun-

dle tickets is to (1) monitor the progress of each specific garment, (2) ensure that all the correct parts are assembled together, and (3) compensate operators

for their work on each garment.

Cut part identification involves identifying and marking parts for further operations. Throughout the sewing process it is essential that each garment be assembled from parts that have been cut from the same ply of fabric, which is ensured by **shade marking** each piece in the lay. Every piece is ticketed with a style number, size, and ply number. Each piece or garment part is ticketed, and the plies are numbered sequentially. Operators can check ply numbers as parts are assembled to be certain that the correct parts are being used in each garment. Shade marking is done prior to bundling.

Fusing applications of interlining are frequently done as part of preproduction operations. This involves separating and laying out cut garment parts, positioning cut interlining parts on the appropriate parts, fusing the required parts, and recombining parts for bundling. Fusing of cut parts involves individual handling of both garment parts and interlining and is frequently done in the cutting room because of the space it requires and because it usually

needs to be completed prior to the first sewing operation.

Garment parts are grouped and bundled for the specific production system to be used. Bundle tickets are attached and the parts are ready to be moved to the sewing operation.

Summary

Each of the preproduction operations—cut order planning, marker making, spreading, and cutting—may noticeably affect succeeding operations and the quality, cost, and performance of garments. Preproduction operations done manually are time-consuming, subject to inaccuracies, and costly. New technologies have increased accuracy and decreased the time required for each operation. Primary concerns for marker making involve accuracy, fabric utilization, grain orientation, and proper selection of method and mode for the specific type of fabric to be cut. In recent years computerized marker making has become more accessible to the apparel industry because of cost reductions for equipment and the extensive time commitment when done manually.

Spreading is the process of laying up plies of fabric to meet marker specifications. Spreading quality is concerned with accurate placement of markers, ply alignment, selection of mode, freedom from flaws, type of spread, and freedom from tension. Spreading problems and inaccuracies often carry over into cutting. Specialized, automated equipment is also available but not used as widely as CAD systems and computerized cutting.

Accuracy is probably the most important factor affecting the cutting operation. Quality of cutting has great impact on the quality of the assembly processes that follow. Manufacturers want to accomplish high-quality output from the cutting process while operating at high speed, lessening fabric waste, and minimizing requirements for operator skill. Cutting equipment may be operator-controlled or automated. Operator-controlled cutting knives are the most widely used type of cutting equipment. Automated cutting equipment, as with almost any technological advancements, represents major capital investments and requires sound economic planning.

References and Reading List

Cole, W. R., and Sanborn, C. (1995, September 11). Fabric utilization in the cutting room. Atlanta, GA: Bobbin Show Seminar.

Heyn, U., and Jung, R. (1987, March). Choosing a mechanized cutting system. *Bobbin*, 28(7), 82–83.

Jung, R., and Heyn, U. (1987, February). Get the lead out of the spread. *Bobbin*, 28(6), 104–106.

Stevenson, R. (1987, February). Faster spreading? It's a set up. *Bobbin*, 28(6), 110–112.

Technical Advisory Committee of American Apparel Manufacturers Association. (1981). The new cutting room. Arlington, VA: Author.

Technical Advisory Committee of American
Apparel Manufacturers Association.
(1992). Report of the Technical Advisory
Committee of American Apparel
Manufacturers Association: The impact of
technology on apparel. Pt. II. Arlington,
VA: Author.

Key Words

asymmetric fabrics
automated cutting
automatic blade cutting
band knives
base plate
blade guard
blocked markers
chart spreading
closed markers
computerized marker making
continuous marker
cut order planning
cutting orders

cutting pitch
defect maps
die cutting
directional fabrics
edge marke
end catcher
end loss
end treatment devices
fabric control devices
fabric defects
fabric utilization
face-to-face (F/F)
facing-one-way (F/O/W)

flatness of spread
folding blade
grain orientation
handle
hot notcher
internal marks
knife blades
knife box
laser cutting
lay
lay planning
lay-up
manually produced markers

marker
marker efficiency
marker making
marker mode
marker planning
material utilization
nap-either-way (N/E/W)
nap-one-way (N/O/W)
nap-up-and-down (N/U/D)
nondirectional fabrics
off loading
open marker
planimeter
plasma jet
plotting

ply alignment
portable knives
positioning devices
power system
remnant marker
rotary or round knives
sectioned markers
servo-cutting system
shade marking
sharpening devices
slack tension
slasher
splice marks
splicing loss
spread

spreading
spreading equipment
spreading mode
static electricity
stationary cutters
stepped spread
strip cutter
symmetric fabric
tension
tensioning
waste
water jet cutting
width indicators
width loss
widths

Discussion Questions and Activities

- Using miniature patterns, experiment with different marker modes for different fabric widths. How do the different marker modes affect fabric utilization?
- 2. Experiment with spreading modes using strips of fabric representing napped fabrics

and fabrics with asymmetrical designs. Lay out the miniature patterns in appropriate marker modes for the spreading modes. What is the relationship between marker modes and spreading modes?

Stitches, Seams, Thread, and Needles

OBJECTIVES

- Define and discuss stitch classifications, characteristics, and formation.
- Identify and discuss seam classifications, types, and appropriate uses.
- Relate the properties of stitches and seams to production costs, product performance, and quality characteristics.
- Examine functions, characteristics, and selection of sewing threads and needles.
- Examine the relationship between needles, thread, and fabric.
- O Discuss seam appearance and performance.

Garments are shaped and formed in three ways: materials molded to a form, fabric pieces cut to shape and assembled by bonding, and pieces cut to shape and sewn. The first two methods are used to a limited degree on specialized products and materials. Sewing garment pieces together with thread formed into stitches and seams is the most used method at this time. In the future more garments may be assembled with seam alternatives, such as bonding, fusing, welding, or molding, but for the present time, thread and stitches are the primary means of garment assembly.

For the purpose of standardization of stitch and seam formations, the U.S. government developed a guide that defines stitches and seams in current use. The United States Federal Stitch and Seam Specifications (Federal Standard 751a) were adopted in 1965, revised in 1983, and most recently replaced by ASTM D 6193, Standards Related to Stitches and Seams. ASTM anticipates that these standards will be used internationally by the apparel industry. Currently these standards are used by sewing machine manufacturers, apparel manufacturers, and the U.S. government to classify stitches, seams, and stitchings.

The use of stitch and seam standards facilitates communication of methods and simplifies specification writing. Each number represents a specific thread configuration and each seam class and type represents a specific configuration of fabric at the seam line or cut edge. Using the ASTM Standards eliminates having to write out the desired seam treatment and the risk of misinterpretation. Some manufacturers may not use ASTM D 6193 if individuals working with products are not knowledgeable about their use. Even though a firm or contractor may not use them currently, ASTM Standards are readily available and easier to interpret than written descriptions. The **Standards Related to Stitches and Seams** includes line drawings of all stitches and seams that are easy to recognize and without language barriers.

ASTM D 6193 makes the following distinctions by defining these terms:

- 1. A **stitch** is the configuration of the interlacing of sewing thread in a specific repeated unit.
- 2. A seam is a line where two or more fabrics are joined.
- 3. A **stitching** consists of a series of stitches embodied in a material for ornamental purposes or finishing an edge or both.

Stitches

Stitch classification is based on structure of the stitch and method of interlacing. Stitch properties such as size, balance, and consistency determine stitch quality, performance, and appropriateness for end use. Stitch quality needs to be good enough to satisfy the consumer's desire for performance and aesthetics.

Stitch Properties

Properties of stitches that relate to aesthetics and performance are size, tension, and consistency. **Stitch size** has three dimensions: length, width, and depth. Each may affect the aesthetic appearance, durability, and cost of a garment. **Stitch length** is specified as the number of **stitches per inch (spi)** and can be an indicator of quality. This may also be referred to as stitch density. Stitch length is determined by the amount of fabric that is advanced under the needle between

penetrations. High spi means short stitches; low spi means long stitches. Long stitches are usually less durable and may be considered lower quality because they are more subject to abrasion, snagging, and grin-through which allows the stitching of the seam to show when stress is placed on the seam. Men's dress shirts with 22 spi are considered higher quality than a similar shirt made with 8 spi. Shorter stitches produce more subtle, less obvious lines of stitches that are often more visually appealing. Generally, the greater the spi, the greater the holding power and seam strength. A high stitch count also has potential to increase seam pucker or weaken the fabric. Attributes must be weighed in determining the stitch length best suited to the materials and product.

Stitch length is also related to the speed of sewing. Each stitch requires one revolution of a sewing machine's stitch-forming mechanism and each machine type has a different capacity for speed or revolutions per minute. A seam sewn with 8 spi could be sewn nearly three times as fast as one requiring 22 spi if maximum speed was maintained. The more spi required, the more time and thread required to sew a seam; thus, costs of production are increased.

Stitch width and depth need to be specified for certain classes of stitches. Overedge, zigzag, and cover stitches are examples of stitches that have width dimensions. Stitch width refers to the horizontal span (bight) covered in the formation of one stitch or single line of stitching. Stitches that have width dimensions require multiple needles or lateral movement of thread carriers such as needle bars, loopers, or spreaders (see Figure 14–1). Stitch width is the distance between the outermost lines of stitches as determined by the space between the needles on the needle bar. This is also referred to as gauge. The gauge for a two-needle cover stitch may be 1/4, 3/16, and so on. Machines can be ordered with different gauges, but it is not an adjustment that can be made.

Stitch depth is the distance between the upper and lower surface of the stitch and is a factor for blind stitches. A curved needle with lateral movement forms blind stitches. The depth of a blind stitch determines the amount of penetration by the curved needle as it rocks left and right. Stitch depth should be sufficient to catch all fabric plies, yet not deep enough to show through on the face of the fabric. The depth of the stitch is controlled by a ridge former that pushes the fabric up under the needle.

Thread tension affects stitch formation in two ways. Thread tension involves (1) the balance of force on the threads that form the stitch and (2) the

Figure 14–1 Stitch-forming devices.

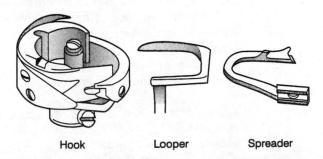

degree of compression on the fabric created by the threads as a stitch is formed. Tension ensures a uniform supply of thread and determines how well stitches conform to the standard formation. Tension is controlled by adjusting a screw that holds the pressure disks. If too much tension is placed on the thread, not enough thread is allowed to form the stitch, and the thread will restrict and compress the fabric that it surrounds. A tight thread will also draw a looser thread over the edge of a seam allowance, which causes an unbalanced stitch. Thus, too much tension causes seam pucker, uneven stitches, unbalanced stitch formation, weakened thread, and potentially damaged fabric. Too little tension may allow too much thread to be pulled off and cause excessive looping or loose and uneven stitches. Stitches formed with too little tension will not hold fabric together under stress. Each thread used in forming the stitch must have some tension in order for the stitch to form properly, but it is usually better to use the least amount of tension possible.

Stitch consistency is the uniformity with which each stitch is formed in a row of stitches. Each stitch should be exactly like the previous stitch regardless of curves, corners, or varying thickness of the fabric. There must be a compatibility of fabric, stitch and seam type, needle, thread, and machine settings. Proper machine maintenance is also a major factor in achieving consistency. If the fabric resists the needle or the machine timing is off, stitches will not form correctly making stitches appear uneven or irregular. When a stitch does not form or is "skipped," it appears as a long stitch in a line of smaller stitches.

Stitch Classes

Industrial sewing machines are classified according to their intended use and the means of forming stitches. Three different types of lower stitch forming parts are shown in Figure 14–1. For example, lock stitch machines require a **bobbin** and a bobbin case with a rotating hook as part of the stitch-forming mechanism, while chain stitch and overedge machines use loopers and spreaders to form the stitches.

Stitch classes, as described in ASTM D 6193, are based on the type of thread formation created by a sewing machine. See Figure 14–2. Machines in each class may have the capability of producing several different types of stitches depending on the machine's structure and how it is set and threaded. For example, a lock stitch machine (300 Class) built with a needle bar that moves laterally can produce the basic lock stitch (301) as well as stitches with a zigzag appearance, 304 and 308. There are many different stitch types, but only a few are versatile stitches. Many stitch types are appropriate for certain sewing operations and product lines.

CLASS 300—LOCK STITCH Stitch Class 300 includes stitch types 301, 302, 303, 304, 305, 306, 307, 308, 309, 310, 311, 312, 313, 314, 315, and 316. The **lock stitch** class (300) is the class most frequently used and easiest to understand.

Figure 14–2 Diagrams of federal stitch classifications. Source: Courtesy of Union Special Corporation.

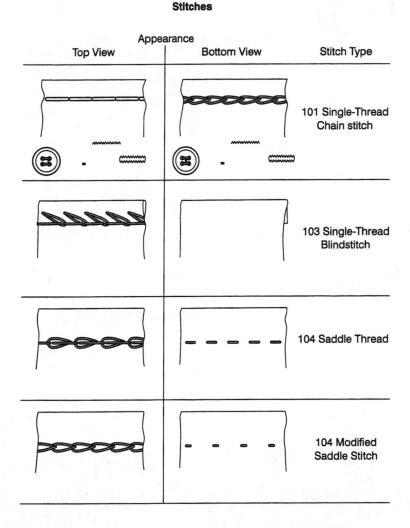

For these reasons, it will be discussed first. Lock-stitch machines require two threads to form a stitch, a **needle thread** that feeds from the top and a **lower thread** that feeds from a bobbin. A **rotary hook** or **shuttle** catches the needle thread loop as it passes around the bobbin and interlocks the two threads. If a lock stitched thread breaks, the two threads used to form the stitch lock and the whole line of stitches will not unravel. Lock stitch machines are versatile and can be used for a variety of operations. Thus, the lock stitch machine is a good choice for the small manufacturer that produces fashion goods. A complete garment could be sewn on a lock-stitch machine.

The 301 lock stitch is sometimes referred to as a plain stitch or straight stitch. It is probably the most familiar to the average consumer because of its wide use on apparel. It is also the stitch type performed by the standard home

Figure 14–2 Diagrams of federal stitch classifications.

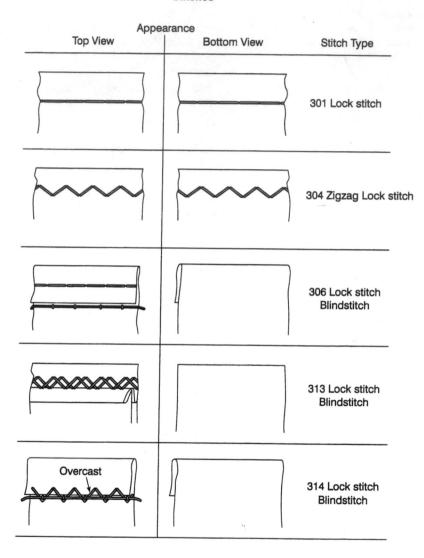

sewing machine. When this stitch forms correctly, equal amounts of bobbin and needle thread are used and upper and lower threads interlock in the center of the fabric. Compared to all other stitch types, the 301 uses the least amount of thread and produces the flattest stitch. This gives the best hand and allows stitches to blend into the fabric surface. Because this stitch formation is the same on both sides of a seam, it is reversible and used extensively for top stitching, especially along collar and cuff edges and fronts of jackets.

The 301 lock stitch is the tightest and most secure stitch, which makes it a good choice for setting zippers and pockets. It is the only stitch formation that can be backstitched if the ends of a seam need to be secured. It is a poor choice

Figure 14–2, continued Diagrams of federal stitch classifications.

Top View	Bottom View	Stitch Type
		401 Two-Thread Chain stitch
(Narrow Needle Spacing)		402 Cording Stitch for Permanent Creases
		406 Coverseaming Stitch
		404 Zigzag Chain stitch
		404 Mod. Multistep Zigzag Chain stitch
		407 Coverseaming Stitch for Attaching Elastic

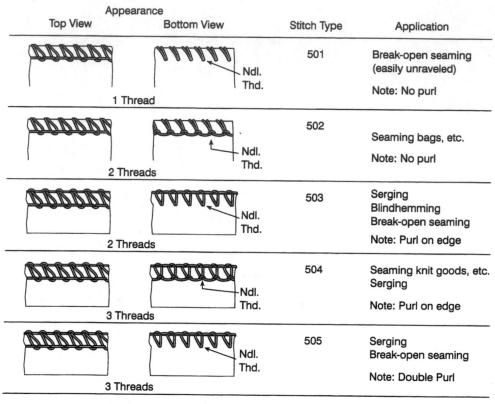

Figure 14–2, *continued*Diagrams of federal stitch classifications.

in areas that need to stretch as it has the least amount of elongation potential. The 301 is inappropriate to attach elastic or sew knit fabrics or bias seams that are expected to stretch.

Other types of lock stitches, in the 300 class, that have more limited use by the industry are the zigzags 304, 308, and 315. Type 304 is the traditional one-stitch zigzag that is used to sew appliqués, attach lace on lingerie, and produce faggotting. Faggotting is a decorative stitching used to connect two pieces of fabric but allowing space (width of stitch) between the pieces. Types 308 (two successive stitches) and 315 (three successive stitches) form a longer and wider zigzag by using several stitches before changing direction. Manufacturers of better lingerie may use these stitches to attach elastic. They provide elongation, are flat and smooth, and will not ravel out. Formation of the 308 and 315 are comparatively slow and thus used primarily for better apparel. Types 306, 313, and 314 are lock stitch blind stitches. These types are used primarily by men's

Appe Top View	arance Bottom View	Stitch Type	Application
COUCUR	AAAAA	515	Safety stitch seaming
4 Th	reads	(401 & 503)	Oalety Suton Seaming
<u>annan</u>		516	Safety stitch seaming
5 Th	reads	(401 & 504)	
		519	Safety stitch seaming
6 Th	reads	(401 & 602)	
TOPPOR	77777	512	Seaming stitch (simulated safety stitch)
4 Threads	reads Ndl.		Note: Purl on edge
	77777	514	Seaming stitch (produces strong seams on wovens or knits)
4 Thr	reads Ndl. Thds	S.	Note: same as 512 but with long upper looper
	AAAAA	521	Hosiery stitch
00000	reads Ndl.	s.	Note: break-open stitch

Figure 14–2, *continued* Diagrams of federal stitch classifications.

suit manufacturers for attaching linings and the inside components of waist-bands for men's dress slacks.

If versatility is needed, a lock stitch machine is a good choice, but if speed and efficiency are the priorities, it may not be the right selection. Lock stitch machines are slower than other classes of industrial machines. Operating speeds range from 3,000 to 5,000 rpm while other classes of machines can operate at 9,000 rpm or more. This can make a considerable difference in production time if the operator is able to sew at top speed. On short seams, an operator would not be able to reach maximum speed; therefore, maximum machine speed would probably not be a factor in production time.

Figure 14–2 Diagrams of federal stitch classifications.

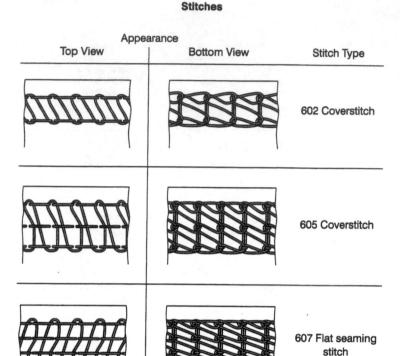

Lock stitch machines generally have more downtime because they operate with a limited thread supply from bobbins that have to be replaced as they run out. The tightness of the interlocking stitch may be a problem for operators when ripping is needed. Repair time is not usually compensated, and removing a line of lock stitches is very time-consuming and costly for an operator.

CLASS 100—CHAIN STITCH Stitch class 100 includes stitch types 101, 102, 103, 104, and 105. The **chain stitch** class (100) is formed with one or more needle threads that form a loop on the underside of the fabric. There is no lower thread. The **single-thread chain stitch** is an intralooping formation that can be recognized by a flat straight thread formation similar in appearance to the look stitch on the face of the fabric and a loop on the underside. The needle carries the thread through the fabric, and a **looper** holds the thread and forms a loop for the needle thread to enter as it descends for the next stitch. The loop formation allows good elongation and stretch and makes unraveling easy if the correct thread end is pulled.

The more widely used stitch types in this class are the single-thread chain stitch (101), single-thread blind stitch (103), and saddle stitch (104). Each stitch type in this class requires a special machine to form the stitches. All of them op-

erate from a continuous thread supply at very high speeds and are efficient for use in mass production. Single-thread chain stitches are often used for temporary operations, such as basting pockets closed. Stitches are also easy to remove if a correction is needed. A small thread tail is often left to prevent unraveling.

The 101 chain stitch is frequently used for closing bags of sugar and pet food. Stitches are easily unraveled by pulling the correct end of thread. Other uses of the 101 stitch include shirring, attaching paper tags, buttons, and sewing some types of buttonholes. Pulling a loose thread may unravel these stitches, and the button will fall off. This stitch is also used for spot tacks that hold pant cuffs in place and bar tacks for reinforcement of stress areas. The stitches are secure unless the thread end that was last stitched is pulled or stitches are broken.

The 103 chain stitch is one of several types of blind stitches used for machine hemming. Blind stitches form on the fabric surface but do not penetrate to the face of the fabric when stitch depth is properly adjusted. The 103 stitch type is formed by a blind-stitch machine that uses a curved needle, single-needle thread, and **spreader** to form the loops on the surface of the fabric. A curved needle barely skims the surface of the underlay of fabric so that little or no thread is visible on the right side of the garment and yet the hem is held securely. Machine saddle stitching (104) is used primarily for ornamental stitching often found on western wear or to stitch down a series of release pleats that may be used on pleated skirts.

Apparel manufacturers use many chain-stitch machines because of their high rate of production; however, many of them are double-thread chain-stitch machines that are discussed under stitch class 400.

CLASS 200—HAND STITCH Stitch class 200 includes stitch types 201, 202, 203, 204, and 205. Stitch class 200 consists of stitch formations done by hand with a single strand of thread with the exception of 205. Stitch class 205 was added with the last revision of Federal Standard 751a because it simulates a hand running stitch but is formed by a special machine. **Hand stitches** usually are characterized by a single line of thread passing in and out of the material. Typical types are basting stitches and back pick stitches. Class 200 stitches are used most on lined jackets and tailored garments. Stitch type 205 is used occasionally on the front edges of men's jackets and coats for aesthetic purposes.

CLASS 400—MULTITHREAD CHAIN STITCH Stitch class 400 includes stitch types 401, 402, 403, 404, 405, 406, and 407. Stitches in the 400 class are widely used. This **multithread chain stitch** requires one or more needle threads that form loops as they pass through the fabric and interloop with the looper thread on the underside. The 400 stitch class has many characteristics that are similar to the 100 class but it is considerably more durable and used extensively on apparel. The major difference is that the 400 class stitches require an upper needle thread and a looper to carry the lower thread and form a thread loop on the underside of the fabric. The most common stitch types in this class are the two-thread straight line chain stitch (401), cording stitch (402), and bottom cover stitches (406 and 407). Each of these types has unique identifying characteristics

and specific uses. Machines producing a 400 class stitch do not back tack although stitches can be condensed to secure the ends of the threads.

The 401 or **two-thread chain stitch** (sometimes called the *double-locked chain stitch*) is the most widely used stitch in this class. Its appearance is the same as the 101 with a flat straight thread formation similar to the lock stitch on the face of the fabric and a loop on the underside. However, it is more durable and less likely to break since it is formed with two threads. The 401 can be unraveled, but only if the looper thread is pulled in the direction the stitches were formed.

Machines forming 401 stitches are capable of operating at very high speeds with cones of thread. These chain stitch machines often use multiple needles to produce parallel rows of stitching. For example, two needles are used for sewing two parallel rows of stitches for lapped side seams of woven shirts and jeans. The loop formation of the chain stitch elongates when extended; thus, it is used for seams that require elasticity, such as setting sleeves and attaching elastic. The 401 stitch is also well suited to automated sewing equipment such as automatic seamers. Multiple needle machines may produce numerous rows of parallel stitching for setting elastic in waistbands or decorative stitching on belts or other garment components.

Stitch type 402 or **cording stitch** is used primarily for stitching permanent creases. It uses two needle threads that produce two parallel rows of stitching on the face of the fabric. A looper thread travels between the two needle threads on the back of the fabric creating a ridge or crease between the needle threads on the face. This type of stitching can often be found on sportswear where a crease needs to be maintained or on the backs of gloves, where it is more decorative than functional.

Stitch type 404 is more elastic than 401. It was designed for use by men's slacks makers to attach curtain to the inside of the waistband. Modifications of this stitch type are also used for ornamental stitching such as some types of faggotting and picot edges. It is very similar in appearance and use to the 304 except that it is formed as a chain stitch.

Stitch types 406 and 407 are known as bottom cover stitches. They are used to cover seams or unfinished edges on the inside of garments and to keep them flat. They appear as two or three rows of parallel "lock stitching" on the face of a fabric while a looper thread connects the rows on the back. A lower looper throws in more thread, which gives the seam more thread cover on the underside to conceal raw edges and produce a flat seam. Stitch type 406 is used to form hems on knit garments, produce flat comfortable seams on necklines of T-shirts, and attach bindings on men's briefs. It is also used for making belt loops on jeans. The 406 stitch uses two needle threads and one looper thread much like the 402 except that it does not ridge up. Stitch type 407 is very similar except that it uses three needle threads and has even more stretch. The primary use of the 407 is attaching elastic to undergarments that require maximum stretch.

CLASS 500—OVEREDGE STITCH Stitch Class 500 includes stitch types 501, 502, 503, 504, 505, 506, 507, 508, 509, 510, 511, 512, 513, 514, 515, 516, 517, 519, 520,

521, and 522. The **overedge stitches** or class 500 are often called overedge, overlock, serge, overcast, or merrow. All 500 class machines trim the edge of the fabric just in front of the needle. Stitches form over the edge of the cut fabric thus finishing the fabric edge or seam. Because the machines trim fabric and form stitches over the cut edge, it would not be appropriate to use in attaching a patch pocket or for top stitching as it would trim along the seam line thus destroying the garment. Overedge stitches are high thread users and stretchy; they can be used on almost all types and weights of fabric. Seams stitched with overedge stitches must be pressed to one side rather than being pressed open (busted) and flat. This appearance may not be acceptable to all garments and quality levels.

Overedge machines must have a pair of knives for trimming fabric and three stitch-forming devices: a needle to carry the thread through the fabric, a looper or spreader to carry the thread from the needle to the edge of the material on the bottom, and a looper or spreader to carry thread up and over the edge of the material on the top. The various stitch types use different combinations of these three devices.

The odd-numbered overedge stitch types, 501, 503, 505, and 521 are known as "break open" stitches because they act similar to the spiral back of a note-book. The fabric is held tight together but not secure along the inner edge of the stitching, which allows the seam to "break open." These stitches are best used for edge finishes and hems rather than for seams. They are characterized by a loose needle thread on the bottom that is pulled to the edge of the fabric where it interloops the looper thread. This creates a purl stitch or interlooping of thread that wraps and protects the edge of the fabric.

Even-numbered stitch types in this class—502, 504, 512, and 514—have a much tighter needle thread that holds the two layers of fabric together at the actual seam line. If stress is placed on these seams, the stitches do not "grin through" or become exposed between the layers of fabric. Seams stitched with the even-numbered stitches have a much smoother appearance and are more durable.

Types 503, 504, or 505 are overedge stitches used for serging. *Serging* is the process of stitching along the cut edge of a single ply of fabric to prevent raveling. This is often one of the first processes in sewing a garment or component. Serging gives a more finished appearance on the inside of a garment.

Stitch types 502 and 503 are formed by two threads, a needle and looper thread. The 502 type is a tight stitch that is used primarily for seaming the outer edges of bags, while type 503 is used for blind hemming and serging. Type 503 is used mainly for hems on T-shirts and other knit garments and serging the seams of dress slacks because the two-thread construction is less likely to press through the garment.

Stitch types 504 and 505 are three-thread overedge stitches that are formed with one needle thread and two looper threads. They require more thread in the formation, but they also have more stretch. Type 504 is a highly extensible but secure stitch that makes an excellent seam for knit garments, such as seams of cut and sewn sweaters, T-shirts, and knit caps. It is the most common of the 500 stitch class. The 505 stitch type is more satisfactory for serging than

seaming since it produces a break-open type of seam. It is sometimes referred to as the *box edge stitch* or *square edge stitch*, which provides excellent coverage of raw edges.

Stitch types 512 and 514 are sometimes called *mock safety stitches*. They are four-thread overedge stitches that are formed with two needle threads and two looper threads. Type 514 is stronger and more elastic than 512, but both may be used for seaming knits and wovens. However, 514 makes a wider seam than may be desirable for some knit garments.

Safety stitches—515, 516, and 519—are a combination of an overedge stitch and a 401 chain stitch. They are called safety stitches because the chain stitch that closes the seam is backed up by another row of "tight" overedge stitches. Both rows of stitches are formed at the same time. Machines operate at about the same speed as the 400 class. Type 516 is the preferred stitch for seaming because the overedge part is not a break-open type. Safety stitched seams are widely used by manufacturers of shirts, jackets, blouses, and jeans. A 516 is also used on moderate and budget woven sportswear and polyester blouses at all price levels. Seam width is established so alteration opportunities are limited.

Type 521 is a three-thread stitch with excellent elasticity and strength that is used primarily for seaming hosiery. It is formed with two needles, a looper, and a spreader. Socks may be knitted as a tube and sewn together with a 521 stitch at the toe.

CLASS 600—COVER STITCH Stitch Class 600 includes stitch types 601, 602, 603, 604, 605, 606, and 607. Cover stitches or 600 Class are often called flat-lock or flat-seam stitches. They are a more complex version of the 400 class and are used primarily on knits and lingerie. Machines producing the 600 class are extremely fast and efficient, operating at 9,000 rpms. The stitch is formed by two or more needle loops passing through the material, interlooping on the underside, and interlocking on the upper side. A spreader or cover thread finger carries the cover thread across the surface of the fabric between the needles. These stitches, referred to as top and bottom cover stitches, are commonly used to cover both sides of the seam with thread. Threads must be chained off and be crossed by another seam. This stitch class uses a lot of thread but provides excellent top and bottom cover and flat seams.

Cover stitches 602 and 605 are strong, elastic stitches used extensively by manufacturers of knit garments to cover raw edges and prevent raveling. They may be used for attaching flat knit or ribbed knit collars. When the upper spreader thread is not used, these stitches become 406 and 407 types, respectively.

The flat seaming stitch, 607 is used to produce the flat, butted seams on infants' panties, men's briefs, and other knitted garments. For every inch of needle thread, this machine requires 1.5–3 inches of looper thread depending on the type of stitch. Advantages are high speed and seams that are stretchy, flat, and smooth.

Seams

In most mass-produced apparel, seams are formed when two or more pieces of fabric are joined by stitches. Manufacturers may have limited knowledge of stitch and seam types because of product specialization. They are familiar with seams and stitches used on the products they make. Certain seam types are more appropriate for some products and fabrics than others.

Seams must have flexibility and strength. Garment design, end use, fabric type and weight, operator skills, and equipment are analyzed to determine which seam types and characteristics are the most appropriate for a particular style. Seam length and degree of curvature of a seam are also important in choosing seam type. The best seam type is one that yields the desired performance at the lowest cost.

Seam dimensions

Seams have three dimensions: length, width, and depth. Seam dimensions affect garment quality, performance, and costs. **Seam length** is the total distance covered by a continuous series of stitches, such as a side seam or shoulder seam. It is determined by garment design and dimensions of the component. Exact measurements of seam length are used in costing, calculating thread usage, writing specifications, and monitoring quality standards. Seam length can be a factor in determining stitch type, seam type, and handling procedures. Long seams are often sewn on chain stitch and overedge machines that have high rpms, but quality and performance standards for each product will ultimately determine the stitch type to be used. Garments with long seams require frequent repositioning of the fabric plies by the operator to keep the seam allowances even. Handling and repositioning may be easier with some types of seams.

Seam width considerations are width of a seam allowance, stitch width relative to the seam, and the seam heading of a lapped or top stitched seam. A seam allowance is measured from the cut edge of fabric to the main line of stitches. This is the amount of fabric that extends beyond the actual seam line. Width of a seam allowance is often a factor in judging garment quality, reducing yarn slippage, and providing fabric for alterations. A wider line of stitches has more holding power and strength than a narrow line of stitches. Wider seam allowances may increase costs because of the fabric they require. They may also need to be serged before seaming to prevent raveling.

A seam heading is the distance from the folded edge of the top ply to the first line of stitches. On a patch pocket, the seam heading would be the distance between the stitches and the folded edge of the pocket. A header reduces the strain on the cut edge of fabric and makes the seam stronger.

Seam depth is the thickness or compressibility (flatness) of a seam, both of which are major factors in appearance and comfort of a garment. Seam depth is affected by fabric weight, fabrication, and selection of seam type. For example, seams of overlapping layers such as those found on back yoke seams of many jeans may be thicker and bulkier but more durable than pressed open seams.

Seam Classes

ASTM Standard D6193, which is the basis of stitch classes, also identifies four seam classes and two stitching classes. Each class includes many seam types. There is a general understanding and reference to the seam and stitching classes throughout the apparel industry even though some garment manufacturers may not use the classification system in as much detail as the U.S. government that established them initially. Sometimes manufacturers adapt the standard to meet their specific needs. Table 14–1 presents the seam and stitching classifications along with the specification notation for each. Copies of Standard Practice for Stitches and Seams can be ordered from ASTM Customer Service, 100 Barr Harbor Drive, West Conshohocken, PA 19428–2959.

Figure 14—3 shows line drawings of seam types in each seam class. There is more similarity among the first five types across the classes than there is with the other types in each class. Line drawings represent cross-sections of a seam. Each long line represents the configuration of one piece of fabric. The short lines at right angles represent the placement and penetration of the needle and lines of stitches. Stitches may be placed through only one piece or several pieces. Notice some short lines penetrate only one fabric line; others penetrate both lines. Two short lines represent two rows of stitching to form the seam. Some stitch types encompass the cut edge of fabric, which is represented by a circle that encompasses the end of the line. Other curved lines indicate a connecting thread between two lines of stitching, for example, a 406 stitch. Some seam types involve more than one operation or step; for example, SSe is sewn as a superimposed seam, turned, and top stitched along the folded edges.

Seams are formed by sewing two or more pieces of fabric together, but the basis of seam classification is the position of the pieces relative to each other at the junction where they are sewn. Many variations in fabric position and treatment account for the many different types of seams in each classification. Compare the first diagram of each class in Figure 14–3. Examine the relationship of the two pieces of fabric depicted in each diagram.

The **superimposed seam** (**SS**) **class** is formed by joining two or more pieces of fabric, usually with seam allowance edges even and one piece superimposed over the second. This class is probably the most widely used although not the largest with 57 different seam types. These seams can be sewn with a lock stitch, chain stitch, overedge stitch, or safety stitch. Superimposed seams include the plain *booked seam* or *busted seam* (pressed open and flat) and the safety-stitched seams (516), which cannot be busted. Either of these could be used for side seams of dress slacks, skirts, and blouses depending on fabric choices and quality level.

Table 14–1Types of seams and stitchings with notation abbreviations according to Federal Standard 751a and some common uses.

Notation	Seam Type and Common Uses		
SS	Superimposed Seam		
SSa	Side seams of skirts, dress slacks, inseams of jeans		
SSb	Finishing belt ends; attaching elastic to waistline		
SSc	Ends of waistbands on jeans		
SSd	Seaming, but not widely used		
SSe	Collars or cuffs, seamed and top-stitched		
LS	Lapped Seam		
LSa	Vinyl and leathers		
LSb	Attaching curtain to waistband of men's dress slacks		
LSc	Side seams of dress shirts and jeans		
LSd	Attaching patch pockets and overlay yokes, sewing on labels		
LSe	Attaching yokes		
BS	Bound Seam		
BSa	Edges bound with ribbon or braid		
BSb	T-shirt necklines or sleeve edges with knot trim		
BSc	Neckline or front edges bound with bias-woven material		
BSd	Seaming and binding		
BSe	Seaming and binding		
FS	Flat Seam		
FSa	Raglan seams of sweatshirts		
FSb	Sweatshirts and underwear		
FSc	Seams of support garments		
FSd	Sweatshirts and underwear		
FSe	Sweatshirts and underwear		
Notation	Stitching Classes		
EF	Edge Finishing		
EFa	Single-fold hem		
EFb	Double-fold hem		
EFc	T-shirt hem		
EFd	Edge finish, serging		
EFe	Ornamental edge finish		
os	Ornamental Stitching		
OSa	Decorative stitching on jean pockets		
OSb	Decorative stitching with cording insert		
OSc	Raised stitching without cording insert for backs of gloves		
OSd	Raised stitching, cording between two plies of material		
OSe	Pin tucks on front of blouse		

Part 1. General Information

Section 2A. Schematic Index of Seams and Stitchings in Alphabetical Order by Class

Seam Class SS (Superimposed)

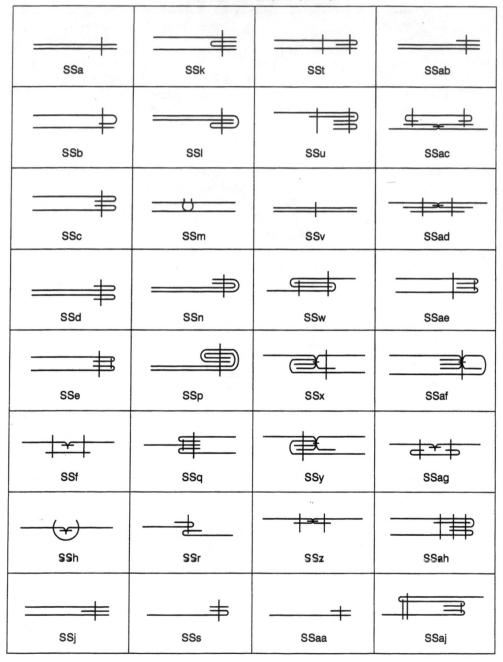

Figure 14–3Seams and stitchings according to U.S. Federal Standard 751a.

Seam Class SS (Superimposed) (cont.)

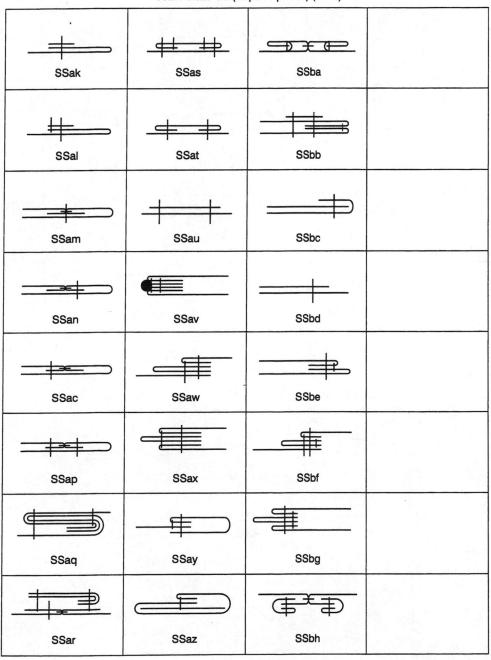

Figure 14–3, *continued* Seams and stitchings according to U.S. Federal Standard 751a.

Seam Class LS (Lapped)

Figure 14–3, *continued*Seams and stitchings according to U.S. Federal Standard 751a.

Seam Class LS (Lapped) (cont.)

Figure 14–3, *continued*Seams and stitchings according to U.S. Federal Standard 751a.

Seam Class LS (Lapped) (cont.)

Figure 14–3, *continued* Seams and stitchings according to U.S. Federal Standard 751a.

Seam Class LS (Lapped) (cont.)

Figure 14–3, *continued*Seams and stitchings according to U.S. Federal Standard 751a.

Seam Class BS (Bound)

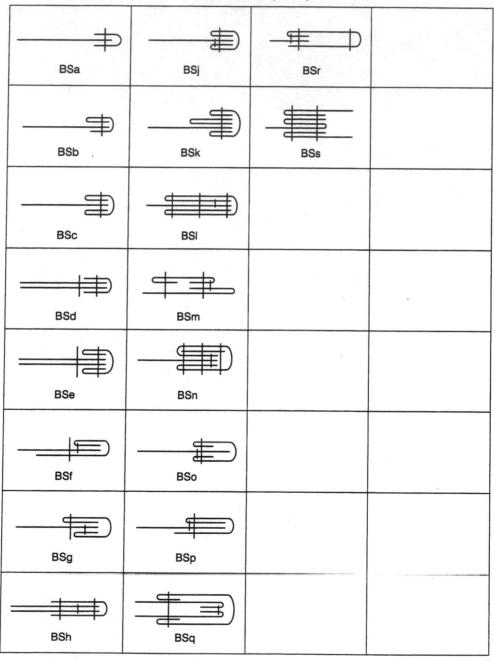

Figure 14–3, *continued* Seams and stitchings according to U.S. Federal Standard 751a.

Seam Class FS (Flat)

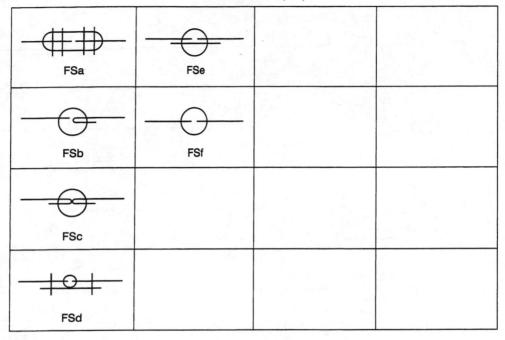

Stitching Class OS (Ornamental)

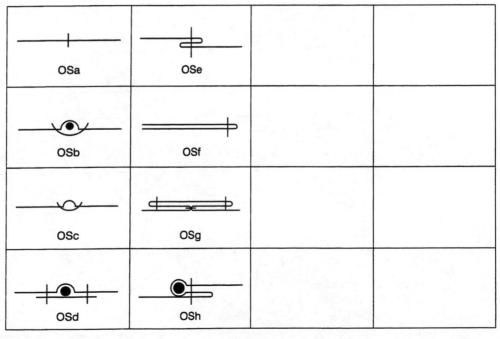

Figure 14–3, *continued*Seams and stitchings according to U.S. Federal Standard 751a.

Stitching Class EF (Edge Finishing) EFa EFj **EFs EFaa EFb EFk EFt EFab EFc EFI EFu EFac** Ф EFd **EFm EFv EFad** 0 **EFe** EFn **EFw EFae** <u>(a)</u> **EFf** EFp **EFx EFaf** EFg EFq **EFy EFag**

Figure 14–3, *continued* Seams and stitchings according to U.S. Federal Standard 751a.

EFr

EFz

EFah

EFh

The lapped seam (LS) class is formed by two or more pieces of fabric joined by overlapping at the needle. Fabric pieces would extend both left and right from the overlap area. This is the largest seam class, including 101 different seam types, with a great deal of variety as to where a seam is lapped and how it is lapped. Lapped seams have many functions. Some are used to reduce the amount of bulk, others are selected because of the durability they provide or the appearance they contribute. These seams are used for attaching front bands to shirts, setting pockets, side seams of quality dress shirts, side seams or inseams of jeans, and so on. Lapped seams may be sewn with a lock stitch or chain stitch but not an overedge stitch.

The **bound seam (BS)** class is formed by sewing one piece of fabric or binding as it encompasses the edge of one or more pieces of fabric. There are only 18 seam types in this class. These seams are used to finish edges of garments or components. Necklines, short sleeves on some styles of T-shirts, and sleeveless tank tops may be finished with a binding. Bound seams may be sewn with a lock stitch, chain stitch, or cover stitch. They would never be sewn with an overedge stitch as the knife would cut off the binding.

The **flat seam (FS) class** is the smallest class with only six different types. Formation of this seam occurs by sewing together two butted pieces of fabric, but not overlapping them. The stitches used are from the 600 class and are wide due to the number of needles used. Stitches extend across the seam, holding both pieces together and covering the seam on one or both sides. Flat seams are constructed to remain flat through care and wear. They are commonly used for seams of sweatshirts, lingerie, and long underwear.

Stitching Classes

The two stitching classes are edge finishing (EF) and ornamental stitching (OS). Stitching for either of these classes is performed on a single piece of fabric. The fabric may be folded in a variety of ways so the stitching may be through more than one thickness, but it remains a single piece of fabric. **Edge finishing** is stitching that encompasses a cut edge or provides a finish for a single ply of fabric with a folded edge configuration. Stitches from any of the classes may be used depending on the type of fold and placement of the stitching. **Ornamental stitching** may be used on a single ply for decorative purposes. It can be done anywhere on a garment except the edge. Ornamental stitching includes decorative stitching on jean pockets, embroidered logos, and pin tucks down the front of a shirt.

Specifications for Stitches, Seams, and Stitchings

Stitch, seam, and stitching specifications are easy to write when ASTM D 6193 standards are used. The standards are usually written as parts of one specification, which leaves little doubt as to the requirements and expected outcomes. The stitch class and type are identified first. Seam classes are identified by two capi-

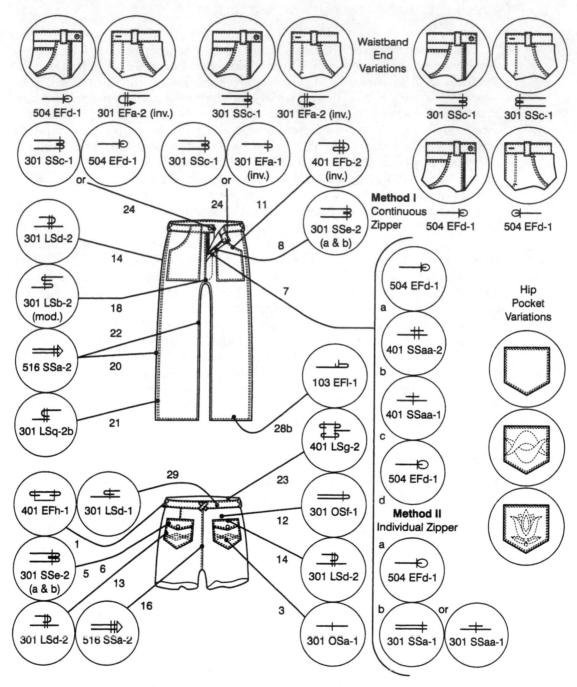

Figure 14–4
Jeans with stitches and seams identified.
Source: Courtesy of Union Special Corporation.

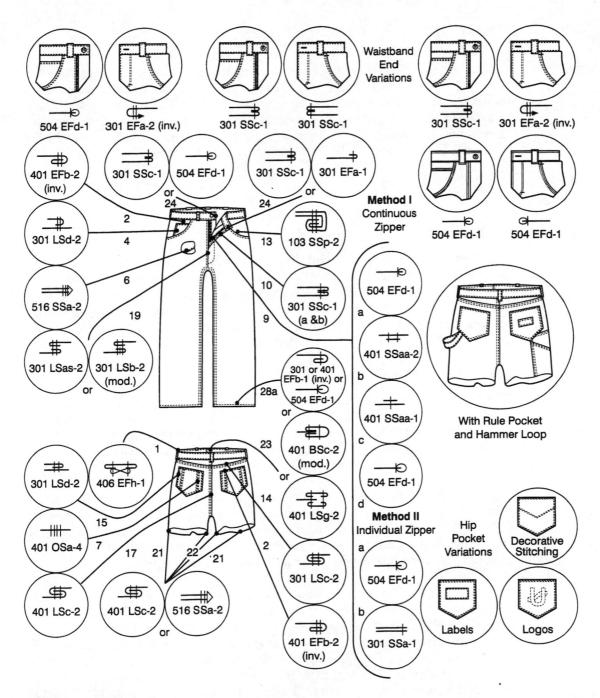

Figure 14–4, *continued*Jeans with stitches and seams identified.
Source: Courtesy of Union Special Corporation.

tal letters and seam types in each class are identified by a lowercase letter. The number at the end identifies the number of independent rows of stitches in the seam. An example of a specification might be 401 LSc-2. The number 401 identifies the stitch class and type, LS identifies the seam class, c identifies the type of seam, and 2 indicates two independent rows of stitches. Figure 14–4 identifies the various seam and stitch types commonly used for assembling jeans.

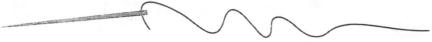

Sewing Threads

Stitches are formed from thread that must be compatible with the stitch type, seams, and fabric on which it is being used. Sewing threads are expected to form strong, smooth, uniform seams or stitching patterns. Thread, although a small part of materials cost, can impact production costs and customer satisfaction. Thread is a major factor in quality and performance of seams, durability of a garment, and consumer satisfaction.

Functions of Sewing Threads

"Sewing threads are special kinds of yarns. They are engineered and designed to pass through a sewing machine rapidly, to form a stitch efficiently, and to function while in a sewn product without breaking or becoming distorted for at least the useful life of the product" (Pizzuto, 1980, p. 81). Thread aesthetics and performance influence the costs of materials and labor and the quality of stitches and seams.

AESTHETICS Color, luster, and fineness are primary selection factors when thread is used for decorative purposes such as top stitching or embroidery. Other aesthetic considerations of thread selection include hue and shade matching, color fastness, stitch selection, and uniformity of stitch formation. Many of these considerations also relate to thread performance.

PERFORMANCE Thread performance is related to sewability and seam performance. Factors relating to performance are seam strength, abrasion resistance, elasticity, chemical resistance, flammability, and color fastness.

Sewability of thread is dependent on consistent loop formation and resistance to breakage. Loop formation is necessary to form a stitch. A thread loop must form below the fabric that will be picked up by a hook or looper and interlooped with the lower thread to form a stitch (see Figure 14–5). If the loop is not formed properly and is missed, the stitch will not form—hence a skipped stitch. Thread tension or twist may interfere with appropriate loop formation and result in skipped stitches. Thread must be durable enough to withstand the abrasion and needle heat that occurs with high-speed sewing, chemical forces of garment finishing and care, and stretch and recovery during wear. Sewing

Figure 14–5 Needle thread loop formation.

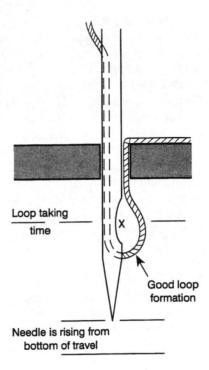

problems related to thread include thread breakage, skipped or irregular stitches, fusing or melting, and seam puckering.

Seam performance depends on the characteristics of the thread that is used. High-quality thread is uniform in diameter and sewable on a number of different types of fabrics and machines. Longitudinal uniformity of thread contributes to uniform strength and reduced friction as it passes through the stitch-forming mechanisms. Uniformity minimizes thread breakage and the associated costs of rethreading machines, repairing stitching, and producing inconsistent quality.

Characteristics of Threads

Threads have many different characteristics and appropriate selection is dependent on knowing the properties needed. Factors that contribute to the aesthetics and performance of sewing threads include fiber content, structure, twist, ply, color, finishes, strength, size, and put-up.

FIBER CONTENT Fibers most commonly used are cotton, polyester, nylon, and rayon. Silk thread is occasionally used in better garments, particularly for hand-sewn buttonholes and pick stitching on tailored jackets. Linen thread may be used for heavy-duty uses such as shoe construction. Cotton, rayon, and silk are high in absorbency and comparatively low in tenacity and elasticity.

They dye easily with a wide variety of colors and have excellent sewability. Rayon has the absorbency and dyeability of cotton and the luster of synthetics, and it is not as susceptible to the needle heat problems of thermoplastic threads. It has low elasticity and strength, especially when wet. Oil can have a weakening effect on rayon, which can create problems during sewing.

Cotton thread provides the standard for sewability in terms of uniformity of stitches and appearance of seams. It has excellent sewability due to its flexibility, loop-forming ability, and resistance to tangling. It also has low elasticity, low strength, and poor abrasion resistance but is resistant to needle heat and does not melt. Cotton threads tend to sew better on machines that are difficult to adjust. Cotton thread is the most desirable for all cotton garments, especially if they are to be garment dyed. Cotton thread will dye the same as a 100 percent cotton garment so thread and fabric match. If a contrasting stitching is desired, polyester is a better choice.

Ten years ago, more cotton thread was used than any other; now less than 20 percent of garments are sewn with cotton thread. In today's markets, cotton fiber is more expensive and weaker than comparable synthetics. Because it is more susceptible to breakage during sewing, it causes downtime for operators and increases the labor costs of garments. Cotton also is weakened by many of the chemicals that are used in fabric and garment finishing and garment care. The chemicals used in processing may cause thread to fail even before the product reaches the consumer.

Synthetic, thermoplastic fibers, nylon and polyester, are high in tenacity and abrasion resistance, which makes it possible to use finer threads to obtain the same seam strength attainable with cotton. Nylon and polyester fibers make strong threads with high elongation, low absorbency, and low melting points, which make them susceptible to needle heat. Special lubricants may be applied to the thread and needle coolers may be used on machines to reduce needle heat problems. Nylon threads have the highest elongation potential. Because of the elongation of nylon and polyester threads, skipped stitches and seam pucker may be problems. Some low-elongation fiber modifications have been developed to minimize this problem. Synthetic threads are often used due to their compatibility with synthetic fabrics. Polyester thread is considered a general-purpose thread because of its versatility.

Some threads are produced of **specialty fibers** to meet specific performance needs. For example, aramid uniforms must be sewn with aramid threads. Creating yarns with special performance properties such as heat and flame resistance is accomplished by using special fibers such as Nomex or Kevlar. GORETEXTM sewing thread is designed for outdoor uses such as boat covers and awnings because it resists moisture. Special threads may be used for canvas products that need nonwick and nondrip properties.

THREAD STRUCTURE The types of yarn structures used in producing sewing thread are spun, filament, corespun, and air entangled. **Spun yarns** are made from staple fibers that are aligned and twisted together to form simple, single

yarns. Singles are twisted together to form multiple-ply sewing threads. The number of ply may vary from two to six. Spun threads generally have good stability and holding power. Abrasion resistance varies with the fiber content and length of the fibers. Synthetics have a much higher tolerance for abrasion than cotton. Spun polyester is one of the most widely used threads and among the least expensive threads and is available in a wide variety of sizes and colors.

Table 14—2 compares cotton and spun polyester sewing threads. Spun polyester threads are stronger than cotton threads of equal size. In most cases, a larger diameter cotton thread can be replaced by a smaller diameter spun polyester thread and still maintain or increase seam strength. This also means a smaller needle can be used which reduces puckering, yarn severance, and needle heat.

Filament threads are stronger than spun threads of the same fiber and size. Three types of filament threads are commonly used: smooth multifilament, textured filament, and monofilament. **Smooth multifilament threads** are usually nylon or polyester and are used where high strength is a primary requirement. Smooth filament thread maximizes the fiber's tenacity. Filament threads are commonly used to sew shoes, leather garments, and industrial products such as tents, awnings, and boat covers.

Textured filament thread is usually polyester and is used primarily as the looper thread for cover stitches. Texturing the filament fibers gives yarn more cover but reduces luster and makes the thread more subject to snagging during sewing and use. The bulk of textured thread may increase friction if used as a needle thread.

Monofilament thread is made from a single continuous fiber. It was once thought to be the answer to all thread problems. Its neutral color and translucent appearance blend with the color of most fabrics. It is strong and uniform, so breakage during sewing is minimal and it is relatively inexpensive. However, monofilament threads lack flexibility and therefore place excessive wear on machines and feel stiff and scratchy when next to the body. The holding power of this type of thread is limited and it tends to unravel from the seams. New innovations in monofilament threads have increased their softness and flexibil-

Table 14–2Comparison of cotton and polyester threads.

	Cotton	Tkt 50/3* (T-40)**	Spun Polyester	Tkt 70/2* (T-27)**
Tenacity (Strength/Size)	Low	2.3 lbs	High	2.37 lbs
Elongation (Stretch)	Low	3-5%	High	15-20%
Lubricity (Drag)	High		Low	
Heat Resistance	Excellent		Good (melts 485°F)	
Abrasion Resistance	Fair		Very Good	
Chemical Resistance	Fair		Excellent	
Colorfastness	Fair		Excellent	

^{*}Tkt—metric size; **T—Tex Size is based on the gram weight of 1,000 meters of undyed sewing thread. This is a direct numbering system which means that the larger the number, the larger the thread.

Source: American & Efrid. Inc.

ity. Because of their limitations, monofilament threads are used primarily for hems in budget garments and for draperies and upholstered furniture.

Corespun thread is a combination of staple and filament fibers. The most commonly used corespun thread has multiple-ply construction; each ply consists of a polyester filament core wrapped with cotton fibers. This thread structure gives the strength of filament polyester and sewability of cotton. Rayon or polyester wrap is sometimes used, although cotton wrap is the most widely used. Polyester wrapped corespun thread is more subject to needle heat and may not be as desirable in terms of color. Corespun thread is higher in tenacity and costs more than spun polyester. Cotton/polyester corespun requires two dye baths to produce an even color which increases costs.

Air-entangled thread is a fairly recent development in texturing polyester with no twist. It can be sewn multidirectionally, which means thread can be pulled off the cone in either direction as there is no twist to be affected. It is compatible with other polyester threads and used on most types of apparel.

Specialty threads include embroidery and monogramming threads and those with special end use requirements such as flame or heat resistance. Color and luster are two requirements of embroidery and monogramming thread. Rayon thread has long been the most widely used in this end use because of low price and excellent color and luster. Spun polyester has replaced much of the rayon for embroidery and monogramming because of greater tenacity, abrasion resistance, and resistance to chemicals.

Twist binds fibers together and gives spun yarns or threads strength (Kadolph et al., 1993). Twist is the number of turns per centimeter of thread. If twist is too low, threads may fray and break. If twist is too high, thread becomes "lively," which results in looping or knots that prohibit stitch formation. The direction of twist is identified as "S" for left twist and "Z" for right twist. Most single-needle lockstitch and other machines are designed for **Z twist** thread; **S twist** thread untwists during stitch formation. Double-needle lock-stitch machines use two bobbins that unwind in opposite directions; therefore, both S and Z twist threads are used at the same time in these machines. S twist thread is better for flat-lock or cover-stitch machines.

Correct and stable **twist balance** is essential to prevent kinking and snarling during sewing. Twist balance can be checked by unwinding a length of thread and holding a suspended end. If the loop twists, there is too much torque and risk of knotting and skipped stitches. The twist in singles yarns is balanced by applying reverse twist when two or more yarns are combined to form thread. Most threads are two-, three-, or sometimes four-ply construction. For example, two S twist singles may be combined with one Z twist for a three-ply thread.

PLY Single strands of yarn are plied or twisted together to form a yarn or thread. Plying increases durability and performance. Most all spun and corespun threads are produced in 2 or 3 ply to provide greater strength. Two-ply threads may be

used for fine, delicate fabrics or for serging where less bulk is desired. Three-ply threads provide greater strength for seams; four-ply thread may be used for more durable construction. Corded threads are much heavier and are made of two or more singles twisted into each ply and then multiple plies are twisted together.

COLOR Two aspects of color are important for aesthetics and performance of threads: color matching and color fastness. Color matching of thread and piece goods is essential when seams are to be inconspicuous. Whether thread can be matched to the color of a particular fabric may depend on the dyeability of the fibers in the thread. Some fibers take certain colors better than others, and some dyestuffs have better colors in certain hues.

Success of visually matching colors depends on the type of light, nature of the surroundings, and the viewer's ability to see color differences. Colors that appear to match in one environment may not appear to match in another; thus, standardized conditions in terms of type of light, angle of viewing, and color of surroundings must be used for reliable visual matching. Instrumental color measurements with a **spectrophotometer** and computerized shade recipes are used for dyeing thread to common color standards for various fiber contents, thread structures, and dyestuffs. These systems may also create dye formulas for custom matching to particular piece goods although the apparel manufacturer would probably be required to buy the entire dye lot.

Color fastness generally means fastness to light and washing, although threads may be subjected to other color altering conditions such as abrasion, polluted atmosphere, chemicals, dry cleaning, and pressing. Color fastness to reduce the risk of bleeding is particularly important when the thread color contrasts with the piece goods. Color fastness is evaluated using standardized tests, such as those developed by AATCC. Polyester sewing threads dyed with disperse dyes exhibit the best color fastness when compared to cotton, rayon, and nylon sewing threads (*Industrial Sewing Threads*, n.d.).

Finishes on sewing threads are used to increase sewability by increasing strength and abrasion resistance, bonding fibers together, or lubricating the thread. For example, cotton threads may be soft, mercerized, or glazed. Soft cotton threads do not have special finishes applied. They are the least expensive but have the most elasticity and shrinkage potential of cotton threads, and limited durability. Mercerized cotton threads have increased strength, luster, and dyeability because of treatment with a sodium hydroxide solution under tension. Glazed cotton threads have special surface coatings of waxes and starches that increase their abrasion resistance and durability. They are used primarily for sewing heavy, dense fabrics. Other thread finishes include water resistance, soil release, and flame retardancy. They are specific to the end use and fabric to be sewn.

Some threads are **bonded** to increase ply security and smoothness. Ply security refers to the cohesiveness of plys during the sewing process (*Industrial*

Sewing Threads, n.d.). Ply security is dependent on level of twist, degree of entanglement, and/or coating with a bonding agent or glazed finish. Bonded threads resist splitting and fraying that may cause the thread to break.

Thread lubrication has two purposes: to reduce the amount of friction and to provide protection from needle heat. On a lock-stitch machine, a length of thread may go through 40 to 50 different cycles of flexing and abrasion before it is formed into a single stitch (*Technology of Thread and Seams*, n.d.). The lubricant must also be nonstaining, nonsoiling, and have negligible effect on thread color. Lubricants are especially formulated for different fiber contents, types of threads, and end use. Applications must be uniform to be effective.

THREAD STRENGTH Tensile strength measures in grams or kilograms the breaking point of a strand of thread that is under tension. Thread strength is related to size, fiber content, amount of twist, number of ply, finish, consistency in its formation, and the amount of abrasion it is subjected to in sewing. Thread needs to be strong enough to withstand the friction of stitching and to hold the garment pieces together during wear and care. Thread generally is not stronger than the fabric that is being sewn because it is easier to repair a broken thread than to repair damaged fabric.

THREAD SIZE Threads should be as fine as possible depending on the strength requirements of the seams. Generally, larger threads have greater strength, given the same fiber content and yarn structure. Finer threads tend to blend into the fabric surface and are less subject to abrasion than seams with heavier thread. Finer threads require smaller needle eyes and finer needles. Finer threads may be used to sew nonstress seams and heavier threads may be used on stress seams.

Thread size in the United States and the world market is most frequently indicated by ticket number (T). References may also be made to denier and cotton count systems. The ticket number or tex system is based on the gram weight of 1,000 meters of undyed sewing thread. It is a direct numbering system meaning the larger the number, the larger the size of the thread; the finer the thread, the lower the ticket number. The cotton count system is an indirect system based on the length of thread in a given weight. Table 14–3 shows the relationships between thread size (ticket number) and needle size. The list gives the minimum recommended needle size for a given thread size. Larger needles may be necessary due to the fabric or operation being sewn.

PUT-UP Sewing threads are put up on different types of **thread packages** called spools, cops or tubes, cones, king tubes or vicones, containers, cocoons, and prewound bobbins to suit different types of threads, machines, and sewing needs. Sewing machines require specific types of thread packages in order for the thread to be presented appropriately to the machine. Thread packages may be color coded by size and type of thread to assist operators in correct thread

Table 14–3Relationships among thread size and needle size.

Thread Siz	e Designations	Nec	edle Size Designat	ions
Tex Size	Metric Size	Metric	Union Special	Singer
T-18		60	025	8
T-21	130	65	025	9
T-24		70	027	9
T-27	120	75	029	10
T-30		75	029	10
T-35	100	80	032	12
T-40	75	90	036	14
T-45		90	036	14
T-50		100	040	16
T-60	50	110	044	18
T-70		110	044	18
T-80	30	120	048	20
T-90		140	054	22
T-105	25	140	054	22
T-120		150	060	23
T-135	20	150	060	23
T-150		180	067	24
T-180	15	200	080	25

Source: American & Efrid, Inc.

selection. Thread is sold by length instead of weight and should be available in both large and small quantities.

Figure 14–6 shows several different types of thread **put-ups. Spools** contain relatively short yardage and have thread wound in a parallel position. Spools have a flange at either end that interferes with off-winding on industrial machines. Spools are designed for home sewing use.

Thread is cross wound on cops or small tubes to increase stability in offwinding. **Cops** are used primarily on lock-stitch machines where a variety of colors are used and production runs in any one color are short.

Cones are symmetric, tapered forms made of paper or plastic that hold over 5,000 meters of cross wound thread. Cones provide good off-winding performance for high-speed machines. Cones are the most economical packages for sewing threads in situations where thread consumption is high and production runs are long with limited shade changes (*Industrial Sewing Threads*, n.d.). They are ideal for automated sewing.

Vicones or king tubes may be parallel tubes or low-angle cones with a flange at the bottom. The flange on the bottom of this type of package is designed to contain spillage of smooth or continuous filament threads during off-winding.

Figure 14–6
Thread put-up.
Source: Technology of Thread and
Seams (n.d.), p. 35. Courtesy of
J & P Coats Limited.

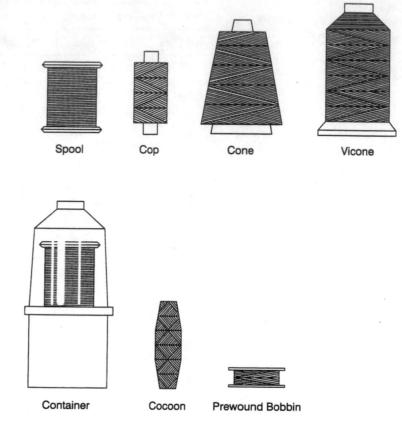

Containers are designed to handle lively monofilament threads that may be difficult to control with traditional packages. Very large spools of thread may have lubricant applied as the thread is off-wound.

Cocoons are centerless thread packages designed for insertion in shuttles of multineedle quilting machines and some types of embroidery machines.

Prewound bobbins are precision-wound packages designed to replace metal bobbins in lock-stitch machines. Generally, more thread is available and the length is more consistent on prewound bobbins than on operator-wound bobbins. Downtime is minimized by elimination of time for winding bobbins. Off-winding is also improved because of precision winding. Prewound bobbins are available in different thread types and sizes for different models of machines.

Thread Specifications and Costs

Sewing threads are made by companies that specialize in thread production. Brand names are commonly used to identify threads with particular performance characteristics. Commonly used thread classifications reflect a combination of fiber content and thread structure. Threads are classified into the following groups: cotton, spun polyester, core spun, filament, textured filament, monofilament, and specialty. Threads may be specified or purchased by classification, brand name, fiber content, and size.

Thread costs include thread that is actually used, thread that is wasted, excess inventory, and costs of poor performance in sewing and garment use. Thread costs are less than 1 percent of total materials costs, but thread performance has a direct bearing on labor costs and productivity. Thread breakage requires time to rethread machines and repair seams. Garments may even be returned when stitching does not meet performance expectations. The quantity of thread required for a particular garment varies according to the types of stitches and seams used. Unravel several inches of stitching and measure the thread consumption. Convert that to the number of inches that will be sewn for a specific style. Figure 14–7 shows a detailed sketch of a man's knit sport shirt in size medium. Table 14–4 details quantities of thread for different seams for the specific sport shirt.

Thread waste occurs in excessive chain-offs and reworking. Inventory costs include thread remaining upon completion of a style. Thread does not age well if stored for several seasons. It becomes brittle and breaks especially when exposed to light. Thread breakage causes downtime for rethreading and restitching. Incorrect selection affects sewability, seam performance, and aesthetics. Garment returns due to poor seam performance can drastically increase costs.

Figure 14–7 Men's knit sport shirt, size medium.

 Table 14-4

 Stitch, seam, and thread specifications for men's knit sport shirt assembly.

Operation Description		Stitch	ű	Seam	Amc	Amount of Thread	ead		Thread Type	
	spi	Type	Туре	Length	Needle	Bobbin	Looper	Needle	Robbin	
Attach placket	12	304	CCA.1	200	8	1				Looper
Tonstitch placket		5 6	0 1	2 < 01.	9.	.36		100 Spun P	100 Spin P	
Spatial placket	2	301	EFb-1	.25 × 2	.83	75		100 001	10000	
Box placket	12	301	1	1	15	9 5		d unde ool	d unds on	
Cuff sleeve	10	504	SSa-1	39 × 2	2 2 3	2	100	d unde ooi	100 Spun P	
Join shoulder seams	9	516/401	SSa-1	21 × 12	52		59.7	100 Spun P		100 Spun P
Topstitch shoulder seem	12	301	LSBn-1	× 10	30.	20	90.1	d unds on		100 Spun P
Set collar	10	301	SS9-1	7.1	. 6	9, 6		4 unds ont	100 Spun P	
Topstitch collar tape	10	301	Shart	5 4	9. c	80.0		100 Spun P	100 Spun P	
Set sleeves	2	200	1000	10.	cs.	.93		100 Spun P	100 Spun P	
Close sleeve and sideseam	2 5	5 6	-800	. × 70.	2.90		13.62	100 Spun P		100 Sprin P
Hom hottom	2 :	500	SSA-1	.69×2	3.45		17.48	100 Spun P		100 60111
mem bottom	9	203	EFc-1	1.1	5.92		3 88	100 Spin D		d unde on a
Hem side vents	12	301	EFa-1	.25 × 2	1.33	67	8	100 Spuir	0007	100 Spun P
Make buttonholes (2)	١	101	1	1	1.06	5		d unde ool	100 Spun P	
Buttonsew (2)	1	101		١	85.			100 Spun P		
Attach label	1	301			7 9	S		I unds on I		
		3				80		100 Spun P	100 Spun P	
				subtotal:	23.52	4.33	48.95			
:					Total Yard	Total Yardage 78.80 yds.	yds.			
Embroidery Threads					Alternativ	Alternative threads:				
00 Decorator					200 Textu	200 Textured polyester	Je			
00/3 or A/3 Cotton					100 Core Thread	Thread	i			
100 or 70 Spun Poly.										

Amount of thread does not reflect waste factor. All measurements in yards.

Source: Courtesy of Threads U.S.A.

Alternatives to Thread

Adhesives, ultrasonic welding, and laser-enhanced bonding are alternatives to using thread for seaming in garment assembly. Use of adhesives in place of thread on textile materials has had limited success because the peel strength on textiles is low. Precoated tapes may be bonded over seams to make seams waterproof, but the peel strength of the adhesive is insufficient to replace the thread. Welding techniques rely on thermoplasticity of synthetic textile materials. Layers of materials are melted, fused, and cooled creating a bond.

Ultrasonic welding is not new but newer equipment and methods are faster and produce a seam that has a much improved hand and wearable comfort. "The technology entails utilizing high-frequency vibrations to bond together two or more materials. The vibrations generate a rapid buildup of heat within the material which causes the materials to melt and fuse" (Devine, 1994). Ultrasonics can be used to join, cut, pattern, and quilt synthetic materials which are used in a wide range of products including lingerie, medical disposables, and diapers.

Laser-enhanced bonding was introduced at the 1995 Bobbin Show by Union Special. It produces a flat seam with minimal bulk that is flexible, stretchy, and waterproof and is used in protective footwear, waders, and wet suits. According to developers the technology "... uses a laser to drive polymers into fabrics and other materials to create a seam that is stronger than its parent materials, impermeable, flexible, environmentally safe, long-lasting, and aesthetically pleasing" (Black, 1995). It has been field tested by some major footwear companies.

Needles

Needles are designed to pierce the fabric and create a hole so thread can be carried through the fabric. A thread loop is formed by the needle after it passes through the fabric and begins to rise. See Figure 14–5 on p. 457. For some types of stitches, the needle must pass through a thread loop formed by the lower looper.

Selection of the appropriate needle depends on the type of machine, other stitch-forming parts, thread size, and fabric characteristics. Thread type and size are selected first, then needle size is matched to the thread. The needle type number classifies the needle as to eye, finish, groove, point, shaft, and total length. Size refers to blade width. An incorrect needle may prevent stitch formation and cause thread breakage, skipped stitches, poor stitch uniformity, and yarn severance.

The parts of a needle are identified in Figure 14–8. Each part represents a variable that may affect selection and performance. The *butt* is the upper end of the thick portion of the needle. Length is measured from the butt to the top of the eye. The *shank* is the thick upper portion that fits into the needle bar.

Figure 14–8
Parts of a needle.
Source: Courtesy of Union Special
Corporation

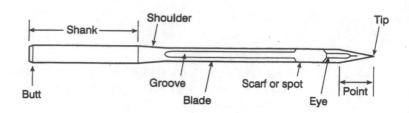

Shanks may be round, flat on one side (slabbed), or flat on two sides (double slabbed) but must be matched to machine requirements.

The blade is the long thin part of the needle that extends from the shank to the top of the eye. Blade length varies with machine type and sewing needs. A blade may have a long groove on one side, be combined with a short groove above and below the eye, or have a spiral groove. The long groove provides a channel for thread as the needle goes through the fabric. If the thread is too large for the groove, abrasion may result. Blades are subject to high friction as they enter and withdraw from fabric with each stitch. Needle size is determined by the blade width in millimeters just above the eye except for lock stitch needle size which is determined at the eye.

The eye is the hole that thread must pass through freely. A scarf or spot is a recess cut across the short groove side of the needle, just above the eye. The bulge around the needle eye increases the spread of yarns as the eye passes through the material. This allows the blade and thread to pass through the fabric with minimum contact and the hook or looper to pass closer to the center of the needle. This facilitates picking up the thread loop. If a machine is skipping stitches, a change to a different scarf may make it easier for the needle loop thread to be picked up.

A common test for appropriate needle size is to suspend a threaded needle by holding the thread at a 45-degree angle. The needle should slide down the thread because of its own weight when the thread is moved slightly.

For best seam appearance, use the smallest needle blade possible. This is not a simple solution, as a small blade has a small eye, which could place stress on the thread and cause friction. Also, needle strength decreases as the diameter of the blade decreases.

The point is the area below the eye, including the tip. The point and tip make the initial penetration into fabric and must be appropriate for the fabric being sewn. There are cloth points and cutting points. Most woven and knit fabric is sewn with a **cloth point.** Cloth points may have set tips (slim, regular, and heavy) which are commonly used on woven fabrics, and ball tips (light, medium, and heavy) which are used primarily on knit fabrics and coarse yarn wovens. A ball tip pushes the yarns aside and allows the needle to pass between them instead of cutting the yarn. Tips are available in varying degrees of bluntness for different types of fabrics. Fabrics with coarser yarns require more rounded points.

There are also a variety of *cutting points* designed for stitching leather and vinyl. In sewing these materials the needle must cut through the material instead of pushing the yarns aside. Rocked-, flat-, or spear-point needles are used specifically on leather. These needle points make a small cut as the thread is carried through the leather. The size and direction of the cut affect seam strength. Selection of the wrong tip and point can cause permanent damage to fabric. If skipped stitches, yarn severance, or fabric damage occur, a different point may need to be used. Figure 14–9 shows some needle points and tips as they are commercially designated.

Needle heat is the result of friction. It occurs when sewing heavy fabric at high speed or when stitching several fabric layers with close stitches as in bartacking pockets or zipper plackets. Dense fabrics create more resistance and more friction. If needle temperature exceeds the melting point of thread, the thread is likely to melt when sewing stops. Needle heat causes thread breakage and fabric damage, and it may fuse synthetic fabric and thread. Heat appears to increase with speed at a rate of 0.08 degrees Fahrenheit per rpm. Lowering the speed from 4,500 to 2,500 stitches per minute produces a drop of 160 degrees. In fabric and threads made of natural fibers, the heat can rise to about 660 degrees without causing damage (Glassman, 1987).

Thread breakage usually appears at the start-up of stitching. Examination of the thread end under a microscope will help determine if melting was the cause of breakage.

The type of needle finish and the needle shape are factors that affect friction. Needles for sewing cloth are often finished with a nickel, chrome plating, or Teflon, while leather needles are polished without any plating. A chrome finish helps dissipate heat as well as resist melted particles that may collect. Needle heat may be reduced by using a smaller needle size, a ball eye, additional fabric and thread lubricants, a different thread type and size, or needle-cooling devices. Needle coolers are built-in tube-like devices that blow air on the needle

Figure 14–9 Needle types. Source: Courtesy of Union Special Corporation

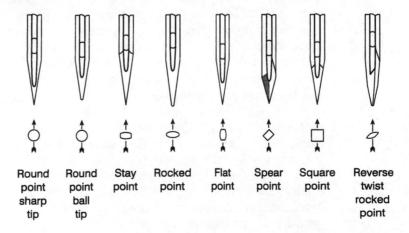

to reduce the temperature created by friction. Coolers are used primarily on machines that sew heavy fabrics and synthetics that have a tendency to fuse at high temperatures.

Seam Appearance and Performance

Seam appearance and performance affect both the aesthetics and performance of a garment and are important to its salability and longevity. Seam appearance and performance are dependent on the interrelationships of fabrics, threads, and needles; stitch and seam selection; performance of sewing and pressing equipment; materials handling; and appropriate operation and maintenance of the equipment.

Seams are evaluated by the manufacturer during product development and prototype testing. Consumers evaluate seam appearance and performance before purchase based on their standards and past experiences and after wear and care procedures based on its original state.

Seam Appearance

Seam appearance is evaluated on drapeability, consistent stitch and seam formation, and flatness.

DRAPEABILITY Drapeability of a seam is affected by the flexibility of materials and seam construction. Seams need the same amount of drapeability as the rest of the garment. Heavy thread, complex seam structures, multiple layers of fabric, and other factors contribute to bulkiness and rigidity of a seam.

Consistent stitch and seam formation. Consistent formation and stitching is critical to garment appearance. Varying stitch density (spi), irregularities in stitch and seam formation, loose tension, and loose thread ends all affect the appearance of a garment. Lack of uniformity in stitch density is particularly apparent in top stitching. Loose tension allows seam grin, stitching that shows along the seam line. Irregularity in the line of stitching affects the shape of the garment and can cause poor fit and unsightly appearance.

SEAM FLATNESS A flat seam is free of fabric creases, waviness, and pucker. Some factors affecting seam flatness may be controlled by pressing, top stitching, and cover stitching. Seam pucker is a quality problem that affects appearance but does not damage fabric. **Seam pucker** is the rippling of a seam that occurs just after sewing or after laundry, causing unacceptable appearance. It is a common problem in garment assembly. It has been studied by engineers, production managers, equipment producers, testing laboratories, and re-

searchers over extended periods of time. The problem is not a simple one, since there are many causes and factors involved. Change in fabrics, styling, and technology creates new potential for pucker. Four probable causes of seam pucker are discussed here.

Feed pucker is due to the resistance or drag of the presser foot on the top ply, as two plies of fabric are sewn together. If the fabric on the bottom is fed more rapidly than the top ply, the bottom fabric puckers. The seam in Figure 14–10 is an example of feed pucker. The armhole seam along the back is puckered and the sleeve is smooth. Use of a top-feeding device may be one resolution to this problem. A top-feed mechanism that moves the top ply of fabric through the stitching process at approximately the same rate as the bottom feed eliminates much of the resistance on the top ply. Slower speeds and less pressure are other alternatives, but not ones most manufacturers are willing to use. Feed pucker can be detected when a garment is puckered on only one side of the stitched seam. Differential stretching of the two plies being sewn may also cause only one side of a seam to pucker. This might occur when braid or trim is sewn to a blouse or jacket. If one piece has a greater degree of bias, it will be more susceptible to stretch.

Tension pucker may be caused by too much tension on the sewing thread, which causes the thread to elongate as stitches are formed. Tight tension settings on upper or lower threads during stitching or bobbin winding, or damaged thread guides, may be causes. Bobbin winders may be set too tight in order to get more thread on a bobbin and reduce the number of changes necessary. When thread is sewn it relaxes and may cause pucker. Lack of adjustment and poor maintenance can also be factors. Tension pucker is primarily a problem with synthetic thread, which has greater elongation capabilities than other thread. As the thread relaxes it can cause the fabric to draw together and pucker.

Figure 14–10 Seam pucker caused by uneven feed.

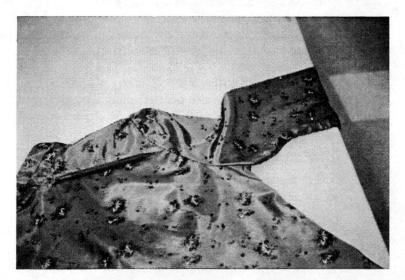

Thread that is poor quality or the wrong size or type and incorrect settings are other probable causes of tension pucker. Tension pucker may not appear until after steaming or laundry if the fabric is heavily sized. When sizing is removed, the fabric may soften and allow the thread to contract. As the thread contracts, pucker appears. If the pucker disappears when threads are snipped, it is likely to be the result of too much tension. Tension pucker may be eliminated with properly adjusted machines and use of consistent quality thread. Fine threads and well-lubricated threads can be sewn with minimum thread tension. A chain stitch can be sewn with light tension due to its looped formation.

Displacement pucker or jamming is due to yarn displacement and crowding as the needle and thread pass through the fabric. Yarns are pushed together as thread forms stitches in the fabric. Displacement pucker is most common on high-count fabrics with long seams cut parallel to warp yarns. The tendency for jamming increases with more stitches per inch, higher count fabrics, finer fabrics, and thicker sewing thread. Possible solutions for jamming are the use of a two-thread chain stitch instead of a lock stitch. The chain stitch forms a loop on the underside of the seam and not in the center of the fabric like the lock stitch. This reduces the possibility of yarn displacement. Other solutions include use of finer sewing thread and a smaller needle, fewer stitches per inch, and cutting adjoining garment pieces with a slight degree of bias so there is more room for yarn displacement.

Moisture pucker is not the result of the sewing process, but one of concern to the lasting appearance of a garment. Moisture pucker is due to differential shrinkage of the shell fabric, thread, or other attached materials such as trims and interlinings. Moisture pucker may occur with the final steaming or pressing or not until after the first cleaning cycle. Differential shrinkage of components may be avoided by early product testing during the development stage to make sure all materials are compatible during sewing and care.

Puckered seams can be avoided with appropriate prototype and materials testing, proper machine adjustments, appropriate selection of stitch and seam types, proper selection of thread, and well-maintained sewing equipment. Analyzing the amount of pucker that is acceptable to the consumer and the costs of eliminating pucker are challenges for production, merchandising, and quality control managers. For some consumers, some pucker is not objectionable and, thus, pucker may not be a factor in the acceptability of a garment.

Seam Performance

Seam performance relates to the elasticity, strength, and flexibility of a seam. These properties are related to fabric characteristics, selection of stitch and seam types, thread type and size, and density of stitches (spi).

ELASTICITY Elasticity involves two factors, elongation and recovery. Seam elasticity is the degree that a seam recovers to its original length immediately

after elongation. Garments such as leotards and swimsuits require high elongation and recovery of both fabric and seams for satisfactory service. Seams vary in elongation potential. *Elongation* is the amount that a seam can be stretched without breaking. Appropriately chosen stitches and thread will elongate to the same degree as the fabric. If a seam will not elongate as much as the fabric, the stitches and thread will usually break. Seam elongation is related to thread properties, thread tension, seam type, stitch type, spi, and fabric properties. A combination of these factors is selected to provide the amount of elongation needed for a particular end use. Highly elastic stitches include 103, 401, 406, 407, 503, 504, 512, 514, and 516. "The 504 three thread overedge stitch provides the maximum attainable extendibility" (Carr and Latham, 1988, p. 121). More stitches per inch can produce more stretch, but too many may stress the yarns and cause fabric damage.

Recovery is the return of the seam to its original length when the stress is removed. Sometimes, seams have high elongation potential but poor recovery. If the seams of a leotard have a "washboard" appearance when the garment is removed from the body, the seams have failed to recover. Seam recovery can be inhibited by selection of inappropriate stitch and seam type, too many stitches per inch, and thread that is too large.

STRENGTH Seam strength is an important factor in determining the durability of a garment. Seam strength is determined by resistance to pulling force and abrasion. Seam tenacity is the amount of force necessary to break the fabric or the weakest stitch of a seam. Seam abrasion resistance is the amount of rubbing action needed to wear away stitches in the seam. Seam strength is related to stitch type, thread strength, thread tension, seam type, seam width, and the stitches per inch. Loop strength of thread is more important in stitch strength than linear strength. Combinations of these factors determine seam strength. Although seam strength is important to durability, the seam does not need to be stronger than the fabric being sewn. A triple-stitched lapped seam would not be necessary for a pair of corduroy jeans since the fabric itself is not strong and would wear out before the seam. It is better to have the thread break in an overstressed seam than to damage the fabric.

FLEXIBILITY **Seam flexibility** affects the drapeability, comfort, and abrasion resistance of apparel. Flexible seams allow for more body conformity and movement. Rigid seams can cause body discomfort and irritation. A flexible seam is able to bend, shift, and fold without damage to the seam or distortion to the silhouette of the garment. Stiffer more rigid seams are subject to abrasion whenever they come in contact with another surface area. Without flexibility, abrasion and wear will occur in the same location or to the same set of yarns. Fabric structure and weight and seam type are major factors that affect seam flexibility. A lapped seam may be stronger than a superimposed or safety-stitched seam, but more subject to abrasion and wear because of its stiffness and lack of flexibility.

Seam Problems

Seam problems that affect appearance and performance include distortion, skipped stitches, grin, thread breakage, slippage, and yarn severance. Seam failure can cause costly repairs, consumer dissatisfaction and returns, and increased costs. Causes of seam failure include inappropriate choice of stitch or seam type and incompatibility among thread, needle, and fabric. Improper adjustment of feed mechanisms and machine settings, and operator performance can also cause dissatisfaction with a garment (see Table 14–5). Often there is more than one contributing factor.

Distortion Distortion is the disruption of the fabric surface or the deformation of a garment. Incorrect handling during garment assembly often contributes to distortion. Excessive or improper handling and positioning during cutting, sewing, and/or pressing can result in stretched, puckered, and twisted seams, unwanted pleats and tucks, and distorted grain. For example, distortion occurs with lapped seams when the fabric is stretched off grain while folding and top stitching. Hems can appear twisted or "roped" if fabric grain is distorted when hems are folded and stitched. Incorrect machine settings, poor machine maintenance, excessive needle heat, and incorrect needle and thread type and size may also be factors in the creation of distortion. Distortion can be prevented with better operator training, more effective work aids, better machine maintenance, and appropriate selection of thread, needles, and stitch and seam types.

SKIPPED STITCHES **Skipped stitches** are a common sewing problem affecting quality, seam performance, and aesthetics of a garment. A skipped stitch appears twice as long as others in a line of stitching. It is caused by a failure in stitch formation when the needle thread loop is not picked up by the hook or looper. It may be related to the size of the needle eye. If it is too large there is a loss of thread control. Skipped stitches create a lack of uniformity in a line of stitching and are susceptible to snagging. They also become the weak link and have potential for breakage. Chain stitch and overedge seams with skipped stitches may unravel and cause seam failures and costly returns. They also reduce productivity of operators and disrupt production. Skipped stitches are most likely to occur when changes are made in fabric, thread, or needles.

SEAM GRIN **Seam grin** is a separation of a sewn seam as a result of transverse stress that allows the stitches and thread to show. It is a condition that is likely to occur with a low stitch count, insufficient tension on threads, or improper stitch and seam selection. It affects both the aesthetics and performance of a seam.

Table 14-5
Common seam problems and their causes.

	Feed Pucker	Tension Pucker	Displace- ment Pucker	Moisture Pucker	Moisture Skipped Pucker Stitches	Thread Breakage	Seam	Distortion	Low Elasticity	Low	Low Low Low Distortion Elasticity Strength Flexibility	Yarn Sever-	Yarn
Fabric structure	×	×	×	×	×	×		>	>	,			Sandding
Fabric and thread								<	<	<		×	×
incompatibility		×	×	×	×	×		×	>	>	>		
Improper feeding	×				×	×			<	<	<		
Flagging					×	< ×						×	
Machine misadjustment	×	×			< ×	< >			¥ 12			×	
Defective machine parts	×	×			< ×	< >	2			× :	143	×	×
Incompatible materials	×			×	<	< >		>		×		×	×
Defective needle			×		×	< ×		<			×		
Needle heat					× ×	< ×				,		× :	
Improper needle hole/size	×		×		×	× ×		>		< >		× :	
Incorrect needle positioning					×	× ×		<		<	E.	×	
Improper operator handling	×				×	: ×		>					
Incorrect needle size to thread size		×	×		: ×	: ×		<					×
Excessive presser foot	×											×	
Improper seam selection	× ×		>				;	;				×	
Differential shrinkage	<		<	×			×	×	×	×		×	×
High stitch count			×					×			*	>	
Low stitch count	×	×					×		×	×	<	<	>
Improper stitch selection			×				×		: ×	< ×			< >
Differential stretch	×									<			<
Heavy tension		×			×	×			×				
Light tension						×	×						
Defective thread		×			×	×				×			
Incorrect thread			×		×	×			×			150	
Thread too large		×	×		×	×					×		
Incorrect threading		×			×	×			×	1			

THREAD BREAKAGE **Thread breakage** is a common problem that has many causes such as needle heat, incompatibility of needle, thread, and fabric, and defective machine parts or adjustments. Dark threads tend to be more brittle. Broken threads affect both aesthetics and performance. Needles must be rethreaded and seams restitched, which affects appearance, performance, and productivity. If stitches break and are not formed correctly during the sewing operation, it is very difficult and time-consuming to go back and repair a line of stitching, especially if the seam is formed with a folder or other work aid.

SLIPPAGE Seam slippage occurs in woven fabrics when yarns slide together along other yarns or a line of stitching thus allowing seam grin. Most slippage occurs in seams that run parallel to the warp. Slippage will more likely occur in fabrics that have filament yarns, low thread count, or unbalanced weaves. Seam slippage may also be affected by stitch type and size, tension, seam type and size, thread choice and excessive use of fabric lubricant. The tighter the stitch grips the fabric, the less seam slippage there will be. More stitches per inch, lapped seams, seam headers, and double rows of stitches all help increase the grip of a seam. Increasing the width of a seam allowance increases the number of yarns that are between the seam and the cut edge, which creates a resisting force to slippage. Fabric grain may also affect slippage. Seams cut along the warp are more prone to slippage than those cut on the bias.

YARN SEVERANCE Yarn severance or needle cutting is the breakage of fabric yarns that occurs during stitching due to incompatibility of needle, fabric, and sewing speed. Causes of yarn severance are damaged needles and incorrect type, point, and size relative to the fabric being sewn. Incorrect thread type and size and high speed sewing are also potential causes. Thick seams often require thicker needles and coarser feeds which can damage yarns. High speeds do not allow time for yarns to move away from the penetrating needle point which may result in ruptured yarns. Lubricants may be added during fabric finishing that will facilitate yarn movement during the sewing process.

Yarn severance can be a serious problem with weft knits. Runs may form and travel beyond the point of damage. With woven fabrics there may be broken yarns, weakened seams, and poor aesthetic qualities. Quality control inspectors may identify the more severe problems, but many of the severed or broken yarns are hidden by thread and seldom show up until laundering or wear causes the yarns to shift. When yarn severance goes unnoticed during production and quality checks, large quantities of garments may be produced before the problem is detected. Excessive yarn severance can mean second-quality garments and customer returns. This is most noticeable around buttonholes or in top-stitched areas where dense stitching is concentrated.

Summary

Satisfactory garment assembly and performance depend on correct choices of stitches, seams, thread, and needles. Selection of appropriate stitch and seam types varies with product components, end use, quality level, and equipment available. Stitch and seam selection affect the aesthetics and performance of a garment. Specifications for threads, seams, and stitches are necessary in order to communicate expectations and minimum requirements. Federal stitch and seam specifications identify the more widely used stitches and seams.

Factors that contribute to the aesthetics and performance of industrial sewing threads include fiber content, thread structure, correct and stable twist balance, size, uniform lubrication, quality of loop formation, and smoothness and uniformity. Thread selection is based on the type of material being sewn, stitch and seam selection, garment end use, and desired aesthetics and performance of the seam.

Needles carry thread through the fabric as a seam is sewn and impact the aesthetics and performance of a seam. Needles must be compatible with the fabric being sewn, thread size, and the stitch forming parts of the machine. Each part of a needle is related to its function.

Seam appearance is affected by drapeability, stitch consistency, seam flatness, seam grin, slippage, and yarn severance. Seam performance is affected by elasticity, strength, and flexibility.

References and Reading List

ASTM. 1998. Standards related to stitches and seams. ASTM West Conshohocken, PA.

American & Efrid, Inc. Needle-thread comparative chart. Mount Holly, NC: Author.

Black, S. (1995, August). LightSeam, Union Special to debut laser enhanced bonding. Bobbin, 98–104.

Carr, H., and Latham, B. (1988). The technology of clothing manufacture. Oxford: BSP Professional Books.

Devine, J. (1994, March). Understanding ultrasonics. *Bobbin*, 74–85.

Glassman, L. (1987, May). Needle selection: Not in a haystack. *Bobbin*, 26(9), 94–95.

Industrial Sewing Threads. (n.d.). Gastonia, NC: Threads U.S.A.

Kadolph, S. J., Langford, A. L., Hollen, N., and Saddler, J. (1993). *Textiles* (7th ed.). New York: Macmillan.

Miller, P. (1985, September). Seam puckering. *Bobbin*, 27(1), 236–238.

Pizzuto, J. (Revised by Price, A., and Cohen, A.). (1980). Fabric science (4th ed.). New York: Fairchild Publications.

Sandow, K. (1990, June). Thread breakage. Apparel Manufacturer, pp. 42–45. Sandow, K. (1990, July). Skipped stitches: Common sewing problems and solutions. Apparel Manufacturer, pp. 46–49.

Sandow, K. (1990, September). Seam puckering: Common sewing problems and solutions. Apparel Manufacturer, pp. 14–18.

Schwartz, P. (1984). Effects of jamming on seam pucker in plain woven fabrics. Textile Research Journal, 54, 32–34. Seiler, R. (1990, February). Seam puckering in shirt manufacturing. *Apparel Manufacturer*, pp. 34–39.

Simons, F. H. (1990, September). How to analyze your sewing thread problems. *Textile World*, pp. 76–78.

Technology of Thread and Seams. (n.d.). Glasgow: J & P Coats Limited.

Key Words

ASTM D 6193 air-entangled thread bobbin. bonded bound seam (BS) class chain stitch cloth point cocoons color fastness cones containers cops cording stitch corespun thread cotton thread cover stitch displacement pucker distortion edge finishing edge stitching fabric distortion feed pucker flat seam (FS) class gauge glazed cotton threads hand stitch jamming lapped seam (LS) class lock stitch looper lower thread mercerized cotton threads moisture pucker

monofilament thread

multithread chain stitch needle coolers needle heat needle thread ornamental stitching overedge stitch prewound bobbins put-ups rotary hook or shuttle S twist safety stitches seam. seam allowance seam classes seam depth seam elasticity seam flexibility seam grin seam heading seam length seam performance seam problems seam pucker seam slippage seam strength seam width sewability of thread single-thread chain stitch skipped stitches smooth multifilament thread soft cotton threads specialty fibers specialty threads spectrophotometer

spools spreader spun yarns standards related to stitches and seams stitch stitch classes stitch consistency stitch depth stitch length stitch size stitch width stitches per inch (spi) stitching stitching classes superimposed seam (SS) class synthetic, thermoplastic fibers tension pucker textured filament thread thread breakage thread costs thread lubrication thread packages thread size thread tension. ticket number (T) twist balance two-thread chain stitch ultrasonic welding United States Federal Stitch and Seam Specifications vicones or king tubes yarn severance Z twist

Discussion Questions and Activities

- Examine a pair of jeans, and determine how many different stitches, seam types, and thread types were used in producing them. Write specifications for them.
- 2. Examine the stitches and seams of a similar garment in three different price ranges: budget, moderate, and better. What are the differences and similarities among them? Examine stitch types, seam types, stitches per inch, seam width, and so on.
- 3. Examine a pair of better-priced ladies slacks, and determine what changes in stitches, seams, and thread could be made if it were to be knocked off. How does the selection of stitches, seams, and thread affect garment performance?

- Select a garment that was produced in another country. List all the factors relative to stitches, seams, and thread that needed to be identified before it was submitted to the contractor.
- 5. Discuss the factors that determine whether stitch and seam specifications are used when a garment is sent to a contractor. What are the advantages and disadvantages of using them versus not using them?
- Examine a men's dress shirt for seam problems. Identify as many types of seam problems as possible and try to determine the cause of the problem.

Equipment for Assembly and Pressing

OBJECTIVES

- Discuss issues related to equipment selection.
- Explain mechanization and automation relative to general- and special-purpose machines.
- Examine the basic components of sewing machines, work aids, and finishing equipment.
- Obscuss the effect of equipment on product quality and performance.

Why is it important to know about apparel production equipment? Many managers will never operate the equipment used in a production plant, but they have responsibility for getting products to market on time. Knowing the capabilities and understanding the complexities of various types of equipment is paramount to managing both products and plants.

Sewing machines, work aids, and pressing equipment are some of the tools used to convert materials to garments. Available equipment often determines how a product is made and can affect both quality and cost. Contractor selection is often based on whether they have appropriate equipment to produce the

product desired. Equipment can impact a plant's capacity, productivity, and potential for making timely deliveries. An understanding of equipment enables managers to develop better methods, be better troubleshooters, and increase productivity.

The number and types of machines and equipment in a particular plant depend on a firm's product line, volume of production, and degree of modernization. In today's markets, there are hundreds of different sewing and pressing machines, varying from manually operated, general-purpose-machines to highly automated, extremely specialized machines.

Stages of Technology Advancement

Mechanization is the process of replacing human labor with machines. Mechanization of the sewing process encouraged mass production of apparel. Sewing that had long been performed by hand could be done more rapidly by machine. By about 1900, most sewing processes could be performed by machine. Many patents for the stitch-forming devices and feeding mechanisms used in sewing machines today were issued in the 1850s and 1860s. Figure 15–1 is a photograph of the first sewing machine developed by the Union Special Corporation in 1881.

Automation is a state of operating without external influence or control. In manufacturing it is often viewed as highly desirable because it eliminates the potential for human error. Automated sewing systems are capable of feeding themselves cut parts from a stack, completing multiple sewing tasks, and delivering finished parts. Automated equipment may be cost-effective for some manufacturers, while the high costs of acquisition, installation, and maintenance are prohibitive to others.

Robotics are the most advanced form of automation. Robots are computerized, reprogrammable, multifunctional manipulators designed to move materials, parts, tools, or specialized devices through variable programmed motions for the performance of a variety of tasks (Rosenberg, 1983). Flexible reprogrammability is one of the hallmarks of robotic automation. This manufacturing flexibility differentiates robotics from fixed-purpose, hard-wired automation, which has to be torn apart and reconfigured for every new application (Lower, 1987).

Purpose and Operation of Equipment

Sewing and pressing equipment may be either general- or special-purpose. General-purpose machines are manually operated and can perform a variety of operations. Special-purpose machines are designed to perform a specific operation and more likely to be semiautomatic or automatic.

Figure 15–1
First Union Special sewing machine, developed in 1881.
Source: Courtesy of Union Special Corporation.

Manually operated general-purpose machines are the most versatile and easiest to repair. A versatile machine can perform a variety of operations on different types of materials. The more versatile the machine, the more skill is required of the operator and the greater the potential for variability. Not all operators produce at a consistent rate or quality level. **Manually operated equipment** requires the operator to control both the machine and materials. Control of the sewing machine includes start, stop, speed, stitch placement, and stitching pattern. Control of material includes positioning, guiding, repositioning, removing, and stacking the sewn part.

General-purpose equipment makes up 50 to 60 percent of machines used in U.S. sewing factories today. Apparel manufacturers that produce fashion goods or diversified product lines need versatile equipment that can be used to perform more than one operation with minimal adjustment. Plants employing about 50 operators are the most common plant size in the United States. These plants often need to be able to change style features and production methods with each new selling period and style. The ruffles that are an important fashion feature one season may be replaced by pintucks and pleats the next selling period. These operations can be done on general-purpose machines with appropriate attachments or on specialized machines.

General-purpose machines, however, are not always the most cost-effective for specific operations. They are often less efficient, less automated, and require more direct labor than specialized machines. The real efficiency of a general-purpose machine is the flexibility to be used for several different operations, which allows diverse styling.

SEMIAUTOMATIC SPECIAL-PURPOSE MACHINES. Semiautomatic machines perform a cycle or operation automatically, such as making a buttonhole. The operator places the materials or garment part, activates the machine, and the machine completes the cycle. Operators are required to position parts and start each cycle. Semiautomatic sewing equipment may use clamps, sewing guides, or templates to control the fabric for stitching. Stitch patterns may be controlled by cams or templates that mechanically guide the material through the sewing cycle. On some more automated machines, programmable stitch patterns and movement of materials are electronically controlled (see Figure 15–2).

For manufacturers with only a few product lines and high volume, basic goods special-purpose semiautomatic equipment can provide substantial benefits in efficiency. Manufacturers and contractors that can justify investment in specialized automated equipment have a strong customer base and specializa-

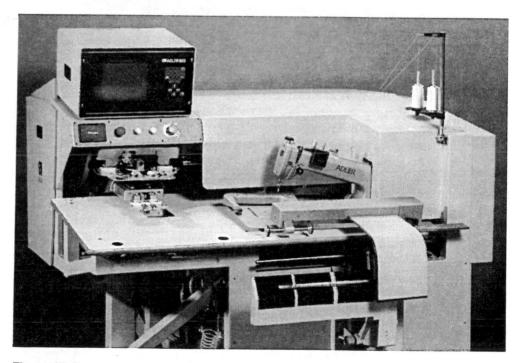

Figure 15–2
Computer-controlled stitchers offer maximum flexibility and numerous applications.
Source: Courtesy of Adler America, Inc.

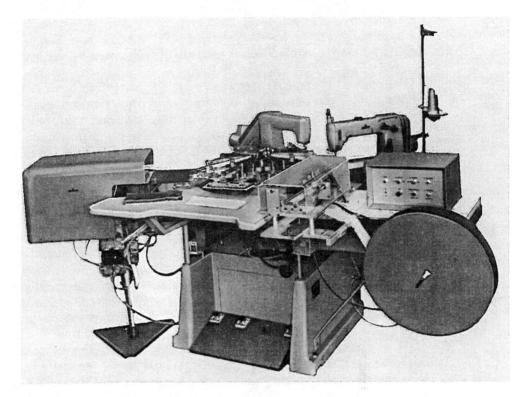

Figure 15–3
Automated workstation for cuff assembly.
Source: Courtesy of Adler America, Inc.

tion that ensures continuance of the specific product line. This keeps the machine in production to ensure the required return on investment.

AUTOMATIC SPECIAL-PURPOSE MACHINES. Automatic machines can complete an entire operation or series of operations with little or no operator involvement. In a fully automated operation, the machine performs the entire process. Automated equipment produces more consistent products with less labor input than manually operated equipment.

Automatic equipment is most often used by firms that produce basic or staple products, such as T-shirts, men's dress shirts, or jeans. For example, shirt cuffs may be assembled by automatic equipment from rolls of edge finished upper cuff pieces and stacked lower cuff pieces (see Figure 15–3). Rolled cuff parts are cut apart and paired with bottom cuffs, loaded under a template, and rotated counterclockwise as cuffs are stitched, trimmed, and stacked. The operator's primary responsibility is to load the parts, monitor the operation, and take action if the equipment malfunctions.

With fully automatic equipment, an operator may supervise the operation of several machines. As operations are combined and automated, operator training time may be reduced, and a full rate of production by the operator and the machine can be attained much faster.

Automated operations make it possible to maintain consistent production and quality levels over an extended period of time. Equipment is not subject to variables that affect human performance, such as personal problems, physical ailments, or fatigue. However, when automated equipment malfunctions, it may cause major delays in succeeding operations. Proper maintenance is essential to the success of its use.

ROBOTIZED MACHINES. Advancements in technology have moved machines toward robotization for many sewing operations. Equipment producers are seeking to meet the needs of apparel manufacturers for more flexibility and operator control of equipment through numeric controls and microprocessors. Microelectronics and microprocessors have brought about revolutionary changes in manufacturing technology and workplace design. Electronic controls give machines the capability of handling both information and materials. Electronic, computer-controlled machines are reprogrammable in terms of stitch patterns, cycle times, and operation of work aids. Machines are able to count stitches, detect bobbin run-out, and trim threads. Electronic control has introduced a new form of machine versatility that allows a general-purpose machine to become semiautomatic with specific programmable processes. At the same time, special-purpose machines can perform more functions and be more versatile through electronic control of the sewing functions.

Engineered Workstations

A workstation is the combination of equipment and work aids that are needed to perform a designated operation. A workstation may include the table or work surface, power supply, clamp stands, mobile work racks, pneumatic hoses, and the various work aids that are attached or built into the station (see Figure 15–3). Engineered workstations are designed to improve the ergonomics, efficiency, and safety of operations. Workstations may be purchased or custom designed by plant engineers or research and development departments. Well-planned utilization of space and equipment can be a major factor in efficiency and productivity of an operator.

Material handling consumes a major part of an operator's time. Stackers reduce handling, help maintain a smooth work flow, and make work easier for the operators. They vary with the type of the operation, size of the parts to be stacked, the type of machine, and work station layout. Pneumatic devices are frequently used for stacking. They may be linked to and controlled by thread trimmers, chain cutters, knee switches, foot controls, or optical sensors. In a highly automated plant, a work station may consist of several pieces of equip-

ment linked by electronic controls, operated in tandem, and monitored by one operator. The automated workstation is an important application of technology in what remains a primarily labor-intensive industry.

A basic sewing machine or sewing head, as it is sometimes called, consists of the fundamental parts required to form a stitch, sew a seam, or perform a specific sewing operation. The major components of a basic sewing machine include a casting, a lubrication system, a stitch-forming system, and a feed system. The speed at which a machine can operate depends on the engineering of the machine's components.

The Casting

The machine **casting** is the metal form that provides the exterior shape of the machine. Shapes vary with the bed type, the sewing function that is to be performed, and how piece goods are to be presented to the needle. The casting houses the internal workings, such as the gears, cams, and shafts, that operate the stitching and feeding mechanisms. The internal workings are extremely important to the operation of the machine and vary with each machine type, but these complexities are beyond the scope of this text. The casting determines the bed type and location of the cloth plate, type of lubrication system, and placement of the stitch-forming system and feeding system.

Bed Type

The **bed** is the lower surface of the machine under which the feed mechanisms and loopers are located. Sewing machines are frequently described by bed type. The most commonly used **bed types** are flat, cylinder, and post. The bed type may affect the type of sewing operation, the size or shape of the pieces to be sewn, and the rate of production. Figure 15–4 shows outlines of machine castings for different bed types. Flat-bed machines (Figure 15–4a), with a cloth plate mounted horizontally on the bed, are the most common. The **cloth plate** is the work surface, the part of the machine on which the fabric rests while being sewn. The flat surface provides a suitable surface for easy manipulations of flat, open garment components. Flat-bed machines allow manipulation of fabric on both sides of the needle for top stitching and lapped seaming.

On cylinder machines, the cloth plate is located horizontally at the upper end of a horizontal cylinder. There are feed-up, around, and off-the-arm cylinder bed machines. Cylinder or "open-arm" beds are used to sew tubular items such as sleeve circumferences or tubular neck bands (see Figure 15–4b). The fabric is

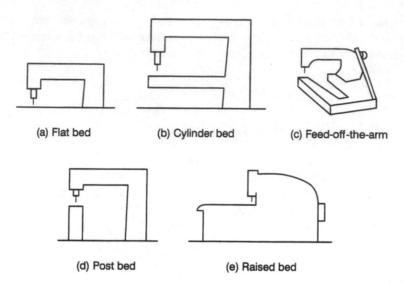

Figure 15–4
Sewing machine castings for different bed types: (a) flat bed, (b) cylinder feed-around-the-arm, (c) cylinder feed-off-the-arm, (d) post bed, and (e) raised bed.

maneuvered around the arm while seaming. Cylinder feed-off-the-arm beds are U-shaped, with one end of the U under the sewing head. They may be used for closing a tube such as sewing inseams of jeans (see Figure 15–4c). Post bed machines have the cloth plate attached horizontally to the top of a narrow post or small platform above the table surface (see Figure 15–4d). This type of machine bed is suited to sewing small concave curved sections such as those found on bras and shoes. Raised bed machines (Figure 15–4e) trim the edge of fabric in front of the needle just as it is sewn.

Lubrication Systems

Lubrication systems are prime factors in maintenance, downtime, efficient operation, and longevity of machines. The mechanical parts of sewing machines, like any other type of machine, must be lubricated (oiled) to reduce friction and keep mechanical parts moving freely. High speeds and temperatures increase the need for lubrication because of increased friction. The ease of lubricating and cleaning the machine, the amount of downtime needed for this maintenance, and the skill needed in maintaining the machine are major considerations when purchasing machines.

Manual as well as automatic lubrication systems are available. Manual lubrication systems require that operators or maintenance technicians oil machines on a regular schedule based on hours of use. Care must be exercised, particularly with manual lubrication systems, to prevent oil splatters and garment stains.

In automatic lubrication systems, the casting provides a reservoir for oil, and a pump force feeds the oil to appropriate parts. In recent years automatic, forced lubrication systems and oil filters have become standard equipment on most basic machines, and the amount of downtime required for maintenance has been greatly reduced. With an automatic lubrication system, an operator only needs to check the lubricant level gauge.

Stitch-Forming Mechanisms

Stitch-forming systems are the mechanical parts that, when correctly synchronized, form stitches and sew seams or stitchings. Many are specific to the stitch or machine type. The various stitch-forming mechanisms are (1) thread control devices, which include tensions and take-ups; (2) needles; (3) bobbins, bobbin cases, and hooks; (4) loopers; (5) spreaders; (6) throat plates, tongues, and chaining devices; and (7) threading fingers and auxiliary hooks. Correct stitch formation is dependent on the appropriate combination of these parts and their precise synchronization. Good maintenance is essential to maintaining the needed precision.

THREAD CONTROL DEVICES. Thread control devices include thread guides, tension devices, and take-ups, which are necessary to provide uniform thread flow. **Thread guides** control the positioning and movement of thread. Damaged or faulty thread guides can damage sewing thread and cause thread breakage and weak seams. **Tensioning devices** control the flow and tautness of thread as it travels through the stitch-forming parts of a sewing machine. Tension determines the balance and tightness of a stitch. Tensioning devices consist of a pair of tension disks, a spring, and thumb nut that can be adjusted to control the ease with which thread passes between the disks.

Compare thread tension to hand-tying a knot. Until the strands forming the knot are pulled, it does not take shape and has no holding power. If pulled too tight, both appearance and performance are affected, and strands may break. In stitch formation too much tension may cause thread breakage or puckered seams; too little tension allows slack and excessive looping, and loose stitches that will not hold. Tension needs to be adjusted when thread, fabric, and/or needles are changed.

Thread take-up controls the supply of thread required to form each stitch. It gives extra thread to the needle to form the stitch but takes it away to set the stitch.

NEEDLES. Needles carry the thread through the fabric so a stitch can be formed. Proper stitch formation is dependent on the formation of a loop of thread below the fabric that can be picked up by a hook or looper. Review the discussion of needles in Chapter 14.

Lower stitch-forming devices are shown in Figure 14–1 in Chapter 14. They include the hook found on bobbin cases of lock stitch machines and loopers on all others. A hook is a rotating device encompassing the bobbin case that picks up the needle thread loop to form a lock stitch. If the hook misses the loop, no stitch is formed. Precision and timing are critical to stitch formation. Loopers may carry lower threads to interlock with needle threads or other looper threads. Loopers on the 100 class machines do not carry thread but hold and elongate the needle loop until the next needle penetration. Loopers have a set motion pattern that must be synchronized with the needle motion and feeding. Spreaders work in conjunction with a looper to assist loop formation. They move thread but do not carry thread. Threading fingers move the cover threads back and forth in forming the 600 class stitches.

Stitch tongues or chaining plates are pointed metal extensions that may be part of or attached to throat plates. Stitch tongues are essential for the formation of the three-dimensional stitches (400, 500, and 600 stitch classes). Tongues vary in length and shape depending on the requirements of the specific stitch type and operation. A long, thin pointed tongue is needed for tight, close stitching such as a rolled edge, while a flatter, wider tongue is used for flat seaming.

The Feeding System

The material-handling components of a machine are often referred to as the **feeding system.** For a precise line of stitches to be formed, fabric must be moved through the stitch-forming area of the machine with accuracy and precision. The feeding system controls fabric movement. It usually consists of three parts: the presser foot, the throat plate, and the feed mechanism. Each of these parts has many variations in shapes, sizes, and functions. They are specific to the machine type, number of needles used, types of attachments used, and types of operations. They are parts of a system and must be compatible. If one is changed, the other parts must be changed to make the system work effectively.

PRESSER FOOT. The **presser foot** is the upper part of the feeding combination that holds the fabric in place for the feeding action and stitch formation. The presser foot, which is attached to the presser bar, controls the amount of pressure placed on the fabric as it is fed through the machine. The amount of pressure can be adjusted for the sewing speed and fabric type and weight. Higher speeds may require more pressure to control the movement of fabric. **Flagging** occurs when the fabric rises and falls with the needle action. This interferes with stitch formation. Flagging can be prevented with more pressure and a smaller needle hole in the presser foot and throat plate.

A basic presser foot may be constructed as a single unit or hinged to facilitate movement over bulky seams. The most common type is the flat presser

foot, which consists of a shank that attaches to the presser bar and the shoe that rests on the surface of the fabric. Figure 15–5 shows the basic parts of a presser foot.

Variations in the basic presser foot occur in the shoe parts, which include the sole, heel, and toe. The *sole* is the surface that is in direct contact with the fabric, which may be smooth, toothed, channeled, and so on. The *toe* is the forward portion of the shoe that is responsible for holding, guiding, and positioning the unsewn fabric. The *heel* is the back portion of the shoe that is primarily responsible for holding fabric and retaining its established position for the feeding and stitching action to take place. Each of these areas of a presser foot has many variations that are adapted for specific operations.

There are well over 100 different types of presser feet and each is specific to function. Some of the possible modifications of presser feet are short toes for sewing curves, long toes for long straight seams, offset soles for stitching along raised edges of fabric (patch pockets and collar edges), channeled soles for fitting over bulky lapped seams, solid narrow feet for sewing close to raised edges or zipper chain, and so on. Some of the more specialized feet contain other operational parts. Presser feet are uniquely designed for different sewing operation and can be changed readily, but they must be coordinated with other feeding and sewing parts.

THROAT PLATES. **Throat plates** are removable metal plates attached to an adapter plate or throat plate support, directly under the needle. Throat plates support the fabric as the needle penetrates to form the stitch. Throat plates have openings for needles and lower feed devices. The appropriate size and shape of the throat plate varies with the machine type and its specific function in the stitch-forming process. The number and size of openings in a throat plate depend on the number, size, and action of needles and the number and location of feeds.

Figure 15–5
Parts of a presser foot.

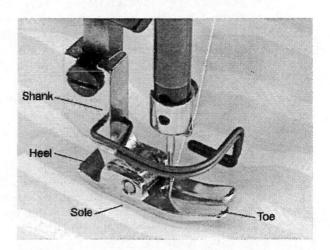

Throat plates are interchangeable and must be compatible with other stitchforming and fabric-carrying parts in order for stitches to be formed properly.

FEED MECHANISMS. **Feed mechanisms** control the direction of fabric movement and the amount of fabric movement for each stitch. There are continuous feeds, intermittent feeds, top feeds, bottom feeds, and simultaneous feeds. Feed mechanisms affect stitch length and the rate of travel. Many feed mechanisms are specific to the type of machine, while others are specific to the operation.

Most machines have bottom-drop oscillation feeds called **feed dogs** that rotate in an elliptical pattern below openings in the throat plate. Feed dogs (feed teeth) rise above the throat plate and carry the fabric toward and away from the needle and drop down and away from the fabric as the needle descends into the fabric to form a stitch. Feed mechanisms must be synchronized with needle motion so fabric is moved only when the needle is rising and completely out of the fabric. Feed dogs are a major part of most lower-feed systems. Variables are tooth height, shape, angle, width, number of rows, number of teeth in each row, and the placement of the rows.

Feed dogs can be changed to suit a specific operation, type of seam, and type of fabric. Fine feeds (20 or more teeth per inch) will cause less damage than larger teeth that are more widely spaced. Rubber feed dogs may minimize damage on delicate fabrics, while larger metal teeth are suitable for more rugged materials.

Performance of feed dogs is also dependent on the amount of pressure from the presser foot. Feed dogs and presser feet should be selected to complement each other. The wrong combination of feed dogs, presser foot, and amount of pressure can cause skipped stitches, uneven stitching, and damaged fabric.

The drop-oscillation feeding action of feed dogs depends on a presser foot to hold the fabric and a throat plate to give support to the fabric while the stitch is formed and the material moved. This system can be set up to provide two different functions. It can carry both layers of the seam at the same rate, or it can be geared to feed each layer at a different speed. **Differential feeding**, when engaged, will overfeed the lower ply of fabric as it is sewn to the top ply. This type of feed is used for shirring and easing sleeves, shirring a skirt to a waistband, and so on.

Top feeds can be used with feed dogs or operate independently of bottom feeds. Top feeds may be needle feeds, puller feeds, rotary feeds, or walking-foot feeds. Foot feeds (walking feet) may be more powerful and are used for even seaming of heavy or bulky fabrics. There are some systems that operate with alternating top and bottom feed. Use of both top and bottom feeds may be necessary when joining multiple plies of some fabric types. In Figure 15–6 the top feed moves the top ply while feed dogs move the lower ply. Ideally both top and bottom plies are moved at the same rate. If there is too much pressure on the top ply, it may not move at the same rate as the lower ply, and feed pucker may occur and the top ply will end up longer than the bottom ply.

Figure 15–6
Lock stitch machine with a puller feed and folder attachment used to form welting for zipper insert to be used in a book bag.

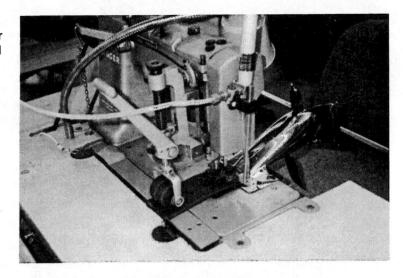

When multiple layers are to be sewn, use of only a top feed or bottom feed may cause ply shift, which occurs when one ply feeds through faster than the second ply and causes plies to be uneven at the end of the seam. This is an undesirable characteristic that can cause feed puck and poor fit. Some fabrics and seam types are more prone to this problem than others. When sewing knitted fabric or plaids, a combined top and bottom feed ensures even ply length and alignment of fabric match lines.

The specific combination of feeding components tailors a machine to handle a particular sewing task. If the sewing operation and/or fabric change, a different combination of parts may be needed. Feeding systems have changed greatly with the evolution of the sewing machine. Automated machines may be equipped with a different set of parts due to the operation of the machine and the material handling. As new machines develop, the feeding systems are among the first parts to change.

Speed Potential

Machine speeds are measured in revolutions per minute (rpm). Speeds are controlled by the ratio between the power pulley diameter and the motor pulley diameter. An operator controls motor speed with a treadle or foot pedal. The treadle is also used to brake the machine by heeling back. Speeds are stated in revolutions per minute (rpm), which are the equivalent of stitches per minute (1 rpm equals 1 stitch). Home sewing machines have the potential to operate at about 500 stitches per minute, while basic industrial or "power" lock stitch machines have the potential for approximately 5,000 stitches per minute. Many machines are now available with high-speed potential, sewing up to 9,000 stitches per minute.

Potential machine speed is identified for all models of machines. However, operators must be able to utilize the speed while maintaining quality standards. High-speed sewing can best be utilized on garments with long, straight seams where speed potential can be maximized. Higher speeds can generally be used on lighter-weight and natural fiber materials, whereas slower speeds are needed on heavier-weight materials and synthetics. The critical factor is to have the capacity for speed that is best suited to the product line, operator skill level, and method of production.

Work Aids

Work aids are labor-saving devices used to simplify an operation, reduce handling, increase productivity, improve work quality, and reduce operator fatigue. Many work aids have been developed to facilitate the use of basic equipment and make it more adaptable to specific operations. Carefully selected work aids can often produce significant savings.

Work aids can be purchased, created by research and development departments, or developed by engineers, mechanics, and technicians on the production floor. Work aids may be used in all types of operations including cutting, sewing, and finishing, but they are most widely used in the sewing room because of the accuracy and labor intensity required. The possibilities are endless, and only a few of the more common aids are covered in this text.

Some work aids depend on manual involvement by an operator. Others may operate mechanically or by pneumatics or electronics. These include separate devices, attachments, and machine options.

Separate Devices

Separate devices positioned in the work station are frequently used to facilitate operations and for materials handling. These may include bundle trucks or carts, stands for positioning bundles so they are easily accessible to the operator's grasp, bins or racks for easy disposal of parts when sewing is completed, or snips for cutting thread. Clamps are helpful in maintaining orderly stacks of parts.

Attachments

Attachments are primarily mechanical work aids that can easily be added or removed from the machine or work station according to the requirements of a particular sewing operation. Attachments may be stationary, swivel, slide, or pivotal in order to be engaged and disengaged from the area of operation. Attachments often assist an operator in guiding, positioning, folding, and regulating the materials during the sewing operation.

Guides are designed to facilitate alignment, accuracy, and consistency in positioning and stitching the fabric. They may provide both a tactile and visual focal point for an operator. The principle of tactile response can be compared to driving on a curbed road. The driver becomes sensitive to the position of the wheels relative to the curb. Contact with the curb is a sure indicator of being too close. For manual operations, using both tactile and visual senses is preferred. Use of tactile guides may increase the rate of production, but visual alignment is needed to develop accuracy. In most cases guides, which may be attached to the casting, cloth plate, bed, or presser foot bar, are adjustable and changeable.

Positioning attachments are designed to guide, fold, or preposition the materials as they are sewn. Positioning attachments are used to facilitate formation and sewing of various types of seams, edge finishes, and trims. They are frequently custom made to suit the width of the trim and thickness of the fabric. They may be used to prepare and position bindings, piping, stripping, and other trim to be included in seams or to cover seams.

Folding devices are used to position trim just in front of the needle (see Figure 15–7). For example, bias strips can be applied by drawing the binding off a roll above or to the side of the machine and through a folder and tensioning device before reaching the needle. The folder, which is an open-ended funnel, causes the edges to turn to the underside as it passes through to the needle. The exact position of the attachment on the cloth plate may be a factor in how bias strips or other trims are applied.

Attachments may also be used to fold various types of edge finishes and trims, including hems. **Hemmers** may have open or closed action. Open-action

Figure 15–7
A folding device is located in front of the needle for easy positioning and accuracy of stitching.

Source: Courtesy of

Source: Courtesy of Phaff-Pegasus, Inc.

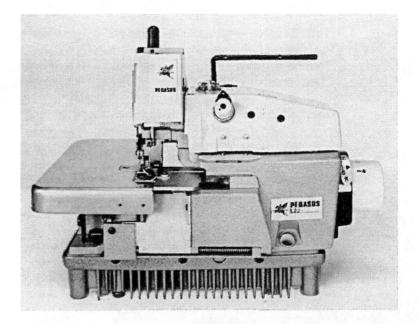

hemmers are needed for hemming tubular goods so the operator may be able to disengage the garment and quickly position another.

Metering devices and cloth pullers are regulating devices that can be installed on many machine types. Elastic or trim may be drawn from a reel and fed through a metering device that applies tension, based on a predetermined ratio of band to finished seam. This provides a consistent amount of elastic with even stretch throughout the waistline.

Shirring is gathering a fabric. A special attachment called a blade shirrer is needed when the center ply of three plies of fabric is to be gathered while the outer plies remain smooth. Blade shirrers feed the fabric that is being gathered by pushing the fabric with the serrated free end of the blade. Knife tucking or pleat tucking is similar to shirring but with small knife-edge folds. Shirring and tucking may also be done with special-purpose machines, special presser feet, and differential feeds.

Machine Options

Machines can be ordered from a manufacturer with a variety of built-in options that will reduce the mental, visual, and physical demands on an operator. Built-in options may perform the same functions that can be manually operated with mechanical devices. Pneumatics, microprocessors, microphotoelectronic sensors, fiber optics, servo motors, and stepping motors have made it possible for machines to control parts of operations. These automated features can be linked to produce customized sewing equipment to improve efficiency of specific operations. The following discussion includes pneumatic and electronic options, cutting devices, and needle and stitch devices.

PNEUMATIC OPTIONS. **Pneumatic equipment** is operated by high-pressure compressed air that drives the mechanisms. Because the air is enclosed in plastic tubing, dirt cannot get in. As a result, pneumatic devices are less affected by lint from materials, abrasion from sizing, oil from machinery, or vibrations created by high-speed sewing. Pneumatics are widely used to operate work aids such as thread trimmers and wipers, chain cutters, and positioning and stacking devices.

ELECTRONIC OPTIONS. **Photoelectric sensors** and **fiber optics** instruct machines to change functions instead of depending on operators to react. For example, the end of a garment piece is determined by a photo sensor and sewing is stopped at a precise point. If the operation is top-stitching a collar, this enables the operator to pivot the fabric and continue stitching, which produces a consistent line of top stitching. Or if a shoulder is being taped, a machine may count so many stitches beyond the end of the piece before engaging an impact cutter to cut the tape and thread.

Electronically driven servo motors allow manufacturers to customize machine and motor functions and achieve a much higher degree of control over the

sewing operation. Some of the functions controlled by servo motors are needle positioning, automatic back tack, stitch counting, thread trimming, thread wiping, and bobbin run-out detection.

Stepping motors are very adaptable and can be programmed to move both forward and backward at precisely the same speed fabric is fed. They are widely used to power pullers, elastic and rubber feeders, edge guides, and other similar devices. Stepping motors make it possible for the machine to control more of the operation, therefore simplifying many operations while providing consistent results.

CUTTING DEVICES. **Thread cutters** are widely sought options that reduce production time and eliminate manual thread clipping. They may be activated by heeling back on the foot control or by sensors. On some machines threads are cut below the throat plate, and a **wiper** pulls the remaining portion of thread out of the way in preparation for the next operation. This system allows the operator to dispose of sewn pieces and position the next item without manually having to use snips or hand-pull the threads against a cutter. Many of the 400, 500, and 600 class machines have chain cutters and latch-back devices built in because the stitch chains formed by these machines should not be broken by hand-tearing action. **Chain cutters** sever chains in such a manner that the stitch is secured against unraveling. Stitches formed on these machines cannot be cut as close as lock stitches, and some thread chain remains. Latch-back beginning devices secure the initial segment of thread chain at the beginning of the seam, which creates a neat, more secure seam with no thread tails.

Fully automated thread-cutting systems are controlled by sensors. This type of cutting system may consist of a specially constructed presser foot with a hinged knife to cut thread or sensor-controlled knives below the bed that are actuated at the completion of a seam. This type of thread cutter is utilized to eliminate thread waste as well as to improve sewing efficiency.

Tape cutters may be used with the application of neck bindings, shoulder reinforcements, elastic, lace, and so on. As stitching is completed, photocell sensing devices detect the end of the piece and automatically engage the cutter. This device may also activate stitch counters that control the knife and the amount of binding stitched off before the next piece is started. Tape may be cut at the beginning and end of the garment piece. Machine options of this type allow a smooth even flow of sewing and minimizes handling and waste.

NEEDLE AND STITCH DEVICES. Many machine options are designed specifically for aiding in the formation of the perfect line of stitches such as needle positioners and stitch pattern regulators. **Needle positioners** allow operators to predetermine the needle position at stops, up (in the raised position) or down (penetrating the fabric). A needle bar set to stop in the down position will always place the needle in the fabric when the machine stops, unless the thread cutter is engaged. This allows the operator to pivot the fabric around the needle for

accurate stitching of corners and sharp points without disrupting the stitch pattern or having skipped stitches. With this mechanism the hand wheel does not have to be used to set the needle in the fabric to maintain a continuous line of stitching. Stopping in the up position allows the operator to have both hands free to maneuver the fabric for quick removal of the completed item and fast placement of the next one.

Programmable sewing offers versatility and increased product consistency. Microprocessors and floppy disks control needle positioning and other needle functions that enable easy pattern changes. Special machines can also be programmed for additional functions.

Pressing Equipment

Pressing is the application of heat, moisture, and pressure to shape, mold, or crease fabrics, garments, or garment parts into the geometric forms intended by their designers. Pressing may be done during assembly to facilitate other operations and improve quality or as a final finishing process. There are many types of pressing equipment, some versatile and others that are specific to the type of operation. Selecting the appropriate equipment for the fabric and operation is important to garment quality and appearance.

Pressing equipment is used to prepare components for stitching and to set the shape in completed garments. **In-process pressing** or underpressing is used to crease, shape, and/or smooth components for more accurate seaming. Sharp edges on garment components increase accuracy in sewing. **Finish pressing** or off-pressing adds the final shape to seams and garments. Without finish pressing even the most well-executed seams will not have a pleasing appearance.

The time, temperature, pressure, and types of mechanical devices that are used for pressing depend on (1) the types of materials used, (2) the shape or form that is desired in the final garment, and (3) the degree of permanency needed. The equipment used for pressing is designed to control the heat, moisture, and pressure applied during the pressing operation. Some equipment is designed to mold or shape the garment.

Elements of Pressing

Heat is needed in most pressing processes to soften fibers, stabilize, and set the desired shape. Temperatures must be selected to suit the fibers, yarns, and fabrics used in a particular style. Sources of heat include heated surfaces and steam.

Steam (moisture) is the fastest means of transferring heat into the fabric. Steam is created by heating water in a pressure/boiler. The higher the pressure, the hotter and drier the steam. Effective use of steam reduces the time for

pressing and the amount of pressure required to shape the garment. Different fabrics require different amounts of moisture and heat; thus, the amount and dryness of the steam are critical to the effectiveness of the pressing operation. Excessive moisture may cause shrinkage and color bleeding and must be used under controlled conditions.

Pressure is applied to alter shape and increase the permanency of the molding or creasing. The amount and type of pressure needs to be appropriate for the fabric characteristics and style. Too much pressure may distort fabric surfaces, flatten textures, and create permanent garment and/or fabric damage. Pressure may be applied by a mechanical device or steam. Mechanical pressure requires a combination of solid surfaces such as tables, bucks, or irons to mold the garment. Mechanical pressure is specified by the amount of force or pounds of pressure per unit of time. When a buck press or shaping device is not used, air or steam pressure depends on the shape of the garment as the mold. Air or steam is blown into the garment to expand it to its full size while heat and/or steam are applied. Air or steam pressure is determined by the amount of pressure at the point of contact with the garment over the time steam is applied.

Controlling the elements of heat, steam, and pressure to suit the materials and styling of the garment is part of the adjustment needed for quality pressing. The amount of pressure and the time of pressure application can be minimized by drying and rapid cooling the garment during the pressing process. Moisture and heat are extracted by the use of a vacuum return system that extracts steam as it penetrates the fabric. The vacuum pulls the steam through the fabric, thus drying and quick-cooling the fabric to set the new shape.

Basic Pressing Equipment

Over the last hundred years, pressing equipment has undergone considerable change. In the 1890s men's suits were pressed with gas-fed irons weighing as much as 20 pounds. Gas was fed by a rubber hose to the center of the iron and then ignited to produce heat. With this system a presser could press 10 men's suits in a 10-hour day. The effectiveness of the pressing job then, as now, depended on regulating the time and temperature of the application of heat, moisture, and pressure. Control of these conditions depended on the skill of the presser.

The old adage "Necessity is the mother of invention" describes the evolution of pressing equipment as well as other segments of the industry. A tailor's apprentice that injured his arm is given credit for inventing a pressing machine that reduced the physical demands of pressing and incorporated the principles of pressing applied today.

Types of Pressing Equipment

Solid-surface pressing equipment uses a firm surface to apply pressure while steam and heat mold the fabric, garment, or garment parts. Pressure may be applied through rolling action, gliding action, or compression. Solid-surface pressing equipment consists of buck presses, irons, blocks, dies, rollers, collapsible forms, and creasing and folding blades.

Buck presses are commonly used by manufacturers of slacks, skirts, and jackets as well as by most dry cleaning plants. Components of a buck press include a lower buck and a complementary moveable head with a linkage system, buck padding, steam and vacuum systems, frame and table, gauges, and manual or automatic controls for steam, vacuum, heat, and pressure (see Figure 15–8). Buck presses may be used for in-process pressing and finish pressing depending on the requirements of the garment.

The actual pressing devices are a lower buck and complementary head that move in a scissor like pattern. Bucks vary in length, width, and contour. The lower surface, or bed buck, is usually in a fixed, horizontal position and supports the garment during pressing. The head is attached to the lower buck but is mobile. The head moves down, when activated by the operator, to cover the material as it rests on the bed buck. Steam is released and drawn through the garment by the vacuum system. When the head is released, it returns to an open position. Timing of steam and vacuum applications are critical to a quality operation.

Buck padding serves to distribute steam evenly, reduces the impact of steam on the fabric, and provides a soft resilient surface for the fabric. Padding protects the fabric from shine due to high pressure and the hard surfaces. It also acts as a baffle to prevent uneven steam pressure or high ejection velocities, which may cause steam spots on the fabric being pressed. Some fabrics are more prone to these problems than others. Adjusting the amount of padding to suit the fabric improves the quality of pressing.

Iron pressing is a manual molding operation in which pressure and heat are applied with a flat contact surface. The iron-pressing work station consists of an iron, power line, bed buck, and an iron support system. In most cases the pressing combination also contains a steam and vacuum system. Systems may be portable or stationary. The primary difference between iron pressing and buck pressing is that the **iron**, which serves as the head, and the bed are not linked. Irons have flexible positioning, which is the responsibility of operators. Also with this type of pressing, the only pressure that is applied is what the operator places on the iron. The pressing station shown in Figure 15–8 includes an iron that can be used on the bed buck.

Irons vary in weight and sole plate dimensions and characteristics depending on the type of pressing operation, fabric, area to be pressed, and quality specifications of the operation. Irons often have support systems to facilitate handling and reduce operator fatigue. In many cases irons have a ceiling suspension system and swivel action so an operator only has to position and/or guide the iron and does not have to lift it. At the completion of the operation, the iron only needs to be released and it will retract into position while the operator positions a new item. Irons are used extensively for underpressing operations and are more versatile and mobile than other types of pressing units.

Figure 15–8
Buck press used for pressing a wide variety of garments, including skirts, slacks, and jackets.
Source: Courtesy of Sussman Automatic Steam Products Corporation.

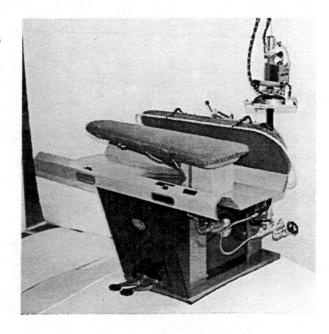

Bed bucks used with iron pressing also vary in size, shape, and occasionally surface contour. On side seams and inseams, slack manufacturers may use long narrow curved bucks that resemble hip curves. This type of buck, when used with an iron with a complementary shape in the sole plate, facilitates seam busting of slacks. Newer bed bucks contain multiple surfaces and varying levels in order that several parts of a garment may be pressed without repositioning (see Figure 15–9).

Irons are the most commonly used pressing device. They are used extensively for in-process pressing and shaping component parts as well as final pressing of certain garment parts.

Block or die pressing is a molding process that establishes a product's conformance to a form. Block pressing may change the surface characteristics and dimensions of a product. The fabric or product is placed on a fixed form (die) or block before pressure, heat, and/or steam are applied. Block pressing may be used by hat and glove manufacturers to shape and mold their products. Another form of automated die pressing is used to fold and crease patch pockets and pocket flaps. An operator positions the component over a die and engages the machine, and folding blades fold and hold the edges to the underside for creases to be set. This may be used in tandem with automated sewing to stitch the pocket in place. Die presses may also be used to shape and mold collars, collar stands, and cuffs.

Form pressing equipment is used primarily for the final pressing in garment production or for renovating garments in dry cleaning plants. Form presses are made in the approximate shape as the finished garment. The expandable/collapsible bags made in the approximate form of the finished

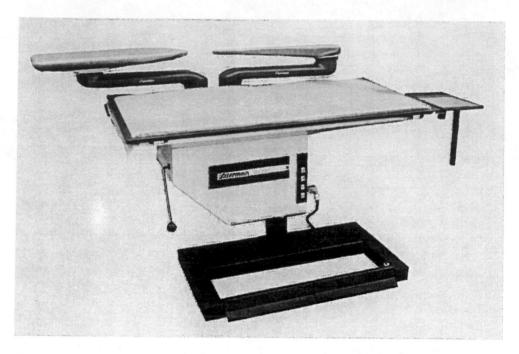

Figure 15–9
Vacuum pressing table with multiple surfaces for flexibility and easy garment placement.
Source: Courtesy of Sussman Automatic Steam Products Corporation.

product are the most common type. Steam is forced from the inside of the form through the garment while the form expands to fill all the space inside the garment. This gives the garment its final form and shape. Form presses are designed to reduce the amount of positioning and repositioning time. The entire garment is pressed with one surge of steam. This type of press smoothes garment fabric, but it does not set creases. Figures 15–10 and 15–11 show two different types of form presses with devices that make them specific to certain product lines and flexible to size variation of the product.

Steamers are pressing machines that use only steam to mold and smooth the garment. The major types of steamers are steam jets, steam guns, steam puffs, and steam tunnels or chambers. These devices may be used either to form and stabilize garment shape or smooth the surface of the fabric.

Steam tunnels or chambers are used for finish pressing. Garments are dewrinkled within a chamber by the average pressure of the circulating steam. Steam chambers may operate intermittently as racks of garments are loaded and unloaded or continuously with garments carried by rail or conveyor. In some conveyorized systems, garments may be carried over the nozzle of a steam jet in order for the garment to receive the full force of the

Figure 15-10

Form press for dress shirt finishing that presses and shapes an entire shirt, including collars and cuffs.

Source: Courtesy of Paris Manufacturing Co., Inc.

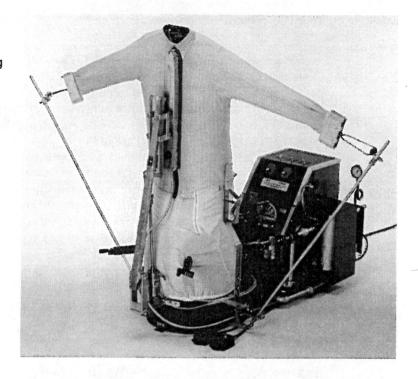

Figure 15-11

Form press or pants finisher with shaping blades and contourtopping device.

Source: Courtesy of Paris Manufacturing Co., Inc.

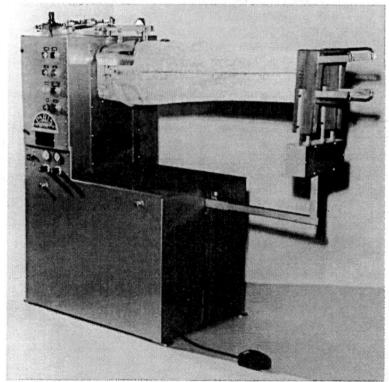

steam pressure. Some steam tunnels have drying chambers that use dry heat to extract moisture from the garments before packaging. Steam tunnels are used for pressing finished garments that do not need creasing or molding of any kind. "Steam tunnels drastically reduce labor costs and process garments at a rate of 1,200 to 3,600 units per hour" (Technical Advisory Committee, 1992).

Boilers, steam generators, and/or vacuum systems are essential parts of any pressing system as they generate the steam and air pressure that is required. The quantity of steam has a major impact on production cycle time and the appearance of the finished garment. These systems are available in various sizes and capacities and for various power sources. The safety controls and efficiency of these units are major concerns in purchasing equipment. The cost and time required for producing steam contribute directly to the cost of operating the pressing equipment and the rate of production. The type of units used and the specific requirements of these units are often unique to the plant and the equipment they operate. Without them, the system could not operate, but their complexities and operation are beyond the scope of this text.

Technological Advancements in Pressing

Advancements in finishing technology focus on several areas: (1) greater versatility, (2) more precision in determining exact pressing requirements of fabrics and finishes, (3) improved quality, and (4) energy savings. Greater versatility is needed to service the wide variety of fashion garments a manufacturer produces over an extended period of time. This may be accomplished with a variety of interchangeable bucks that are designed for specific garment shapes and a greater range of settings suited to a wider variety of fabrics. Self-contained units are moveable workstations so components can be pressed while in a modular production line.

Microprocessors with a wide variety of settings can control factors such as conveyor speed, steam and air volume, and temperatures. Computers determine settings and control the processing so that each garment can be treated in the exact same manner. Carousel pressing combines several pressing operations that one operator can complete at one workstation with minimal handling and control.

Energy costs are high, and many equipment manufacturers have concentrated efforts to improve the energy efficiency of the pressing systems. This includes things such as increasing the insulation to prevent heat loss, self-contained systems so the source of heat and steam is closer to the pressing unit, and the inclusion of vacuum systems to reduce the amount of heat and steam needed for effective pressing.

In some new pressing equipment, the steam generator and pressing devices are included in a self-contained unit that makes it portable in the plant. Advancements in buck pressing include more automation, with less operator handling and control. Automated buck presses control the amount of time, temperature, and pressure for the steam application and the vacuum cycle. The head releases automatically when the determined amount of time lapses. This guarantees equal exposure to steam and extraction for each garment. With manually operated presses, the operator controls the time of exposure.

Steam tunnels may be automated, too. The steaming, drying, and degree of exposure may be controlled by microprocessors to provide consistency throughout the operation (see Figure 15–12).

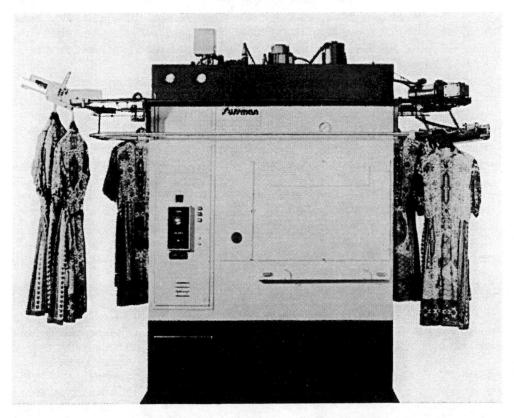

Figure 15–12

Tunnel finisher that carries garments through a steam chamber for final finishing. Steam is used to remove wrinkles without the application of surface pressure.

Source: Courtesy of Sussman Automatic Steam Products Corporation.

Summary

Garment production involves use of a broad range of sewing machines, work aids, and pressing equipment. Equipment may be general-purpose or highly specialized, manually operated or automated. Sewing is dependent on synchronized operation of stitch-forming parts and the feeding combination. Quality and efficiency of sewing operations may be affected by selection and use of work aids, engineering of workstations, and degree of automation. Garment quality, cost, aesthetics, and performance are affected by finishing. Pressing, a common finishing process, uses heat, steam, and pressure to shape, mold, and crease garments. Irons, special types of bed bucks, and buck presses are frequently used in underpressing operations. Die presses, form presses, steam tunnels, and various types of steamers are used for final pressing.

References and Reading List

Lower, J. (1987, May). Robotics advance softly. Bobbin, 28(9), 106–113.

Rosenberg, J. M. (1983). Dictionary of business and management. New York: Wiley.

Technical Advisory Committee of American Apparel Manufacturers Association. (1992). Arlington, VA: Author.

Key Words

attachments
automatic machine
automation
bed
bed buck
bed type
block or die pressing
boilers
buck
buck presses
casting
chain cutters
chaining plates
cloth plate

cloth pullers
differential feeding
feed dogs
feed mechanisms
feeding system
fiber optics
finish pressing
flagging
folding device
form pressing
general-purpose machines
guides
heat
hemmers

hook
in-process pressing
iron
iron pressing
loopers
lubrication systems
manually operated equipment
mechanization
metering devices
microprocessors
needle positioners
photoelectric sensors
pneumatic equipment
positioning attachments

presser foot
pressing
pressure
robotics
separate devices
semiautomatic machines
shirring
special-purpose machines
spreaders

stackers
steam
steam generators
steam tunnels
steamers
stitch tongues
stitch-forming system
tape cutters
tensioning devices

thread cutters thread guides thread take-up throat plates top feeds vacuum systems wiper work aids workstation

Discussion Questions and Activities

- Select a specific type of equipment and search the trade press for ads promoting the specific type of machine or work aid.
 Determine (a) how many similar products were advertised, (b) the specific features being promoted, and (c) the type of manufacturers the ads are directed toward.
- Examine several ads or diagrams for sewing machines. Identify the major sewing parts and describe how the part would facilitate the sewing operation.
- Tour a local dry cleaning plant to see the operation and use of the various types of presses in molding and reshaping garments. Determine how the elements of pressing are applied in garment finishing.
- Discuss the relationship of garment construction to specific problems in dry cleaning and pressing.
- Chart a comparison of industrial pressing and sewing equipment with pressing and sewing equipment designed for home use.

PAIRT WAY

Findings Management

Chapter 16 Support Materials

Chapter 17 Closures

Chapter 18 Trims

chapter ()

Support Materials

OBJECTIVES

- Oiscuss types of support materials, their characteristics, and use.
- Analyze the functions of interlinings, linings, and other support materials.
- Examine the contributions of support materials to quality, cost, and performance of apparel.

Support materials are used to enhance the appearance and performance of garments. They include interlinings, linings, adhesives, tapes, shoulder pads, sleeve headers, and collar stays. Fashion trends create the demand for different types of support materials. For example, soft shoulder suits require entirely different characteristics in interlinings than structured, squared shoulder suits. Styles that require a specific shoulder shape one season may be out of fashion the next. Thus, designers and producers of interlinings have to work together to develop the appropriate materials to support and retain the appearance the designer wants. Decisions made during product development determine how the designed shape of a style will be supported and/or enclosed.

Support materials seldom are mentioned on labels so the consumer may not be aware of their presence and use. Most of them are hidden in the structure of the garment and are taken for granted. Often the first time a consumer may be aware of the support materials is when they do not perform properly. Support materials must be compatible with shell fabrics and other materials in the garment if an acceptable appearance and appropriate performance are to be

maintained over extended periods of use and care. Selection and application of the appropriate support materials may have a major impact on the success and performance of the style.

Purposes of Support Materials

Support materials are important to the intrinsic quality of garments and may be used to provide shape, stability, reinforce points of stress, increase retention of the original appearance during wear and care, and/or conceal garment interiors. Several different types of support materials may be used in one garment, but not all garments require support materials. Support materials are often unique to the specific function for which they are developed. They are also available in a wide variety of physical characteristics, performance capabilities, and costs.

Manufacturers determine the need for support materials in a style during prototype development. Materials should be selected to serve specific functions. Selection may be based on material specifications, technical information, and product test results provided by suppliers. Producers of support materials often operate their own product testing laboratories to develop the technical data needed for specific applications and to test the performance of garment prototypes. Based on this information, suppliers of support materials may make recommendations for specific uses. Some manufacturers also do their own testing of prototypes containing specific support materials. Because of the constant change in styles, piece goods, and materials, it is sometimes difficult for the garment manufacturer to know the best options for every style. Therefore, they may work with vendors to make the most appropriate selection.

Inadequate and inappropriate support materials often become apparent after a period of display, wear, or cleaning when the original shape or appearance of the garment cannot be recovered. In such cases, less expensive or less appropriate support materials may have been used to reduce costs. As a cost-cutting alternative, support materials are sometimes omitted even though they may improve the performance of finished garments.

Compatibility Factors

Aesthetics and performance of a style are affected by the compatibility of the selected support materials with the piece goods and specific application methods. It is not enough to analyze the characteristics of each material. The materials will be used together and therefore should be tested together. **Compatibility factors** to consider are hand, flexibility, bulk, care, heat sensitivity, pressure sensitivity, common care characteristics, and application method (see Table 16–1).

Table 16-1

Compatibility factors for materials and considerations for evaluation.

Hand and Flexibility

Does the combination of materials produce the desired hand and flexibility?

Will they maintain a soft rolled line?

Is friction between the materials a problem?

Is stretch or stability needed?

Does the combination of materials produce an unwanted stiffness?

Bulk

Is there excessive bulk in seams and edge of the garment? Is filler needed?

Care

Do all materials require the same care process in laundry or dry cleaning?

Do any of the materials require special care procedures? Will materials withstand the same processing temperatures? Agitation?

Are materials stable to normal care procedures? What is the shrinkage potential of each material? Are all materials colorfast?

Heat Sensitivity

What are the heat set temperatures for each material? Will fuse temperatures cause shrinkage? Will shine occur with high temperatures? What dwell time can be tolerated?

Pressure Sensitivity

Are any of the materials changed in hand or appearance by pressure?

How much pressure can be applied without permanent distortion? Will pressure decrease loft?

Application Method

Is the application temporary, permanent, or durable?

Does the application impact the shape, drape, or contour of the style?

Does the application restrict the fit and/or movement of the style while on the body?

Does the application method impact other materials or components?

Shrinkage

Shrinkage is a particular problem with regard to support materials. Shrinkage is often attributed to moisture and/or heat and may not be apparent in the production process until final pressing. Sometimes shrinkage problems do not appear until garments are renovated by consumers. Thus, both interlining and **shell fabrics** (the outer layers of garments) should be tested to determine their shrinkage potential.

Differential shrinkage occurs when garment parts or different materials shrink unequal amounts. If one material shrinks more than the other, it will cause puckering and buckling of the garment component, as shown in Figure 16–1. Satisfactory performance is dependent on similar shrinkage of the materials used. Materials that are to be used together should be tested together.

Differential shrinkage can be a major cause of second-quality goods and customer dissatisfaction and returns. The cost of returns attributed to inappropriate support materials or improper applications is often greater than the cost of the defective product because dissatisfied customers are often lost customers. Problems occur because of inappropriate selection of materials, improper application, equipment that does not perform correctly, and lack of quality control or testing procedures.

Figure 16–1 Example of differential shrinkage.

Proper selection, application, and use of support materials influence the aesthetics, quality, performance, and cost of finished garments. Although it is not possible to cover all the variables, the following discussion focuses on the more commonly used support materials and the major factors affecting their performance. For purposes of this discussion, support materials are classified into interlinings, linings, and other support materials.

Interlinings

Interlinings are materials that are fused or sewn to specific areas on the inside of garments or garment components. They may provide shape, support, stabilization, reinforcement, hand, and improved performance for garments. Also called interfacings, particularly by the home sewing industry, interlinings are the most extensively used support material in ready-to-wear. Hundreds of different interlinings are readily available from suppliers that specialize in support fabrics, but interlinings with special characteristics can also be engineered to meet the needs of a specific product or manufacturer.

Selection of interlining with the appropriate properties for the fabric and style requires knowledge of the available products, the processes to be used, and an understanding of compatibility factors. As styling needs change, producers of interlinings may create new fabrications, weights, and adhesives. The soft unstructured look that has been popular during the 1990s does not mean interlinings are omitted; the characteristics have been modified.

Functions of Interlinings

Interlinings serve two major functions: (1) to produce and retain the desired aesthetic appearance and (2) to improve garment performance. Selecting the most appropriate interlining is not a simple task as many considerations need to be taken into account. Interlinings must be compatible with piece goods and other materials used in the style and be adaptable to the equipment used in the plant. Interlinings that enhance the hand of the shell fabric and create the desired aesthetic characteristics for a garment component may be the preferred choice. In other instances, performance during sewing operations, wear, or care may be more critical.

AESTHETICS Appropriately chosen interlinings provide the foundation for the shape and hand of garments and the stability to maintain the same appearance through use, care, and storage. Aesthetic standards are often subjective and vary by designers. One designer's interpretation of a soft silhouette may be interpreted as limp by another designer's standards. A firm with highquality standards may determine that shrinkage of either the interlining or shell fabric is unacceptable; other firms may allow tolerances for shrinkage if both the shell and interlining shrink the same amount.

Interlinings help form and maintain the hand, stability, durability, and resiliency of the shell fabric. **Hand** refers to the drape, stiffness, or softness of materials used in a garment. Interlinings are available in a variety of different hands and must be analyzed with the shell fabric when determining the best combination. Chemical composition, structure, sizing, coating, and/or resins may affect the hand of a fabric. An interlining may be stiff but lightweight without a lot of bulk. Stiffness is important to those garments, components, or fabrics that require a lot of support but little bulk. Tailored shirt collars need a stiffer interlining than soft rolled collars. Interlinings that are too stiff cause rolled edges to break and buckle. The blouse collar in Figure 16–2 has some obvious breaks because the interlining is too stiff. Some collar styles and lapels need a soft but not limp hand that will create a gentle smooth roll.

Different interlinings are often used for mass market merchandise than for more expensive garments produced for the better specialty markets. Mass market merchandise, which may be warehoused for extended periods, often has a stiffer, more resilient type of interlining to provide hanger appeal and to pre-

Figure 16–2
Example of buckled interlining.

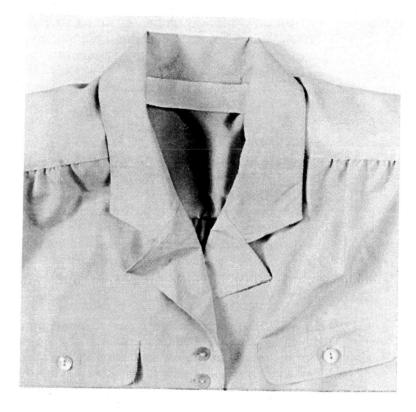

vent a limp appearance when displayed on the retail floor. More expensive garments may require a softer hand and different hanger appeal. Mass market merchandise and better upper end apparel often have different performance expectations in long term use and care.

PERFORMANCE Interlining performance may be evaluated from two different perspectives: performance during production and performance in the finished garment. Manufacturers may select certain types of interlinings to facilitate handling and improve the sewability of fabrics and garment parts. Interlinings may be used to reduce raveling and provide stability for the sewing process. They are frequently used under embroidery to stabilize fabrics for better executed stitching.

Performance of the garment may be enhanced by using interlining in small areas to reinforce points of stress and weakness and in larger areas to provide stability and shape retention. Interlinings may be used for reinforcement and extended durability of yokes, necklines, welt pockets, buttons, buttonholes, and so on. Interlinings are used in larger areas to provide body, improve resiliency, and increase durability of many low-count and lightweight fabrics. Whole fronts of jackets or coats are frequently interlined to provide a smooth, clean look.

Characteristics of Interlinings

Factors that contribute to the aesthetics and performance of interlinings are material (fiber) content, weight, and fabrication. Combinations of these factors produce the specific performance characteristics of particular interlinings.

FIBER CONTENT Fiber content contributes to the strength, hand, weight, and resiliency of interlining. Fibers may be blended to incorporate the best properties of each. Polyester and nylon fibers are often used in fiber webs, wovens, and knits to contribute strength, stability, and resiliency without adding bulk and weight. Monofilament nylon fiber may be used for stiffness and resiliency, producing a lightweight material with little bulk. This type of interlining is often used in waistbands of skirts and slacks.

The main contribution of cotton and rayon is softness and hand. Wool and hair fibers may be used in hair canvas to provide resiliency and compatibility with wool piece goods. Hair canvas is widely used in better tailored suits and coats because of its resiliency and shape retention. Identification of the fiber content of garment interlinings is not required by law, which makes it difficult for consumers to relate interlining performance to fiber content since the information is often unavailable.

WEIGHT Interlinings are available in a wide range of weights from 0.4 to 4.0 ounces per square yard. Heavier interlinings provide more support for heavier, more structured garments such as coats and suits. Lighter-weight interlinings

offer resiliency and some support, but they may provide a softer hand. Because the fashion trend in recent years has been to a softer, less structured look in men's and women's clothing, many newer interlinings are lighter weight. However, lighter-weight interlinings may provide less support, which may decrease the stability and resiliency of garments.

FABRICATION Interlinings are available in four basic fabrications: fiber webs, wovens, knits, and **foam laminates. Fiber webs** are the most widely used fabrication for interlining due to low cost, versatility, and the ease of engineering specific characteristics into the interlining. Fiber webs may have less strength but do not ravel in handling, which is a benefit during sewing operations. The performance of interlinings made of fiber webs is very closely linked to fiber content, fabric weight, and the fiber orientation in the web. Fiber web interlinings are most often found in washable garments.

Fiber webs are frequently made from lightweight, strong synthetic fibers such as nylon and polyester. The high strength and resiliency of these fibers are used in producing lightweight interlinings of varying hand and performance. High-bulk or high-loft interlinings are also produced as fiber webs.

Fiber webs may have fibers randomly distributed or oriented in the lengthwise direction. Randomly arranged fibers allow some stretch in any direction. This type of fiber web may be called *all-bias*, which means it does not have a specific grain orientation. All-bias fiber webs may be cut more economically but do not provide stability in areas of stress, such as buttonholes or waistbands (see Figure 16–3).

Lengthwise orientation of fibers in fiber webs provides lengthwise stability and crosswise stretch. Special consideration should be given to grain alignment in cutting and placement in a garment when using lengthwise-oriented webs. Lengthwise-oriented webs may provide appropriate stability for knit garments, except when horizontal buttonholes are used. If not stabilized, horizontal buttonholes on a knit fabric will stretch out and not recover.

Pilling is a problem often associated with fiber webs since fiber webs tend to have low abrasion resistance (see Figure 16–4). Abrasion from the garment itself may cause pills to form and continue to enlarge with use. Over time, pilling of interlining alters the hand of garment components and affects garment appearance. Pills tend to collect lint, and when used with light-colored fabric, they show through.

Woven interlinings may be produced from almost any type of fiber. This fabrication is usually the most expensive and subject to raveling and shrinkage. Unless used as true bias for greater flexibility or as straight grain to stabilize a bias component, woven interlining should be cut on the same grain as the garment component for satisfactory performance. When like grains of the shell and interlining are not used together, stretching, distortion, and poor drapeability of garment pieces can result. The performance of the interlining can alter the performance of the shell fabric. Woven interlining used in collars and front shirt bands may be cut on the bias to provide good flexibility and shaping as the collar rolls and bends, unlike the garment shown in Figure 16–2.

Figure 16–3
Examples of lengthwise-oriented fiber web (left) and randomoriented fiber web (right).

Figure 16–4
Fiber web interlinings that have pilled.

Knit fabrics used for interlinings are primarily warp knit tricots, raschels, and weft insertion raschels. The tricots and raschels used for interlining purposes are produced in varied weights with high stability and little or no stretch. They are used for strength in relation to weight, low bulk, and smooth hand.

Weft insertion raschel knits are used primarily as fusible interlining with adhesive applied to one surface. The weft insertion structure provides resiliency in the width, stability and control in the length, flexibility, and good drapeability with a soft hand. This type of knit interlining is commonly used with wool and wool-blend fabrics because of their loft, soft hand, and resiliency. They are also used with knit fabrics because of flexibility. Knit interlinings allow more tolerance for grain variation without affecting performance than woven interlinings.

Foam substrates may be laminated to shell fabrics or linings to improve body and increase stiffness, durability, and warmth. Foam, which also provides insulation, may be used as interlining on budget- and moderate-priced cloth coats.

Interlining Applications

There are two basic means of applying interlinings: sew-in and fusing. The method of interlining application must be integrated into the garment assembly process.

SEW-IN INTERLININGS **Sew-in interlinings** are sewn directly to the garment or garment component. They require extra handling and manipulation during the sewing process, which generally adds to the cost of the garment and the need for more skilled operators. Sew-ins require proper placement and accurate grain alignment. They may stretch or distort as sewn causing seam pucker and twisting. During use, sew-ins are more flexible, less boardy, and tend to have fewer performance problems than fusibles.

Sew-in interlinings may be attached at different stages during construction of components:

- Interlining may be sewn to a component part before construction of the component. For example, interlining may be sewn to collar bands and cuffs before the component is assembled. This is a separate operation that may be automated.
- 2. Interlining may be attached or inserted in a seam as the component is assembled. For example, interlining may be inserted as a pocket hem is turned and stitched.
- 3. A third option is inserting the interlining after the component is nearly completed. An example of this would be interlining placed at center front of a shirt but held in place only with buttons or buttonholes.

Sew-in interlinings may be completely secured along all edges, partially secured with stitching along one edge, or secured only by tacking or minimal

stitching in the center. The earlier the interlining is attached in the assembly process, the more secure it is likely to be. The more secure the interlining, the more structured the garment, the better its performance, and the higher the quality level, if application has been done correctly. The more sewing that is done to secure the interlining, the less distortion there is likely to be during additional sewing processes or during care of the garment. The more securely interlining is attached, the greater the risk that differential shrinkage will distort garment appearance.

Fusible Interlinings

Fusible interlinings are fabrications coated with some form of resin or adhesive that serves as a bonding agent to hold the interlining to the shell fabric. Substrates may be wovens, knits, or fiber webs. Fusible interlinings must be fused to shell fabric prior to the construction of components. The fusing process usually requires that garment pieces be individually matched with interlining pieces and fused together. Fused garment parts have more body, do not ravel, and are easy to handle in sewing.

Fusing is the process of bonding fabric layers by application of heat and pressure for a specific amount of time. The time required for fusing is called dwell time. The precision of the fusing process depends on three elements: heat that softens the resins, pressure that spreads the resin and forces it onto the fabric surfaces, and time needed for application of heat and pressure. Cooling time is also necessary to allow the resin to set. Fusing may require more direct labor initially, but it may also reduce handling and irregularities as garment components are assembled. Fusible interlinings make certain fabrics easier to handle, which may reduce labor and improve quality.

Fusing interlinings to microfiber fabrics may require different processing. Fabrics made from microfibers have much finer yarns and fibers than most other synthetic fabrics, and generally it is best to use interlining with the same polymer composition as the shell fabric and the lightest weight possible. Fusing temperatures need to be lower, pressure reduced, and dwell time increased for microfibers. Application methods should be tested on the actual fabric to be used. New innovations in interlining fabrications, adhesives, and application methods are continually being researched and developed for better compatibility and performance with new innovative fabrics.

Most equipment used for fusing differs from the equipment used for garment pressing and finishing. Types of equipment used to fuse interlinings include (1) roller presses, (2) flat-bed presses, (3) continuous pressing machines, and (4) irons. Most equipment used for fusing has complex controls for altering and monitoring fusing conditions. Roller presses are occasionally used for fusing interlining to piece goods prior to cutting. For flat-bed presses and continuous presses, garment pieces that are to be interlined are individually placed facedown on a tray or carrier, and fusible interlining pieces (which are cut slightly

smaller) are accurately placed on the pieces with the resin side against the back of the fabric. Shuttle trays are placed in the fusing machine or paper trays put on a conveyer to be carried to and through the continuous press machines. Fused garment pieces are stacked and bundled for additional assembly.

Continuous press machines have high productivity and controlled pressure and temperature, but they are costly to purchase and operate. A major requirement for successful fusing is setting the pressing equipment to the desired conditions and maintaining those conditions. Lack of consistency in fusing conditions (heat, time, and pressure) causes numerous problems for manufacturers and consumers. Microprocessor control units used in newer machines improve consistency of the fusing process.

Irons have limited use in fusing interlinings. They may be used for application of small pieces of fusible interlining to reinforce points of stress. The main problem with iron fusing is inconsistency of pressure, dwell time, and temperature. Roller presses are sometimes used for small parts with better productivity and more consistency in heat, time, and pressure than irons. Table 16–2 itemizes problems associated with the use of fusible interlinings.

Costs of Interlinings

When evaluating the costs of using interlinings in garments, the aesthetics, hanger appeal, quality, and consumer needs and expectations must be evaluated. There is no question that the use of interlining increases the cost of producing a garment, but lack of appropriate interlining may decrease its appeal and performance and make it less desirable. Interlinings require special equipment and extra handling and processing. The increased costs of materials, inventory, handling and production time, equipment, and quality control must be figured into the total cost of the garment.

Interlinings are available in a wide range of prices. Often interlinings with similar performance characteristics are available at different price points. Performance from the manufacturer's perspective examines the total cost of each alternative compared with the functions it serves. What matters is whether the interlining provides the characteristics for which the consumer is willing to pay. Consumers want flexibility and stability but not rigidity and bulk.

Application costs for interlining are often higher than the initial cost. Interlinings may be used in small amounts in small areas, but application may require individual handling and processing. In some instances sew-in interlinings are less costly to apply than fusible interlinings depending on the method of application, characteristics of the shell fabric, and the amount of automation that is utilized. Hair canvas may be used on tailored garments, but it may involve much higher labor costs. Fusible interlinings require special equipment, handling, and additional energy costs.

The cost of maintaining consistent quality may also be a factor in total garment costs. Fusible interlinings are particularly susceptible to inconsistencies

Table 16-2

Problems associated with use of fusible interlinings.

- Strike back is the penetration of resin through the interlining substrate. It causes resin to stick to the fusing press, conveyor, or shuttle tray. It can affect both cost and quality of fusing. It may be the result of too much resin for the type of fabric and interlining fabrication or too much pressure.
- 2. Strike through is the penetration of resin through to the face of the shell fabric. It may be caused by too much pressure, too high a fusing temperature, or too long a fusing time. This is a greater problem with sheer, lightweight, nonabsorbent fabrics than with heavier, bulkier, more absorbent ones. Strike through is the cause of many other problems such as color change, differential shrinkage, bubbling, poor strength, and boardiness. This is a common problem with microfiber fabrics because of the construction and weight.
- 3. Shrinkage may cause performance problems if one garment part shrinks because of application of fusible interlining and adjoining pieces do not shrink. This is a common problem with jacket fronts and facings. Often the high temperature needed for fusing causes the fabric to shrink. This may make accurate seaming impossible, create puckered seams, or cause puckered surfaces of shell fabric. With proper testing the amount of potential shrinkage of the shell fabric and interlining can be determined and adjustments made in patterns.
- 4. Delamination is the loss of bond between the interlining and the shell fabric. Resin, because it migrates toward heat, becomes embedded in the interlining substrate instead of the shell fabric, which prevents an effective bond between the two materials. The shell fabric may appear to be bubbled. Delamination may be the result of underfusing, overfusing, not enough cooling time, or incompatibility of resin and the shell fabric.
- Color change may be a temporary or permanent discoloration caused by the high temperatures and resins used in the fusing process. Certain types of dyes may change color with the application of high temperature.
- Bubbling occurs when the face fabric or interlining becomes puckered from delamination, poor bonding, differential shrinkage, uneven temperatures or pressure, and inconsistent use of resin.
- 7. Boardiness is another problem related to the inappropriate selection of adhesives used on fusible interlining. If resins liquefy and run together to form a resin coating instead of being retained in a sintered or dotted manner, a stiff hand is produced. This can be the result of overfusing, too much adhesive, and the application of excessive heat and/or pressure. This is a problem when the interlining distorts the shape of microfiber fabrics.

involving the materials, equipment, and fusing process. Extra quality control may be required to inspect the fused garment parts and test fusing equipment and performance of fused parts. Unacceptable quality of garments with sew-in interlinings may result from poor design, poor preparation in preassembly, inadequate training, lack of operator skill, or incorrect methods. Sew-in interlinings also may need quality checks, but this may be included with monitoring other sewing processes.

Linings

Linings are materials that increase aesthetics and performance by supporting and/or enclosing the interiors of garments or garment components. Garments may have full linings, partial linings, component linings, or no linings. Some mills specialize in the production and marketing of lining materials, which are sampled, analyzed, tested, and sourced similarly to other piece goods.

Functions of Linings

Linings may be used to improve aesthetics, performance, and comfort of styles. In many garments, linings accomplish all of these functions.

AESTHETICS Linings are used to enhance the aesthetic value of garments. Lining fabrics are available in fashion and basic colors, prints, and special weaves, which may be used to provide special visual effects. Lining fabrics are usually different than the shell fabrics, but in some instances the same fabric is used for the garment and lining. Sometimes designers choose to use signatures, logos, or brand names on lining fabrics to provide identification and differentiation.

Aesthetically, linings are used to conceal the back of shell fabrics and the inner construction of a garment such as seams, interlinings, and other support materials. This contributes to the hanger appeal of garments. Linings can also be a means of covering poor construction techniques and inferior materials. In the case of light-colored and/or lightweight shell fabrics, linings may be used to make the shell fabric look more opaque and have more body.

The hand of linings should complement the aesthetics of the shell fabric and provide comfort to the wearer. Linings need to be flexible and soft unless a firmer fabric is needed for support. Linings with a stiff heavy hand may be strong and provide support, but they may alter the drape of the shell fabric and fit of the garment. A stiff garment tends to push up instead of flexing with body movement. Stiff linings of filament yarns may also make rustling noises as the lining rubs against itself or the shell fabric during wear. This is often the case with taffeta linings.

PERFORMANCE Performance expectations of linings vary with product type and end use. Performance criteria for jacket or coat linings are quite different from the criteria for swimsuit linings. Factors that affect the quality and performance of linings include fabric characteristics, design and structure of linings, compatibility with other materials and garment structure, and suitability for end use.

Properly designed and constructed linings may extend the wear life of garments. Linings absorb the stress of body movement and activity, which prevents stretching and overextension of the shell fabric. For example, better-quality slacks and skirts are lined to prevent bagginess in the knees and seat areas. Linings are designed to be slightly smaller than the outer shell to absorb stress that occurs during use. Linings also reduce abrasion on seams and other support materials during use and care.

Linings also extend garment life by preventing hanger stress and body contact with the shell fabric. When used, linings are the garment part closest to the body, the layer that separates the body from the garment. This prevents absorption of perspiration and body oils that may deteriorate or stain shell fabrics. Linings also provide the structure for additional details or components such as internal pockets.

COMFORT Linings may provide tactile comfort, better garment fit, and thermal comfort for a garment. **Tactile comfort** is provided by the lining fabric if it is smooth, absorbent, or has a pleasant hand. The lining also protects the human body from the shell fabric, seams, and support materials that may be harsh or abrasive to the skin.

Linings improve **garment fit** by absorbing the stress of tight fit and movement, thus allowing the outer garment to hang free and relaxed. Linings of smooth filament yarns provide **slip ease** of movement by reducing friction with other garments the individual is wearing. With slip ease, dressing is easier and garments are less restrictive. For this reason fabrics with filament yarns are commonly used, especially for sleeve linings.

Coat and jacket linings usually have vertical ease pleats at center back and horizontal ease pleats at hems to allow freedom of movement. These are particularly important if the lining is entirely sewn down. Higher-quality gar-

ments tend to have deeper ease pleats.

Linings may also be used to provide **thermal comfort**, warmth or insulative characteristics. Lining materials may be selected for breathability or insulative properties. Comfort of a water-resistant garment may depend on the absorbency and breathability of the lining material used. For example, nylon mesh may be used for lining to allow for more air circulation.

Garments may reduce body heat loss by creating wind resistance, using layers to trap air, and/or using insulative linings. Wind resistance may be achieved by using high-count, tightly woven linings or shell fabrics. Fabrics may be coated with resins to improve their wind resistance.

Insulative linings are designed to trap body heat and may be inner layers of multiple-layer constructions. Free-hanging insulative linings may be permanently sewn in or removable. Materials such as down or synthetic fiberfill are commonly used for quilted constructions. Insulation materials are available with a soft or firm hand to support various fashion silhouettes—thin, medium, and lofty. Insulative linings may be covered by another lining to improve aesthetics and/or performance.

Characteristics of Linings

Factors that contribute to the performance of linings are fiber content, fabrication, finishes, hand, and drape. Choice of lining materials relates to the intended end use, characteristics of the piece goods, performance expectations, quality level, and cost.

FIBER CONTENT Fiber content is a major determinant of fabrication, aesthetics, performance, and durability of linings. The synthetic fibers, nylon and polyester, are used for durable lightweight linings. Nylon and nylon/spandex blends are used in linings for active sportswear (football pants, swimsuits, jogging shorts, and so on) providing high strength, elasticity, and minimal weight and bulk. Synthetic fibers are clammy, do not breathe, and allow buildup of static electricity. Fiber modifications with **wicking** properties that increase comfort and reduce static buildup are sometimes used for lining fabrics. Fabrics with wicking properties transfer moisture away from the body surface to the outside of the garment for evaporation.

Acetate is used extensively for lining coats, jackets, skirts, and slacks, although its performance may be short-lived. Acetate is less expensive than some other fibers when cost is a major consideration. It takes a press well, has pleasing hand and drape, retains its shape, and is frequently available with printed designs. However, acetate may be subject to fume fading if not solution dyed. Acetate also is a very weak fiber, does not withstand stress and abrasion, and needs to be dry cleaned. Acetate linings often wear out long before the garment shell. Acetate blends are also used in warp knits for many of the napped or brushed linings found in moderate- and budget-priced windbreakers. Nappedback satins found in women's and men's dress coats are often acetate blends.

Cotton and rayon are used in linings because of their hand and absorbency. Filament rayon makes a comfortable lining that may be used in better suits, uniforms, and other garments, but rayon also has low abrasion resistance. Cotton lining is most often a fashion fabric used as part of a component or to match shell fabric. Cotton is absorbent and comfortable, but with less slip ease because of staple fiber structure. Cotton or rayon may be blended with polyester to improve resiliency and abrasion resistance.

Wool is an excellent insulating material and is used only as an insulative lining. Wool materials are often used to line gloves and the bodies of topcoats. If a wool lining is used in a coat, other slick materials are often used to line the sleeves and upper part of the garment to provide slip ease. Many other materials such as acrylics and quilted fabrics provide the same amount of insulation for less cost and less weight.

Silk is used for its aesthetic appeal, comfort, and status in better-tailored garments. Silk is lightweight, smooth, drapeable, and absorbent, but its cost prohibits common usage.

Weight Weight of lining fabric affects wearing comfort, thermal comfort, compatibility, opacity, hand, and drapeability. Generally, lighter-weight linings may be selected for wearing comfort, hand, or drapeability, while the heavier linings are selected for their support, shaping characteristics, and/or warmth. Heavy weight is not necessarily required for warmth. With synthetic materials, such as polyester fiberfill, it is possible to have high bulk for warmth without heavy weight.

FABRICATION Linings are available in many different fabrications. Fabrications may affect the drape, opacity, durability, and thermal comfort of the lining and garment. Lining fabrications range from the lightest-weight, balanced, plain-weave fabrics to the bulky quilted or pile fabrics. Common fabrications found in jacket linings are satins and twills. These provide slip ease, comfort, flexibility, durability, and wind resistance with high-count and filament yarns. Skirts and slacks are best lined with balanced plain-weave fabrics due to their flexibility and strength.

Support, Enclosure, and Quality

The amount of lining used for a garment depends on the type and style of garment, quality level, type of shell fabric, expected garment performance, and cost limitations. Garments with **full lining** have completely enclosed interiors, a finished appearance, and protection for the garment shell. Full or partial linings may be assembled as separate components and partially or completely attached to the garment shell (see Figure 16–5). Linings need to be long enough to be functional, but not too long to extend beyond hems and edges of garments.

Partial linings enclose only a portion of garment interiors but provide some degree of protection and comfort. They are used to protect garment components or shell fabric in areas of high stress or high contact. They also provide slip ease in sleeves and across shoulders. Partial linings are a means of reducing costs of materials, but reductions in labor costs depend on the methods used. Partial linings in skirts may protect only the back that is stressed during sitting, or it may be a complete front and back lining but only long enough to cover areas of stress.

Lining may be part of garment components or used to enclose interiors of components. Components may be lined in garments where full or partial linings are not desired. For example, shirts may have lined yokes and pockets. Manufacturers of jackets may choose to line only sleeves, shoulder areas, fronts

Figure 16–5
Examples of quality variations in fully lined skirts.

and sleeves, or any other combination that will best meet consumer needs and/or cost limitations.

Unlined garments have less structure, are more casual, and do not depend on the aesthetics of the lining for hanger appeal. Many types of products are never lined and do not need to be, such as sweaters, underwear, T-shirts, and jeans. Linings if properly constructed tend to increase the quality of typically lined products such as jackets and skirts. A gathered cotton skirt with a lining is regarded as higher-quality than the same skirt without a lining even though it may not need the lining to prevent stress. Lined garments hang and drape better.

LINING STRUCTURE Linings should be designed and structured similar to the garment shell. Linings do not need to be cut to the same identical shape as the garment, but they must be complementary and usually maintain a similar grain orientation. In some cases, the lining needs to be identical to the outer garment. If the outer garment has design ease, the lining is more functional if it is designed with a basic shape that complements the fashion silhouette. A full-pleated skirt needs only a smooth-fitting A-line-shaped lining. This lining structure avoids the bulk of the pleats but provides smooth fit that absorbs the

stress and allows the skirt pleats to hang smoothly. A fitted lining in a garment with **styling ease** needs to be carefully proportioned to minimize fitting problems that may limit the sale of the style. Linings that are too short or too tight cause garments to pucker or draw up.

Lining Applications

Lining construction may be judged by the same standards as garment assembly. Standards may vary according to the quality level, operator skill, and equipment. Seam busting, seam finishes, and in-process pressing are part of producing better-quality linings. Linings are installed primarily by machine, but better-quality garments may have some operations done by hand.

Full linings may be completely assembled and attached by machine. In jackets, when full linings are completely attached by machine, an opening is left in one sleeve lining seam for turning the garment. Completely attached linings avoid twisting that might occur during wear, but the lining must fit the garment accurately and have adequate room for movement. Completely attached linings make it difficult for retail buyers and consumers to evaluate the intrinsic construction and to alter the garment.

Better-quality jackets and coats may have hand-set sleeve linings. The sleeve lining and garment body lining are assembled and attached as separate components. One of the final processes is the attachment of the sleeve lining at the armhole, which is often done by hand. This is a traditional method of assembly that prevents the lining from shifting across the armhole and shoulder area. Generally this method provides better fit and durability but results in costlier garments.

Full or partial linings that are partially attached are usually attached at the front, neck, waist, or upper part of the body and are free-hanging at the lower edge. In some cases, lower edges of these linings are held in place by lining tacks or long-thread chains. This allows flexibility but keeps the lining in place. Coats, women's jackets, and skirts are often constructed in this manner. In some garments, the lining forms a whole separate component that is attached only at the waist as may be found in jogging shorts, men's swimwear, and skirts.

Linings of garment components are usually installed as the components are assembled. Linings may be a means of enclosing seams or hems.

Costs of Linings

The major costs of lining garments are materials and labor. Material costs vary with the fabrication and yardage requirements. Labor costs vary with the number of steps needed to complete the garment lining, the number of hand operations, and the finishing processes used. The design and production of complete linings can contribute a significant proportion to production costs. Linings that do not perform according to consumer expectations may incur the high costs of returns.

Other Support Materials

Other support materials—including adhesives, shoulder pads, sleeve headers, tapes, and collar stays—provide special support needed in specific types of garments. Trims, closures, and thread may also provide support to certain areas of garments as well as aesthetics or functional use.

Adhesives

Adhesives may be used as support materials or as bonding agents to hold support materials in place. They are used to stabilize, support, and/or bond layers of fabric together. Adhesives are synthetic, thermoplastic resins with a variety of chemical compositions and performance characteristics. The resin content of adhesives includes polyamides, polyesters, and polyethylenes, each with different heat sensitivities and bonding powers.

Adhesives are selected according to specific end use requirements and fusing equipment. Each type of resin requires a different fusing temperature or glue line temperature for a secure bond. Glue line temperature is the temperature reached between the fabric and adhesive at the time of fusing. Bond strength refers to the strength of the bond achieved by the adhesive. A peel test determines bond strength by measuring the force required to separate the fused materials. Bond strength may be tested after fusing and again after care procedures.

Adhesives and resins, which may be permanent or temporary, may be added to either piece goods or interlinings. Adhesives or resins may be (1) applied to the surface of substrates to create fusible interlinings, (2) applied as webs or filament threads between two layers of fabric, or (3) applied as polymer paste or powder directly to the back of shell fabrics. **Resins** are applied to a substrate as even or randomly printed dots, randomly sintered or sprinkled deposits, or as even uniform coatings. Dot size and number of dots may vary with the degree of bonding needed and the weight of the substrate. Bonding security is affected by resin type, amount of application, pattern and uniformity of application, compatibility with fabrics, and the fusing process. Too much or too little resin can affect bond strength and hand of the fabric.

Resins applied as webs or filament fibers between layers of fabric act as a glue to hold fabric pieces in place. Resins may be used as glues to stabilize fabric pieces for appliqués or other sewing. A resin web may also be used to hold hems in place without use of thread. Adhesives or resins are also used to hold seams and hems in leather garments and to hold components of leather garments for sewing.

Direct application or **direct stabilization**, as it may be called, stabilizes garment pieces without the use of a separate interlining. The resin is mechan-

ically applied to the back of garment parts and set by radiant heat. Improvements in the technology of resins and adhesives suggest increases in the use of direct stabilization because of economy and efficiency of application.

Shoulder Pads

Shoulder pads provide support and shape for the desired shoulder silhouette. They also add hanger appeal to garments displayed in retail settings and protect garments from hanger stress over long periods. Shoulder pad shapes are influenced by fashion and may be thick, thin, rounded, oblong, crescent shaped, or domed. Shoulder pads may be designed especially for raglan sleeves, set-in sleeves, kimono sleeves, suit coats, blouses, and so on.

In a well-designed garment, the shoulder pad is an integral part of the design. The designer and/or merchandiser decide on the look that is appropriate for each style, and the selected shoulder shape is placed on the body form as the initial garment is draped. This is the best way to get the desired look. Alternatively, designers may make selections from samples shown by vendors or work with a vendor in designing new shapes. Some apparel manufacturers who are more cost-conscious than style-conscious buy a single style of shoulder pad in large quantities and use the same pad for all garments. Shoulder pads provide hangar support for garments and enhance the store presentation, but often the style of the pad may not be suited to the garment style or its appearance on the body.

Shoulder pads for men's clothing are quite different from those used in most women's garments. Men's wear quality standards are often higher, and life expectancy for garments is often longer. Shoulder pads for men's clothing often are an integral part of garment construction and are critical to the aesthetics and performance of garments. Men's shoulder pads are made of a combination of different materials and are larger and more structured than those used in women's apparel. Shoulder pads for women's garments are made in a greater variety of shapes, sizes, and materials. Shoulder pad styles change as fashion silhouettes change; thus, shoulder pads for women's styles may change from one selling season to the next.

Garment manufacturers usually do not produce their own shoulder pads; instead, they order from firms that specialize in shoulder pad production. One manufacturer may produce as many as 4,000 different variations of the basic shoulder pad (Pettit, 1990). Shaping materials form the shoulder pads, which may or may not be covered by other materials before installation in garments.

SHOULDER PAD MATERIALS The most common materials used for shoulder pads are foams, needle-punched fiber webs, fiber bats, and wadding. **Foam** is generally the least expensive material but often has the least desirable performance. Foams discolor due to aging, exposure to light, and the baking (oxidation) process used in their production. Foams also may distort easily with

high dryer temperatures. Foam pads are generally used in blouses and dresses because they are inexpensive and lightweight.

Needle-punched fiber webs are used as the basic shaping material in many types of shoulder pads for both men and women because they are lightweight, flexible, and less expensive than some other materials. Fiber webs are layered and shaped to provide the thickness and shape desired. Fiber bats and wadding are large sheets or bats of fiber. Bats and wadding may be used alone or as filler in combination with other materials.

Shoulder Pad Construction Shoulder pads are sewn, molded, fused, and cut. Decisions are based on materials, desired appearance, cost limitations, and compatible care procedures. **Sewn shoulder pads** consist of multiple layers arranged in a stepped manner to provide a sloped look and smooth blending of layers. Materials used in sewn pads may be polyester batting, needle-punched fiber webs, woven canvas, cotton or wool wadding, or any combination of these. Layers are stitched together to provide stability and durability through use and care. They are commonly used in men's wear because of their durability. Sewn shoulder pads are usually uncovered and used in structured garments with linings. They are time-consuming and require skilled operators to produce them; thus, they are often the most costly.

Molded pads are shaped to a preformed mold or die. Developing a new shoulder pad begins with designing the new shape and producing a mold that duplicates the shape. Once the mold has been developed, pads can be mass-produced in the desired shape in a process called baking. High-loft polyester bats are sprayed with a resin that acts as a binder and allows the fiber bat to be heat set in the desired shape. Bats are die-cut and then molded to the shape desired. The hand or stiffness varies with the baking process. The higher the temperature and pressure applied to the mold, the firmer the pad produced. For a softer shape, the temperature and pressure on the mold are decreased.

Molded pads have good resiliency, but resins tend to breakdown during dry cleaning, which can affect the shape retention of the pad. They are relatively slow to produce because of the molding process. Polyurethane foam may also be molded with a somewhat different process, but its use is limited due to the cost of the process and poor performance of the material.

Fused pads are made from layers of fiber web that are sprayed with resin and then spot fused to hold the pieces together. This is a fairly new process and faster to produce than the molded pad, which puts them at a lower price point. Care and use can weaken their structure and shape.

Cut shoulder pads require very little time to produce. Large polyurethane foam blocks are cut with an automated knife. This process can produce large quantities in short periods of time with very little waste. Needle-punched fiber webs may also be die-cut and covered to make an inexpensive pad.

SHOULDER PAD COVERS Many of the shoulder pads used in women's garments are covered in style-matching piece goods or a basic taffeta or tricot in basic colors. Many shoulder pad manufacturers provide the service of covering the shoulder pads if the piece goods are supplied. This is another instance when lead time must be carefully planned in order to have all materials available for garment production at the same time.

Shoulder pad coverings are a major cause of dissatisfaction with shoulder pads. If the covering shrinks, it crinkles the pad inside the cover so it cannot lie flat. Another problem occurs if the inner materials are not caught completely in the stitching. With the first washing, the inner material will fold and wad up, which makes the pad totally unusable. These problems can usually be remedied with better methods, proper testing to determine compatibility of materials, and better quality control procedures to ensure that pads have been sewn correctly.

Shoulder pads in garments depend on garment type and structure, styling, care procedures, quality level, price range, and the equipment used. The best-quality shoulder pads in coats, suits, and jackets may be permanently attached to the garments. They may be sewn or tacked to shoulder and armhole seams and covered with lining. Shoulder pads in blouses and dresses are minimally tacked to the shoulder seam and armhole seam. This often allows shifting during care, which may overstress the shell fabric and seams.

Removable shoulder pads are often attached to the shoulder area by means of a hook-and-loop strip. This enables consumers to remove the shoulder pads before care procedures. It also allows consumers to decide whether they want to use shoulder pads on any given day. With hook-and-loop attachment, the investment in materials and labor costs are greater for the garment manufacturer, but the benefit may be a better-satisfied consumer.

Sleeve Headers

Sleeve headers are an additional support material used in moderate- and better-quality tailored coats and jackets. Use of sleeve headers is a quality feature that adds primarily to the appearance of the garment, especially after extended wear and renovation. Sleeve headers support the tops of sleeves to provide a smooth hang over the arm. They are sewn to the top of the armhole seam and provide shape for the fall of a set-in sleeve. Sleeve headers are soft, flexible fiber webs or lamb's wool materials.

Tapes

Tapes are support materials used primarily for shape retention and/or aesthetics. Application of tape may be an intrinsic factor that affects garment quality

and performance, or it may add color and interest to a style. Tape may be used to stabilize seams with potential for excessive stretching that could permanently alter the shape or fit of the garment. However, a critical factor is the dimensional stability of the tape. Tapes that shrink cause garment distortion. Some firms preshrink tapes to avoid this problem.

Tape may be sewn into seams, used to cover seams or hems, or used as a separate garment component. Tape may be narrow twill fabrics (twill tape), knits, braids, woven bias, or strips cut from matching shell fabric. It can be as narrow as one-eighth inch or as wide as two inches. The fiber content of tape may be cotton, polyester, acetate, rayon, or blends of these fibers.

Tape is frequently used to prevent stretching along shoulder seams and neck edges of knit garments; provide shape retention of lapel edges, collar edges, necklines, and armholes of jackets; and trim plackets and other parts of garments. It may be used as a binding, incorporated in a garment component, or serve as a garment component such as the plackets on rugby shirts.

In many instances, tape is fed directly from a roll, through an attachment in front of the needle, and stitched directly to the garment as seams are sewn. On some garments, tape application is a separate step that requires extra handling and processing.

Collar Stays

Collar stays are support materials often used to build shape retention into structured collars of shirts and blouses. Plastic collar stays are available in various types, lengths, widths, and weights. Thin flexible collar stays may be superimposed on the front edge seam of the collars as they are sewn. They fold and become doubled as the collar is turned. Other flexible plastic stays are stitched through the center as they are attached to the interlining or under collar. This type of collar stay remains permanently attached to the collar.

Permanently attached stays are the fastest and least expensive application, but they may have performance problems. Stays that are stitched in place are susceptible to heat during care procedures and may cause excessive wear or abrasion of the shell fabric. Excessive heat may also cause distortion. The image of the collar stay may be pressed through to the top collar, or the stay may abrade the top collar with use and agitation in laundry.

Removable stays are found in higher-quality garments. The undercollar of better dress shirts is structured with two pieces that overlap to form a pocket with an opening through which stays can be removed and reinserted. Removing stays during laundry and cleaning prevents bending and permanent distortion.

Summary

Support materials are part of the intrinsic quality of garments. They include interlinings, linings, adhesives, shoulder pads, sleeve headers, tapes, and collar stays. Interlinings are used to retain the desired aesthetic appearance and to improve the performance of the garment. Performance is a concern both on the production floor and during use and care. Proper testing of prototypes can determine compatibility of materials and help avoid severe performance problems. Interlinings are used in garments at all price points, although fiber content, fabrications, and application methods may vary.

Linings may enclose interiors of garments, add hanger appeal, and provide comfort and protection. Linings are available in many different fiber contents and fabrications. Lining construction may be judged by the same standards as garment assembly. Garments may be unlined, partially lined, and fully lined lines with a performance decired.

depending on the performance desired.

Shoulder pads provide shape for garment silhouettes and are important to retain the desired shape. They are available in a wide variety of shapes, sizes, materials, and assemblies at different price points and quality levels. Application methods vary but impact consumer satisfaction. Testing garment prototypes is essential to anticipate potential problems. Testing only the support material is not adequate.

References and Reading List

Kozlosky, J. (1981, May). Strike back. *Bobbin*, 22(9), 90–94.

Pettit, K. (1990, January). Shoulder pads:
Better than ever, still not perfect. Apparel
Manufacturer, pp. 18–29.

Key Words

adhesives boardiness bond strength bubbling collar stays color change compatibility factors component cut shoulder pads delamination differential shrinkage direct application direct stabilization dwell time fiber bats fiber webs foam foam laminates

foam substrates full lining fused pads fusible interlinings fusing garment fit glue line temperature hand insulative linings interfacings interlinings knit linings molded pads needle-punched fiber webs partial linings peel test resins

sew-in interlining sewn shoulder pads shell fabrics shoulder pads shrinkage sleeve headers slip ease strike back strike through styling ease support materials tactile comfort tapes thermal comfort unlined wadding wicking woven

Discussion Questions and Activities

- Compare similar products at varying price points in retail stores and/or direct-mail catalogs. List and describe the support materials used, location, methods of application, and effectiveness in the product.
- Gather information on support materials by examining garment labels, hang tags, and catalog copy or by making inquiries to
- retail sales associates. Compare the quantity and quality of information available on the support materials.
- Analyze the support materials used in a specific garment from the upper-moderate or better price range. Determine changes that could be made in support materials that would help reduce costs.

Closures

OBJECTIVES

- © Examine different types of garment closures.
- Relate the selection and application of closures to aesthetics and performance of garments.
- Discuss the relationship of closure selection to garment quality.

Human body shape requires certain garment components to separate or expand so a garment that surrounds and conforms to the body or specific body parts can be put on or taken off. Expansion is built into garments through structural openings and elastic materials. **Plackets** are structural openings that are usually dependent on mechanical devices called *closures* to secure openings. **Closures** are fasteners, such as zippers, buttons, buttonholes, snaps, hooks, elastics, hook-and-loop tapes, and other devices used to open, close, and secure garments. Appropriate selection, correct application methods, and skilled workmanship result in properly working closures.

Purposes and Costs of Closures

Closures may be used as single or multiple fastening units or combined with other types of closures or trims. Closures contribute to garment aesthetics and performance of the style. The number, type, and placement of closures affect garment appearance, fit, comfort, durability, and care.

Aesthetics

Plackets and closures may be used to add interest, carry out style features, or enhance the piece goods and trims used in a garment. Closures may be selected to blend, create an accent, or support the overall ambiance of the garment. When closures are used as trim, simulated plackets may be designed to carry out a fashion or traditional look.

Specific styles of closures are traditionally used for certain garment types and become part of the aesthetics of the style. For example, metal zippers are used in jeans, and molded zippers are used in ski wear. Flat, four-hole buttons are customarily used on men's dress shirts and sport shirts. Some clothing manufacturers may use metal shanked buttons for jackets and blazers, while others use flat, four-hole, color-matched buttons. Even though closures may not be noticeable or obvious, a certain look is expected with certain garments and styles. Large contrasting buttons may seem inappropriate on men's dress shirts while they may be an important feature of women's blouses.

Performance

Performance criteria for closures may be established relative to garment design, quality standards, end use, and performance standards for other garment materials. Closures may allow the wearer to adjust openings for personal size or thermal comfort. Garments are usually designed to surround the body and accommodate body movement. Usually closures are subject to more horizontal stress than vertical stress because of the nature of body kinetics. When more than one closure is used, horizontal stress may be shared with other fastening units for greater strength and holding power. For example, a single fastening unit used on a waistband must absorb all the stress; all the strain is placed on one small area of shell fabric. When a skirt is closed with a zipper that is supported by both outer and inner buttons with corresponding buttonholes, the whole assembly is stronger. If one part fails, the remaining closures should hold the garment in place.

Costs of Closures

Closure costs focus on four main areas: cost of materials and inventory maintenance, labor costs for placket formation and closure installation, costs of purchasing or leasing specialized equipment, and cost of returned garments because of closure failure. For manufacturers of outerwear and sportswear, inventory management of closures is a major responsibility. It involves a large number of vendors and dozens of stock keeping units (SKUs) from each vendor. Variables include minimums, lead times, and order requirements, all of which may impact costs.

Closure failure can be attributed to faulty garment design, inappropriate selection of closures, faulty materials, incorrect production methods, poor sewing or application procedures, and customer abuse. Plackets that are too short or poorly placed impact performance of the closures and customer satisfaction. Construction that is not appropriate for the closure type, shell fabric, or other fasteners may cause excessive strain during use and result in closure failure. Poor design and incorrect installation methods may not be apparent until garments have been worn. This may put turnaround time for problems at 4–6 months after initial production. Meanwhile, a lot of garments can be produced with potential for closure failure. Thorough testing of prototypes can help to identify problem areas and support styling decisions.

Zippers

Zippers are mechanical slide fasteners. A zipper closes a placket when two rows of interlocking elements (teeth, scoops, or coils) are drawn together by a slider. Zippers allow garments to expand for dressing and to become smooth and fitted when closed. They may provide closer, smoother garment fit and accept more seam stress than buttons, snaps, or other closures. When used as closures, they are essential to the performance of garments since zipper failures often render garments unusable. "Probably no single element of a garment can cost so little but cause so much dissatisfaction among consumers when it [the zipper] malfunctions" (Apparel Quality Committee, 1985, p. 19).

Many zippers are also used for their aesthetic value such as those with elaborate or ornate pulls, decorative zipper tapes, or color-coordinated chains. Zippers that are used on lower ends of side seams in sweatpants and jeans allow expansion of lower pant legs over shoes or boots, but they may be more important from a styling/aesthetic perspective than from a performance perspective. The cut of the pant leg determines the use of the zipper.

Characteristics of Zippers

Hundreds of different sizes and types of zippers are available. For example, YKK, one of the world's largest zipper manufacturers, produces approximately 2,000 zipper styles in over 400 basic and 1,000 specialty colors in its Macon, Georgia, manufacturing plant (Smarr, 1987). Zipper selection may be based on

input from merchandising, design, production, and quality assurance with assistance from the zipper manufacturer. Factors that contribute to the aesthetics and performance of zippers include type, size, and fabrication of parts, selection, and application.

ZIPPER PARTS AND MATERIALS Zippers consist of four main parts: two stringers which consist of tape and half the chain, one slider, and stops (see Figure 17-1). Table 17-1 includes definitions of the basic functional parts of zippers based on ASTM D 2050-87, Standard Terminology Related to Zippers and diagrams of parts. The zipper chain consists of two interlocking stringers of teeth, scoops, or coils that lock or unlock with the movement of the slider. Metal chains may be stronger than continuous coils and are often used in slacks and jeans where durability and strength are required. Metal teeth, made of brass, nickel, steel, or zinc, are clamped onto zipper tapes. During zipper application, metal teeth may be removed without damaging the tape. This provides a space for stitching or bar tacking across the zipper. Teeth can also be pulled off the tape due to stress during use, meaning the zipper would have to be replaced or the garment discarded. Chains that do not rust or corrode are essential for garments that are wet processed, chemically treated, or garment dyed. Sliders will not operate on corroded zippers.

Figure 17–1
Parts of a zipper.

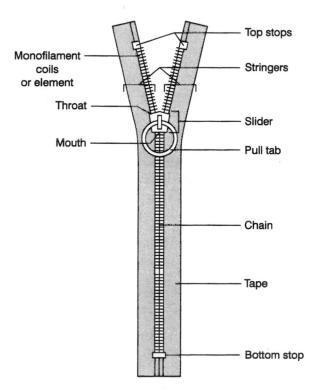

Table 17–1Zipper terminology based on ASTM D 2050-87.

Zipper Part	Definition
Chain	
Element	A device designed for interlocking, capable of being affixed along the edge of one of the opposing edges of two tapes and being engaged and disengaged with the movement of a slider
Continuous element zipper	A zipper consisting of two continuously formed elements; coils
Separate element zipper	A zipper consisting of two series of separately formed elements; teeth or scoop
Stringer	The tape, bead, and element assembly that constitutes one side of a chain
Chain	Formed by interlocking several elements of two stringers
Shoulder	The bearing surface of an interlocking element by which the chain is contained inside the flanges of the slider
Tapes	
Tape	A narrow strip of material to which the elements are attached
Bead	An enlarged section on the inner edge of each tape to which interlockable elements are affixed on a separate element zipper
Bead	An optional enlarged section of the tape located at the edge of continuous interlockable elements and against which the slider flanges bear
Sliders	
Slider	The part that opens and closes the zipper
Mouth	The opening in a slider that receives the chain
Pull	A part connected to a zipper slider used to operate the slider
Flanges	The edges of the slider formed to contain the chain
Flange lock slider	A slider with notches in the flanges that block the shoulders of the elements when the stringers above the slider are pulled apart
Automatic lock slider	A slider that provides involuntary, positive locking action on the chain when the pull is released
Pinlock slider	A slider that incorporates a projection on the pull that fits between adjacent interlocking elements of a zipper
Camlock slider	A slider that incorporates curled projection(s) on the pull that extend through a window on the slider to effect a locking action by pressing against the chain
Top and Bottom Assembly	
Stop	The device at the top and bottom of the chain or stringer that prevents the slider from leaving the chain
Bottom stop	A part affixed to both stringers immediately below, or over the chain
Top stop	A part affixed between or immediately above the interlocking elements on either or both stringers
Bridge top stop	A part affixed immediately above the chain, holding the tops of two stringers together
Nonseparable zipper	A zipper having two stringers that are permanently attached to each other at one or both ends
Separable zipper	A zipper fitted with special components at the bottom of a chain so as to permit complete disengagement and then reengagement of the two stringers

Chain made of synthetic materials, such as nylon or polyester, may have molded scoops or continuous monofilament coils. Synthetic chains are more flexible, cause less abrasion and snagging than metal zippers, and are more comfortable to wear in cold conditions. Synthetic zippers are also available in a much wider range of colors with the chain and tapes dyed to match. Molded synthetic scoops are an integral part of the tape so individual scoops cannot be removed without damaging the tape. Coil-type chains are available in varying sizes and degrees of strength. Coils can usually be pulled apart to remove fabric or thread caught in the elements, usually without damage to garment or zipper. However, coils may also separate during wear but can usually be reunited by operating the slider. Coil zippers that are folded or creased may be weakened and permanently separated at the point of damage.

Chains are available in varied widths and thicknesses. Chain width and fabrication affect holding power, zipper profile, and visibility. Zippers with wider chains have more holding power. A low-profile chain is flat and nearly smooth, which produces smooth plackets and reduces the potential for the zipper image becoming embossed on the shell fabric during pressing. A high-profile zipper chain has more depth and is raised from the tape.

A **slider** is the movable part of a zipper that disengages or interlocks the stringers to form a chain. Elements on separate zipper stringers enter the throat of the slider, are interlocked, and emerge from the mouth of the slider as chain (see Figure 17–1). Sliders must be compatible with the chain and placed correctly on the chain if the elements are to engage correctly. Sliders are usually metal, even though they may be used with synthetic chain, since metals are resistant to wear and heat distortion. Many metal parts are enameled to match the color of synthetic chains and tapes, but the enamel may wear or chip off during use.

Zipper sliders have different types of pulls and locking action. Zipper pulls are handles for moving sliders. They also contain the locking mechanism for some types of sliders. They may be small, large, flat, round, plain, ornate, or stamped with the logo of the zipper manufacturer or garment manufacturer. There are flange lock, automatic (auto) lock, camlock, pinlock, and nonlock sliders. Flange lock sliders prevent zippers from being accidentally opened by pressure on the stringers. Camlock sliders, used commonly in jeans, lock if the tab is in a straight up or down position and move easily when the tab is at a right angle to the zipper. Automatic lock sliders lock when the tab is in a down position, which allows the zipper to be closed with the tab in the down position but not opened. Pinlock sliders have a small pin or projection that fits between the zipper teeth. Pinlock sliders are used primarily on garments such as coats and sweatshirts and tend to give the most operating problems. Nonlock sliders do not lock in position and are used primarily on purses, backpacks, upholstery, and in areas without stress.

Improper handling and use by manufacturers and consumers may damage the locking device, teeth, or coils and cause sliders to malfunction. Too much force in pulling a slider can cause the slider to separate and cease to mesh the chain. Sliders can also be damaged by excessive pressure in the pressing operation at the factory or dry cleaners.

Zipper tapes are the substrate for attachment and support of the zipper chain. Durability of the tape is a major factor in zipper performance. Tapes may be cotton, synthetic, or fiber blends. Synthetic tapes are strong, lightweight, and tend to have less shrinkage potential. Tapes may be stable knits or narrow twill weaves produced in different widths. High-count woven tapes are stronger. Stress may cause the teeth to become detached from low-count tapes.

Zipper tapes that shrink cause puckered plackets and seams. Tapes may be treated with resins for compatibility with permanent press garments and for dimensional stability. Resin-treated cotton tapes may be semi- or fully cured for compatibility with shell fabrics. It is important to use semicured tape with semicured materials since fully cured zipper tapes may degrade with final curing of the garment because of double treatment of the resin on the tapes.

Zipper stops are essential in preventing the slider from advancing and becoming disengaged from the chain. They are needed at both ends of a zipper chain. They may be enlarged teeth, metal bars, staplelike devices that wrap the chain, a seam, or a line of stitching. Stops that are not tightly secured may not prevent the slider from advancing. This happens frequently with slacks when the wearer applies stress to the lower end of the zipper while stepping into the garment. If the stop does not hold, the slider continues to unlock the chain until the slider comes off and the chain completely separates. Bar tacks or back stitching across the chain are frequently used to support zipper stops at the closed end of zippers.

ZIPPER TYPES There are two main types of zippers: separable and nonseparable. **Separable zippers** consist of two completely separate stringers with a bottom assembly to reengage the zipper. Separable zippers are used for jackets and coats. Some separable zippers use two sliders so the chain can be disengaged from both ends. This arrangement may be found on car coats so that the wearer can unzip the coat from the bottom for more comfortable sitting. Separable zippers are purchased as complete zipper units because of the special ends required for starting the chain through the slider.

Nonseparating zippers open only in one direction and have a stop across both halves of the chain at one or both ends so that the slider will not run off the chain. Nonseparating zippers are used in pants, skirts, and dresses. They are available as complete zipper units or as continuous chain. A complete zipper unit is constructed to a predetermined length and consists of the chain and tape, slider, and stops.

Continuous chain is purchased by the reel and cut to the desired length as it is applied to garments. Sliders and stops are purchased in bulk and applied to the chain during assembly. Continuous chain eliminates stocking a wide range of zipper lengths and provides flexibility in selecting the length needed for specific

products. Continuous chain zippers are less costly, reduce inventory, and are widely used by manufacturers of basic goods and industrial products. Special equipment is used to strip metal teeth from a portion of the stringers so machines can sew across the tape during application.

ZIPPER APPLICATIONS The two basic types of zipper applications are exposed and enclosed. Many different methods may be used with either of these types of applications depending on the quality level, anticipated stress, climatic conditions for end use, structure of the garment, and aesthetic expectations. Features that improve the durability of zipper plackets are interlining, properly placed bar tacks, double-stitched plackets, and properly placed supporting closures. Zipper plackets may include a zipper facing installed under the zipper to make the zipper more comfortable to wear. More structure also requires more materials, more parts, and more operations, which may result in greater costs.

Exposed zippers are not covered or concealed by fabric and may be aesthetic as well as functional (see Figure 17–2c). Zippers may provide color accent and texture variation for a style. The chain, slider, and/or tape may be part of the garment's trim. Exposed applications require the least structure and fewest assembly operations. Exposed zippers may be applied in seams but do not require seams for application; they may be installed in a slash cut in a garment. Exposed zipper applications are symmetric and commonly used for neckline openings in knit garments, front openings of jackets and sweatshirts, and pocket closures on various types of outerwear. Exposed zippers may also be se-

Figure 17–2
Symmetric zipper plackets:
(a) typical symmetric enclosed zipper, (b) invisible zipper, and (c) exposed zipper.

lected for the flexibility and lack of bulk associated with this type of application. Minimal fabric is required in applying exposed zippers.

Enclosed zippers are concealed by plackets located in seams. Enclosed zipper applications may be symmetric or asymmetric plackets. Symmetric plackets may use seam openings and are formed from seam allowances and continuous topstitching or formation of the zipper tape, which provide equal cover for the zipper from both sides of the seam. The invisible zipper placket shown in Figure 17–2b is formed by a permanently folded zipper tape that must be flattened during stitching. When closed, the formation of the zipper tape brings the fabric together without a need for topstitching. Application requires a special proprietary sewing machine. Symmetric applications are often found at the center fronts and backs of garments, lower ends of sleeves and pant legs, and so on.

Asymmetric applications include lapped plackets or fly plackets. Lapped plackets, which are approximately 1/2-inch wide, also use the seam opening with the overlap and underlap formed from corresponding seam allowances (see Figure 17–3a). Zippers are offset under the seam opening and covered with the overlap half of the seam allowance. Lapped zippers are commonly used in women's skirts, dresses, and slacks.

Fly plackets are traditionally used on men's pants and some women's and children's wear. A fly placket is wider (1–1 1/2 inches) and more structured than the typical lapped placket (see Figure 17–3b). To construct a fly placket, extensions of the seam allowances or separate pieces of shell fabric are required. A more structured fly placket increases durability and quality.

Figure 17–3
Asymmetric zipper plackets:
(a) traditional lapped zipper placket and (b) fly front.

Buttons and Buttonholes

Buttons are small knob- or disklike devices that perform as closures when paired with buttonholes. Buttonholes are slit or loop openings that retain buttons. Slit buttonholes have edges finished with thread, fabric, or other material. Loop buttonholes may be formed from thread, fabric, narrow elastic, or braid. Loops are usually attached to garment edges or seams, while other buttonholes are cut through the piece goods.

Together, buttons and buttonholes form fastening units or closures. The performance of button and buttonhole closures depends on materials, structure, quality, and performance of each device and its compatibility with garment styling and materials.

Functions of Buttons and Buttonholes

Button and buttonhole selection is not a simple matter, as many different aspects of garment design and production must be considered. Buttons and buttonholes may be decorative, functional, or both.

AESTHETICS Buttons can be produced in nearly any shape, color, and size. Some buttons are works of art made by hand using precious metals and precious and semiprecious stones. These buttons may each sell for \$5–100 or more and would be used on couture, one-of-a-kind garments. Buttons appearing on most apparel are mass-produced just as the garments are mass-produced.

Buttons may be flat, domed, concave, ball shaped, oblong, round, square, or irregular. They may be produced in the shape of objects, animals, toys, or abstract shapes to complement a style feature. Buttons are often stamped with logos or symbols to increase differentiation for garment manufacturers. They may add interesting texture and color to what might otherwise be a very ordinary shell fabric and garment. In contrast, buttons covered with matching fabric blend with the garment. Buttons used as trim may or may not be functional or have a corresponding buttonhole. In some cases the buttonhole may be visible but not functional.

PERFORMANCE Functional buttons and buttonholes close plackets, support other closures, or support other buttons. Closing security and flatness of plackets depend on button shape and spacing, and buttonhole size, structure, and placement. Flat, round buttons remain buttoned under stress better than irregular shapes. Closer spacing prevents buckling and gapping of plackets. Garment styling and fit influence button spacing.

Buttonholes should retain the button, be stable in size and shape, and not become distorted during use. Buttonholes must be the correct size for the button or the closure will not hold. Buttonholes should be tight enough to prevent buttons from slipping through without manual assistance but allow buttoned garment pieces to move as the body moves. Gapping, distorted buttonholes look unsightly and do not stay buttoned. Interlining is often used to support buttonholes and prevent stretching. Buttons must be accurately placed for the corresponding buttonholes or gaps will be created and plackets will not lie flat. Automation can provide consistent spacing of buttons and buttonholes, but the placement of the garment part depends on the operator.

Buttons that support other buttons may be attached inside a garment, directly behind the primary button fastener to reduce the strain on the shell fabric. Support buttons are most often used on better-quality coats and jackets to increase the durability of buttons that receive excessive use and stress. Support

buttons reinforce other buttons and do not require a buttonhole.

Performance specifications may include mildew resistance, colorfastness, heat resistance, strength, launderability, and dry cleanability. High performance and durability of buttons will often elevate costs. Performance tests most often used for buttons are breaking strength and impact strength. Garment manufacturers may choose to do their own performance testing, or they may make their selection based on specifications and testing provided by the button manufacturer. Buttons need to be compatible with the shell fabric, other materials in the garment, determined care procedure, and button-setting equipment. The choice of shell fabrics affects the selection of color, finish, size, and weight of buttons. Heavy buttons may place excessive stress on lightweight fabrics, especially if many buttons are used without proper support. Some synthetic buttons cannot be dry cleaned and will dissolve or become tacky in cleaning solution, while others such as leather and wood may not perform well when washed. Dyed buttons may change color during laundering or dry cleaning and may no longer match the shell fabric. Dye may not penetrate the button so abrasion quickly removes the color, particularly along edges and ridges.

Garment end use is also a factor in button selection. For example, **rubber buttons** are used on authentic rugby shirts, while synthetic buttons are often used on rugby styles designed for street wear. Rubber buttons are selected for their comfort and resistance to impact when worn for contact sports. To protect the attaching thread from abrasion on garments that get hard use, buttons may be chosen that are concave on the top, have a deep thread groove, or have a

rimmed edge.

Even with the best selection of button type and application method, button loss is still a consumer problem. On better garments, extra replacement buttons may be attached to the garment in an inconspicuous place or to a hangtag or contained in a small plastic bag.

Characteristics of Buttons

Button quality, aesthetics, and performance are affected by the materials incorporated in the buttons and methods of coloring, finishing, styling, craftsmanship,

and method of application. Visible buttons should be of similar quality as the garment. A producer of high-quality men's jackets may choose to use pewter or silver buttons instead of antiqued nickel or synthetic buttons. Makers of better topcoats may use leather, bone, or horn instead of buttons made of synthetic materials.

Color-matched buttons are found on better-quality garments. Matched buttons create sourcing problems to secure an exact match and require more quality control to monitor shading and button strength. The outer buttons used on men's slacks and women's skirts often match or coordinate with the shell fabric, but inner buttons are often a standard color or clear and a flat style. In order to control inventory costs and setup delays, manufacturers may opt to use a neutral color button that will suit all fabrics and styles.

Buttons are often marketed by findings representatives who work with garment manufacturers to meet the needs for aesthetics, performance, delivery, quality, and cost. A findings rep may market several lines of buttons produced by different manufacturers and made from a variety of materials. Buttons are often selected from sample cards and ordered by the gross. Manufacturers may also work directly with designers and merchandisers to develop buttons for specific garments. Practical considerations include types of materials, fabrications, types of buttons, methods of attachment, and costs.

Button manufacturers often specialize in certain types of buttons. The Waterbury Co., a major button manufacturer, has over 22,000 styles of buttons in its line, some plated with gold, silver, and bronze. Their specialty is highly detailed metal shanked buttons for uniforms, blazers, and other fashion garments. Waterbury is one of the few button manufacturers that sell direct to their customers.

BUTTON MATERIALS AND FABRICATION Buttons may consist of one piece or a combination of pieces and materials that are clinched, clamped, glued, soldered, or molded together. Multipart buttons often have the top or face made of different materials than the back. The security with which the parts or materials are assembled is important in button performance. Button parts that have been glued together may not be adequate to withstand the rigors of buttoning, wear, and care. Glued buttons may also separate in cleaning if the glue is soluble in water, detergent, or dry cleaning solvents.

Buttons are available in a wide variety of finishes and textures ranging from shiny, glossy buttons to dull, matte finishes (see Figures 17–4 and 17–5). Button finish is selected for compatibility with shell fabric. Buttons may be polished, antiqued, glazed, painted, and dyed after formation of the button blank. Dyeing finished buttons may not be as permanent as adding color to the liquid resin, but it allows the button manufacturer to delay color decisions. Dyes may weaken some buttons.

True, not imitation, pearl buttons, which are cut and developed from natural mussel shells, have long been recognized for the appearance, quality, and

Figure 17–4
Two- and four-holed buttons of varied textures and materials.

Figure 17–5
Shanked buttons of varied materials and shank fabrication:
(a) molded shanks, (b) wire shanks, (c) glued or soldered shanks, (d) multipart buttons with clinched shanks, and (e) shanked button with toggle.

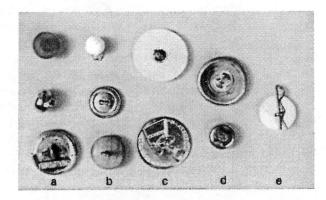

status they contribute to garments. Buttons made from shells are fragile and have many variations in color and shape. Designers often try to imitate the natural irregularities in coloring while using more durable synthetic substances to produce a smooth button without irregularities in shape. Irregularities of natural materials may not be compatible with automatic button-setting equipment and dry cleaning presses.

Buttons are also made of other natural substances, including wood, bone, shell, horn, tagua nuts, glass, rubber, leather, and metals including brass, pewter, nickel, copper, and silver. Buttons have been in use for many centuries and use of different materials in the buttons have evolved over time. The first buttonmaker's guild was established about 1250 A.D. The original buttons were symbols of rank and made of fine metals and tapestry. Today, buttons are used on all types of apparel at all price points. One of the new materials being used for buttons is the tagua nut grown in tropical areas of Ecuador on a tagua palm. These were used initially in the early part of the 1900s and were known as vegetable ivory buttons. World War II and plastics greatly reduced its usage, and the tropical rain forests in which these trees flourished were cut down for agriculture. Conservation International, Emsig Manufacturing Corporation, Patagonia, and Smith & Hawken have teamed to develop the tagua nut button in an effort to provide an alternative to clearing land and still have an important cash crop. Tague nut buttons can be produced in many shapes, sizes, finishes, and can be dyed in most colors.

Plastic buttons are made of nylon, polyester, melamine, and urea. Button manufacturers tend to specialize in certain materials because of the expertise and special equipment needed. Most buttons used on mass-produced garments are made of plastics. Polyester, melamine, and urea are thermoset plastics whereas nylon is thermoplastic. Once hardened, thermoset plastics cannot be remelted; thus, thermoset buttons are less subject to damage from heat during garment processing and care than thermoplastic buttons.

Buttons selected for garment dyeing must be able to withstand dyeing and finishing processes and not take on any color. Buttons and fabrics cannot be dyed to match in the same dye bath. Neutral buttons are often used for garment-dyed apparel as button materials require different types and methods of dyeing than fabrics and other materials.

Plastic buttons are commonly fabricated by casting and molding. **Casting** is the process of pouring synthetic resin inside a rotating drum. The resin forms a pliable sheet from which button blanks are cut with a dye. **Blanks** are the disks cut from the resin that will eventually become finished buttons. Blanks are machined to the desired shape and holes are drilled. The machined blanks are polished for many hours with pumice, corn cobs, or other materials to develop the desired level of smoothness and luster.

More than one layer of resin may be cast for special effects. One method for making a simulated pearl button has streaks of brown or black pigment added to the first layer of resin to simulate the appearance of the back of natural shell buttons. The top layer of resin, with pearl essence (a creamy liquid extracted

from fish scales) added, is cast for the luminous appearance of pearl. Casting tends to be less expensive than molding. **Casted buttons** are commonly used for basic buttons on budget- and moderate-priced apparel.

Compression- and injection-molded buttons tend to be more aesthetically pleasing than cast buttons, but molded buttons are also more expensive because production processes are much slower. Compression-molded buttons are formed by pressing a mold into soft resin, which sets up to form the button blanks. Injection molding requires special molds created to the precise shape and size of the desired button. Injection molding is used to achieve greater three-dimensional shape and more surface pattern.

BUTTON TYPES There are two basic types of buttons: holed and shanked. Thread or other material is passed through the holes or shanks to secure buttons to garments. Holed buttons may have two to four holes extending through the center of the button. Buttons may be all one piece or a combination of parts and materials (see Figure 17–4).

Holed buttons may be sewn flat or attached with thread shanks. The thread shank allows the button to be elevated to provide more flexibility and ease of movement. Thread shanks reduce the strain on the thread and fabric and allow the garment to lie flat when buttoned. The length of the shank can be varied depending on the thickness of the buttonhole. A special presser foot is used to hold the button above the garment to provide slack as it is attached.

Wrapped thread shanks are used in areas of excessive wear on better-quality garments or if thread shanks are long. Wrapping is a process of placing the button on its side after attachment and stitching over the thread shank. Thread shanks may be wrapped in order to protect the thread and help the button maintain its position. Wrapping makes a more durable button application. Wrapped button shanks are found on better jackets, coats, and some skirts and slacks. It is common for a manufacturer to wrap center front buttons that receive extensive use but not to wrap pocket or sleeve buttons even though they may have thread shanks. Some manufacturers may use an extremely small rubberband around the thread shank instead of wrapping it with thread. It serves the same purpose but may be more visible.

Shanked buttons have short, stem-like devices (the *shanks*) on the backs of the buttons (see Figure 17–5). Shanks may be made of fabric, molded of the same material as the button face, or formed from a separate metal part and combined with the face or back of the button. Cloth shanks are found primarily on fabric-covered buttons and are the least durable. Molded shanks are produced through injection molding. The durability of molded shanks depends on the thickness of the shank and the strength of materials used to produce the button.

Metal shanks may be cast as part of the button, formed as looped, wire like structures attached to or through the center of the button, or stamped and shaped from sheet metal to form a button back that includes the shank. Shanks may be glued, soldered to metal, screwed into wood, set into the molded buttons

during formation, or clinched in place as multiple part buttons are assembled. Stamped button backs and shanks sometimes have sharp edges that sever thread and abrade or discolor fabrics. Shanked buttons are subject to crushing with compression, which may occur in pressing or consumer wear.

Shanked buttons are permanently attached or removable if held in place by a toggle or ring on the inside of the garment as shown in Figure 17–5e. Permanently attached buttons are sewn to the garment or mechanically tacked. For removable buttons, a small eyelet is made in the garment that allows the shank of the button to be inserted. The toggle or ring slides through the shank to hold the button in place. Removable buttons may be used on uniforms and other garments when buttons must be removed for cleaning and pressing.

Tack buttons are a type of shank button named for the method of attachment. They have no thread to wear and abrade and are strong and durable (see Figure 17–6). Tack buttons are multiple-part buttons attached with tacks that pass through the back of the fabric into molded shanks on the back of the button. They consist of four parts: cap, disk, shank, and tack (see Figure 17–7). The face is the outer, aesthetic portion that is often stamped with a design, logo, or firm's name that wraps the back or shank portion. The cap is supported and protected by a hard concave disk that prevents the tack from piercing the but-

Figure 17–6
Tack button with no thread to wear and abrade.

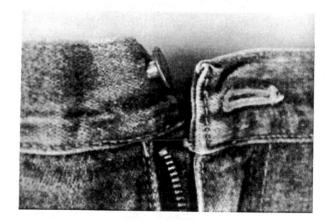

Figure 17–7
Parts of a tack button.

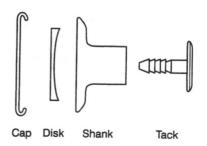

ton face. The tack has a post that consists of one or two prongs to secure the tack in place. The shape of the disk causes the post to bend when forced through the shank, thus locking it in place. Generally, a two-prong tack has more holding power and is less likely to come out. Special button-setting equipment is used to apply pressure and secure the tacks in place.

Once inserted, tacks cannot be removed without damaging the button and garment. Tack buttons, commonly found on jeans, jean jackets, and overalls, are fast and easy to apply but applications must be accurate. Tack buttons are also more rigid and therefore more difficult to manipulate in the buttoning process.

BUTTON SIZE Button diameter is specified in **lignes**, a unit of measure equal to 1/40 of an inch. Dimension specifications would include diameter and thickness of the buttons, number of holes and the diameter and spacing of holes, shank type, depth, hole size, and thickness of the bridge. (The *bridge* is the distance from the end of the shank to the edge of the hole. This is the distance that the needle must travel in attaching a shanked button.) Button dimensions may be limited by the method of application and the available equipment that a manufacturer uses.

Button size, for a particular garment, is determined by the number of units to be used on the style, holding strength, appearance desired, and fashion trends. Some types of garments may use different sizes of the same button style. For example, some men's shirts use larger buttons down the front and smaller ones for button-down collars; coats often use large buttons for the front and a smaller size for sleeves, neckline, or belt. As many as three different sizes may be used on one garment and some garments may use more than one style.

Button Application

Button sewers are cycle machines with templates that are adjusted to produce a specific number of stitches in a specific pattern (see Figures 17–8 and 17–9). Cams control the movement of the foot, which holds the button as stitches are formed. Depending on the production needs and sophistication of the machine, buttons may be fed automatically or placed by hand in the foot. Automatic button-feeding systems feed buttons from a hopper, face-up, into a tube that carries them to the foot. Operators position the garment or component and engage the machine. During a cycle, buttons are stitched, threads cut, and the garment or component is released.

Buttons must be smooth and consistently shaped to feed properly through automatic systems. Irregular buttons may feed through upside-down or block the tubes. Automatic systems may have button indexers with automatic spacers that move the garment for placement of multiple buttons. These systems are regularly used by the shirt industry.

With automatic feeding systems, changing button types, sizes, or colors is not a simple matter; thus, automatic button-feeding equipment is most frequently

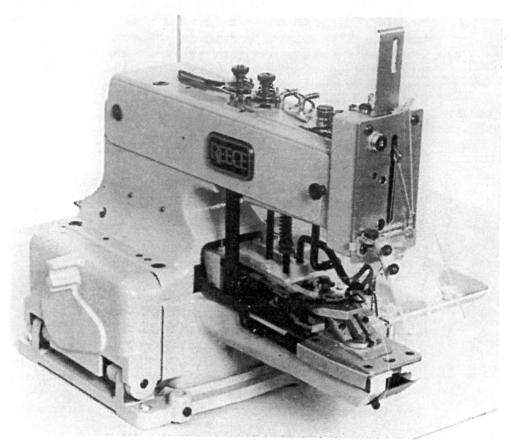

Figure 17–8Reece button sewer for attaching buttons to a variety of garments. *Source:* Courtesy of Reece Corporation.

used on basic goods with less frequent changes in type and color. Feeding systems must be emptied and tubes changed to accommodate the new button size; machines are refilled, reset, and rethreaded. To save time and costs, manufacturers often limit selection to one size of neutral-colored buttons that blend with many different materials in the line.

Buttons are often attached with a 101 chain stitch. This stitch can set a button in a minimal amount of time, but it is also likely to unravel if a loose thread is pulled. The secret of good button application is using a sufficient number of stitches to hold the button and trimming thread close to the last stitch.

Four-hole buttons may be stitched with parallel- or cross-stitched patterns controlled by a template (see Figure 17–10). Parallel-stitched buttons are the most widely used. Stitches form in the first pair of holes and then

Figure 17–9
Reece button sewer with a button feeder automatically inserting the button into the machine for sewing.

Source: Courtesy of Reece Corporation.

the second set. Cross-stitching uses diagonal holes in the button as stitches are formed.

Cross-stitched buttons are often regarded as better-quality, but the only real difference may be aesthetic. When cross-stitching is done as one operation it is primarily a merchandising feature rather than a performance feature. When cross-stitching is two separate operations, the button attachment is stronger.

Figure 17–10
Different patterns for stitching four-hole buttons: (a) parallel-stitched buttons and (b) cross-stitched buttons.

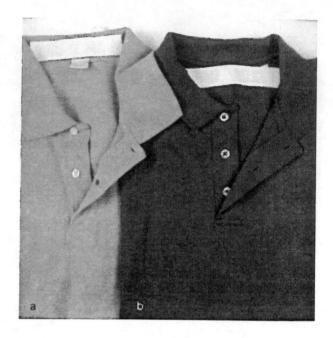

Characteristics of Buttonholes

Buttonhole aesthetics and performance are related to type, materials used, method of construction, size, and placement of the buttonhole in relation to the button and type of fabric. Buttonhole quality relates to stitch type, stitches per inch, formation of stitches, and method of construction.

Buttonhole Types Buttonhole types are bound, loop, straight, and keyhole (see Figure 17–11). Bound buttonholes or welt buttonholes are rectangular in shape with sides finished with fabric, leather, or other material. They are produced much the same as the welt on a jacket or coat. There are automated machines that stitch and cut the welt but several other operations are required for finishing. They are labor-intensive and therefore have limited use in mass-produced garments. A single bound buttonhole may involve several operations. Bound buttonholes are sometimes used on leather garments as the tight stitching used on straight or keyhole buttonholes could damage the leather. Leather may also be used as the binding on buttonholes. Bound buttonholes also may be found on better women's coats and on women's custom-made apparel.

Loop buttonholes are attached in a seam with the loop extending beyond the edge of the garment part. Loops are used in areas where there is little or no overlap of garment pieces and little stress. Loops are frequently used for their aesthetic value. Loops may be nearly invisible, as with thread loops, or visibility may contribute to the style of the garment, such as the button loops often used down the back of wedding gowns.

Figure 17–11
Types of buttonholes: (a) loop buttonhole formed from fashion fabric, (b) loop buttonhole formed from braid, (c) keyhole buttonhole, (d) bound buttonhole, and (e) straight buttonhole.

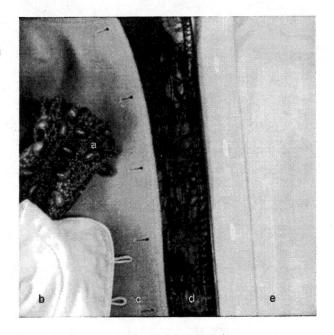

Loops may be made of piece goods, narrow fabrics, such as braid, elastic, or tape, or thread. Piece goods are made into tubing from bias strips of fabric. Tubing may have cord in the center to make it three-dimensional and increase its durability. Manufacturers may make their own tubing out of matching piece goods, contract the production of the tubing, or purchase basic colors and types of tubing that can be used on different garments.

Straight buttonholes are a slit with cut edges encased in thread and ends reinforced with stitching. Straight buttonholes are used on most types of garments and at all price points. They may be placed vertically or horizontally based on their position in the garment.

Keyhole buttonholes have an enlarged, round shape at the end closest to the garment opening. This provides space for shanked buttons to fit into buttonholes without causing the buttonhole to gap open. Keyhole buttonholes are usually positioned horizontally on coats, jackets, and jeans.

Edges of straight and keyhole buttonholes are finished with thread. Thread size varies with the type of buttonhole, weight of the shell fabric, and the expected performance. Threads used on shirt buttonholes are much finer than threads used on coats, jeans, and so on. **Gimp** is extra-heavy thread frequently used to reinforce and strengthen keyhole buttonholes. It is laid on top of the buttonhole ahead of the stitching. Stitches encase the gimp and cover the cut edge of the fabric as the buttonhole is formed.

Buttonholes are usually stitched with a lock stitch (301 or 304) or singlethread chain stitch (101). The lock stitch is more durable and will not ravel out if a loose thread is pulled. The number of stitches used in making buttonholes can be adjusted for each style. Stitches should be close together but not piled on top of other stitches. If they are too close, they may damage the fabric. Excessive stitching can put stress on the stitching line, wear out the fabric, or prohibit recovery when stretched. High-stitch count on some stretch fabrics will cause buttonholes to gap unless the fabric has been stabilized. Stitches that are too far apart do not provide adequate support to the cut edge, allow fabric to ravel, and are less durable and aesthetically pleasing.

The sequence of buttonhole making varies with the style of the garment, type of equipment, fabric type, and quality level of the garment produced. Buttonholes are produced with cycle machines that require an operator to position the garment and engage the machine. The most common type of buttonhole machine stitches a complete buttonhole before a knife comes down and cuts a slit between the rows of stitching. With this method, yarns from the piece goods or interlining may ravel from the cut edges and get caught on the button during the buttoning process. When this happens, snags and pulled yarns can occur in the piece goods in any direction from the buttonhole.

Another method that makes a more finished buttonhole is the machine that cuts the opening first, followed by the stitching. This method is more likely to secure all threads and produce smooth edges and a more finished buttonhole. This method requires that the fabric be heavy enough to support the stitching. If it is too lightweight, the stitches over the cut edge will draw the fabric together, and the buttonhole will not lie flat. Automated equipment can produce multiple buttonholes at one time similar to button-setting equipment. Buttonhole indexers can make six buttonholes in approximately a 19-second cycle time.

BUTTONHOLE SIZE Buttonhole size is determined in relation to the corresponding button. A minimum size for a buttonhole is the diameter of the button to be used. Other factors that should be considered are depth and smoothness of the button, and the amount of stretch in the buttonhole. Buttonholes that are too small for the buttons are difficult to use and receive excessive wear. Buttonholes that are too loose will not retain the button during wear and stress.

BUTTONHOLE PLACEMENT Buttonholes may be vertical, horizontal, or diagonal. Vertical buttonholes are usually centered on front bands or narrow plackets as found on many shirts and blouses. Horizontal buttonholes are used on fronts of coats and jackets and on cuffs and collar bands of shirts. Horizontal buttonholes have better holding power because the point of stress is the end of the buttonhole rather than the center, as is the case with vertical buttonholes. Buttonholes may be placed on the diagonal for special aesthetic or functional effects, but they must be stabilized. For example, diagonal buttonholes are sometimes used for the support button on the underside of waistbands to keep waistband ends from showing.

During wear, buttons pull to the end of buttonholes closest to the garment opening; therefore, buttonholes need to be positioned knowing this is the natu-

ral button position. Center-closing horizontal buttonholes should be located just beyond the center of the garment to allow the button to center itself. Vertical buttonholes are centered on the button. For example, buttonholes are commonly vertical down the center front of a shirt, but the collar band buttonhole is horizontal. Buttonholes should be perfectly aligned with the buttons in order to avoid gaps and buckling of the garment.

Buttonhole placement that is too close to the edge of a garment may allow too much stress on a weakened area of fabric. When this happens on skirts or slacks, the buttonhole may eventually tear out. Buttonholes should be set far enough into the garment to prevent buttons from extending over the edge of the component or from putting too much stress on other closures.

If buttonholes are used on knit or bias-cut woven fabric, the length of the buttonhole should be stabilized to prevent gapping as shown in Figure 17–10. Interlining should be chosen that is stable in at least one direction. The stable grain of the interlining should be aligned parallel with the buttonhole. For example, bias-cut woven interlining used in button-down collars is straight grain under the collar buttonholes. This provides a base for a stable, flat buttonhole.

Snaps and Hooks

Snaps and **hooks** are mechanical closures that are frequently used on adult and children's clothing in place of buttons, particularly when a less formal look is desired. They are used as closures on outerwear, active sportswear, and many types of casual apparel.

Snaps

Snaps allow easy access and fast change. Compared to buttons, snaps are quick and easy to press closed and pull open, which makes opening a pocket or placket faster and more accessible to the wearer. However, they require precision matching and strength that may not be necessary for buttons.

Snaps are available with varied degrees of opening and closing action. The gripping power of snaps tends to increase with size since larger snaps have more gripping surface. Snaps may be used to secure garments and accessories that are too bulky or stiff for buttons and buttonholes such as belts and purses. ASTM has standard tests for evaluation of snap performance relative to lateral holding strength and snap action, D 4846-88.

Snaps also may be selected for their aesthetic value. *Caps*, the primary visible part of snaps, are separate coverings used on the outside of the snap unit. Caps may be made to look like buttons, exhibit a logo, or provide aesthetic enhancement. Occasionally only the decorative half of the snap is applied to the garment if it does not have to be functional.

Snaps are sized by lignes the same as buttons but are produced in fewer sizes. The more common sizes are 15, 16, 18, 20, and 24 lignes, although special sizes and types may be produced to specifications. Sport snaps, which are 12-or 14-ligne snaps, are a smaller version. Sport snaps are used extensively on both woven and knit sport shirts, blouses, and some dresses.

SNAP PARTS Snaps are paired mechanical closures that consist of a closure unit and an attaching unit. A **closure unit** consists of two different closure parts: a stud and socket, that must be compatible. **Studs** are the projecting half of the closure unit with an expanded rim, ball, or flattened end that must fit the socket half of the closure unit. They are available in varied diameters, depths, and shapes that affect the holding power of the snap. Studs are attached to the underlap of a garment or component, and sockets are attached to the overlap (see Figure 17–12).

Sockets are the hollow half of the closure unit that contains a spring to retain the stud. The spring and corresponding shape of the stud provide the holding power for the closure unit. Larger sockets generally house one of two types of springs: a floating ring spring or parallel springs. A floating ring spring expands and contracts behind the expanded rim as the stud is forced into the socket. Ring springs are generally more durable and have greater holding power. Parallel spring snaps can be identified by two parallel bars on either side of the socket.

Snaps are attached to garments by sewing or clinching. Sewn snaps are attached with a 101 chain stitch similar to button setting or by hand as may be

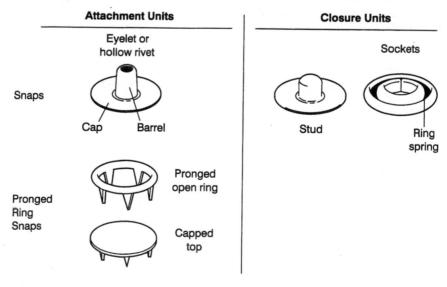

Figure 17–12 Snaps and snap parts.

the case with custom sewn garments. Snaps used on most mass-produced garments are clinched in place by attachment parts positioned behind the closure parts. **Attaching units** establish the position and provide holding power for setting closure parts. There are two main types of attaching units: eyelets (hollow rivets) and pronged disks or open-top rings.

An **eyelet** consists of two parts: a top, which is often called a *cap* (also called a *button* or *cover*), and a barrel. The cap is the decorative part of the snap and the most visible portion. Caps may be formed separately and attached to the rest of the snap or formed as part of it. The barrel is inserted through the fabric into the closure unit and compressed to clinch the fastener. Barrels may be self-piercing, which means the barrel cuts a small slit in the garment as it is inserted. This eliminates drilling holes prior to setting the snaps. The eyelet with attached cap is used to attach the socket or overlap unit. The eyelet of the underlap unit consists of a flange that supports the snap and protects the surrounding fabric.

Pronged rings or disks are used to secure smaller, flatter snaps, which are sometimes referred to as press fasteners or grippers. Pronged rings may be stainless steel, brass, nickel plated, or white enameled. Prongs penetrate the fabric and are clinched to the closure units by means of a special tool. The strength and holding power of pronged snaps are dependent on the length and number of prongs used. Rings are available with four or five prongs, different prong lengths, and fineness. Long-length prongs are designed for use with bulky fabrics in order to provide better penetration. Fine prongs are sharper and able to penetrate fabrics with less damage to yarns. Pronged rings need to be supported with interlining, especially on knits. When stretched, knits will pull away from the prongs unless stabilized.

MATERIALS FOR SNAPS Materials used in producing snaps are primarily metal: steel, brass, and nickel. Snaps may be plated with various metals to produce a product more compatible with processing and care procedures. Snaps must be compatible with other materials used in the garment and the required care procedures. Caps may be made of nylon, polyester, urea, melamine, leather, cloth, bone, vinyl, or stamped metal and produced in nearly any shape, size, color, or finish. Caps may be antiqued, plated, enameled, painted, or cloth covered. Many different types of finishes are available, similar to those used on buttons. Plastic snaps are seeing wider usage on specific types of products such as children's wear, rainwear, lingerie, and some packaging.

APPLICATION OF SNAPS Accurate placement and durable snap setting are important factors in producing quality garments. Clinched snaps usually cannot be removed and replaced without damaging the garment. A snap that is lost or not clinched properly causes a defective garment. Manufacturers cannot supply an extra snap in case one is lost or damaged.

Snaps can be applied with manual or automatic equipment. Snap-setting equipment, regardless of the complexity and degree of automation, is dependent

on pressure applied with a chuck and die. A die is the lower portion that must be the proper size and shape for the specific cap to be used. The die holds the cap of the snap. The chuck that must fit the die exerts pressure for clinching. Improper fit of the die and snap or the die and chuck will not allow the snap to be set properly. Once snaps are set, there is little flexibility in changing position. Snaps with pronged rings may be pried loose and reset if the fabric has not been damaged; however, the holes required by hollow barrel eyelets mean they cannot be applied in another location. Throat depth of the attaching device is a factor in how far from a garment edge a snap can be set.

Automated snap setters have automatic feeding systems that alternately feed the appropriate parts. Inventory and the setting process can be simplified if only one type of attaching part is used. The equipment used to attach or apply closures is often proprietary and will fit only on that supplier's product. Vendors determine minimum orders that will qualify the manufacturer to have title to the attaching equipment without monetary outlay.

Hooks

Waistband hooks are paired metal fasteners, a hook and a bar (eye), that are set prior to waistband assembly. Each part of the fastener is held in place by a clinch plate that is placed inside the band. The hook and bar are designed with staple-like devices on the back. The prongs on the hook or bar penetrate the band and clamp around the plate. Hooks attached in this manner may be used on many types of pants and skirts at all price levels. Hooks may be used singly, in multiples, or supported by buttons.

Elastic

Elastic may be used to create an expandable closure or opening in a garment. Elastic has two functions: to expand when stretched and to recover to its original dimension when released. The loss or reduction of either function inhibits the aesthetics and performance of elastic and the garment to which it is attached. The degree of expandability and recovery is provided by the structure of elastomeric fibers, fabrication of the elastic, and application methods.

Elastics may be sampled and tested, and garment prototypes with elastic incorporated may be tested to determine if the performance of the elastic is adequate. Elastics may be purchased from open stock or ordered to specifications. Vendors of open-stock elastics usually provide a specification data sheet that apparel manufacturers may use in making purchase decisions. Elastics must be suited to the desired aesthetics and expected performance of the product. They are often a factor in determining garment structure, fit, and comfort. Garment life may be determined by the performance of elastic.

Functions of Elastic

Elastics perform a wide variety of functions and may be used as a separate component, incorporated in garment components, or applied directly as a facing or means of incorporating fullness. Elastic components include bra straps and waistbands made entirely of elastic. Elastics used in casings are often referred to as **insert elastic** or **commodity elastic**. **Casings** are fabric or thread enclosures that completely encase elastic so that it is not visible or in contact with the body. Elastics used as **facings** are protective coverings and finishes for garment edges. Facing elastics are used for waists of underwear, edges of bras and swimsuits, and for some jogging shorts.

AESTHETICS Elastic used as trim may be selected for its particular color or design. Structural design elastics include stripes, jacquard patterns, logos, or special constructions; applied designs are printed on elastics. Logos may be incorporated into elastic structures to provide differentiation for garments, as is often the case with underwear elastic. Trim elastics are applied to the outer part of the garment so they are readily visible instead of being concealed in a casing. Casual skirts and shorts sometimes use elastic trim as the waistband.

Elastic may also contribute to aesthetics as part of garment fit and styling. Used in a component, it can provide a tight fit with flexibility that would otherwise be uncomfortable and restrict movement. Elastics may gather a sleeve or waistline, finish an edge, or provide shape and support to garment components. Elastics are often used to produce firm edges and provide shape retention for fabrics such as nylon tricot, power net, and swimwear fabrics. Without elastic, fabric edges would roll and curl when stretched and would not return to the original flat state.

PERFORMANCE Elastic materials are selected for their specific performance characteristics such as the amount of stretch, holding power, flexibility, comfort, and hand. The performance in any given application is dependent on the elongation and recovery of a particular type of elastic, method of application, and weight and structure of shell fabric.

Elastics provide a comfortable fit for waistlines, cuffs, and necklines as long as they are sized correctly. Elastics allow for a close body fit and expansion without a placket as long as the garment itself is large enough. Elastic expansion makes it easier to pull on garments and in many cases eliminates the need for plackets or other closures. Garments or components with elastic expansion require fewer materials and operations, thus reducing production costs.

Elastics, which are produced in varied amounts of elasticity, must be suited to the size of the opening needed and the tightness of fit expected. Once installed, elastics cannot expand further than the garment component in which they are contained. Elastics used inside a woven waistband can be stretched only to the maximum of the fabric casing, while elastics used on the waist of knits are limited only by the stretch of the fabric.

Elastics provide flexibility for comfort and movement and in size and fit for a variety of body shapes. As the body moves and bends, soft elastic will flex, fold, bend, and stretch rather than remaining rigid and firm. This allows the wearer to move freely without being restricted.

Garments with expandable waistlines may often be sized in small/medium/large as one size fits a wider range of customers. From the manufacturers' and retailers' perspectives, flexibility in size and fit means one garment will fit a greater variety of body shapes and dimensions and fewer SKUs are needed.

Resistance to strain provides the **holding power** of elastic. Elastics are made with varying degrees of stretch and holding power. Elastics with high elasticity and little resistance to strain provide low holding power. High-control stretch provides greater resistance to strain and thus more holding power. Elastics with a high degree of stretch are used to retain gathers or fullness in areas needing easy expansion and recovery. If elastic is sewn in an expanded condition, it will cause gathering or shirring when it relaxes. Probable uses include the cuffs or sleeves of children's dresses and sleepwear. Higher holding power is required for athletic apparel, tops of hosiery, and some types of intimate apparel.

Power stretch elastics, those with a greater resistance to stretch, are often used in support clothing, protective devices, and foundation garments. Special elastic garments or elastic components are structured to provide support, protection, and shape to muscles and body parts. Full garments structured with power stretch fabrics may be used by athletes to support muscles and retain special types of pads or for surgical wraps and support devices. Power stretch fabrics and elastic components are also used in foundation garments to firm, shape, and smooth the human body. Expanded elastic, whether high- or low-control, must contract to its original dimension in order to provide consistent fit, shape, and appearance.

Characteristics of Elastics

Characteristics of elastics depend on materials, fabrication, and size. Elastics are often produced for a specific end use, with high or low stretch, and fabricated for a specific garment category. For example, elastics used in the waist-line of men's briefs may have 100–110 percent stretch, while elastics used in women's briefs may have 130–140 percent. Facing elastics have approximately 160 percent, and strap elastic has 70–80 percent stretch. Fiber content and fabrication determine the amount of stretch.

MATERIALS Fiber content is a major factor in the longevity, stretch, performance, and care of elastics. The high extendibility of elastics is due to elastomeric fibers: rubber or spandex. Both of these **elastomers** have excellent elongation and recovery properties, but rubber, in the same size fiber or yarn, has lower strength. Rubber costs less than spandex, ages faster, yellows with age, and is

susceptible to damage by heat, dry cleaning solvents, and chlorine bleach. Spandex tolerates both dry cleaning and laundering. Elastomers may be combined with cotton, rayon, acetate, nylon, and polyester in yarns and fabrics. The percentage of elastomer often has a direct relationship to the stretch and recovery percentage of a specific type of elastic or material.

Elastics produced for swimwear are sometimes treated to increase resistance to chlorine, sun, and salt water. In spite of this modification, deteriorating

elements will eventually reduce the effectiveness of the elastic.

FABRICATIONS Elastomeric material may be used as broad elastics made in widths that exceed 15 inches, as thread, flat filament yarns, or finished narrow fabrics in widths ranging from 1/8 inch to 15 inches. Broad elastics may be cut and sewn similar to other fabric yardage. Elastic thread or yarn commonly consists of an elastomeric core wrapped with cotton or acetate. The wrapping contributes to aesthetic effect and comfort, and it facilitates the sewing operation. Elastic thread or yarn can be woven or knitted into fabrics or used for decorative rows of stitching. Flat strips of elastomer may be encased in thread during the sewing process or used in casings. This type of application is often found on underwear or cuff casing of sweats.

Common narrow elastic fabrications are braids, knits, and wovens. **Braided elastics** usually have a high degree of stretch but become narrower as stretched. Stitching through stretched elastic that has narrowed may prevent total recovery depending on the type and closeness of stitches. Braided elastics, which may be called *tunnel elastics* because they are widely used in casings,

have a high degree of stretch and are often used on children's wear.

Woven elastics are heavier than knitted and braided elastics and have more width stability, better rigidity to fold over, and more holding power because the elastomer is easier to control. According to specific quality standards, woven elastics provide better appearance and are frequently used in garments with tighter specifications and less tolerance. Most military uniforms that require elastic specify wovens. Woven elastics are more expensive to produce because fewer strips can be produced at one time and more operations are required. On a 36- to 40-inch bed, approximately four 1-inch strips can be woven at one time as compared to warp knitting, which can produce up to twenty-five 1-inch strips on a machine of the same size.

Woven elastics may be plain weaves, satin weaves, or a novelty variation. Plain weaves are used for the commodity insert types of elastic; satin weaves are used to produce strapping elastic and plush elastic. **Plush elastic**, which has a napped surface on one side, is used as an edging or facing that may be used next to the skin. Plush elastics are constructed of stretch nylon and spandex that elongate when stretched. The nylon "bulks up" when the elastic is relaxed to produce a plush surface. Woven elastics may be produced with a scalloped, looped, or picot edge, that adds aesthetic value to the elastic and garment. These may be referred to as *toppings*.

Knit elastics are produced on warp knitting machines with individual needles fed by separate yarns. Yarns are knitted around the elastomers to hold them in place vertically and horizontally. This provides vertical elongation and horizontal stability and does not allow the elastic to become narrower when elongated as with braided elastics. Knit elastics are cheaper to produce as raw elastomeric fibers are used instead of covered yarns. Warp knitting machines can produce more yards per hour because more strips can be knitted at the same time.

Knit elastics weigh less than woven, which may be an advantage for some uses. Lightweight, open-construction elastic allows body heat to escape and is less bulky. In other instances, extra body may be needed to produce the hand or aesthetics desired. Additional weight or body may be added to elastic by use of filler yarn, increasing yarn size of filler yarns, and raising the number of courses per inch. Filler yarns, which may be referred to as *courses*, can be added to knit structures to provide more stiffness or substance. As more courses are used, more yarn is incorporated, which increases both weight and cost. Width of knitted elastics is controlled by the number of needles and the amount of space between the needles used in the knitting operation.

Needle spacing may be adjusted on knitting machines to form channels or sewing tracks in the elastics. Sewing channels are lengthwise spaces without elastomer where the elastic can be stitched without damage to the elastomer or loss of recovery. Needle spacing on sewing machines must be compatible with the sewing tracks for effective application. Quick/Cord, which is a variation of this type of construction, is an elastic with a draw cord knitted into the center in place of elastomeric fibers. This elastic is attached in the traditional manner, but the operation of inserting a draw cord through a casing is eliminated. The cut ends of the cord are drawn out and positioned ready to tie. This type of elastic is frequently used on shorts, sweatpants, and other active wear.

Elastic Applications

Elastic applications may be exposed or enclosed. **Exposed elastic** applications are often used at the waistline of underwear and lingerie. Exposed elastic may be applied to the outside or inside of a garment and not covered by a casing or cover stitch. It has direct contact with the body or other garments, which may limit its durability and aesthetic appeal. Most exposed applications have elastic fed from a reel and sewn directly to flat components, such as sleeves of children's dresses, lingerie, underwear, and swimwear.

Direct application of exposed elastic is often the fastest and least expensive method of application because it involves only one operation. It requires the elastic be attached or closed off in a seam, which may be bulky and uncomfortable to the wearer. Manufacturers may choose to bar tack across the seam to make it lie flat or cover it with a label. Better lingerie may have seams in elastic covered with a small square of fabric to conceal the seam area.

Direct application of elastic requires uniform stretch of the elastic during the entire stitching process in order for the elastic to contract evenly. This is done

with a metering device that can be adjusted to apply a specific amount of tension to the elastic as it is being sewn to the garment.

Elastics are most often applied with a chain stitch because of the stretch built into the stitch. In some cases, an overedge stitch is used to combine operations of finishing the cut edge of the casing and attaching the elastic in the same operation. This method is risky unless special attachments are used to protect the elastic. Exposed applications on lingerie may be attached with a 406 cover stitch or a 308 multiple zigzag; the latter is the neatest, most time-consuming, and most costly. A top and bottom cover stitch (607) is often used to attach elastic to briefs.

Enclosed elastic applications are concealed by a fabric casing or cover stitching. (As mentioned earlier, a *casing* is a fabric channel to encase elastic or a drawstring.) Casings may be formed by folding fabric around elastic for stitching, or applying casing materials to the garment, double-stitching two adjacent garment pieces together, or using a cover stitch over the elastic.

Enclosed elastic may be more comfortable and aesthetically pleasing because the elastic is covered or concealed. Enclosed elastics may also be more durable because the elastic is covered and protected but bulkier due to the double thickness of fabric used. Enclosed elastics may be applied directly prior to final seaming, or the elastic may be cut and sewn together prior to enclosure. They may be allowed to remain free in the casings without additional stitching that could restrict recovery. In some types of garments, rubber bands of specified dimensions may be used in a casing. This is a fast method of encasing elastic and eliminating bulky seams.

Hook-and-Loop Tape

Hook-and-loop tape was developed as a touch fastener by Georges de Mestral, a Swiss engineer, who noticed how tenaciously cockle burrs clung to his dog and clothing. Hook-and-loop fasteners consist of paired synthetic tapes, one covered with tiny hooks and one covered by tiny loops (see Figure 17–13). The two tape structures are closed by touch and pressure and opened or separated with peeling action. The original patent has expired, but parts of the production process are still protected. Research efforts are ongoing to improve the product and its production processes and to increase product specialization.

Hook-and-loop tapes have many uses, including but not limited to apparel. On clothing, hook-and-loop tapes provide a means of attachment or closure. It is used to hold accessories or garment parts such as shoulder pads in place, or as fasteners on jackets, shoes, slacks, shorts, swimsuits, gloves, and lingerie. Hook-and-loop tapes are often used on clothing for children and people with disabilities because of the ease in opening and closing compared to other types of closures that require a higher degree of motor skills and strength.

Figure 17–13
Functional parts of hook-and-loop tape.
Source: Courtesy of Velcro, USA, Inc.

Performance

Hook-and-loop tapes are more important functionally than aesthetically, although they have been used as a fashion closure in active sportswear and are available in a variety of basic colors. Hook-and-loop tapes are **contact fasteners** with hooks to grasp and hold the loops. Holding power is affected by the amount of pressure applied to the tapes, structure of the tapes, and method of application to the garment or product. The more pressure that is applied, the more interlocking there will be between hooks and loops. Vibration or agitation also increases holding power by allowing hooks to attain a deeper grasp of the loops.

Performance of hook-and-loop tape is determined by peel strength and shear strength. **Peel strength** is a measure of the amount of force needed to pull the two tapes apart from one end. **Shear strength** is the amount of force required to cause two parts to slide on each other thus separating the tapes. In measuring shear strength, force is applied to opposite sides of the paired tapes (see Figure 17–14). Durability of hook-and-loop tapes is determined by testing the holding power and checking the appearance of the tapes after a specified number of opening and closing cycles. Tapes may be tested after a specified number of cycles, such as 5,000, 10,000, or 20,000.

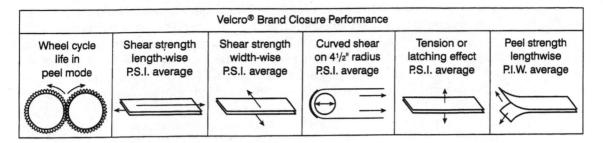

Figure 17–14Performance of hook-and-loop tape is determined by shear strength and peel strength.

Source: Courtesy of Velcro, USA, Inc.

Closure strength or holding power may be altered by increasing or decreasing the size of the tapes, hooks per inch, hook strength, and hook length in relation to the size of the closure. In Figure 17–14, notice the different means of evaluating performance of hook-and-loop tape. The more hooks per square inch, the more force it takes to separate the tapes. Flexibility of the hook affects hook strength and the amount of resistance the hook has to straightening when stressed.

Performance problems related to the use of hook-and-loop tape include tendencies of the hook side of the tape to attach to other materials or garment parts, especially during laundering. The hooks are also scratchy and tend to collect lint over time and become nonfunctional. The tapes are stiff and have limited flexibility which can affect the garment where it is used.

Materials

Apparel hook-and-loop tapes are fabricated from nylon filament that is knitted or woven into narrow fabric with 1/16-inch selvages. The loop tape is interwoven or knitted to form a dense pile surface consisting of a mass of fine loops. The pile surface is napped to disorient the surface and provide better holding power. The surface of the hooked tape is formed from monofilament loops that are cut to form hooks. Both hook-and-loop tapes may be heat-set to ensure shape retention of hooks, loops, and dimensional stability of the tapes.

Tapes are dyed, back coated, and cut. Back coating involves coating the tapes with a synthetic resin to prevent yarn slippage. It contributes to the stiff hand, which can be an advantage during application but may be uncomfortable when used in garments.

Applications

Hook-and-loop fasteners may be applied by sewing, adhesive bonding, ultrasonic sealing, or heat sealing depending on the particular type of hook-and-loop

fasteners used and the product to which it is applied. Although sewing is the most common application used on apparel, hook-and-loop fasteners are available with a wide variety of factory-applied adhesive precoats, including solvent-activated, heat-activated, and pressure-sensitive backings for easy application to specific products. There are also liquid adhesives suitable for most applications.

Hook-and-loop tapes are available in standard widths (5/8-4 inches), and shapes may be die cut to specified dimensions. It is available on reels for continuous application or in dispenser packages for easy access and handling by operators.

Summary

Closures are fasteners, including zippers, buttons, buttonholes, snaps, elastics, hook-and-loop tapes, hooks, and other devices that make it possible to open and close garments. They are functional and decorative and are part of product development and production decisions. Closure failure is a primary cause of consumer complaints. Appropriate selection and application of closures contribute to garment aesthetics and serviceability. Considerations when selecting closures include garment characteristics, quality standards, assembly methods, application procedures, and costs. Availability of appropriate equipment and skill may limit closure selection.

References and Reading List

Apparel Quality Committee of American Apparel Manufacturers Association. (1985). Elements of an apparel quality control program. Arlington, VA: Author.

Standard Terminology Relating to Zippers. (1988). Annual book of ASTM standards: 07.01, pp. 321–324.

Smarr, S. L. (1987, December). YKK (USA) adds zip to apparel. *Bobbin*, 29(4), 124–128.

Key Words

attaching units automatic lock sliders blank bound buttonholes braided elastic buttons camlock sliders casings casted buttons casting chain closure unit

closures coils commodity elastic compression-molded buttons contact fasteners cross-stitched buttons elastomers enclosed elastic enclosed zippers exposed elastic exposed zippers evelet facings flange lock sliders gimp holding power holed buttons

hook-and-loop tape

hooks injection-molded buttons insert elastic invisible zipper keyhole buttonholes knit elastics lignes loop buttonhole nonlock sliders nonseparating zippers peel strength pinlock sliders plackets plush elastic pronged rings rubber buttons scoops separable zippers

shanked buttons shear strength slider snaps sockets spandex straight buttonhole stringers studs tack buttons thread shanks woven elastics wrapped thread shanks zipper pulls zipper stops zipper tapes zippers

Discussion Questions and Activities

- Examine a number of different zippers installed in garments. For each, identify the zipper type, various parts, type of locking device on the slider, and effectiveness of stops. Discuss the appropriateness of end use.
- 2. Compare the buttonholes used on different types of shirts. Examine stitch type,
- tightness of stitches, type of thread, positioning, aesthetics, and durability.
- 3. The U.S. military service is presently interested in developing a silent hook-and-loop tape. What causes hook-and-loop tape to make a noise when it is operated? What modifications in design might allow it to become silent?

chapter 5

Trims

OBJECTIVES

- Examine the role of trims relative to garment design, production, cost, and quality.
- Discuss characteristics and applications of various types of trim.
- Explore quality factors of various trims used on apparel.

Trims are materials used to ornament or enhance garments. They are visible parts of garments that may be used to increase hanger appeal, provide product differentiation, relate to current fashion trends, and carry a theme through an entire collection. Trims include a broad range of materials and treatments that may be superficially applied or structurally incorporated into nearly any type of garment. Possibilities for trim are limited only by availability, design creativity, costs, and equipment to produce and apply them.

To simplify this discussion, trims are grouped into four categories: bindings, edgings, flat applications, and other trims. Selected types of trims, including embroidery, lace, appliqués, knit trims, screen printing, heat transfers, and labels, are discussed in more depth to develop a better understanding of quality and performance.

Types and Sources of Trims

Trims, which are an integral part of garment design, may be decorative and/or functional. **Decorative trims** are selected and applied to enhance the aesthetic appeal of a garment but are not essential to garment function and performance. Examples of decorative trims are embroideries, screen printing, and appliqués. **Functional trims** are an integral part of garment structure and use. They serve a specific purpose in garment performance, and aesthetic contributions are optional. Examples of functional trims are knit collars and cuffs, buttons, edge finishes, and labels.

Trims may be added to piece goods, garment components, or finished garments, or they may be garment components such as knit collars and cuffs. Piece goods may be embroidered or narrow fabrics may have edgings applied prior to cutting.

Trims are often applied to garment components prior to assembly to facilitate handling and application. They become a more integral part of a garment if applied early in the production process. Finished garments may be trimmed to customize a product, but rarely are structural trims added after assembly. Screen printing may be applied to garment components or finished garments depending on the nature of the design and customer needs.

Types of Trims

A wide variety of materials may be used as garment trim, including piece goods, support materials, closures, thread, and special purpose fabrications. These materials are applied to garments as bindings, edgings, flat applications, and other trims.

Bindings are primarily functional trims that finish outer edges of garments or garment components by encompassing them. They are used to finish necklines, armholes, hems, front openings, and so on. Bindings may be made of a wide variety of materials including bias cut wovens, knit strips, and folded braid, which might be used to bind the edge of jogging shorts.

Bindings need flexibility to conform to garment curves. Knit and bias bindings have more stretch and flexibility than woven goods cut on straight grain. Binding width and stretch must be appropriate for the amount of contour expected. Narrow bindings work best on sharp contours, while either wide or narrow bindings can be used on straight edges. Bindings are selected to match or accent piece goods or to carry out a specific color theme in a garment design. They are applied using methods specified in the Bound Seam Class of the Federal Stitch and Seam Specifications.

Edgings are used to accentuate style lines, outline shapes, or compartmentalize blocks of color. They may be applied to edges or included in seams of garment components. Edgings are used on straight edges such as hems, ruffles,

tucks, and straight design lines and on curved edges such as necklines. Edgings on straight edges need to be flexible but not necessarily shapeable. Edgings can also be gathered for aesthetic appeal and shaping along contoured seams. Common types of edgings are piping, lace, ribbon, fringe, tapes, picot trim, and so on.

Piping is a covered cord that forms a raised edge along seams. It is used to stabilize seams, outline components, and absorb wear and abrasion that would otherwise affect seams. Stiff piping lacks flexibility, is difficult to shape, may distort component shape, and is more susceptible to abrasion than a more flexible type.

Laces are often used to trim necklines and sleeves, particularly of sleepwear and infant and toddler dresses. Edging laces often have a stiff hand. That is why little children become fussy when dressed in frilly dresses with scratchy lace edging around the neck and sleeves. A softer hand is more comfortable and considered to be better-quality.

Piping, lace, and other types of edgings may be applied as lapped seams or superimposed seams depending on whether the edging has one or two finished edges and where it is being applied to the garment. Unfinished edges of trims should be enclosed in seams or covered by garment components. Edgings with two finished selvages can lap edges of components for application.

Flat trims are applied to the surface of garment components to ornament a style. Flat trims include braids of all types and designs, twill tapes, ribbons, knit tubings, narrow weaves, warp knit bands, embroidery, appliqué, and screen printing. Braids, tapes, ribbons, and bands may be sewn to garment components in single or multiple rows, scrolled on collars or fronts of blouses and dresses, or used to stripe sleeves or pant legs or to cover seams. These trims are available in a vast variety of widths and fabrications. Width affects use and application. Scrolling requires very narrow and flexible trim. Wider trims are difficult to curve and manipulate for a flat application. Coverage of seams with trims requires wider, more durable applications. Flat trims may be applied with lock or chain-stitch machines.

Embroidery, appliqué, and screen printing are applied to garment piece goods, garment components, and trims to create special visual and textural appeal. These trims are discussed in more depth later.

Other trims, including nail heads, rivets, rhinestones, grommets, and buckles, are sewn or clinched into garments with special equipment. Use of these trims is subject to fashion acceptance. Prongs or other attaching devices need to grasp and hold shell fabrics securely without cutting or snagging the garment or scratching the wearer. Prongs may cut yarns and damage shell fabrics if not properly selected and carefully applied. Soft and knitted piece goods often need a backing to stabilize and support metal trims.

Aesthetics and Performance

Appropriate trim selections can make ordinary garments special; the wrong trim can make garments unsalable. High-quality trims can make otherwise inexpensive garments look terrific, while cheap buttons or laces can ruin the appeal of well-made garments. Some trims have specific appeal to certain market segments. For example, lace trims and ruffles on little girls' dresses are more important to the gift market and certain ethnic markets than more functional trims. Trims are also part of the fashion scene. Appliqués may be in high demand some seasons, while leather trims and rhinestone studs are popular another season.

For good performance, trims must be compatible with other materials used in the garment and suited to assembly methods, equipment, and skill of operators. From a production standpoint, trims serve best when they can embellish basic, easy-to-produce, easy-to-wear fashions. Care must be taken to select trims that (1) have similar care requirements as the piece goods, (2) are colorfast, and (3) are dimensionally stable or dimensionally compatible with piece goods.

Bindings, edgings, and flat applications should be flexible, have a soft hand, and resist abrasion. Bindings and edgings are used in areas of high body contact such as armholes of sleeveless garments, necklines, fronts of jackets, and hems. Bindings are especially subject to abrasion because they surround garment edges and rub against the body.

Dimensional stability during application, use, and care is important to aesthetics and performance. Fiber content is a selection criteria related to durability, abrasion resistance, and care. Shrinkage can cause puckering of garment components and poor fit. Excessive stretching during application may result in uneven application, pucker, and distortion. Work aids such as folders and guides are frequently used to facilitate sewing operations and to improve quality and consistency of application.

Common performance problems include failure of trims in laundry or dry cleaning, color bleeding, shrinkage, stretching, distortion during application, and distortion following renovation. A better understanding of aesthetics and performance of trims is gained by the more in-depth discussion of the production methods and characteristics of some major types of trims.

Sources of Trims

Apparel manufacturers may purchase trims or produce their own. Purchased trims may be selected from open stock or produced to specifications. Trim manufacturers specialize in certain types of products such as lace, embroideries, knit collar and cuffs, and narrow fabrics. Many trim manufacturers work with fabric houses and garment manufacturers to develop trims to coordinate with piece goods or to enhance garment styling. Trim wholesalers market a variety of products produced by multiple sources that may include appliqués, braids, buttons, and laces. This enables garment manufacturers to work with fewer vendors in sourcing materials for their product line and reduce the marketing done directly by a trim manufacturer.

Trim buyers depend on a vendor's testing and specifications when ordering from open stock, but compatibility with other garment materials must also be

checked. The garment manufacturer is responsible for the compatibility of all the materials. Open-stock items have smaller minimum orders and are easier to reorder but have limited confinement. They are often available in traditional colors and limited fashion colors, which may create difficulties in matching specific colors a garment manufacturer may use. Trims may be ordered to specifications to obtain a specific color match, logo, or fabric consistency, but the benefits of ordering from open stock disappear.

Garment manufacturers that produce their own trims may have their own specialized machines or contract production. When trims are produced in house or by affiliated plants, there is more product control, exclusivity, and less opportunity to be copied than when trims are contracted or purchased from open stock. When a firm produces its own trims, delivery is more dependable, quality control is easier, shading and matching problems are reduced, lead time is reduced, and inventory adjustments are easier. Manufacturers may choose to produce some types of trims and contract production of others in order to limit investment in specialized equipment and skills.

Knit Trims

Knit trims are primarily functional trims used as bindings and edgings with aesthetics added through color, pattern, and texture. Knit trims may be used for flat applications such as stripes or bands or for components, such as collars and cuffs. Yarn-dyed stripes and jacquard designs are frequently part of knit trim structures. Knit trims are designed and used primarily on knit sportswear, but they may also be used to trim woven sportswear. Fashion sometimes dictates knit trims on wovens or woven trims on knits.

Knit trims may be cut and sewn or knitted to specified dimensions, depending on methods of fabrication. **Circular knit trims** are produced in tubes that range from 1 inch to 60 inches in circumference. Tube size depends on the size of a needle bed and gauge (number of needles per inch). Neckbands, cuffs, and some knit braid may be produced as a tube and cut to specific lengths or widths as needed. Narrow tubes may be cut to specific lengths and used as a tubular trim, while wider tubular piece goods may be cut crosswise as a continuous strip and rolled for application during assembly.

Flat-bed knitting machines may be used to produce knit trims, such as collars or cuffs. Trim pieces may be knitted to specific size dimensions, have finished edges, or be shaped by decreasing and connecting wales to form fashion marks. Moisture-soluble yarns may serve as connecting courses between pieces of trim. On completion of a run, application of steam dissolves the soluble connecting yarns, leaving separated pieces that are the prescribed size. Cutting or pulling the connecting yarns may also separate trims.

Warp knitting can be used to produce yardage for cut and sew trims or flat narrow trims with finished edges. Narrow knit trims are used for racing stripes on pants, sleeves, and shoulder trims on athletic uniforms. Warp knit tricots may be produced in standard widths and cut to size for specific types of trim such as bindings on lingerie and sleepwear and spaghetti strapping.

Rib trims used to complete necklines and lower sleeve edges are produced as 1×1 or 2×2 ribs depending on the amount of bulk and stretch needed. Edge structures determine whether a knit trim is used as a single- or double-ply. Rib trim with one finished edge may be used as single-ply trim on sweater necklines and cuffs of polo shirts. Two-ply folded trims may be used as sleeve, waist, or neck bands. Folded trims applied with a superimposed seam result in an exposed seam at neckline and cuff edges.

Two-ply trims may also be seamed before folding to enclose the seam and form a tube. This treatment is often found on letter jackets with ribbed cuffs; it is regarded as better-quality construction because the seam is enclosed. Another type of **ribbing** used on sweaters is formed on a machine with two needle beds. The outer edge of the band is single-ply, and the attaching edge is double-ply. This forms a binding to cover the seam and a single-ply ribbing at the neckline to reduce bulk. This is used on sweaters and bulkier knits.

Knit trims often need to stretch and recover as a garment is put on and taken off. Stretch and recovery are affected by fiber content, knit structure and gauge, and method of application. Knit trims are often the same fiber content as knit garments on which they are applied. When knit trims are used on woven piece goods or other fabrications, the fiber content may not be the same, which can cause compatibility problems. Spandex yarns are often knitted into trims to provide better recovery and shape retention. Some firms preshrink knit trims to tighten the gauge and provide more stretch.

Embroidery

Embroidery is an art form that uses close or overlapping stitches to form intricate, three-dimensional, surface designs to embellish piece goods, trims, or garments. Embroidery has evolved from hundreds of years of handwork by dozens of cultures to an established art form. Today, the embroidery process uses advanced technology to embellish styles and mass produce trims for the garment industry. Embroidery is a flat trim that adds interest and differentiation to a product.

Embroidery has evolved from a customized hand-sewing process to computercontrolled stitching for mass production. Some of the first embroidery machines made it possible to apply names on individual garments, such as hats and shirts. This required a great deal of operator skill to manipulate garments and form the lettering. Modern embroidery machines only require the operator to hoop and place the garment or fabric to be embroidered under the needles. Embroidered designs may be applied directly to piece goods, garment components, finished garments, or as individual emblems that are an add-on type of trim.

Direct Embroidery

Direct Embroidery becomes an integral part of garment structure as stitching cannot be removed without damaging piece goods. Fabric yardage may be embroidered for an overall textured design. Garment components such as pockets, shirt fronts, and collars, may be embroidered with designs or logos prior to assembly to facilitate handling and manipulation of materials. Completed garments may be embroidered to customize garments with logos and special designs. Monogramming is a means of personalizing finished garments for specific consumers by direct embroidery of their names or initials. Monogramming is usually done on a special order basis by retailers.

Embroidery Machines

Many firms own multiple embroidery machines to embellish their own products and other firms use contractors to do the embroidery for them. There are many small entrepreneurial firms that do nothing but embroidery. Computerized **digitizing** and computer controlled embroidery machines have enabled small firms to provide a service that was previously impractical.

There are three categories of embroidery machines and each serves a special function. Piece goods are embroidered with Schiffli embroidery machines. Single head and multihead machines are used to embroider garment components and finished garments. Garment manufacturers select machine types that best suit their product lines, sizes of embroidery most commonly stitched, and order sizes. Some manufacturers may own more than one type of machine to give them more flexibility in design size and better productivity.

Embroidery machines operate on a predetermined stitch cycle that is specific to each design that is sewn. A computer disk or punched tape controls the stitching patterns and needle action. The stitch pattern controls the sequence and time that the machine stitches. All needle beds on a machine are controlled by the stitch pattern and operate at the same time or stop at the same time. This can cause a major reduction in productivity if there are excessive thread breaks or delays in hooping or loading.

Garments or components are secured in hoops or frames to span or hold materials taut for stitching. The term **framing** is used with Schiffli embroidery machines because full lengths of fabric must be secured for stitching. **Hooping** is the process of securing components or small areas of whole garments in a small hoop that stabilizes the fabric for stitching.

Embroidery is sold and costed based on the number of stitches in a design although the stitching time is only a part of the total production time. Productivity of embroidery equipment is based on how many stitches can be generated per day.

Schiffli Embroidery Machines Schiffli embroidery machines are large, loomlike machines used to stitch designs on lengths of piece goods. They are used to embroider piece goods, produce emblems, and make novelty and Venise lace trims. Most machines operate with two frames that hold two fabric lengths of 10, 15, or 21 yards that span the frame. Machine size varies with production needs (see Figures 18–1 to 18–4). Frames, which are mounted vertically, have controlled vertical and horizontal movements directed by a punched tape or a computer disk. Actions of some types of Schiffli machines are controlled by an automat, which is a system of rods, cams, and levers, used to read punched tapes and direct embroidery frames in forming a design.

Needles are mounted on two horizontal fixed tracks that span the length of the frames. Needle bars move needles horizontally in and out of piece goods in syn-

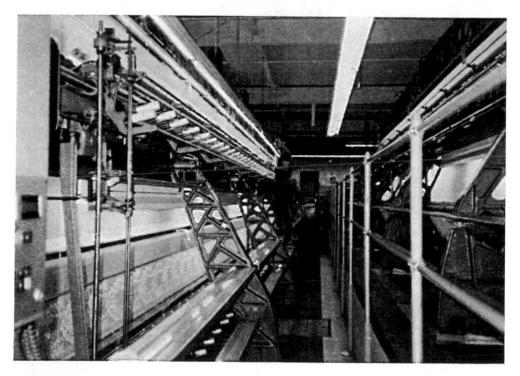

Figure 18–1
Frames of a Schiffli embroidery machine.
Source: Courtesy of J. Else and Touch of Lace.

chronization with frame movement. Needles are pushed into framed piece goods and retracted for stitch formation (see Figure 18–2). A stitched pattern evolves from frame movement. Eyelet fabrics and trims are made by borers mounted directly below the needle bars. *Borers* puncture fabric and push aside yarns prior to stitching that encompasses the edge. Schiffli embroidered fabrics may experience a reduction in yardage due to the heavy concentration of stitches.

Because of the complexity, size, and cost of Schiffli equipment and the specialized training and expertise needed to operate it, most apparel firms use contractors that specialize in Schiffli work. Fabrics can be sent to the contractors to embroider, or embroidered trims can be special ordered.

SINGLE-HEAD EMBROIDERY MACHINES Single-head embroidery machines are similar to basic lock stitch sewing machines. They were developed for small orders and may be used for customizing garments. Single-head machines are most often used for custom work and monogramming. They may be manually operated or computer controlled. Manually operated machines depend on skilled operators to position and manipulate materials under the

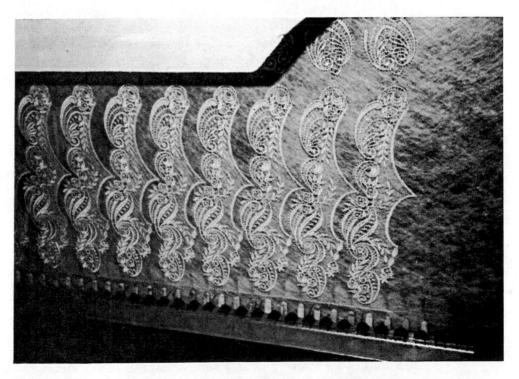

Figure 18–2

Needle bar that forms stitches in synchronization with frame movement. Stitches are being formed on Solvron, which is later dissolved to leave individual lace trims.

Figure 18–3 Multihead embroidery machine. Courtesy of Macpherson Meistergram, Inc.

needle. Computerized embroidery machines are programmed to stitch the selected design and all the operator needs to do is place the garment.

Technology has expanded the use of single-head embroidery machines. A computer network can interface and control up to ten different single-head machines so that each machine can run a completely different embroidery program at the same time. This allows the manufacturer to customize its service and produce very small orders as needed by its customers. To stitch a small order of three on a large multihead machine would waste a lot of capacity that could be better used for large orders.

MULTIHEAD EMBROIDERY MACHINES Multihead embroidery machines are similar to single-head machines except they may contain two or more heads that stitch the same pattern at the same time. Smaller areas are best done with more, close-set heads; larger patterns need a wider needle range and fewer heads. Border machines may provide the most flexibility, as close-set heads can be spaced close together and alternate ones uncoupled to allow stitching a wider pattern. With multihead machines, garments are individually hooped and inserted horizontally under each head.

Each head may utilize one to six needles and up to six colors in stitching a design. Machines are purchased with a specific number of heads. The optimum number of heads is generally dependent on the firm's average order size, average number of stitches per a design, and size of the area to be stitched. Higher stitch counts are more efficiently done on machines with more heads. Loading time should be less than stitching time if the operation is to be productive. More heads require more loading time and for designs with a lower stitch count there is more idle time during the loading process.

Emblems

Emblems are individual embroidered designs with finished edges. They are mass-produced trims known as embroidered patches, appliqués, insignia, or badges frequently used on outerwear. The largest single customer in the world for embroidered emblems is the U.S. government. Emblem embroidery was originally developed in Switzerland under extremely high-quality standards. Because of the quality and tradition associated with the industry in Switzerland, the term Swiss embroidery is often used even though the emblems may be produced somewhere else.

Compared with direct embroidery, emblem designs are often larger, more complex, and use more stitches, colors, and thread. Designs may involve more intricate lettering, figures, or symbols. Emblem designs may be customized for a particular firm or organization or sold by souvenir shops. Emblems are used in place of direct embroidery when

- · Materials are not suitable for direct embroidery
- Emblems are more cost-effective than direct embroidery
- There is a need for a specific customized emblem with great detail
- Trims are stocked for sale to manufacturers or consumers

Emblems may be applied to visors or hats, coat fronts, sleeves, and so on, that would otherwise be too heavy or awkward to embroider.

PRODUCTION OF EMBLEMS The majority of embroidered emblems are produced on Schiffli machines because of efficiency and cost. Time and volume of production are major factors in the wide usage of Schiffli machines for large quantities and multihead machines for producing small quantities. Multihead machines can produce one emblem per head during one run, while Schiffli machines can produce hundreds of emblems at one time depending on the size of the emblem.

Emblems are stitched on lengths of piece goods, cut or separated from other emblems, and edges finished with a tight 504 stitch for easy application and durability. Emblems are applied to garments by sewing, heat sealing, and electrostatic adhesion. Some emblems may be stick-ons, but usually this is only a temporary application until it can be sewn in place.

Materials for Embroidery

Materials required for all embroidered designs are piece goods (also called ground or base fabric) and thread; digitized patterns or punched tapes are essential for the operation of the equipment and will be discussed later. Some types of embroidery also require backings.

Piece goods need to be sewable, durable enough to withstand a high stitch count, and able to maintain dimensional stability. Durable ground fabrics make

it possible to use a high stitch count and more overstitching without damaging piece goods. Backgrounds of emblems may be solid stitching or exposed ground fabric. When ground fabrics are the background for designs, color and surface texture are important factors. Solid-stitched designs depend on ground material for support and strength. Medium- and lightweight fabrics may need backing for additional support.

Thread used for embroidery must be strong, lustrous, sewable, and compatible with the care procedures for the garment. Thread breakage has a major impact on productivity of the embroidery process. Thread breakage on one machine head stops production on all the other heads of the machine. Based on a 20 second rethread time and 7.5 hour work day, one thread break means lowering output by approximately .07 percent. This means that eliminating 14 thread breaks would increase productivity by 1 percent. How many breakages occur in a work day? Which head has the most breakage? What color breaks the most often? Answers to these questions will help determine the cause of many of the breakage problems. "A well run machine with good thread should have 5 or fewer breaks per 10,000 stitches" (Krasnitz, 1997). Compromising quality can be a costly choice.

Fiber contents most used for embroidery threads are 100 percent rayon and 100 percent polyester. Cotton threads have very limited use. Rayon has been the most used embroidery thread due to its luster, wide range of color selection, and sewability. Colorfastness can be a problem with some care procedures used on garments. Polyester thread is stronger and colorfast. Improvements have been made to provide better luster and sewability. Thread size is an important factor in interpreting and digitizing a design. Fine thread requires more stitches to form a design and fill-in an area, but it is frequently related to better-quality execution. Synthetic threads may range in size from 70 denier for extra-fine lettering and definition to 600 denier for overlocking edges. Some threads are specific to cover stitching, while others are developed for fine detail stitching. Embroidery threads may be plied for strength and texture. Different color plies may be used to increase texture and color variations. Metallic threads are difficult to run due to a tendency to knot and break. Metallics are not as flexible as other threads and are not a good choice for small, thin-lined areas.

Thread shrinkage can distort a design and garment components. Because of the high concentration of thread, shrinkage in even a small amount can result in an unusable garment. Color bleeding can also be a major problem with thread if compatibility is not considered. Testing the compatibility of thread, fabric, and the stitched design would reduce potential long range problems.

Backings are used with both direct embroidery and emblems. Direct embroidery is often backed to provide support, prevent distortion, and produce more aesthetically pleasing designs. Backings for direct embroidery are usually pieces of nonwoven material placed under garment components as they are hooped for stitching. Backings are of varied weight and hand. Excess backing

may be cut away by hand, or a tear-away backing may be pulled away from the stitching. Stiffer, tear-away backing may not tear away completely, leaving rough and scratchy areas. Backing does not cover stitch buildup, knots, or loose threads that may accumulate during the embroidery process. These can also be very irritating to the wearer.

Due to its stiffness, buckrum is often used to back piece goods used to produce solid-stitched emblems. Emblems are frequently backed or coated with plastic substances to provide a firm hand, ease in handling, greater durability, and to secure loose threads. Back coating provides extended body and life. Emblems may be backed with plastic films for heat sealing or adhesives that make emblems pressure sensitive for stick-ons.

Embroidered Design Development

Design development begins with submission of a sketch by the customer or the sales representative. Artists determine a design's suitability to embroidery, interpret the design, and examine potential execution for a specific garment or location. Artists develop designs based on a customer's specifications. Final designs are produced in exact dimensions with full-color representation and submitted to the customer for final approval. Approved designs are interpreted and translated into stitches by digitizers or punchers.

Digitizing and Punching Designs

Stitch patterns are formulated by varying stitch types, length, spacing, direction, placement, and density. Both digitizers and punchers convert artwork into commands for embroidery machines to execute. The main difference is in the equipment used to develop the design and output. Digitizers work electronically and punchers manually develop a punched tape that operates the machine. Older machines may be driven by punched tapes and new electronic controlled machines are computer operated. Computer output can be converted to punched tape, electronic tapes, or disk, depending on equipment requirements. Some firms operate both types of equipment.

Digitizers and punchers work with an enlarged (6×) detailed drawing of the design, as shown in Figure 18–4. This same image could be enlarged on a computer monitor and stitches plotted between points on the drawing. With manual punching, each stitch and function noted on the enlargement are recorded and transferred to a punch drum that perforates the pattern tape. Figure 18–5 shows a manually operated punch machine. When the puncher activates the trip mechanism, it is recorded by punching the tape as shown in Figure 18–6. The manual process is much more cumbersome and time consuming, but it is used by some highly skilled technicians in the industry. Understanding the manual process helps to show the importance of each stitch on the design.

Digitizer's decisions impact the aesthetics of the design and the production time. It is the digitizer's interpretation of the design and skill in executing it

Figure 18–4
Design for lace trim that has been enlarged six times. The designer is determining the stitch types that will be used.

Figure 18–5
Manually operated punching machine. Each stitch in the design is identified and punched by the operator and registered and transferred to a punched tape.

Figure 18–6
Punched tapes control the movement of the frames and needle bars as embroidery or lace is produced.

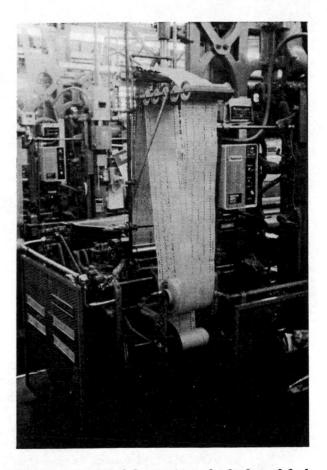

that adds life, beauty, and quality to a design and determines the look and feel of finished embroidery. Digitizers determine placement of tie-in stitches that fasten areas of an embroidery together, loft and tensions relative to stitch size, color changes, the number of stitches to fill an area, and the operational functions needed to complete a design. Tie-ins are needed to connect parts of embroideries or lace with open designs. Less tension is used with long stitches to reduce pulling and allow piece goods to lie flat. Machine functions such as boring, color change, cord in-lay, and tension change are also determined by the digitizer.

Density of stitches (number of stitches in a specific length) is directly related to stitch length and yarn size. Finer yarns require more stitches to provide the density and cover needed. Stitch density and stitch length are cost factors. Longer stitches take longer to form and more stitches require more machine time. As columns of stitching get narrower, the stitches per inch (spi) can be reduced without changing the appearance. Underlays may be used to reduce the number of top stitches needed. Underlays are the initial stitches that outline and stabilize the fabric for additional top stitching. The number of thread trims

are also a time/cost factor. Color changes and planned breaks in stitching leave thread ends that require trimming.

Digitizers need to understand the performance of piece goods, yarns, equipment, and their effect on execution and performance of design. Digitizers have a great deal of responsibility for translating the creativity of a design and the success of its execution.

Digitizing may be contracted by some firms, while others do all their own. Large firms may do both. Firms that do their own digitizing reduce the risk of having their designs copied. Trims are knocked off just as any other fashion goods, but no two digitizers will interpret a design in precisely the same manner or with the same quality characteristics (see Table 18–1 for issues that are considered as digitizers develop designs). It is also possible to purchase digitized designs from firms that specialize in developing creative designs for embroidery.

Embroidery Stitches

Machine embroidery uses three basic **stitch types** that can be varied and manipulated to produce a wide variety of affects (see Figure 18–7). A design should contain more than one type of stitch for best execution. **Steil stitches** (Figure 18–7a) are small, closely aligned stitches that follow a tight back-and-forth pattern. They are used for edges and reinforcements for scallops, finishing edges of eyelet embroidery, and so on. **Blatt stitches** (Figure 18–7b) are wider (1/8 inch or more) with the same back-and-forth configuration and less tension. Often called *satin stitches*, they create dramatic textured effects when used in different directions. Blatt stitches require more stitches per inch unless an underlay is used to prevent gapping.

Running stitches (Figure 18–7c) form a design with one thickness of thread. They can be placed in any direction and may not be covered by other stitching. Running stitches are often used for shading and connecting parts of a design. Changing stitch direction changes the way light reflects off the thread and creates an interesting effect. Many variations and combinations of these are used by the digitizer in creating an embroidered design.

Table 18–1Considerations in preparing punched tapes.

How will the piece goods respond to framing?
How will the piece goods respond to a heavy concentration of stitches?
How much will piece goods pull in with stitch formation?
How small can a stitch be on piece goods and still be visible?
How will the thread react?
Where should tie-in stitches be placed?
Where should tight tension and loose tension be used?
How close should the stitches be relative to yarn size?

Figure 18–7
Basic types of embroidery
stitches can be used to form any
design: (a) steil, (b) blatt, and
(c) running.

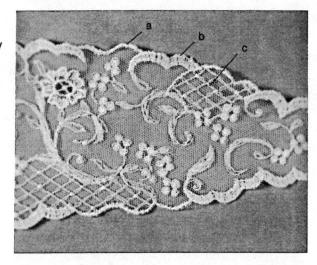

Other stitch formations include **chain stitches** and chain-stitch variations. Chain stitching forms loops on the surface of the fabric from a single thread source. Moss or **chenille stitches** are formed by a chain-stitch machine with a drop stitch or loop formation on the face of the piece goods. Moss stitches are used to fill and provide a three-dimensional appearance to the design. They are usually formed with heavier wool or acrylic yarn and are commonly used on award letters.

A similar stitch, looping, is rapidly gaining attention. **Looping stitches** attach to the fabric surface by a monofilament thread instead of being pulled through the fabric. Looping stitches are used to add a three-dimensional look to designs. These stitches require much heavier yarns than other embroidery stitches.

Trapunto

Trapunto is a specialized form of embroidery, with raised designs that have been stitched and padded to create a relief effect. With new automated multihead machines, trapunto designs can be stitched with closely spaced twin needles and cording fed in on the underside. This creates an interesting surface trim that can be personalized if desired (see Figure 18–8).

Costs of Embroidery

Costs of embroidery are related to size of a design, number of stitches in a design, materials used, complexity of a design, color changes, and handling of garments or components. Smaller designs or repeats cost less. Costs increase by using more stitches, finer yarns, more detail, more expensive materials, more handwork, and more finishing.

Figure 18–8
Trapunto design formed by stitching over a cord to form a raised design.

Manufacturers with a concern for the cost of a design may establish a ceiling on the number of stitches to be used in a design. The number of stitches required is related to the size of the design and thread to be used. For embroidery to look good, a fixed amount of stitches must be used for each size yarn. A smaller design requires fewer stitches, and coarser yarns require fewer stitches to fill a space. It is important not to lose sight of either **design execution** or **cost control.** Both factors are important to the salability of garments.

The time required to produce each piece of embroidery determines its cost and production capacity. The primary cost factors are stitching time and hooping time. Downtime can add up very quickly with thread breakages. High speeds tend to increase thread breakage thus the gains from high speed need to be weighed with costs of stoppage and rethreading. The Technical Advisory Committee of AAMA suggests that an average machine speed during the course of a day's production in a well run plant should be between 400–450 stitches per minute. This would factor in down time, hoop loading, rethreading, and initial setup time.

Hooping can be done while the machine is running but it may take more than one operator to prepare and load one machine, depending on the length of the stitch cycle and the number of heads being used. Some firms use teams to load and unload several machines.

Planning production schedules can help reduce set up time. Plan consecutive jobs with the least possible color changes. In some instances thread changes can be made while the machine is running if all thread colors are not in use.

Quality Factors

Quality of embroidered trim is based on designs and execution of the products. Many variables can be evaluated: thread type and size, stitch count and size, stitch formation, stitch patterns and density, and materials selection. Each of these variables can affect a product's aesthetics, performance, and quality. Planned placement of embroidered designs is important to execution, aesthetics, and performance. Embroidered designs should not cross seams and yet

should be far enough away from seams that an embroidered area can be secured in a hoop during stitching.

Appliqués, Insets, and Lace Trims

Appliqués, insets, and lace trims are used as topical applications or incorporated into the structure of the garment. Lace trims may be used as appliqués, insets, or edge finishes.

Appliqués

Appliqués are emblems or cut-out fabric shapes, figures, or motifs that are superimposed and sewn or fused to garment components. Appliqués may be a single ply of fabric, preembroidered sequin, or beaded emblems, Venise lace, or other materials. Appliqués have had a strong fashion emphasis with the popularity of these designs on sweatsuits, sweaters, children's clothing, and other types of sportswear. Appliqués are also used with embroidery to fill areas of design.

MATERIALS FOR APPLIQUES Materials used for appliques are limited only by their sewability and compatibility with other materials used in a garment. Contrasting and unusual textures are often used for appliques that may create care and performance problems. Leather is often selected for its interesting texture and ease of stitching with little concern for the limitations and complications of dry cleaning the garment. Compatibility is often taken for granted as appliques are often small and seem insignificant to the performance of a total garment, although a small piece of fabric that is not colorfast or dimensionally stable could render an entire garment unusable.

Appliqués are often backed with some type of fusible interlining to facilitate handling and sewing. Fusible interlining adds body to small pieces that may be difficult to grasp and position. **Backing** also reduces potential for raveled and stretched edges during sewing.

Some appliqués may have a heat-activated adhesive applied to the back for fused applications to hosiery, lingerie, and so on. Others may have a glue substance that enables immediate attachment to a variety of surfaces. This type of application is usually considered temporary but can be used for accurate positioning prior to sewing.

QUALITY AND PERFORMANCE Quality and performance of appliqués are related to creativity of the design, materials used for the appliqué and garment, method of application, stitch selection, sewability, and product testing. Well-designed appliqués are integrated into the style, structure, and aesthetics of

a total garment; they are not just an add-on for color or detail. Carefully planned and accurate placement of appliqués is also a factor in garment aesthetics and quality. Appliqués are often used to establish or support a focal point on a garment, but they may also distract from a focal point if not well planned and positioned.

Execution of details affects the quality of appliqués. Use of intricate shapes, more stitching, and added trims may enhance the interpretation of a design, but too much detail that is poorly done can have an adverse affect on quality. Fabric appliqués are frequently die-cut for accuracy and greater consistency. Die cutting produces a smooth, well-defined edge that facilitates the sewing operation and results in better-finished products.

METHODS OF ASSEMBLY Most appliqués are manually applied by sewing operators. Emblems, which have finished edges, are often applied with a basic lock stitch. A lock stitch is secure and does not distract from emblem designs. Fabric pieces may be attached with a basic zigzag (304 or 404) stitch to accent shape and design. With this type of application, stitches must be close enough to prevent raveling, create a solid outline for the appliqué, but not so close as to damage piece goods. The execution of stitching patterns on corners and curves affects appliqué appearance, performance, and quality. Corners must be stitched down without stitch buildup or irregular stitching. This is often dependent on skills and quality standards of operators. A high stitch count with accurate stitching requires more time and increases costs but creates a more defined outline and better-quality appliqué.

Thread selection and use require thorough preplanning. On better-quality appliqués, thread color is often matched to each part unless a dominant outline is needed in which case contrasting thread, braid, sequins, or other trim may be used. Use of several thread colors on one appliqué requires extra handling or thread changes that are time-consuming and costly.

Inset Trims

Inset trims are frequently formed from laces, sheer, or contrasting fabrics and used on fronts of sleepwear, blouses, dresses, and so on (see Figure 18–9). Insets are a structural trim that are cut to a specific shape and inserted into a garment component. They are a single ply of material that is different from the shell fabric. It may be a sheer material inserted into an opaque fabric or a contrasting color used as an accent. In mass-produced garments inserts are usually along edges of components because application is easier. The shell fabric is removed where the inset will be inserted, and the cut edges are finished. The inset, depending on the type of material and shape of the inset, may be applied with an LSa or an SSa seam (see Chapter 14). Quality of workmanship is important to the aesthetics and performance of insets as they become focal points of a garment.

Figure 18-9

Neckline of blouse with an inset design. The blouse fabric was removed from behind the inset. The area may be removed in the cutting room as the garment is cut, which is the fastest approach, or it may be removed after the inset has been sewn in place.

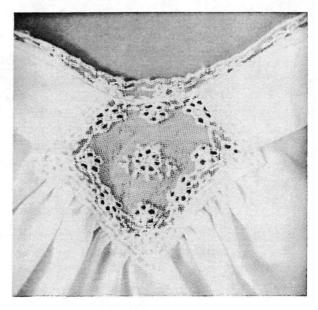

Lace

Lace is an ornamental openwork fabric or trim made into a variety of designs by intricate manipulation of fiber or yarn. Traditionally, laces were formed by hand, but today most laces are machine made.

TYPES OF LACES Machine-made laces are produced on Leavers machines, raschel knitting machines, or Schiffli embroidery machines. Leavers lace is controlled by a jacquard system and formed by bobbins that wind yarn around a set of warp yarns to form a pattern. Quality and cost of Leavers lace depend on yarn quality and intricacy of design. Many European laces are produced on Leaver machines.

Raschel knit laces resemble Leavers lace but are less intricate, produced at much higher speeds, have a stiffer hand, and are much less expensive. Raschel laces are used extensively on moderate and budget lingerie and children's wear. Many of the stretch laces used on intimate apparel are also produced on raschel knitting machines.

Schiffli embroidery machines are used to produce novelty and Venise (venice) lace trims. This method results in a lace type of trim that is widely used on apparel. It can be fine, soft, and have an intricate and open design that meets high-quality standards even though it is produced in a nontraditional manner.

Venise lace is produced by stitching designs on a base fabric with Schiffli embroidery machines and dissolving the base fabric to leave only the stitched threads or open lace trims. This is a process called *aetzing*. Designs are stitched

to net or Solvron. **Solvron** is a moisture-sensitive nonwoven material that dissolves during the bleaching process. Once the backing is dissolved, only individual lace trims remain. This process is used to produce lace collars, cuffs, medallions, yokes, and a variety of other small lace trims.

Shapes of laces made on Schiffli machines are limited only by the stitch range of the machine. This makes it possible to produce small or large irregular shapes that can be used for collars or insets. The quality of Venise lace depends on the originality and intricacy of design, thread fineness, and stitching pattern. Tieins are especially important for Venise lace in order for parts to link together. Better-quality Venise lace may be made from 300-count 100 percent cotton yarn.

Lace selection should be based on appearance, hand, color, and care procedures. Many lace trims are produced for a specific style, use, and location, and in any size, shape, and dimensions needed.

Screen, Heat Transfer, and Digital Printing

Print fabric design is growing in importance because of developments in printing technology.

Screen Printing

Screen printing is the process of applying a printing medium through a mesh stencil to produce a surface design. It is commonly used for printing piece goods. However, the focus of this discussion is screen printing as it is presently used as trim for garments or garment components. Screen printing may be used to convert an ordinary, plain garment into a garment with identity, fashion, humor, or status. Designs may focus on contemporary themes, humor, politics, logos, status symbols, or aesthetic enhancement. Screen printing is used to place designs on many types of garments including T-shirts, jackets, hats, shorts, blouses, dresses, and athletic uniforms. Designs may be simple or complex, large or small, one color or multiple colors.

Screen printing may be used for limited or large volume production, although design development costs are the same regardless of whether one or a thousand garments are printed. Screen printed designs are less costly to produce than embroidered designs and allow a wide variety of aesthetic effects. Garments may be screen printed to strategically place a design that would otherwise create excessive waste if the fabric were printed with a large repeat. Screen printing may be used on larger garment pieces if the design is large and only limited yardage is needed. In some cases it is less costly to screen print a garment individually than to purchase printed fabric with high minimum yardage requirements. Screen printed garments or components offer design confinement and less lead time than many other types of fabric printing.

Design Development Designs for screen printing may be developed from original artwork or by cutting and pasting from a variety of existing artworks, lettering, and so on. Once the desired appearance is achieved, designs may be enlarged or reduced to specified dimensions. To be able to print the design, color separations must be planned and accurately executed to produce clear, well-defined screen prints. Register marks, sometimes referred to as registration targets, are established to provide for accurate alignment and placement of each color in the design. Register marks are used to accurately align garments and screens for precise color placement.

MATERIALS AND EQUIPMENT Basic materials and equipment required for screen printing include screens that are made into stencils, squeegees, and ink. Screen making involves frame selection, mesh selection and preparation, and stretching. Frames are used to hold and tension mesh materials that are used for stenciling. Frames are wood or metal, rigid or self-stretching. Wood frames are less expensive, lighter weight, and easier to stretch onto, but they are not adjustable. Adjustable frames make it possible to take up slack in a screen that may occur with printing and cause poor registration. Metal frames are easier to reclaim after use, but they are more expensive, heavier, and take longer to stretch.

Screen materials are polyester or nylon mesh that are stretched over frames to make a stencil. Mesh needs to be abrasion-resistant and dimensionally stable. Polyester has less elongation and retains stretched tension with varying atmospheric conditions better than nylon. **Mesh count** (the number of openings per linear inch) affects quality of a print and the amount of ink deposited with each pull of the squeegee.

Greater thread diameter results in greater ink deposit. High-count mesh with finer yarns allows less ink deposit, while low-count mesh with coarser yarns allows more ink deposit. Garment piece goods is also a factor in selecting mesh to be used. Finer mesh is better for hard-finish piece goods; coarser mesh is better for soft surfaces and garments, such as uniforms, which need a high deposit of ink due to high abrasion during use.

Stretching the screen is one of the most important factors in successful screen printing. Improper stretching of the mesh screen material can cause poor registration, excessive wear on screens, breakdown of stencil materials, and poor prints caused by crimping the screen as the squeegee passes over it.

Stencil making involves coating a screen with photo-sensitive emulsion. Designs are placed on the emulsion-coated screen and exposed to light to burn the design into the emulsion. This leaves areas of the design open so ink can pass through the screen onto a garment.

A squeegee is a rubber or plastic blade held by a wooden strip and used to force ink through the openings of a screen-printing stencil. The type of squeegee, angle of the blade, form of the edge, pressure, and sweep speed all affect the quality of a print.

Imaging materials are the inks used to print the designs. Inks are blends of vinyl chlorides, dispersion resins, plasticizers, pigments, heat and light stabilizers, surfactants, fillers or extenders, and other additives a particular printer may choose to use. On proper heat curing, the ink forms a tough flexible film on the piece goods that withstands stretching and rubbing. Various types of additives may be selected to achieve the desired hand and performance of the printed design. For example, puff inks are used to create three-dimensional portions of screen-printed designs.

Screen Printing Process The **printing process** may be a manual operation or carried out with varying degrees of automation. Garments or garment components are precisely placed on a palate. Sometimes an adhesive spray is used on the palate to ensure stationary placement of the item to be printed. A screen for each color in the design is loaded onto a rotating carousel. An operator lowers each screen, one at a time in a predetermined sequence, over the garment on the revolving palette (see Figure 18–10). A squeegee is used to force a thick, viscose ink through the screen and onto the garment.

Figure 18–10 Screen printer creates multicolor image on athletic shirt.

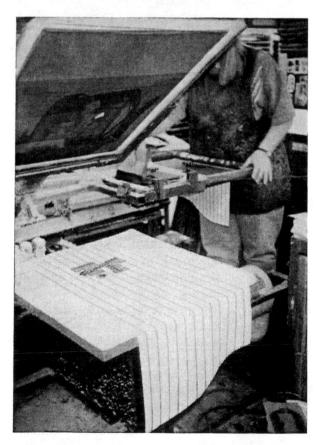

For multicolor designs, the ink may be partially cured (flashed) between applications to eliminate discoloration or smearing. Inks are cured by exposing them to heat, usually between 300 and 350 degrees Fahrenheit. Heat softens resin particles and causes them to swell. Resins absorb liquid around them and meld together to form a film.

Ink curing time and the amount of heat required vary with each brand of ink, amount of ink applied to a garment, blend of ingredients, and the type of drying oven. Light-color inks may require more heat than darker inks due to reflection characteristics. Garment color may also alter curing time. Curing can be tested by stretching the printed design forcefully. If cracks appear or the film crumbles or smears when rubbed, the film is undercured.

QUALITY AND PERFORMANCE OF SCREEN PRINTS Printing quality involves uniform ink film thickness, maximum resolution of detail, and adequate curing. All of the materials and processes previously discussed can affect print quality. The combined effects of the screen mesh, squeegee blade, ink, and piece goods determine quantity and distribution of ink. Correct size and the tightness of frames and screens allow for appropriate action of a squeegee and flexing of the screen for contact of ink with the garment. Correct curing makes the design permanent.

Precise **color registration** involves placement of a garment or substrate as well as placement of screens during color applications. Accurate registration is essential for clarity of a design. Correct registration is achieved by precise placement of a garment and careful matching of register marks within the design as each color is applied.

Heat Transfer Prints

Heat transfer is the process of transferring an image to a substrate by applying heat and pressure. A design is printed on paper with special dyes and transferred to a product by application of heat and pressure. Specific temperatures and dwell times change a dye from a solid to a gaseous state and back to a solid form on the product. **Heat transfer prints** are available in stretch, flock, puff, reflective, and foil designs.

Heat transfer designs used to be limited to synthetics or synthetic blends and nonstretch fabrics but improved technology now makes it possible to apply heat transfers to a wider variety of materials. Heat transfers may be applied by fabric converters, garment and trim manufacturers, and retailers. Garment manufacturers can make applications before or after sewing.

Heat transfers are colorfast. The depth of color depends on temperature, dwell time, and pressure used in application and the amount of color available on the paper for vaporization. The paper printer is responsible for design development, definition, color matching, and ink selection. Advantages of the use of heat transfer prints are speed and flexibility for meeting specific orders. Printed goods do not have to be carried in inventory.

Digital Printing

Digital printing is the process of being able to apply color to fabric upon demand. This means no screens or complicated set up, maximizing design flexibility, small orders, limited fabric inventory, and minimal waste. Traditionally fabric printing has been with rotary screens, multistation flat-bed screens, and rotating-table screens all of which incurs excessive lead time and high costs for engraving and storage of screens. Traditional methods are still widely used but ". digital printing is well poised to change the rules as far as what can be designed, how it can be produced and when it can be delivered" (Ross, 1998, p. 56).

The apparel industry views digital printing as a means of maximizing mass customization and agile manufacturing. A customer can select a print design and have it graded to fit the pattern pieces of the selected style. White fabric can be printed after a marker is developed so the print will fit the components of a garment precisely and in proper proportion. This ensures that adjoining pieces match up accurately. It is an excellent method of producing an engineered print that can be graded to fit the individual.

There are two methods of digital printing currently being tested and used on fabric yardage: thermal transfer and ink jet printing. **Thermal transfer** is also known as dye sublimation or heat transfer. With this type of printing, dye is printed on to a paper using a digital electrostatic printing device and then transferred to the fabric surface with the application of heat and pressure. Thermal transfer produces a colorfast design with fine detail and is fast and easy to print, but requires a fabric with a high percentage of synthetic fiber or poly film treatment. Digital printing on the paper surface is the new technology that has evolved which allows printing a design on demand.

With **ink jet** printing the image is applied directly to fabric. It is created by depositing individual drops of ink onto a substrate in a precisely controlled manner. Drop formation may be a continuous stream or drop-on-demand depending on the technology used. Resolution of the image is determined by the number of drops or pixels per inch. Systems work with multiple densities four colors: cyan, yellow, magenta, and black that are mixed as they are deposited on the substrate. There are many systems for creating drops and each system has its advantages and disadvantages.

Ink jet printing can be done on cotton fabric but it is very slow—5 yards per hour on less expensive printers to 60 yards per hour on more expensive printers. Thermal transfer can print 3 yards per minute and therefore is more cost effective at this time. There were seven different digital printers demonstrated at the Japanese International Apparel Machinery show (JIAM) in 1996 and these firms have continued their research and efforts to improve their technology and make it faster and more affordable.

There are many variables that impact the effectiveness of digital printing and that need to be examined. These include variations in fiber content, fabric width, desired hand, area of print coverage needed, color definitions, and inks. There are also a wide variety of CAD systems and file formats to drive the equipment.

Thermal transfer printing on white fabric has seen increased use. Wide-spread use of digital controlled ink jet printing on apparel is still under development but the advantages have certainly increased interest. "Conventional textile printing requires a pattern repeat and printing of the fabric from selvage to selvage, fabric printed digitally has no repeat limitations other than the length of the fabric, and can be printed either from selvage to selvage or as individual garment parts that can be laser cut" (Ross, 1998, p. 58).

The benefits of digital printing on white fabric include:

- · Design flexibility
- Engineered prints that can be matched at the seams, darts, armholes, and across components
- Low cost engineered prints
- Limited fabric inventory
- · Parts positioned by grain, not design repeat
- · Less waste in cutting
- Customized product

Labels

Most garments have multiple labels that provide information for both the apparel firm(s) that manufacture and distribute the garments and the consumers who select and use them. Brand name and/or RN number (the manufacturer's identification number), fiber content, country of origin, and care information are required by law. Other product information such as style number and size, construction features, and whether the garment was produced by union labor is voluntary.

Brand labels are the large, colorful, image builders that are strategically located for obvious visibility. Size labels help the apparel firm(s) and the customer identify a garment. Other informational labels may be used by consumers to formulate performance expectations and determine the garment's suitability for their needs.

In some instances, the label information is combined on a single label, but many times each bit of information is provided on separate labels. For example, not all size 12 blouses will be 100 percent cotton, and not all 100 percent cotton garments will have the same care requirements. Thus, for accuracy and flexibility, multiple labels are used.

Label Materials

Label materials must be compatible with the garment materials, appropriate for the location in which the label is placed and the processing to which the garment will be subjected. In addition, labels must be durable, easy to attach, and meet cost constraints.

Labels are available in nearly any fiber content, from 100 percent combed cotton to vinyl. There are also many different types of fabrications for labels including nonwoven fiber webs; narrow weaves in satin, twill, plain; yarn-dyed jacquard fabrications; and molded designs. Narrow woven fabric labels may range from 1/4 inch to several inches in width.

Images and messages are woven in or printed on the narrow fabrics. Wovenin messages tend to be the most durable but also may be more costly. Apparel firms frequently use woven-in messages for brand names and less expensive printed labels for the rest of the information.

Fabric coatings are used to make labels more durable, smoother for printing, and more receptive to inks. Some **jacquard weaves** may be coated on the back to prevent yarn slippage, and label tapes may be coated to make them easier to handle and less likely to be affected by care procedures. Coatings also add stiffness that consumers may find uncomfortable; thus, coated labels cannot be used indiscriminately inside garments. Labels may have a short life if the consumer decides to remove them because of their discomfort.

Label materials must be selected to be able to withstand garment finishing operations. For example, garment dyeing may alter the appearance because the labels pick up the color of the dye. There also may be a problem with blurring or loss of printed images after chemical treatments such as laundering.

Styles of Labels and Application Methods

Labels are made in four basic styles: double with a single fold and open at one end, flat with no ends folded, flat with ends folded in, and folded loops. In many cases the style determines how the label will be attached.

Labels that are double with a single fold are designed to be sewn into a seam or attached to another label. Information is often on both sides of the fold so the folded end needs to be free. Often they are used for combining different types of information such as care and RN number, which may reduce the number of labels needed.

Flat labels are finished on two sides and heat-sealed as they are cut on the other two sides. This prevents raveling so they can be applied almost anywhere on a garment. Flat labels can be superimposed on a garment and sewn on all four sides as may be done to apply brand labels with a special label setter. This application may be used to sew labels to the outside of garments as well as to back yokes, pockets, or facings where the stitching only needs to go through one ply of the shell fabric. Sewing all four sides is probably the most secure approach, but it is the most likely to show problems with differential shrinkage. Flat labels may also be sewn on two sides or inserted in a seam or hem. They provide the most flexibility for application.

Flat labels with folded ends are another commonly used style. The ends are folded toward the underside so the cut edge will not ravel or be irritating to the wearer. They are usually stitched on each end with a 304 or 404 stitch type, which allows good flexibility for the label and garment. Application of this type of label requires a separate process and is usually done with a label setter. They are frequently used inside of garments, on collar bands, back neck facings, waistbands, and so forth. Because the center of the label is loose, it allows flexibility of the garment. Differential shrinkage can be a problem if the label shrinks and stresses the shell fabric.

Folded loop labels are functional as well as informative. They have a horizontal orientation with diagonally folded ends that are inserted in a seam. This type of label is usually a brand label and most often inserted in neckline seams of jackets and sport shirts.

As indicated in the previous discussion, label application methods are determined by the look desired, garment construction methods, and equipment that is available. Labels may be attached as separate pieces, sewn in seams, sewn to other labels, or fused to the garment. If labels are inserted as seams or hems are sewn, a separate label-setting operation is not necessary, but it requires a label with three finished edges. Labels are often sewn to other labels so when they are finally inserted into a garment, there is a whole collection of the various types attached in one operation.

Manufacturers that produce private-label merchandise for multiple retailers may add the individual retailer's brand name just before garments are shipped. With this type of product line, garments are all assembled the same, and all but the brand label are attached during construction. Prior to shipping the label for an individual retailer is added. These may be fused in place rather than sewn so the stitching does not show on the finished garment. The attachment of private-label brand names is sometimes done in the warehouse or distribution center.

One major concern of application is getting the correct label into the appropriate garment. This takes diligent attention to specifications and order numbers. Placing incorrect information in a garment is much worse than no information at all.

Sources of Labels

Labels may be purchased from firms that specialize in the production of certain types of labels or apparel firms may produce their own. Firms that specialize in label production have the capability to design and produce labels on a custom-order basis. They work closely with the apparel firm to determine the requirements for image building, label type, and available equipment. If fancy woven labels are desired, they are best ordered from a firm with high-tech equipment that specializes in fancy narrow weaves. Labels of jacquard weaves or printed tapes can be ordered on rolls or fuse-cut ready to use.

Apparel firms that choose to make their own labels purchase label-making equipment that can print and fuse-cut labels as needed. When labels change frequently, it may be cost-effective for manufacturers to produce their own. Producing labels in-house provides shorter lead times and more flexibility. Some firms order custom-made brand labels and produce their own printed information labels.

Label costs vary with the intricacy of the design, the size of the label, additional processing that is done, and the volume ordered. Compared to printed labels, fancy woven brand labels are considerably more costly for a small quantity because of the design and setup cost. When large quantities are ordered, the price difference narrows considerably.

Summary

Trims contribute to both garment aesthetics and performance. Trims can be grouped into three general classifications—bindings, edgings, and flat applications. The production and use of embroidery, lace, appliqués, and screen printing require specialized machines and operator skills. Labels are essential for communicating information to the consumer and providing differentiation and identity to products. Compatibility among piece goods and trims is essential for good quality and performance.

References and Reading List

Glossary of Screen Printing. (1974). Technical guidebooks of the screen printing industry, #IV. N.p.: Screen Printing Association International.

Goodridge, M. (1986, September-October). Screen printing for designers. Step-by-Step Graphics, 2, 100-105.

Griffiths, F. (1992, April). How the crest was run. Stitches Magazine, pp. 26–28.

Griffiths, W. (1992, January). The price of a stitch. Stitches Magazine, pp. 42–46.

Holzmark, L. (1992, May). What lies ahead. Stitches Magazine, pp. 112–120.

Krasnitz, R. (1997, Winter). Factors effecting productivity in embroidery. Technical Advisory Committee of AAMA.

Kyle, E. (1974). "Principles of quality control."

Technical guidebooks of the screen
printing industry, #3. N.p.: Screen
Printing Association International.

Nielsen, B. (1992, February). The emergence of looping and embroidery. *Bobbin*, pp. 78–79.

Robin, A. (1973). "Heat transfers." Technical guidebooks of the screen printing industry, #2. N.p.: Screen Printing Association International. Ross, Teri A. (1998, May). Providing a new set of rules. ATI, pp. 56-59.

Schneider, C. (1978). Embroidery: Schiffli and multihead. Tenafly, NJ: Author.

Wanger, M., and Wanger, B. (1987, September). Transfers make heat wave. *Bobbin*, 29(1), 196–198. Webster, R. (1977). "Screen making for garment printing." Technical guidebooks of the screen printing industry, #3. N.p.: Screen Printing Association International.

Key Words

appliqué backing bands bindings blatt stitches braids chain stitches chenille stitches circular knit trims color registration cost control decorative trims design execution digitizing direct embroidery edgings emblem embroidery flat trims

flat-bed knitting frames

frames framing functional trims heat transfer prints hooping imaging materials ink jet iacquard weaves knit trims laces Leavers lace looping stitches mesh count piece goods piping printing process raschel knits rib trims ribbing

running stitches Schiffli embroidery machines screen making screen materials screen printing Solvron squeegee steil stitches stencil stitch types stretching tapes thermal transfer threadtrapunto trims Venise lace warp knitting

ribbons

Discussion Questions and Activities

- 1. Visit a children's department or specialty store and determine the number of different trims that are used. Is trim quality compatible with garment quality?
- 2. Compare laces used on budget, moderate, and better lingerie. How do they differ in
- complexity, fineness of yarn, and detail of design?
- 3. Examine several children's garments with trim. Is the trim decorative or functional? How will the trim perform?

GARMENT ANALYSIS APPLICATION #1

Analysis of T-Shirts

Product Positioning Strategies

T-shirts are multifunctional garments worn by all age groups as underwear and outerwear. T-shirts are simply structured garments that consist of a front and back or body, sleeves, neckline treatment; a few styles may have a pocket. They are basic, staple garments in white and other solid colors. Many styles are considered unisex in styling and sizing.

Outerwear T-shirts may have neckline variations, pockets, fashion fit, trim, or applied designs to add to fashion, functional use, and aesthetic appeal (see Figure A1–1). Neckline styling may include turtlenecks, crew necks, V-necks, or scoop necks. Fashion may be reflected in oversize styling, deep armholes, extra-long lengths or short, cutoff lengths, and fitted body. Seasonal changes in outerwear T-shirts may be reflected in sleeve length, color, and fabric weight. Reversible T-shirts may be made with two layers of fabric, combining a stripe and solid or two solids to increase versatility, warmth, and fashion.

Plain T-shirts are often referred to as *blanks* for the imprint market. Printed T-shirts, which appeal to both males and females, provide humor, identification and association with specific groups, activities, ideas, or interests. T-shirts are widely used for souvenirs of special personal experiences. They provide identity through screen printed or heat transfer applications of logos, lettering, and licensed designs. Athletic teams, church groups, social clubs, and so on, order T-shirts with customized logos from companies that specialize in meeting that demand. Custom prints and licensing increase costs of shirts, but designs provide consumer appeal well beyond the intrinsic value of the garment.

T-shirts are available at a wide range of prices that may or may not be consistent with the quality level. Underwear T-shirts have more consistency between price and quality. Outerwear T-shirts vary widely in quality and price and may rely more on emotional appeal than intrinsic quality.

Figure A1–1
Basic outerwear T-shirt with pockets.

Sizing and Fit

T-shirts are produced in all size ranges. Infant and toddler shirts are sized by month and weight. Youth and adult sizes are sized by small, medium, large, extra large, and so on. Stretch is inherent in circular knit fabrics, allowing flexibility in fit and reducing the need for dimensional sizing. Underwear T-shirts have more consistency in sizing than outerwear T-shirts.

T-shirt fit is concerned with length and circumference of a garment body, cut of sleeves, and neckline shape and depth. Length is a factor in fit and quality. Longer shirts can be tucked in and are generally considered to be more comfortable. As more length is provided, more fabric is required, which increases costs.

Sleeve fit is often determined by styling. T-shirt bodies are designed for specific sleeve styles such as basic set-in sleeves, raglan sleeves, or athletic jerseys that incorporate yokes, wide shoulders, and loose-fitting sleeves. Set-in sleeves, which fit close to the body, require room for movement and arm expansion. A sleeve cut too narrow may not provide enough ease under or around the arm. Raglan sleeves, when well proportioned, provide more comfort ease through the arm and shoulder area. Long sleeves must have enough length and width to remain in position during activity but not be tight enough to bind.

Necklines of T-shirts should lay flat against the body regardless of styling, depth of the neckband, or method of assembly. Neckbands of crew neck T-shirts have a circular formation with a smaller circumference at the neck edge than the seam. During application, neckbands are stretched slightly to fit neck edges. When neckbands are not stretched during application, they will stand

away from the body and gap during wear. Another cause of poor neckline fit is banding that stretches but does not recover. This may be attributed to fabrication of the neckband, incorrect stitch selection, or too many stitches per inch. Product testing and complete product specifications can help prevent poor fit.

Infant and toddler T-shirts often have shoulder openings to provide room for pulling over the head. Infants have very large heads in proportion to their neck and body. These differences in body proportions must be accommodated in the styling and fit of garments.

Materials

Fabrics used for T-shirts are primarily 100 percent cotton or cotton/polyester blends. All cotton is generally used in producing better-quality garments, although other factors such as yarn type, fabrication, and fabric finishes also affect quality.

Fiber length and alignment (combing) affect durability and appearance retention. Yarn type, structure, and method of production are closely related to fabric quality and performance. Yarn quality is not apparent to the untrained eye, but ring spun yarns provide better long-range performance than yarns produced by open end spinning. Fabric weight, gauge, yarn characteristics, and type of knit affect fabric quality, aesthetics, performance, and cost. Fabric weight, which is affected by fiber content, yarn size, and coarseness or fineness of the gauge, is directly related to cost and quality of T-shirt fabrics. Heavier fabrics are often 100 percent cotton and require more yarn, which increases cost. Cotton fiber generally is also more expensive than polyester fiber.

Knit fabrics most commonly used for T-shirts are jerseys, rib knits, and interlock ribs. Jerseys are the most widely used fabrication because of their versatility, low cost, and comfort. Solid-color jerseys are often used in tubular form to reduce cutting and seaming costs. Jerseys are widely used for screen prints and heat transfers. Rib knits may be used for shirts that require high stretch and close fit. Interlock ribs are used primarily for better-quality, solid-color, cut and sewn shirts with more fashion styling.

Trims used on T-shirts consist of neckbands, cuffs, bindings, screen-printed designs, embroidery, appliqués, stripings, and so on. Trims may be matching or contrasting colors. T-shirt neckbands are used to finish necklines (see Figure A1–2). A 1×1 rib is used most often, especially on medium and lightweight knits such as those shown in Figure A1–2. Heavier weight, high-quality garments may occasionally have 2×2 rib neckbands, which have a heavier, coarser appearance.

Neckbands are cut from rib-knit piece goods or narrow tubes of specified width. Tubular neckbands (Figure A1–2b) do not require seaming and are often used for better turtlenecks and crew necks. Neckbands may also be knitted to specifications for particular color or structural effects. Additional considerations for this type of trim are the amount of inventory needed and color matching.

Figure A1–2
Neckline treatments of basic T-shirts: (a) ribbing closed before attaching, (b) tubular ribbing, (c) ribbing applied to front and back separately and joined at the shoulders, and (d) ribbing used as a binding.

Other trims used on outerwear T-shirts are braids, stripes, and bindings. These trims may be used to provide color accents, add special interest or fashion, and tie together a contrasting color scheme. Trims such as these may be used across sleeves, shoulders, down fronts, and so on. Use is limited only by ideas and cost limitations. Trims must be compatible with other materials, garment performance, use, and care. For example, warp-knit braids may prohibit stretch, thus restricting activity; cotton or nylon bindings or strips may absorb color from other garment materials; trims and piece goods may be subject to differential shrinkage.

Tape may be used on back necklines and/or shoulder seams of both underwear and outwear T-shirts to stabilize and enclose the seams and improve durability and performance (see Figure A1–3). Different types of treatment may be used for several different performance expectations and costs. Narrow twill tape or stable strips of shell fabric may be sewn in shoulder seams to prevent stretching and breaking of the stitching line. If stretch is desired, narrow elastic may be applied to shoulder seams. Elastic application ensures recovery of stretched seams. Purchased binding or strips of matching piece goods may be used to cover back neckline seams for stability and shelf appeal.

More than one **thread** type may be used in the manufacture of T-shirts, depending on the quality level. Seams of moderate and budget shirts are often stitched with white thread, while topstitching is usually done with color-matched thread (corespun or spun polyester) for all price levels. Cover stitches may be done with textured filament used in the lower looper to provide more cover.

Figure A1-3 Back neckline and s

Back neckline and shoulder treatments: (a) only back of neck taped; (b) shoulder seams and back of neck cover stitched; (c) bound seam, with no additional treatment of neckline and shoulders; and (d) shoulder seams and back of neck taped.

Spreading and Cutting

Tubular knit fabric, which is frequently used in adult T-shirts, creates some challenges in preproduction that are different than products being spread and cut from flat goods. Closed markers are usually used to cut tubular goods to be able to utilize the full width of the fabric. Tubular goods may be cut with an open marker but primarily for children's clothing. Fabric may be knife cut or die cut. If it is die cut, lengths of fabric cut to the length of a die must be cross cut or sectioned from the new fabric. Sections or blocks of fabric are stacked until they meet the specified ply height and the spread is moved to the die cutter.

Better T-shirts will have the tubular goods turned 1/4 turn before cross cutting and stacking. This will transfer the crease lines from the sides of the spread to the center. This moves the fold from what would be center front and center back to the underarm area. This is illustrated in Figure 13–5. Turning the fabric although automated, provides a less distorted surface for center front. Die cutting usually causes less distortion problems in the cutting process.

Assembly

The production of a T-shirt requires relatively few operations. Assembly sequence is dependent on styling, materials, seam types, quality level, and equipment. Most T-shirt seams are superimposed seams, stitched with a 504 overedge stitch. This stitch/seam combination produces a narrow, finished seam with good stretch and flexibility if properly executed. Knitted fabrics do not need a wide seam allowance for good performance. However, seaming of knit

fabrics needs to be monitored to prevent yarn severance. Broken yarns caused by faulty needles or the wrong needle type may allow runs to start at seams.

Because of automation and ease in handling, sleeves are often finished prior to setting into T-shirts. Edge treatments, whether bands or hems, are easiest to apply while sleeves are flat. Bands may be applied as binding (BSb) or as superimposed seams (SSa). Automated seaming allows sleeves to be carried by conveyor to the sewing head for hemming. For tubular T-shirts, sleeves are seamed before setting. For other cut and sewn T-shirts, the sleeve is set into the garment and the sleeve and the side seam are closed in one operation.

Hems on T-shirts and other knit garments are frequently done with a 406 EFa, which produces a finished, stretchy hem with a neat appearance. Budget T-shirts are often hemmed with 503 EFc. Other knit garments may be hemmed in a two-step operation combining 504 EFd with 103 EFa. From a quality perspective, hems must be stretchy, flat, and wide enough to avoid rolling when the fabric is stretched. A narrow hem on a jersey is likely to curl when tension is applied to the edge of the garment. Stitch tension should be loose and the stitches not visible on the right side. Hems may be the first operation on a T-shirt or the last depending how the production line is set up.

Patch pockets are found on some outerwear T-shirts. Pocket hems of better T-shirts have filler or interlining in the pocket hem to retain shape and prevent stretching (see Figure A1–1). Support material is fed in as hems are stitched to the pocket. Automatic pocket setters may be used to attach pockets to shirt fronts. With automation, an operator places a pocket and shirt front and engages the machine. The machine aligns and stitches the pocket. If pockets are applied, it may be one of the first operations because it is easier to manipulate a flat open piece.

Shoulder seams are usually seamed with a 504 SSa. Budget garments may only be seamed, while better garments have the shoulders taped or elastic applied. This approach builds in durability and shape retention. One or both shoulder seams may be closed before the neckband is applied.

Neckline treatments on T-shirts may be applied as bound seams (BSb) as shown in Figure A1–2d or superimposed seams (SSa) shown in Figure A1–2a, b, c. There are many variations of each of these methods that affect the appearance, quality, and cost of shirts. The method used impacts the assembly sequence. Bound seam neckline applications (406 BSb) stitched with a cover stitch (Figure A1–2d) are fast and easy to apply. They may be used to finish necklines of crew necks, scoops, tanks, and so on. Bound seams are flat except where joined at shoulder(s), and provide a neat topstitched appearance. Neckbands, when applied as bound seams, are strips of rib knit fed off rolls through tensioning devices and folders. When neckbands are applied and the shoulder seam(s) closed, the neckline is completed.

Neckbands may be applied separately to the neckline back and front (see Figure A1–2c) or to the neckline after one shoulder seam is closed (Figure A1–2a). Closure of the shoulder seam(s) after trim is applied leaves exposed seam(s) at the neckline edge. This method is fast, minimizes handling, and is widely used on budget and moderate shirts.

Neckbands in tubular form require both shoulder seams to be closed before application (see Figure A1–2b). Tubular neckbands may be cut from appropriately sized tubular knits or cut and sewn from piece goods (see Figure A1–2a). Tubular neckbands are folded with wrong sides together, positioned on top of the neckline in a superimposed seam, and stitched with a 504 stitch. Attaching tubular neckbands to necklines with closed shoulder seams requires manual application. Sewing operators fold, stretch, and align neckbands and shirt necklines while sewing them together.

Superimposed neckline seams are often taped, cover stitched, or topstitched to improve comfort, aesthetic appeal, and durability (see Figure A1–3). Unfinished superimposed seams at the neckline may not remain flat during wear or may stretch and not recover.

More durable T-shirts are taped continuously along the back neckline and shoulder seams to flatten the seams (Figure A1–3d), maintain shape, and provide hanger appeal. Continuous taping reinforces the junction of shoulder and neckline seams, which is subject to high stress. Tapes may be applied with 406 SSf, SSag, or LSbn. Only back neckline seams may be taped when neckbands are applied with both shoulder seams open. This gives the appearance of a better-quality shirt when only the back neck is stabilized. Topstitching may also be used on better-quality garments in areas where the neckline is not taped.

V-necks are assembled the same as crewnecks except for formation of the V. There are lapped and mitered V-necks. *Lapped V-necks* have one side of the neckband overlapping the other at the point of the V. Operators manipulate banding to position the overlap so both sides are even. *Mitered V-necks* have neckbands seamed at center front and the ends of the band are secured in the neckline seam. A true mitered seam, which is used on better garments, creates a flat, secure, finished neckline treatment, but it requires accuracy, extra manipulation, and seaming. It is also difficult to automate.

The appearance of a mitered V-neck is achieved by applying banding to the entire neckline seam and sewing a tuck in the banding at the point of the V. This method is faster and involves less handling than a true miter, but it is not as flat or finished.

Label setting is often combined with neckline seaming. Most T-shirts have neckline labels to provide information and shelf appeal while some shirts have a second label sewn to the outside lower front in a separate operation. This is intended to add fashion appeal and differentiation to some types of shirts.

Closing the **underarm seam** on cut and sewn garments is the last assembly operation. One operation with a 504 SSa seam will close the sleeve underarm seam and garment side seam.

Finishing

Finishing operations may include pressing, screen printing, inspection, trimming, and packaging. If T-shirts are pressed, they are circulated through a steam tunnel to remove wrinkles. This procedure is used only on better shirts

and those likely to be hung. The majority of T-shirts are inspected, trimmed, and folded. Some are boarded (folded around a cardboard insert) and boxed in dozens or half dozens. Others are bagged. Finishing operations vary with the quality level being produced and the performance expected.

Presentation

T-shirts are sold by a wide variety of retailers, from better department and specialty stores to street vendors. Underwear T-shirts are often folded and packaged for display. Printing on the plastic cover may point out the product's quality and merchandising features. Outerwear T-shirts, particularly those with printed fronts or backs, are usually displayed on hangers.

Rock groups may sell T-shirts as part of their concert promotions; beer and soft drink manufacturers may sell or give away shirts as advertising or promotion of special events they sponsor; equipment manufacturers or seed companies may provide T-shirts as bonuses for their customers. Basic T-shirts may be stocked by specialty shops for customizing with application of screen print or heat transfer designs.

GARMENT ANALYSIS APPLICATION #2

Analysis of Men's Dress Pants

Product Positioning Strategies

Men's dress pants are primarily basic, staple products that lend themselves to constant stock levels, reorders, and quick response. Many of the major producers of men's pants are linked with electronic data interchange to both retail customers and material suppliers.

MERCHANDISING AND PRICE FACTORS Men's pants, produced for budget, moderate, and better markets, have different product characteristics, production methods, and marketing strategies. Variations in aesthetics, performance, quality, and cost are related to piece goods and other materials, structure of garment components, and methods of assembly. Intrinsic quality builds durability into pants, but also contributes significantly to production costs.

Automation is important to many aspects of pants production, but the impact may be most noticeable in large firms that produce moderate and budget lines. Because of basic styling and production automation, there are many similarities across lines. Firms strive to build product differentiation and brand loyalty through consistent quality, fit, and performance.

STYLING ISSUES Men's dress pants are primarily basic garments, although some lines have more fashion emphasis than others. Subtle fashion changes occur from year to year. Style variations may be incorporated in fabrications, front styling, waistline treatments, pocket structures, leg width, and finish. Seasonal changes focus primarily on fabric type, weight, and color.

Pant fronts may be plain or pleated. Plain fronts have a smoother fit across the front than pleated. Front pleats add styling ease for a looser fit and are often considered more comfortable than plain-front pants. Pleated fronts may be traditional or have more fashion styling, depending on type, depth, and position of pleats and other style features (see Figure A2–1). Pleats may be folded toward the center front or away from the center front; deeper pleats may have a stronger fashion look. Box pleats consist of two pleats folding away from each

Figure A2–1
Styling feature of men's slacks, pleated fronts: (a) forward pleating and (b) reverse pleating.

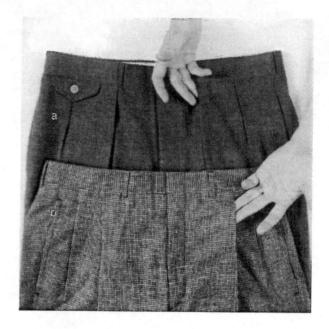

other; *inverted box pleats* fold toward each other. This type of pleating is more trendy and follows a soft, comfortable fashion look.

Waistline treatments on dress pants are concerned with structure, bandwidth, and band-end treatments. Waistbands on dress pants may have a two-piece (split) waistband that is seamed at center back, a one-piece band without center back seaming (similar to the structure of jeans), or an adjustable waist with side tabs or expandable fasteners. Two-piece bands, which are the most widely used on dress pants, allow full construction of the pant before the center back seam is closed. This type of styling reduces handling during assembly and makes fit and adjustment easier. Some younger, trendy styles in the budget range may use one-piece waistbands because of construction costs and less concern for alterations and precise fit.

Waistband width varies with fashion and other styling features. Wide waistbands were fashionable with flared legs, while narrower waistbands are used more with fuller-pleated fronts and suspenders. Waistband width is also influenced by how customers prefer to wear pants or how fashion is perceived. Men who prefer to wear waistbands at their waistline may want a narrower band than men who want a waistband to fit down on the hips.

Ends of waistbands may be squared, rounded, or tabbed. Waistbands ending flush with zipper plackets are the most common, least time consuming to produce, and found at all price ranges. Found primarily on better pants, rounded upper corners create a flatter, more aesthetically pleasing overlap and are more costly to produce. A *tab extension* is a styling feature that extends closures beyond the center front. It serves to spread out the bulk of closures and placket

overlap. Tab fronts are seldom worn with belts. Tabs are made during band assembly, prior to attachment to the garment.

Pocket structures vary with fashion but not necessarily with quality or cost. Front pockets may be on-seam (see Figure A2–2) (structured in the side seam) or offset slanted pockets (see Figure A2–3). Offset pockets are described as one-eighth top, quarter-top, or half-top, which refers to the slant of the opening—the

Figure A2–2 Men's slacks with on-seam front pockets and single-welt back pockets with tab closing.

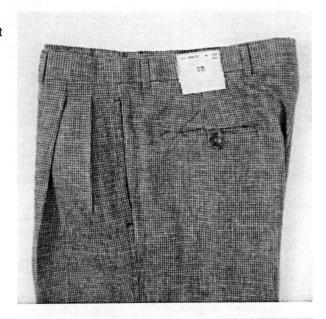

Figure A2–3 Men's slacks with quarter-top front pockets and single-welt back pockets.

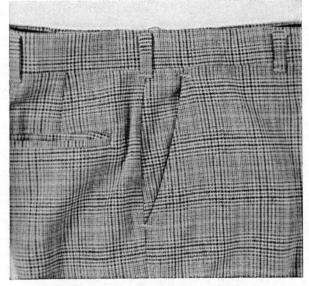

Figure A2–4
Men's slacks with double-welt front pockets, double-welt back pockets with tab closing, and side tabs at waistline for adjustment.

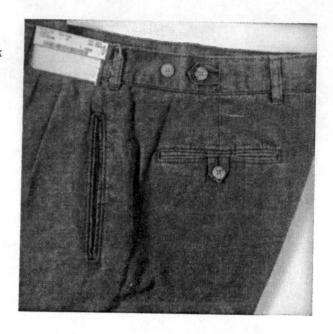

distance the top of the pocket opening is set in from the side seam in relation to pocket width. Women's pants are more likely to have quarter-top pockets as they lie flatter with a more rounded side seam. There are unique front pocket treatments that may be used on more trendy styles. Vertical welt pockets are occasionally used on men's pants with inverted box pleats to add fashion interest and updated styling (see Figure A2—4).

Some better pants with traditional styling may have a watch pocket with the opening built into the waistline seam. A watch pocket is a small, shallow, narrow pocket located just in front of the right front pocket opening and below the waistband. Traditionally, it was designed to hold a pocket watch and has been retained as a styling feature on some pants. Budget and moderate pants may include a nonfunctional flap in place of an actual pocket. Coin pockets are small functional pockets constructed inside a front pocket. They are designed to keep change separate from other contents in the pocket.

Back pockets may be welt pockets with single or double welts (see Figures A2–2, A2–3, and A2–4). Usually the left back pocket on men's dress pants has a closure for retaining a billfold. More casual pants may have closures on both back pockets. Closures may be button-through, V-tabs, or button flaps. Button through pockets require less time to produce and are used in all price ranges. Flaps require more time to produce but are often used as a styling detail. Fashion dress pants may have plain backs without pockets.

Lower leg width, which describes the cut and style of the pant, knee to hem, is influenced by fashion and preferences of target customers. Lower pant legs may be straight, slightly tapered, tapered, or flared. Straight-legged pants are

straight from the knee to hem. Slightly tapered legs are considered more traditional styling. Tapered pants, comparatively, are narrower at the knee than the thigh and continue to taper to the hem. Tapered pants usually are not cuffed. Flared legs were a popular fashion feature during the late 1960s and cycle with fashion. A flared leg pant gets as much as 4 inches wider from knee to hem. Pleated pants, which tend to be fuller cut at the top, are usually slightly tapered below the knee and often cuffed. Popularity of cuffed pants also tends to cycle with fashion.

Sizing and Fit

Unlike dress shirts, pants have many size and fit variables. Pants are nearly always tried on to determine fit before they are purchased. Better dress pants are usually altered free of charge; therefore, customers expect exact fit. Retailers of budget pants stock specific, popular sizes according to waist and inseam. Budget customers are usually interested in selecting garments that will fit as well as possible without additional costs or time for alterations.

Firms use dimensional sizing systems, but each firm has its own standards for fit within the sizing system. Manufacturers may develop pattern blocks for different body types. One may produce a fuller cut pant with more ease, while another firm will develop standards for more fitted garments. Some retailers carry several lines in order to fit a wide range of customers with different body types.

Common waist sizes range from 28 to 42, with increments of 1 inch. Some manufacturers and retailers stock only even waist sizes while others stock even sizes and more popular odd sizes—31, 33, and 35. Many retailers cannot carry all sizes because of inventory investment and slow stock turn on some sizes. Larger sizes are available in specialty lines such as "big and tall" departments or specialty retailers. Some moderate and most better pants are designed with potential for adjusting fit. Wider seam allowances, split waistbands, and unhemmed legs are all part of the planned adjustments that may be needed to fit and alter pants.

Waistline placement and fit vary with individual preference. Adjustable side tabs and elastic inserts are used on some styles (often called *polos*) to provide a closer fit and more flexibility. Adjustable slides or buckles may also be used to provide more variation in waistline fit. This type of styling is good for customers with fluctuating size or weight. Some styles may be structured with elastic in the waistband to provide a snug but comfortable fit. This type of waistline treatment is often used on knit pants or textured polyester pants with some inherent stretch in the shell fabric.

A split waistband allows for waistline and hip alteration if the seat seam has adequate seam allowances. Alterationists can take in or let out the back crotch seam without having to totally disassemble the garment or cut through the band. Generous seam allowances in this area are often an indication of quality. One-piece waistbands, which are seldom found on dress pants, are less likely to

be altered because of the complexity of construction and lack of seam allowance to be let out.

The **rise** is the front length, crotch seam to waistline. Proportional relationships are developed between the length of the rise and the inseam. Men's pants are available in short, regular, and long rise that are approximately 1 inch different in length (it varies with each manufacturer's standards). Rise length is related to the length of an individual's torso, preference for waistline placement, and ease of fit preferred by the consumer. Some tall men prefer a regular rise because they like to have the waistband fall at the upper hip area, while others prefer to position the waistband at the waistline and want a long rise because of the comfort and ease it provides.

Total length of the crotch seam is also a fitting factor, only part of which is the rise. Better pants have a wider back inseam at the upper leg that can be let out to provide more crotch length and a wider thigh circumference.

Inseams are the inner leg seams of pants, crotch seam to bottom of hem. Many dress pants are not hemmed in order to provide the precise inseam length needed by each customer. Catalogs often specify the potential inseam length for hemmed pants and cuffed pants so consumers can select the specific length that meets their needs. Manufacturers estimate an average length needed for a specific rise in order to cut pants with adequate length. Pants that are produced with hemmed legs are purchased by size and not usually altered. Predetermined inseam length requires greater inventory for the retailer and manufacturer but less handling after purchase.

Materials

Piece goods are a major factor in quality, cost, and performance of dress pants. Fabric weight, hand, finish, and durability are important considerations in selection of piece goods, and may be affected by fiber content, yarn fineness, and count. Summer pants are expected to be lightweight and breathable with good shape retention. Winter pants should have warmth, comfortable hand, and good shape retention.

Natural fibers, cotton, wool, silk, and linen are important to the better market that expects ultimate comfort and hand. High performance of natural fibers requires long staple fibers, combed or worsted yarns, plied yarns, and high-count fabrics. Cotton has seen increased use in dress pants in recent years. Fine imported cottons and cotton-microfiber blends are important to the better market. Wool is the most widely used natural fiber, both summer and winter, especially in better pants. A lightweight fabric made with 100 percent worsted wool yarns may weigh as little as 5.1 ounces per square yard. This fabric would have the resiliency and breathability of wool and yet be extremely lightweight to wear in hot weather. Silk is used on a limited scale in better fabric blends. Improved methods and equipment have created a renewed interest in 100 percent cotton wrinkle resistant pants. Consumers can have the com-

fort of cotton and shape retention of other wool and synthetic fibers. Linen may be blended with cotton to improve softness and retain the characteristics of all natural fibers.

Microfibers have opened new markets for synthetic fibers and novelty blends in dress pants. Polynosic rayons and polyester microfibers have been used as the primary fiber and in blends with cotton and linen. Natural fibers may be blended with synthetics to improve durability and wrinkle resistance and to reduce the cost of piece goods made from more expensive natural fibers. Various percentages of polyester are used, but a higher percentage of polyester produces a more synthetic hand to the piece goods and has less appeal to better markets. Polyester-dominated blends are also susceptible to pilling, which may affect garment aesthetics over time. Some styles in budget lines are 100 percent polyester. Acrylic is used in blends to produce a wool-like appearance and hand. Often it is the third fiber in a blend and used primarily in winter fabrics in the moderate and budget range.

During the late 1980s and early 1990s, rayon was an important fashion fiber in both men's and women's wear because of the soft silhouette. One hundred percent rayon may be used in trendy moderate and budget pants, but often it is used in blends to contribute to hand, drapeability, and fashion appeal.

Popular fabrications are flannels, gabardines, and poplins. *Tropical worsted* is a term often used to describe lightweight, high-count piece goods with a smooth appearance that would be comfortable in warm climates. It does not describe the weave, yarn, or fiber used. This type of piece goods is traditionally made with fine worsted wool yarns, but it may also be a polyester/wool blend. Flannels are usually winter fabrics with a slightly napped face to improve warmth and hand. Gabardines are widely used, durable fabrications that may be made from wool, cotton, or blended fibers. Fine, high-count, and plied yarns increase gabardine durability.

Finishes may be applied to pant piece goods or completed pants to increase wrinkle resistance, reduce shrinkage, and improve soil resistance. The finishes used depend on the fiber content, quality level, price range, and prescribed care method. Many of the wools used in better pants are preshrunk or sponged to keep the sizing consistent after dry cleaning.

Pocketing fabrics are used to form pocket bags, waistband curtains, and fly linings. Pocketing may be selected for comfort and/or durability. Pocketing is available in a variety of fiber contents, fabrications, and colors. Pocketing materials used in better dress pants are often high-count, 100 percent cotton that is comfortable and durable. Polyester/rayon pocketing that combines strength and hand is a popular blend used in many moderately priced garments. Many of the blended fabrics use textured polyester fibers in the filling to increase body and wrinkle resistance. Plain and twill weaves are the most commonly used. Polyester/cotton blends are also used in moderate and budget garments. Polyester blends have a problem with pilling, which may reduce comfort and durability with extended use.

Interlinings are used in pants to provide support, stabilize specific areas of a garment, create a smooth surface, and improve shape retention. Interlinings are used to stabilize pocket edges, zipper plackets, belt loops, and waistbands. Fusibles are widely used in pants due to ease of handling and because small pieces are needed in isolated small areas. Eventually interlinings are stitched in place during component assembly. Interlining is also used to stabilize zipper plackets and prevent images of the zipper and seam allowances from pressing through to the right side. A zipper fly with adequate interlining will have better shape retention for the life of the garment.

A waistline curtain is used to shape, support, face, and finish split waistbands on pants. Materials used in a waistband curtain vary with cost, quality, and expected performance. Curtains may be ordered from suppliers or pants manufacturers may assemble the curtain in their own plants.

A basic curtain consists of two strips of firmly woven fabric attached to some type of support material. A single-ply strip extends above the support material to form the top and is sewn to the top of waistbands. A second folded strip of bias finishes the lower edge and covers the waistline seam and support materials. Piping or tape may be used to join the materials (see Figure A2–5). Attached support material may be a firm stiff woven or nonwoven material that varies in cost and durability. Some support materials retain their hand with repeated use and care, while others may become limp and flimsy over time.

Better-quality curtains may have a 1/2-inch strip of folded bias buckram covering or attached to the support material. This adds additional support and shaping directly below the waistline seam. Curtains used in better-quality pants may also have a jacquard tape that identifies the designer or manufac-

Figure A2–5
Assembled waistband and curtain for men's slacks:
(a) shell fabric, (b) bias lining or pocketing material, (c) piping or tape with logo, (d) interlining, (e) monofilament nylon strip, (f) bias buckram for shaping, and (g) folded bias to finish lower edge.

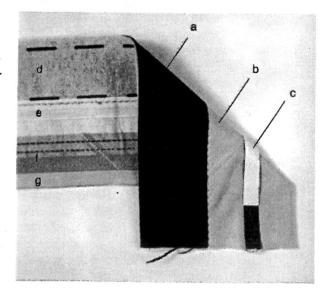

turer, stitched in the center of the curtain. On better pants the lower part of the curtain may be pleated in the side seam area as it is attached to the top ply. This provides more flexibility and better fit.

An additional support material, a strip of woven monofilament nylon, is often added to the waistline of moderate and better pants during application of the curtain. Some types may have coated edges to prevent breakout and abrasion. The attached strip may be the width of the waistband or narrower depending on the amount of structure wanted. There is risk of band roll-over if it is narrower than the waistband. Better pants makers may use it along the entire waistband, while manufacturers of moderate and budget dress pants may use it only along the front edge of the waistband.

Lining material may be used on most pants to face the zipper placket, but the treatment is different on better pants. Lining is also used in better pants to reinforce and smooth the lower part of the front crotch seam and upper inseam. A small folded piece of lining forms a triangle between the crotch seam and inseam and is attached in the seams (see Figures A2–6 and A2–7).

Lining materials are also used to form belly bands. A belly band is a piece of lining attached to the zipper placket and front pocket bag or side seam. It is used primarily on pants with pleated fronts to take stress off the pleats and allow them to hang straighter and flatter. Belly bands are found on both men's and women's wear, except belly bands on women's pants are often cut as part of the front pocket. Some styles of men's better pleated pants have the whole front of the pant lined to the knee. This provides slip ease and a better-hanging front. Leather pants are often lined (front and back) to the knee. Women's better pants are frequently lined completely, waist to hem.

Linings may be cut from pocketing materials or synthetic piece goods. Pocketings provide a consistent aesthetic appearance inside the pant. In some

Figure A2–6
Better dress slacks with
(a) extended lining of zipper
placket, (b) reinforced inseam,
(c) inseam with wider back seam
allowance, (d) curved fly
extension at waistline, and
(e) double-stitched back pocket.

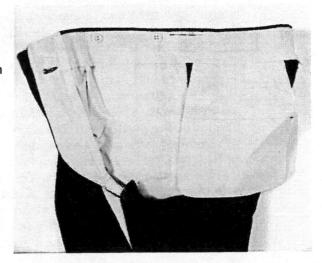

Figure A2–7
Moderate or budget slacks with
(a) zipper placket lining, (b) no
treatment of inseam, and
(c) inseam with seam
allowances with even width.

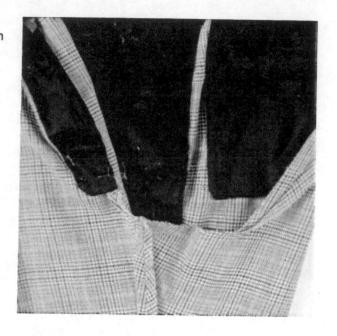

garments rayon or polyester/cotton twill may be used. The main criteria for pant lining materials are a comfortable hand and compatibility with garment care procedures.

Threads of various types, weights, and colors are used in assembling dress pants. Threads may be very specific to the operation for which they are used. Pants may be serged and seamed with two-ply spun polyester or polycore thread. Heavier threads may be used for buttonholes and button attachment, and hems may be stitched with monofilament nylon. Pockets are often done with off-white thread to match the pocketing material, and garment seaming and topstitching is done with matching thread. Some manufacturers will even be specific in matching thread to the labels sewn into the pants. Because of the basic nature of the garment, volume of production, specialization of equipment, and little change in materials, there is little need for frequent changes.

Hooks are often used as the primary waistline closure on dress pants as they are flatter and do not interfere with belt buckles. Clinch-type hooks are applied as the waistband is assembled, prior to attachment to a garment. Hooks are usually supported by an inside button tab on better pants.

Buttons are important closures for beltless styles, pockets, zipper plackets, and brace attachments. Concave pant buttons protect the thread. Outer edges of concave buttons absorb abrasion instead of the connecting thread. Outer buttons are expected to match or blend with the piece goods. Better-quality garments have closely matched buttons. Better buttons used on pants are made from a compound of horn, bone, and synthetic resin. Inner buttons may match

the curtain and pocketing and are often thicker because of the durability needed. Pant styles that use braces depend on buttons to secure the brace. Brace buttons are larger than other buttons often used on pants and are attached inside the waistband.

Pant **zippers** are commonly made from continuous chain. They need to have a flat profile so the zipper image will not press through to the right side of the pant. Flexibility of zippers is essential to maintain the hand of fashion fabric and avoid distortion. Chains may be metal or polyester coil. Brass chain zippers are frequently used in men's better dress pants. Generally, metal zippers cost more, have better abrasion resistance, and are often used in better pants because of their increased performance. Coil zippers are also widely used at all price ranges due to their flexibility and because the image does not press through to the right side. Proper installation and correct use are essential for expected performance. Firms make zipper choices based on their own special preferences.

Subassembly of Components

Production of dress pants is an involved and complex process. Forty to fifty separate operations are required to produce an average pair of moderately priced dress pants, and there may be considerably more on some styles of better pants. Producing cost-effective garments with so many operations requires thorough planning, automation, and skilled operators.

On dress pants, seam allowances of major components are **serged** (EFd). This is frequently an automated process in which one operator manages three or four machines. The operator places the front or back piece and the machine stitches, turns, stitches, and turns the piece until all edges have been serged. Better pants are serged with a three-thread 504 stitch prior to assembly, and budget pants are often serged with a two-thread 503 stitch. On some better pants, seam allowances may be taped (BSc).

Underpressing or in-process pressing of components is an important part of producing high-quality pants. Underpressing allows each component to be fully shaped before it is incorporated into the rest of the garment. Application of adequate pressure to set the shape of components would also press images into the garment itself if left until final pressing. Final pressing consists of a general steaming and setting creases, but fine-tuning of the component shape needs to be done as components are completed, prior to garment assembly. This practice requires extra time and handling and elevates costs, which is why underpressing is used less on budget pants.

Inseam and offset front pocket styles have very similar construction. Front welt pockets are assembled similar to back welt pockets, except for construction of the pocket bag. Most pockets consist of an opening, front and back facings for the opening, a pocket bag, and point(s) of attachment. Differences in quality, cost, and performance are in pocket depth, materials, and methods of assembly.

Pocket facings provide a finished appearance and enable pockets to be used without exposure of pocket bags. Most dress pants have front and back pocket facings of shell fabric that are applied to pocketing material prior to attachment. Facings are attached while the pocketing is flat and before the bag is formed. Facing depth and method of attachment vary with quality level and price point. Deeper facings require more fabric but cover more of the pocket bag leaving less chance of exposure. In better-quality pants, facings are turned under and stitched to the pocketing with a lock stitch (301 LSd). Pocket facings may also be attached with a cover stitch (406 LSbj), which is not as durable since more stitching is exposed and there is a greater chance of fraying with use.

Facings and pocketing are attached to the front of the pants in a two-step operation (301 SSe-2), in which a superimposed seam is turned and topstitched. On moderate and better pants, strips of interlining or stabilizer are included in this operation to strengthen the seam and prevent stretching and distortion that occurs with use. Strips may be fused to pocket edges during preassembly or laid in the seam as it is stitched. Pocket fronts are positioned over back pocket pieces, and pocket bags are formed by closing the bottom seam. On better pants this is done in a two-step operation (SSae) that provides double stitching and extra strength. Pockets are stitched, turned, and stitched. The turning operation is similar to point turning. A one-step operation reduces time and handling on budget pants.

On better pants, side seams are stitched and pressed open (seam busted), independent of the pocketing. Lower edges of pockets are stitched (SSa), turned, and stitched a second time. The second stitching is continued to the waistline as it closes the pocket, and it attaches the pocket bag to the back half of the side seam allowance. Other methods close the pocket independent of the side seam. These methods take the strain off the side seam and allow it to lie flat regardless of stress or pocket use. Bar tacks are placed to reinforce points of stress at the top and bottom of the opening.

The fastest method of completing front pockets is to use a safety stitch (516 SSa) to close the lower edge of pockets and include the sides of pockets in the side seams as pants are stitched. Bar tacks are applied after the pocket and side seams are completed. Pocket bags closed with only one stitching are more susceptible to raveling out and there is more strain on the side seam. With this method, side seams may rip out at the point it joins the pocket.

Back pockets are slit or cut-in pockets made with one welt or two (see Figures A2–3 and A2–4). Interlining is placed under the pocket opening for added strength. Pockets are stitched and cut with corner knives to allow turning and formation of sharp corners. Factors affecting quality of back pockets are depth, method of facing application, method of bagging, and accuracy of stitching, cutting, and finishing ends of the welt. Basically, welt pieces are positioned and stitched to the outside of the pant, openings cut, and welts turned inside where pocketing is attached, bagged, and hung. Welts are often made by automatic welt pocket makers that can be adjusted for welt size and number. Accuracy of

welt setting is important to the efficiency of other operations and durability of pockets with extended periods of use.

Back pocket facings cover pocketing under the opening just as on front pockets. The depth and position of this piece determine how well the pocketing fabric is concealed. Facings may be applied with a 301 LSd, which is the most durable, or 406 LSbj, which is the least time-consuming. Back pockets as well as front pockets are more durable if bagged with a seam (301 SSae) that is stitched, turned, and stitched. The lower part of a quality pocket is double stitched although the pocketing above the pocket opening may be closed with a SSc seam where there is little or no stress. Budget garments may use a 301 SSc seam or a 516 SSa, which is stitched only one time. Some larger firms are currently using adhesive bonding to bag back pockets without stitching.

Ends of welts must be sewn to the turned seam allowances and pocket sides. If this stitching is not strong and accurate, corners will fray. Some manufacturers bar tack ends of a welt to the pant instead of seaming it underneath, but the high stitch count of a bar tack can overstress shell fabric and cause yarn severance. Back pockets on better garments are often stitched from the inside so topstitching is not visible on the outside.

Pocket flaps or tabs must be inserted prior to securing the upper part of the pocket or welt to the pocketing or facing. On better garments this is done with a superimposed seam through the seam allowances, pocketing, and back pocket facing. A faster method uses overstitching to secure the top and sides of pockets. Completed pockets are hung from the waistline.

Zipper plackets are long and curve into the crotch seam at the bottom on men's pants. Zippers in women's wear are shorter and often applied to the straight part of the crotch seam. A curved zipper placket creates a need for separate facings and placket pieces. Facings are needed to convert the center front seam into a zipper fly placket. (On budget women's wear, extensions are often cut as part of the center front seam and used as facings for a fly placket.)

Zipper fly plackets consist of an overlap, underlap, and zipper. Differences in quality levels and costs are due to placket structure, materials, and automation used. Interlining may be included in one or both parts of a placket to retain shape and prevent images from pressing through.

The **overlap** is formed from the garment front and a facing. The **underlap** consists of an extension to the front seam. This extension may be shaped to include a tab, or a separate tab may be constructed and attached to the extension prior to attaching the lining. A shaped one-piece placket underlap may be called a *French fly*. This part of the placket is formed from shell fabric, interlining, and pocketing fabric as a lining. The button tab or French fly provides firm support, takes stress off the waistband and zipper, and helps the front lie flat along the zipper placket. The placket underlap of better pants may be shaped so a single buttonhole attaches to a button placed at the waistline. Fly extensions on better garments are double stitched (SSe) to keep the edges flat, while the second stitching may be eliminated on budget pants.

A small section of the front crotch seam at the base of the zipper is sewn prior to assembling the zipper placket. This allows the seam to be secured before the placket is attached above the seam. On dress slacks the seam does not extend to the inseam. The full crotch seam is completed after the inseam is closed. The seam allowances all change direction at the base of the zipper, therefore, the sequence of completion is important.

Most **zippers** are sewn with lock stitches, as they are more secure and less susceptible to abrasion. There are various methods for attaching zippers that produce a durable operable zipper. Zippers may be sewn to facings and extensions during preassembly because of the ease and speed of handling small parts. Automation may determine the method used. In the first operation zipper stringers are sewn to placket facings with two rows of stitching, one close to the chain and one on the edge of the tape (301 SSa-2) to form the underlap. The matching stringer is included in the placket seam as the front extension and center front edges are sewn (504 SSa) to form the underlap. In some plants these operations are automated. Facings are later attached to the center front overlap seam in a separate operation. The final topstitching of the fly, often called the *J-stitch*, is completed after the waistband is in place. The preliminary stitching prior to setting the zipper in the garment makes the placket durable, but it also complicates zipper replacement for alterationists.

Stress on the zipper stop can be prevented by a bar tack strategically placed just above the lower stop. Bar tacks may be used at the bottom of the fly and at the bottom of the zipper to support the stop.

On better garments, fly lining is cut longer than the rise. Extra length at the top is sewn to the waistband. Lining is also extended below the fly to the inseam and stitched to the opened seam allowances of the crotch seam. This provides reinforcement for the crotch seam and keeps it flat. Budget garments frequently do not have an extended fly lining or buttoned fly guard. (Notice the differences in construction of the pants in Figures A2–6 and A2–7.)

Belt loop construction affects durability and may be an indicator of garment quality. Belt loops on dress pants are usually smooth with no topstitching, unlike belt loops on casual pants (406 EFh). Belt loops are formed around a stiff fusible interlining and secured with resin bonding or sewing. The least costly and lowest-quality belt loops have no stitching. Resin adhesive is used to hold the fabric in place. A more secure method used on moderate and better pants is to wrap the support material with fabric and secure it with a blind stitch (103 EFae) on the back.

Another factor in quality and durability is attachment of the belt loops. On better-quality pants, belt loops are included in the lower waistband seam and back tacked to the top of the waistband. This method helps pants to lie flatter, increases strength of belt loops, and has more aesthetic appeal. Stress placed on belt loops is transferred to the waistband seam, not the top of the pants.

Belt loops may be stitched below the waistband and below the top of the waistband. Belt loop location in relation to the waistband is dependent on equipment. The number of belt loops used and their position on the waistband are choices of the manufacturer. Some manufacturers may use a center back loop, while others prefer to have loops on either side but close to center back. Some better pants may have a small belt loop at center front to secure the prong of a belt buckle to keep the belt from slipping.

Waistbands are attached to the curtain and other support materials while they can remain flat. Dress slacks use a left and right waistband that eventually will be joined at center back. Better-quality waistbands require more materials. Interlining is often used as a buffer between the waistband and curtain and other materials. A strip of interlining (fusible or sew-in) may be placed inside the waistband and attached in the seams. This helps produce a smooth band with improved shape retention. Curtain is sewn to the upper seam allowance of the waistband (LSb). As the curtain is seamed to the waistband of better pants, a strip of stiff woven monofilament nylon is placed 1/4-1 inch above the seam joining the curtain and waistband (see Figure A2-5). This nylon strip stabilizes the top edge of the waistband, prevents roll-over, forces the waistband to wrap the top of the stabilizer, and prevents the curtain from showing at the top of the pants. Often, better pants feature turned-down waistbands. This means the waistband wraps to the inside at least 1 inch instead of the standard 1/4 inch. Narrower curtain is used with this method. Labels are often attached during waistband assembly.

Final Assembly

During final assembly, completed garment components come together and are assembled according to a predetermined sequence into completed garments. Side seams are stitched (301 SSa) and pressed open (seam busted). Better pants may have side seams sewn with a lock stitch because it is flatter and stronger. Other firms will use a chain stitch due to its stretch, speed, and availability on automated seaming equipment. Budget garments may be sewn with safety stitch machines and not pressed open. Seam allowances range from 3/8 inch to 1/2 inch for side seams.

Inseams are stitched in the same manner as side seams except that better pants have uneven seam allowances. Back seam allowances are often 1/2 inch wider than front seam allowances to make adjustments for fit.

Waistbands are attached to the left and right sides of pants after side seams are sewn. On better pants the waistline seam attaches the waistband, interlining, and belt loops. Waistbands are sewn across the top of opened zipper plackets on both sides. When the placket is topstitched (the J stitching), the stitching extends through the placket and waistband. Waistline seams on better pants may be pressed open before being covered by the curtain, which creates

a flat smooth seam. On many pants, the waistline seam is pressed toward the waistband during the final pressing.

On moderate and better pants the under part of a curtain is attached across the pockets with a 103 blind stitch. The outer curtain also is spot tacked (101) at strategic points on better pants. On some moderate and budget garments, belt loops attached below the waistline may be the only means of securing the curtain.

Crotch seams are often the last part of assembly. Crotch seams are sewn (401 SSa) from front to back across open inseams, through the waistband and curtain at the center back. Seam allowances taper from 1/2 inch to 1 1/2 inches at the waist line. A 401 chain stitch is most often used because of its stretch and easy removal for alterations.

Finishing

Finishing operations include final pressing, curing for wrinkle resistant fabrics, trimming threads, inspecting, labeling, ticketing, and bagging. Final pressing involves steaming the waistline area with a pant topper, setting creases with a buck press or Paris press that shapes and steams pant legs. Curing for some types of wrinkle resistant processing involves baking pressed garments in a curing oven. Pressed garments are tagged and bagged for shipping. The labels and tickets used depend on a retailer's needs and the customer appeal desired.

Presentation

In the retail setting pants are treated different at different price ranges. Budget and moderate pants may be folded and stacked or hung on pipe racks, or rounders. Better pants are often displayed on racks that show only a fold of the fabric. Fashion features, quality characteristics, and fit are really not apparent until the customer decides to examine the garment more closely. The reputation of the retailer and a manufacturer's reputation for consistent fit and quality are important to the better market. Tags are used to identify the manufacturer and provide fiber content information, but they are sewn to the inside of the waistband.

Hang tags are important to budget and moderate lines to provide immediate manufacturer identity, relay information on materials, and promote product performance.

GARMENT ANALYSIS APPLICATION #3

Analysis of Men's Dress Shirts

Product Positioning Strategy

The majority of dress shirts are mass produced by high-volume manufacturers. Because styling and fabrications of men's dress shirts change slowly, firms are able to develop and invest in automation and achieve a reasonable payback. In 1985, the average single-needle shirt required approximately 14–16 minutes to produce (Armfield, 1985). Today, with the application of technology, the production times for dress shirts have been reduced by 30 percent (Hill, 1994). This means a single-needle shirt can now be made in 9.8–11.2 Standard Allowed Minutes.

Men's dress shirts are traditionally styled garments designed to be worn with neckties and suit coats. Dress shirts are primarily basic, staple garments with only subtle variations in styling, color, and fabrication across many seasons. Short sleeves and lighter colors are featured during summer months, although white is generally a staple sold year-round. Dress shirts are designed and developed as a durable product, but the degree of durability is dependent on materials used and methods of assembly.

Style Variations

Fashion and styling focus on collars and cuffs. Collars are the most visible part of any shirt whether in the package or on the consumer. Collar styles may include Windsor spread, button-down, tab, eyelet, and white contrast collar. Some firms may use as few as two collar styles but many more colors and fabrications. Collars may become wider or narrower with changes in fashion or fitting standards. Cuffs also vary in width and styling with curved, notched, or squared corners, but the basic structure and methods of assembly are similar within a line.

Style features often found on better men's shirts include split yokes, buttonthrough sleeve plackets, single-needle sleeve seaming, lapped side seams, curved-edge pockets, removable collar stays, and enclosed right front facing. Some features improve performance, while others are merchandising features that are promoted by manufacturers and retailers. Some of these style features also have been adapted for lower price points.

Prices

Although there are no established industry standards for production of dress shirts, certain characteristics tend to be more evident at specific price levels. Budget lines may feature basic colors, traditional styling, and standard fabrications. Moderately priced shirts may have a mixture of characteristics from budget and better price points. Lines that target customers of upper moderate and better men's departments and specialty stores usually incorporate more intrinsic quality by using higher-quality materials, more durable construction, and a variety of collar, cuff, and pocket styles (see Table A3–1 for a summary of characteristics of budget and better dress shirts).

For the elite customer, a few high-end retailers offer luxury shirts in the \$400–700 range. These shirts may be made from luxury imported fabrics made with 100–200 plied yarns, natural mother-of-pearl buttons, and hand stitching. Some companies provide a custom, **made-to-measure fit.** Rome-based tailored clothing leader Brioni's "Clients may select from 2000 different fabrics, 35 collars, 100 cuffs, and 80 dress shirt details" (Waterhouse, 1998, p. 30). A precise measurement system is used by trained fitters to collect information needed to ensure the desired fit for each customer. A major benefit of custom shirts is a precise fit for a customer's unique body proportions and the luxury feel of specially selected fabrics.

Sizing and Fit

Sizing of men's shirts is not standardized, but there is a great deal of consistency in the sizing systems used in the menswear industry. Traditionally, shirts have been sold by neck size and sleeve length. Commonly offered neck sizes range from 14 to 18 with 1/2-inch increments and sleeve sizes range from 32 to 36 with 1-inch increments. A size 16/35 indicates there are 16 inches in the circumference of the buttoned neckband and 35 inches from center back to the end of the cuff. Shirts may be cut fuller through the body and have deeper pleats and different collar shapes and proportions, but generally the neck measurement and sleeve length are fairly consistent with dimensions for a specified size. Some manufacturers have tried to use SML (small, medium, large) like sport shirts, but with little customer acceptance.

Fit of dress shirts is varied by offering regular and tapered cuts. Regular fit has side seams on straight grain with extra fullness built into shoulder or center back pleats. Tapered shirts often feature a special descriptive label that describes the fit as slim fit, tapered, or athletic cut. Tapered means the waist of the shirt is smaller than the chest area. Tapered shirts may have tapered side seams, darts at the waist, but no pleats.

Neckband double stitched to collar (SSq 2)

Stitched pocket hem (EFb)

Reinforced pocket corners

Pocket

Table A3-1

Comparison of better and budget men's dress shirts including quality characteristics and

merchandising features. Better **Budget** Product positioning strategy Product positioning strategy · White and fashion colors · White and traditional colors Straight voke Split voke (seamed) · Button-through sleeve placket · Plain placket · Curved pocket corners Angled corners · Pleats each side of back · Center back box pleat Locker loop No locker loop · Prototype fit to live model Prototype produced to specific dimensions **Materials Materials** Fabric Fabric All cotton or high-percentage blend High-percentage polyester blend Fine, combed, plied yarns Medium, carded, single yarns High-count fabric (100) Low-count fabric (40) Yarn-dyed patterns Printed patterns Thread Thread Corespun, matching thread Spun polyester, white/neutral Buttons Buttons Extra buttons One size, white/neutral Varied sizes, matching color Shiny, high luster Parallel stitched Chalky, dull finish No reinforcement or rough hand Cross-stitched Reinforced collar buttons Buttonholes Buttonholes 100+ lock stitches per buttonhole 50 chain stitches per buttonhole Stabilized collar buttonhole Buttonholes elongate Edges covered Loose yarns from fabric Interlining Interlining Fusible, nonwoven Sew-in, woven/bias cut Attached prior to assembly Attached in seam Collar stays Collar stays Removable Sew-in stays Component assembly Component assembly · 8 spi, less concern for seam pucker · 22 spi, no pucker Collar Collar Die or computer cut Knife cut Removable collar stavs Sew-in collar stavs Bias-cut interlining Cut straight of grain

Single stitched (LSe)

Loose pocket hem (EFd) Straight back stitching

Pocket

Table A3-1, Continued

Comparison of better and budget men's dress shirts including quality characteristics and merchandising features.

Cuffs

Interlining sewn to top cuff

Right front

Enclosed front edges (EFb)

- Left front (LSk)
- Sleeve plackets

Traditional 1-inch placket with overlay at top (BSq)

Final assembly

- · 22 spi, no pucker
- · Attach yoke

Back (LSf)

Front (SSa and LSd)

· Attach collar band

Two steps (SSa and LSd)

Sleeves

Single-needle tailoring (LSaw)

· Side seams

Lapped seams (LSc or LSr) 401

Finishing

- · Trim threads
- · Hand pressed

Presentation

- · Boarded and unpackaged
- Printed labels
- · Tissue paper/white cardboard
- · Two clear plastic collar supports

· Cuffs

Applied in one operation

· Right front

Serged, loose edge (EFd)

- · Left front (EFb)
- · Sleeve plackets

Continuous 1/2-inch binding (BSc)

Final assembly

- · 8 spi, less concern for seam pucker
- Attach yoke

Back (SSa)

Front (SSa or LSe)

· Attach collar band

(LSe)

Sleeves

Superimposed seam (SSa)

Side seams

Superimposed seam (SSa) 516

Finishing

- · Trim threads
- · Press front only

Presentation

- Boarded and packaged
- Printed on package
- · Gray cardboard
- · One cardboard collar support

Collar fit is an important aspect of shirt comfort and appearance, but factors affecting collar fit are often not understood. Dress shirts have four factors affecting collar fit: (1) circumference of buttoned collar band, (2) position of the shirt neckline in relation to the body's neck curve, (3) collar height, and (4) relationship of front height to back height of the collar. Shirt neck size provides the circumference of the buttoned collar band. A shirt's neckline shape and position relative to the neck curve of a body determines the position for the necktie. Necklines that are too high in front cause the knot of the tie to form higher on the neck and may feel tight and restrictive. Back collar height is the depth of the collar at center back. Back collar height may be established as a standard for a firm or varied with fashion or styling detail. Collar height affects the depth of collar bands, which

must be 1/4 inch less than collar depth at center back if the band is to remain covered. An established collar height may not be suited to all neck and body proportions, which is why custom firms may work with many different collar heights.

Collar bands connect neckline curves with collars and establish the position of the collar in relation to the body. The relationship of front collar height to back collar height is controlled by varying the shape and width of the collar band, the depth of front and back neckline curves, and neckline width at the shoulders. Some collar bands are nearly straight, while others curve noticeably from center back to center front. Some bands may be widest at center back and taper to a very narrow band at center front. A high-back collar band and low-shaped front band are best suited to the young, more athletic customer. Mature customers may need more band height in front to raise the collar front and reduce the strain at the back of the neck. An ill-fitted collar may cut into the neck and cause discomfort and excessive abrasion.

Sleeve fit depends on sleeve length, depth of the armhole, and curve of the armhole seam. Sleeve length is specified as the second part of dress shirt sizing. Measurements for sleeve length are taken from center of the back yoke at the neckline, across the shoulder to the end of the cuff. Corresponding measurements of the consumer are taken from the neckline at center back, across the shoulder, over a bent elbow to the wrist. Armhole depth is not specified in sizing, but in fitted shirts armhole depth generally runs shallower and is more curved than regular cut.

Materials Selection

Materials used in dress shirts include piece goods (shell fabrics), interlinings, threads, and buttons. Some collar styles also require stays or reinforcement under collar buttons. Materials selection is based on customer preferences, cost limitations, availability, and suitability of materials to equipment.

Fiber contents of shirting fabrics are primarily cotton and cotton blends. Better shirts tend to be 100 percent cotton or have a high percentage of cotton blended with polyester. Fabric costs increase proportionally with count, yarn fineness, and intricacy of fabric design. Better dress shirts made from imported extra fine, long staple cottons may retail at \$80 to \$700 per shirt.

The most widely used dress shirt **fabrics** are oxford and broadcloth. Other fabrications include fancies or dobby weaves that may be yarn dyed or white-on-white stripes or designs. Varying qualities of oxford shirtings are used at budget and moderate price levels, while pinpoint oxford is a staple in the better shirt market. Quality of oxford is determined by yarn type, yarn size, fabric count, and fabric weight. Pinpoint oxford provides a smoother, finer, fabric with excellent hand, durability, and resistance to seam slippage. High-count broadcloth with fine-combed yarns is used in better-quality shirts; lower-count broadcloth with carded yarns, and a higher percentage of polyester is more often used in budget and moderate garments.

Color is another important factor in developing and merchandising dress shirt lines. White has been a traditional color for dress shirts for many decades, but the influence of active sportswear became evident during the early 1980s when more intense nontraditional colors became acceptable. "White represents 60 percent of the solid colors in some lines, because it is the dressiest of colors" (Orgel, 1988, p. 6). Stripes and subtle plaids have gained importance in recent years, partly because of a crossover of the sportswear customer who wants a shirt to serve double functions. Yarn-dyed pencil stripes and subtle checks perform better than printed designs.

Sewing threads are important to the aesthetics and durability of finished garments. Primary factors that influence quality and performance of thread for shirts are fineness, strength, and color. Fine threads blend with fabric, create less displacement pucker, and provide a better aesthetic appearance. Better-quality dress shirts with a high stitch count require strong, fine thread because of the high-count lock stitching used in topstitching on collars and cuffs. High-count lock stitches may cause yarn displacement in the line of stitches and abrasion during stitch formation that can weaken thread. Cotton/polyester corespun thread is the most suitable. Spun polyester thread may be used for chain stitched side seams because of less friction in stitch formation. Budget shirts with much lower stitch count may be sewn entirely with spun polyester thread.

Matching thread color to the piece goods is essential for high-quality topstitching, but matching thread throughout a shirt is also characteristic of higher-quality levels. Matching thread gives less flexibility in the production line and may require down time for rethreading machines.

Buttons on dress shirts are usually four-hole. Better shirts may use a different size button for each component (cuffs, collar, and center front), while budget shirts may use the same size button in all locations. Smaller buttons are more aesthetically pleasing on button-down collars. Variable size buttons may increase costs owing to additional inventory and handling.

Color-matched buttons are considered better-quality than white or neutral unless the shell fabric is white, although some dyed buttons may be weakened by the dyeing process. Application of matching-colored buttons requires changing over of automated equipment, which also creates downtime. Button finishes range from shiny pearlized buttons that are used primarily on budget and moderate shirts to matte or dull, chalklike finishes that are often found on better shirts. Some better and moderate shirts provide extra matching buttons attached to a hang tag or sewn to the inside of the shirt. This is a service to the consumer in case a button is lost or damaged.

Buttons for the points of button-down collars need reinforcement to protect shell fabrics. Reinforcement patches are applied to the back of the shell fabric at the time collar buttons are set. Reinforcements usually are a small circle of some type of nonwoven interlining. The hand and performance of the reinforcement are important comfort factors. Some are stiff and paperlike when ap-

plied, while others may be soft and supple; some types become stiff and abrasive with care and use.

Interlinings are important to the structure and shape retention of shirts. Interlinings that are used in the collar, collar band, cuffs, and left front band (plait) may be different types. Fusibles are used in some budget and moderate lines to provide a smooth collar finish. A softer fashion look has increased the use of sew-in woven interlinings. Sew-in synthetic taffeta is widely used in budget and moderate lines because of its flexibility, compatibility, and durability. High-count wovens are often used in better shirts. Woven interlinings are often cut on the bias to improve their flexibility and to avoid breaking as the collar rolls and the cuff or front plait bends. Bias-cut wovens also stabilize buttonholes on the button-down collar styles because straight grain of the interlining is parallel to the buttonhole.

Collar stays are used in some styles to provide shape and support. Removable stays are stiffer and retain their shape better because they are not subjected to high temperatures and distortion in the laundry process. Sew-in stays are used extensively in moderate and budget shirts because of their ease of application.

Component Assembly

Components of dress shirts are often assembled in small parts or subassembly areas of a plant. Specialized equipment is widely used for component construction of dress shirts. There are many different ways components can be assembled; some options represent better quality and durability than others. Garments may consist of a mix of components that represent high-quality and low-quality characteristics. This is especially true of moderate-priced garments.

When processes are automated, differences in quality and cost are largely due to materials used, a plant's ability to maintain equipment, and management of quality control. As plants increase the use of automation, assembly methods become standardized across styles. Automated component production may include making collars, collar bands, sleeve plackets, cuffs, setting pockets, and front plait assembly. Topstitching, buttons, and buttonholes may be a part of component assembly on dress shirts.

Stitches contribute to shirt quality and durability. Stitch type and stitches per inch can be evaluated for component assembly and final assembly. Lock stitches (301) are often used for topstitching on collars, cuffs, and neckbands because they are reversible and the stitch type least susceptible to abrasion. Chain stitches (401) are often used for automated parts assembly, such as sleeve plackets, front plaits, and side seams. Chain stitching allows more stretch and is often used in setting sleeves. Automated equipment is often set up to use chain stitches because it is fast and threads can feed continuously. Safety stitches (516) are also used to seam budget shirts.

Better dress shirts may be seamed with 22 spi, while budget shirts may have a stitch length as low as 8 spi. High-quality dress shirts have a higher stitch count than most other garments. On shirting fabrics, high stitch count increases seam strength, reduces seam slippage, and produces a flatter, smoother seam if pucker is prevented. Correctly made shirts do not have seam pucker. Seam pucker may be the result of yarn displacement or an incorrect sewing combination including thread size, needle size, stitch selection, and tight tension.

Collars are probably the most important component of a shirt because they are always available for close scrutiny at eye level. Quality and durability of collars are determined by cutting accuracy; interlining type, application, and performance; selection and installation of collar stays; and assembly methods. Better-quality collars and interlinings are often die or computer cut to ensure consistency. Precise cutting makes alignment and assembly easier during other operations. Plaid and stripe collars on better-quality shirts are often block cut and stripes individually realigned prior to die cutting. This ensures that stripes will be consistent across the collar and match other coordinating pieces.

Casings for removable collar stays are often one of the first steps in collar construction on better shirts (see Figure A3–1). They may be formed with an extra piece of fabric to protect the top collar from abrasion by the stay. Casings may also be formed by stitching a casing between the interlining and under collar. Sew-in stays, frequently used on moderate and budget shirts, are stitched to the interlining or undercollar prior to collar assembly.

Collars depend on interlining for structure and shape retention. To be effective, interlining needs to be attached (fused or sewn) to the top collar in order to create a smooth surface for the top collar and to prevent seam images from pressing through to the right side. Budget and moderate shirts are most likely to have fused interlinings for a smooth, crisp appearance. Fused interlining performance depends on accurate control of dwell time, pressure, moisture, and temperature in the fusing process.

Figure A3–1
On better shirts of

On better shirts one of the first operations is making the casings for collar stays:
(a) reinforcement applied in area of stays, (b) separate piece of fabric applied to form casing, and (c) completed casing for collar stays.

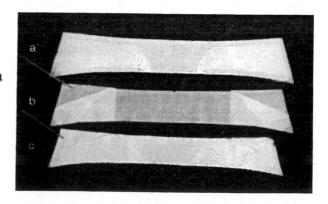

For automated collar assembly, collar pieces and interlinings are aligned and sewn (run stitched) around a template. In other plants, seaming collars is a manual operation. Sewn collars may be processed on a die press equipped for trimming points, turning, and pressing prior to topstitching. Final topstitching serves to keep collar edges sharp and flat. Depending on where the topstitching is placed, collars are completed as an SSe or SSae seam.

Collar bands are also dependent on interlining for structure and support. The type of interlining used in collar bands may be different from collars, depending on the structure needed, method of construction, and the type of equipment available. Depending on the method of assembly to be used, one or both collar bands may be formed around interlining prior to assembly. One method of constructing collar bands uses a template to fuse interlining and shape each band in a single operation. This method produces identical bands with all the seam allowances fused to the inside of the piece for ease in assembly. With this method, the only stitching that occurs is topstitching that attaches the bands to the collar and later to the shirt (see Figure A3–2).

Sewing interlining to collar bands may be the first step in making the band, or it may be attached at the same time the band is attached to the collar. If the interlining is to be sewn in place prior to assembly, the inside band may be folded over the edge of the interlining and stitched. This method, which is similar to cuff assembly, requires an extra step, but it produces a flat durable application that is easy to seam in place.

Attaching the band to the collar may be done in one operation, as shown in Figure A3–2, or two, depending on the durability and quality level desired and the equipment used. The single operation is automated and fast. If a template is used to form both collar bands, their shape is identical. This makes it possible to stitch around a template with bands aligned on either side of a collar seam. This produces a lapped seam (LSe) with a single row of lock stitching. It is fast, accurate, and consistent, but it does not provide the durability gained from two rows of stitching to hold fabrics in place. At a higher quality level, an SSq seam is used in which collar bands are seamed to the collar, turned, pressed, and topstitched along the lower end of the collar seam. Double stitching provides greater holding power for narrow seam allowances in areas of

Figure A3–2
Collar bands may be molded to shape and topstitched to the finished collar.

excessive wear and stress. Completion of collar bands involves making a horizontal buttonhole in the center of the band and setting the button. These operations usually occur prior to setting the collar on the shirt.

Pocket hemming and setting are highly automated in many plants. Pocket hems may be straight or shaped depending on the shirt design and methods used. At a lower-quality level, straight pocket hems are often serged (504 or 516 EFd) and pressed to the inside. At a better-quality level, shaped pocket hems are secured with a 301 EFb, which encloses the hem edge and makes a more durable, aesthetically pleasing pocket.

Automated pocket setters are often used to fold, position, and stitch pockets to shirt fronts. An operator's primary responsibility is the correct placement of the shirt front; with some systems even placement is automated. Different templates are available for style changes in pockets; however, the cost of a single template is approximately \$5,000.

Cuff assembly processes are similar to some methods of making collars. Top cuff pieces are creased around the interlining and topstitched in place (EFa) in a continuous line of stitching. This is the inner line of stitching found approximately 1/4 inch from the line of attachment on the top of the cuff (see Figure A3–3). This creates a sharp even edge that eventually will be topstitched to the sleeve. If automated equipment is used for cuff assembly, stacks of cut cuff pieces are loaded into position. Automated equipment picks up, aligns cuff pieces, and seams according to template shape (SSa). Cuffs produced with two stitching operations are stitched and trimmed simultaneously, turned, and pressed, and the outer edges are topstitched (SSae). Adding buttonholes and buttons completes the cuff.

The **center front placket** consists of two different front pieces. The right front or underlap facing is cut as part of the shirt front. No interlining is used

Operations of making cuffs: (a) rectangular top cuff piece is folded over edge of interlining and stitched; (b) top and bottom cuff pieces are aligned, stitched.

Figure A3-3

and trimmed in one operation; and (c) turned cuff is pressed and topstitched.

for support, and facings are only wide enough to support buttons. Budget shirt facings may be finished with an overedge stitch (Efd) and folded to the inside and secured only by button applications. On better garments the turned edge of facings are lock stitched in place (EFb). An enclosed finish is more durable and provides a more finished appearance when the collar is unbuttoned at the neck.

Front bands are often called center plaits. They form the overlap or the left front placket of men's dress shirts. Widths may vary with fashion and styling, and assembly methods vary with types of fabric and available equipment. Center plaits may be cut as one piece with the front or cut as a separate piece and attached as the placket is formed. Separate center plaits are often used with plaid or striped fabrics in order to position stripes at center front and cross match plaids.

Center plait applications are primarily automated processes that insert interlining as plaits are stitched. Most bands are constructed as a type of lapped seam (LSk or LSm). Fronts with cut-on plaits are folded and edge finished (EFv). Specific methods may vary with the type of equipment, folders, and so on. Conveyors carry shirt fronts through folding, positioning, stitching, and stacking. Plaits are sewn with a multiple-needle chain stitch that can be adjusted to a specific style or plait width. Performance of the plait is dependent on interlining, stitches per inch, shell fabric, and consistency.

Buttons and buttonholes are applied to the shirt front prior to garment assembly. Indexing equipment is set up to produce five or six buttonholes on the band, depending on the firm's standards. A seven-button front is considered better-quality and more secure, with less gapping than a six-button front. One button is applied to the collar band in a separate operation.

Buttonhole quality is judged by the size of the buttonhole in relation to button size, closeness of stitches, and type of stitch used. Buttonholes should fit the button but not be noticeably larger. Better-quality buttonholes are lock stitched (301) instead of chain stitched (101) with a high stitch count (100+ stitches per shirt buttonhole). Balanced tension is also a factor in buttonhole appearance. Tight top tension causes stitches to form on the top of the buttonhole instead of on the cut edge that needs to be finished. Monitoring tension requires time and will often be ignored on budget garments. Some luxury shirt manufacturers use hand made buttonholes and hand sewn buttons to provide the customized look.

Sleeve plackets vary in structure and styling but most are structured as bound seams (BSc) or modifications of bound seams (see Figure A3-4). There are three types of bound seam shirt plackets: continuous narrow binding, continuous wide strip with topstitched overlay, or two separate strips of different widths with an overlay. Plackets on budget shirts are often constructed with a continuous narrow binding strip (see Figure A3-4). At the top of the placket the completed binding may be topstitched to the inside of the sleeve or stitched together. This method does not have the same strength or appearance at the top as traditional plackets.

Figure A3–4
Sleeve plackets: (a) bound seam sleeve placket often used on budget-priced shirts, (b) traditional sleeve placket with a topstitched overlay used on shirts at all price ranges, and (c) traditional button-through sleeve placket frequently used on better shirts.

Traditional dress shirt plackets with a topstitched overlay are found on shirts at all price points (see Figure A3–4a and b). Traditional plackets may be structured with a binding strip 1 to 1 1/4 inches wide. At the top of the placket, the binding is folded under to form the triangular shape and lock stitched in place. Some better shirt plackets are made with two separate binding pieces. Binding pieces may be set in a two-step operation that requires a double row of stitching and produces a stronger, more durable placket. Better shirts also have button-through plackets with a button and buttonhole located in the middle of the placket to prevent gapping (see Figure A3–4c).

Final Assembly and Finishing

Final assembly is the stage when preassembled components are matched and combined for the final sewing operations and finishing. Differences in seam selection, stitch selection, assembly methods, and quality control affect costs, quality, and performance of finished shirts.

Fronts and backs of dress shirts are first joined at the yokes. **Yokes** on dress shirts are style features often used to incorporate fit into the shirt. Dress shirt yokes consist of two identical pieces, an outer yoke piece and yoke lining. Yokes are usually cut straight grain across the back and attached to a back body component that may have a curved upper edge to incorporate shape. The back yoke seam (armhole to armhole) allows extra fullness and shaping to be incorporated by adding pleats to the back of the shirt. Yoke depth determines where the full-

ness will fall. A shallow yoke places the fullness higher in relation to the shoulder line and is better for fitting a person with a more rounded shoulder. A deeper yoke places the pleats lower across the shoulder area. Striped yokes may provide shoulder emphasis by contrasting the direction of stripes.

Split yokes are a style feature often associated with high-quality shirts. Split yokes have a seam or line of stitching at center back. Originally a split yoke seam was used as a shaped fitting seam that has evolved into a merchandising feature associated with better shirts. On some shirts a split yoke is cut as two pieces and seamed; other styles have a back yoke cut as a single piece and a tuck stitched at center back.

Shirt backs may be attached to yokes with LSf or SSa seams that use one row of stitching. Front yoke seams may also be assembled with a single line of stitching, SSa or LSe, or a two-step operation combining an SSa and an LSbd, which results in completely enclosed seams.

Collar bands may be attached with several different methods. The fastest method with the least handling and stitching places the neckline of the shirt between creased collar bands. Pieces are clamped in place and topstitched along the neckline seam (LSbo). There is only one row of stitching with this method. A more secure method that is commonly used on better shirts is a two-step operation. One collar band and the shirt neckline are joined with a superimposed seam (SSa). The seam allowance of the second collar band is folded inside and topstitched over the previous seam (LSd). Most firms prefer that the outer collar band be topstitched, but other firms are set up to do it in reverse order. The result is the same if the stitching is accurate. The double row of stitching contributes to the durability and quality of the garment, but inaccurate stitching detracts from the aesthetics of the shirt.

Sleeve assembly is associated with quality, durability, and comfort of shirts. The manner in which sleeves are attached to the body of the shirt has become a means for classifying shirt construction: single-needle construction or safety stitched. True single-needle construction is a three-step operation that creates a lapped seam (LSaw). This type of seam uses three rows of stitches to complete an armhole seam, all of which absorb stress that occurs in the sleeve/shoulder/back area and makes a much stronger, flatter, and more durable seam. This type of seam structure has a concealed line of stitching at the seam line and a single row of stitching on the outside of the garment. Unequal seam allowances are cut for the shirt (1/4 inch) and sleeve (5/8 inch). When superimposed, the shirt seam allowance is 1/2 inch inside the sleeve seam allowance. This allows room for the sleeve seam allowance to be folded in and stitched as shown in Figure A3-5. The first stitching stitches a crease in the sleeve seam allowance. The second stitching seams the shirt to the sleeve. The third stitching attaches the creased seam allowance to the shirt (see Figure A3-6). It is possible to shorten this process without sacrificing performance of the seam. By using a double needle and folder, the first and second stitching can be done in one operation.

Figure A3–5
Single-needle application of a shirt sleeve involves three operations and unequal seam allowances. The extended seam allowance is folded and stitched. The sleeve is sewn to the armscye.

Figure A3–6
Completed single-needle
armscye seam. The extended
seam allowance was folded over
the shorter one and topstitched.
A single row of topstitching is
visible on the outside of the
shirt.

Single-needle sleeve setting reduces seam slippage and raveling, and keeps the seam flatter for greater comfort. Single-needle sleeves add approximately 2 minutes to the construction of a shirt, but many manufacturers feel that it is essential for quality and durability. In the past, single-needle tailoring was featured only on better shirts, but many manufacturers have felt it necessary to improve the quality of their products and are now using single-needle construction at all price levels.

Sleeves can also be set with a regular lapped seam construction (LSc), which is done with two needles and a folder. The difference in appearance is two rows of completely parallel topstitching on the outside of the garment as compared to one row of topstitching.

A safety-stitched sleeve (516 SSa) is the fastest means of attaching sleeves. This type of seam does not have topstitching, and all the stress is placed on a row of chain stitching along the seam line. Width of the seam allowance may affect the amount of seam slippage and strength for this type of seam. Depending on needle spacing, a safety stitched seam may be 3/8 or 1/2 inch wide. A wider seam allowance is stronger than a narrower one, but overall performance does not equal single-needle construction.

Underarm/side seams are a factor in quality and durability of dress shirts. Better shirts have lapped seams (LSc) sewn with a double-needle chain stitch or a two-step operation in which the two overlapping plies are offset when stitched. A second stitching is through the top ply of fabric and turned edge of the bottom ply (LSr). Moderate and budget shirts may be assembled with safety-stitched seams (516 SSa). This type of seam is often used on shirts that have safety-stitched sleeves. Operators closing underarm seams are also concerned with matching sleeve seams at the underarm. Specifications for higher quality levels will specify matched underarm seams.

Cuff attachment, which requires a completed sleeve and cuff, may be done with one operation (LSe) or two operations (LScp). Cuffs attached in one operation require that both cuff seam allowances be folded to the inside and placed on either side of the lower edge of the completed sleeve (see Figure A3–7). A single line of lock stitches attaches the cuff and completes the operation. For a double-stitched cuff attachment, each side is attached separately. The undercuff is stitched to the inside of the sleeve with an SSa seam after which the top cuff is placed on the outside of the sleeve and stitched in place. The advantage of the double-stitched cuff attachment is that it is flatter, stronger, and less likely to ravel with stress.

Finishing

Hems are one of the final operations in assembling a dress shirt as all other seaming must be completed. Dress shirts have long tails and are finished with an edge finish (301 EFb). Length of shirt tails may also be an indication of quality. Longer lengths require more yardage; thus, budget manufacturers may

Figure A3–7 Completed cuffs may be applied to completed sleeves by means of topstitching.

choose to reduce the amount of fabric to control costs. Some shirts have longer tails in the back.

Completed garments are **inspected** and excess threads **trimmed** prior to buttoning, pressing, folding, and packaging. Shirts may be **pressed** on forms or by hand. A primary area of concern is the collar and upper front plait, because that is what shows most when folded and packaged.

Garment Presentation

Because of their basic nature, men's dress shirts are sold by classification, while women's shirts, which have a stronger fashion orientation, are sold by styling concept. **Classification selling** puts more emphasis on products, features, and performance than on presentation of a total fashion look. Men's shirt lines feature a limited number of styles with depth of assortment in color, sizes, and fabrications. Dress shirts are differentiated by styling, price, fit, materials, quality of garment assembly, packaging, and labeling. Shirts are packaged and often purchased without trying on to check fit and quality. Consistency in sizing and quality is expected.

Dress shirts are seldom merchandised on hangers like sport shirts. Most dress shirts are folded, boarded, and pinned displaying the collar, front plait, piece goods, and label, which are the primary selling features of a shirt. Budget and moderate shirts are usually packaged and merchandised in cubes by color and size. Better shirts may be shelved individually or stacked and shelved without packaging to encourage the customer to feel and appreciate the workmanship and quality of materials.

Packaging is important to image formulation. A shirt that has supports for the collar, tissue folded inside (perhaps printed with the designer's logo), strategic areas pinned, and visible areas well pressed presents an image of quality and perhaps status. Some firms feature little more than the brand name on the package in order to focus attention on the garment itself. Other firms, those that target different markets, cover the entire bag surface with copy to promote special features. Some companies have changed to larger packages that show more of their product. Others have changed the folding in order to be different from all other packaged shirts.

Labels add shelf appeal and provide identification for consumers to associate certain characteristics with a specific manufacturer or retailer. Customer loyalty is important to the success of a manufacturer of basic products, especially when the product is not tried on before purchase. Large manufacturers may produce several different lines under different labels to be marketed to different market segments.

Private labels compose a major portion of retail assortments in the dress shirt category. Many retailers have their own labels that are used only on their products, while other specialty retailers may use the store's or firm's name as a means of identification. Private-label merchandising enables various specialty stores to develop customer loyalty and association with a specific product. In dress shirt assortments, a private label is often part of the upper-moderate or better assortment. Manufacturers that specialize in producing garments to be marketed under private labels may design, produce, and market the same shirt to several different retailers using each retailer's special label. Heat-set labels are used instead of sew-in labels if the volume is small. Luxury shirt producers often use lightweight Bemberg rayon labels because of their flexibility and soft hand.

References and Reading List

Armfield, J. (1985, August). New shirt technology. *Bobbin*, 26(12), 92.

Dardis, R., Spivak, S. M., & Shir, C. (1985).

Price and quality differences for imported and domestic men's shirts. Home

Economics Research Journal, 13, 391–399.

Hill, E. C. (1994, October 31). Personal communication. Clemson Apparel Research, Pendleton, SC. Marion, P. (1985, June). Shirts. Shirting: The issues. *Bobbin*, 26(10), 89–94.

Orgel, D. (1988, May 19). DH's Rapson is bullish on dress shirt outlook. *Daily News Record*, 6.

Waterhouse, V. (1998, October 9). U.S. high-end stores hooked on Italian luxury shirts. Daily News Record, 30–33. and the second s

Glossery

Absorption costing Method of determining cost that includes all manufacturing costs, both variable and nonvariable, as product costs

Acceptance sampling Method of determining whether to accept or reject a defined lot of goods based on the evaluation of a selected sample

Accessories Items that enhance the aesthetic appeal or function of a garment including belts, scarves, bows, pins, or other objects

Activity-based costing Costing process that accounts for all processes that contribute to value added

Actual costs Developed during production and distribution; determines cost variance between planned costs and real costs

Adhesive Synthetic resins, such as polyamides, polyesters, and polyethylenes, used to stabilize, support, and/or bond layers of fabric together

Adjusted gross margin Gross margin less inventory carrying cost and distribution costs

Agility Information based decision making along with flexible supply and distribution systems

Allowable costs Wholesale price or product development costs that will allow achievement of planned gross margin

Anthropometrics The study of human dimensions

Apparel design systems (ADS) Computer software applied to garment design processes

Apparel market system A system of local, regional, national, and international markets; their primary purpose is transferring ownership of apparel from manufacturer to retailer

Apparel mart Building designed to house manufacturers' showrooms and apparel market functions

Apparel professional Individual who has education, training, and commitment to the management of an apparel business

Applied design Aesthetic appeal created by printing, embroidery, quilting, appliqué, or other forms of decoration

Appliqué Emblems, cut fabric shapes, figures, or motifs that are superimposed and sewn or fused to garment components

Assortment Range of choices offered at a particular time; usually determined by style, size, and color

Augmented visual inspection Visual analysis of quality or performance of a garment supplemented by use of simple tools such as a ruler or a magnifying glass

Automated cutting Cutting devices controlled by electronic microchips; may be knife, laser, water jet, or plasma jet cutters

Automation A state of operating without external influence or control

Backward vertical integration Merger between a firm and its supplier

Balancing The process of planning a smooth work flow with a steady supply of work for each operation

Band knife Stationary cutting device with a fine blade that rotates through a slot in a cutting table; the operator positions, controls, and guides fabric blocks around the knife

Basic block A set of pattern pieces that form the simplest garment of a particular type

Basic goods Products with little demand for change in style because of fashion change

Bed type Classification of sewing machines based on the structure of the sewing surface; commonly used bed types are flat, cylinder, and post

Better price Above-moderate prices for a product category implying higher quality but not exclusive design; widely distributed in department and specialty stores

Bight See Stitch width

Binding Functional trim that encompasses outer edges of garment components

Block Basic pattern

Bobbin Device for holding the lower thread supply on lock stitch machines

Body Perfected pattern for a style that has been fitted and graded; a combination of styled blocks that create a particular style

Body type A set of proportional relationships in body dimensions that is representative of some population segment

Bond strength The force required to separate fused materials

Bottleneck Constraint to throughput that limits the volume of work that can be completed in a work day

Bottom line The figure that reflects profit or loss on an income statement

Bound seam (BS) Formed by a narrow strip of fabric encompassing the cut edge of one or more plies

Brand name A word, term, or logo used for identification

Breakdown A complete sequential list of operations involved in assembling a garment component or style

Bridge price The price line between better and designer; merchandise incorporates some features of couture goods at lower price points; sold in designer departments in department stores and in designer named specialty stores

Buck press Pressing machines with two opposing flat or contour surfaces that shape garments with pressure, heat, and steam; commonly used by manufacturers of slacks, skirts, jackets, and most dry cleaning plants

Budget Financial plans for allocation of resources to achieve financial and operational goals; based on sales goals, cost containment goals, and profit objectives

Budget price Below-average prices for product category; promotion to the consumer often based on value; widely distributed by mass merchandisers and discount stores

Buffer A planned backlog of work that is available for processing for each operation

Capacity Output of materials, product parts, or finished goods in a specified period of time at the expected quality level

Capital-intensive Production process requiring more capital investment than labor

Casing Fabric or thread enclosure that conceals and/or prevents body contact with elastic or other materials

Casting The metal form that determines the exterior shape of a sewing machine; a method of forming button blanks

Chain stitch See Single-thread or Multithread chain stitch

Chapter 9802 (Item 807) Provision in the Harmonized System of Tariffs that allows products to be partially made in the United States, exported for further manufacturing processes, and imported with tariff assessment based on value added

Closure Device that allows a garment to open and close

Certification programs A statement of compliance to specifications

Code of conduct Company policy that defines the firm's expectations for policies and behavior of employees and contractors on human rights issues

Compensation Payment for time and service provided to the firm; wages or salary and fringe benefits

Computer-aided design (CAD) Software that assists with pattern development and marker making

Computer-integrated manufacturing (CIM) Links the strategic business plan with marketing, merchandising, materials management, production planning, and production management; apparel computer-integrated manufacturing (A-CIM)

Conglomerate Firms involved in unrelated markets joined under common ownership

Consistency Produces the same results when processes are repeated

Constraint operation Determines throughput time and limits capacity

Contract terms Point of negotiation between buyer and seller; quantity or seasonal discounts, payment terms, cash discounts, or dating

Contractor Firm that provides sewing or specialty services

Contribution Amount of revenue left over to cover overhead and profits after variable costs have been deducted from sales revenue

Contribution margin Difference between sales revenue and variable costs

Converter Buys greige goods from mills, contracts the dyeing, printing, and/or finishing, and sells finished goods

Cooperative A business enterprise, jointly owned by a group of persons or businesses, and operated without profit for the benefit of the owners

Coordinates Jackets, blouses, slacks, and skirts designed to be produced, sold, and worn with other items in the group

Copyright Legal protection of the rights of an artist or author to a specific work

Core customers People identified as central to the target market

Corporation A company that is legally chartered to act as an individual; the capital of a corporation is divided into shares that are owned by stockholders

Cost The value given up in order to receive goods or services; the total dollar amount invested in a product

Cost estimating Costing during preadoption product development that is used as a basis for line adoption and price setting

Cost-insurance-freight (CIF) Terms that mean the manufacturer pays all costs of delivery; the buyer does not assume responsibility for the merchandise until it reaches the store, warehouse, or distribution center

Cost variance Difference between budgeted costs and actual costs

Costing Process of determining the costs of producing each style in a product line

Count Numerical designation of yarn size (cotton count); the number of warp and filling yarns in a square inch of woven fabric

Counterfeit An imitation of what is genuine with the intent to defraud the customer

Counterfeiting The act of making an imitation of an original with the intent to defraud

Countervailing duty A special tax that increases the price of goods to a competitive level

Country of origin Where a garment has its last major conversion

Cover stitch Stitch formation that has surface thread that covers a raw edge or seam

Creative design Primarily preadoption product development processes involving development of line concepts, creation of new designs, and presentation of merchandise groups for line adoption; focuses on analysis, creation, and the formation of salable merchandisable groups

Cut order planning Process that coordinates preproduction processes of marker making, spreading, and cutting with production planning and sales

Cut-make-trim (CMT) Sewing contractors that supply operators, machines, and thread to make garments

Cycle time Time required for production or reorder cycle; length of time to complete one operation

Decorative trim Selected and applied to enhance the aesthetic appeal of a garment; not essential to garment function and performance

Defect Variations from specifications, allowed minimums, or tolerances

Defectives Products evaluated as seconds, thirds, irregulars, or scraps depending on the number and types of defects

Design A specific or unique version of a style; the innovation aspect of product development

Design specifications Specifications developed during the preadoption phase of product development; provide guidelines for the first pattern maker and sample sewer; provide information for line adoption presentation; basis of style specifications

Designer price range The highest relative price for a product category; made possible because of use of exclusive materials, design creativity, personalized

fit, and limited production runs; sold in exclusive department store boutiques and specialty stores

Detailed costing Extensive cost estimates based on postadoption style samples

Die Cutting device in the shape of pieces to be cut; mold for shaping materials or components

Differential shrinkage Uneven amounts of shrinkage among materials in a garment or component of a garment

Differentiation See Product differentiation

Digital printing A computerized process of applying individual drops of ink onto a substrate in a precisely controlled manner using an ink-jet printer; resolution is determined by the number of drops or pixels per inch

Direct costing A process of determining production costs considering only variable manufacturing costs

Direct costs Costs incurred by increasing the value of a product

Direct embroidery Decorative stitching applied to materials, garment components, and finished garments

Direct labor First-line supervisors and factory employees who make the products

Discount price Retail price that offers good value, usually on budget merchandise, by controlling overhead and selling costs; price that has been reduced

Distressed merchandise Merchandise not salable at the intended first price; seconds, overruns, samples, last season's goods, retailer returns, and so forth

Distribution center A merchandisehandling facility **Diversification** Marketing strategy based on new products for new markets

Dumping Illegal practice of selling goods in a foreign country below the domestic price of the goods

Dynamic effort Requires body movement, muscle contraction (both relate to muscle) and relaxation; increases circulation and reduces the load on the heart

Edge finish (EF) Stitching that provides a finish for a single ply of fabric; it may retain a folded edge or encompass a cut edge

Edging Trim used to accentuate style lines, outline shapes, or compartmentalize blocks of color; piping, lace, ribbon, fringe, tape, picot trim, and so forth

Electronic data interchange (EDI) Computerized, two-way exchange of information to facilitate ordering, manufacturing, or distribution of goods

Element One of many sequential steps in an operation or a cycle

Embargo Stops trade until issues can be negotiated

Emblem Cut-out embroidered design with finished edges; patch, appliqué, insignia, or badge

Embroidery An art form that uses close or overlapping stitches to form intricate, three-dimensional surface designs to embellish piece goods, trims, or garments

Employee empowerment A management strategy that transfers authority and responsibility for completing a task from management to an individual or a team; distinguishes modular production from traditional production systems

Engineered work station The equipment and work aids, arranged in the most efficient manner, needed to perform a designated work assignment

Engineering specifications Detailed description of equipment, workstation layout, method, handling, and quality for performing each operation in a garment breakdown

Ergonomics Study of the interaction of workers and their work environment

Extrinsic cues to quality Indicators of quality originating from outside the product; not inherent parts of a product; prices, brand names, reputations of retailers, visual merchandising techniques, and advertising

Fabric broker Facilitates the transfer of ownership from the manufacturer of the primary product to the manufacturers of the secondary product but does not take ownership of the goods

Fabric grading Determining quality of fabric by identifying the size or length of defects and the number of defects in a lot

Fabric jobber Buys fabric in comparatively small quantities from mills, converters, and apparel manufacturers for resale

Fabric utilization The percentage of fabric actually used in garment pieces; remainder is waste

Fabric weight Ounces per linear or square yard; yards to the pound

Fabric wholesaler Assembles a broad assortment of fabrics and/or findings and sells to small apparel manufacturers and/or over-the-counter retailers

Fabrication The method used to produce the material; woven, knitted, molded, cast, and so forth

Factory overhead Variable and nonvariable manufacturing costs that cannot be traced to specific units of production

Fancies Special or fashion fabrics; structural design fabrics such as brocade and pique

Fashion "A continuing process of change in the styles of dress that are accepted and followed by a large segment of the public at any particular time" (Jarnow, Guerreiro, and Judelle, 1981, p. 419)

Fashion business Term commonly applied to apparel business because of intensive product change

Fashion change Changes in color, styling, fabrication, silhouettes, and performance to reflect fashion trends

Fashion goods Products that experience demand for frequent changes in styling

Fastener A device that holds a placket closed

Federal Military Standards 105E (MIL-STD-105E) Guide for statistical quality control and acceptance sampling; used for quality audits by the federal government

Feed mechanism Device that controls the direction of fabric movement and the amount of fabric movement for each stitch; includes continuous feeds, differential feeds, intermittent feeds, top feeds, bottom feeds, and simultaneous feeds

Feeding combination Materialhandling components of a machine; consists of the throat plate, the feed mechanism, and presser foot

Fiber web Fabric produced by bonding and/or interlocking fibers; nonwoven

Final assembly Processes used to combine garment components and complete the garment structure

Final pressing Finishing operation that shapes garments and removes wrinkles; pressing after garment is no longer in the production line; off-pressing

Findings Materials used in garments other than piece goods; trims, threads, closures, labels, and so forth

Finishing Processes required to give a garment its final appearance; thread trimming, wet processing, garment dyeing, and final pressing

Firm An association of people who are organized to carry on business activities

First pattern Original paper pattern created from the designer's sketch, draft, or drape, and specifications

Fit How a garment conforms to or differs from a body

Fit model Person of sample size used to test garment fit and comfort

Fit standards Determined by a firm's sizing system and grade rules

Flat seam (FS) Two pieces of fabric abutted together and stitched, usually with a 606 or 607 cover stitch

Flat trim Decoration applied to the surface of shell fabrics or garment components; braid, twill tapes, ribbons, knit tubings, narrow weaves, warp knit bands, embroidery, appliqué, and heat transfer and screen printing

Flaw See Defect

Flexible manufacturing The capability to quickly and efficiently produce a variety of styles at low volume for each style with zero defects

Floor ready Goods can go directly from production floor to the retail sales floor;

manufacturers install the retailer's hangers and tickets

Form press Equipment used primarily for the final pressing operation in garment production or by dry cleaners; the garment is shaped with a surge of steam while a form fills the space inside the garment

Forward vertical integration A firm merges with one of its customers

Franchise A contractual arrangement that allows two parties to conduct a given form of business under an established name and according to a given pattern

Fringe benefit Usually included in compensation for full-time employees; medical, dental, sick leave, vacation, and so forth

Fringe customer Peripheral portion of the target market that may add to sales potential

Functional trim Integral part of garment structure and use; aesthetic contributions are optional; knit collars and cuffs, buttons, stripe elastics, and so forth

Fusible interlining Support material with adhesive coating for bonding

Fusing The process of bonding fabric layers with an adhesive by the application of heat and pressure for a specific amount of time

Garment analysis Establish priorities among aesthetics, performance, price, and value; match customer preferences to garment characteristics

Garment components Garment parts that require one or more separate pieces to be assembled as a unit; the basic sections of garments; includes top fronts, top backs, bottom fronts, bottom backs, sleeves, collars/neckline treatments,

cuffs/sleeve treatments, plackets, pockets, waistline treatments, and hems

Garment dyeing Garments produced and stored in greige goods state and dyed to order

Garment finishing Final stages of production; trimming, wet processing, garment dyeing, postcuring, final pressing, ticketing, folding, and packaging

Garment presentation Merchandising techniques used to make products appeal to retail buyers and/or ultimate consumers

Gauge Distance between needles; related to number of wales per inch on knitted fabric; distance between stitching lines made by multineedle sewing machines

General Agreement on Tariffs and Trade (GATT) Multinational trade agreement whose fundamental purposes were to promote free trade and equalize trade among countries

General-purpose machine Manually operated sewing machine that can perform a variety of operations

Generic goods Goods not identified by brand name or trademark

Global marketing Activities that accelerate the movement of goods from producer to consumers around the world

Global sourcing Determining the most cost-efficient vendor of materials, production, and/or finished goods at the specified quality and service level anywhere in the world

Government subsidy Government payment to a business to defray business costs

Grade Indicator of quality; increase or decrease in a single size of a pattern

Grading See Pattern grading

Grain line Marking on a pattern piece used for alignment with warp yarns or wale lines in piece goods and positioning patterns in markers

Gross margin See Gross profit margin

Gross margin return on inventory Gross margin divided by average inventory

Gross profit margin The difference between cost of goods sold and net sales

Hanger/shelf appeal Attractiveness of products to consumers in retail stores

Hang tag Item for retail display not permanently attached to garment; convey brand name(s), trade mark(s), and product information to customers

Hard goods Products made of rigid materials, such as household appliances and furniture

Harmonized Commodity Code International system for assessing tariffs on imports and exports based on the metric system; replaced Tariff Schedules of the United States in 1989

Harmonized System (HS) Name commonly used for Harmonized Commodity Code

Heat transfer print Image is transferred from preprinted paper to a substrate by application of heat and pressure

Hook Lower-loop-forming mechanism on lock stitch sewing machines; catches the needle thread loop as it passes around the bobbin and interlocks the two threads to form a lock stitch; type of closure unit

Horizontal integration Merger with a competitor; a firm offering products or services for the same market

Hourly wage Payment for a unit of time worked

In-process pressing Used to crease, shape, and/or smooth garment components for more accurate stitching during assembly

Incentive pay Compensation plan designed to motivate workers, increase productivity, and/or quality of output

Income statement A summary of revenue and expenses for a specific period of time; sometimes called a profit-and-loss statement

Indirect costs Manufacturing costs not associated with specific units of production

Indirect labor Workers in the manufacturing area who do not work directly on the product but are essential to production process; repair and maintenance technicians, materials handlers, and security people

Infringement The reproduction or use of intellectual property to mislead the public into believing the items were produced by the owner of the intellectual property that might include copyrights, trademarks, patents, trade secrets, and semiconductor chips

Inspection Process of examining materials, garment components, or finished garments to determine acceptability against standards

Intellectual property Inventions or other discoveries that have been registered with government authorities for the sale and use by their owner

Intellectual property rights Legal protection for exclusive use by owners of copyrights, trademarks, patents, trade secrets, and semiconductor chips

Interfacing See Interlining

Interlining Materials that are fused or sewn to specific areas inside garments or garment components; provides shape, support, stabilization, reinforcement, hand, and improved performance

International marketing Selling of domestically produced goods in foreign markets

International sourcing Determining sources of materials, apparel production, or finished garments to import for domestic markets

International trade Exchange of goods between nations

International trade regulation

Barriers and limits on types and quantities of goods that can cross political boundaries

Intrinsic cues to quality The innate and essential parts or inherent nature of a garment

Intrinsic quality Product characteristics created during product manufacturing; dependent on styling, fit, materials, assembly methods, and finishing

Inventory All the items that have been purchased for conversion and sell through that are in the system at any given time; includes materials waiting to be processed, work in process, and finished goods

Item 807 See Chapter 9802

Knockoff Adaptation or modification of a style from another firm's line; usually offered for sale at a lower price than the original

Labels Permanently attached printed or woven items presenting brand names and/or trademarks and legally required information Labor-intensive Production process requiring more labor investment than capital

Lapped seam Two or more pieces of fabric joined by overlapping at the needle

Laser cutting Focusing a powerful beam of light on a minute area to cut fabric by vaporization

Latent defect Flaw in performance, such as color loss or shrinkage, that appears after the product has been subjected to processes such as steaming, wet processing, pressing, and/or home laundry

Lay See Spread

Lead time The amount of time between placing an order and merchandise delivery

Learning curve A scale on which proficiency in completing a task is related to the frequency of completing a task

Licensee Buyer of the right to use an intellectual property

Licensing A means of legally using intellectual property that belongs to someone else

Licensing agreement A contract in which the licensee agrees to pay the licenser a royalty or fee for the use of an intellectual property

Licenser Owner of a licensed intellectual property

Limiting fit points Rigid garment components that do not readily expand or contract to accommodate different body shapes and dimensions; examples include collar length, shoulder width, waistband length, and hip circumference

Line See Product line

Line development The process of determining the styles, fabrications, colors, and sizes to be offered for sale; putting real merchandise in the line plan

Line plan summary The framework for developing a line for a particular selling period includes parameters for line development, sourcing, product development, and line presentation

Line planning Combination of budget and assortment plans based on sales history, goals, and forecasts; framework for line development

Line presentation Processes required to evaluate the line and make the line visible and salable

Line preview Date when a season's line is presented to the sales staff by the merchandising and marketing divisions

Line release Date when a new line is first shown to retail buyers

Lining Materials that increase aesthetics and performance by supporting and/or enclosing the interiors of garments or garment components

List price An estimate made by the manufacturer of the value of a product to the ultimate consumer; provides the basis of trade discount

Lock stitch Stitch formed with top and bottom threads interlocking within the fabric(s); stitches are formed the same on face and back

Looper Stitch-forming mechanism that controls lower thread(s) of chain-stitch, overedge, and cover-stitch machines

Lot A unit of production; a group of units or packages; used for identification, statistical sampling, or shipment; may be used in reference to materials, garment parts, or finished goods

Low-end price The lowest relative price for a product category; made possible because of cost-cutting measures in merchandising, production, and marketing; distributed by flea markets, outlets, street vendors and some discount stores

Made- (make-) to-measure Garments made to an individual's size specifications; new technology that determines body size by scanning and converts size specifications into a pattern

Made- (make-) to-order Produced after products were ordered by a buyer

Made- (make-) to-specifications Manufactured according to criteria provided by the buyer

Made- (make) to-stock Produced before orders are received; orders draw on inventory on hand

Manufacturer's identification number (RN number) Number assigned by the Federal Trade Commission to identify a product's producer

Manufacturing cycle Includes product development, production, and distribution of a product; involves mills, manufacturers, and retailers

Marker Diagram or arrangement of the pattern pieces for style(s) and size(s) that are to be cut at one time

Marker efficiency Percentage of fabric utilization

Marker making Process of arranging pattern pieces in a most economical manner for cutting

Marker mode Orientation of pattern pieces within a marker: nap-either-way (N/E/W), nap-one-way (N/O/W), or nap-up-and-down (N/U/D)

Market The sales potential for a particular type of goods; the process of getting buyers and sellers together to exchange ownership of goods

Market calendar Key dates in the wholesale marketing of a fashion/seasonal

product line including line preview, line release, start to ship, season ship complete; provides the basis for the timing of all other schedules

Market development Seeks greater sales of present products from new markets or develop new uses for present products

Market penetration Expand sales of present products in present markets through more effective advertising, promotion, and or customer service

Market positioning Identifying the strategic role of a firm relative to target markets and the competition

Market power The ability of a firm to control price and quantity of products in a market

Market segmentation Identification of a homogeneous submarket that will respond to a unique marketing strategy

Market share A firm's percentage of total sales in a market

Marketing Activities that accelerate the movement of goods from producer to consumer

Market(ing) strategy A plan that identifies the means for products to meet objectives set by management

Marking Process of transferring marks from patterns to garment pieces to assist operators with assembly

Mass customization The integration of information technology, automation, and team-based flexible manufacturing to produce a wide variety of products and services based on individual customer demand

Mass market Usually includes the middle income class and part of the lower-and upper-income classes

Master pattern See Basic block

Materials Piece goods and findings; includes fabrics, trim, closures, and other products required for producing garments

Mechanization Performing operations with the assistance of machines

Megabrands Using well-known brand name on the product it is known for as well as compatible merchandise

Merchandising The planning, development, and presentation of product line(s) for identified target market(s) with regard to prices, assortments, styling, and timing

Merchandising calendar Plan of activities required for the planning, development, and presentation of a product line within an identified time frame

Merchandising cycle One-week period from the first week of February to the last week of January

Merchandising division Central coordinating point for development, design, execution, and delivery of apparel product lines

Merchandising properties Labels, symbols, brand names, trademarks, and so forth, that have market value

Merger The acquisition of one firm's assets by another firm

Method How an operation should be performed; description of equipment, arrangement of the workstation, position of the worker, and the motion sequences to be performed in completing the procedure

Method analysis Each operation is broken down into elements or sequences of motions that are required for execution

Mill A company that owns textile machinery and makes yarn and/or woven, knitted, or fiber web materials

Minimum See Order minimum

Mission statement The purpose of a firm relative to service, organization, and profit; the central concept of the firm

Model stock Determines the number of styles, sizes, and colors that will be included in an assortment

Moderate price Goods sold at average prices for a product category; widely distributed in department and specialty chain stores

Modular Production System Strategy based on teamwork and shared responsibility for quantity and quality of output; a form of line production; a contained, manageable work unit (module) that includes an empowered work team, equipment, and work to be executed

Multipiece style Two pieces of merchandise with the same style number and sold for one price

Multithread chain stitch Needle thread passed through the material and interlooped on the underside with looper thread

Multi-Fiber Arrangement (M-FA)
International trade agreement that allows
textile and apparel trade to be regulated
through bilateral agreements between
nations

Multiple-segment strategies Directing appeal to more than one target market segment

Niche marketing Narrowly defined, very specialized market segment

Normal operator One who is qualified, experienced, and working under ordinary conditions at a work station; concept used to develop production standards; 100 percent operator

North American Industry Classification System (NAICS) A hierarchical system that uses a six digit code for defining industries; replaced the U.S. Standard Industrial Classification (SIC) in 1997

Number See Style number Off-pressing See Final pressing

Off-price Practice of selling goods at less than regular retail price

Off-shore production Manufacture of products outside North America

Open stock Product lines produced and made available for immediate delivery to any buyer

Operation One cycle or step in a production sequence; one of the processes that must be completed in converting materials into a finished garment

Operation breakdown See Breakdown

Operator reporting Work measurement system in which each operator reports the amount of work completed in a specified period

Order minimum The smallest quantity a vendor will sell

Ornamental stitching (OS) Stitching on a single ply for decorative purposes

Over-the-counter Fabric sold at wholesale and retail for the home sewing market

Overhead Variable and nonvariable manufacturing costs that cannot be traced to specific units of production

Overedge stitch Thread encompasses the cut edge of the fabric piece; machine trims fabric as overedge stitches are formed

Partnering Negotiated agreements relative to aspects of business relationships that benefit both parties

Partnership A contractual agreement between two or more people who agree to share, not necessarily equally, in the profits and losses of the organization

Patent Legal protection of the rights to an invention

Patent defect Visible irregularity such as a hole, streak, slub, or stain that is created as the fabric is made; identifiable flaw in garment assembly

Pattern grading The process of increasing or decreasing the dimensions of a pattern at specific points according to certain grade rules of proportional change

Perceived quality Composite of intrinsic and extrinsic cues to quality

Perceptual map Two-dimensional diagram of relationships among concepts

Performance The ability of products and people to meet the needs and goals of individuals and organizations

Performance rating Assessment of work pace; technique for adjusting observed time values to those that are considered normal

Performance standards Consumer expectations for product performance as interpreted by apparel firms; expectations for productivity

Piece rate Payment for units produced

Piece goods Fabrics that are cut and assembled into garments; includes shell fabrics, linings, and interlinings

Plant An establishment that manufactures, packages, and/or distributes items or services

Plant layout The spatial arrangement and configuration of departments, workstations, and equipment used for the conversion of materials into finished goods **Plant loading** Allocation of work to work centers or production lines to meet production schedules

Plotting Process of drawing or printing patterns or markers on paper so they can be used for cutting

Ply Single strand of yarn; single layer of fabric

Positioning A marketing strategy that matches the benefits provided by a particular product or service to the needs and wants of a specific target market

Precosting Rough estimates of costs developed during preadoption product development before samples are made

Predetermined motion-time system
Form of work measurement based on
historical data for hundreds of replications
of basic motions; time values are based on
normal time; produces the most consistent
production standards and the most indepth examination of motion

Preliminary costing See Precosting

Price The dollar amount asked or received in exchange for a product

Price classifications Categories including low end, budget, moderate, better, and designer

Price lining Grouping several items of varying costs together and selling them all at the same price

Pricing The process of determining the amount that will be asked for goods or services

Primary source Mills and converters that produce and finish fabric

Private label A brand owned by a retailer

Privately owned Firms with assets owned by a few individuals who completely control the firm

Producer goods Products and materials that are used in the production of other goods

Producibility Difficulty of forming finished goods from materials considering labor skills, materials handling, equipment availability, and costs

Product development Design and engineering required for products to be serviceable, producible, salable, and profitable

Product differentiation Making a product unique and identifiable in the mind of the consumer through the use of styling, materials, brand names, fit, performance, and/or image

Product line A grouping of related merchandise designed for a specific target market

Product specifications See **Specifications**

Production Processes required to convert materials (input) into completed products (output)

Production capacity The productive capability (output) of a plant, machine, or work center in a given period of time

Production pattern Perfect, final patterns that meet all quality and production requirements including seam allowances and markings

Production planning An integrative process of coordinating plant resources with the demand for finished goods

Production samples Garments made for evaluation of production processes, quality, cost, and performance

Production standard The normal time required to complete one operation or cycle using a specified method that will produce the expected quality

Production system An integration of materials handling, production processes, personnel, and equipment that directs work flow and generates finished products

Productivity The ratio of outputs of a production process to the inputs that are used; a measure of performance toward an established goal

Profit Excess of revenue over costs

Progressive bundle system Groups of garment parts routed in sequential order to specified workstations; may use line or skill center layout

Proprietorship A business owned by one person that has rights to all profits as well as all liabilities and losses

Publicly owned Firms that have shares traded on a stock exchange; required by law to reveal annual reports of business activities

Pull-through Customer-driven market system

Push-through Manufacturer-driven market system

Quality Essential character of something; superiority, degree, or grade of excellence; perceived level of value; conformance to standards

Quality assurance Total quality management philosophy combined with appropriate quality evaluation systems

Quality audit Inspection of a selected sample of goods; used to determine the defect level of the output of a particular plant; prevents defective goods from entering the distribution system

Quality control (QC) Effort applied to assure that end products/services meet the intended requirements and achieve customers' satisfaction **Quality features** Essential characteristics that are perceived as contributing to quality

Quality specifications Describes and illustrates the final appearance expected for each style and each operation; includes stitch and seam types, spi, equipment requirements and critical dimensions, and tolerances for placement and alignment of stitching, seams, trims, and parts for each operation; developed by apparel engineers and technical designers

Quality standards Minimum specifications and tolerances for materials, production processes, and finished goods; basis of product development and production decisions and quality control

Quick Response (QR) A comprehensive business strategy incorporating time-based competition, agility, and partnering to optimize the supply system, the distribution system, and service to customers

Quota Regulates quantities of goods that can be traded internationally

Real time Actual time; data are collected at the source and provide immediate accessible information

Registered trademark Name or symbol used for identification followed by R with a circle around it ($^{\textcircled{\$}}$) indicating registration of intellectual property with the Patent and Trademark Office

Related separates Conceived, displayed, and sold like separates but coordination potential is built in with color, style, and fabrication

Reorder cycle Time between placement of an order and receipt of merchandise previously stocked Return on investment (ROI) The amount earned in direct proportion to amount invested

RN number See Manufacturer's identification number

Robotics The most advanced form of automation; operations performed by computerized, reprogrammable, multifunctional manipulators of materials, parts, tools, or specialized devices

Rotary knife Round blade that cuts with a downward stroke at the leading edge

Routing The basic operations, sequence of production, and the work centers where operations are performed; the path a style follows during conversion

Royalty Compensation for the use of a property; often based on a percentage of sales

Ruboff Line-for-line copy of a style Safety stock Quantity of materials required to cover production until the next order can be received

Sales forecast Expected sales of a good or service to a target market for an identified time period

Sales projections Estimates of future sales based on past sales

Scheduling Process of assigning start times and completion times to jobs

Schiffli embroidery Decorative stitching applied to lengths of piece goods with large, loomlike machines; used to decorate fabric and produce emblems and lace trims

Screen printing Process of applying a dye or pigment paste through a mesh stencil to produce a surface design

Seam A series of stitches used to join two or more pieces of material together

Seam class One of four types of seams identified by ASTM D6193

Seam width Combination of the width of a seam allowance and the width of a line of stitches relative to the seam

Seasonal change Demand for change in styling and/or materials related to the calendar year; weather changes, seasonal events, and cultural tradition

Seasonal goods Products that have materials or styling changes related to the time of the year

Secondary source A firm involved in resale of materials including jobbers, brokers, wholesalers, retail stores, and apparel manufacturers

Sell-through Sale of a product all the way through the market channel to the ultimate consumer

Selling period Time during which a particular product line is salable

Sewing thread See Thread

Separates Product line made up of blouses, skirts, slacks, and so on, whereby each category is marketed individually

Shading Process of measuring or identifying a range of color that "matches"

Shell fabric Outer fabric of a garment

Simulation A problem-solving tool that enables modeling of a real object or a real process; usually allows testing of "what if" scenarios

Single-thread chain stitch Needle thread passes through material and interlooped on the underside with previous stitch

Size Indicator of physical measurements of a garment or actual physical measurements of a garment

Sizing standards Basic dimensions and proportions of garments specified by a firm

Sizing system A range of sizes based on gradation of dimensions for a body type

Skill center Equipment grouped together according to operation and/or type of function to be performed; provides flexibility and allows variety in styling without major adjustments or changes in plant layout

Sleeve header Support material attached to the upper portion of a sleeve seam; provides a smooth hang over the arm

Sloper See Basic block

Soft goods Products made of textiles and/or other flexible materials; apparel, piece goods, linens, towels, and small fashion accessories

Source Resource; vendor; supplier

Sourcing Determining the most costefficient vendor of materials, production, and/or finished goods at the specified quality and service level

Special-purpose machines Designed to perform a specific operation; frequently semiautomatic or automatic

Specialty contractor Job shops that provide services such as grading patterns, cutting, embroidering, making belts, pleating fabric, and screen printing

Specifications Brief, written descriptions of materials, procedures, dimensions, and performance for a particular style; properties and characteristics desired for a particular product

Spread Superimposed layers of fabric for cutting

Spreader Machine used to create a spread

Spreading Process of superimposing predetermined lengths of fabric on a spreading table, cutting table, or specially designed surface in preparation for cutting

Spreading mode Manner in which fabric plies are laid out for cutting; may be face-to-face (F/F), all plies facing one way (F/O/W), nap-up-and-down (N/U/D/), or nap-one-way (NOW)

Standard A set of characteristics or procedures that provide a basis for resource and production decisions; industry or individual firm's guidelines for quality and performance; the quality level and quality characteristics that are important to a firm's target customers

Standard allowed hours (SAH) Converted from SAM; often used when costing in dozens instead of units

Standard allowed minutes (SAM)
Unit of measure for determining the time required for an operation; costing; basis of production standards

Standard data Work measurement based on a firm's own repetitive operations, equipment, and specific product line; used the same as predetermined motion-time data

Standard Industrial Classification (SIC) A numerical system used by the U.S. Bureau of the Census to classify markets for systematic collection and analysis of data relative to business activity

Staple fabrics Fabrics made continuously, year after year, with little or no change in construction or finish

Staple goods Products that have little change in demand relative to the time of the year

Static effort Requires a sustained position that puts stress on body parts; impedes circulation and does not allow muscle recovery

Statistical quality control (SQC)
Inspection of a specified sample of goods based on the probability that the proportion and type of defects found in the sample are representative of the proportion and type of defects in the total production run

Stationary cutter Cutting machines or blades that remain in a fixed position; band knives and die cutters

Steam tunnel Automated steamer in which garments are placed on forms and automatically moved through the steam chamber

Steamer Pressing device that uses only steam to remove creases and wrinkles from a garment; types include steam jets, steam guns, steam puffs, and steam chambers

Stitch A formation of thread for the purpose of making a seam

Stitch class A type of thread formation created by a sewing machine as described in ASTM D6193

Stitch consistency The uniformity with which each stitch is formed in a row of stitches

Stitch depth The distance between the upper and lower surface of the stitch

Stitch width The horizontal span (bight) covered in the formation of one stitch or single line of stitching

Stitching A series of stitches used to finish the edge or decorative stitch on a single ply of material

Stitching class A type of stitching as identified by ASTM D 6193

Stock keeping unit (SKU) Designation of a product at the unit level for merchandise planning or inventory purposes; usually represents a combination of style, size, and color

Strategic plan Mission statement, formulation of goals, and strategies for accomplishing goals for a specified period

Structural design Aesthetic appeal that is intrinsic to the product; created during production through manipulation of fabrication, color, texture, or assembly

Style The characteristic or distinctive appearance of an item; unique piece of merchandise in a product line identified by style number

Style block Variations of individual pieces of a basic block including both comfort and design ease to create a particular design

Style number Name, letter, or number that provides identification of a style during development, production, sales, and distribution

Style specifications Detailed description of a style as developed in the postadoption phase of product development; basis of engineering specifications

Subsidy Payment by a government to defray costs of production

Superimposed seam Two or more plies of fabric, usually joined with seam allowance edges even and one ply superimposed over the second

Supplier Source; resource; vendor Support material Foundation for shape, structure, and appearance of garments including interlinings, linings, adhesives, tapes, shoulder pads, collar stays, and so forth **Target customer** A defined group a firm seeks to serve

Target market A group of customers identified through a process of market segmentation that have similar wants and needs for certain products or services

Tariff Tax on imported goods

Tariff Schedules of United States (TSUS) See Harmonized Commodity Code

Technical design Primarily postadoption product development processes required to perfect a design into a style and make the style producible at the quality level desired by the target customer; involves perfecting the style, fit, and patterns and developing detailed specifications and costs

Terms See Contract terms

Textile Fiber Products Identification Act Law that requires labels to identify the generic name of the fiber content, the manufacturer's name or number, and country of origin

Thread Special kinds of yarns that are engineered and designed to pass through a sewing machine rapidly, form stitches efficiently, and function while in a sewn product without breaking or becoming distorted for at least the useful life of the product (Pizzuto, 1980)

Thread tension The balance of force on threads that form the stitches; degree of compression on the fabric created by the threads as a stitch is formed

Throughput time The amount of time it takes for a style to go through the production process, cutting through shipping

Throughput volume The amount of work that can be completed in a specific amount of time

Tickets Attachments to a garment that provide numerical product information to manufacturers, retailers, and consumers; may be sewn in or disposable

Time-based competition Effectiveness of compression of time-lines throughout the manufacturing and distribution process to make production closer to time of sale

Time study A work measurement technique; determines the actual time required for an operation to be completed

Tolerance Allowed variation from a specified minimum value

Total quality management (TQM)
Philosophy of quality that involves
performance of all the company's divisions
as well as the products and services that
are produced by the firm

Trade association A nonprofit organization formed to serve common needs of its members

Trade balance Quantitative relationship between exports and imports; exports minus imports equals trade balance

Trade deficit Negative trade balance
Trade discount Reductions from list
price granted by a manufacturer to a firm
who performs some marketing or

distribution function

Trademark See Brand name

Trade show See Market

Trademark infringement Misleading the public into believing the items bearing the trademark/brand name are produced by the owner of the trademark

Training The process of imparting jobrelated knowledge to employees

Transshipment Shipping goods from one country to another to illegally change

the country of origin of the goods to avoid tariffs or quota limitations

Trim Materials used to ornament or enhance garments

Underpressing Pressing during garment assembly; facilitates production and increases quality level

Unit production system (UPS) An overhead transporter system that moves individual units from work station to workstation for assembly; a type of line layout that provides centralized production control

Validation cost Verifying the accuracy and appropriateness of information for new styles including product specifications, graded patterns, costing, and computer data entry

Value Suitability to end use at a price the consumer is willing to pay

Vendor Supplier of goods to be used or sold; also called *source* or *resource*

Vertical integration A merger between suppliers and users in the chain of production

Vertical knife Cutting device with straight, vertical, reciprocating blades

Volume per SKU Number of units for each unique SKU in an assortment

Volume per SKU for an assortment (VSA) Average number of units for each SKU in an assortment; total number of units divided by total number of SKUs

Wet processing A finishing process in which assembled garmonts are soaked in solutions designed to alter hand and appearance; includes washing, bleaching, dyeing, stonewashing, acid washing, and so forth; used to produce washed and distressed fashion look

Wholesale price List price less trade discounts

World Trade Organization (WTO) Currently the primary means of regulating international trade; replaced General Agreement on Tariffs and Trade in 1994

Work aids Devices designed to make performance of sewing operations more efficient; needle positioners, thread cutters and wipers, chain cutters, back tackers, and folders

Work flow The movement of materials and garment parts through conversion processes

Work in process The number of garments under production at any given time

Work measurement Means of determining the amount of time necessary to perform a specific operation; time studies, judgment or past experience of an engineer or production manager, predetermined time systems, standard data, operator reporting, and work sampling

Work sampling Work measurement method based on simple random sampling techniques derived from statistical sampling theory; analyst determines the activities involved, amount of time spent, and the number of units processed during a time period

Workstation All the equipment and work aids needed to perform a designated operation

Worth Street Textile Market Rules Industry-endorsed common and fair trade practices in the textiles business

Index

A-CIM, 381, 382 AAMSB, 39 AATC, 141, 142 ABC system, 302-304 Absorption costing, 298-301 Acceptance sampling, 151, 212–214 Accessories, 124 Activity-based costing (ABC), 302-304 Actual costs, 307 Adhesives, 467, 530, 531 Adjusted gross margin (AGM), 63 Administered prices, 319 Administrative overhead, 297 Aesthetic finishes, 250 Aesthetic purpose, 106 Aetzing, 593 Agents, 281 Agility, 22, 267 AGM, 63 Air-entanglement thread, 460 All-bias fiber webs, 518 Allowance factor, 356 Allowances, 356 American Association of Men's Sportswear Buyers (AAMSB), 39 American Association of Textile Chemists and Colorists (AATC), 141, 142

Allowances, 356

American Association of Men's Sportswear

Buyers (AAMSB), 39

American Association of Textile Chemists
and Colorists (AATC), 141, 142

American Society for Testing and
Materials (ASTM), 141

work flow, 332–337

work measurement, 3

Apparel engineers, 126

Apparel industry

functional organizati
nature of, 4–7

ANSI/ASQ Z1.4-1993, 213 Anthropometrics, 359

Anti-infringement ads, 48 Apparel analysis. See Garment analysis Apparel Computer Integrated Manufacturing (A-CIM), 381, 382 Apparel design systems, 184, 185 Apparel design technology apparel design systems, 184, 185 CAD systems, 183-185 fabric design systems, 183, 184 MTM systems, 186, 187 pattern making/grading/marker making, 185 specification programs, 185, 186 Apparel engineering, 331-364 ergonomics, 358-362 job design, 360, 361 materials handling, 335-337 method analysis, 351-353 plant layout, 333-335 production processes, 347-351 production systems, 337-347. See also Production systems work flow, 332-337 work measurement, 353-358

Apparel Manufacturing Protocol Suite, 382 Apparel mart, 49 Apparel product lines, 64-66 Apparel production systems. See Production systems Apparel professionals, 95, 125-133 Apparel technology centers, 381, 382 Applied design, 116, 246 Appliqués, 591, 592 Assortment, 64, 76 Assortment distribution, 77 Assortment diversity, 76 Assortment factors, 76 Assortment plans, 77–80 Assortment volume, 76 ASTM, 141 ASTM D 6193, 428, 442 ASTM performance standards, 259, 260 Asymmetric fabric, 398 Asymmetric zipper plackets, 545 Attaching units, 560, 561 Attachments, 494-496 Augmented visual inspection, 98 Automated cutting, 419 Automatic blade cutting, 419 Automatic lock sliders, 542 Automatic machines, 485 Automation, 482

Back pockets, 624
Backings, 584, 591
Backward vertical integration, 8
Baking, 532
Balance, 166, 167
Balanced assortment, 76
Balancing, 274, 332
Band knives, 414, 415
Bands, 575
Bar codes, 88
Base plate, 414

Availability hypothesis, 14

Average observed time, 355

Available capacity, 271

Base rate (BR), 311, 369 Basic block, 168 Basic block pattern, 168 Basic goods, 67, 68 Basic/seasonal goods, 70 Basic staple goods, 69 Bed, 487 Bed buck, 500, 501 Belt loop, 626 Better price classification, 7 Bid package, 179, 180 Bids, 144 Bierrebi die-cutting system, 417 Bill of materials, 307 Bindings, 574 Blade guard, 414 Blade shirrers, 496 Blanks, 550, 605 Blatt stitches, 588 Block pressing, 501 Blocked markers, 394 Blocks, 168 Boardiness, 523 Bobbin World, 386 Body, 163 Body types, 108, 109 Boilers, 504 Bond strength, 530 Bonuses, 370 Bottleneck, 271, 332, 333 Bottom back, 118 Bottom cover stitches, 438 Bottom front, 118 Bound buttonholes, 556 Bound seam, 610 Bound seam (BS) class, 453 Bow, 256 Box edge stitch, 440 Box pleats, 613 Braided elastics, 565 Braids, 575 Brand labels, 599

Brand names, 46, 47

Break-even cost, 317

Index

Break open stitches, 439	Casings, 563
Breakdown, 311	Casted buttons, 551
Bridge, 553	Casting, 487, 550
Bridge price classification, 7	Cellulosic fibers, 243
BS class, 453	Center front placket, 638
	Center of gravity, 166
Bubbling, 523	Center plaits, 639
Buck, 500	Certificate of origin, 277
Buck padding, 500	- :
Buck presses, 500	Certification, 278
Buckled interlining, 516	Chain cutters, 497
Budget price classification, 6	Chain stitch, 436, 437
Budgets, 21, 318, 319	Chain stitches, 589
Buffer, 332	Chaining plates, 490
Bump-back, 345	Chart spreading, 391
Bundle system, 337	Chenille stitches, 589
Bundle ticket, 337	CIF, 325
Business concepts, 9–13	CIM, 381
Business plan, 20, 21	Circular knit trims, 577
Button sewers, 553–555	Circular knitted fabrics, 249, 250
Buttonhole placement, 559, 560	Class 100-chain stitch, 436, 437
Buttonholes, 556-559	Class 200-hand stitch, 437
Buttons	Class 300-lock stitch, 430-436
aesthetics, 546	Class 400-multithread chain stitch, 437, 438
application, 553-555	Class 500-overedge stitch, 438-440
characteristics, 547–553	Class 600-cover stitch, 440
defined, 546	Classification of materials, 115
materials/fabrication, 548–551	Classification selling, 644
performance, 546, 547	Clemson Apparel Research, 381
size, 553	Closed construction, 120
types, 551–553	Closed specification, 147
Buyers/merchandisers, 82	Closer markers, 398
Buyers/meronanasers, e2	Closure unit, 560
CAD systems, 183–185	Closures, 115, 537–571
Camlock sliders, 542	aesthetics, 538
	buttonholes, 556–559
Capacity, 270–275	buttons, 546–556. See also Buttons
CAPS, 55	costs of, 538, 539
Caps, 559	defined, 537
Carded cotton and carded blended greige	
goods, 247, 249	elastic, 562–567. See also Elastic
Care, 117	hook-and-loop tape, 567–570
Care symbols, 50	hooks, 562
Carpal tunnel syndrome (CTS), 359	performance, 538
Cash discounts, 324	snaps, 559–562
Cash, insurance, freight (CIF), 325	zippers, 539–545. See also Zippers

Cloth plate, 487	Constraint operation, 271
Cloth pullers, 496	Constraints, 332
CMT, 279	Consumer goods, 194
Coalition to Advance the Protection of	Consumers, 9
Team Logos (CAPS), 55	Contact fasteners, 568
Cocoons, 464	Containers, 464
Code of conduct, 276–278	Continuing education, 374, 375
Coils, 540	Continuous chain zippers, 543, 544
Collar bands, 633	Continuous markers, 395
Collar fit, 632	Contract terms, 324
Collar stays, 534	Contractor compliance, 276
Collars, 118	Contractors, 8, 281
Colleges/universities, 206	Contracts, 144
Color, 246	Contribution, 296
Color application, 116	Contribution margin, 298
Color change, 523	Converters, 197, 237
Color fastness, 461	Cooperative, 10
Color managers, 126	Coordinates, 65
Color registration, 597	Cops, 463
Comfort ease, 167	Copyright, 56
Commercial testing laboratories, 210	Cording stitch, 438
Commercial testing services, 209	Core customers, 30
Committed capacity, 271	Corespun thread, 460
Commodity elastic, 563	Corporation, 10
Compatibility factors, 512, 513	Cost, 106, 293
Compensation, 368–370	Cost-based pricing strategies, 321, 322
Competitor analysis, 33, 34	Cost control, 318, 319
Components, 119	Cost estimating, 169, 305
Components assembly, 117–120	Cost of goods sold, 295
Compression-molded buttons, 551	Cost-plus pricing, 321
Computer-aided design (CAD), 183–185	Cost variance, 319
Computer-generated flats, 162	Cost/volume relationships, 313–319
Computer integrated manufacturing	Costing
(CIM), 381	ABC system, 302–304
Computer pattern grading, 185	absorption, 298–301
Computerized marker making, 185, 392	defined, 294
Concept board, 81, 161	direct, 298
Cones, 463	labor, 310-313
Configuration, 278	materials, 308–310
Confinement, 163	stages of, 304–307
Conglomerate, 13	Costing engineers, 127
Conglomerate merger, 13	Cotton count, 244
Consistency, 123, 144, 182	Cotton threads, 459
Consolidation, 278	Count, 116
	The state of the s

Index

Counter sample, 277	plasma jet cutting, 422
Counterfeit, 55	portable knives, 412–414
Counterfeiting, 54, 55	quality, 410, 411
Countervailing duty, 17	servo cutters, 416
Country of origin, 50	stationary cutters, 414–416
Courses, 566	transferring marks, 418, 419
Cover stitches, 440	water jet cutting, 421
Creative design, 72, 84, 158–173	Cutting devices, 497
copying styles, 163	Cutting orders, 391
costing/specifications, 169–171	Cutting pitch, 411
fabric, 163–166	Cye seams, 167
fit, 166, 167	
line adoption, and, 172–173	Daily News Record (DNR), 198
line concept, 160, 161	Dating, 324
modification of styles, 162, 163	de Mestral, Georges, 567
original designs, 161, 162	Decorative trims, 574
patterns/samples, 168, 169	Defect maps, 391
Creative designers, 127	Defectives, 202
Croquis, 161	Defects, 150, 202, 253
Cross-stitched buttons, 555	Degree of enclosure, 119, 120
Cross-trained, 374	Delamination, 523
Crosswise symmetry, 165	Demand-based pricing strategies, 322
Crotch seams, 628	Deming, W. Edwards, 212
CTD, 359	Demographic changes, 32
Cuff attachment, 643	Demonstrated capacity, 228
Cuffs, 118	Denier, 243
Cumulative trauma disorders (CTD), 359	Design, 64
Customer driver, 63	Design ease, 167
Customer service, 373	Design process, 155–190
Customs, 289	apparel design technology, 183-187
Customs broker, 282	creative design, 158-173. See also
Customs issues, 289	Creative design
Cut-make-trim (CMT), 279	influences on, 156-158
Cut order planning, 390-392	technical design, 173-183. See also
Cut orders, 288	Technical design
Cut shoulder pads, 532	Design prototype, 168
Cutting, 410-423	Design sample, 168
automated cutting, 419	Design specification sheet, 170, 171
automatic blade cutting, 419	Design specifications, 148, 169
band knives, 414, 415	Designer price classification, 7
die cutting, 415, 416	Detailed costing, 178, 305, 307
laser cutting, 420, 421	Development package, 277
off loading, 422, 423	Die cutting, 415, 416
operator-controlled, 411–419	Die pressing, 501
·F, **** ****	

Edgings, 574, 575

Differential feeding, 492 EDI, 22, 229 Differential shrinkage, 514 Elastic, 562-567 Differentiation, 36 aesthetics, 563 Digital printing, 598, 599 application, 566, 567 Digitizers, 585-588 fabrication, 565, 566 Direct applications, 530 materials, 564, 565 Direct costing, 298 performance, 563, 564 Direct embroidery, 579 Elastic demand, 320 Direct exporting, 43 Elasticity of demand, 320 Direct labor, 367, 370 Elastomers, 564 Direct labor costs, 296 Electronic communication systems, 229 Direct materials costs, 296 Electronic data interchange (EDI), 22, 229 Direct stabilization, 530 Electronic sketching systems, 184 Directional fabrics, 398 Element, 348 Discounts and allowances, 323-325 Elemental description, 349 Displacement pucker, 472 Embargo, 15 Display devices, 125 Emblems, 583 Distortion, 474 Embroidery, 578-591 Distressed merchandise, 38 costs, 589, 590 Distribution centers, 373 digitizing/punching designs, 585-588 Diversification, 33 direct, 579 DNR, 198 emblems, 583 Domestic sourcing, 280, 281 machines, 579-582 Double-locked chain stitch, 438 materials, 583-585 Double sampling plan, 213 quality factors, 590, 591 Down time, 384 stitches, 588, 589 Downward sloping demand curves, 320 trapunto, 589 Drafting, 168 Embroidery machines, 579-582 Drape, 162 Embroidery stitches, 585, 589 Drapeability, 116, 245 Employee empowerment, 342 Draping, 168 Enclosed elastic, 567 Dress pants. See Men's dress pants Enclosed zippers, 545 Dress shirts. See Men's dress shirts End catcher, 407 Dumping, 15 End loss, 409 Durable finishes, 250 End treatment devices, 407 Dwell time, 521 Engineered workstations, 486 Dyes, 246 Engineering. See Apparel engineering Dynamic efforts, 360 Engineering specifications, 148, 348 Equipment acquisition, 384-386 Ease, 167 Equipment design/use, 361, 362 Edge finishing, 453 Equipment for assembly and pressing, Edge marks, 418 481-507 Edge stitching, 440 engineered workstations, 486

general-purpose machines, 482-484

Fabric face, 165

Fabric flaws, 255 pressing equipment, 498-505 Fabric grading, 257-259 sewing machines, 487-494 Fabric inspection system, 252 special-purpose machines, 484-486 Fabric jobbers, 198 work aids, 494-498 Fabric problems, 253-257 Equipment management, 379-386 apparel technology centers, 381, 382 Fabric production and marketing, 197, 198 Fabric put-up, 239 efficiency, and, 384 Fabric research and development equipment acquisition, 384-386 directors, 128 job skills, 383, 384 Fabric samples, 234, 235 product-related issues, 382, 383 Fabric selection, 234-250 simulation, 380, 381 color, 246 Ergonomics, 358-362 fabric put-up, 239 Ergonomist, 358 fabric weight, 244, 245 Even dollar pricing, 323 fabrications, 246-250 Excess capacity, 272 fiber content, 241-243 Excess labor cost, 311 finishes, 250 Exclusive license, 158 hand/drapeability, 245 Executive leadership, 19–21 lead times, 235-238 Expediting, 274 materials testing, 239, 240 Experience curve, 275 order minimums, 238, 239 Exploitation, 17, 18 prices/price adjustments/costs, 240 Exposed elastic, 566 product identification, 234, 235 Exposed zippers, 544 structural/applied design, 246 Extrinsic cues, 6, 107 supplier credibility, 240, 241 Eyelet, 561 yarn quality and size, 243, 244 Fabric specifications, 235 F/F, 400 Fabric utilization, 396 F/O/W, 400 Fabric utilization standards, 397 Fabric, 163-166 Fabric waste, 409 Fabric brokers, 198 Fabric weight, 244, 245 Fabric buyer, 251 Fabric wholesalers, 199 Fabric certification, 235 Fabrication, 116, 246-250 Fabric control devices, 406 Face-to-face (F/F), 400 Fabric defects, 401 Facing one way (F/O/W), 400 Fabric design systems, 183, 184 Facings, 563 Fabric distortion, 474 Factory overhead, 298 Fabric evaluation, 250-261 Faggotting, 434 fabric grading, 257-259 Fancies, 197 fabric problems, 253-257 Fashion/basic continuum, 67 latent defects, 254, 257 Fashion business, 5 patent defects, 254-257 Fashion change, 5 receiving/inspecting materials, 251-253 Fashion goods, 66, 68 textile performance standards, 259-261 Fashion/seasonal goods, 70

Fashion staple goods, 69, 70 Federal Standard 751a, 428 Feed dogs, 492 Feed mechanisms, 492 Feed pucker, 471 Feeding system, 490 Fiber bats, 532 Fiber content, 241–243 Fiber optics, 496 Fiber production and marketing, 196, 197 Filament (smooth) and textured (bulked) filament and filament/spun greige goods, 248, 249 Filament threads, 459 Final assembly, 120 Final assembly and finishing, 120-124 Final pressing, 623 Finance, 25 Findings, 114, 231 Findings production and marketing, 200 Fine cotton and blended greige goods, 247. Fine fancy goods and cotton and synthetic yarn mixtures and blends, 247, 248 Finish pressing, 122, 498 Finished garment evaluation, 215 Finishes, 116, 250 Firm, 9 First pattern, 168 First quality, 150 Fit, 111, 166 Fit evaluation, 175 Fit indicators, 111, 112 Fit model, 174 Fixtures, 87 Flagging, 490 Flange lock sliders, 542 Flat-bed knitting, 577 Flat seam (FS) class, 453 Flat trims, 575 Flatness of a spread, 403 Flats, 161 Flaws, 150

Flexible manufacturing, 266

Floor ready, 22 Foam substrates, 520 FOB, 325 Folding blade, 407 Folding devices, 495 Form pressing, 501-503 Forward dating, 324 Forward vertical integration, 9 Four Point Grading System, 258 401 stitches, 438 Frames, 595 Framing, 579 Franchise, 10 Free on board (FOB), 325 Freelance designer, 157 French flv. 625 Fringe benefits, 370 Fringe customers, 30 Front bands, 639 FS class, 453 Fulcrum, 166 Full lining, 527 Full package sourcing, 279 Fullness, 112 Functional finishes, 250 Functional purpose, 106 Functional trims, 574 Fused pods, 532 Fusible interlinings, 521–523 Fusing, 521 Fusing of cut parts, 423

Gain sharing, 370
Garment analysis, 95–135
apparel professionals, and, 126–133
augmented visual inspections, 98
components assembly, 117–120
final assembly and finishing, 120–124
garment presentation, 124, 125
goals/processes/limitations, 96, 97
laboratory test, 99
materials selection, 114–117
overview (garment analysis guide),

100-105

product positioning strategy, 106-108	Grade points, 177
sizing and fit, 108–114	Grade rule, 177
visual inspection, 97, 98	Graded patterns, 177
Garment closures. See Closures	Grain orientation, 397
Garment components, 117–120	Graniteville System, 258
Garment dyeing, 122, 165	Greige goods, 194
Garment finishing, 121	Grippers, 561
Garment finishing processes, 122	Gross margin (GM), 62
Garment fit, 525	Gross margin return on inventory
Garment presentation, 124, 125	(GMROI), 63
Garment purchase agreement (GPA), 277	Gross profit margin, 295
Garment structure, 117	Group concepts, 82
GATT, 15	Growth, 11–13
Gauge, 116, 429	Guides, 495
General Agreement on Tariffs and Trade	
(GATT), 15	Hamiter, Jim, 375
General body size, 110	Hand, 245, 516
General operating expense, 297	Hand stitch, 437
General-purpose machines, 482–484	Handle, 414
Generic goods, 47	Handling, 335–337
Gimp, 557	Hang tags, 88
Glazed cotton threads, 461	Hanger/shelf appeal, 85, 124
Global issues, 13–18	Harmonized System of Tariffs (HS), 15
Global marketing, 42	Heat, 498
Global sourcing, 43	Heat transfer prints, 597
Global textile complex	Hemmers, 495
fabric production and marketing, 197,	High control, 352
198	Holding power, 564
fiber production and marketing, 196,	Holed buttons, 551
197	Hook, 490
findings production and marketing, 200	Hook-and-loop tape, 567–570
primary/secondary sources of fabrics,	Hooks, 562
198, 199	Hooping, 579
producer and consumer goods,	Horizontal integration, 13, 194
194–196	Hot notcher, 418
Worth Street Rules, 199, 200	Hourly wage system, 368
Glue line temperature, 530	House brands, 47
GM, 62	HS, 15
GMROI, 63	Human factors, 359
Goods sold for rubberizing, coating, and	Human resource management, 367–37
laminating, 248, 249	compensation, 368–370
Government specifications, 144, 145	productivity of direct labor, 370–372
Government subsidies, 17	productivity of other areas, 372, 373
Grade, 257	training and development, 373–377
01440, 201	Taming and activity and att

Illegal trade activities, 15, 17	Internet web site 45
Imaging material, 596	Internet web site, 45 Intrinsic cues, 5, 106
In-process pressing, 120, 498, 623	그런 그렇는 얼마나 내가 되었다면 그 전에 가장 하는 것이 되었다면 하는 것이 없는 것이었다면 없는 것이 없는 것이었다면 없는 것이 없는 것이 없는 것이 없는 것이 없는 것이 없는 것이었다면 없는 것이 없는 것이었다면 없는 없는 것이었다면 없는 없는 것이었다면 없는 없었다면 없는 것이었다면 없는 것이었다면 없는 것이었다면 없는 것이었다면 없는 것이었다면 없는 것이었다면 없었다면 없었다면 없는 것이었다면 없었다면 없었다면 없었다면 없었다면 없었다면 없었다면 없었다면 없
Incentive system, 369	Intrinsic quality, 5
Income statement, 294, 295	Inventory, 377
Independent quality management group,	Inventory control, 378
205	Inventory management, 377–379
Indirect exporting, 42	Inventory turns, 379 Inverted box pleats, 614
Indirect labor costs, 296	Inverted box pleats, 614 Invisible zipper, 545
Inelastic demand, 320	Invoice terms, 324
Infringement, 47	IPR, 46
Injection molding, 551	
Ink jet, 598	Iron pressing, 500
Inseams, 618, 627	Irons, 500, 501, 522
Insert elastic, 563	ISO, 138
Inside sales representatives, 40	ISO 9000, 138, 139
•	Item 807/Chapter 98, 15
Inspection, 211, 212 Inspiration board, 81, 161	T1 200
	Jacquard weaves, 600
Insulative linings, 526	Jamming, 472
Intellectual property, 45, 46, 56	Jeanswear market analysis, 35
Intellectual property rights (IPR), 46	JIT delivery, 336
Interdependency, 342	Job description, 368
Interfacings, 515. See also Interlinings	Job design, 360, 361
Interlinings	Job skills, 374
aesthetics, 515–517	Job training, 373
costs of, 522, 524	Just-in-time (JIT) delivery, 336
defined, 515	T7 - 1 - 047
fabrication, 518–520	Kanban, 345
fiber content, 517 fusible, 521–523	Kawabata Evaluation System for Fabrics
	(KES-F), 245, 246
performance, 517 sew-in, 520, 521	Keyhole buttonholes, 557
	King tubes, 463
weight, 517, 518 Internal growth, 12	Knife blades, 413
Internal marks, 418	Knit design systems, 184
	Knit elastics, 566
International Anti-Counterfeiting	Knit interlinings, 520
Coalition, 55 International Organization for	Knit trims, 577, 578
Standardization (ISO), 138	Knockoffs, 55, 56, 156, 163
International sourcing, 281–283	I abal auttin a C11
International textile industry, 195	Label setting, 611
International trade, 14	Labels, 46–51, 88, 124, 599–642
International trade assistance, 282, 283	fit, and, 112
International trade regulation, 14–16	legal requirements, 49–51 private, 47, 49
The state of the s	private, 41, 40

Labor costing, 310–313	Line preview, 41, 86
Labor costs, 218	Line release, 41, 86
Labor utilization, 372	Linings
Laboratory technicians, 128	aesthetics, 524
Laboratory testing, 208–210	application, 529
Laboratory tests, 99	comfort, 525, 526
Lace, 593, 594	costs of, 529
Landed cost, 277	defined, 524
Lapped seam (LS) class, 442	enclosure, 527
Lapped V-necks, 611	fabrication, 527
Laser cutting, 420, 421	fiber content, 526, 527
Laser enhanced bonding, 467	performance, 525
Latent defects, 254–257	structure, 528, 529
Lay, 392	weight, 527
Lay planning, 392	List price, 319
Lay-up, 399	Liz Claiborne, 278
LC, 280	Loading, 274
Lead time, 63	Lock stitch, 430-436
Lead times, 235–238	Logistics, 289
Learning curve, 275	London Fog products, 53
Leavers lace, 593	Long range, 297
Legal counsel, 282	Long-term planning, 269
Legal organization of apparel firms, 10, 11	Loop buttonholes, 556
Lengthwise symmetry, 165	Loop formation, 456
Letter of Credit, 280	Looper, 436
Licensed product, 51	Looping stitches, 589
Licensee, 51	Low control, 352
Licenser, 51	Low-end classification, 6
Licensing, 51–54, 146	Lower stitch-forming devices, 490
Licensing agreement, 51	Lower thread, 431
Licensing design/designer names, 158	LS class, 442
Life-style segmentation, 31	Lubrication systems, 488, 489
Lignes, 553	
Limiting fit points, 112	M-FA, 15
Line adoption, 72, 84, 85, 172	Made in USA, 50
Line concept, 72, 81, 160, 161	Made-to-measure fit, 630
Line development, 72, 73, 80–83	MAGIC, 39
Line development calendar, 158, 159	Make-or-buy decisions, 226-229
Line direction, 81	Make-to-measure (MTM) technology, 186,
Line layout, 333, 334	187
Line plan, 71	Make-to-order, 229, 230
Line plan summary, 73, 74	Make-to-stock, 229, 230
Line planning, 71, 72, 74–80	Make-up cost, 314
Line presentation, 72, 73, 85–88	Management, 367
•	

Management of quality. See Quality	marketing objectives, 33
management	product sell-through, 36, 37
Manually operated equipment, 483	protecting rights to merchandising
Manually produced markers, 392	properties, 55–57
Manufacturer merchandisers, 62	retail strategies, 38, 39
Manufacturer's identification number, 50	sales forecasting, 37, 38
Manufacturing costs, 296	wholesale strategies, 39, 40
Marker, 164, 177	Marketing strategy, 32
Marker efficiency, 396	Mass customization, 267
Marker making, 392–399	Mass market, 31
defined, 392	Master pattern, 168
dimensions of markers, 394, 395	Material content, 115
marker efficiency, 396, 397	Material name, 115
marker quality, 397, 398	Material utilization, 390
types of markers, 398, 399	Materials, 231
Marker mode, 398	Materials buyers/sourcers, 128, 233
Marker planning, 392	Materials cost worksheet, 308
Markers, 392, 398, 399	Materials costing, 308–310
Market, 11	Materials costs, 218
Market development, 33	Materials defects, 202
Market grade, 243	Materials handling, 335–337
Market penetration, 33	Materials selection, 114–117
Market penetration pricing, 322	Materials sourcing, 231
Market positioning, 34	Materials sourcing and selection, 225–263
Market power, 11	fabric evaluation, 250-261. See also
Market pricing, 322	Fabric evaluation
Market segment, 31	fabric selection, 234-250. See also
Market share, 11	Fabric selection
Marketing, 23, 24	make-or-buy decisions, 226-229
Marketing calendar, 40–42	make-to-stock vs. make-to-order, 229,
Marketing managers, 128	230
Marketing objectives, 33	materials sourcing processes, 231-234
Marketing strategies, 29–60	Materials specifications, 150, 178
competitor analyses, 33, 34	Materials testing, 239, 240
counterfeiting, 54, 55	Maximum capacity, 270
global marketing and sourcing, 42–45	Mechanization, 482
Internet sales, 45	Medium control, 352
labeling, 48–51	Megabrands, 46
licensing, 51–54	Men's Apparel Guild of California
market positioning/product	(MAGIC), 39
differentiation, 34–36	Men's dress pants, 613–628
market segmentation/target markets,	final assembly, 627, 628
30–32	finishing, 628
marketing calendar, 40–42	materials, 618–623

presentation, 628
product positioning strategies, 613-617
sizing/fit, 617, 618
subassembly of components, 623-627
Men's dress shirts, 629–645
better/budget shirts, compared, 631, 632
component assembly, 635-640
final assembly, 640-643
finishing, 643, 644
materials selection, 633-635
presentation, 644, 645
prices, 630
product positioning strategy, 629
sizing/fit, 630–633
style variations, 629
Mercerized cotton threads, 461
Merchandisable group, 65
Merchandise assortments, 76, 77
Merchandise budget, 75
Merchandise coordinator, 87
Merchandise plans, 77
Merchandisers, 129
Merchandising, 24, 61
Merchandising calendar, 62, 158
Merchandising cycle, 68
Merchandising license agreements, 51-54
Merchandising processes, 61–91
apparel product lines, 64–66
line development, 80–83
line planning, 74–80
line presentation, 85–88
merchandising taxonomy, 71, 72
perceptual map of product change,
66–71
product development, 83–85
Quick Response, 62, 63
sourcing materials and production, 88,
89
Merchandising properties, 45
Merchandising taxonomy, 71, 72
Mergers, 12, 13, 194
Mesh counts, 595
Metering devices, 496
Method, 348

Method analysis, 351-353 Method descriptions, 348 Method of application, 117 Methods of assembly, 117 Microprocessors, 504 MIL-STD-105D, 213 MIL-STD-105E, 213 Mill, 197 Mill flaw repair, 216 Mill level, 7 Minimum requirements, 149 Mission statement, 20 Mitered V-necks, 611 Mock safety stitches, 440 Model stock, 76 Model stock plan, 76 Moderate price classification, 7 Modernization of equipment. See Equipment management Modular production system, 341-347 Moisture pucker, 472 Molded pads, 532 Monofilament thread, 459 Motion, 352 Motion-time systems, 357 MTM systems, 186, 187 Multi-Fiber Arrangement (M-FA), 15 Multihead embroidery machines, 582 Multipiece style, 65 Multiple sampling plan, 213 Multiple-segment strategies, 31 Multithread chain stitch, 437, 438

Nap-either-way (N/E/W), 399
Nap-one-way (N/O/W), 399
Nap-up-and-down (N/U/D), 399
Natural fibers, 243
Neckline treatments, 610
Needle coolers, 469
Needle heat, 469
Needle positioners, 497
Needle-punched fiber webs, 532
Needle thread, 431
Needle thread loop formation, 457

Needles, 467–470
Niche marketing, 31
No-name products, 47
Nondirectional, 165
Nondirectional fabrics, 398
Nonlock sliders, 542
Nonseparating zippers, 543
Nonvariable overhead costs, 297
Normal operator, 354
Normal time, 356
North American Industry Classification
System (NAICS), 4

Observed time, 354
Occupational Safety and Health
Administration (OSHA), 358
Odd price ending, 323
Off loading, 422, 423
Off-pressing, 122
Off standard, 372
Omnibus Trade and Competitiveness Act,
57
On standard, 372

On standard, 372
100 percent inspection, 211
101 chain stitch, 437
103 chain stitch, 437
One-way fabric design, 164
Open construction, 120
Open marker, 398
Open specification, 147
Open-stock, 237
Operation, 348
Operation breakdown, 119, 348
Operations division, 25
Operator reporting, 357
Order backlog, 230

Order minimums, 238, 239 Orientation, 373 Orientation programs, 373

Orientation programs, 373 Original designs, 161, 162 Ornamental stitching, 453

OSHA, 358

Outerwear T-shirts, 605

Outside design studio, 157
Outside sales representatives, 40
Over-the-counter, 239
Overedge stitch, 438–440
Overhead, 296
Overhead application rate, 298
Overlap, 625
Overruns, 199
Overspecified, 149

Packaging, 125 Pant fronts, 613 Pants. See Men's dress pants Partial linings, 527 Partnering, 22 Partnership, 10 Patch pockets, 610 Patent, 56 Patent defects, 254–257 Pattern grading, 176, 177, 185 Pattern making, 185 Pattern pieces, 396 Pattern verification, 390 Patterned fabrics, 164 Patterns, 168 Payment per unit of production, 369 Payment terms, 324 PBS, 337-339 Peel strength, 568 Peel test, 530 Perceived quality, 5 Perceptual map, 66–71 Perfection of style and fit, 173-175 Performance rating, 355 Performance reports, 319 Performance standards, 141 Permanent care labels, 50 Photo/catalog samples, 177 Photoelectric sensors, 496 Piece goods, 115, 583, 618 Piece rate wage system, 369

Pigments, 246

Pinlock sliders, 542

Presser foot, 490, 491 Piping, 575 Pressing, 498 Plackets, 118, 537 Pressing equipment, 498–505 Plain stitch, 431 Pressure, 499 Plain T-shirts, 605 Prewound bobbins, 464 Planimeter, 396 Price, 6, 7, 293 Plant, 10 Price classifications, 6 Plant capacity, 271 Price discrimination, 325 Plant efficiency, 311 Price fixing, 325 Plant layout, 333-335 Price lining, 323 Plant modernization. See Equipment Price quote, 227 management Pricing, 294 Plasma jet, 422 Pricing strategies Plied yarns, 243 basic pricing decisions, 319, 320 Plotting, 393 cost-based, 321, 322 Plush elastic, 565 demand-based, 322 Ply, 460, 461 discounts and allowances, 323-325 Ply alignment, 403 legal restrictions, 325, 326 Pneumatic equipment, 496 odd price endings, 323 Pocketing fabrics, 619 price level, 320 Pockets, 118 price lining, 323 Polyester threads, 459 Primary sources, 198 Portable knives, 412-414 Print manager, 129 Positioning, 167 Printing process, 596 Positioning attachments, 495 Private brands and labels, 47, 49 Positioning devices, 407 Privately owned, 10 Postadoption product development, 160 Postadoption samples, 177–182 Process, 347 Process analysis and control, 348–351 Postcure durable press, 122 Process-oriented layout, 334, 335 Postproduction quality assurance, 216, 217 Process simulation, 380 Potential capacity, 270 Produce against forecast, 230 Power system, 414 Producer goods, 194 Preadoption product development, 160 Product all-through, 36, 37 Precosting, 169, 305 Product analysis. See Garment analysis Predetermined motion/time systems, 356, Product change, 66-71 357 Product development, 83-85 Preliminary costing, 305 Product development costs, 315 Preproduction operations, 389-425 Product development team, 207 cut order planning, 390-392 Product differentiation, 36 cutting, 410-423. See also Cutting Product identification, 234, 235 marker making, 392-399 spreading, 399-409. See also Spreading Product line, 64 Product managers, 129 Preproduction quality assurance, 208 Product-oriented (line) layout, 333, 334 Press fasteners, 561

Product positioning strategy, 106-108 production management of sourced Product standards and specifications, goods, 287, 288 137-154 quality management of sourced goods, bids/contracts, 144, 145 286, 287 communicating product descriptions, terminology, 276 143, 144 vendor selection, 283-285 floor-ready specifications, 152 Production sourcing specialists, 130 government specifications, 144, 145 Production specifications, 146 international standards, 138, 139 Production standards, 273, 307, 350, 351 licensing, 146, 147 Production strategies, 266-268 performance standards, 140-142 Production systems, 337–347 product consistency, 144 combinations of systems, 347 quality standards, 140 modular production system, 341-347 size and fit standards, 140 progressive bundle system, 337-339 sources of standards, 138, 139 unit production system, 339-341 specifications, 142 Production tolerances, 182 tolerance, 150 Productive capability, 271 writing specifications, 147-152 Productivity, 365-367 Product tolerances, 182 Productivity index, 371 Product variation, 201 Productivity of direct labor, 370-372 Production, 24, 25 Profit, 11, 293 Profit and loss statement, 294, 295 Production capacity, 270-275 Production concepts, 268 Profit sharing, 370 Production management, 365–388 Progress function, 275 Progressive bundle system (PBS), 337-339 equipment management/plant modernization, 379-386 Pronged rings, 561 human resource management, 367–377 Proprietorship, 10 inventory management, 377-379 Protecting rights to merchandising productivity concepts, 365-367 properties, 55-57 Production managers, 130, 266 Protocol, 382 Production pattern makers, 130 Publicly owned, 10 Production patterns, 176 Pull-through, 36 Pull-through production, 344 Production planners, 130 Production planning, 269–276 Punchers, 585–588 Production processes, 347–351 Purchasing agents, 232 Production samples, 177, 286 Push-through, 36 Production sourcing, 276-289 Put-ups, 239, 463 codes of conduct, 276-278 domestic sourcing, 280, 281 QA, 203 financial options, 278-280 QC, 203 international sourcing, 281-283 QR. See Quick response (QR) international trade assistance, 282, 283 Qualitative research methods, 37 logistics/customs issues, 289 Quality, 5, 6, 201 product preparation, 284-286 Quality Assurance (QA), 203

Quality assurance managers, 131	Quick response (QR)
Quality auditors, 283	expectations, 200
Quality audits, 216	merchandising calendar, and, 62, 63
Quality control (QC), 203	overview, 22, 23
Quality control engineers, 131	Quota, 15, 277
Quality cost indexes, 220	
Quality cost per dollar of sales, 220	Raschel knit, 593
Quality cost per unit, 220	Raschel knitted fabrics, 249, 250
Quality costs per direct labor hour, 220	Rate of product change, 66, 68
Quality costs per manufacturing dollar,	Real time, 341
220	Realistic tolerance, 150
Quality management, 193-223	Reece button sewer, 554, 555
acceptance sampling, 212-214	Registered trademark, 56
cost-benefit analysis, 217–220	Registration targets, 595
finished garment evaluation, 215	Reject, 150
global textile complex, 194-200	Related separates, 65
inspection, 211, 212	Remnant marker, 392
laboratory testing, 208–210	Remnants, 239
mill flow/general repair, 215, 216	Repetitive motion disorders (RMD), 359
monitoring garment assembly process,	Required capacity, 228, 271
214, 215	Research and development (R&D), 384,
organizational structures, 205–209	385
postproduction quality assurance, 216,	Resins, 530
217	Retail buyers, 82, 131, 233
preproduction quality assurance, 208	Retail displays, 87
product variation/defect classification,	Retail level, 9
201–203	Retail merchandisers, 62
quality assurance during production,	Retail sales associates, 132
210–216	Return on investment (ROI), 321
quality assurance policy, 203–205	Returned merchandise, analysis of, 217
returned merchandise, analysis of, 217	Revenue, 293
sourced goods, 286, 287	Rib trims, 578
statistical quality control, 212	Ribbons, 575
trends, 221	Rigid specifications, 150
Quality manual, 203, 204	Rise, 618
Quality of seams, 121	Robotics, 482
Quality of stitches, 121	Robotized machines, 486
Quality policy, 203–205	ROI, 321
Quality specifications, 348	Rotary hook, 431
Quality standards, 140, 205	Rotary knives, 413
Quantitative research methods, 37	Round knives, 413
Quantity discounts, 324	Routing, 274, 338
Quick/Cord, 566	Royalty, 52
Quick costing, 169	Rubber buttons, 547
quien cosume, 100	

Seasonal discounts, 324

Ruboffs, 156, 163 Seasonal goods, 68 Running stitches, 588 Seasonal/staple continuum, 69 Second, 150 S twist, 460 Secondary sources, 198 Safety stitches, 440 Sectioned markers, 394 SAHs, 271, 307 Selling periods, 41, 62, 66 Salaries, 368 Semiautomatic machines, 484 Sales forecast, 37 Separable zippers, 543 Sales forecasting, 37, 38 Separate devices, 494 Sales projections, 37 Separates, 65 Sales representatives, 40, 132 Serged/serging, 439, 623 Sales samples, 85, 177 Servo-cutting system, 416 Sample makers, 168 Sew-in interlinings, 520, 521 Samples, 168, 169 Sewability of thread, 456 Sampling plans, 213 Sewing channels, 566 SAMs, 271, 307 Sewing machines Scale of design, 166 bed type, 487, 488 Scheduling, 274 casting, 487 Schiffli embroidery machines, 580, 581 feeding system, 490-493 Scoops, 540 lubrication systems, 488, 489 Screen making, 595 speed potential, 493, 494 Screen materials, 595 stitch-forming mechanisms, 489, 490 Screen printing, 594-597 Sewing threads, 456-467 Seam allowance, 441 characteristics, 457-464 Seam appearances, 470-472 classifications, 465 Seam classes, 441–453 color, 461 Seam depth, 441 fiber content, 457, 458 Seam dimensions, 441 finishes, 461, 462 Seam elasticity, 472 functions, 456, 457 Seam flexibility, 473 ply, 460, 461 Seam grin, 474 put-up, 462-464 Seam heading, 441 thread size, 462 Seam length, 441 thread strength, 462 Seam performance, 472, 473 thread structure, 458-460 Seam problems, 474–476 twist, 460 Seam pucker, 470 Sewn shoulder pads, 532 Seam slippage, 476 Shade marking, 423 Seam strength, 473 Shading, 121, 255 Seam width, 441 Shanked buttons, 549, 551, 552 Seams, 428, 440, 441. See also Stitched Sharpening devices, 414 and seams Shear strength, 568 Season ship complete, 42 Shelf appeal, 85, 124 Seasonal change, 5 Shipping, 289

Shipping terms, 325

China Car Man's duoga abinta	Sockets, 560
Shirts. See Men's dress shirts	Soft cotton threads, 461
Short range, 297	Solvron, 594
Short-term planning, 269	Sourcer, 280
Shorts, 239	Sources of production. See Production
Shoulder pad coverings, 533	
Shoulder pads, 531–533	sourcing
Shoulder seams, 610	Sourcing, 225. See also Materials sourcing
Shrinkage, 257, 514, 523	and selection
Shuttle, 431	Special-purpose machines, 484–486
Silhouette, 112	Special sewing and finishing
Silver-knitted pile fabrics, 249, 250	specifications, 182
Simulation, 380, 381	Specialty contractors, 9, 279
Simulation systems, 183	Specialty fibers, 458
Single-head embroidery machines, 581,	Specialty thread, 460
582	Special 301 provisions, 57
Single-piece hand-off, 345	Specification programs, 185, 186
Single sample plan, 213	Specification writers, 132
Single-thread chain stitch, 436	Specifications, 138, 142. See also Product
Sit/stand approach, 361	standards and specifications
Size and fit specifications, 178	Spectrophotometer, 461
Size consistency, 182	Speed sourcing, 280
Size indicators, 110, 111	Splice marks, 395
Size labels, 599	Splicing loss, 409
Size specifications, 178	Split yokes, 641
Size standards, 144	Spools, 463
Sizing and fit, 108–114	Spot prices, 198
Sizing standards, 112–114	Spread, 399
Sizing system, 109	Spreader, 437
Skew, 256	Spreaders, 490
Skill center, 334, 335	Spreading
Skill set, 125	costs, 408, 409
Skipped stitches, 474	defined, 399
Slack tension, 403	equipment, 405–408
Slasher, 412, 413	fabric waste, 409
Sleeve fit, 633	overview of process, 400, 401
Sleeve headers, 533	quality, 401–404
Sleeve plackets, 639	setup, 404, 405
Sleeves, 118	Spreading equipment, 405
Slider, 542	Spreading machines, 406, 407
Slip ease, 525	Spreading modes, 400
Sloper, 168	Spreading surfaces, 405
Smooth multifilament thread, 459	Spreading tables, 405, 406
Snap back, 257	Spun yarns, 458
Snaps, 559–562	SQC, 212
Snaps, 555-562	Sq0, 212

Common alexantital 440	
Square edge stitch, 440	Stitch width, 429
Squeegee, 595	Stitches and seams
SS class, 442	definitions, 428
Stackers, 486	seam classes, 441–453
Standard allowed hours (SAHs), 271, 307	specifications, 453–455
Standard allowed minutes (SAMs), 271,	standards, 428
307	stitch classes, 430–440
Standard conditions, 348	stitch properties, 428-430
Standard data, 357	stitching classes, 453
Standard labor cost, 310	Stitches per inch (spi), 428
Standard Practice for Stitches and Seams,	Stitching, 428
428, 442	Stock keeping unit (SKU), 76
Standard test methods, 150	Stockholder, 10
Standards, 137. See also Product	Store brands, 47
standards and specifications	Straight buttonholes, 557
Staple goods, 68	Straight stitch, 431
Staples, 198	Strategic planning, 20
Start to ship, 42	Stretching, 595
Start-up costs, 313	Strike back, 523
Start-up curve, 275	Strike through, 523
Static efforts, 360	Stringers, 540
Static electricity, 404	Strip cutter, 416
Stationary cutters, 414	Structural design, 116, 246
Statistical quality control (SQC), 212	Structural style specifications, 178
Status pricing, 322	Studs, 560
Stays, 534	Style, 64
Steam, 498	Style blocks, 168
Steam generators, 504	Style costing sheet, 312
Steam tunnels, 502	Style evaluation, 174
Steamers, 502	Style features, 82
Steil stitches, 588	Style number, 64, 172
Stencil, 595	Style release, 42
Stepped spread, 395	Style sample, 177
Stepping motors, 497	Style samples, 284
Stitch and seam types, 119	Style specification, 178
Stitch classes, 430–440	Style specification sheet, 181
Stitch consistency, 430	Style specifications, 148
Stitch depth, 429	Styling, 66, 68
Stitch-forming devices, 429	Styling ease, 167
Stitch-forming systems, 489	Subcontractor, 277
Stitch length, 428, 429	Superimposed seam (SS) class, 442
Stitch size, 428	Supplier, 227
Stitch tongues, 490	Supplier credibility, 240, 241
	,

Support materials, 511-536	product quality and consistency, 182,
adhesives, 530, 531	183
collar stays, 534	production patterns and grading, 176,
interlinings, 515–524. See also	177
Interlinings linings, 524–529	style specifications/detail costing, 178–182
purposes, 512–515	Technical designers, 132, 133
shoulder pads, 531-533	Technical fabric design systems, 184
sleeve headers, 533	Template programs, 184
tapes, 533, 534	Temporary finishes, 250
Support or shaping materials, 115	Ten Point System, 258
Support staff, 367	Tension, 403
Sweatshops, 17, 18	Tension pucker, 471
Swiss embroidery, 583	Tensioning, 406
Symmetric, 165	Tensioning devices, 489
Symmetric fabric, 398	Test methods, 142
Synthetic fibers, 242	Tex, 243
Synthetic, thermoplastic fibers, 458	Textile complex. See Global textile
	complex
T-shirts, 605–612	Textile Fiber Products Identification Act
assembly, 609–611	(TFPIA), 50
finishing, 611, 612	Textile performance standards, 259–261
materials, 607, 608	Textile technologies, 133
presentation, 612	Textiles/Clothing Technology Corporation,
product positioning strategies, 605	381
sizing/fit, 606, 607	Textured filament thread, 459
spreading/cutting, 609	TFPIA, 50
Tab extension, 614	Theory of constraints, 332
Tack buttons, 552, 553	Thermal comfort, 525
Tactile comfort, 525	Thermal registration, 598
Tailings, 199, 239	Thread, 115. See also Sewing threads
Tape cutters, 497	Thread breakage, 476
Tapes, 533, 534, 575	Thread costs, 465
Target market, 30	Thread cutters, 497
Target ROI, 322	Thread guides, 489
Tariff, 15	Thread lubrication, 462
Team-based system, 342, 343	Thread packages, 462
Team incorporating management	Thread put-up, 462–464
representatives, 206	Thread shanks, 551
Teams of production workers, 207	Thread size, 462
Technical design, 72, 84, 173–183	Thread take-up, 489
perfection of style and fit, 173–175	Thread tension, 429, 430
postadoption samples, 177–182	301 lock stitch, 431–434

Throat plates, 491
Throughput, 333
Throughput time, 268
Throughput volume, 268
Ticket number, 462
Tickets, 88, 124
Time analyst, 353
Time-based competition, 22
Time study, 353
Time study sheet, 354, 355
Tolerances, 150, 182
Top and bottom cover stitches, 440
Top back, 118
Top feeds, 492
Top front, 118
Toppings, 565
Total quality management (TQM), 203
Toyota Sewing System (TSS), 345
TQM, 203
Trade advisor, 282
Trade balance, 14
Trade deficit, 14
Trade discount, 323
Trade shows, 384, 385
Trademark symbol, 56
Trademarks, 46, 56
Training and development, 373–377
Training programs, 374
Transhipment, 17, 277
Transsimplient, 17, 277 Trapunto, 589
Trend directors, 133
Tricot fabrics, 249, 250 Trimming, 122
Trims, 115, 573–603
aesthetic/performance, 575, 576
appliqués, 591, 592
digital printing, 598, 599
embroidery, 578–591. See also
Embroidery
heat transfer prints, 597
knit, 577, 578
labels, 599–602
lace, 593, 594

screen printing, 594–597 sources of, 576, 577 types, 574, 575 unset trims, 592 Tropical worsted, 619 TSS, 345 Tunnel elastics, 565 Twist, 460 Twist balance, 460 2/10 net 30, 324 Two-thread stitch, 438

Ultrasonic welding, 467 Underarm seam, 611 Underarm/side seams, 643 Underlap, 625 Underpressing, 120, 623 Unfair trade practices, 325 Unique original design, 237 Unit, 76 Unit production system (UPS), 339-341 U.S. Customs Service, 15 United States Federal Stitch and Seam Specifications, 428 Unlined garments, 528 Unset trims, 592 Up and down, 165 UPS, 339-341

V-necks, 611
Vacuum systems, 504
Validation costs, 315
Value-added manufacturing, 266
Variable base rates, 369
Variable costs, 297
Variation, 150
Variety, 76
Variety hypothesis, 14
Vegetable ivory buttons, 550
Vendor, 280
Vendor selection, 283–285
Venise lace, 593
Vertical integration, 12, 194

Vertical straight knives, 412
Vestibule training, 376
Vicones, 463
Visual inspection, 97, 98
Visual merchandisers, 133
Visual merchandising, 87
Volume, 76
Volume per SKU, 76, 80
Volume per SKU for the assortment
(VSA), 76
VSA, 76

Wadding, 532 Waistbands, 627 Waistline curtain, 620 Waistline treatments, 118, 614 Warp knitting, 578 Waste, 396 Watch pocket, 615 Water jet cutting, 421 Weight, 116 Welding, 467 Wet processing, 122 Wholesale price, 319 Width (widths), 166, 394 Width indicators, 407 Width loss, 409 Width variations, 256 Wiper, 497 Work aids, 494-498 Work environment, 358 Work flow, 332 Work in process, 268, 269, 333 Work measurement, 353-358 Work sampling, 357

Work station, 361
Work station layout, 362
Work study, 351
Work zone, 345
Workstation, 486
World Trade Organization (WTO), 15
Worth Street Textile Market Rules, 199, 200, 247–250
Woven elastics, 565
Woven interlinings, 518
Woven textile goods classified for marketing, 247
Wrapped thread shanks, 551
WTO, 15

Yarn number, 243 Yarn quality and size, 243, 244 Yarn severance, 476 Yarn type and size, 116 Yokes, 640, 641

Z twist, 460
Zero tolerances, 150
Zipper plackets, 625
Zipper pulls, 542
Zipper stops, 543
Zipper tapes, 543
Zippers
application, 544, 545
defined, 539
nonseparating, 543, 544
parts of, 540–543
separable, 543
terminology, 541